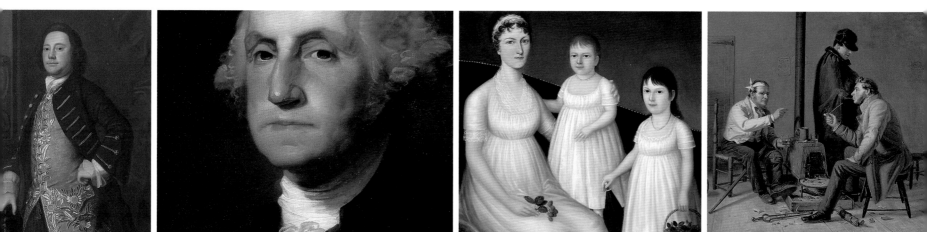

1837

1800

1860

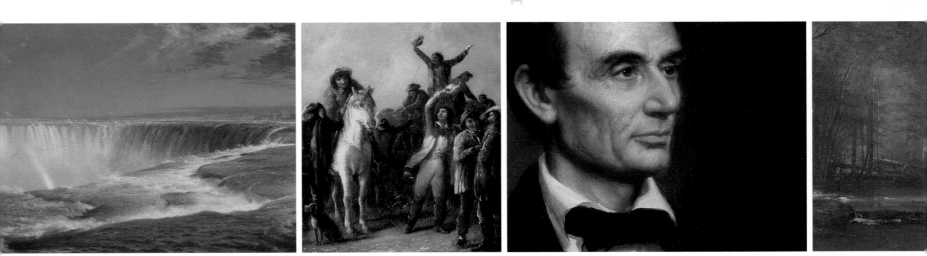

Corcoran Gallery of Art, Washington, D.C.
in association with Hudson Hills Press, Manchester and New York

Corcoran Gallery of Art

AMERICAN PAINTINGS TO 1945

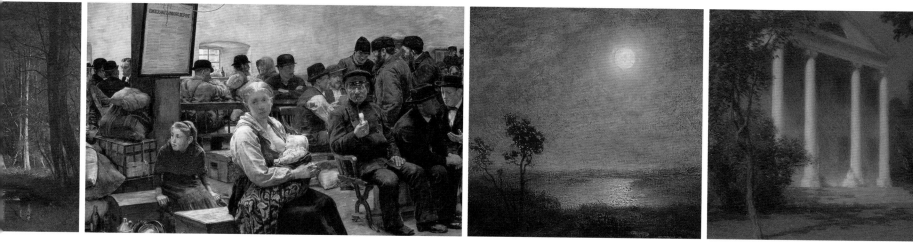

1906

Sarah Cash, Editor

in collaboration with
Emily Dana Shapiro
Lisa Strong

with contributions by

Jennifer Carson

Sarah Cash

Lee Glazer

Adam Greenhalgh

Franklin Kelly

Susan G. Larkin

Valerie Ann Leeds

Crawford Alexander Mann III

Randall McLean

Ellen G. Miles

Dorothy Moss

Asma Naeem

Laura Groves Napolitano

Jennifer Raab

Katherine Roeder

Emily Dana Shapiro

Marc Simpson

Paul Staiti

Lisa Strong

Ann Prentice Wagner

Jennifer Wingate

NATIONAL
ENDOWMENT
FOR THE ARTS

Major support for this project has been provided by The Henry Luce Foundation, Inc.; The Getty Foundation; the National Endowment for the Arts; The Page and Otto Marx, Jr. Foundation; Martha A. Healy; Ambika Kosada, James Atwood, and Richard Atwood in memory of Joyce Rose Atwood; and Furthermore: a program of the J.M. Kaplan Fund, Inc.

Published by the Corcoran Gallery of Art
500 Seventeenth Street, N.W. Washington, D.C. 20006
www.corcoran.org

Published in association with Hudson Hills Press LLC
3556 Main Street, Manchester, Vermont 05254

Distributed in the United States, its territories and possessions, and Canada by National Book Network, Inc. Distributed outside North America by Antique Collectors' Club, Ltd.

Publisher and Executive Director: Leslie Pell van Breen
Founding Publisher: Paul Anbinder

Library of Congress Cataloging-in-Publication Data
Corcoran Gallery of Art.
 Corcoran Gallery of Art : American paintings to 1945 / Sarah Cash, editor ; in collaboration with Emily Dana Shapiro, Lisa Strong ; with contributions by Jennifer Carson . . . [et al.].
 p. cm.
 Includes bibliographical references and index.
 ISBN 978-1-55595-361-4
 1. Painting, American—Catalogs. 2. Painting—Washington (D.C.)—Catalogs. 3. Corcoran Gallery of Art—Catalogs. I. Cash, Sarah. II. Shapiro, Emily Dana. III. Strong, Lisa Maria, 1966–. IV. Carson, Jennifer. V. Title. VI. Title: American paintings to 1945.
 ND205.C582 2011
 759.13074'753—dc22 2010042555

Produced by Marquand Books, Inc., Seattle
 www.marquand.com

Front and back covers: Albert Bierstadt, *Mount Corcoran*, detail, 141

Page 1: Joseph Blackburn, *Portrait of a Gentleman*, detail, 49; Gilbert Stuart, *George Washington* (26.172), detail, 59; Joshua Johnson, *Grace Allison McCurdy (Mrs. Hugh McCurdy) and Her Daughters, Mary Jane and Letitia Grace*, detail, 63; William Sidney Mount, *The Tough Story—Scene in a Country Tavern*, detail, 83

Page 2: Frederic Edwin Church, *Niagara*, detail, 114–15; Alfred Jacob Miller, *Election Scene, Catonsville, Baltimore County*, detail, 125; George Peter Alexander Healy, *Abraham Lincoln*, detail, 122; Worthington Whittredge, *Trout Brook in the Catskills*, detail, 139

Page 3: Worthington Whittredge, *Trout Brook in the Catskills*, detail, 139; Charles Ulrich, *In the Land of Promise, Castle Garden*, detail, 167; Ralph Albert Blakelock, *Moonlight*, detail, 169; Willard LeRoy Metcalf, *May Night*, detail, 193

Page 12: Albert Bierstadt, *Mount Corcoran*, detail, 141

Page 46: Willard LeRoy Metcalf, *May Night*, detail, 193; John Sloan, *Yeats at Petitpas'*, detail, 201; Frank Weston Benson, *The Open Window*, detail, 217; Emil Carlsen, *The Picture from Thibet*, detail, 225

Page 47: Guy Pène du Bois, *Pierrot Tired*, detail, 239; Aaron Douglas, *Into Bondage*, detail, 247; Edward Hopper, *Ground Swell*, detail, 249

Project Director and General Editor: Sarah Cash
Copyedited by Fronia W. Simpson
Proofread by Laura Iwasaki
Indexed by Candace Hyatt
Designed by Jeff Wincapaw
Layout by John Hubbard
Typeset by Marissa Meyer
Color management by iocolor, Seattle
Printed and bound in China by Artron Color Printing Co., Ltd.

Contents

Director's Foreword

The Corcoran Gallery of Art's *American Paintings to 1945* is a landmark publication for this institution. As the first volume in nearly half a century to extensively research, document, and interpret the Corcoran's outstanding collection of American paintings, it fills a substantial void in scholarship on our many canonical works of American art as well as the history of art patronage and institutional collecting.

Begun in 1850 and donated to the institution nearly twenty years later, William Wilson Corcoran's private collection has grown to become one of the nation's finest and most important holdings of historic American art. Comprising more than five hundred objects dating from 1718 to 1945, the collection now includes a remarkable number of iconic works in all genres of American painting from the mid-eighteenth to the mid-twentieth century. This list includes Samuel F. B. Morse's *The House of Representatives* (1822), Rembrandt Peale's *Washington before Yorktown* (1824–25), Thomas Cole's *The Departure* and *The Return* (1837), Frederic Edwin Church's *Niagara* (1857), John Singer Sargent's *En route pour la pêche* (1878), Thomas Eakins's *Singing a Pathetic Song* (1881), Albert Bierstadt's *The Last of the Buffalo* (1888), George Bellows's *Forty-two Kids* (1907), and Aaron Douglas's *Into Bondage* (1936). It also boasts outstanding breadth and depth in Hudson River School painting, nineteenth-century portraiture and genre painting, American Impressionism, and early-twentieth-century realism.

This catalogue and its companion section of the Corcoran's website document years of research by many scholars, highlighting the institution's commitment to the study and display of its permanent collection. It offers the most comprehensive and up-to-date interpretation of the museum's renowned collection of historic American paintings. Special thanks must go to Bechhoefer Curator of American Art Sarah Cash, who conceived this project in 2003 and has since served as project director and editor of this volume. Her introductory essay provides the first in-depth examination of the institution's long history of collecting and supporting American art.

Such a project could not have been completed without the support of a number of foundations, institutions, and private contributors. The Henry Luce Foundation provided the first crucial gift, which allowed this project to take shape. The foundation's generosity was followed by major contributions from the Getty Grant Program and the National Endowment for the Arts, among many others. Each was essential to support the exhaustive research that underpins the essays published in this book. Their philanthropy has been rewarded by a publication that will enlighten readers for generations to come.

Fred Bollerer
Director and Chief Executive Officer
Corcoran Gallery of Art / Corcoran College of Art + Design

Acknowledgments

This catalogue of the Corcoran Gallery of Art's historic American paintings, which comprises the present volume and an accompanying section of the Corcoran's website, featuring exhaustive documentation on individual paintings, was conceived in 2003 as a publication that would fill a long-acknowledged need for scholarship on the museum's signature holdings. It builds on the several fine publications that have addressed aspects of the collection over the years, while presenting the first thorough scholarship. The only modern catalogue of the collection was published in two volumes, in 1966 and 1973. The result of pioneering efforts by curator Dorothy W. Phillips, it illustrated in black and white only a few of the works included and limited discussion to biographical information on the artists represented. Most important, the present volume is dependent on the remarkable vision of the individuals who have built the Corcoran's world-renowned American paintings collection, beginning with William Wilson Corcoran and the gallery's first curator, William MacLeod, and continuing to the dedicated later-twentieth-century curators Phillips and Linda Crocker Simmons.

A project of this scope, duration, and complexity necessarily incurs many debts. Fred Bollerer, the Corcoran's Director, Paul Greenhalgh, President and Director from 2006 to 2010, and Philip Brookman, Chief Curator, along with the Board of Trustees, have strongly supported this vital collections documentation project.

My most important debt of gratitude is to Emily Dana Shapiro, who served as Assistant Curator of American Art from 2004 to 2008. Emily came to the Corcoran as a Research Fellow in 2003, shortly after the project's inception, and assisted with nearly every aspect of its development, from selecting featured works to soliciting essayists to reading the final manuscript. Emily was also responsible for helping develop and supervise the extensive, multiyear endeavor of thoroughly researching the provenance, exhibition history, and historical context for each of the featured paintings. I am also deeply grateful to Lisa Strong, who joined the catalogue in early 2009 as Project Manager, energetically embracing complex details of budgeting, schedule management, organizing photographs, and cataloguing data at a critical juncture. This volume simply would not exist without Emily's and Lisa's tenacity, intellectual mettle, and unwavering collegiality and friendship.

The Corcoran Gallery of Art staff, present and former, has provided invaluable support with every aspect of this publication, beginning in its earliest stages. In particular, I would like to thank Jennifer Adams, Mario Ascencio, Michael Baltzer, Amanda Bloomfield, Kate Denton Earnest, Ila Furman, Kate Gibney, Cory Hixson, Andrea Jain, David Jung, Douglas Litts, Janice Marks, Debbie Mueller, Pat Reid, Brian Sentman, Jacquelyn Days Serwer, and Nancy Swallow.

Dare Hartwell, Director of Conservation, spearheaded the enormous task of performing technical examinations on each of the 102 works featured in the catalogue. In this effort she was aided by several expert colleagues who examined paintings within their area of expertise: Sian Jones, Lance Mayer, Gay Myers, Barbara Ramsay, and Elizabeth Steele. Marisa Bourgoin, Corcoran Archivist from 1993 to 2007, assisted with countless research questions, deftly located documents for Research Fellows, and shared her unsurpassed knowledge of William Wilson Corcoran and the history of the institution with me as I prepared the introductory essay.

I am very grateful to the contributing authors, who are listed on the title page. A number of these writers also served as Research Fellows over a period of four years: Jennifer Carson, Adam Greenhalgh, Randall McLean, Laura Groves Napolitano, Katherine Roeder, Emily Dana Shapiro, Lisa Strong, and Jennifer Wingate. The vast amount of new information compiled about the history of the collection, including the recovery of more than fifty original titles, dates, and attributions, and thorough provenances for all of the featured works, is the legacy of their skillful and dedicated work.

A number of talented young Corcoran interns also provided invaluable assistance over the course of this project: Matthew Bacon, Margaret Carragher, Aaron Cator, Andrew D'Ambrosio, Abigail Davis, Emma Dent, Diana Kaw, Margaret Morrison, Michael Raven, Heather Saeger, Ingrid Seggerman, Elizabeth Shook, Amy Torbert, and Victoria Yetter.

Several museum colleagues who have recently completed excellent American collection catalogues were of enormous assistance and support as we considered the different forms this project could take. For their input and support, I am most grateful to Teresa A. Carbone, Brooklyn Museum; James W. Tottis, formerly of the Detroit Institute of Arts; Pamela Belanger, formerly of the Farnsworth Art Museum; Thayer Tolles, The Metropolitan Museum of Art; Margaret C. Conrads, The Nelson-Atkins Museum of Art; and Linda Muehlig, Smith College Museum of Art.

I am also grateful to the manuscript's readers, Emily Dana Shapiro and Margaret C. Conrads, for their insightful comments on the essays. Their keen eyes and sharp intellects helped to bring clarity to the disparate voices showcased in the catalogue. I was delighted to collaborate once again with Fronia W. Simpson, who brought her matchless copyediting skills to the entire volume.

Ed Marquand and his team at Marquand Books expertly guided this volume to fruition. Managing Editor Brynn Warriner, Image Librarian/Media Manager Sara Billups, and Production Manager Keryn Means saw to myriad details and kept the book on schedule, and Jeff Wincapaw translated its many components into a clear and elegant design.

Deepest appreciation is due to the individuals and organizations that generously provided funding for the project. The seminal gift from The Henry Luce Foundation, Inc., whose long-standing support of American art research and publication projects has been essential to undertakings such as this one, was followed by contributions from the Getty Foundation; the National Endowment for the Arts; The Page and Otto Marx, Jr., Foundation; Martha A. Healy; Ambika Kosada, James Atwood, and Richard Atwood in memory of Joyce Rose Atwood; and Furthermore: a program of the J. M. Kaplan Fund, Inc. Additional support was provided by the Peters Family Art Foundation; Catherine Dail; James Graham and Sons; Max N. Berry; Debra Force Fine Art, Inc.; Conner•Rosenkranz, New York; Ted Cooper; Maryann and Alvin Friedman; Betty Krulik Fine Art, Limited; Arthur J. Phelan; Richard D. Chalfant; Diana Kaw; Lawrence W. Chakrin; and Marjorie S. Lindemann. Each of these gifts was essential for supporting the comprehensive biographical, provenance, and exhibition research that underlies each of these essays. Support for the photography of original frames included in the catalogue was provided by Eli Wilner and Company.

I would like to extend my warmest thanks to the many museum colleagues, librarians, archivists, art dealers, collectors, and other scholars in the United States and abroad who gave their time and energy to answering questions or sharing research as we prepared the catalogue. Many of those who helped are recognized in this volume's endnotes. A special debt is owed to William H. Gerdts, whose superb files resolved many of our quandaries and allowed us to compile more thorough histories of the Corcoran's objects than we had ever hoped to be able to do. The tireless Washington researcher Colonel Merl M. Moore, Jr., also assisted with many queries. Numerous scholars also provided specialized assistance with particular artists: Gerald Carr, Rowena Houghton Dasch, Peter Hassrick, Pamela Ivinski, Kenneth Maddox, Mark Mitchell, Alan Wallach, and James Yarnall. Valuable assistance was also provided by the outstanding staff of several Washington, D.C., research institutions. At the National Portrait Gallery and Smithsonian American Art Museum Library, which provided our Research Fellows with stack access and free photocopying, thanks go to Cecilia Chin, Alice Clarke, Douglas Litts, Patricia Lynagh, and Stephanie Moyes. The staff of the Archives of American Art, especially Marisa Bourgoin, Richard Manoogian Chief of Reference Services, and her predecessor, Judith Throm, made researchers' use of that incredible resource efficient and pleasant. The staffs of the Library of Congress, the National Gallery of Art Library, the Historical Society of the District of Columbia, and the Library of the Daughters of the American Revolution were also extraordinarily helpful to the many researchers on this project.

Sincere thanks also go to Phimister Proctor Church, A. Phimister Proctor Museum; Arnold Tunstall, Akron Art Museum; Ellen Alers; Jonathan Frembling, Jana Hill, Rebecca Lawton, Paula Stewart, and Rick Stewart, Amon Carter Museum; Elizabeth Botten and Richard J. Wattenmaker, Archives of American Art; Liana Radvak and Catherine Spence, Art Gallery of Ontario; Nancy Beahall, The Art Institute of Chicago; Sona Johnston, Baltimore Museum of Art; Laura St. Clair, Barbara Mathes Gallery; Linda Baumgarten; Ron Michael, Birger Sandzin Memorial Gallery; Graham Boettcher and Alexis Gould, Birmingham Museum of Art; Diane Goldman, B'nai B'rith Klutznick National Jewish Museum; David Dearinger, Boston Athenæum (formerly of the National Academy of Design Museum); Patricia Hills, Boston University; Jennifer Brathovde; Marianne LaBatto, Brooklyn College Library; Teresa A. Carbone and Karen Sherry, Brooklyn Museum; Christine C. Brindza and Mary Robinson, Buffalo Bill Historical Center; Russell Flinchum and Jonathan Harding, Century Association; Richard David Chalfant; Bruce Chambers; Jan Hiester, Charleston Museum; Kaye Crouch and Jochen Wierich, Cheekwood Botanical Garden and Museum of Art; Elizabeth Sterling and Eric Widing, Christie's; Laura Christiansen, Irene Roughton, and Matthew Wiggins, Chrysler Museum of Art; Julie Aronson, Mona L. Chapin, and Kristin Spangenberg, Cincinnati Art Museum; M'Lissa Kesterman, Cincinnati Historical Society Library; Dell Fillmore and Mary Lou Manzon, City University of New York Graduate Center; Mark Cole, The Cleveland Museum of Art; Del Moore, Colonial Williamsburg Foundation; Janet Kachinske and Jenny Wilkinson, Columbus Museum of Art; Janis Conner and Joel Rosenkranz, Conner•Rosenkranz; Gail Davidson, Cooper-Hewitt, National Design Museum; Aileen Ribeiro, The Courtauld Institute of Art;

Holly Keris, Cummer Museum of Art and Gardens; James Cunningham; Jenny Sponberg, Curtis Galleries; William Davis; Heather Campbell Coyle, Rachael Duffin, and Sarena Fletcher, Delaware Art Museum; Joan Troccoli, Denver Art Museum; Neil W. O'Brien, Dixon Gallery and Gardens; Jocelyn Todisco, Evansville Museum of Arts, History, and Science; Karen Convertino, Everson Museum of Art; Norman Flayderman; John Ollman, Fleisher Ollman Gallery; Noel Frackman; Estelle Freidman; Kinney Frelinghuysen, Frelinghuysen Morris House and Studio; Lydia Dufour, The Frick Art Reference Library; Tricia Miller and Annalies Mondi, Georgia Museum of Art; Abigail Booth Gerdts; Tobie Anne Cunningham, Carole Klein, and April R. Miller, Gilcrease Museum; Johanna Plant, Glenbow Museum; Miriam Stewart, Harvard Art Museum, Fogg Art Museum; Jane LeGrow and Jennifer Y. Madden, Heritage Museum and Gardens; Rose Merola and Zachary Ross, Hirschl & Adler Galleries; Catherine N. Howe; Brigitta Bond, James A. Michener Art Museum; Richard J. Ring, John Carter Brown Library; Richard Ormond, John Singer Sargent Catalogue Raisonné; Peter Konin, Joslyn Art Museum; Cynthia A. Weiss, Kendall-Young Library; Edye Weissle, Knoedler and Company; Sherry Spires, Knoxville Museum of Art; Marie Charles, Lachaise Foundation; Thomas Cook and Thomas Breslin, Letchworth State Park; Amie Alden, Livingston County Historical Society; Sandra Nixon, Mackenzie Art Gallery; Dorothy MacMullen, Marshfield Historical Society; Kip Peterson, Memphis Brooks Museum; Kevin J. Avery, Carrie Rebora Barratt, Virginia Budny, Robyn Fleming, Linda Seckelson, and Thayer Tolles, The Metropolitan Museum of Art; Dawn Frank and L. Elizabeth Schmoeger, Milwaukee Art Museum; Martha Mayberry and Katherine Stocker, Mint Museum; Patterson Sims and Gail Stavitsky, Montclair Art Museum; Maureen O'Brien, Museum of Art, Rhode Island School of Design; Laila H. Abdel-Malek, Erica E. Hirshler, Patrick Murphy, Ursula Murphy, and Karen Quinn, Museum of Fine Arts, Boston; Amy Scott, The Museum of Fine Arts, Houston; Louise Reeves, Museum of Fine Arts, St. Petersburg, Florida; Eve Lambert, The Museum of Modern Art; Hilary Anderson, Museum of Our National Heritage; Art Martin, Muskegon Museum of Art; Stephen Z. Nonack, Paula Pineda, Marshall Price, and Bruce Weber, National Academy Museum; Karen Whitecotton, National Cowboy and Western Heritage Museum; Nancy Anderson and Charles Brock, National Gallery of Art, Washington, D.C.; Cyndie Campbell and Steven McNeil, National Gallery of Canada; D. Chris Cottrill and Paul F. Johnston, National Museum of American History, Smithsonian Institution; James Barber, Brandon Brame Fortune, Ellen Miles, and David Ward, National Portrait Gallery, Smithsonian Institution; Maurita Baldock and Kimberly Orcutt, The New-York Historical Society; Ronald Burch, New York State Museum; Jeremy V. Moy, Mary Kate O'Hare, and William A. Peniston, The Newark Museum; Bertram Lippincott III, Newport Historical Society; Everl Adair and Carol Lurie, Norton Museum of Art; Christine Oaklander; Barbara A. Wolanin, Office of the Architect of the Capitol; Kayla Carlsen and Evelyn Trebilcock, Olana State Historic Site; Estill Curtis Pennington; Cheryl Leibold and Anna O. Marley, Pennsylvania Academy of the Fine Arts; Kathleen A. Foster and Mark Tucker, Philadelphia Museum of Art; Darcy Claybourne and Thomas E. Young, Philbrook Museum of Art; Rusty Freeman, Plains Art Museum; Lauren Silverson, Portland Museum of Art (Maine); Virginia H. Pifko, Princeton University Art Museum; Sara Desvernine Reed; Laura A.

Foster, Remington Museum; Debra Royer, Rex Arragon Library, Portland Art Museum (Oregon); Douglass Dell, Museum of Art, Rhode Island School of Design; Andrew Potter, Royal Academy of Arts Library; Henry Duffy, Saint-Gaudens National Historic Site; Darlene Leonard, Saint Lawrence University Archives; Pat Boulware, Norma Syndalar, and Clare M. Vasquez, Saint Louis Art Museum; James Grebl, San Diego Museum of Art; Heather Brodhead, Santa Barbara Museum of Art; Richard Saunders; Sarah Woolworth, Sarah Woolworth Fine Art; Robert W. Torchia, Schwarz Gallery; John Davis, Smith College; Betsy Anderson, Robin Dettre, Fiona Griffin, George Gurney, Eleanor Harvey, and Christine Hennessey, Smithsonian American Art Museum; Rebecca Cooper, Society of the Cincinnati Library; Lauren Began, Sotheby's; Carole Lowrey and Lisa N. Peters, Spanierman Gallery, LLC; Richard Stamm; Richard Hunter, Stark Museum of Art; Cody Hartley, Sterling and Francine Clark Art Institute; Devon Larsen, Tampa Museum of Art; Stephanie Lathan, Telfair Museum of Art; Tom Rohrig, Texas Tech University Library; Nicole M. Rivette and Michael D. Ryan, Toledo Museum; Betty Moore, Tuck Museum; Carrie T. Hayter, The Union League Club; Annette Stott, University of Denver; Doris Peterson, University of South Dakota; Susan Beagley, Valerie Carberry Gallery; Suzanne Freeman, Virginia Museum of Fine Arts; Siobhan Wheeler, Vose Galleries; Edward G. Russo, Wadsworth Atheneum Museum of Art; Nancy Patterson, The Walters Art Museum; Laura Muessig, Weisman Art Museum; Ashlee Whitaker; Barbara Haskell, Kristen Leipert, and Sasha Nicholas, Whitney Museum of American Art; David A. Yutzey, Windham Historical Society; Debby Aframe and Tiffany Racco, Worcester Art Museum; Suzanne Greenawalt, Lisa Hodermarsky, and Elise K. Kenney, Yale University Art Gallery; Laura Tatum, Yale University Library; and Lila Fourhman-Shaull, York Heritage Trust.

As the director of the catalogue, I would like to offer a personal reflection. Over its years of preparation, a number of friends have offered unwavering support; besides Emily Shapiro and Lisa Strong, who provided daily collegiality and reinforcement, those at a greater distance include Teresa A. Carbone, Margaret C. Conrads, Erica E. Hirshler, Thayer Tolles, and Sylvia Yount. Closer to home, this project has been a presence in my life nearly as long as my son, Colin; to him and to my husband, Glenn R. MacCullough, I owe deep gratitude for their patience and support.

I have been deeply honored to oversee a project that renders the Corcoran's fascinating history and holdings accessible to the field of American art and to future generations of museum visitors. As such, I hope this contribution to the tradition of collections stewardship upheld with such dedication by my predecessors will inspire all who have the good fortune to mine the rich American paintings collection of this distinguished institution.

Sarah Cash
Bechhoefer Curator of American Art
Corcoran Gallery of Art, Washington, D.C.
January 2010

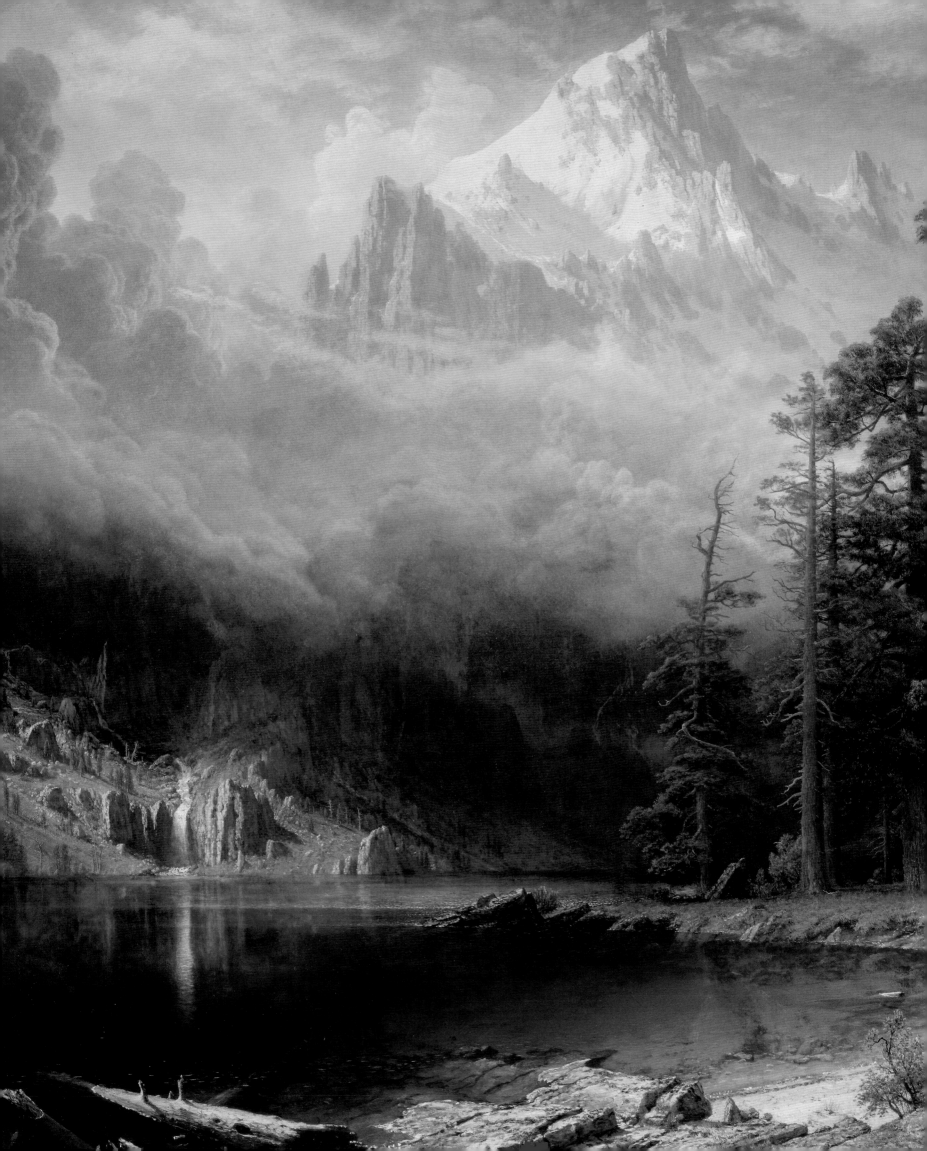

Sarah Cash "Encouraging American Genius":
Collecting American Art
at the Corcoran Gallery of Art

The Corcoran Gallery of Art occupies a unique and venerable position in the history of American culture. Founded in 1869 with the personal art holdings of the Washington banker and philanthropist William Wilson Corcoran (1798–1888), it was the country's first cultural institution to be established expressly as an art museum.[1] Moreover, it was the first gift of an art museum of substantial size to the American public by a single individual and, as such, established a paradigm for cultural philanthropy in the young nation. Its successful charter was testament to the vision, perseverance, and generosity of its namesake, particularly in a city that, relative to New York, Boston, or Philadelphia, was something of a cultural backwater in the middle of the nineteenth century. Since the gallery's founding, its core holdings of American paintings and sculpture, complemented by European examples, have expanded to become a world-renowned collection that also encompasses works of art on paper, photography, media arts, and decorative arts. The American paintings collection—the focus of this catalogue and its companion component on the Corcoran's website—traces its roots to the start of Corcoran's collecting of American art, which had begun by at least 1850. In that year he made his first known acquisition of an American canvas, Daniel Huntington's *Mercy's Dream*, close on the heels of his first European art-buying trip, in 1848.[2] What began modestly with a few European paintings, followed by the purchase of the Huntington and of a handful of genre scenes and Hudson River School landscapes, soon evolved into one of the premier private collections in nineteenth-century America. This essay traces the development of the Corcoran's holdings of American paintings and sculpture, beginning with Corcoran's earliest acquisitions and continuing through the publication of this volume. Since no such account can be comprehensive, this one highlights the most important episodes in the fascinating history of the institution.[3]

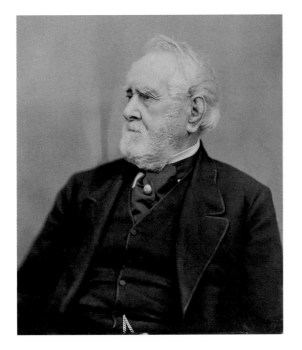

FIG. 1 Mathew Brady, *Mr. William Wilson Corcoran*, 1883. Collodion print. Courtesy of Library of Congress, Brady-Handy Photograph Collection, LC-BH832-1100

William Wilson Corcoran (Fig. 1) was born in Georgetown on 27 December 1798 to Thomas and Hannah (Lemmon) Corcoran, the second-youngest of the couple's six surviving children. Thomas Corcoran (1754–1830) had immigrated from Limerick, Ireland, to Baltimore in 1783, to work as a clerk in his uncle William Wilson's shipping business. After several voyages abroad on his uncle's behalf and his marriage to Hannah Lemmon (1765/66–1823), Thomas Corcoran settled in Georgetown in 1788 and set up a leather and tanning business. He quickly became one of the town's leading citizens, serving as magistrate, mayor, and postmaster. His connections to prominent Georgetown and Baltimore families made through his political and civic activities and real estate holdings would prove of great benefit to his youngest son.[4]

As a boy, William Wilson Corcoran attended primary schools before enrolling in Georgetown College in 1813. After one year there, he completed his formal education at the

Reverend Addison Belt's school and in 1815 joined his brothers James and Thomas in their dry goods store. After a few years they helped him establish his own business, which prospered until the panic of 1823. Although Corcoran tried to settle his debts, his firm declared bankruptcy, and he went to work for his father, managing Thomas Corcoran's real estate holdings and other affairs.[5] At the same time, he began to learn more about the banking business, assisted by his father's relationships with local bankers such as Elisha Riggs (1779–1853) and his brother Romulus (1782–1846) of Baltimore. His first formal position was as a clerk at the Bank of Columbia, the oldest bank in Washington. When the bank failed in 1828, its assets were taken over by the Bank of the United States, which engaged Corcoran to manage its real estate and suspended debt holdings.[6]

Busy with his father's affairs and his burgeoning banking career, Corcoran also had an active civic life. Like his father and brothers, he was awarded commissions in the local militia by a succession of presidents, culminating in the rank of colonel.[7] Early on, Corcoran was interested in cultural matters: in 1829, for example, he was a member of a committee charged with planning a new theater in the city, established in 1835 as the National Theatre.[8] He led a busy social life as well, although he remained a bachelor until nearly age thirty-seven, long after many of his friends had married. His courtship of Louise Amory Morris (1818–1840), the daughter of Commodore Charles Morris and Harriet Bowen, was marked by parental objections and forced separations—Morris disapproved of the twenty-year difference in the couple's ages and worried about Corcoran's financial prospects—but eventually the two eloped to Baltimore on 23 December 1835. Just five years later, Louise, never in good health, died of tuberculosis, a month shy of her twenty-second birthday. She left behind the couple's second daughter and only child to survive infancy, Louise Morris Corcoran (1838–1867), and their son, Charles Morris Corcoran, who died the following August at the age of thirteen months. Corcoran never remarried and mourned his wife's death for the rest of his life.

When courting Louise, Corcoran had to reassure her that her parents were wrong about his prospects: "I am not the beggar they would fain to persuade you."[9] In the late 1830s he began to prosper, finding new opportunities after the closure in 1836 of the Washington branch of the Bank of the United States. Turmoil in national financial markets lent itself to entrepreneurship, and for several years, Corcoran served as a currency broker and stockbroker, exchange dealer, and collections agent. In 1837 he moved his office from Georgetown to Washington, where he solidified his connections with his mentor and patron, Elisha Riggs, and his family. In 1840 Corcoran and George W. Riggs (1813–1881), Elisha's son, formed a new firm to combine the advantages of Corcoran's political connections and social acumen with Riggs's access to capital and his experience in the family business. Corcoran & Riggs quickly became a major player in government finance, and this success afforded Corcoran a measure of financial comfort—enough so that in 1847 he was able to repay his creditors from the 1823 bankruptcy. The firm's biggest triumph occurred in 1848, when Corcoran traveled to Europe to sell United States bonds to finance the Mexican-American War, the market for them in the United States having declined. The sale made the partners wealthy men and established Corcoran as the leading international banker in the U.S. He retired from business in 1854, although

he continued to act as a financial agent and adviser to the firm, thereafter known as Riggs and Company.[10]

As Corcoran's fortunes grew in the 1840s and 1850s, he began to apply them in the service of religious, educational, and cultural causes in Washington, continuing the family tradition of civic duty established by his father.[11] He also could not help but be aware of the remarkable benefactions, beginning in the 1850s, of George Peabody (1795–1869). Peabody, the first great modern philanthropist, had been the business partner of Elisha Riggs in Baltimore in the 1810s and 1820s and became Corcoran's great friend. Corcoran's donation in January 1841 to Washington's orphanage for girls—in his wife's memory—is among the first of his documented philanthropic gestures.[12] His first major gift was the establishment, by act of Congress in 1849, of Georgetown's picturesque Oak Hill Cemetery. This interest in urban beautification extended to the landscaping of Lafayette Square in the 1850s and the establishment of the Washington Horticultural Society, of which he was the first president. He also often helped the less fortunate: in the late 1860s he established the Louise Home, in memory of his wife, to help Confederate widows and others destitute after the war; provided private pensions to a number of individuals; and was a vice president of the Washington Association for the Improvement of the Condition of the Poor. His charity toward churches included the Ascension Church at 12th Street and Massachusetts Avenue, N.W., and St. John's Church near his home on Lafayette Square. He was generous toward educational causes, including the Columbian University, now the George Washington University. Following a famous meeting with Peabody and Robert E. Lee in 1869 in which the men discussed sectional reunion and the reviving power of education, Corcoran made generous donations to Virginia universities left damaged and in need.[13] At the time of his death, it was estimated that he had donated more than five million dollars to various causes during his lifetime.[14] As he wrote to his grandchildren at age eighty, he had, "from early youth to old age, endeavored to be . . . generous to the deserving" and regarded his uncommon wealth "as a sacred trust for the benefit of knowledge, truth, and charity."[15]

Early Collecting

Little is known of Corcoran's early knowledge of, or interest in, art. There is no evidence that he was influenced in the 1830s and 1840s by other collectors in the area or the country, although he may have known of the several prominent patrons of European art in nearby Baltimore, one of whom, Robert Gilmor, Jr. (1774–1848), had been amassing American paintings and sculpture in addition to old masters well before Corcoran began to collect; in 1874 Corcoran would acquire Gilmor's painting by William Sidney Mount, *The Tough Story—Scene in a Country Tavern* (1837).[16] Men such as Edward Carey (1805–1845) in Philadelphia, also a collector of American and European art, and Luman Reed (1785–1836) in New York, who focused almost exclusively on American art, were others whose collections Corcoran may have known through newspaper accounts or business connections.[17] It seems more likely, however, that he was inspired to begin amassing the art collection that would become his founding gift to his eponymous gallery as a result of his growing philanthropic interests. These, in turn, were closely intertwined with the mores of the Victorian era, when

successful individuals were proud of American achievement and deeply mindful of their responsibilities for the country's social and cultural improvement. By the mid-1840s Corcoran's considerable means and his evolving prominence in Washington society led him to support art and architecture projects in the nation's capital.

Corcoran Gallery of Art records, compiled by the museum's first curator, William MacLeod, state that Corcoran's first purchase was a small battle scene thought to be by the Flemish artist Jan Brueghel the Elder, from Commodore Stephen Decatur (1779–1820), but Decatur seems an unlikely source for the painting.[18] Since Corcoran was only twenty-two when Decatur died, and without much disposable income or evident interest in art, it is probable that he received the painting somewhat later from Decatur's widow, Susan, a friend for whom he acted as financial advisor in the 1830s, when she faced the burden of her late husband's large debts.[19] If Corcoran acquired the battle scene then, it would have been around the time he commissioned an unidentified artist—probably in Baltimore—to paint his portrait in miniature as a gift for Louise during their courtship.[20] This present appears to have been in exchange for the miniature self-portrait she herself painted and had given to him by July 1835.[21] His next acquisitions probably were some paintings once at Mount Vernon that he owned by 1845, although nothing is known of their precise nature.[22] By the late 1840s Corcoran was buying contemporary European paintings fairly regularly, often while traveling abroad on business and sometimes directly from artists. Although the records of many of his early purchases do not survive, according to MacLeod, Corcoran's first purchase of a work of art (apart from the Brueghel) was a portrait of a lady attributed to the seventeenth-century Dutch painter Peter Lely that he acquired in London in 1848 "on the recommendation of a connoisseur."[23] The following year, while traveling in Brussels, Corcoran purchased a pastoral scene directly from the Belgian artist Henri Robbe.[24] As early as 1849 Corcoran acquired more space for himself and his daughter, Louise, as well as his growing art collection: in March he purchased his friend Daniel Webster's home from the orator. At 1 Lafayette Square (at the intersection of H Street and Connecticut Avenue, N.W.), it was situated at the northwest corner of the park opposite the White House

FIG. 2 Moses P. Rice, William Wilson Corcoran reading in the library of his home on the northeast corner of H Street and Connecticut Avenue, N.W., c. 1886. Photograph. Corcoran Gallery of Art Archives

FIG. 3 William Wilson Corcoran's home on the northeast corner of H Street and Connecticut Avenue, N.W., c. 1905. Photograph. Historical Society of Washington, D.C., General Photograph Collection, CHS 02868

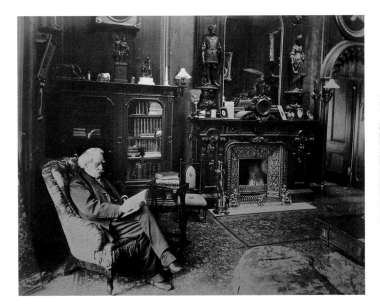

(Figs. 2, 3). By 1855 Corcoran had opened the private picture gallery in his residence to the public at least two days each week.[25]

Corcoran seems to have purchased his European paintings on the advice of friends, business associates, and political allies (or with such individuals acting as his agents).[26] The South Carolinian Thomas G. Clemson (1807–1888), who served as U.S. chargé d'affaires in Belgium from 1844 to 1851, greatly influenced Corcoran's early taste for contemporary Belgian painters and in 1850 sent him two landscapes by Robbe and a floral still life by "the celebrated French artist Baptiste."[27] In the letter alerting Corcoran to the shipment, Clemson remarked that the best Belgian painters "are as much esteemed as any of the ancient masters" and that "[p]ersons that have money here in Europe think it is a good investment to purchase paintings . . . of those artists, as they increase in value with time." While abroad, Clemson also purchased a *Christ Bound* for Corcoran, said to be by Anthony Van Dyck.[28] In 1850 and 1851 Corcoran bought two Swiss scenes from Baron Friedrich von Gerolt (1797–1879), the German ambassador to the United States.[29] It was von Gerolt who introduced his friend the German naturalist and explorer Alexander von Humboldt (1769–1859) to Corcoran in 1855.[30] Another Washington diplomat, Lewis Cass, Jr. (c. 1814–1878), who served in Rome from 1849 to 1858, made several purchases for the collector in that city about 1853.[31] Corcoran's dealings were not restricted to diplomats, since he also bought paintings from military officers residing in Washington.[32] Sometime in the late 1840s or early 1850s, these forays into collecting European art culminated in Corcoran's purchase of a massive canvas by the German Neoclassical painter Anton Raphael Mengs entitled *Adoration of the Shepherds* (Fig. 4).[33]

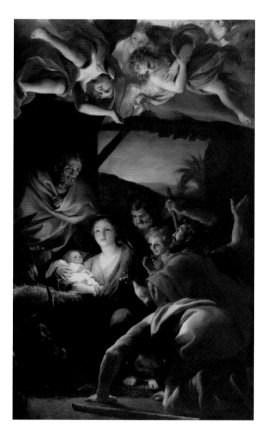

FIG. 4 Anton Raphael Mengs, *Adoration of the Shepherds*, 1764–65. Oil on canvas, 104 × 60 in. (264.2 × 152.4 cm). Corcoran Gallery of Art, Gift of William Wilson Corcoran, 69.75

These European purchases show Corcoran, like other collectors active in the antebellum period, to be quite traditional in his tastes, concentrating primarily on paintings by French, German, and Belgian academic artists popular at the time. As MacLeod later recalled, Corcoran "never professed to be a thorough judge of pictures but his taste was a natural one that never led him to purchase an indifferent one for the gallery," noting that the collector often remarked that he "liked what was pleasing and beautiful and recoiled from works of a tragical and painful character."[34] Also like many of his peers, he exhibited an interest in older European paintings, though he acted wisely by restricting his purchases in that area and relying heavily on the advice of friends and associates in selecting works. Before the 1880s most dealers and auction houses were unreliable and sometimes disreputable, leading to frequent transactions involving copies or fakes. In the 1857 catalogue of Corcoran's collection compiled by the Washington landscape painter and writer Charles Lanman, the collector recognized the limitations of his knowledge: the catalogue records a seascape "supposed to be by [the eighteenth-century marine painter] Joseph Vernet, and certainly in his style," a *View of Venice* and a *Seaport* "attributed to 'Canaletti' [*sic*]," and a "copy after" Rubens.[35]

Corcoran's interest in the art of his own country developed nearly concurrently with his collecting activity in the European realm, and in 1857 about one-third of the eighty-three works listed in Lanman's catalogue were by American artists. In 1850 Corcoran made his first known acquisition of an American painting, a subject picture equal in importance and scale to the Mengs. This was Daniel Huntington's second version of his acknowledged masterpiece, *Mercy's Dream* (1850), based on

John Bunyan's popular *Pilgrim's Progress*, purchased from the New York gallery Williams, Stevens & Williams. The artist hoped that Corcoran would also buy his pendant to *Mercy's Dream*, but Corcoran—who later generally limited his acquisitions by any given artist—declined the second work.[36]

Sentimental scenes like *Mercy's Dream* were very popular with American collectors in the third quarter of the nineteenth century, and the conservative nature of Corcoran's first American purchase forecast his collecting pattern over the next twenty years. Indeed, the acquisition was not only conventional but was most likely inspired by another collector. In 1841 the Philadelphian Edward L. Carey had commissioned the first version, which became famous through engravings. Corcoran's taste for historical and religious scenes was closely aligned not only with the interests of Carey but also with those of Corcoran's friend Abraham M. Cozzens (d. 1868), a New York collector and president of the American Art-Union; both men were buyers from that organization's important sale in 1852.[37] Cozzens (who owned a small, undated sketch for *Mercy's Dream*) favored elaborate scenes by Emanuel Leutze, Louis Lang, and Henry Peters Gray as well as landscapes by John F. Kensett—all artists whom Corcoran patronized in his early years of collecting.[38] Corcoran's contacts with fellow collectors at this time extended to other East Coast cities besides New York, including, for example, Samuel Gray Ward (1786–1858), a Boston financier and founder of the Metropolitan Museum of Art.[39]

Corcoran's acquisition of the small Kensett oil *Sketch of Mount Washington* (1851) in 1852 attests to his growing interest in collecting American landscapes by already established artists.[40] One year earlier, in the fall of 1851, he had made his first known purchase of an American landscape painting, Christopher Pease Cranch's *Castel Gondolfo, Lake Albano, Italy* (1852) after visiting the artist's studio in New York.[41] This was followed by the acquisition of Thomas Doughty's *View on the Hudson in Autumn* (1850, from the New York dealers Williams, Stevens & Williams in the summer of 1852) and by the American Art-Union purchases just mentioned.[42] By March 1853 Corcoran had purchased—from the New Yorker William P. Van Rensselaer (1805–1872), who had commissioned them, or his intermediary—what would remain the most significant American landscape paintings in his collection, Thomas Cole's allegorical pair *The Departure* and *The Return* (1837).[43] By the time Lanman compiled his catalogue in 1857, Corcoran had acquired thirteen American landscapes, including not only the Kensett, Cranch, Doughty, and Coles but also those by Jasper Francis Cropsey, Alvan Fisher, George Inness, and the French-born Hudson River School painter Régis Gignoux.[44]

In the same year that he began collecting American landscapes, Corcoran commenced acquiring American genre paintings, though in slightly lesser numbers. In genre, too, he patronized reasonably well-established artists such as the vastly popular William Tylee Ranney; in 1851 he lent the painter's *The Retrieve* (1850) to the National Academy of Design annual. In 1856 or 1857 he bought Eastman Johnson's *Girl and Pets* (1856), and by 1859 he had purchased from the Baltimore artist Frank Blackwell Mayer his morality scene *Leisure and Labor* (1858).[45] In 1854 Corcoran added another historical painting by Leutze to his collection, purchasing *Evening Party at Milton's, Consisting of Oliver Cromwell and Family, Algernon Sidney, Thurlow, Ireton, &c.* (1854) from the artist.[46] By the middle of the decade, he began to add a

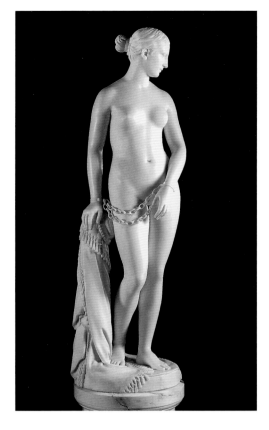

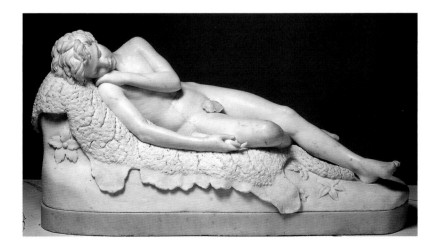

few western paintings, which, like Hudson River School and genre scenes, had achieved great favor among collectors. These canvases were popularized through the sales, lotteries, and popular prints sponsored by the American Art-Union and other organizations, leading one critic to complain that such images were "becoming painfully conspicuous in our exhibitions and shop-windows, of which glaring red shirts, buckskin breeches, and very coarse prairie grass are the essential ingredients."[47] Although the date of Corcoran's purchase of Seth Eastman's *Ball Playing among the Sioux Indians* (1851) is unknown, it may have been bought as early as 1851 or 1852, and in 1854 Corcoran paid George Brewerton for his *Crossing the Rocky Mountains* (1854).[48] By 1859 he had acquired another western genre scene, John Mix Stanley's *The Trappers* (1858), which he lent to the Washington Art Association's third annual exhibition that year.[49]

Nearly from the start of his collecting, Corcoran was interested in American sculpture, albeit not as earnestly as he was in painting. Among the six sculptures he donated to the gallery in 1873 was one of his most momentous purchases in any genre, and the work that surely sparked his interest in expanding his sculpture holdings. This was his acquisition in 1851 of the first of five replicas of Hiram Powers's renowned *The Greek Slave* (Fig. 5), the original of which earned Powers instant fame when it was exhibited at the Great Exposition of 1851 in London's Crystal Palace.[50] Placed on view in Corcoran's home on Lafayette Square for the first time at his annual Christmas party in December 1851, the marble engendered reactions of shock at the figure's nudity yet acclaim for the collector's good taste in acquiring the most celebrated sculpture in antebellum America. Indeed, many writers promoted the figure's innocence; a copy of an oft-quoted poem written in 1847 by H. S. Chilten, the first line of which reads, "Naked, yet clothed with chastity, she stands," was kept by Corcoran with his letters until his death.[51] The sculpture's tremendous significance to the collector was manifested not only in this momentous unveiling—and in the special octagonal gallery he later commissioned to showcase it in his gallery—but also in the central role it played in his personal life. In 1859 his daughter, Louise, married George Eustis, a Louisiana congressman, in the Corcoran home with *The Greek Slave* serving as their altarpiece.[52]

Soon after purchasing *The Greek Slave*, Corcoran acquired Alexander Galt's *Bacchante*, another sculpture he gave to the gallery in 1873 along with Powers's busts *Proserpine* and *A Country Woman*, William Rinehart's *Penserosa*, and Larkin Mead's *Echo*. These, along with Rinehart's *Endymion* (acquired 1875; Fig. 6) and the same artist's bust of William Wilson Corcoran (acquired 1877), followed by a bust of Henry Clay by Joel Hart, laid the groundwork for the Corcoran's esteemed collection of American sculpture. Corcoran's taste for sculpture by artists living in Italy and working with that country's famous marble, called "the White Marmorean Flock" by Henry James, would inform the gallery's sculpture purchases for the next few decades.

Governing Corcoran from the start was his interest in supporting Washington artists and arts organizations.

This aspect of his considerable local philanthropy was particularly well aligned with his background. The son of immigrants who had made his fortune from scratch through various business opportunities, Corcoran apparently was eager to "discover" contemporary American artists and to support them by financing their study, purchasing their paintings, and providing them with commissions. Corcoran heavily patronized local artists active in the short-lived but exceedingly influential Washington Art Association (1856–60), of which he was an honorary member.[53] By the time of Lanman's 1857 catalogue, Corcoran had purchased works from several of the association's annual exhibitions (1857–60) as well as directly from local members Oscar Bessau (born in France), William Brenton Boggs, Eastman Johnson, Seth Eastman, John Mix Stanley, Charles Lanman, Emanuel Leutze, William MacLeod (a painter as well as the gallery's first curator), and William D. Washington.[54] Washington, who served as the association's vice president for two years, sold his 1854 canvas *The Huguenot's Daughter* to Corcoran in that year when he was supported by the collector while studying with Leutze in Düsseldorf.[55] Works by G. P. A. Healy, also a resident member and director, like those by many of the association's nonresident members of significant national reputation—the painters Albert Bierstadt, George Caleb Bingham, John W. Casilear, Frederic Edwin Church, Asher B. Durand, Huntington, Kensett, Charles Bird King, Rembrandt Peale, and Thomas Sully and the sculptor Henry Kirke Brown—had been or soon would be acquired by Corcoran or his gallery.

The Formation of a Gallery of Art

In 1859, having amassed and catalogued a fairly substantial collection, Corcoran began construction of his own art gallery at the corner of 17th Street and Pennsylvania Avenue, N.W., a prominent—and carefully chosen—location diagonally across from the White House and directly across from the War Department (now the Old Executive Office Building). Corcoran's strategic placement of the gallery reveals his ambition to shape his holdings into the core of a national collection for the capital city. As Alan Wallach has observed, Corcoran was the only nineteenth-century American collector who showed no hesitation in developing such an institution and, indeed, briefly succeeded in doing so; his gallery existed as the capital's only art museum until the opening of the Phillips Collection in 1921 (which was followed by that of the National Gallery of Art a long two decades later).[56] Although there are few known statements by Corcoran outlining his specific plans for collecting art and establishing a gallery, his letter to the trustees in 1868 suggests his intent to formulate a national collection—one meant for the nation, that would tell its history through portraits, inspire patriotism, and showcase the best examples of American talent. He expressed his wish that his gallery would provide "a pure and refined pleasure for residents and visitors at the National metropolis . . . and something useful accomplished in the development of American genius."[57]

The short-lived Washington Art Association's mandate and activities, with which he was intimately familiar, must have inspired Corcoran's development of his gallery. As expressed by the association's president, the sculptor and physician Dr. Horatio Stone, the group's goals were "to advance the fine arts in regard to comprehensive national interests . . . and to establish a gallery of art at the seat of Government," a gallery, in Stone's words, "having in view not only local and temporary

interests but those of the whole country and the far future."[58] The demise of the association, as well as that of earlier and ongoing endeavors to establish Washington as an art center, surely lent impetus to Corcoran's initiation of his gallery.[59] It might even be said that he assumed as a personal mission what one writer deemed an important objective of the association: "to excite our public men to constitute themselves the true patrons of the living genius of the land."[60]

Corcoran chose the New York architect James Renwick, who had won the commission to design the building for the Smithsonian Institution in 1846 (when Corcoran became involved with that body), to design his gallery. Renwick had recently completed several commissions for Corcoran, including the Corcoran Building at 15th and F Streets, N.W. (1847), the 1849 chapel for Oak Hill Cemetery, and the renovation and expansion of his Lafayette Square home in order to accommodate his growing art collection. Corcoran asked Renwick to design a gallery in the Second Empire style modeled on the new wings of the Musée du Louvre, added during the reign of Napoleon III, which evidently had impressed Corcoran when he visited Paris in 1855.[61]

Work on the new building proceeded rapidly, according to contemporary accounts, and the exterior—including the words "Dedicated to Art," one of the first decorative elements added to the facade—was largely complete by early 1861 save for some decorative details. However, the interior remained unfinished, and on 10 April 1861, Corcoran advised Renwick to suspend work on the project owing to the "present state of the country."[62] Corcoran felt that politicians had brought the country to the unavoidable impasse that led to the Civil War and consequently realized it was not advisable, from either a political or a practical standpoint, to move forward with such a visible project in the heart of the nation's capital. His political views were such that he did not endorse the perpetuation of slavery—in 1845 he had freed his thirty-five-year-old slave Mary and her four children and may have left her money in his will—but he upheld the right of Southern states to secede.[63] Moreover, having managed the finances of several Confederate leaders and entertained other Southern sympathizers at his home, Corcoran became the target of hostility from government officials. Against his protests and demands for rent, the government soon appropriated most of his property for federal use—the incomplete gallery building became the Quartermaster General's Department, a center for storage and distribution of clothing, until the close of the war (Figs. 7, 8). Left with little choice, Corcoran fled to Europe with his assets in October 1862 and remained there for the duration of the war. His hopes for a gallery undaunted, he traveled extensively, met with artists about his plans, and continued to buy European art.

Corcoran's return to Washington in 1865 was not an easy one, since the secretary of state was attempting to bring charges of tax evasion against him. Corcoran continued to pledge loyalty to the South despite its defeat, donating money to Southern causes. For example, in 1870 he presided over the Washington, D.C., memorial service for Robert E. Lee and in 1873 was made vice president of the Southern Historical Society in Richmond, an organization of Southern men dedicated to promoting the Confederacy's vision of the Civil War.[64] Ignoring continued animosity toward him, Corcoran revived efforts to build his art collection, purchasing the John George Brown pendants *Allegro* (1864) and *Penseroso* (1865) as well as landscapes such as

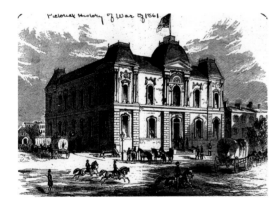

FIG. 7 "Clothing Dept. Corcoran's Private Art Building," 1861. Woodcut. From Paul Fleury Mottelay, T. Campbell-Copeland, and Frank Leslie, *Frank Leslie's The Soldier in Our Civil War: A Pictorial History of the Conflict, 1861–65* (New York: Stanley Bradley Publishing Co., 1893), 1:158–59. Historical Society of Washington, D.C., General Photograph Collection, CHS 04663

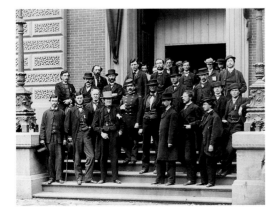

FIG. 8 Group at Quartermaster General's office, Corcoran's Building, 17th Street and Pennsylvania Avenue, N.W., April 1865. Photograph. Courtesy of Library of Congress, Prints and Photographs Division, lot 4188

Doughty's *Landscape* (c. 1849) and Church's *Tamaca Palms* (1854) from the estate of his friend A. M. Cozzens in 1868.[65] *Tamaca Palms* surely reminded the collector of his friendships with Cozzens and Humboldt, whose influential book *Cosmos* (begun 1845) had inspired Church to visit the tropics.

It was not until 1869 that the Renwick-designed building was restored to Corcoran. Feeling that his relationship with the government had improved to the point that he could resume work on his museum, he deeded the building, grounds, and his private collection to the first nine members of a self-perpetuating board of trustees, thereby founding the Corcoran Gallery of Art. Among the trustees were Corcoran's business partner George W. Riggs and his friend William T. Walters (1819–1894), later to be cofounder of the Walters Art Gallery (now the Walters Art Museum). In the deed and charter, Corcoran planned for the majority of his art collection to form the nucleus around which the gallery, to be "dedicated to Art," would develop; the gallery was to be "used solely for the purpose of encouraging American genius, in the production and preservation of works pertaining to the 'Fine Arts' and kindred objects." Also according to the charter, the trustees would ensure the "perpetual establishment and maintenance of a Public Gallery and Museum for the promotion and encouragement of the arts of painting and sculpture and the fine arts generally."[66]

Reconstruction and adaptation of the building for the purpose of displaying art were largely accomplished by February 1871, when Corcoran opened it temporarily for a ball to benefit the Washington Monument Society, of which he was a founder (in 1859) and for many years its vice president.[67] However, with the exception of portraits of Corcoran, George Washington, Andrew Jackson, and Henry Clay, there were few works of art on view; many had not yet been transferred from Corcoran's home, and he and the trustees must have wanted to further enrich the collection before a public opening. In 1873 Walters, who chaired the trustee Committee on Works of Art, was charged with that task—a responsibility he held until 1877 and in which he was assisted by his friends, the premier art agents and collectors George Lucas of Baltimore (1824–1909) and the New Yorker Samuel P. Avery (1822–1904).[68] It is not known how Corcoran met Walters. However, since both men were Southern sympathizers and Walters was the only major art collector in the vicinity and, at that, one with strong connections to the international art market through Lucas and Avery, he was a natural choice for the Corcoran's board.[69]

To fill the large rooms of the new gallery and to complement Corcoran's extensive holdings of American paintings and small-scale European pictures, Walters went on a buying trip abroad and purchased a number of large-scale paintings, such as Jean-Léon Gérôme's monumental *Dead Caesar* (1859–67), as well as bronzes by Antoine-Louis Barye, the extremely popular French animal sculptor and watercolorist whom he had patronized and promoted since the early 1860s.[70] Corcoran advised the trustees on certain opportunities, such as the 1873 sale of part of Avery's New York gallery.[71] By the fall of 1873 the board completed the

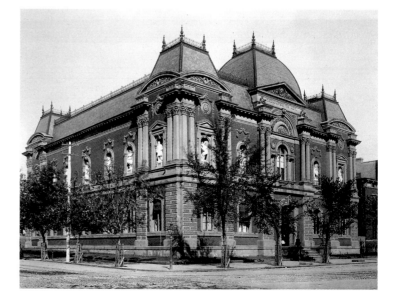

FIG. 9 First Corcoran Gallery of Art building, at the corner of 17th Street and Pennsylvania Avenue, N.W. (now the Renwick Gallery, Smithsonian Institution). Undated photograph. Corcoran Gallery of Art Archives

organization and staffing of the institution, which opened to the public in three stages the following year. On 19 January 1874, fifteen years after construction began, the galleries for paintings and bronzes, as well as an octagon designed for *The Greek Slave*, opened (Fig. 9). On 29 April still more galleries could be visited, and by December all of the spaces were accessible to the public and displayed about 350 objects, including 112 paintings—nearly double the number catalogued by Lanman in 1857.[72]

Growth of the Gallery, 1874–1888

While it is unknown whether Corcoran or Walters collaborated on the installation of the works of art, the execution of such plans was likely overseen by William MacLeod (1811–1892; Fig. 10), who served from 1873 to 1889 as the gallery's first curator. The son of Scottish immigrants, the Alexandria, Virginia, native attended the University of Glasgow and soon discovered his talent for painting. Beginning in the late 1830s, he traveled in New York, New Hampshire, Pennsylvania, Virginia, and what is now West Virginia in search of landscape scenes to paint, and in 1843 his work was included in the Eighth Annual Exhibition of the Artists' Fund Society in Philadelphia, his first known exhibition. After returning to Washington in 1854, he taught painting and draftsmanship at the school he established and continued to exhibit his work. When the Civil War forced his school to close, he became a clerk at the Treasury Department from 1861 to 1873, after which he began to work as the Corcoran's curator. He was responsible for the day-to-day operations of the gallery, including hanging and arranging the works of art, receiving new acquisitions, overseeing copyists, handling correspondence, and maintaining the catalogue of paintings and sculpture.[73] Corcoran purchased MacLeod's *Great Falls of the Potomac* sometime before 1869, including it in his original gift (Fig. 11). The Corcoran now owns two more of MacLeod's oil paintings as well as several works on paper.

From the outset, visitors to the Corcoran Gallery were meant to view American paintings and sculpture as a continuation of the great tradition of Western art.[74] To that end, the ground-floor sculpture hall on the north end of the building (Fig. 12) welcomed visitors with replicas of dozens of famous sculptures in the collections of

FIG. 10 Probably Moses P. Rice, *William MacLeod*, c. 1866. Photograph. Corcoran Gallery of Art Archives

FIG. 11 William MacLeod, *Great Falls of the Potomac*, c. 1869. Oil on canvas, 34 × 45 in. (86.4 × 114.3 cm). Corcoran Gallery of Art, Gift of William Wilson Corcoran, 69.47

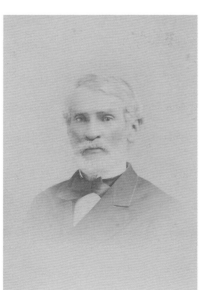

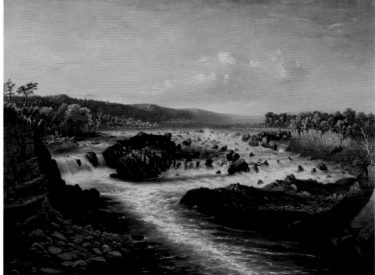

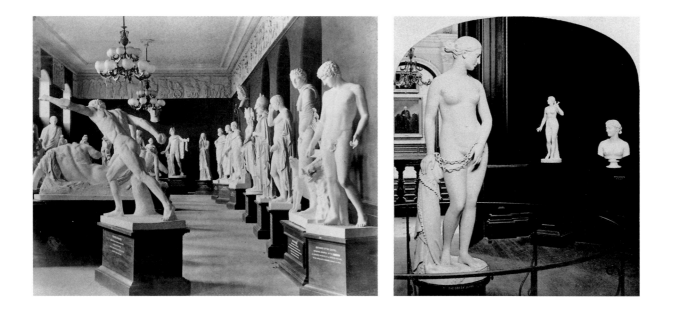

the Musée du Louvre, in Paris, the British Museum, in London, and the Vatican, in Rome, including the Discobolus, the Venus de Milo, the Laocoön, and the Apollo Belvedere. Soon after the January opening, plaster casts "made by a new process . . . to perfectly reproduce the originals" of the Elgin Marbles from the British Museum and the frieze from the Parthenon—a portion of which adorns the south atrium of the 1897 building today—were installed in the main sculpture gallery.[75] Also included was a gallery of casts of Renaissance sculptures such as Lorenzo Ghiberti's doors of the Baptistery of San Giovanni in Florence and Michelangelo's Medici tomb figures, from the Laurentian Library in Florence. Yet another gallery featured the Barye bronzes, American marble sculptures, majolica, and electrotype reproductions of Roman silver, medieval and Renaissance armor, and European decorative arts objects from the South Kensington Museum, London (now the Victoria and Albert Museum). After ascending the grand staircase, visitors could visit the octagonal gallery specially designed to house Powers's magnificent *Greek Slave* (Fig. 13), which was joined by Galt's *Bacchante* and the *Veiled Nun* by an unknown European sculptor.

This sweeping survey of the history of Western art, deftly interspersed with examples of American painting and sculpture, continued directly above the sculpture hall on the north side of the building. Here was the museum's greatest feature— its vast Main Gallery of Paintings, showcasing ninety-odd canvases hung floor to ceiling in the Salon style characteristic of the period. These, in turn, surrounded Charles Loring Elliott's centrally placed 1867 portrait of the gallery's benefactor, visible through the doorway in a stereoscopic photograph of the octagonal gallery (see Fig. 13) and on the right-hand wall in a photograph of the Main Gallery (Fig. 14). American works hung alongside examples from the Corcoran's growing collection of portraits of American presidents.[76] The American paintings, in turn, were interspersed with European ones, almost certainly to demonstrate, as Wallach observes, that native art could hold its own against Continental examples.[77] The two large canvases anchoring the east and west ends of the hall were Gérôme's *Dead Caesar* and *The Drought in Egypt* by the Belgian painter Jean-François Portaels.[78] A critic for the *Washington Star* also noted paintings by the French artist Ary Scheffer and the Scotsman Thomas Faed, and works by American artists, including the Coles, Leutze's *Evening Party at Milton's*, Sully's portrait of Andrew Jackson (1845) and Jane Stuart's of George Washington (c. 1854), Huntington's *Mercy's Dream*, and Church's *Tamaca Palms*.[79]

Corcoran must have been exceedingly pleased with the opening of his gallery, and a portrait commissioned from around this time is a telling likeness (Fig. 15). It

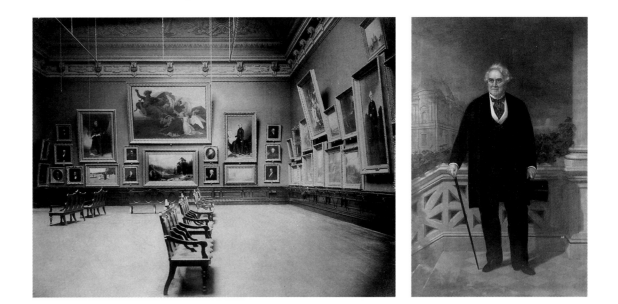

shows the proud founder standing in front of his new building—positioned, appropriately, on the entrance steps of a nearby structure that offered a number of artists' studios—with the Capitol seen over his left shoulder.[80] Strategically positioned between his "pleasure for residents and visitors at the National metropolis" and the structure housing Congress, whose attention he constantly courted, the benefactor all but touts the "national" quality of his museum.[81] Corcoran's stated desire to establish a gallery to encourage American genius in the nation's capital seemed to be realized. Key to reinforcing his plan was the interest of the Smithsonian regents, who issued a statement noting that the gallery would be "an important means of improving the intellectual and moral condition of the citizens of Washington."[82] Notably, the Smithsonian secretary Joseph Henry filled a vacancy on the Corcoran's board in 1873, and the organization transferred several works of art to the gallery, carrying out in small measure a plan from a decade earlier to shift its entire art collection to the Corcoran so it could stay focused on its scientific mission.[83]

Even more significant for spreading the word of Corcoran's patriotic goals was the popular press. As early as 1869, and building to a crescendo when the gallery opened in 1874, critics far and wide resoundingly emphasized the national nature of the institution. In 1869 a writer for the *Philadelphia Bulletin* anticipated that the gallery-to-be would be "fit to make a highly creditable Louvre . . . [facing] President's Square" and hailed Corcoran as "an American Mecænas."[84] Writing in 1872, a critic for the *Daily Patriot* was explicit in his hopes for the gallery, certain that it would "have a direct and happy influence on the General Government of the nation." He continued:

> After looking upon genuine works of art . . . produced by men of world-
> wide fame and illustrating important historical events, or depicting the
> wonders of physical nature, our Congressmen would find it hazardous
> and inexpedient to waste the public money, as they have frequently done
> in times past, upon second or third-class productions.[85]

The *Patriot* writer went on optimistically to predict that the gallery "will be visited by people from every section of the country, and the ideas thus obtained will naturally permeate the body politic at home, and the time may come when . . . Congress . . . will be instructed to vote for good pictures or statues, rather than for political measures of doubtful policy." The words of a columnist for the *Aldine* in 1874 echoed

those of the *Philadelphia Bulletin* writer five years earlier, stating, "Washington may now pride herself upon a National Gallery of Art." Illustrations, too, like one in the *New York Daily Graphic*, delineated the gallery's patriotic nature (Fig. 16). A writer for the *New York Times* further noted that the gallery was "a benefaction to the whole country. . . . fitly located at the capital, . . . a Gallery of Fine Arts which will rival the most famous collections in the world."[86] A writer for the *Washington Evening Star* observed that *The Greek Slave* "mark[ed] our first success in National Art" and lavished praise on the gallery's premier status among American art establishments and its key role in presenting a comprehensive history of Western art. He exulted, while acknowledging New York's newly opened Metropolitan Museum of Art: "In one year from this time we shall have the best collection south and west of the Hudson"; "ten years from this time we shall have the second gallery in rank in the United States."[87]

All of this critical and official praise, as well as the public's enthusiastic attendance at the new gallery, must have bolstered Corcoran's stated aim of "encouraging American genius." Almost immediately after opening the Renwick building to the public in 1874, he set in motion a plan to cement the reputation of his new museum as the first successful national gallery—one that would, by virtue of its location and its presentation of works by nationally recognized American artists within the great continuum of Western art, educate, inspire, and engender patriotic fervor in its local and national visitors. Moreover, the plan undoubtedly was also based on Corcoran's desire to demonstrate his patriotism and return himself to national favor after his flight to Europe during the Civil War and his continued support of the defeated South.

Corcoran's plan was two-pronged. The institution would incorporate a national portrait gallery, and its patriotic nature would be enhanced by the acquisition of additional major landscapes and genre paintings by contemporary (or near-contemporary) American artists. By 1874 Corcoran already had a substantial corpus of official likenesses on which to build his portrait gallery. Among his founding gifts to the gallery were Jane Stuart's copy of her father's full-length portrait of Washington, bought in 1858, and Thomas Sully's 1845 likeness of Andrew Jackson, purchased by 1867 from John F. Coyle, editor of the *National Intelligencer* newspaper.[88] In 1873 Corcoran presented a portrait of Henry Clay by an unidentified artist.[89]

Between its 1874 opening and 1885, the gallery—often with Corcoran's encouragement—expanded its portrait collection to include portraits of all the United States presidents as well as many statesmen and other notable Americans.[90] To ensure the success of his plan, Corcoran remained deeply involved in shaping the direction of the gallery's acquisitions. He often bought works for the gallery and served as a conduit of information to the trustees, despite the fact that he officially vested all purchasing power in them in accordance with the gallery's charter;[91] the gallery's scant early accounting records do not reveal how acquisitions were funded.[92] In 1875, for example, he bought Chester Harding's portrait of John Randolph of Roanoke, which was acquired immediately by the gallery.[93] Also in 1875 he eagerly paid for an important group of likenesses that the Library of Congress declined to acquire: 818 profile portrait engravings of distinguished Americans by the French-born artist Charles Balthazar Julien Févret de Saint-Mémin.

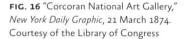

FIG. 16 *"Corcoran National Art Gallery," New York Daily Graphic*, 21 March 1874. Courtesy of the Library of Congress

The most significant acquisition of a group of official portraits occurred in 1879, when Corcoran purchased for his gallery a collection of fifteen presidential likenesses by G. P. A. Healy from the Chicago businessman and philanthropist Thomas B. Bryan.[94] The series, which included portraits of all the presidents through Abraham Lincoln save for George Washington (already represented by the Jane Stuart portrait) and William Henry Harrison (whose portrait by Eliphalet Andrews was added the following year), was updated by additions in 1882 and 1883 and continued as new presidents were elected, up until the turn of the century.[95] This acquisition fostered the collector's continued goal to garner the government's financial support, and he requested that MacLeod write a "good article . . . about them . . . to show Congress how *national* in character the institution is."[96] "This interesting and valuable series of portraits of our Presidents," MacLeod wrote dutifully in the *Washington Evening Star*, "shows the determination of Mr. Corcoran and the trustees to make national portraiture a strong point in the gallery."[97] The curator made plain that in this case "national" meant that the gallery should be representative of American history in the country's capital:

> As our great men pass away, it is well not only to have authentic portraits of them, but to gather them in such an abiding-place as the Corcoran Gallery of Art, here in the metropolis of the nation, where so many of them figured in its history, ever to remain on free exhibition to the public.

Perhaps to accommodate his growing national portrait gallery, Corcoran tried to purchase key lots for a major expansion from Samuel Phillips Lee (1812–1897) in 1879–80. However, Lee, a rear admiral in the Union navy, refused to sell, causing an uproar in the press.[98] Undeterred, Corcoran continued to build the collection, and the single most important acquisition of a presidential likeness occurred several years later. In 1884 Phebe Warren Tayloe (1804–1884), widow of the Washington diplomat and collector Colonel Benjamin Ogle Tayloe (1796–1868), bequeathed to the gallery its first of two Gilbert Stuart Athenæum-type portraits of George Washington.[99] Showing the first president wearing a shirt with a linen ruffle under his jacket, the painting is one of about seventy-five replicas Stuart made after his well-known life portrait of Washington, painted in Philadelphia in 1796. Curiously, Corcoran had been offered a Stuart likeness of the first president in 1875 but was then not interested in acquiring it, writing to Isabella Stewart Gardner in Boston that the "Gallery [was] supplied" and not in need of the "very valuable portrait," asking if she might "know of a purchaser . . . among . . . your millionaires."[100] Whether Corcoran owned another Stuart portrait of Washington in 1875, had known after Tayloe's death that his widow would bequeath the portrait to the gallery, or simply favored the Jane Stuart portrait he had purchased in 1858 is unknown.[101]

The second prong of Corcoran's plan, implemented following the opening of the Renwick building, was to expand the gallery's collection of American art more generally, obtaining major landscapes and genre paintings by artists not already represented. As with the portrait acquisitions, Corcoran often played a direct and sometimes an advisory role. At the Centennial Exposition of 1876 in Philadelphia, for example, he purchased several paintings, now unlocated, for the gallery.[102]

Durand's *The Edge of the Forest* (1868–71), James McDougal Hart's *The Drove at the Ford* (1874), and Worthington Whittredge's *Trout Brook in the Catskills* were all bought directly from the painters, continuing a tradition Corcoran began in the 1850s;[103] William Sidney Mount's *The Tough Story* was acquired from Freyer & Bendann, a Baltimore dealer that had acquired the painting from the nephew of the Baltimore collector Robert Gilmor, Jr.[104] At the famous 1877 sale of Robert M. Olyphant's collection, Avery brokered the Committee on Works of Art's purchase of two Kensett landscapes to complement the small 1851 *Sketch of Mount Washington* that Corcoran had acquired in 1852—*View on the Genesee near Mount Morris* (1857) and *Autumnal Afternoon on Lake George* (1864)—as well as a third major Thomas Cole painting for the collection, his 1831 *Tornado in an American Forest*.[105]

In 1876 the gallery attempted to add another painting by the renowned landscapist Frederic Church to the collection to complement *Tamaca Palms*, which Corcoran had bought in 1868. Given Corcoran's friendship with and fondness for Alexander von Humboldt, the collector no doubt played an influential role when in April 1876 the trustees, led by Riggs, planned to buy the artist's homage to the naturalist, the massive *Heart of the Andes* (1859, The Metropolitan Museum of Art, New York). They agreed to bid as much as $8,000 at the William T. Blodgett collection sale in April 1876; the painting sold for $10,000, the highest price paid to date for a work by a living American artist. Just eight months later the trustees resolved to purchase *Niagara* (1857) from the John Taylor Johnston collection. Walters asked MacLeod's opinion of the canvas, noting that if it could be secured, it "would make others of small importance," to which MacLeod replied, "urging the expediency of getting [the Church] at any expense, within our reach"; the bid was successful, at a price of $12,500.[106] Just as famous, if not more so, than the *Heart of the Andes*, *Niagara* made an interesting—and perhaps not entirely coincidental—purchase for the museum during the country's celebration of its centennial year. The painting proved ever more popular after its acquisition; just four years later, for example, MacLeod hosted the visit of Jicarilla Apache delegates, who posed in their native dress in front of the indelible icon of Manifest Destiny (Fig. 17).

If Corcoran's role in the acquisition of *Niagara* was so minor as to be undocumented in the museum's records, the situation two years later was quite different. Albert Bierstadt, Church's greatest rival in the American landscape marketplace, was surely chagrined when Corcoran and his museum purchased works by other prominent living artists such as Church, Durand, and Kensett. Despite protest from MacLeod, in 1878 Bierstadt succeeded in selling Corcoran his massive scene titled *Mount Corcoran* for $7,000, one-half his original asking price; the painting entered the gallery collection later that year.

Despite the trustees' interest in owning multiple paintings by Church and a few other artists, by the mid-1870s Corcoran and the trustees became more selective in their acquisitions, often rejecting offers of paintings by artists who were already well represented in the collection, including Sully, Stuart, Leutze, and Cropsey.[107] Offers of Stuart portraits of Washington were particularly numerous.[108]

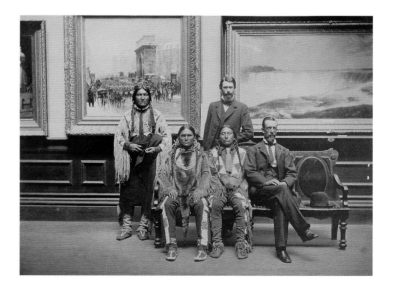

FIG. 17 Jicarilla Apache delegation at the first Corcoran Gallery of Art building, 1880. Albumen photograph. National Anthropological Archives and Human Studies Film Archives, Smithsonian Institution, INV 02064500

The steady collecting of contemporary American paintings in the 1870s was articulated as policy by Corcoran in 1879, when he firmly stated that "it is not the design of the institution to purchase old works, but for the encouragement of American genius."[109] His proclamation came at the end of a decade that had witnessed an enormous increase in the number of artists and photographers living and working within just a few blocks of the gallery, a trend that must have greatly pleased him. In 1871 the New Yorker Joseph B. Varnum built Vernon Row at 10th Street and Pennsylvania Avenue, N.W., a Second Empire building boasting twenty-three rooms that provided studio, teaching, and exhibition space for more than fifty artists and architects and hundreds of students.[110] Its first tenant arrived in 1873, and by 1875 it was considered Washington's studio building and receiving considerable notice in the press as the "centre or nucleus in and about which many of the knights of the pencil and palette . . . are gathering."[111] Perhaps not coincidentally, in 1875 Corcoran razed his 1847 office building at 15th and F Streets, N.W., to build one twice its size that housed many artists' studios into the 1880s.[112] Among the artists occupying Vernon Row was the Warrenton, Virginia, native Richard Norris Brooke, whom Corcoran had helped by offering studio space and later recommending for a portrait commission. Brooke served as vice principal of the Corcoran School of Art from 1902 to 1918. Corcoran also helped the Richmond-born Moses Jacob Ezekiel, a Confederate soldier turned sculptor, after he completed eleven portraits of famous artists for the Corcoran's facade niches in the 1870s and early 1880s while he was working in Rome.[113]

The 1880s saw a marked upswing in Corcoran's purchasing activity on behalf of the gallery, perhaps in part due to the conclusion, in 1877, of Walters's term on the Committee on Works of Art in 1877. The gallery trustees bought Brooke's *A Pastoral Visit*, undoubtedly on Corcoran's recommendation. On 16 April 1881 Corcoran supplied funds for the acquisition of Sanford Gifford's last important painting, *Ruins of the Parthenon* (1880), the first canvas by the artist to enter an art museum.[114] Gifford had tried unsuccessfully to place the picture, which he considered the crowning achievement of his career, in a museum collection before his death.[115] Corcoran bought the painting from the artist's estate auction in New York, perhaps after visiting or learning of Gifford's memorial exhibition at the Metropolitan Museum of Art in the fall of 1880.[116] In 1883 the gallery followed this important purchase with a commission to William Trost Richards to paint his majestic *On the Coast of New Jersey* (1883). In the mid-1880s Corcoran continued his pursuit of portraits of American statesmen by buying Joseph Wright's 1782 likeness of Benjamin Franklin and tried to acquire Chester Harding's portrait of Corcoran's friend Daniel Webster.[117] Corcoran bought a handful of other American and European paintings for the gallery in the 1880s.[118]

Perhaps nearly as important for understanding the institution's history is an examination of those works that Corcoran or the trustees declined to buy. In the spring of 1882, for example, Corcoran expressed a strong desire to acquire a work by John Singer Sargent, the ambitious young portraitist to the American and European elite. He asked Harper Pennington, an American artist then living in Paris, what Sargent had for sale (and, prudently, about the prices) and when Sargent could paint something for him on commission.[119] Yet the gallery would not acquire a work by Sargent until 1917, with the purchase of his masterpiece *En route pour la*

pêche (*Setting Out to Fish*) of 1878. Rivaling the gallery's failure to buy Church's *Heart of the Andes* in 1876 was Corcoran's refusal (for unknown reasons), in December 1885, to acquire George Inness's *Peace and Plenty* (1865, The Metropolitan Museum of Art) from the New Jersey statesman Cortlandt Parker (1818–1907), which would have well complemented the early Italian landscape by the artist he had bought in the 1850s.[120]

William Wilson Corcoran may be characterized as a collector who made acquisitions in order to echo his accomplishments as a self-made man and to embrace the culture of philanthropy prevalent in his era. Like the few other East Coast collectors of American art during his era, Corcoran amassed American paintings and sculpture in tandem with European examples and was of a more independent mind in selecting American works than he was when purchasing European ones.[121] Unlike some collectors, however, Corcoran did not forsake American for European art after the Civil War but rather increased his American purchases, to develop his national gallery and to demonstrate his patriotism.[122] Nonetheless, his taste for American art was never radical or adventurous, nor was it particularly varied: he accomplished his goals by collecting portraits, landscapes, genre, and historical works by the leading artists of his time and did not collect still-life paintings or colonial portraits. Later on, the gallery's board, with Corcoran's guidance, also declined to acquire such paintings and portraits.[123]

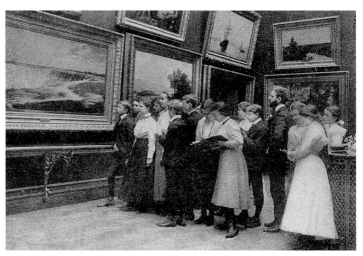

Perhaps most important, unlike other nineteenth-century American patrons, Corcoran ensured that his collection had a permanent home in his gallery.[124] Additionally, the education of the nation's artists, or the "encouragement of American genius," as stated in its charter, played a critical role in the gallery's history from the very beginning. When it opened its doors, art students immediately flocked to the gallery to observe, sketch, and paint copies of the collection's famous works, especially its casts after antique sculpture.[125] In 1878 Corcoran donated additional funding to establish a school associated with the gallery. In 1890, two years after his death, the Corcoran School of Art officially opened when a small annex to house students was constructed on the north side of the building, furthering the gallery's burgeoning identity as a place for education in the arts (Fig. 18).[126]

William Wilson Corcoran's Legacy:
The Twentieth Century and Beyond

Following William Wilson Corcoran's death on 24 February 1888, his legacy endured in the museum he had created for the city of Washington and the nation. The gallery steadily continued, through gift and purchase, to make acquisitions that furthered its core mission, to "encourage American genius." By 1891 the expanding collection, the demand for more space for the new School of Art, and the desire for a special exhibitions program led the trustees to use money from Corcoran's will to buy a larger lot three blocks south of the Renwick building, at 17th Street between New York Avenue and E Street, N.W., and commissioned the architect Ernest Flagg to design a building to house both the museum and the school. Ground was broken for the Beaux-Arts style building on 26 June 1893, and the finished building opened

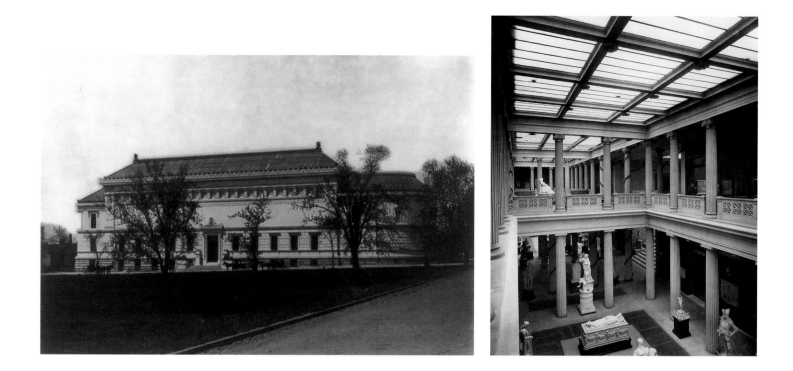

to the public on 8 January 1897, with President Grover Cleveland and his cabinet in attendance at the festivities (Figs. 19, 20). By this time the collection included approximately 1,850 works of art.[127]

While in its inaugural building, the gallery had been able to display only its permanent collection supplemented by a small number of loans from artists and private collectors. The new, much larger facility allowed the museum both to expand its collection and to pursue other activities, such as temporary exhibitions. Although the Corcoran's holdings did not grow dramatically in the years around the turn of the century, there were several very significant additions. The gallery's second curator, P. Sinclair Barbarin, purchased George Inness's commanding *Sunset in the Woods* (1891) as well as postbellum genre paintings in the academic style. These included J. G. Brown's *The Longshoremen's Noon* (1879) and Charles Frederic Ulrich's *In the Land of Promise, Castle Garden* (1884), purchased at the 1900 sale of works belonging to the important collector of American art William T. Evans (1843–1918). Also in that year, shortly before Barbarin's death, the gallery acquired its first American Impressionist painting—Theodore Robinson's 1897 *The Valley of the Seine, from the Hills of Giverny* (1892). This prescient purchase, made at a time when American Impressionism was just beginning to unfold, forecast the active acquisition of such work in the early decades of the twentieth century. In 1905, under its third leader and first director, Frederick B. McGuire—in 1900 the position of curator officially shifted to that of director[128]—the Corcoran also became the first museum to buy bronzes by the western master Frederic Remington, purchasing *Off the Range (Coming through the Rye)* (modeled 1902, cast 1903) and *The Mountain Man* (1903) from the sculptor's New York dealer, Knoedler.[129] Despite these successes, the turn of the century brought an acquisition disappointment reminiscent of those in the 1870s and 1880s, and once again involving the Corcoran's rival museum, the Metropolitan Museum of Art. In 1897 the gallery attempted to acquire a third Leutze painting for its collection—his massive *Washington Crossing the Delaware* (1851)—but the trustees were outbid in a vigorous battle at the estate sale of the wealthy New York merchant Marshall O. Roberts by none other than Samuel P. Avery, who had assisted with so many Corcoran acquisitions in the 1870s. Avery was bidding for John S. Kennedy, who immediately made the painting a gift to the Metropolitan.[130]

If acquisitions were few during this period, the museum was ambitious in mounting special exhibitions. In the tradition of its founder, many were annual displays promoting contemporary Washington artists' organizations, such as the Washington Water Color and Architectural Clubs, the Capital Camera Club, the Society of Washington Artists, and, of course, the students of the Corcoran School of Art.[131] The popularity of such shows led to the establishment, just ten years after the opening of the Flagg building, of the nationally recognized Biennial Exhibitions of Contemporary American Painting, which became the institution's single most important vehicle for the acquisition of American paintings.[132] The biennials were almost certainly inspired by those begun a century before by the nation's first art academies, the Pennsylvania Academy of the Fine Arts and the National Academy of Design, but also surely resulted from several concrete factors: the strong interest in contemporary art espoused by the gallery's founder; the presence of the Corcoran School of Art; and the fact that the Corcoran, as the only art museum in Washington until the Phillips Collection opened its doors in 1921, was the logical venue for such exhibitions.[133] As McGuire, who proposed the exhibitions in 1906, wrote to the trustees the following year, the program would be "of great advantage to the Gallery and a distinct factor in awakening public interest in it; it would prove highly beneficial to contributing artists; and at the same time, [it would be] instructive and interesting to art lovers, students, and the public at large."[134]

The large exhibitions immediately became a nationally recognized forum for the display, examination, appreciation, and debate of the latest ideas in contemporary American painting. One important way this was accomplished was to include examples by lesser-known artists, whose work was juried and eligible for prizes, and work by more recognized painters (who were invited to exhibit without the threat of rejection but also without eligibility for prizes).[135] The First Exhibition of Contemporary American Paintings, which comprised 397 works, opened to enormous fanfare in 1907 and attracted an astonishing 62,697 visitors during its thirty-three-day run.[136] Under McGuire's leadership, the Corcoran purchased half of the 26 paintings sold from the exhibition, which included work by a wide range of artists, from the academically trained realist Thomas Anshutz to the American Impressionists Mary Cassatt, Childe Hassam, Gari Melchers, and Edward Redfield, to the Taos painter Albert Groll. Also purchased by the gallery was Willard Metcalf's 1906 nocturne *May Night*, depicting the Old Lyme, Connecticut, gathering place for American Impressionists. Winslow Homer, invited to exhibit alongside Metcalf and other juried artists, submitted his equally commanding canvas *A Light on the Sea* (1897). Its purchase marked a particularly progressive moment for the institution, only the third American museum to collect the artist's work.[137]

The first exhibition set a high standard for those that followed, which continued to show the work of some of the country's most important painters. The number of purchases made from the exhibitions decreased after the first show, although the quality and variety of works remained astonishingly high. The second exhibition, for example, yielded nine acquisitions, again by a variety of artists ranging from the academically trained Charles Sprague Pearce to the expatriate Impressionist Mary Cassatt and the Boston School painter Edmund Tarbell. Cassatt's endearing *Young Girl at a Window* of about 1883–84 and Tarbell's intimate portrait of his daughters,

FIG. 21 Installation view of the front galleries, Eleventh Biennial Exhibition, Corcoran Gallery of Art, present building, 1928. Photograph. Corcoran Gallery of Art Archives

Josephine and Mercie (1908), have endured as masterworks in the permanent collection.[138]

By and large the biennial acquisitions were, like the exhibitions themselves, representative of the best living artists of the time. However, both were comparatively conservative in nature, usually recognizing major styles such as American Impressionism, the urban realism of the Eight, and regionalism, well after their heyday (Fig. 21). Around the time of the Eight's momentous debut exhibition in 1908, works by the American Impressionists— sometimes intermixed with paintings by academically trained and Taos school artists—dominated Corcoran biennials and their resulting purchases. Works by members of the Eight generally were not acquired until much later: for example, in 1923 Robert Henri's *Indian Girl in White Blanket* (1917) was acquired from the Ninth Exhibition, in exchange for a work much more representative of the height of that artist's career in New York, *Willie Gee* (1904, Newark Art Museum, N.J.), which had been bought from the Sixth Exhibition in 1919.[139] This was not the only instance in which Corcoran trustees upgraded biennial purchases when they deemed it appropriate: Cassatt's *Woman and Child* was purchased from the First Annual Exhibition and returned to her dealer Durand-Ruel in New York in 1909 as partial payment for *Young Girl at a Window*.[140]

As the museum's acquisitions and visibility increased as a result of the biennials, so did the variety of its other exhibitions, some of which yielded important additions to the collection. In 1910, when the gallery mounted the first solo exhibition of the work of the Gilded Age sculptor Bessie Potter Vonnoh, it purchased her *Day Dreams* (1903), and the artist donated a cast of *Enthroned* (modeled 1902, probably cast 1911). Indebted to the Corcoran for this exhibition opportunity—as well as for her second solo show, in 1919—and delighted that the museum was attached to a school where students might benefit from studying her work, Vonnoh bequeathed twenty-five of her bronzes to the Corcoran in 1955.[141] The Vonnoh exhibitions were just two examples of the new program, which continued some of the annual club exhibitions but also featured other displays, providing exposure to nationally recognized American painters. For example, in late 1908 the work of the late sculptor Augustus Saint-Gaudens was presented, and 1912 alone saw monographic exhibitions of the work of the painters Cecilia Beaux, Birge Harrison, Childe Hassam, Jonas Lie, Walter Elmer Schofield, Gardner Symons, and Charles Morris Young. Major exhibitions of American Impressionist painters were held in the 1910s and 1920s, into the tenure of the gallery's fourth leader, C. Powell Minnegerode, including one-person exhibitions of Benson, Frieseke, Daniel Garber, Redfield, Tarbell, and John F. Carlson and a joint show for Redfield and Tarbell in 1918. An important milestone occurred in 1919 with the final exhibition of the Ten American Painters, who had shown together annually since 1898. Another took place in 1922, when Hassam exhibited his flag paintings created during World War I. Important memorial exhibitions were held for John White Alexander (1916), Abbott Handerson Thayer (1922), and William Merritt Chase (1923).

In the early twentieth century, other important additions to the collection complemented acquisitions made from the biennials. In 1909 Bierstadt's widow gave

the Corcoran the artist's final great western painting, *The Last of the Buffalo* (1888). In 1911 the gallery purchased Samuel F. B. Morse's massive *The House of Representatives* of 1822, and in 1917 it bought Sargent's *En route pour la pêche* (1878) and Chase's masterful portrait of the Corcoran's benefactor William Andrews Clark, Jr. (1839–1925; Fig. 22). Clark, one of the richest men in the world in his day, was responsible for greatly enhancing the museum's collections, physical plant, and financial security. He made a fortune in banking, mining, and railroads—earning fame as one of the "Copper Kings" of Butte, Montana—and later became U.S. senator from that state.[142] He became involved with the Corcoran while serving in the Senate (1901–7) during McGuire's tenure as curator, primarily due to his friendship with Charles A. Glover, a trustee of the gallery and longtime friend of Corcoran.[143] In addition to supporting the biennials with prize money (in the form of the William A. Clark Prizes and their corresponding medals) and donating purchases he made from them, Clark ultimately established an endowment of $100,000 for the awards. This act of generosity was repeated following his death by his widow, Anna E. Clark, who established another endowment to defray the costs of organizing the biennials and to support acquisitions. Proceeds from both funds have been used to purchase American paintings for the collection over the years. The William A. Clark Fund has supported the acquisition of such popular paintings as George Bellows's *Forty-two Kids* (1907) and Edward Hopper's *Ground Swell* (1939), and the Anna E. Clark fund has been used to buy John La Farge's *Flowers on a Window Ledge* (c. 1861) and Thayer's *Mount Monadnock* (probably 1911/1914).

FIG. 22 William Merritt Chase, *William Andrews Clark*, c. 1915. Oil on canvas, 50½ × 40¼ in. (128.3 × 102.2 cm). Corcoran Gallery of Art, Gift of William A. Clark, 17.3

Senator Clark also played a key role in perpetuating William Wilson Corcoran's desire that American viewers see their native art alongside European examples. He bequeathed to the gallery nearly two hundred examples of European art as well as seven major American paintings, including his portrait by Chase and canvases by Edwin Austin Abbey, Ralph Albert Blakelock, John Francis Murphy, and Gilbert Stuart (the second Athenæum-style portrait of Washington to enter the collection), as well as a sculpture by the Vienna-born American Isadore Konti. Under the direction of Minnegerode, the new wing to house Clark's collection, designed by the architect Charles Platt and completed with funds donated by the senator's family, nearly doubled the size of the museum when it opened in early 1928.

In the years since the Clark wing was completed, many individual donors have followed in Corcoran's footsteps though their gifts, bequests, and funding for purchases. A 1941 bequest by the Cleveland businessman James Parmelee (1855–1931), a Washington resident later in life, added a broad range of significant American paintings, sculptures, and works of art on paper to the collection, such as Sargent's late landscape *Simplon Pass* (1911) and James McNeill Whistler's *Battersea Reach* (c. 1863). In 1949 Mrs. Francis Ormond, the sole surviving sister of John Singer Sargent, deeded more than one hundred drawings and one painting by her brother.[144] This gift, together with the gallery's six other oils, two watercolors, and one bronze, makes Sargent one of the best-represented artists in the collection. One of those oils, *Seascape with Rocks* (c. 1875/77) joined the collection in 2009, on the occasion of the Corcoran exhibition *Sargent and the Sea*.

The Corcoran continues to expand its outstanding collection of American paintings through purchase, gift, and bequest. In the 1980s two important early American

portraits joined the collection: Joshua Johnson's likeness of the McCurdy family (c. 1806) and John Singleton Copley's portrait of the Boston distillery owner Thomas Amory II (c. 1770–72). In 1995 and 2004 Olga Hirshhorn, the widow of the modern art collector Joseph Hirshhorn, generously donated several hundred works of American and European modern and contemporary art. A significant gift of thirty works by twenty-eight African American artists, as well as an important, large archive and library intended to aid scholarship on American art and African American art, were the 1996 gift of the local collector and gallerist Thurlow Evans Tibbs, Jr. (1952–1997). Tibbs presided over an artistic and literary salon in his family's historic home located just off the famous U Street corridor, which was a cultural hub of Washington for several decades. The most important group of historic American art and reference materials to be donated to the gallery in decades, the gift contained paintings by Henry O. Tanner, Loïs Mailou Jones, Hale Woodruff, and others as well as important photographs by James Van Der Zee and Addison Scurlock. Tibbs acknowledged the Corcoran's important legacy as not only Washington's community museum but also one with vast potential, noting that it "has the opportunity to leap generations ahead of any other institution in the country and I want to see that happen in my home city. I think that generations to come will say how this is forward thinking."[145] That same year, Aaron Douglas's 1936 mural *Into Bondage* came to the Corcoran from the Evans-Tibbs Collection (named for the gallery he operated in his home) as a museum purchase and partial gift from the Washington collector.[146]

Also in the late twentieth century, significant attention was given to acquiring preparatory and related works that serve the invaluable purpose of contextualizing iconic paintings in the collection. The display and study of Bierstadt's *The Last of the Buffalo*, for example, have been greatly enhanced through several acquisitions: the 1994 purchase of three oil studies for the figures and horse; the 2003 acquisition of two previously unknown sketchbooks that document the artist's trips to Yellowstone and that include pencil studies for the completed canvas; and the 2002 purchase of a rare chromolithograph after the painting. In the spring of 2009 the Corcoran purchased the only known oil study for J. G. Brown's *The Longshoremen's Noon*. The acquisition of historically and stylistically appropriate American frames has been another priority, and three major paintings in the collection have been reframed to better feature them in the galleries: Mary Cassatt's *Young Girl at a Window* (frame purchased in 1998), Winslow Homer's *A Light on the Sea* (frame purchased by the Corcoran Women's Committee in 2000), and John Singer Sargent's *En route pour la pêche* (frame also purchased by the Women's Committee, in 2009).

Through his generous gifts, gallery purchases made with his guidance, and multiple legacies to the institution that bears his name, William Wilson Corcoran succeeded in pioneering a landmark in the nation's cultural history. He was alone among nineteenth-century American collectors to establish a school of art as well as a museum that would become one of the most important and historically significant repositories of American painting, sculpture, photography, and works on paper in the world. During its distinguished history, now well into its second century, the institution has continually and enthusiastically renewed its founder's aspiration that it be "used solely for the purpose of encouraging American genius."

Notes

Unless otherwise specified, all works of art acquired by the Corcoran referenced in this essay remain in the museum's collection. Of those, all of the American paintings are catalogued in this volume.

1. Other early institutions were not established expressly as art museums. For example, the Pennsylvania Academy of the Fine Arts was founded in 1805 to acquire art and to educate artists but, unlike the Corcoran, did not begin with a collection or a museum building. What is today the Wadsworth Atheneum Museum of Art was founded in 1842 as an atheneum. The founding of the Corcoran was soon followed by that of the Metropolitan Museum of Art (1870, opened in 1872) and of the Museum of Fine Arts, Boston (opened in 1876). For an excellent history of the evolution of the art museum in the United States, see Alan Wallach, "Long-Term Visions, Short-Term Failures: Art Institutions in the United States, 1800–1860," in Wallach, *Exhibiting Contradictions: Essays on the Art Museum in the United States* (Boston: University of Massachusetts Press, 1998), 9–21.

2. Corcoran may well have begun buying American paintings before this date, since Huntington, in a letter to the collector regarding Corcoran's interest in *Mercy's Dream*, makes note of "that collection which you are forming"; Huntington to William Wilson Corcoran (hereafter WWC), 28 August 1850, Incoming Letterbook 7, no. 7689, W. W. Corcoran Papers, Manuscript Division, Library of Congress, Washington, D.C. (hereafter WWC Papers). Transcriptions of these letters, made in the spring of 2006 by Lisa Strong and Katherine Roeder, are maintained by the Department of American Art, CGA. Corcoran's outgoing letters for the years 1849–50 did not go to the Library of Congress collection and are unlocated, so the date of his first purchase cannot be documented.

3. Little on the history of the Corcoran has been published before the present essay. Substantial (yet largely undocumented) accounts of the history were compiled by Davira Taragin, a George Washington University graduate student in the 1970s, who wrote *Corcoran* (Washington, D.C.: Corcoran Gallery of Art, 1976), which accompanied the exhibition *The American Genius* (24 January–4 April 1976), and an undated draft for her master's thesis, on which *Corcoran* is based; CGA Curatorial Files. When he was curator of American art at the Corcoran in the late 1980s, Franklin Kelly wrote an unpublished essay, "William Wilson Corcoran and the Encouragement of American Genius"; CGA Curatorial Files. See also Holly Tank,

"Dedicated to Art: William Corcoran and the Founding of His Gallery," *Washington History* 17, no. 1 (Fall–Winter 2005): 26–51.

4. W. W. Corcoran, *A Grandfather's Legacy, Containing a Sketch of His Life and Obituary Notices of Some Members of His Family, Together with Letters from His Friends* (Washington, D.C.: Henry Polkinhorn, Printer, 1879).

5. Ibid., 5–6.

6. Ibid., 6.

7. Ibid.

8. *Daily National Intelligencer*, 4 February 1829, 3. On the National Theatre connection, see Mark L. Goldstein, "Washington and the Networks of W. W. Corcoran," *Business and Economic History On-Line* 5 (2007): 7, at http://www.thebhc.org/publications/BEHonline/2007/goldstein.pdf (accessed 20 June 2010).

9. WWC to Louise Morris, 24 February 1835, Unbound Family Papers, WWC Papers.

10. For more detailed analysis of Corcoran's business life, see Henry Cohen, *Business and Politics in America from the Age of Jackson to the Civil War: The Career Biography of W. W. Corcoran* (Westport, Conn.: Greenwood Publishing, 1971).

11. Corcoran's philanthropy is documented in "The Story of His Life," *Washington Post*, 25 February 1888, 1; Holly Tank, "William Wilson Corcoran: Washington Philanthropist," *Washington History* 17, no. 1 (Fall–Winter 2005): 52–65; and in Cohen, *Business and Politics in America*.

12. G. M. Cassin to WWC, 9 January 1841, Unbound Family Papers, WWC Papers.

13. The meeting, to discuss resuscitating education in the antebellum South, occurred at the Greenbrier in White Sulphur Springs, West Virginia, in the summer of 1869; I am grateful to William R. Johnston of the Walters Art Museum for bringing this to my attention. See Franklin Parker, "Robert E. Lee, George Peabody, and Sectional Reunion," *Peabody Journal of Education* 37, no. 4 (1960): 196, 199, 200. In this vein, Corcoran supported Washington and Lee University, the College of William and Mary, the Virginia Military Institute, and the University of Virginia. See "The Story of His Life," 1.

14. "The Story of His Life," 1.

15. WWC, *A Grandfather's Legacy*, letter from Corcoran to his grandchildren, 1 July 1878, preface, n.p.

16. Other Baltimore collectors close in time to Corcoran's own included Thomas Edmonson (1808–1856), whose collection held only American works of art; Johns Hopkins (1795–1873); S. Owings Hoffman; George A. Lucas (1824–1909); Granville Sharp Oldfield (1794–1860); Thomas Swann (1809–1883); and, of

course, William T. Walters (1819–1894), who in the 1870s, as Corcoran's friend, was instrumental in building the collection of the Corcoran Gallery of Art. Walters began collecting about 1855 (though he did not begin collecting American paintings until 1858, nearly a decade after Corcoran). Corcoran may have known of Gilmor's plans to bequeath his holdings to the Smithsonian Institution and the 1848 sale of his large collection due to financial reversals. By 1856 Corcoran was acquainted with Edmondson (see n44 below). For more on these Baltimore collectors, see William R. Johnston, *William and Henry Walters: The Reticent Collectors* (Baltimore: Johns Hopkins University Press, in association with the Walters Art Gallery, 1999), passim and 10–13. See also *A Century of Baltimore Collecting* (Baltimore: Baltimore Museum of Art, 1941); and William R. Johnston, ed., *The Taste of Maryland: Art Collecting in Maryland, 1800–1934* (Baltimore: Walters Art Gallery, 1984).

17. Others who collected American and European art at this time were the Philadelphian Joseph Harrison (1810–1874), New Yorkers John T. Johnston (1820–1893) and George A. Hearn (1835–1913), and George Walter Vincent Smith (1832–1893) of Springfield, Massachusetts. Corcoran began collecting at nearly age fifty, placing him among peers of his generation and the next. These men may be seen in contrast to Reed's and Corcoran's friend of later years, the New Yorker Abraham M. Cozzens (d. 1868), as well as the later collectors William T. Evans (1843–1918) and Thomas B. Clarke (1848–1931), whose collections comprised mostly American art, and Robert M. Olyphant (1824–1918), who collected it exclusively. See Frederick Baekeland, "Collectors of American Painting, 1813 to 1913," *American Art Review* 3, no. 6 (November–December 1976): 122, 128.

18. "Register of Paintings Belonging to the Corcoran Gallery of Art, 1869–1946," Curatorial Records, Registrar's Office, CGA Archives (hereafter "Register of Paintings"), 2, records that Corcoran purchased the "Velvet Brueghel" battle scene copper (4½ × 7 in.) from Commodore Decatur. It was deaccessioned in 1979. "Register of Paintings," 5, records that Susan Decatur gave Corcoran an oval entitled *The Coquette*, brought from Naples. This, too, was deaccessioned in 1979, as a painting by an unidentified European artist.

19. See Susan Decatur to WWC, 15 September 1832, Unbound Family Papers, WWC Papers.

20. WWC mentions plans to go to Baltimore to find an artist to execute his likeness; WWC to Louise Amory Morris,

1 July 1835, Unbound Family Papers, WWC Papers. He enclosed the miniature (now unlocated) in his letter to her of 6 September 1835; ibid. In another letter to Louise, WWC notes that the miniature had been painted by an Italian artist; 30 August 1835, ibid. I am grateful to Marisa Bourgoin, Corcoran Gallery of Art Archivist from 1993 to 2007, for bringing this portrait miniature to my attention.

21. WWC refers to having Louise's miniature in a letter to her, 23 July 1835, Unbound Family Papers, WWC Papers. The miniature is now in the Prints and Photographs Division, Library of Congress, Washington, D.C.

22. In 1845 Corcoran was persuaded by Robert E. Lee to return the pictures to Lee's father-in-law—and George Washington's step-grandson—George Washington Parke Custis; George Washington Parke Custis to WWC, 2 April 1845, Incoming Letterbook 6, no. 7369, WWC Papers. Although the nature of the works and how and when he acquired them are not known (nor their current locations), Corcoran's interest in art—and Washington relics—seems to have its roots in this early episode. I am grateful to Marisa Bourgoin for bringing this to my attention. Even from the age of fourteen, Corcoran had taken notice of Washingtoniana. Years later, he recalled seeing the White House painting of George Washington—thought by many to have been cut from its frame by Dolley Madison to protect it from the British during the War of 1812—hidden in Georgetown. WWC to F. Fitzgerald Esq., 20 December 1879, Outgoing Letterbook 77, no. 635, WWC Papers. See also William MacLeod, "Some Incidents in the Life of the Late Wm. Wilson Corcoran," manuscript and typescript, MS 325, William MacLeod Papers, 1839–1890, Folder 2, The Historical Society of Washington, D.C., 3.

23. "Register of Paintings," 8.

24. Ibid., 3.

25. *Crayon* 1, no. 6 (7 February 1855): 88. The house was demolished in 1922 to make way for the U.S. Chamber of Commerce building. See Keith D. Mackay, "The Corcoran Mansion: House of Feasts," *White House History*, no. 27 (Spring 2010): 32–43. I am grateful to Corcoran docent Terry Adlhock for bringing this article to my attention.

26. Despite his reliance on friends and associates to make purchases abroad, Corcoran sometimes refused to buy paintings he could not see. This was the case for a painting by Sir Edwin Landseer in 1853, about which WWC wrote to the artist Joshua Shaw (20 May 1853, Outgoing Letterbook 32, no. 249) and, in 1857, when he was offered a (Charles)

Le Brun, *Judith and Holofernes* (WWC to Francis Brinley, 5 January 1857, Outgoing Letterbook 39, no. 20), both WWC Papers.

27. One of the Robbe landscapes was surely the one recorded in the 1857 catalogue of Corcoran's collection compiled by the Washington landscape painter and writer Charles Lanman, and the other was a copy after a painting by the German painter Andreas Achenbach or his brother, Oswald. Baptiste may have been the seventeenth-century French flower painter known only by that surname or Martin Sylvestre Baptiste (French, 1791–1859). Thomas G. Clemson to WWC, 24 August 1850, Incoming Letterbook 7, no. 7687, WWC Papers. Charles Lanman, *Catalogue of W. W. Corcoran's Gallery* (Washington, 1857), in CGA Archives.

28. "Register of Paintings," 5. *Christ Bound* was deaccessioned in 1979. Clemson, like Corcoran, left Washington when the Civil War began because of his Southern sympathies; Clemson had served as secretary of agriculture in 1860–61 in the Buchanan administration but resigned his post in 1861 to return to South Carolina, his adopted state after 1838.

29. "Register of Paintings," 3, records that Corcoran bought a *Swiss Landscape* (1850) from Baron von Gerolt, and ibid., 5, records that he bought a *Swiss Mill Scene* (1849) by C. Fribel from the baron (deaccessioned 1979). Gerolt was friendly with such eminent artists as Albert Bierstadt and Samuel F. B. Morse as well as the collector Alexander T. Stewart and the poet William Cullen Bryant, all of whom were present at the dinner marking his retirement from his position of German ambassador to the U.S.; see "Baron von Gerolt; Farewell Banquet to the German Diplomat—Brilliant Assemblage and Eloquent Addresses," *New York Times*, 17 May 1851, 1.

30. Von Humboldt to WWC, 16 October 1855, Incoming Letterbook 8, no. 8037 (English translation; original, Incoming Letterbook 8, no. 8089). The following year Corcoran purchased a portrait of the naturalist by the Boston painter Emma Gaggiotti-Richards and a bust depicting him by the German sculptor Christian Daniel Rauch; WWC to Emma G. Richards, 7 March 1856, Outgoing Letterbook 37, no. 242, and 2 November 1856, Outgoing Letterbook 38, no. 704, both WWC Papers. The portrait appears in Lanman, *Catalogue of Corcoran's Gallery*, as a painting by "Mad.[ame] G. Richards." On the bust, see Rauch to WWC, 23 August 1856, Incoming Letterbook 8, no. 8079, mentioning its completion; and WWC to Mr. J. M. Schmidt, 24 January 1857, Outgoing Letterbook 39, no. 999, regarding its shipment, both WWC

Papers. The German artist Eduard Hildebrandt, a friend of von Humboldt's, painted *Moonrise at Madeira* for Corcoran at the behest of the naturalist. [WWC's secretary Anthony] Hyde to J. C. Carpenter, Esq., 22 January 1871, Outgoing Letterbook 61, no. 261 and enclosure for no. 260, WWC Papers. The Hildebrandt was deaccessioned in 1979.

31. Cass served as U.S. chargé d'affaires to the papal states from 1849 to 1854 and U.S. minister to the papal states from 1854 to 1858, when he purchased for Corcoran a port scene by "Canaletti" [*sic*] ("Register of Paintings," 3, and Lanman, *Catalogue of Corcoran's Gallery*); this work has not been linked to one in, or formerly in, the Corcoran's collection. Either during that post or while U.S. minister to the papal states, he purchased for Corcoran a seascape said to be by Joseph Vernet ("Register of Paintings," 4, deaccessioned in 1989); an oval painting of Iris (ibid., 8; deaccessioned 1979); and an 1856 coastal scene by an unknown painter (ibid., 9, not linked to a work in, or formerly in, the collection). Corcoran wrote to Cass in September 1853 regarding pictures Cass purchased for him and bills for these pictures (mostly illegible letter, Outgoing Letterbook 33, no. 63, WWC Papers). Corcoran may have known Cass's father, Lewis Cass (1782–1866), twice U.S. senator from Michigan and secretary of state under President James Buchanan, since in 1885 Corcoran was asked to recommend a sculptor to create a statue of Cass for the U.S. Capitol (WWC to P. Parsons, Esq., 24 June 1885, Outgoing Letterbook 87, no. 651, WWC Papers). Cass's advocacy of popular sovereignty aligned with Corcoran's support of states' rights.

32. Corcoran purchased a small portrait of Napoleon I from General Winfield Scott (1786–1866), a Mexican War hero; see "Register of Paintings," 6. From a Colonel Maynardier, likely the soldier by that name who served in the Mexican War, he bought a *Virgin and Child*. "Register of Paintings," 5, lists it as "said to be by Murillo . . . from a church in Valparaiso." On Maynardier, see James M. McCaffrey, *Army of Manifest Destiny: The American Soldier in the Mexican War, 1846–1848* (New York: New York University Press, 1992), 216n2. The "Murillo" was deaccessioned in 1979.

33. In an unpublished gallery talk draft text entitled "A Gift from the Past," dated 9 December 1981, CGA Curatorial Files, Joanna Degilio indicates (2–3) that the painting was owned by Joseph Bonaparte and sold in a public auction in September 1845 after his death. After the sale, "we know nothing about the painting's whereabouts until it was purchased by William Wilson Corcoran from a

Mr. Whelan of Philadelphia for about $1500."

34. MacLeod, "Some Incidents in the Life of the Late Wm. Wilson Corcoran," 1. Corcoran's letters reveal little of his knowledge of contemporary trends or of the history and literature of art; in 1880 he owned *Art Treasures of America* (17 July 1880, Outgoing Letterbook 97, no. 348) and subscribed to the *Magazine of Art* for eleven months in 1885 before canceling his subscription (A. Hyde to Messr. Caswell and Co., 16 January 1885, Outgoing Letterbook 87, no. 44, and 21 October 1885, Outgoing Letterbook 88, no. 324), all WWC Papers.

35. Lanman, *Catalogue of Corcoran's Gallery*. On the work listed as by Vernet, see n31 above. The two works attributed to "Canaletti" [*sic*] (one of them surely the one purchased by Cass, see n31 above) and the copy after Rubens have not been linked with works in, or formerly in, the Corcoran's collection.

36. Huntington to WWC, 28 August 1850, Incoming Letterbook 7, no. 7689, WWC Papers. The pendant, *Christiana, Her Children, and Mercy*, is now in the collection of the John and Mable Ringling Museum of Art, Sarasota, Florida (SN405). The first versions of the two *Pilgrim's Progress* paintings are in the collection of the Pennsylvania Academy of the Fine Arts, Philadelphia. It is interesting to note that, according to the "Register of Paintings," 3, Huntington also sold Corcoran a hunting scene by "M. Gouquet."

37. Corcoran purchased Leutze's *The Amazon and Her Children* for $600 (as well as a landscape by Leutze, which does not appear in Lanman, *Catalogue of Corcoran's Gallery*). Cozzens apparently purchased Kensett's *Sketch of Mount Washington* (1851) on Corcoran's behalf (or bought the canvas and sold it to him shortly thereafter). See "Special Auction Sales," *New York Evening Post*, 13 December 1852, 3. According to the *New York Daily Times*, 18 December 1852, 6, Cozzens purchased the Kensett, and Corcoran paid for Leutze's *The Amazon and Her Children*. WWC or MacLeod recollected this differently; "Register of Paintings," 4, notes that *The Amazon and Her Children* was bought for Corcoran in New York by Cozzens from the artist at the 1852 Art-Union sale.

38. On Cozzens's study for *Mercy's Dream*, see *Crayon* 3 (April 1856): 123; and *Catalogue of the Paintings of the Late Mr. A. M. Cozzens*, Clinton Hall Galleries, New York, 22 May 1868, cat. no. 4. WWC's Louis Lang painting, *Norma* (1853, 69.78), is recorded in Lanman, *Catalogue of Corcoran's Gallery*. "Register of Paintings," 19, says Henry P. Gray's 1861 *The Judgment of Paris* was among the

lots WWC bought at the Olyphant sale on 26 December 1877, brokered by Avery.

39. WWC to Samuel G. Ward, Esq., 19 May 1852, Outgoing Letterbook 30, no. 939, WWC Papers. WWC decided not to purchase a picture or pictures from Ward, the American representative of Baring Brothers, the English banking firm that was later to finance the U.S. purchase of Alaska. He resided in Europe for a time, collected engravings after the old masters, and lived in Washington late in his life. See his obituary in *Springfield (Mass.) Daily Republican*, 23 November 1907, 7. I am grateful to Thayer Tolles, Curator, American Paintings and Sculpture, The Metropolitan Museum of Art, for her assistance with this.

40. He also purchased directly from artists and from New York dealers, in particular Williams, Stevens & Williams. Corcoran also sold at least one picture through the gallery. See WWC to David Austen, Jr., 10 January 1853, Outgoing Letterbook 31, no. 561, WWC Papers.

41. WWC to Cranch, 17 October 1851, Outgoing Letterbook 30, no. 535, WWC Papers (here and below), mentions WWC's plans to visit Cranch's studio at the end of the month; WWC to Cranch, 5 November 1851 (Outgoing Letterbook 30, no. 575) encloses a check for $150 "on acct. of the picture"; WWC to Cranch, 25 February 1852, Outgoing Letterbook 30, no. 806, encloses a check for $150, "which completes the price of the Picture."

42. Corcoran bought the Doughty in July 1852 from Williams, Stevens & Williams; WWC to Williams, Stevens & Williams, 13 July 1852, Outgoing Letterbook 31, no. 61, WWC Papers. "Register of Paintings," 11, notes that the Doughty, which cost $450, "was painted for Mr. Corcoran." In 1851 and 1852 WWC made at least two more purchases from Williams, Stevens & Williams, possibly the Seth Eastman, *Ball Playing among the Sioux Indians*, the William Benton Boggs, *On Catskill Creek* (1850), or the Walter M. Oddie, *Lake near Lenox, Massachusetts* (1850). WWC to Williams, Stevens & Williams, 25 March 1851, Outgoing Letterbook 30, no. 52, records a payment for $899; and WWC to Williams, Stevens & Williams, 25 February 1852, Outgoing Letterbook 30, no. 805, both WWC Papers, mentions another payment. The Eastman, Boggs, and Oddie paintings appear in Lanman, *Catalogue of Corcoran's Gallery*.

43. Davira Taragin, undated draft for George Washington University M.A. thesis, CGA Curatorial Files, 23, notes that the Coles were acquired by spring of 1851, but her *Corcoran*, 13, omits them. Ben Perley Poore, "Waifs from Washington," *Gleason's Pictorial Drawing-Room*

39

Companion (1851–1854) 4, no. 11 (12 March 1853): 167, notes the acquisition.

44. The Gignoux works, *A Winter Scene* and *Lake Scene*, are recorded in *Crayon* 1, no. 6 (7 February 1855): 88, and are surely the two Gignoux canvases recorded in Lanman, *Catalogue of Corcoran's Gallery*. *A Winter Scene* was, like Leutze's *Amazon and Her Children* and Kensett's *Mount Washington*, sold at the 1852 American Art-Union sale; its purchaser was B. Buckingham, who probably sold it to Corcoran soon thereafter. Corcoran may also have bought the second Gignoux at the sale. See *New York Daily Times*, 18 December 1852, 6. In 1856 Corcoran purchased Alvan Fisher's *Autumnal Landscape with Indians* (1848), the payment for which he mentioned in a letter to T. Edmondson of Baltimore (probably the collector Thomas Edmondson [1808–1856]), probably dated 23 March or May 1856 (no Letterbook or number), WWC Papers. Corcoran may have purchased the 1851 Cropsey, *Tourn Mountain, Head Quarters of Washington, Rockland Co., New York* (1851), from Williams, Stevens & Williams on 15 April 1854; Outgoing Letterbook 33, no. 633½, WWC Papers. It was still in the artist's collection in early 1853, when he lent it to the First Semi-Annual Exhibition at the Massachusetts Academy of Fine Arts, Boston (24 January–1 May 1853, cat. no. 16). Cropsey may have consigned it to Williams, Stevens & Williams, since a sale to WWC does not appear in the artist's account book (1845–68, Newington-Cropsey Foundation, microfilmed at Archives of American Art, Smithsonian Institution, Washington, D.C.). The early (c. 1852) Italian landscape by George Inness is recorded in Lanman, *Catalogue of Corcoran's Gallery*.

45. Johnson's *Girl and Pets* is included in Lanman, *Catalogue of Corcoran's Gallery*. Corcoran's purchase of the Mayer for $175 is recorded in the artist's account book (1842–62), John Sylvester, Jr., Collection, Waynesboro, Georgia. On 8 November 1859, WWC wrote to Mayer saying that "the picture has arrived in good order"; Outgoing Letterbook 44, no. 635, WWC Papers.

46. The purchase of *Evening Party at Milton's* involved numerous parties. On 13 October 1854 Corcoran paid A. M. Cozzens $90.72 for "the painting forwarded by Mr. Leutze to your care"; Outgoing Letterbook 34, no. 597, WWC Papers. On 15 December 1854 Corcoran wrote to William D. Washington in Düsseldorf that the painting had been in New York for three months, that he is waiting for a response to his letter to Leutze of 5 September (presumably about the price) to have it transported

to Washington, and that he likes the painting except for the figure of Milton; Outgoing Letterbook 35, no. 157. Corcoran paid $2,500 for the painting to Mr. Herman Lachins, New York, on 9 February 1855; Outgoing Letterbook 35, no. 377. "Register of Paintings," 6, notes that "the original price asked was $5,000 but the painting was bought for $2,500. The painting's transfer to Washington apparently was handled by Williams, Stevens & Williams, since Corcoran wrote to them on 17 February 1855; Outgoing Letterbook 35, no. 395, requesting that the painting be shipped immediately for exhibition in the Metropolitan Mechanics' Institute Fair, held in the Patent Building in Washington, 3–19 March 1853; all WWC Papers.

47. *Literary World*, 1 May 1852, 316, quoted in Elizabeth Johns, *American Genre Painting: The Politics of Everyday Life* (New Haven: Yale University Press, 1991), 81. I am grateful to Lisa Strong for bringing this passage to my attention.

48. WWC to Brewerton, 6 February 1854, Outgoing Letterbook 33, no. 436, WWC Papers, with a payment of $100. The Eastman appears in Lanman, *Catalogue of Corcoran's Gallery*.

49. *Catalogue of the Third Annual Exhibition of the Washington Art Association* (Washington, D.C.: William H. Moore Publishers, 1859), reprinted in Josephine Cobb, "The Washington Art Association: An Exhibition Record, 1856–1860," in *Records of the Columbia Historical Society of Washington, D.C., 1963–1965*, ed. Francis Coleman Rosenberger (Washington, D.C.: Columbia Historical Society, 1966), 168.

50. Corcoran purchased the sculpture from I. d'Arcy of New Orleans, who had won the marble from the Cincinnati Western Art Union drawing in January 1851. See "Art-Union Drawing," *Cincinnati Gazette*, 22 January 1851, 2; and "Town Facts and Fancies, by the Local Editor; More of the Arts Union," *Cincinnati Daily Enquirer*, 22 January 1851, 2.

51. The poem, noted as being by R. S. Chilton, is preserved in Incoming Letterbook 28, no. 12613, WWC Papers, and appeared in the *Knickerbocker* 30, no. 4 (October 1847): 365, as by R. S. C. According to the *Knickerbocker* 48, no. 6 (December 1846): 650, its contributor Robert S. Chilton, Esq., was "of the State Department at Washington" and as such may well have been acquainted with WWC. Robert Seager II, ed., *The Papers of Henry Clay* (Lexington: University Press of Kentucky, 1988), 9:353, notes that Chilton was a clerk in the State Department during and after the Civil War.

52. See Lauren Lessing, "Ties That Bind: Hiram Powers's *Greek Slave* and

Nineteenth-Century Marriage," *American Art* 24, no. 1 (Spring 2010): 41–65. The discussion of the wedding is on 41–44.

53. Corcoran provided space for the first two annual exhibitions of the Washington Art Association in his building on H Street, "opposite the second Presbyterian Church"; see Cobb, "The Washington Art Association," 122. In 1852 he also helped establish the association's forerunner, the Metropolitan Mechanics' Institute, with a $1,000 donation.

54. The Washington Art Association members are detailed in Cobb, "The Washington Art Association." Lanman's *Lake George* and MacLeod's *Mount Vernon* are recorded in Lanman, *Catalogue of Corcoran's Gallery*. *Mount Vernon* must have been the painting of "inferior value" that MacLeod later exchanged for *Great Falls of the Potomac*, 1873, by permission of the trustees (there are now three paintings by MacLeod in the collection). See "Register of Paintings," 7. Corcoran lent Oscar Bessau's *Little Falls of the Potomac* (1856) to the association's 1857 exhibition and purchased the German-born Paul Weber's *Scene in the Catskills* from the 1858 show. The catalogues of the four association exhibitions are reproduced in Cobb, "The Washington Art Association," 139–90.

55. "Register of Paintings," 8, notes that the Washington was purchased by WWC in 1858, but in a letter of 11 July 1854 to Washington in Düsseldorf, Outgoing Letterbook 34, no. 233, Corcoran asks that the artist send him the painting when he has finished it. On 15 December 1854 WWC writes to Washington acknowledging that the picture "has been sent"; Outgoing Letterbook 35, no. 157. Washington (in Düsseldorf) to WWC, 3 July 1855, Incoming Letterbook 8, no. 7997, makes reference to the completed painting and also notes his "appreciation of [Corcoran's] kindness" and the desire to show Corcoran pictures on which he is working; all WWC Papers.

56. See Alan Wallach, "William Wilson Corcoran's Failed National Gallery," in Wallach, *Exhibiting Contradictions*, 22–37.

57. William MacLeod, *Catalogue of the Paintings, Statuary, Casts, Bronzes, & c. of the Corcoran Gallery of Art* (Washington, D.C.: Corcoran Gallery, 1878), 6. This quote derives from WWC's 10 May 1868 letter to the trustees. See Tank, "Dedicated to Art: Corcoran and the Founding of His Gallery," 40.

58. Cobb, "The Washington Art Association," 124.

59. The Washington Art Association played a critical role in establishing Washington as an art center, spawning the National Art Association (which soon led to the creation of the United States

Art Commission) and the National Gallery and School of Arts, begun in 1860 only to dissolve before decade's end. However, the Washington Art Association lapsed as a result of divergent political views, with Stone active in the Union cause and Washington, the vice president, supporting the Confederacy; Cobb, "The Washington Art Association," 135. For a summary of other endeavors to create art museums in the capital, including those relating to the Smithsonian, see Wallach, "Corcoran's Failed National Gallery," 23–25.

60. Mary J. Windle, *Life in Washington, and Life Here and There* (Philadelphia: J. B. Lippincott, 1859), 147, quoted in Wallach, "Corcoran's Failed National Gallery," 30.

61. Corcoran visited Europe in 1855, as evidenced by a letter of introduction from Joseph Henry, secretary of the Smithsonian, dated 11 July 1855, Incoming Letterbook 8, no. 8005, WWC Papers.

62. WWC to James Renwick, 10 April 1861, Letter 47, p. 63, WWC Papers.

63. WWC to Negress Mary & Children [Delia, Mary, Alfred, and Hudson], Recorded 29 September 1845, Records of Manumissions, vol. 3, Records of the U.S. Circuit Court for the District of Columbia, Record Group 60, National Archives and Records Administration, Washington, D.C. It is possible that this Mary (or her daughter Mary) is the Mary Neale "once owned by me, & long since manumitted" mentioned in Corcoran's will as the intended recipient of $200; CGA Archives. As the executor of his father's estate, Corcoran sold two of his father's slaves to Roger Jones, who broke his guarantee they would not be sold down the Potomac. In 1839 Corcoran sued Jones for the return of the slaves but lost the court case; see *The Federal Cases Comprising Cases Argued and Determined in the Circuit and District Courts of the United States* (Saint Paul, Minn.: West Publishing Co., 1894), book 6, 544–45, case no. 3,229. I am grateful to Marisa Bourgoin for this information.

64. "The Funeral of Gen. Lee," *Washington, D.C., Critic-Record*, 15 October 1870. On Corcoran's involvement with the Southern Historical Society, see WWC, *A Grandfather's Legacy*, 428.

65. Church had shown his painting at the Thirtieth Annual Exhibition of the National Academy of Design in 1855. For Doughty, see "Register of Paintings," 2; for Church, ibid., 3. Ibid., 11, erroneously says the Browns were purchased in 1867 for $150. See *Catalogue of the Paintings of the Late Mr. A. M. Cozzens*, Leavitt, Strebeigh & Co., New York, 1868, cat. no. 49.

66. Deed and Charter of the Corcoran Gallery of Art, 10 May 1869, CGA Archives.

67. See "The Ball of the Season: Festive Celebration of Washington's Birthday, Brilliant Scene at Corcoran Art Building," *Daily Patriot*, 21 February 1871, 2. In 1871 WWC was the largest stockholder in the *Daily Patriot*; see "Mr. Corcoran's Newspaper," *Washington Post*, 25 February 1888, 1.

68. Johnston, *William and Henry Walters*, 63.

69. I am grateful to William R. Johnston for his views on the question of how Corcoran and Walters became connected. Although Corcoran and Peabody were acquainted through the Riggs family and served on a committee to revive education in the South following the Civil War, Johnston has not been able to determine a direct connection between Walters and Peabody. Emails to the author, 11 and 12 January 2010, CGA Curatorial Files.

70. For paintings Walters purchased at the Vienna Weltausstellung in 1873, of which he was a commissioner, as well as those he purchased elsewhere from 1873 to 1875 (from Samuel P. Avery and Goupil in New York and the 1874 Paris exposition), see "Register of Paintings," 17, 18, 19. Sixty-four Barye bronzes were acquired in 1873, and thirty-one in 1874. The Gérôme was deaccessioned in 1951.

71. WWC to Avery, 7 May 1873, Outgoing Letterbook 64, no. 22, WWC Papers, referring to a sale of "part of [his] gallery" on 13 and 14 [May].

72. William MacLeod, *Catalogue of the Paintings, Statuary, Casts, Bronzes, & c. of the Corcoran Gallery of Art* (Washington, D.C.: Corcoran Gallery, 1874). The copy of the catalogue preserved in the CGA Curatorial Department Library is annotated in pencil: "December 23, 1874" and presumably documents all that was on view by the end of that calendar year (including the Parthenon sculptures). The Corcoran collection database records 141 objects acquired from the first accession in 1869 through the end of 1874, suggesting an unsurprising discrepancy between modern collection records and nineteenth-century inventories.

73. MacLeod maintained a fascinating journal recording these responsibilities, detailing the daily activities happening in the gallery and in the city of Washington. His journals for the years 1876–84 and 1886 have survived and remain in the CGA Archives. The Corcoran has begun a project to transcribe, annotate, and publish these journals.

74. Wallach touches on this in his "Corcoran's Failed National Gallery," 32.

75. "Art in Washington," *New York Times*, 17 January 1874, 3. See also MacLeod, *Catalogue of the Corcoran Gallery of Art* (1874), 187.

76. This patriotic installation is reminiscent of Frederic Church's 1864 display of his *Heart of the Andes* (1859), which Corcoran would attempt to purchase in 1876. When it was shown in the New York Metropolitan Fair in aid of the Sanitary Commission, the painting was displayed under a trio of portraits of the nation's first three presidents, Washington, Adams, and Jefferson; see Kevin J. Avery, *Church's Great Picture: The Heart of the Andes* (New York: Metropolitan Museum of Art, 1993), fig. 20 (following p. 31).

77. Wallach, "Corcoran's Failed National Gallery," 35.

78. "The Corcoran Gallery: An Hour's Stroll through the Collection," *Washington Evening Star*, 17 January 1874, 1, cites the gallery's 1874 purchase of the Portaels, and the painting's gold medal at the Crystal Palace exhibition, as noted in the *London Art Journal* for January 1874. The Portaels was deaccessioned in 1951.

79. "The Corcoran Gallery: An Hour's Stroll through the Collection."

80. The apartment building containing some artists' studios was located at the southwest corner of Pennsylvania Avenue and 17th Street, N.W., and the studios in it were called, informally, the Barbizon studios; it was torn down in 1902 to make way for the construction of the Mills Building (itself razed in 1964). The artists Max Weyl and Wells Sawyer had studios there. I am grateful to Mark Herlong for this information.

81. MacLeod, *Catalogue of the Corcoran Gallery of Art* (1878), 6.

82. *Smithsonian Institution Annual Report*, 1874, 44, quoted in Tank, "Dedicated to Art: Corcoran and the Founding of His Gallery," 39.

83. See Tank, "Dedicated to Art: Corcoran and the Founding of His Gallery," 40.

84. Gaius Maecenas was a wealthy, generous, and enlightened patron of the arts during the reign of Caesar Augustus. "Art in Washington: The Corcoran Gallery, 'Dedicated to Art'; Have We a Louvre among Us?" *Philadelphia Bulletin*, 17 May 1869 [page number unknown], preserved in WWC's Scrapbook no. 80.187, CGA Archives.

85. "The Corcoran Art Gallery," *Daily Patriot*, 15 August 1872, preserved in WWC's Scrapbook no. 80.133, CGA Archives.

86. *Aldine*, no. 6 (June 1874); and "Art in Washington," *New York Times*, 20 January 1874, 3.

87. "The Corcoran Gallery: An Hour's Stroll through the Collection."

88. Jane Stuart's portrait was shipped to Corcoran after 18 October 1858, when WWC wrote to J. R. Thaer and Co. in Boston regarding payment and shipment; Outgoing Letterbook 42, no. 596, WWC

Papers. "Register of Paintings," 8, notes the painting was purchased from Miss Stuart at Newport in 1854. Coyle was one of the buyers of American art from the Washington Art Association; Cobb, "The Washington Art Association," 130. Corcoran's possession of the Sully portrait of Jackson was contested in 1867 when Jacob Thompson, secretary of the interior under President Buchanan, attempted to claim ownership. No author or addressee, but likely written by WWC, "Picture of Gen'l Jackson," 18 November 1867, Outgoing Letterbook 93, no. 404, WWC Papers. See also William MacLeod's Curator's Journals, 19 June 1876, Director's Records, CGA Archives; and MacLeod, "Some Incidents in the Life of the Late Wm. Wilson Corcoran," 2.

89. The portrait (73.12) is attributed to Henry Inman in "Register of Paintings," 12, which notes that Corcoran purchased it from H. N. Barlow(?). Also in 1873 the gallery received as a gift a Henry Kirke Brown marble bust of John C. Breckinridge, vice president under James Buchanan, from the New York State congressman George Taylor (1820–1894). Corcoran surely was acquainted with Taylor, who had lectured at the Washington Art Association on the influence of Hinduism on American art; see Cobb, "The Washington Art Association," 130.

90. A number of other portraits filled out the collection. For example, in 1877, the year following the acquisition of his *Niagara*, Frederic Church gave the Corcoran (through Samuel P. Avery) a 1876 portrait of President James Madison by Thomas Sully; "Register of Paintings," 26.

91. By mid-June 1869 Corcoran is informing art dealers that he is referring purchases to the trustees of the art gallery; see WWC to Mr. Geo. A. Macile(?), 10 June 1869, Outgoing Letterbook 56, no. 196; A. Hyde to Geo. Bourdely(?), 29 July 1869, Outgoing Letterbook 56, no. 281; WWC to Juan Thyson(?), Esq., 24 September 1869, Outgoing Letterbook 56, no. 380; and WWC to Mr. A. Clements, 19 October 1869, Outgoing Letterbook 56, no. 431, all WWC Papers.

92. In a letter of 6 January 1875, Hyde chastised MacLeod for submitting bills to WWC that had not been approved by a gallery committee, thereby suggesting that WWC alone paid the gallery's expenditures; Outgoing Letterbook 67, no. 424, WWC Papers. However, in another instance, WWC apparently paid half the purchase price for Bierstadt's *Mount Corcoran*, while the gallery paid the remaining amount.

93. WWC to Mr. Leigh R. Page, 5 November 1875, Outgoing Letterbook 69, no. 299, WWC Papers. WWC followed the same pattern in 1878 with Thomas Le Clear's portrait of William Page. On

28 June 1878 Corcoran's secretary, Anthony Hyde, wrote to Mrs. Thomas Le Clear in New York enclosing payment of $200 for Le Clear's *William Page* (1876, 78.5), which Hyde calls "Portrait of Page the Artist"; Outgoing Letterbook 75, no. 83, WWC Papers.

94. WWC to G. P. A. Healy, 3 May 1879, photograph of letter in CGA Curatorial Files for Healy, Lincoln. A note by curator Linda C. Simmons states that the original letter is in the WWC Papers, but the letter was not among those transcribed by Corcoran researchers in 2006. Healy had received a commission from King Louis-Philippe of France to produce a series of portraits of distinguished American statesmen, but the Revolution of 1848 and the king's subsequent abdication scuttled the project. When Bryan purchased the group in 1860, he commissioned additional portraits to update the collection. For the French commission, Healy painted several posthumous presidential portraits from originals by Gilbert Stuart, Jean-Jacques Amans, and John Vanderlyn as well as portraits from life, such as those of John Quincy Adams, Andrew Jackson, John Tyler, and James K. Polk. The purchase also included a portrait of Martha Washington (after Stuart) and one of George Peabody.

95. The Healy acquisitions continued into 1884, when Corcoran donated the artist's 1884 portraits of President Chester Arthur and Vermont senator Justin Smith Morrill (as well as John Adams Elder's 1876 portraits of Robert E. Lee and Thomas Jonathan "Stonewall" Jackson).

96. William MacLeod's Curator's Journals, 26 April 1879.

97. "Corcoran Gallery of Art: Purchase of Fifteen Portraits of Presidents by Healy," *Washington Evening Star*, 3 May 1879, [1].

98. See "Impeding a Noble Design," *Washington Post*, 19 January 1880, 2.

99. Tayloe, secretary of the U.S. legation to London and, like Corcoran, a homeowner (and slaveholder) on Lafayette Square, was a buyer from the Washington Art Association annual exhibitions; Cobb, "The Washington Art Association," 130. His widow conveyed the deed to her husband's collection to the Corcoran in 1878, and at her death in 1884, the collection was relocated to the Corcoran in accordance with her will. In 1902, after a legal disagreement regarding Phebe Tayloe's estate, the painting was formally and legally accessioned into the collection. See Adam Greenhalgh, provenance summary for the Tayloe Washington, CGA Curatorial Files.

100. WWC to Mrs. [illeg.] Gardner [Boston], 20 May 1875, Outgoing Letterbook 68, no. 358. A few days earlier, WWC had written to Samuel P. Avery,

who had repaired the portrait (that Corcoran then had framed), asking for his help in "disposing of it"; 17 May 1875, Outgoing Letterbook 68, no. 349, both WWC Papers.

101. The first mention of the Tayloe collection coming to the gallery at Phebe Tayloe's death was in February 1877; William MacLeod's Curator's Journals, 23 February 1877.

102. A news clipping, possibly an enclosure in an undated note from George Bancroft (see Incoming Letterbook 28, no. 12542, WWC Papers), mentions Corcoran's purchase of "several pictures at Philadelphia for his Art Gallery." The clipping also cites WWC's unsuccessful efforts to procure the collection of marbles, bronzes, jewels, and majolica assembled by Alessandro Castellani on view at the centennial; he lost the Castellani collection to the Metropolitan Museum of Art; see "A New Art Acquisition: The Castellani Collection," *New York Times*, 30 December 1876, 2. Corcoran also purchased two large Japanese vases from the centennial; see MacLeod, *Catalogue of the Corcoran Gallery of Art* (1878), cat. nos. 1 and 2.

103. "Register of Paintings," 15, records the Durand as purchased from the artist on 14 April 1874 for $3,000. Ibid., 16, records the 3 July 1874 purchase of the Hart from the artist for $1,200. Ibid., 19, records the sale of *Trout Brook in the Catskills* from the artist for $750 on 29 May 1875. The "Register" does not indicate if the purchases were made by the gallery or by Corcoran himself.

104. The Mount descended to Gilmor's nephew before being sold to the Corcoran on 20 October 1874 by Freyer & Bendann. See Curator's Report, 31 December 1874, Board of Trustees Meeting Reports, 1869–1885, CGA Archives.

105. "Register of Paintings," 19, states the lots bought at the Olyphant sale on 26 December 1877, were the Kensett, *Lake George*, the Cole, Henry P. Gray's *Judgment of Paris*, and [Arthur Fitzwilliam] Tait's *Quail and Young*. Ibid., 26, records that Kensett's *View on the Genesee near Mount Morris* was acquired on 29 December 1877 from Avery.

106. MacLeod's Curator's Journals, 14 December 1876. Walters was also interested in the Swiss sculptor Vincenzo Vela's 1871 marble *Dying Napoleon* in the sale and had sent MacLeod a marked catalogue. The Vela was deaccessioned in 1982.

107. See WWC to William A. Bryan, 7 January 1880, Outgoing Letterbook 78, no. 16, rejecting another portrait of Andrew Jackson by Sully. Several letters decline offers of portraits of Jackson by unspecified artists: WWC to Mrs. M. E.

Morsell, 26 May 1880, Outgoing Letterbook 78, no. 537; WWC to Mrs. Forstall, 5 July 5 1885, Outgoing Letterbook 88, no. 15; and WWC to Jas. E. Woodman, 21 November 1885, Outgoing Letterbook 88, no. 434. Letters rejecting works by Leutze are WWC to John Sartain, [no day] February 1879, Outgoing Letterbook 76, no. 130; WWC to Mrs. S. G. Wheeler, 8 March 1880, Outgoing Letterbook 78, no. 269; WWC to Mrs. Cornelia Talbot, 10 June 1884, Outgoing Letterbook 86, no. 33. Regarding Cropsey, see WWC to Mrs. J. F. Cropsey, 25 March 1887, Outgoing Letterbook 91, no. 149, mentioning that the "[t]rustees will not care to duplicate works of the same artist"; all WWC Papers.

108. See n100, above. See also WWC to Mrs. Ellen L. School, 6 May 1882, Outgoing Letterbook 82, no. 91, declining to purchase a portrait of Chas. Ridgely by Stuart, stating that "the Gallery now contains several studies of Gilbert Stuart and the Trustees do not desire to add to their number"; WWC to Miss Carrie Jenkins Harris, 18 March 1884, Outgoing Letterbook 85, no. 385, regarding "one of eight original portraits of Washington by Gilbert Stuart . . . the Gallery is already supplied with such a work"; and WWC to C. P. Williamson, 4 July 1884, Outgoing Letterbook 86, no. 108, all WWC Papers, declining offer of Stuart's Washington, adding that "I have to state that the Gallery has Stuart's study of Washington and does not wish to duplicate it."

109. A. Hyde to H. E. Brown, Esq., 6 February 1879, Outgoing Letterbook 76, no. 146, WWC Papers, with regard to the offer of sale to Corcoran of a painting entitled *Io and Jupiter*.

110. See Mark Herlong, "Vernon Row: An Early Washington Arts Community," MS, emailed to the author, 19 April 2006, CGA Curatorial Files.

111. "Art Notes," *Washington Star*, 18 December 1875, 1, quoted in ibid., 4.

112. Tank, "Corcoran: Washington Philanthropist," 55, 56.

113. Ezekiel's facade sculptures, begun in 1873 or soon thereafter (WWC to William T. Walters, 16 December 1873, Outgoing Letterbook 65, no. 203), apparently were complete by 1885, when WWC began to recommend the sculptor for commissions. See WWC to P. Parson, 24 June 1885, Outgoing Letterbook 87, no. 651, mentioning the completed sculptures and recommending Ezekiel for a commission to sculpt General Lewis Cass for the House of Representatives, and WWC to Ezekiel, 27 February 1886, Outgoing Letterbook 89, no. 144, trying to get him a commission for the Confederate monument to be erected at Montgomery, Alabama. WWC also purchased antique sculptures from Ezekiel; WWC

to Ezekiel in Rome, letters of September and October 1885, Outgoing Letterbook 88, no. 77, and 18 December 1885, Outgoing Letterbook 88, no. 525; all WWC Papers. The facade sculptures were sold soon after the Corcoran's Flagg building opened in 1897 and since the early 1960s have been in the Norfolk Botanical Garden in Norfolk, Virginia. See James Goode, *Historic American Buildings Survey, Corcoran Art Gallery, Northeast Corner of Seventeenth Street and Pennsylvania Avenue Northwest, Washington, District of Columbia, D.C.*, 1971, 7–8, Library of Congress, Washington, D.C., at http://www.loc.gov/pictures/item/D0071 (accessed 21 June 2010).

114. The National Academy of Design acquired Gifford's diploma picture, *Huntington River*, in about 1854 and in 1865 received his *Mount Mansfield, Vermont* (1859) as part of the James Suydam bequest. However, the National Academy was not founded as a museum, nor did it operate with one as part of its program until the late twentieth century. I am grateful to Bruce Weber, Senior Curator, National Academy of Design, for his assistance. Despite the fact that it mounted the Gifford memorial exhibition in 1880, the Metropolitan Museum of Art did not acquire a painting by the artist until 1912.

115. See Franklin Kelly's essay on the painting by Gifford in this volume.

116. On 16 April 1881 Hyde wrote to Thomas E. Kirby enclosing a check in the amount of $5,106 for the Gifford, purchased for the gallery by "Mr. Kauffman, one of its Trustees" (Outgoing Letterbook 80, no. 2442); in 1881 he also exerted his decision-making powers by declining a George Caleb Bingham painting (Outgoing Letterbook 80, no. 347) and by buying a portrait of a lady (A. Hyde to Mr. Porter, 3 January 1881, Outgoing Letterbook 79, no. 496, all WWC Papers).

117. The purchase of the Wright portrait is documented in a letter from A. Hyde to Henry Stevens and Son, London, of 13 October 1885 (Outgoing Letterbook 88, no. 296); Corcoran's interest in a portrait of Webster by Harding is cited in his letter to Rice W. Payne, 15 February 1883 (Outgoing Letterbook 83, no. 286) and in WWC to Mrs. Virginia Semmes Payne, 8 December 1884 (Outgoing Letterbook 86, no. 523), all WWC Papers.

118. In 1885 he bought two paintings from the American Art Association for $10,800; A. Hyde to the Association, 8 April 1885, Outgoing Letterbook 87, no. 310, WWC Papers. The European purchases included some paintings in 1883 from Knoedler in New York; A. Hyde to Knoedler, 18 March 1883, regarding a "Battle on the Sea Shore" by

the Dutch artist R[ichard] Burnier (Outgoing Letterbook 83, no. 369); A. Hyde to Knoedler, 28 March 1883 (Outgoing Letterbook 83, no. 472), and a Corot, for which he paid Thomas E. Kirby $15,000 on 18 March 1886 (Outgoing Letterbook 89, no. 213), all WWC Papers. This was likely *The Wood Gatherers*, deaccessioned in 1966.

119. WWC to Harper Pennington, 6 May 1882, Outgoing Letterbook 82, no. 90, WWC Papers.

120. WWC to Cortlandt Parker, 31 December 1885, Outgoing Letterbook 88, no. 586, WWC Papers. The provenance for *Peace and Plenty* does not mention Cortlandt Parker, yet the owners and precise dates of ownership between 1866 and George A. Hearn's donation of the painting to the Metropolitan in 1894 are not fully known. See Michael Quick, *George Inness: A Catalogue Raisonné*, 2 vols. (New Brunswick, N.J.: Rutgers University Press, 2007), 1:241.

121. As Frederick Baekeland, "Collectors of American Painting, 1813 to 1913," 120, has noted, newly wealthy men may have felt more comfortable collecting American art, and the work of relatively unknown American artists, than amassing numerous examples of European art as did their more elite counterparts from older, more conservative families.

122. His friend William T. Walters, for example, who began collecting American paintings in 1858, sold his American works by non-Baltimore artists (as well as some European paintings) in February 1864, including Church's epic *Twilight in the Wilderness* (1860, The Cleveland Museum of Art). Johnston, *William and Henry Walters*, 39 and 252n59. I am grateful to Lisa Strong and William R. Johnston of the Walters Art Museum for sharing their knowledge of Walters.

123. As more evidence that he followed contemporary collecting trends, Corcoran chose not to acquire American colonial portraiture, which did not become popular until much later. In 1856 and 1859, for example, he declined to pursue opportunities to purchase a portrait by John Singleton Copley. See D. W. Alvord(?) to WWC, 17 February 1856 (Incoming Letterbook 8, no. 8055), referring to a portrait of General Joseph Warren by Copley; one regarding the same portrait from Edward Everett to WWC dated 15 March 1856 (Incoming Letterbook 8, no. 8060); and one from WWC to D. N. Allard(?) of Mansfield, Mass., 13 October 1859 (Outgoing Letterbook 44, no. 585), regarding a Copley portrait of Samuel Warren (surely the same portrait as referenced in the 1856 letters, likely Copley's *Joseph Warren*, c. 1765, Museum of Fine Arts, Boston), all WWC Papers.

124. William T. Walters and his son Henry Walters made their collection available for public viewing at various venues in Baltimore, but the Walters Art Museum did not fully become a public institution until Henry Walters bequeathed the collection and several buildings to the City of Baltimore at his death in 1931.

125. The many copyists are noted in "Our School of Design," *Washington Post*, 4 April 1879, 1. The most popular painting amongst copyists, according to this article, was *Charlotte Corday in Prison* by the French academic painter Charles Louis Müller; the painting was deaccessioned in 1979.

126. Owing to the construction of the annex, 1890 is considered the founding date of the school. However, the school's first principal, Eliphalet Fraser Andrews, was engaged by the trustees to offer instruction as early as 1887. Later, in the 1930s, despite difficult economic times, the school saw enough growth to continue expansion and began offering commercial art classes, scholarships, children's courses, ceramics facilities and courses, weekend classes, and summer learning opportunities; it also instituted a library. The school became a member of the National Association of Schools of Art in the mid-1970s and in 1978 awarded its first BFA degree. The school became fully accredited in the 1980s, formally changed its name to The Corcoran College of Art + Design in 1999, and has established itself as Washington's only four-year accredited institution for education in the arts.

127. The Corcoran's collection database records 1,856 works of art acquired between 1869 and the end of 1896, including a number of photographs and the Saint-Mémin portrait engravings. The old building was sold to the U.S. government in 1901 and since 1972 has been known as the Renwick Gallery, where it has housed the Smithsonian American Art Museum's craft and decorative arts program.

128. Corcoran Gallery of Art Annual Report, 1900, CGA Archives.

129. McGuire may well have known of the several one-man shows of Remington's work begun at Knoedler in 1905, and in March 1905 *Collier's* magazine showcased Remington's latest works by devoting an entire issue to the artist and his art.

130. "Painting to Remain Here," *New York Times*, 21 January 1897, 12. See also Raymond Stehle, "Washington Crossing the Delaware," *Pennsylvania History* 31, no. 3 (July 1964): 291. I am grateful to Kevin Avery of the Metropolitan Museum of Art and Jochen Wierich of Cheekwood for bringing these citations to my attention.

131. Compilation of exhibitions held at CGA, CGA Curatorial Files.

132. The first and second exhibitions were annual competitions; the biennial tradition began with the third exhibition. The annuals and biennials, though displaying a broad spectrum of contemporary American art, generally included prominent painters (such as Cassatt, Hassam, and Homer) who also showed in the annual exhibitions of the National Academy of Design and the Pennsylvania Academy of the Fine Arts. The exhibition juries at all three institutions were made up largely of artists. See Peter Hastings Falk, ed., *The Biennial Exhibition Record of the Corcoran Gallery of Art, 1907–1967* (Madison, Conn.: Sound View Press, 1991); Falk, ed., *The Annual Exhibition Record of the National Academy of Design, 1901–1950* (Madison, Conn.: Sound View Press, 1990); and *Catalogues of the Annual Exhibitions* (Philadelphia: Pennsylvania Academy of the Fine Arts).

133. Annual exhibitions began at the Pennsylvania Academy of the Fine Arts in 1811 and at the National Academy of Design in 1826. These were modeled on the annual European academic exhibitions such as the Paris Salon (dating to the seventeenth century) and the Royal Academy of Arts annual in London (begun in the eighteenth). Annual exhibitions were occasionally mounted by small art clubs and associations such as the Washington Art Association and the Boston Art Club, both founded in the 1850s.

134. F. B. McGuire to the Board of Trustees, 1 January 1906, CGA Archives, cited in Linda Crocker Simmons, "The Biennial Exhibitions: The First Sixty Years from 1907 to 1967," in *The Forty-fifth Biennial: The Corcoran Collects, 1907–1998* (Washington, D.C.: Corcoran Gallery of Art, 1998), 17.

135. This two-tiered exhibition system remained in place for the next sixty years. A complex two-phase, multicity jury system for the first two contemporary exhibitions—four separate juries of four men each, working in Boston, New York, Philadelphia, and Washington, vetted the initial submissions, followed by groups of five who made the final decisions on awards and the arrangement of paintings in the galleries—was simplified in time for the third biennial in favor of a single jury. The juries primarily comprised practicing artists until 1949, when staff members such as director Hermann Warner Williams, Jr., were added, although artists continued to serve until the early 1960s. The juries included some of the best-known artists of the time, from Childe Hassam to Edward Hopper, who were often accompanied by esteemed art historians and museum

professionals such as Lloyd Goodrich and Charles Parkhurst.

136. The show opened on the evening of 6 February 1907, with President Theodore Roosevelt and Eleanor Roosevelt, members of the cabinet, senators and representatives, and foreign dignitaries in attendance along with artists, patrons, and others.

137. The Museum of Fine Arts, Boston, acquired its first two Homer canvases in 1894 and 1896, and the Metropolitan Museum of Art acquired three in 1906.

138. This tradition continued, averaging twelve acquisitions from each exhibition in the early part of the twentieth century. For an excellent overview of the Corcoran biennials, see Simmons, "The Biennial Exhibitions"; see 35 for the reference to the popularity of Sargent and Melchers. The tradition of purchasing biennial works continued through the early twenty-first century, with major additions by Ida Applebroog, Robert Mangold, Sean Scully, Jessica Stockholder, and others. The Corcoran Women's Committee, founded in 1953, has supported many purchases, often those made from the biennials, and acquisitions were an important motivation in the 1961 founding of the Friends of the Corcoran.

139. Works by other members of the Eight represented in the Corcoran's collection—Arthur B. Davies, William Glackens, George Luks, and Maurice Prendergast—were not acquired until the Ninth Exhibition in 1923–24 (Prendergast's 1921 *Landscape with Figures*), the Eleventh Exhibition in 1928 (Davies's c. 1927 *Stars and Dews and Dreams of Night* and his 1925 *The Umbrian Mountains*), the Thirteenth in 1932–33 (Sloan's 1910–c. 1914 *Yeats at Petitpas'* and Luks's 1932 *Woman with Black Cat*), and the Fifteenth in 1937 (Glackens's *Luxembourg Gardens*, 1906); Simmons, "The Biennial Exhibitions."

140. *Reine Lefebvre Holding a Nude Baby* (1902) was purchased in 1909 by the Worcester Art Museum. Such exchanges also occurred in the Second (Schofield), Third (Symons), Fifth (Redfield), Seventh (Frieseke and Henri), Eighth (Ufer), Ninth (Johansen), Eleventh (Garber), Twelfth (Grabach), and Eighteenth (Weisz) exhibitions.

141. According to the Vonnoh expert Julie Aronson, the sculptor's good friend (and estate executrix) Lulette Thompson (Mrs. Robert Rowe Thompson) mentioned her two shows and her pleasure that students could study her work to Aronson on several occasions and confirmed it during an interview on 23 September 1989. Aronson, email to the author, 5 January 2010, CGA Curatorial

Files. Nine of the bronzes were deaccessioned in 1955.

142. For an excellent history of Clark's collecting, see Laura Coyle and Dare Myers Hartwell, *Antiquities to Impressionism: The William A. Clark Collection, Corcoran Gallery of Art* (Washington, D.C.: Corcoran Gallery of Art, in association with Scala Publishers, London, 2001).

143. The fascinating story of Clark's involvement with the gallery is recounted in Laura Coyle, "A Golden Opportunity: The William A. Clark Collection at the Corcoran Gallery of Art," in ibid., 28–33.

144. In 1929 Violet Ormond and Emily Sargent had planned to donate a selection of their brother's work to the National Gallery of Art, but since that museum's building did not open until 1941, the works were stored at the Corcoran for safekeeping. However, the National Gallery was not able to accept the sisters' gift, and in 1949 Violet Ormond deeded it to the Corcoran.

145. "Corcoran Gallery of Art Presents the Evans-Tibbs Collection: Prints, Drawings and Photographs by African-American Artists, September 12– January 6, 1997," CGA press release, 28 August 1996. See also Jo Ann Lewis, "Corcoran to Be Given African American Art," *Washington Post*, 8 May 1996, sec. A, 1.

146. After his death in January 1997, several more works were received by the Corcoran as gifts in Tibbs's memory, most notably a group of prints by Hale Woodruff donated by Tibbs's friends E. Thomas Williams, Jr., and Auldlyn Higgins Williams.

Notes to the Reader

This catalogue is divided into two sections. The first features 102 paintings selected by the editor for their importance within the collection and within the history of American art more broadly. These works are discussed in essays by authors who offer a range of interpretations as well as a variety of methodologies. These featured works are organized chronologically. Works of the same date are ordered alphabetically by artist's last name; those begun in the same year are arranged according to the earliest date of completion. Frames known or believed to be original are reproduced in the colorplates; technical information about them may be found in the essay endnotes or in the apparatuses on the Corcoran's website (see below). The second section presents all of the Corcoran's American paintings executed from about 1718 to 1945 (excluding the featured works) in illustrated list form, arranged alphabetically by artist's last name.

An apparatus, containing information related to the full history of the object, was prepared for each of the featured works. In addition to facts about the painting's physical nature—medium, dimensions, and inscriptions, which have been included with each essay—the apparatuses also contain a comprehensive history of the object's title(s), provenance, exhibitions, and references plus technical notes, related works, and information on frames. These exhaustive apparatuses, published separately on the Corcoran Gallery of Art's website, support the research and interpretations found in the essays.

The abbreviation CGA (for Corcoran Gallery of Art) has been used throughout the endnotes.

The Union List of Artist Names (ULAN) was used as a guide to artists' names. The title of each featured work has been restored to the original title that the artist gave it, the title used during the artist's lifetime, or the title under which the object was first exhibited or published (when such titles have been discovered). Where the original title of a painting or sculpture is in a foreign language, it appears in parentheses following the title in English. In rare cases, a painting has been so well known by a certain title that it has been retained to avoid confusion; in others, errors in transcription, spelling, or nomenclature in original titles have been corrected and explained in the endnotes. A portrait that was not given a title by the artist is referred to by the sitter's proper name at the time of the sitting and is identified as fully as possible. If a female sitter was married at the time of the sitting, her married name appears in parentheses, after the primary title. Honorifics, such as "General" or "President," and courtesy titles, such as "Mr.," have been omitted from the titles of all portraits and are instead acknowledged in the accompanying entry. Dimensions for featured works were measured separately in both inches and centimeters, height before width; those that fall within a range are listed by their largest dimension.

The following conventions have been used for dating.

1840	executed in 1840
before 1840	executed before 1840
after 1840	executed after 1840
by 1840	executed in or before 1840
c. 1840	executed sometime about 1840
1840–42	begun in 1840, finished in 1842
1840/1850	executed sometime between 1840 and 1850
1840; completed 1850	begun in one year, set aside, completed in another year
1840; reworked 1850	completed in one year, purchased, published, or exhibited, then reworked at a later date
n.d.	date unknown

Contributing Authors

Jennifer Carson	JC
Sarah Cash	SC
Lee Glazer	LG
Adam Greenhalgh	AG
Franklin Kelly	FK
Susan G. Larkin	SGL
Valerie Ann Leeds	VAL
Crawford Alexander Mann III	CAM
Randall McLean	RM
Ellen G. Miles	EGM
Dorothy Moss	DM
Asma Naeem	AN
Laura Groves Napolitano	LGN
Jennifer Raab	JR
Katherine Roeder	KR
Emily Dana Shapiro	EDS
Marc Simpson	MS
Paul Staiti	PS
Lisa Strong	LS
Ann Prentice Wagner	APW
Jennifer Wingate	JW

Portrait of a Gentleman, c. 1760

Oil on canvas, 50 1/16 × 40 1/8 in. (127.2 × 102 cm)
Signed middle left: I: Blackburn Pinx
Museum Purchase, 66.25

In this handsome portrait by the English painter Joseph Blackburn, a gentleman wearing a light blue waistcoat with silver embroidery stands in a formal pose near an open window, his body turned to the viewer's left. His dark brown coat and dark wig provide a foil for the brilliantly painted waistcoat, and he holds a tricorner hat in his right hand. Behind him to our right is a green drape. Although the portrait is signed, its date and provenance before 1956 are not known, nor is the sitter identified. This lack of information raises unresolvable questions: Did Blackburn paint this portrait during his ten years in Bermuda and New England; during his years in England, either before his arrival in Bermuda in 1752; or after his return to the British Isles about ten years later?[1] If it was painted before 1752, it would be his earliest known work, since nothing at all is known of Blackburn—his birth, training, or early work—before he went to Bermuda that year.[2]

Blackburn painted about twenty portraits in Bermuda during his two years there. His sophisticated compositions indicate training with a professional English portraitist, who remains unidentified. By 1754 he had moved to Rhode Island, where he painted a small number of portraits. In Boston in 1755–59 he painted at least sixty likenesses of merchants, public officials, military men, and their families. His portraits were admired for their decorative qualities: Mary Cary Russell praised his ability to paint "such extreme fine lace and satin, besides taking so exact a likeness."[3] In Boston his work was a major influence on the young American artist John Singleton Copley, an aspect of their careers that deserves further study.[4] In

1760 and 1761, perhaps because of competition from the more talented, younger artist, Blackburn moved from Boston to Portsmouth, New Hampshire, where he painted about twenty portraits. He was last documented there on 12 July 1762 by the payment for the portrait of Sarah Sayward (Mrs. Nathaniel Barrell, Historic New England, Boston).[5] By January 1764 he was back in England; his remaining fifteen portraits are dated 1767–77 and depict sitters in the west of England and Ireland.

The Corcoran Gallery's *Portrait of a Gentleman* is first recorded in a letter from John P. Nicholson dated 20 February 1956 to the Corcoran Gallery, when the dealer, writing from New York, offered the painting for acquisition: "A number of American pictures have been turning up in England of late. I bought a very nice signed Blackburn portrait (50 by 40 inches) there that must have been painted when he was over here, about 1760 I would say."[6] His dating may have been based on the notable similarity of the background to Blackburn's portrait of Hannah Wentworth Atkinson (Fig. 1), which is signed and dated 1760 in very small letters along the ledge to the left. The window and masonry ledge, the green trees, and the curtain to the right are identical in the two portraits. Other works from the late 1750s and early 1760s have similar settings, including his portrait of Margaret Lechmere Simpson (1758, Museum of Fine Arts, Boston). Portraits of men are seen in similar poses or in coats decorated with braid, notably sitters from Portsmouth, including Governor Benning Wentworth, in a full-length portrait (1760, New Hampshire Historical Society, Portsmouth),

Fig. 1. Joseph Blackburn, *Hannah Wentworth Atkinson*, 1760. Oil on canvas, 49 × 39 in. (124.7 × 99.3 cm). The Cleveland Museum of Art, Gift of the John Huntington Art and Polytechnic Trust, 919.1005

Fig. 2. J. Aberry, after Thomas Hudson, *Sir Watkin Williams-Wynn, 1749*, 1753. Engraving, image, 14 7/8 × 10 5/8 in. (37.8 × 27.1 cm). The British Museum, 1880, 1113.1319 (recto)

although none has such an elaborately embroidered waistcoat.[7] The American clothing historian Linda Baumgarten observes that "the way Blackburn renders the waistcoat with a loom-woven sub-pattern in the blue silk suggests that he was working from a genuine garment—it is very accurately observed."[8] Its unusual scalloped coat cuff, a style called *à la marinière*, was fashionable in England from at least the 1730s into the 1760s. According to Baumgarten, a date of 1745–55 is most likely, although "it is equally possible that it is from around 1760 and shows a conservative man in equally conservative clothing."[9]

Yet it is difficult to pin down a date based solely on these compositional features. While the portrait's similarity to Blackburn's later American work strongly suggests a date about 1760, the portrait could have been painted soon after his return to England. The discovery of the portrait in England referred to by the dealer John Nicholson when he wrote to the Corcoran in 1956 supports an English origin. Also possibly pointing to an English origin is the size of the signature, which is quite large in comparison to signatures on

his American work. The signatures on portraits of Hannah Atkinson (Fig. 1), Governor Benning Wentworth, Mary Sylvester (1754, The Metropolitan Museum of Art, New York), and many others are so exceedingly small as to be almost inconspicuous. The least likely date would be before Blackburn left England for Bermuda in 1752, although similarities to his work in Bermuda in terms of technique or to the work of the English artist Thomas Hudson suggest that earlier date. The closest portrait in Hudson's work is his painting of Sir Watkin Williams-Wynn, 1749, which was etched by J. Aberry in 1753 (Fig. 2). Whether Blackburn had studied with Hudson, a painter from Exeter whose career was primarily in London, is not known.[10] The similarity to the print could also be evidence that Blackburn imitated English prints when painting his American sitters. Because of these uncertainties, a date of about 1760 seems reasonable. Because of the great interest among contemporary scholars in trade and commerce in the broader Atlantic world, Blackburn is an artist deserving of close study.

EGM

49

John Singleton Copley (Boston, 1738–London, 1815)

Thomas Amory II, c. 1770–72

Oil on canvas, 49¹¹⁄₁₆ × 39¾ in. (126.2 × 101 cm)
Museum Purchase, through the gifts of William Wilson Corcoran, 1989.22

Born in Boston, John Singleton Copley by the early 1760s had established himself as the preeminent portrait painter in colonial America. Before relocating to London in 1775, Copley painted more than 350 portraits of New Englanders and New Yorkers. Some, like Paul Revere and Samuel Adams, were destined for fame, but most of Copley's sitters were ordinary citizens: men, women, and children from the merchant and business classes. Sizable fortunes were being amassed in the prosperous years before the American Revolution, and having one's portrait painted by Copley was an unmistakable indicator of wealth and social prestige.[1]

Thomas Amory II was born in Boston on 23 April 1722, the eldest son of a successful merchant and distiller of rum and turpentine. His father died when he was just six, leaving his mother to run the business.[2] Amory attended Harvard and initially intended to enter the ministry but acceded to his mother's wish that he take over the family business; he ran it with considerable acumen. In 1764 he married his cousin Emily Coffin, daughter of a competing distiller, thus uniting his family's fortunes with hers. Amory became a well-known and admired member of Boston's merchant society, a gentleman who was said to have manners "typical of his social group."[3]

The Amory family first engaged Copley's services in 1763, when Amory's sister-in-law (Katharine Greene) had her portrait painted (Museum of Fine Arts, Boston), and Amory's brother John commissioned his own portrait from Copley five years later (Museum of Fine Arts, Boston). By 1770 or so, Amory had ordered a half-length portrait of himself and a bust-length portrait of his wife (location unknown).[4] Copley often painted pendant portraits during these years, and it is curious that Amory chose not to have his wife's portrait painted in the same size as his.[5] In 1770 Amory acquired a large house at Washington and Harvard Streets in Boston, and once he had received his portrait from Copley, he hung it in the entrance hall.[6]

Copley's portrait of Amory is one of his most successful exercises in restrained elegance. In many other paintings of the same period, Copley lavished attention on the rich fabrics worn by the sitters or situated them in the opulent settings that were often largely imaginary (an example is his portrait of Amory's close friend Nicholas Boylston at the Museum of Fine Arts, Boston). Amory was about fifty years old at the time, and he is shown wearing a brown coat and a simple white shirt, posed against a dark background and leaning on the base of a column. His left hand is bare and his right, gloved hand holds his other glove while resting on a walking stick with a gold cap. He seems to have stopped for a moment on one of the walks he regularly enjoyed with his brothers along Boston's streets. Gazing thoughtfully off to his left, he is illuminated by a strong light that draws the viewer's attention to his ungloved left hand and to his head and face. We are left with the impression of a sympathetic, dignified man who has surely attained a measure of wisdom from life's experiences.

Although a staunch loyalist who once faced down an angry mob that had gathered outside his house, Amory never actively opposed the quest for independence. He remained in Boston during the war and kept his business interests secure. When the colonials retook the city, he was denounced and sent for two months' detention in Waltham, Massachusetts. Undaunted, Amory returned to Boston after his release from prison, and, following his death on 18 August 1784, he was able to leave his family businesses in good shape and his children comfortably provided for. His portrait remained in the family's possession for more than two centuries until it was acquired by the Corcoran in 1989. It has survived in exceptionally fine condition.

FK

Benjamin West (Swarthmore, Pa., 1738–London, 1820)

Cupid, Stung by a Bee, Is Cherished by His Mother, 1774

Oil on canvas, 48 × 48³⁄₁₆ in. (121.9 × 122.4 cm)
Signed and dated lower left: B. West. / 1774–
Gift of Bernice West Beyers, 63.29.1

Benjamin West, the first American artist to earn an international reputation, was one of the most influential painters of his day.[1] One of ten children born to Quaker parents in rural Pennsylvania, he had few early educational or economic advantages. In his desire to become a painter, he actively sought out instruction from several artists, the most influential being the English itinerant William Williams. Williams lent him theoretical tracts on the art of painting as well as paintings to copy. Supported by generous patrons, West traveled to Italy in 1760 to further his artistic education. There he became acquainted with the German artist and theorist Anton Raphael Mengs, who encouraged him to paint stories from mythology, ancient history, the Bible, and famous works of literature. After three years in Italy, West traveled to London, where his mythological paintings found favor with the British artistic community. His novel paintings of classical subjects and his innovative history pictures drew the attention of King George III, with the result that the king was a regular patron of the American for several decades.

Although much of West's career was occupied with the execution of large-scale history paintings, he also produced a number of smaller-scale works, such as landscapes, portraits, genre scenes, and mythological pictures. *Cupid, Stung by a Bee* is one of at least twelve paintings of Cupid that West completed during his career in London, which lasted almost sixty years. It likely combines scenes from two poems about the young god: "Cupid Wounded," the fortieth ode of Anacreon, translated from the Greek and published in London by Francis Fawkes in 1760; and the nineteenth idyll of the Greek poet Theocritus, "The Honey Stealers," published in a collection of poems also translated by Fawkes several years later.[2] In "Cupid Wounded," the poem illustrated in the foreground of the picture, Cupid plays on a bed of roses, unaware of a bee lurking in one of the blossoms. After the bee stings his finger, the young god cries out to his mother in pain. As Venus comforts her son, she gently reproaches him,

> Dry those Tears, for shame! My Child;
> If a Bee can wound so deep,
> Causing Cupid thus to weep,
> Think, O think! What cruel Pains
> He that's stung by thee sustains.[3]

West depicts Cupid being consoled by his mother as he gazes with tear-filled eyes at his wounded finger. The deep red of the velvet cushion, Venus's blue drapery, and the dark green backdrop emphasize the marblelike flesh of the foreground figures. Venus's arms cradling Cupid suggest a sense of intimacy between mother and son that is enhanced by the painting's circular composition. The round shape of this canvas calls to mind any number of Renaissance devotional images of the Virgin Mary and Christ Child that West would have seen during his stay in Italy in the early 1760s. The artist used a similar format for several paintings of his wife cradling their young son Raphael, from about 1770.[4]

The background scene is possibly inspired by Theocritus's "The Honey Stealers," a poem that tells the story of Cupid being stung by a bee as he attempts to steal honey from a hive. As in "Cupid Wounded," in "The Honey Stealers" Venus comforts him while she compares his behavior to that of a bee. Deviating from the text, West includes several putti in the background,[5] two of whom seem to be struggling on the ground while a third runs toward them clutching a bit of yellow drapery over his head.

West's apparent use of the works of Anacreon and Theocritus reflects the growing interest in England in classical art and literature during the second half of the eighteenth century. While paintings featuring Cupid and Venus had been popular in France for some time, the subject was not shown to the British public until 1765, when West's *Venus and Cupid* (The Parthenon, Nashville, Tenn.), also a circular composition, was included in the annual exhibition of the Society of Artists.[6] Nine years later, when West painted the Corcoran's picture, he had firmly established his reputation as a painter of mythological subjects.

By 1805 the Irish landowner Agmondisham Vesey purchased *Cupid, Stung by a Bee* for Lucan House in Dublin, a large home designed entirely in the Neoclassical manner.[7] Although Vesey was a member of the Irish Parliament, he and his wife spent every other winter in England, where they kept company with leading intellects of the day. In addition to the Corcoran's picture, the couple also purchased West's *Agrippina and Her Children Mourning over the Ashes of Germanicus* (1773, The John and Mable Ringling Museum of Art, Sarasota, Fla.) for Lucan House.[8] Both paintings probably hung in the house's dining room until the family collection was dispersed in 1925.[9] The Veseys' patronage of West reflects the fashionableness of his Neoclassical pictures and may have inspired his return to this theme over the next several decades.

JC

Joseph Wright (Bordentown, N.J., 1756–Philadelphia, 1793)

Elizabeth Stevens Carle, c. 1783–84

Oil on canvas, 38⅛ × 31⅝ in. (96.8 × 80.3 cm)
Museum Purchase, Gallery Fund, 50.20

Elizabeth Stevens Carle (1761–1790) was the daughter of Thomas and Catherine Smith Stevens of Baker's Basin, New Jersey. This portrait represents her in her early twenties, around the time of her marriage to Israel Carle of Ewing, New Jersey, in nearby Trenton Township.[1] When the portrait was acquired by the Corcoran in 1950, Israel Carle was described as a Hessian soldier with the British army during the American Revolution. The legend held that, during troop movements that took place between Trenton and Princeton, he caught sight of Elizabeth at her family's home and "fell in love at first sight, saved the home and family and returned after the war to marry her."[2] It turns out, however, that Carle was not a German mercenary. Instead, he was the son of Trenton Township landowner Jacob Carle, a resident of the colony and an elder in the Presbyterian Church of Ewing, New Jersey. During the Revolution, Israel Carle served as a captain in the New Jersey Light Horse cavalry unit that was formed in 1777. He and Elizabeth were married sometime between 1779 and 1786.[3]

Elizabeth's seated pose, especially the position of her elegant hands, has been interpreted as showing the influence of an early-eighteenth-century English portrait of Anne, Countess of Sutherland by Jacopo d'Agar, which was engraved by John Simon.[4] American colonial portrait painters often used English portrait mezzotint engravings as models when planning their compositions. The artist may also have been following a print source for the sitter's pale blue dress, which was frequently done for portraits of women. The tight, low-cut bodice, the lack of a center-front closure, and the full sleeves are reminiscent of styles twenty years earlier, in the 1760s, and the pearls on the sleeves hint at decoration that imitates fashions seen in seventeenth-century English portraits. However, the lower square neckline of the dress was in style in the 1780s.[5] Her elaborate hair, powdered and decorated with pearls and pale blue feathers, is in the fashionable mode known at the time as à l'hérisson (like a hedgehog).[6]

Her right hand gesturing toward her heart has a specific meaning: she has tucked a portrait miniature into the bodice of her dress. A faint cord around her neck that dangles downward hints at its secret location. The fashion of wearing a miniature on a cord, close to one's heart, can be seen in other late-eighteenth-century American portraits. Some miniatures are visible, such as the one worn by Mrs. Thomas Lea in the Corcoran's portrait by Gilbert Stuart. Other miniatures are hidden, such as those belonging to several women depicted in the 1770s by the American portrait painter and miniaturist Charles Willson Peale; they include *Mrs. James Carroll* (c. 1770–75, Yale University Art Gallery) and the unknown sitter in his *Portrait of a Woman* (1775, Harvard Art Museum, Fogg Art Museum, Cambridge, Mass.). The art historian Robin Jaffee Frank observes, "in many paintings of adult women, the black cord drawing the eye from an exposed throat to a lace-covered bosom concealing a portrait alluringly implies romance."[7]

At the time of its acquisition, the portrait was attributed to Matthew Pratt, a Philadelphia artist who studied with Benjamin West in London and returned to the colonies before the Revolution.[8] The portrait can now be reattributed to Joseph Wright, a younger artist and a native of New Jersey, the son of the wax modeler Patience Wright of Bordentown.[9] After receiving his training in London at the Royal Academy and with West, Wright settled in Philadelphia in 1782.

The soft, muted colors, delicate technique, and elegant formality of the pose are hallmarks of Wright's work. The portrait of Mrs. Carle is especially similar to his slightly smaller depiction of Hannah Bloomfield Giles, who wears a feathered headdress identical to Mrs. Carle's and a black dress with white sleeves. Wright painted her portrait and that of her husband, James Giles, in 1784, the year they were married. That pair of portraits places Wright in New Jersey, since Hannah Bloomfield was from nearby Burlington, New Jersey, and James Giles had studied law with her father, Joseph Bloomfield. Wright was also in New Jersey the previous year, 1783, when he might have had the opportunity to paint Mrs. Carle's portrait in the early fall. He was then in nearby Rocky Hill, New Jersey, at work on a painting and life mask of George Washington.[10] Her mother may have been painted at the same time; a portrait of her, attributed to Pratt, was recorded at Knoedler's in 1963 by Corcoran director Hermann Warner Williams, Jr.[11] Elizabeth died childless on 12 March 1790, and the portrait, later owned by her great-niece, was neither published nor exhibited until it was acquired by the Corcoran in 1950. Portraits of her husband, his second wife, Lydia, and their daughter Eliza Ann, painted in 1807 by the New Jersey artist John Paradise, are still owned by descendants.[12]

EGM

Gilbert Stuart (near Kingston, R.I., 1755–Boston, 1828)

Edward Shippen, 1796

Oil on canvas, 29 × 23¾ in. (73.7 × 60.3 cm)
Museum Purchase, Gallery Fund, 74.8

Sarah Shippen Lea (Mrs. Thomas Lea), c. 1798

Oil on canvas, 29⅛ × 23¹⁵⁄₁₆ in. (74 × 60.8 cm)
Anonymous Gift, 1979.77

Edward Shippen (1729–1806), a member of the prominent Shippen family of Philadelphia, was trained as a lawyer in London's Middle Temple and served on Philadelphia's Common Council before siding with the American cause in the Revolution. In 1791 he was appointed to the Pennsylvania Supreme Court, where he served as chief justice from 1799 to 1805. This portrait, one of Gilbert Stuart's earliest in Philadelphia, was painted at the request of his daughters, one of whom was Sarah Shippen Lea, also portrayed by Stuart.[1]

Shippen's undocumented introduction to Stuart must have occurred fairly early during Stuart's decadelong stay in Philadelphia. After returning to America from Dublin in 1793, Stuart painted portraits for a year and a half in New York City before going to Philadelphia, the temporary capital of the United States, in November 1794 specifically to fulfill his goal of painting a portrait of the president, George Washington. His first sittings with Washington, in 1795, resulted in the group of bust-length portraits known as the Vaughan portraits.[2] A comparison of the portrait of Shippen with one of these (Henry Francis DuPont Winterthur Museum, Winterthur, Del.) reveals many similarities. In both, Stuart has depicted his sitter in bust length in front of a red curtain, with a suggestion of a distant landscape with blue sky and pink reflections on clouds. Both sitters wear a black suit and look directly at the viewer. Shippen's blue-gray eyes engage the viewer with a forceful directness, and his rosy face and pursed lips endorse that intensity. Stuart's quick brushwork gives Shippen's features, powdered hair, and lacy white shirt frill a

sense of life, energy, and spontaneity. Behind him, the folds of the red curtain catch a bright reflected light coming from the left.

Shippen wrote to another of his daughters, Margaret ("Peggy"), on 20 January 1796 in London, where she and her husband, General Benedict Arnold, had fled at the end of the war after his dramatic switch of allegiance to the British side. Shippen told her that he planned to send her a copy of the portrait, which "is thought to be a strong likeness. I have therefore employed a Mr. Trot a young man of talents in that way to take a Copy of it in miniature. When finished I shall embrace the first good Opportunity of transmitting it to you, as I flatter myself it will be an acceptable present."[3] The copyist was the American miniaturist Benjamin Trott; the miniature is unlocated today.[4] The portrait was also copied by the English engraver David Edwin, in a print that Stuart praised.[5] The engraving, inscribed "Edward Shippen, L L D. Chief Justice of Pennsylvania AE.74," was first reproduced in The Port Folio magazine in 1810, after Shippen's death.

After painting Edward Shippen, Stuart was commissioned to paint his daughter Sarah Shippen Lea (1756–1831). Stuart was "said to have spoken of her as one of the most beautiful women he ever painted."[6] Sarah married the Philadelphia merchant Thomas Lea in 1787.[7] The mood of the portrait is a striking contrast to that of her father. Her expression is both sweet and sad, her heavy eyelids closed slightly over her blue eyes, her bright pink cheeks and lips conveying good health perhaps artificially. Her hair is loosely fashioned in the

Fig. 1. Adolph-Ulrich Wertmüller, Robert Lea, 1796. Oil on panel, 10 × 8½ in.
(25.4 × 21.6 cm). Corcoran Gallery of Art, Anonymous Gift, 1979.78

French style with the brown curls piled high and cascading onto her shoulders. Her black Empire-style dress has a low-cut bodice and tight-fitting long sleeves. A gauzy fichu, or scarf, draped over her shoulders slightly covers her soft flesh. Its edges, sketched in strokes of black and white, are so loosely painted on her right side that they appear almost cloudlike. Behind is a tree with golden brown leaves that catch the sunlight from the left.

Mrs. Lea's portrait is traditionally dated to about 1798, but it could be closer to the date of her father's portrait.[8] At the very least, it must have been painted after August 1795, the date of a portrait of her son Robert that she wears as a miniature at the end of a large gold chain. The original oil portrait (Fig. 1), painted on a wood panel about ten by eight and a half inches in size, is larger than the miniature that Stuart has depicted. He has taken license with the original, which is the work of Adolph-Ulrich Wertmüller, a Swedish artist who had gone to Philadelphia in 1794.[9]

This group of family portraits demonstrates how such images cemented and expressed close family relationships. Sarah Shippen had lost her husband in 1793, and her mother in 1794. Her son Robert died in 1801, at which time his grandfather described him to his aunt Peggy as "a beautiful child about 8 or 9 years old."[10] As Margaretta Lovell explains, the miniature "performs the function of mnemonic for Mrs. Lea in the same fashion that her full-scale image on the wall in her home points its viewers to her face, her form, her role, and her position within a family web."[11]

Stuart's portrait of Edward Shippen descended in the family, a memoir to his children and grandchildren of the family patriarch. His great-granddaughter Jane Pringle offered it for sale to William Wilson Corcoran: "It has been reckoned one of Stewart's very best paintings and is in all respects in perfect preservation—the wonderful flesh tints being as well preserved and as fresh as if painted yesterday. I should like it to belong to a public institution safe from all the risks and chances of private ownership in the South."[12] After the portrait was acquired by the Corcoran Gallery in 1874, Corcoran curator William MacLeod described it to George C. Mason, who was compiling the first biography and checklist of Stuart's work, at the request of Stuart's daughter Jane Stuart, as "among the finest of Stuart's works, and when in New York to be cleaned, elicited the greatest admiration from [Daniel] Huntington and other artists."[13] The portrait of Sarah Shippen Lea was acquired as a bequest from her descendants more than one hundred years later.

EGM

Gilbert Stuart (near Kingston, R.I., 1755–Boston, 1828)

George Washington, c. 1800

Oil on canvas, 28¹³⁄₁₆ × 23¹³⁄₁₆ in. (73.2 × 60.5 cm)
William A. Clark Collection, 26.172
(*left*)

George Washington, probably 1803

Oil on canvas, 29⅛ × 24³⁄₁₆ in. (74 × 61.5 cm)
Gift of Mrs. Benjamin Ogle Tayloe, 02.3
(*right*)

These portraits of George Washington by Gilbert Stuart are two of approximately seventy-five similar paintings that the artist made of the first American president between 1796 and 1825.[1] Collectively known as the Athenæum portraits, they are replicas (copies an artist makes of his own work) of Stuart's famous life portrait of Washington, painted in Philadelphia in 1796 (Fig. 1).[2] The popular name of the life portrait is derived from that of the Boston Athenæum, the private library that acquired it and the pendant portrait of Martha Washington soon after Stuart's death in 1828. Martha Washington commissioned the original portraits in 1796 at the end of Washington's second term as president. They were left incomplete by Stuart, who at Washington's retirement believed he had the president's permission to keep them in order to satisfy the demand for copies. Stuart referred to the portrait of Washington as his "hundred-dollar bill" because he charged that sum for each replica that he painted.[3]

The marketability of portraits of Washington had been very much on Stuart's mind when he returned to the United States from Ireland in 1793, having been out of the country since 1775. Stuart knew of a number of English and Irish admirers of Washington and told an Irish friend, the artist John Dowling Herbert, that he was returning to America for the purpose of making a portrait of the president. "There I expect to make a fortune by Washington alone. I calculate upon making a plurality of his portraits, whole lengths . . . ; and if I should be fortunate, I will repay my English and Irish creditors."[4] He went to Philadelphia from New York in 1795 and first painted Washington that winter. This initial portrait and its replicas, in which the president faces to the viewer's right, are known today as the Vaughan portraits after the original owner of one version, now at the National Gallery of Art in Washington, D.C. Stuart soon had commissions for thirty-nine replicas. This success led Martha Washington to commission a second portrait and one of herself, intending them, when finished, to be displayed at Mount Vernon. Instead, the second portrait of Washington was so successful in its characterization of the president as a heroic leader that it quickly became the preferred version for the replicas. Stuart asked permission to retain it, too, to make the copies, with the result that he kept both portraits in his studio for the rest of his life.

The American artist William Dunlap later wrote about the challenges Stuart had faced when painting the first president: "Stuart has said that he found more difficulty attending the attempt to express the character of Washington on his canvas than in any of his efforts before or since. . . . He was more fortunate in the second attempt, and probably not only had more self-possession, but had inspired his sitter with more confidence in him, and a greater disposition to familiar conversation."[5] The second, an Athenæum portrait, is a more idealized image of Washington than the Vaughan and evokes the sitter's moral character by its emphasis on his broad brow. The replicas of the portrait, which show more of the figure than the unfinished original, are abbreviated bust-length images that depict Washington in a black velvet suit, which he wore for public

Fig. 1. Gilbert Stuart, *George Washington (Athenæum)*, 1796. Oil on canvas, 48 × 37 in. (121.9 × 94 cm). National Portrait Gallery, Smithsonian Institution; owned jointly with Museum of Fine Arts, Boston, NPG.80.115

occasions during his two terms as president (1789–97). His powdered hair is tied back with a black ribbon that is barely visible in the shadows at the back of his head. Turned to the viewer's left, looking out, Washington holds his lips firmly closed around a new set of false teeth.

Stuart's copying technique may have included a tracing cloth, and he probably relied on assistants to draft the essentials of the composition.[6] However, Stuart completed each replica, and his handiwork is visible in the technique. In the two examples owned by the Corcoran, he painted the lighter tones of the face and shirt with a thick impasto or pastelike paint, returning when it had dried to refine the modeling and add darker details with more fluid brushwork. The shadows under Washington's chin and darker areas of the coat and background are more thinly painted, and the hair is created with wisps of paint over a light-colored ground. The darker background, which was painted last, was brought up to the contours of the figure.

Stylistic details of these portraits help to date the paintings.[7] Over the thirty years that Stuart made copies of the Athenæum

portrait, he put less and less effort into the painting process itself. It is apparent from such details that both of the Corcoran's portraits were among the earliest replicas, which makes it likely that they were painted in Philadelphia. The amount and type of detail in the example from the Clark collection suggests a slightly earlier date than the second portrait owned by the gallery, whose first owner was the Washington resident John Tayloe. In the Clark version, whose history before 1895 is unknown, Stuart painted a lacy shirt ruffle, a feature it shares with several other early replicas, including one owned by Thomas Lloyd Moore of Philadelphia (Sterling and Francine Clark Art Institute, Williamstown, Mass.).[8] By contrast, the plain linen shirt ruffle in the portrait that belonged to Tayloe required less effort to paint and thus indicates a slightly later date.[9]

Despite this broad chronology, establishing firm dates for the two portraits is not possible. Without knowing the identity of the early owner of the portrait from the Clark collection, a Philadelphia provenance cannot be firmly established.[10] Conflicting comments about the provenance of Tayloe's Washington appear in the earliest published references to the portrait. Gilbert Stuart's daughter Jane wrote in 1876 that the portrait was painted for John Tayloe, whereas George C. Mason, Stuart's first biographer, asserted in 1879 that Stuart brought the portrait with him "as a specimen of his skill as an artist" when he moved to Washington from Philadelphia in 1803 and subsequently sold it to Tayloe.[11] In either case, Tayloe, builder of the Octagon House, probably acquired the portrait when he and his wife, Ann Ogle Tayloe, had their own portraits painted by Stuart in 1804.[12] No doubt these portraits of Washington were treasured by their early owners as evidence of the continued importance of the first president even after his death in 1799.

EGM

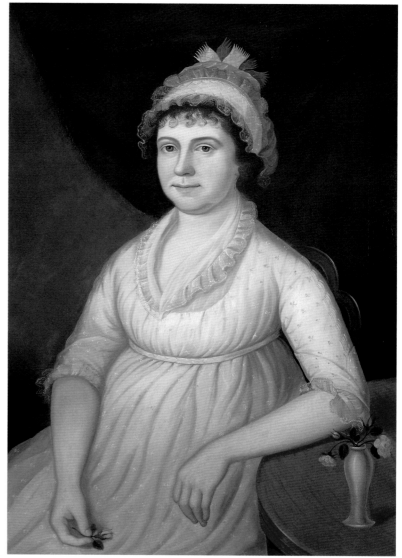

Charles Peale Polk (Annapolis, Md., 1767–Warsaw, Va., 1822)

Thomas Corcoran, c. 1802–10
Oil on canvas, 36½ × 26⁹⁄₁₆ in. (92.5 × 67.5 cm)
Gift of Katharine Wood Dunlap, 47.14

Hannah Lemmon Corcoran (Mrs. Thomas Corcoran), c. 1802–10
Oil on canvas, 36 × 26⅛ in. (91.3 × 66.4 cm)
Gift of Arthur Hellen, 47.15

Thomas Corcoran (1754–1830), the father of banker, art collector, and gallery founder William Wilson Corcoran, was born in Limerick, Ireland, in 1754.[1] He went to Baltimore in 1783, where his mother's brother William Wilson had become one of the city's principal shipping merchants. In 1788 he married his second wife, Hannah Lemmon, of Baltimore (1765/66–1823).[2] They settled in the thriving Potomac River port of Georgetown, where he began a shoe and leather business and also purchased tobacco and flaxseed for his uncle. In 1801 Corcoran was appointed to the Levy Court of the District of Columbia as a justice of the peace by the recently elected American president Thomas Jefferson. This tax court, on which he served until his death, made important decisions about the governing of the city. He was also mayor of Georgetown for four different terms and a founder and trustee of Columbian College, which subsequently became the George Washington University.

The Corcorans' likenesses were painted by Charles Peale Polk, nephew of the American portrait painter and museum founder Charles Willson Peale.[3] Orphaned at ten, Polk grew up at his uncle's home in Philadelphia and studied painting with him. His earliest works include numerous copies of Peale's portraits of George Washington. Polk married Ruth Ellison in about 1785, and in 1791 the family settled in Baltimore. He painted portraits there and in western Maryland and northern Virginia during the following decade. Polk's portraits feature oval faces and gracefully posed bodies, imitated from his uncle's work, as well as a continued fondness for the decorative elements of clothing and backgrounds. His technique is more linear than his uncle's: he usually outlined elements of the composition, notably the sitters' features.

By the time of the presidential election of 1800, Polk was living in Frederick County, Maryland. A supporter of Jefferson and his party, Polk found that his liberal politics were at odds with those of the residents, who were conservative Federalists. Seeking a political appointment in Washington, he wrote to James Madison that the people who could afford portraits were "a Class of Citizens, whose political principles seem to have forbidden . . . the encouragement of those who dared to differ in Opinion from them."[4] After he and his family moved to Washington in 1801, he received an appointment as a clerk at the Department of the Treasury. In Washington, Polk continued to paint portraits on occasion until his last dated work of 1810; among these were the Corcorans. Polk and Corcoran shared political views as supporters of President Jefferson. They may have met at the Presbyterian Church, which the Corcorans belonged to until 1804. Polk attended services there for three years and painted portraits of several sitters who were pew holders.

As is true of Polk's earlier portraits, those of the Corcorans showcase the artist's careful attention to detail. Husband and wife are seated and turn slightly toward each other. The fringed green curtain behind each figure helps to form a symmetrical setting when the pendants are hung as a pair. Corcoran, who was probably approaching fifty years of age when he was painted, wears a russet red suit with metal buttons and a double-breasted white vest with a diamond-shaped pattern in the fabric. Its folds reveal the curve of his stomach. At his waist he wears a watch key and a seal on a chain.

His wife, in her thirties, wears a dress in the new French Neoclassical style, with a high waist and low-cut bodice. It is made of a delicate white fabric, probably cotton, with a woven pattern of small rose-buds. She modestly wears a white fichu tucked into the bodice of the dress. A white cap covers her brown hair, and her pink cheeks radiate her good health. She holds a pink rosebud in her right hand, and on the table nearby is a vase with two pink roses in full bloom and two pink rosebuds. The five flowers may refer to the Corcorans' five children: James, born in 1789; Eliza, in 1791; Thomas, 1794; Sarah, 1797; and William Wilson, 1798. If so, the portraits were painted before 1807, when their sixth child was born.[5]

Thomas Corcoran holds a document that has been folded in three that reads in part, on the center section: "United States House of Representatives . . . day April 24. Debate On the bill from the Senate." On the right section of the paper, the word "Virginia" is visible. Linda Simmons believed that this document was the announcement of Corcoran's appointment as a justice of the peace on the Levy Court of the District of Columbia by President Jefferson in 1801.[6] However, the document is not worded as an executive appointment. Instead, the text and the tripartite configuration of the paper indicate that it is a legislative document, folded when in use during congressional meetings. The writing on the center section is the endorsement page, which identifies the legislation, while the text would be on the reverse side.[7] Unfortunately, it has not been possible to identify the paper in Corcoran's hand, despite a search through the published journals of the United States Congress for a Senate bill that was debated by the House of Representatives on 24 April of any year from 1797 through 1810. The closest debate took place in the Seventh Congress in the spring of 1802 and con-cerned the "Act to incorporate the inhabitants of the City of Wash-ington, in the District of Columbia." No legislative business was conducted on 24 April 1802, which was a Saturday, but the legisla-tion had been voted on by the Senate when, on Tuesday, 27 April, the House passed an amended version. The Senate passed the amended act on 3 May 1802.[8] Corcoran's role in this legislation, if any, is not known. However, his position on the Levy Court gave him a significant role in the new government, and his public role is clearly referred to here, just as his wife's maternal, private role is implied in her portrait. The paintings were valued by later genera-tions, who gave them to the Corcoran Gallery, founded by Thomas and Hannah Corcoran's son.

EGM

Joshua Johnson (probably Baltimore, 1761/63–probably Baltimore, after c. 1825)

Grace Allison McCurdy (Mrs. Hugh McCurdy) and Her Daughters, Mary Jane and Letitia Grace, c. 1806

Oil on canvas, 43⅝ × 38⅞ in. (110.8 × 98.8 cm)
Museum Purchase through the gifts of William Wilson Corcoran, Elizabeth Donner Norment,
Francis Biddle, Erich Cohn, Hardinge Scholle, and the William A. Clark Fund, 1983.87

This engaging record of a mother and her two young daughters is among the nearly one hundred works by Joshua Johnson, America's earliest-known professional black artist, that have come to light since his rediscovery in the late 1930s.[1] The son of a white man and an unidentified slave woman, Johnson was apprenticed to a Baltimore blacksmith before being freed sometime between 1782 and 1784.[2] In the years around 1800, the apparently self-taught portraitist received commissions from a number of prominent families in Baltimore. Besides these particulars, several addresses for the artist, and two newspaper advertisements for his business, little else of Johnson's life is known save for his remarkable portraits.[3]

In the Corcoran's canvas, Johnson portrays the prominent Baltimore matron Grace Allison McCurdy (1775–1822),[4] accompanied by her children, Mary Jane (c. 1802–1866) and Letitia Grace (1797–1875).[5] Grace had married the prosperous Baltimore merchant Hugh McCurdy (c. 1765–1805) in 1794,[6] and several years later the couple ordered the first of two portraits from Johnson, a full-length likeness of young Letitia (Fig. 1). As the Johnson scholar Carolyn Weekley has noted, the birth of Mary Jane in about 1802 likely explains the rather unusual circumstance of a second McCurdy portrait commissioned from the painter within such a short span of time. It is also possible that the triple portrait originally was planned as a likeness of all four family members, but that Hugh's untimely death in 1805 altered that arrangement, effectively making the image one that memorializes the family patriarch through his absence.[7]

Stylistically, the McCurdy family likeness bears all the hallmarks of Johnson's distinctive manner and specifically what Weekley defines as his middle period (1802–13/14).[8] The stiffly posed figures feature bodies and clothing with little or no modeling and faces with carefully delineated, if somewhat formulaic, details. The Sheraton-style horsehair sofa framing the family is dotted with brass tacks, and, as in many of the artist's other compositions, the subjects' heads are haloed against a somber, unadorned background. The mother and older daughter delicately grasp strawberries (both loose and in a basket) and a parasol, decorative props of the type Johnson often used. Finally, the painting's subdued palette, enlivened by brilliant accents, is typical of the artist's work.

In his portrait of the McCurdys, Johnson integrates these characteristic traits into a strikingly simple arrangement unified by subtly complex details. The straightforward, if somewhat awkward, female bodies nearly fill the picture plane. Johnson suggests their corporeality through their full-skirted Empire dresses and ample, columnar arms[9] while conveying their individuality through particularities of pose, visage, and costume.[10] He relates the figures one to another by means of relatively sophisticated compositional elements. Grace's hand rests on Mary Jane's shoulder while the girl returns her mother's gesture, and the sisters are connected by their parallel arms and by the green parasol, which continues the folds of Mary Jane's dress.[11] The three are linked by the repetition of their white dresses and by the slope of the sofa, which echoes the rising line of their heads. They are also integrated by the recurrence, along a roughly horizontal axis, of the red accents of strawberries and slipper. Together, the picked fruit, basket, and parasol imply that the trio

Fig. 1. Joshua Johnson, *Letitia Grace McCurdy*, c. 1800–1802. Oil on canvas, 41 × 34½ in. (104.1 × 87.6 cm). Fine Arts Museums of San Francisco. Acquired by public subscription on the occasion of the centennial of the M. H. de Young Memorial Museum with major contributions from The Fine Arts Museums Auxiliary, Bernard and Barbro Osher, the Thad Brown Memorial Fund, and the Volunteer Council of the Fine Arts Museums of San Francisco, 1995.22

has just returned to their parlor from an outdoor activity, a narrative sequence unusual in the artist's work.[12] In this, one of his most captivating portrayals—at once unassuming and intricate—Johnson has succeeded in expressing his subjects' individuality as well as their appealing familial closeness.

The ambitiousness of compositions like the McCurdy portrait is among the primary reasons for scholarly hesitation to accept Johnson's description of himself as a "self-taught genius."[13] Another is the extraordinarily rich artistic milieu in Baltimore, which included the prolific Peale family of painters, particularly Charles Peale Polk, who may well have influenced Johnson.[14] Finally, there is evidence to suggest the painter's exposure to artists even farther afield, particularly since his whereabouts are unknown from the time of his manumission, between 1782 and 1784, to the mid-1790s, when he probably became active in Baltimore.[15]

Whatever Johnson's artistic training and exposure may have been, the McCurdys chose him, rather than one of his Baltimore colleagues, for two of their portrait commissions. By 1800, the approximate date of the artist's important first commission from the family, the McCurdys certainly would have been aware of the

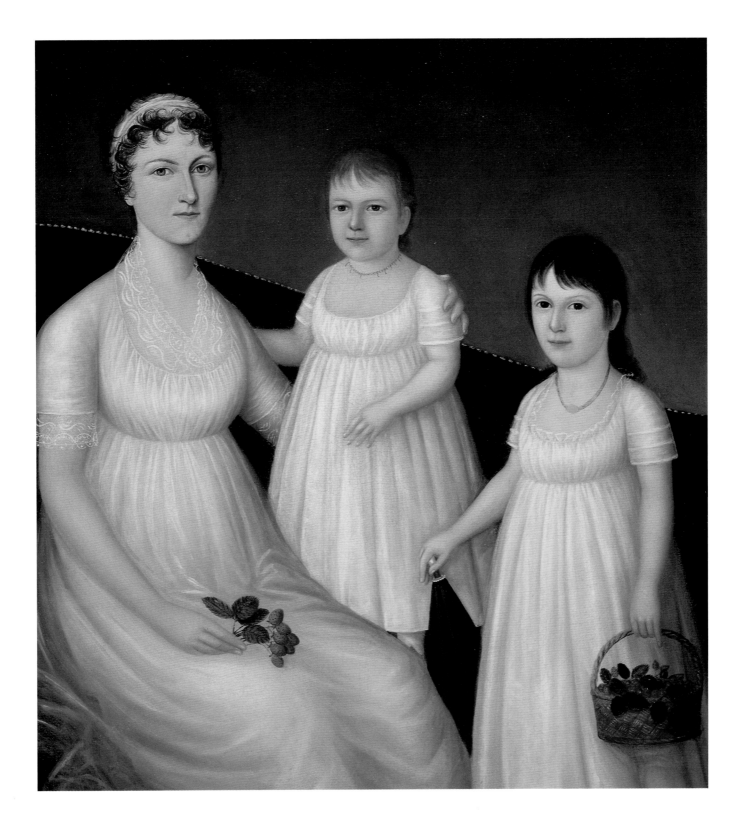

painter's presence in Baltimore; Johnson's first newspaper advertisement, in 1798, suggests that he had been active there for several years.[16] One of his contemporaries may have introduced him to the family; Rembrandt Peale, for example, had painted Hugh McCurdy's portrait in 1798.[17] Moreover, by 1800 Johnson had begun to develop what appears to have become a specialty in children's portraiture, judging from the many such likenesses among his located works.

Before ordering Letitia's portrait, the McCurdys may have met Johnson independently or via an introduction from a common neighbor, since in the late 1790s both families lived near the intersection of Hanover and German Streets in Baltimore.[18] There may well have been political and social motivations behind the commission of Letitia's portrait and, subsequently, that of the Corcoran's portrait (as suggested above, this may have been ordered before Hugh McCurdy's premature death). Many of Johnson's patrons both lived in this vicinity and were leaders of Baltimore's burgeoning abolitionist movement; they sought the painter's services, at least in part, because they wished to support his success as a freedman.[19] McCurdy may have shared the abolitionist leanings of many of his family's neighbors, among whom was his brother-in-law, the patriot and abolitionist James McHenry,[20] as well as those of Johnson's abolitionist patrons living outside this immediate area, such as Dr. Andrew Aitken, a member of the newly formed Abolition Society.[21] Although the manner in which the McCurdys met Johnson and their motive or motives for engaging his services may never be uncovered, *Grace Allison McCurdy (Mrs. Hugh McCurdy) and Her Daughters, Mary Jane and Letitia* presents a sensitive and appealing likeness of the three McCurdy females from a fascinating, pivotal era in the social and cultural history of federalist Baltimore.

SC

Charles Bird King (Newport, R.I., 1785–Washington, D.C., 1862)

Poor Artist's Cupboard, c. 1815

Oil on panel, 29¹³⁄₁₆ × 27¹³⁄₁₆ in. (75.7 × 70.7 cm)
Museum Purchase, Gallery Fund and Exchange, 55.93

In *Poor Artist's Cupboard*, Charles Bird King introduces his audience to the sad story of the fictional artist C. Palette.[1] King's trompe l'oeil (fool the eye) panel is painted to resemble a niche containing a revealing assortment of Palette's possessions. A case of drafting tools—with compass and protractor visible—is at the center, flanked by a crust of bread perched, ironically, on the richly bound tome *Lives of Painters* and a humble glass of water. Just below are two calling cards, each addressed to Mr. C. Palette. One, from a parsimonious patron, Mrs. Skinflint, requests that he visit her *after tea*, and a second records a debt of five dollars that Palette owes to a lover of the "Arts of Painters." Above, lying horizontally, are two thin volumes whose handwritten titles were proverbs about poverty: "We Fly by Night" and "No Song, No Supper."[2] On top of them lies a stack of unpaid bills. Surrounding these objects is a host of books with inauspicious titles: *Miseries of Life, Advantages of Poverty—Third Part,* and *Cheyne on Vegetable Diet.*[3] Opening this sad tableau at the upper left is an advertisement for a sheriff's sale, which lists the "property of an artist": a few articles of clothing, a peck of potatoes, and several still lifes of rich repasts painted "from recollection."

King's painting contains several references to the city of Philadelphia, where he lived from 1812 to 1816. The sheriff's sale takes place there, and the painting includes a perspective view of the city jail (Fig. 1), which housed debtors. King makes pointed reference to the state of the arts in Philadelphia, as well. A tally of paintings sold in Philadelphia, which peeks out from the red portfolio, records a large number of portraits, the most popular but least artistically challenging genre of the period.[4] Mrs. Skinflint's invitation suggests the stinginess of art patronage in Philadelphia, and a book titled *Choice Criticism on the Exhibitions at Philadelphia,* at the very bottom, is noticeably thin.

King himself had little professional success in Philadelphia. After four years in the city, he is documented as having sold only two portraits.[5] But he was not, in the truest sense, a starving artist. Born in Newport to a wealthy family, he always had independent means and appears never to have relied on sales for his livelihood. As a result, art historians have theorized that *Poor Artist's Cupboard* is not a statement on his own experience as a struggling artist but a meditation on the impoverishment of American cultural life, symbolized by the tattered books.[6] But King may also have had a more pointed statement to make about artists' role in their penury. Despite his means, he chose to live in self-imposed privation. When a student in London, for example, he and the portraitist Thomas Sully made a pact to share a small, one-room apartment and subsist on bread, milk, and potatoes to stretch their budgets.[7] King's parsimony went hand in hand with his desire to live an ascetic life. His landlady in London told the visiting American critic John Neal that King curiously slept on the floor even though he was provided with a bed.[8]

Given that private art patrons in America were few and public patronage almost nonexistent, the expensive tastes of King's fictional artist—note the stylish beaver felt top hat at center right—and his grand artistic ambitions, suggested by the sixteen-by-twenty-foot history painting *Pursuit of Happiness* advertised in the sheriff's sale, reveal that Palette is unrealistic and unwilling to compromise.[9] King's painting has also been understood within the context of Dutch still life paintings, particularly the niche paintings of the *fijnschilders* (fine painters) of Leiden as well as the tradition of *vanitas* paintings, the meditation on the fleeting pleasures of life.[10] Indeed, the tattered books and the cylinder of papers, which, when viewed obliquely, resembles a skull, suggest decay and death.[11]

Fig. 1. Charles Bird King, *Poor Artist's Cupboard*, detail

Fig. 2. Charles Bird King, *Vanity of the Artist's Dream*, 1830. Oil and graphite on canvas, 35⅛ × 29½ in. (89.2 × 74.9 cm). Harvard Art Museum, Fogg Art Museum, Gift of Grenville L. Winthrop, Class of 1886, 1942/193

Palette's vanity and the *vanitas* theme also play a role in King's second installment in the tale of C. Palette, the allusively titled *Vanity of the Artist's Dream* (Fig. 2), now in the Harvard Art Museum, Fogg Art Museum. In that painting, C. Palette's name reappears as a signature in a sketchbook, as an inscription on a last-place medal, in a news article announcing the closing of an unsuccessful exhibition of his works, and in a letter from his patron, A. Skinflint, who now complains that a carpenter painted three of her doors for less than the price of one of Palette's paintings.[12] Details suggest that Palette's circumstances have worsened. Twenty or more "inscriptions" appear on the painting's trompe l'oeil frame, including notes about debts and forgoing milk, butter, and cab rides, and copies of the same books pictured in *Poor Artist's Cupboard* show considerably more wear. The artist's imprudence, however, persists. A sheriff's sale notice, again in the upper left, lists a painting of King Croesus, known for his vanity and who is usually pictured among luxurious goods. A note on the frame also indicates that Palette was long missing his second volume of *Human Prudence*.[13]

A curious detail in the picture at Harvard raises an intriguing question about the provenance of the two paintings. Wrapped around a scroll, prominently placed in the center, is a letter to Palette from the Boston Athenæum. The part that is visible reads,

"I regret to inform you that the picture you *lent* to the Boston Athenaeum for their exhibition is sold (by mistake at half-price) to Mr. Fullerton who refuses to relinquish it or pay your price."[14] James Fullerton, a Boston collector, likely saw the Corcoran's *Poor Artist's Cupboard* when it was exhibited at the Boston Athenæum in 1828 alongside two works from his own collection.[15] By 1832 he owned a version of King's painting, which he exhibited at the Boston Athenæum under the title *Poor Artist's Study*. Scholars have always assumed this was the painting now at Harvard, and that its trompe l'oeil letter was a teasing reference to the picture's owner. But the situation recounted in *Vanity of the Artist's Dream* may also be true, and the Corcoran's painting was the one Fullerton purchased from the Boston Athenæum at half price.[16]

In 1818 King moved to Washington, D.C., where he found great success as a painter of society portraits and diplomatic portraits of visiting Native American delegations. He also ran a for-profit gallery in his home on 486 12th Street, between E and F Streets, on and off from 1824 to 1861. There he exhibited about two hundred of his own paintings. *Poor Artist's Cupboard* was likely among the works on exhibition during the gallery's first decade, an enduring token of leaner times.[17]

LS

65

Alvan T. Fisher (Needham, Mass., 1792–Dedham, Mass., 1863)

Mishap at the Ford, 1818

Oil on panel, 27⅝ × 35¹⁵⁄₁₆ in. (70 × 91.3 cm)
Signed and dated lower center: A. Fisher, Pinx. Feb 7 1818
Museum Purchase, Gallery Fund, 57.11

Alvan T. Fisher was one of America's first landscape and genre painters. He received his early training in the studio of John Ritto Penniman, a Boston painter who specialized in a variety of artistic enterprises including portraiture, ornamental painting, and stage design. After approximately two years with Penniman, Fisher established his own portrait studio in Boston at the age of twenty. According to his own account, this is when he "truly became a painter," and over the next few years he earned a reputation as a painter of portraits, animals, landscapes, and rural scenes of everyday life.[1] *Mishap at the Ford* is one of Fisher's earliest extant genre paintings, and it epitomizes the thematic range of his oeuvre. In this humorous scene, a carriage with four well-dressed travelers becomes stuck in the mud while attempting to traverse a ford. As the figures in the carriage gesticulate wildly, a man up to his knees in the water attempts to free one of the wheels, while another on shore tries to calm the four frantic horses. Just behind the carriage, three laborers or fishermen stand in a small, flat-bottomed boat, as an unlucky fourth man, likely knocked from the vessel into the water as a result of this mishap, is being pulled back in. Fisher's painting implies that this was a peaceful scene in the country before the elegant city folks arrived.

By the second decade of the nineteenth century, genre paintings featuring farcical or moralizing stories had become popular with the American art-buying public. While these paintings were inspired by English art, particularly humorous paintings and prints by such artists as William Hogarth, David Wilkie, and Thomas Rowlandson, their subject matter was tailored to appeal to an American audience.[2] The foursome in *Mishap at the Ford* is likely on a sightseeing jaunt, a subject that reflects the growing popularity of tourism in America during this period.[3] The carriage pictured is a barouche, an expensive vehicle that typically was used for short pleasure outings.[4] Although Fisher's New England landscapes are generalized, his audience would probably have recognized the familiar plight of the passengers; many roads at the time were suitable only for horses and walking, not elegant wheeled vehicles.[5] Additionally, the military uniforms worn by the gentlemen in the barouche readily identify them as United States Army officers; the soldier in the front appears to be a junior officer, while the hat of the other identifies him as an officer of high rank.[6] The members of the military provide the narrative with an additional touch of humor, since the present circumstances render these trained professionals helpless.

Like other genre painters of his generation, Fisher tells his story through figural placement and exaggerated gestures.[7] The figures in the carriage stand unsteadily, the soldiers' arms are outstretched, and the woman in the rear recoils in fear. The man on shore attempting to calm the horses waves his arms frantically, conveying a sense of urgency to the scene and probably scaring the horses even more. Fisher developed the figural elements and composition for *Mishap at the Ford* in a series of preparatory drawings in several sketchbooks dating from about 1818; these are the earliest of his preliminary sketches that can be linked to a specific painting.[8] Once the artist developed a composition he deemed successful, he often repeated it. He was apparently pleased with *Mishap at the Ford*, for he made at least one other almost identical version of this picture dated May 1818, approximately three months after the 7 February date on the Corcoran's canvas.[9]

JC

Washington Allston (Georgetown, S.C., 1779–Cambridgeport, Mass., 1843)

A Landscape after Sunset, c. 1819

Oil on canvas, 17⅞ × 25¼ in. (45.5 × 64.3 cm)
Museum Purchase, William A. Clark Fund, Gallery Fund, and gifts of Orme Wilson,
George E. Hamilton, Jr., and R. M. Kauffmann, 63.9

A Landscape after Sunset is one of a trio of landscapes Washington Allston made after his return to Boston from England in 1818.[1] Like *Moonlit Landscape* of 1819 (Museum of Fine Arts, Boston) and *Landscape, Evening* of 1821 (IBM Corporation), it is more dream than place, a product of memory rather than observation. A mysterious traveler follows his dog along a meandering path toward a pool of water, where cattle drink in the dim light of the magic hour, that time between sunset and nightfall when objects start to blur into tonal oneness. A shadowy hill town in the middle distance suggests Italy, but it is, deliberately, not meant to be anywhere in particular. Working in London (1811–18), Allston had initially endeavored to paint historical narratives, but his enthrallment with the English poet Samuel Taylor Coleridge turned him in a new, poetic direction.[2] Increasingly, Allston became preoccupied with the human imagination and with what it means to create. He turned his attention away from the external, empirical world and moved, in the words of biographer Elizabeth Johns, toward "making art about the internal life of the mind."[3] *A Landscape after Sunset*, in its visual and narrative indeterminateness, exemplifies Allston's newfound aesthetic. Instead of painting the here and now (at the time he was living in a neighborhood near Boston), he conjured up memories of Italy, a ruminative process that to him fulfilled the poetic possibilities of painting.

Allston's writings elucidated his thinking. His gothic novel, *Monaldi*, which he completed in 1822, opens with a scene much like *A Landscape after Sunset*, "when the peculiar features of the scenery are obscured by the twilight."[4] The main character, Monaldi, who is Allston's alter ego, is an artist of inner "depth and strength" who wants to "shut out" the external world "and to combine and give another life to the images it had left in his memory; as if he would sleep to the real and be awake only to a world of shadows." Monaldi "looked at Nature with the eyes of a lover" and, instead of transcribing its beauties, "treasured [them] up in his memory."[5] His antagonist, Maldura, embodies the values Allston despised: for Maldura, "the world, palpable, visible, audible, was his idol; he lived only in externals, and could neither act nor feel but for effect."[6] In his *Lectures on Art*, Allston's summa on aesthetics, he further articulated his argument against artists like Maldura, who make "a mere mechanical copy of some natural object."[7] Would any viewer "be truly affected by it," he asked? If nature is rendered as "faithful transcripts," that is, with information that has not been processed through the imagination, then "*feeling*," which was to him the supreme purpose of any art or literature that claims to be poetic, "will not be called forth." True art should not be confused with nature, the former possessing a "*peculiar something*," a "considerable admixture of falsehood."[8] When seen in Allston's own terms, *A Landscape after Sunset* is a mysterious image that forsakes the temporal and visible in a poetic quest for the spellbinding. Margaret Fuller, the Transcendentalist, thought that Allston's landscapes were his truest subjects, ones that had "a power of sympathy," where "Nature and Soul combined; the former freed from slight crudities or blemishes, the latter from its merely human aspect."[9]

Fig. 1. Claude Lorrain, *Landscape with Tobias and the Angel*, 1663. Oil on canvas, 45½ × 60½ in. (116 × 153.5 cm). The State Hermitage Museum, St. Petersburg, GE-1236

As much as Allston's visual poetry—that dark inexplicitness that suggests quiet emotional rapture—shows the influence of Coleridge, it was also the result of his intensive study of the sixteenth-century Venetian masters and the seventeenth-century French painter Claude Lorrain.[10] "Titian, Tintoret and Paul Veronese absolutely enchanted me," he told William Dunlap, not because their technique served their subjects, but because, remarkably, he thought their technique "took away all sense of subject."[11] To Allston, whatever the subject, whether biblical or portrait, the Venetians' color and glazing (thin films of transparent color) not only obscured details but also produced the mystifying effect of light from within that he valued: "it was the poetry of color which I felt."[12] Surely he knew Claude's *Landscape with Hagar and the Angel* (1646, The National Gallery, London), which was owned by his friend and patron, Sir George Beaumont. *A Landscape after Sunset*, however, more closely resembles Claude's *Landscape with Paris and Oenone* (Musée du Louvre, Paris) and *Landscape with Tobias and the Angel* (Fig. 1). Yet Allston does not seem to want to imitate Claude as much as he wants to top him: more moody, less structured, more ambiguous, less composed than the old master's work. Claude paints sunsets; Allston moves the clock ahead toward darkness. Claude animates trees with a delicate breeze; Allston silences and stills them as if the picture were a memorial rendering of nature. Claude masses his delicate foliage; Allston makes it wispy and insubstantial. Claude organizes around a story line, but Allston's blurry figure and static cattle wander in the residue of the day, slowly and dimly, like indistinct poetic forms.

PS

Samuel Finley Breese Morse (Charlestown, Mass., 1791–New York City, 1872)

The House of Representatives, completed 1822; probably reworked 1823

Oil on canvas, 86⅞ × 130⅝ in. (220.7 × 331.8 cm)
Signed and dated lower left: S. F. B. MORSE. pinx / 1822
Museum Purchase, Gallery Fund, 11.14

When Samuel F. B. Morse painted *The House of Representatives*, he was in the second decade of a twenty-six-year career as an artist, a profession that would end in disenchantment when he abandoned painting in 1838 to embrace a future built around his invention of the electromagnetic telegraph.[1] But in 1821 he felt there was an urgent need to produce a significant artistic statement. When he was a student at the Royal Academy in London, his teachers had encouraged him to paint historical subjects that were large, idealized, complex, and capable of transmitting moral lessons. Morse saw pictures like that cropping up across the East Coast after he returned to America: Benjamin West presented an epic *Christ Healing the Sick* to Pennsylvania Hospital in 1817; Morse's mentor, Washington Allston, exhibited *Dead Man Restored to Life by Touching the Bones of the Prophet Elijah* at the Pennsylvania Academy of the Fine Arts in 1816 (Pennsylvania Academy of the Fine Arts) and began his ambitious *Belshazzar's Feast* in 1817 (The Detroit Institute of Arts); Thomas Sully sold his *Passage of the Delaware* (p. 74, Fig. 2) to a Boston frame maker in 1819; and John Trumbull's four pictures on the subject of the American Revolution, which were commissioned by the federal government in 1817 for installation in the Rotunda of the United States Capitol, earned him a princely thirty-two thousand dollars. Perhaps the most spectacular example of the "grand" picture was Rembrandt Peale's *Court of Death* (1820, The Detroit Institute of Arts), a gothic carnival of suffering that attracted thirty thousand viewers across the East Coast between 1820 and 1822 and brought Peale more than nine thousand dollars in ticket sales.[2]

At the age of thirty, Morse felt it was time to paint his own summa. Yale-educated, Calvinist-raised, deeply pious, and always correct, Morse avoided an impolite subject like Peale's by coming up with the high-minded idea of painting the Congress of the United States, to be accompanied later by canvases on the Senate and the Executive Branch—a Washington trilogy to match Trumbull's Revolutionary quartet. In principle, his plan should have worked. Few Americans in 1822 could imagine what the federal government looked like, let alone what it did or who was there. Washington was a largely unseen, unvisited city, at a hopeless distance from population centers. Wouldn't citizens of New York, Boston, and Philadelphia be enthralled to see the center of American politics and power come to life? After all, the Capitol had just been majestically rebuilt by Benjamin Henry Latrobe after the devastating sack of the city by the British in 1814.

Morse arrived in Washington from New Haven on 6 November 1821, obtained permission to set up a studio in rooms just off the House floor, and began an oil sketch of Latrobe's new House chamber (Fig. 1). He decided on a view that put the Speaker's chair on the far left, with the half dome and colonnade swinging off to the right. Morse admitted—and the sketch confirms—that he was having trouble getting the perspective of the room correct. In January 1822 he started taking small, rough portraits of the men—including the Corcoran's sketch of Joseph Gales, a reporter for the *National Intelligencer* who appears in the finished painting at the far left (Fig. 2)—whom he would call away from the House floor and into his studio for about an hour at a time.[3] He talked about his work schedule in a letter to his wife: waking at dawn, breakfast, prayer, painting until 1:00, fifteen minutes for lunch, more painting until 8:00.[4] Every day. Except Sundays. By February he was on his way back to his home

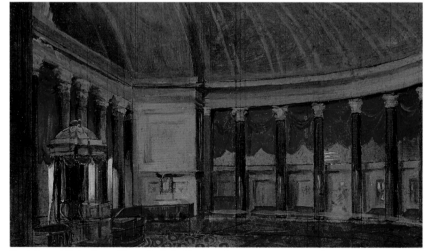

Fig. 1. Samuel Finley Breese Morse, Study for *The House of Representatives*, c. 1821. Oil on panel, 8¼ × 13¾ in. (20.9 × 35 cm). Smithsonian American Art Museum, Museum purchase through a grant from the Morris and Gwendolyn Cafritz Foundation, 1978.166

Fig. 2. Samuel Finley Breese Morse, *Joseph Gales*, 1821–22. Oil on panel, 5½ × 3½ in. (14 × 8.9 cm). Corcoran Gallery of Art, Museum Purchase, Gallery Fund, 51.23

and family in New Haven. By July 1822 he had most of the architecture and objects in place on the seventy-six-square-foot canvas and then began folding in the ninety-four figures.[5] With unrelenting effort, he had it all finished in January 1823, fourteen months after he started.

The picture shows the Seventeenth Congress at the beginning of an evening session. Congressmen mill about the saucerlike depression of the room in strings and clusters that knit the picture together. A box for sorting mail, located in the right foreground, tosses light toward the center. The primary illumination, though, comes from a large Argand chandelier that is the nexus of the picture. The composition spins outward from the oil-fired rings that the silhouetted doorkeeper, Benjamin Burch, ignites while balancing on a ladder. Congressmen mingle with clerks; the Supreme Court, which was then housed in the Capitol, gathers at the back of the room; two journalists stand attentively on the far left. Everyone is informal, caught chatting, reading, reclining, and walking. In the visitors' gallery on the far right is the artist's father, the Reverend Jedidiah Morse, an impeccable Calvinist minister who was in Washington to see Congress accept his report to Secretary of State John C. Calhoun on the state of Indian affairs. Seated next to him is Petalasharo, a Pawnee chief who was part of a diplomatic delegation there to see President James Monroe. The chief wears a medal given him by Miss White's Female Seminary for Select Young Girls, in recognition for saving a Comanche woman from being burned at the stake.

However, Morse's genteel scene is not an accurate representation of Congress at the time. In reality, by 1822 Congress had grown to include the distant states of Indiana, Mississippi, Illinois, Alabama, Maine, and Missouri, and the congressmen from those rural areas threatened the elite leadership from the eastern states. Men less polished and more demagogic recognized how the new demographics, in concert with emerging white male suffrage, were shifting power away from the old guard. The Congress that Morse actually saw in 1822 was a "scene of confusion" filled with "hortatory outcry in milling throngs."[6] The English travel writer Basil Hall saw "desk drawers banged, feet shuffled on the floor, bird dogs from the hunt bounding with their masters, yapping accompaniment to contenders for attention, contenders for power" when he visited.[7] In her controversial and highly critical *Domestic Manners of the Americans* (1832), the English expatriate Frances Trollope described how she was aghast to see "this splendid hall fitted up in so stately and sumptuous a manner, filled with men sitting in the most unseemly attitudes, a large majority with their hats on, and nearly all spitting to an excess that decency forbids me to describe—a Cosmos of evil and immorality."[8]

The House of Representatives is not a picture of Congress as it was but Congress the way Morse wanted it to be. His compulsion to depict it as harmonious, courteous, and tranquil, to stress institutional civility, spatial clarity, and architectural magnitude, was an effort to vanquish the present and recuperate the past. The artist's polite, homogeneous, capacious image of the American political system, which he believed was fast decaying into factious debate, crude behavior, and democratic boorishness, stemmed from his own conservative belief in patrician rule, now on its way out.

Morse took his giant picture (and its ideology), packed it in a crate, and shipped the 640-pound package to David Doggett's Repository in Boston for exhibition in February 1823. Admission was 25 cents, 50 cents for the season; the guidebook cost 12½ cents. He then had his agent, Henry Cheever Pratt, distribute five hundred handbills on the streets of the city. He augmented the pictorial effects of the canvas by placing six tin lanterns on the floor in front of it.[9] But Bostonians stayed away, preferring other attractions, such as the tightrope-walking baboon at the Grand Menagerie of Living Animals on Hanover Street or the wax figure of President Monroe at the City Museum. Morse had no choice but to close the show in April. After the painting appeared briefly at the Essex Coffee House in Salem, Massachusetts, he shipped everything to a gallery at 146 Fulton Street in New York. But there he had to compete with Peale's spectacular *Court of Death* and Sully's *Passage of the Delaware* as well as a hippopotamus on Nassau Street and an Egyptian mummy at Scudder's Museum. "Should a man paint Hercules strangling serpents," wrote Morse's brother-in-law, "he would please New York. But . . . the owner of a lion, bear, or monkey would realize more money and receive greater applause [than you]."[10] Giving up on cities, Morse had C. M. Doolittle take the picture to Albany; Hartford and Middletown, Connecticut; and Springfield and Northampton, Massachusetts. Then he abandoned the tour. In 1828 Morse rolled up the canvas and sent it to his friend and fellow artist Charles Robert Leslie in England, who tried to sell it to the eccentric art patron George Wyndham, third Earl of Egremont, who was wholly indifferent to it. "Had it contained a portrait of Jefferson, Madison or Adams," Leslie told Morse, then "it would have interested [Egremont] more."[11]

What had gone wrong? All of Morse's efforts to civilize Congress led to a picture that looks like an inventory of a place and thus lacks eventfulness.[12] Short on drama, its small, static figures and uncomplicated egalitarian ethics could hardly compete with the varied spectacles vying for the public's attention. To be sure, he could have done more with his subject: Congress had recently been producing major legislation, such as the Slave Trade Act of 1820 and the Missouri Compromise of 1821, that pitted proslavery congressmen against abolitionists, both of which had dramatic possibilities as subjects. But Morse seemed intent on a picture that avoided the debates and votes that would have demonstrated the tensions built into the two-party system, and at the same time he steered clear of spotlighting famous individuals. His idealized image of collegiality and collectivity whitewashes the rancor and factionalism that permeated the House floor. Instead of a dramatic event, which was a hallmark of large-scale historical painting, Morse substituted a colossal panorama of objects and people, with the result that scale, space, and calmness dominate the viewing experience. In the end, his *House* resembled interior pictures, such as François-Marius Granet's popular *Choir of the Capuchin Church of Santa Maria della Concezione in Rome* (1815, The Metropolitan Museum of Art, New York) more than Trumbull's narrative pictures of the Revolution. Even in his accompanying pamphlet, *Description*, Morse declared that the picture is meant only to be a "faithful representation of the National Hall."[13] He mentions no figures by name, except in the dispassionate key that accompanied the *Description*, nor does he cite an eventful moment. Instead, he describes the architecture and gives the dimensions of the room.

Morse's gambit—to expel harsh democratic realities and create in their place a pantheon of political idealism—was his nostalgic way of claiming the superiority of the old ruling class, of willing a mythic past into modern existence. If only, as Morse wished, pictures ruled the world, then concordance, rationality, and high purpose would triumph over contingency, dissent, and the erratic behaviors of men. As much as the past was irretrievable, the future was not to be derailed by a painting, however big and heartfelt it might be.

PS

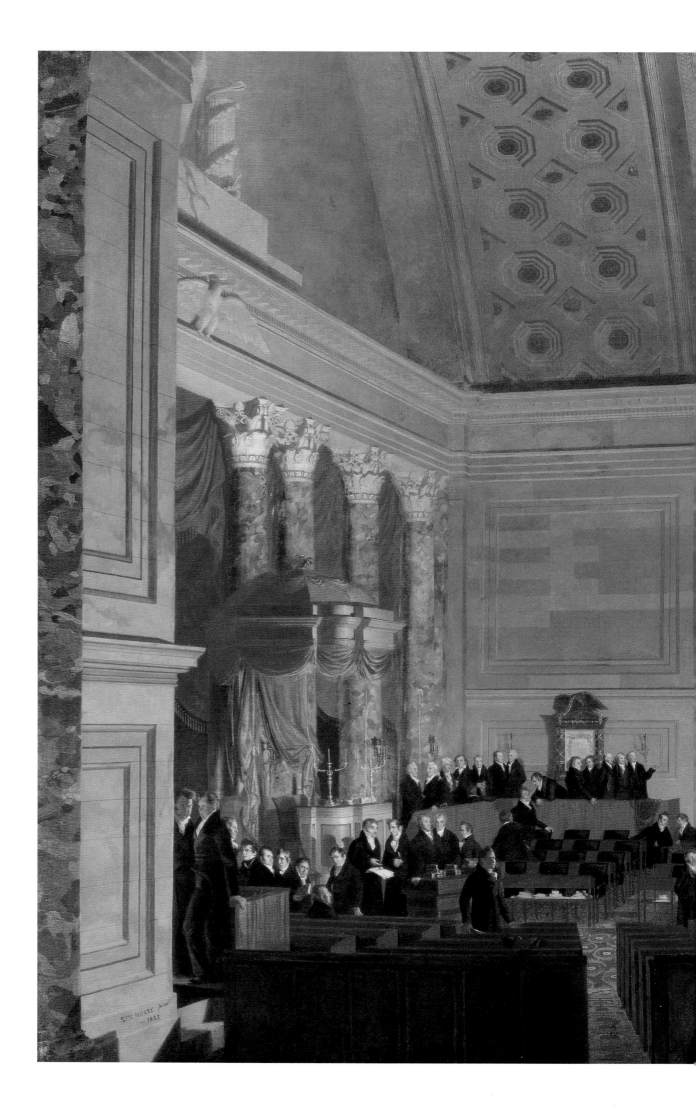

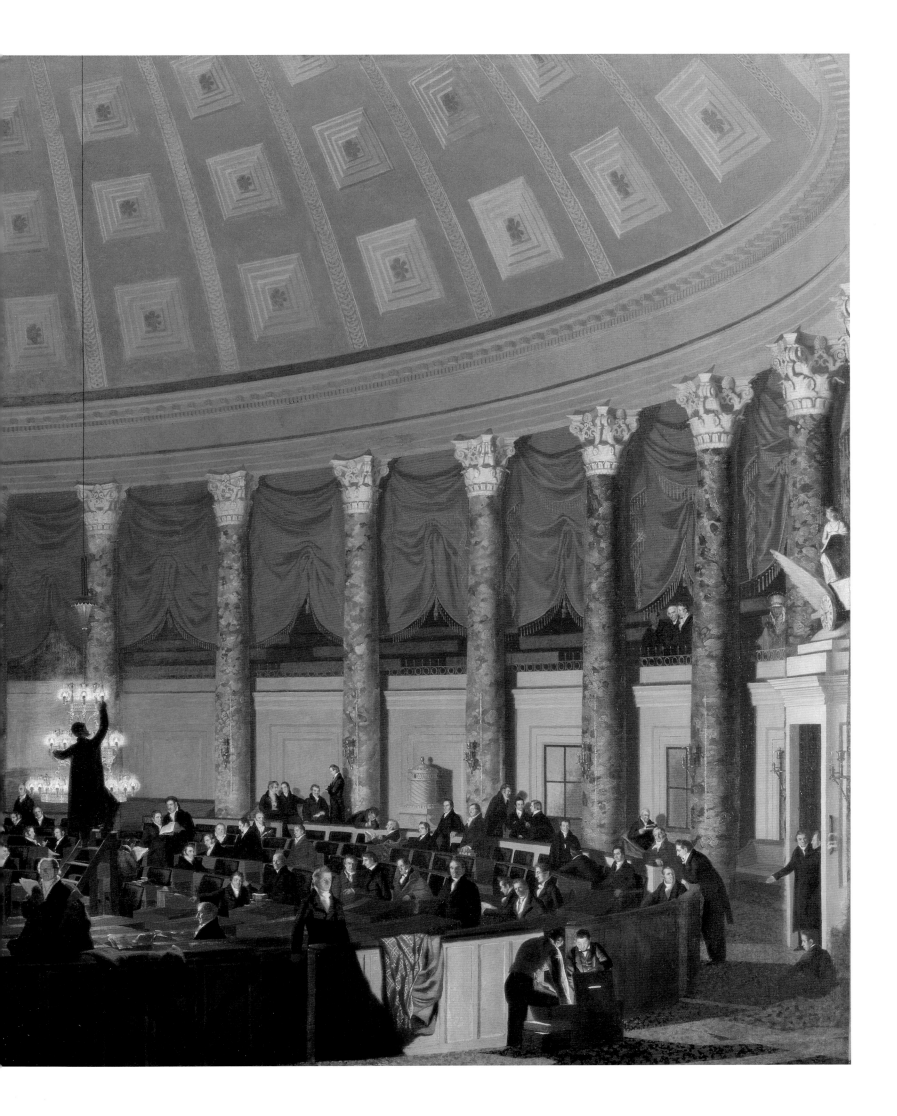

Rembrandt Peale (Bucks County, Pa., 1778–Philadelphia, 1860)

Washington before Yorktown, 1824; reworked 1825

Oil on canvas, 137½ × 120½ in. (3.5 × 3 m)
Signed lower left: Rem.[t] Peale
Gift of the Mount Vernon Ladies' Association, Mount Vernon, Virginia, 44.1

In 1795 Rembrandt Peale painted his first portrait of George Washington, from life, when he was the seventeen-year-old student of his illustrious father, Charles Willson Peale of Philadelphia. He returned to the president only in 1823, with *Patriæ Pater*, a magisterial image (Fig. 1) meant to tap into the nostalgia for the Revolutionary generation at the time of the nation's semicentennial. For the remainder of his long career, Peale built his reputation and business on the nearly eighty replicas and variants of that picture.

He painted *Washington before Yorktown* the year after *Patriæ Pater*, and, not surprisingly, the heads and demeanors are nearly identical.[1] Even the celestial light that arcs over Washington in the Corcoran canvas corresponds to the circular aura surrounding the president in *Patriæ Pater*. In both works, Washington is seen as the man of gravitas, the calculated result of Peale's assiduous study of the iconic portraits by Gilbert Stuart, John Trumbull, Jean-Antoine Houdon, and his own father.

Yet the pictures are different. The giant *Yorktown* canvas is more than four times larger than the other, the composition is multi-figured and complex, and Washington is set within an energetic historical narrative.[2] His eyes angle horizontally instead of upward, and the presidential head of the mid-1790s is transported back in time, unaltered, to 1781, when General Washington led American and French troops into the concluding battle of the Revolution. Peale's goal in the 1820s had been to establish the definitive image

of Washington—the "Standard likeness," as he put it—that would be immediately recognizable and unchanging. Here, that meant representing the forty-nine-year-old general in the physical form of the sixty-odd-year-old president.[3]

When Washington was painted with a horse in the founding era, he was typically shown standing to the side, the horse's head bowed so as not to detract from the man. It was a type of Enlightenment portrait best typified by Charles Willson Peale's *Washington at the Battle of Princeton* (1779, Pennsylvania Academy of the Fine Arts). If a battle was nearby, Washington was distanced from it, shown as the thoughtful coordinator or gentlemanly victor but not the leader of his troops. The major exception to that is John Trumbull's *The Death of General Mercer at the Battle of Princeton* (1787, Yale University Art Gallery, New Haven), which shows Washington leading his troops in the midst of furious fighting.[4] In *Yorktown*, Peale elected to show Washington battle-ready. The idea may have sprung from Thomas Sully's equally huge *Passage of the Delaware* (Fig. 2), which puts Washington on a skittish horse preparing his troops to cross the river in the winter of 1775.[5]

The three-week siege of Yorktown occurred during the early autumn of 1781. Washington controlled a total of fourteen thousand troops from the Continental Army and the French Expeditionary Force under the command of the marquis de Lafayette and the comte de Rochambeau as well as twenty-four French warships under the

Fig. 1. Rembrandt Peale, *George Washington (Patriæ Pater)*, 1823. Oil on canvas, 71½ × 53¼ in. (181.6 × 135.3 cm). U.S. Senate Collection, 31.00001.000

Fig. 2. Thomas Sully, *Passage of the Delaware*, 1819. Oil on canvas, 146½ × 207 in. (372.1 × 525.8 cm). Museum of Fine Arts, Boston, Gift of the Owners of the old Boston Museum, 1903, 03.1079

comte de Grasse. Washington commands his restless white horse—either Blue Skin or his Arabian, Magnolia—and while holding a cocked hat in his extended right hand, he swivels his upper body backward to Lafayette and three other mounted officers: Henry Knox, Benjamin Lincoln, and Rochambeau.[6] The notoriously impulsive Alexander Hamilton, a lieutenant colonel and Washington's aide-de-camp, is "galloping off to execute" orders, perhaps the assault that he led on a British stronghold during the siege.[7]

Equally significant to the imagery is the spirited mullein plant in the foreground. Shining in the sunlight below Washington, it was meant as a symbol of Washington's character. A medicinal herb,

mullein was used to treat a variety of ailments and, according to folklore, to cast out evil spirits. Known colloquially as Aaron's rod, it was named after the brother of Moses who is described in the book of Exodus as stretching out his staff to inflict the first three plagues on pharaoh's Egypt. Symbolically, the mullein was Peale's reference to Washington smiting George III's England. Next to the mullein, a creeping weed grows in the shadows, in effect, the British presence in North America, which Washington's horse crushes, finally, under its hoof.

PS

Thomas Birch (London, 1779–Philadelphia, 1851)

View of the Delaware near Philadelphia, 1831

Oil on canvas, 40½ × 60¼ in. (101.5 × 152 cm)
Signed and dated lower left: Tho⁵ Birch / 1831
Museum Purchase, Gallery Fund, 55.83

Born in England, Thomas Birch came to the United States at age fifteen with his father, William Russell Birch, a miniaturist and engraver. Father and son settled in Philadelphia in 1794, and several years later the pair collaborated on a series of topographical paintings and engravings of the city and its surrounding countryside.[1] Moving beyond the topographical tradition that occupied his father, Thomas Birch was among the first painters in America to specialize in local landscape paintings and marines.[2] In *View of the Delaware near Philadelphia*, a group of well-dressed city dwellers stands on the river's shore, presumably having gone there to enjoy the area's bucolic scenery. Commercial ships sail up the Delaware River in the distance, reminding the viewer of Philadelphia's thriving port and commercial activities. The artist combines his knowledge of ship portraiture with landscape and genre painting, thereby highlighting both industrial commerce and the popularity of local tourism among Philadelphia's leisure class during the second quarter of the nineteenth century.

In the Corcoran's painting, four well-dressed women, a man, and a young girl have apparently just disembarked from a rowboat, since two ferrymen are still securing the craft. The group pauses onshore, and, although two of the women turn back toward the water, their gestures, as well as the dog running inland, suggest the visit has only begun. The women's scarves blowing inland echo the excitement of the little girl and dog as they run toward the path on the left. Birch draws our attention to the civilized aspects of this landscape: the fence, the Philadelphia skyline barely visible along the distant horizon, and the ships on the water. Additionally, the other rowboats beached farther along the shore indicate that these visitors are not the only ones enjoying this rural spot. Yet in this cultivated tourist spot, the decaying log and stump in the left foreground recall more rugged aspects of American scenery at a time when many citizens lamented the growing disappearance of wilderness areas along the country's eastern seaboard.

In his harbor and river views that include sailing vessels, Birch was likely influenced by his father's collection of prints after marine paintings by the Dutch Baroque artists Jan van Goyen and Jacob van Ruisdael.[3] In *View of the Delaware near Philadelphia*, Birch reveals his familiarity with the Netherlandish marine tradition in the lowered horizon line and the ships placed in profile against a sky filled with rolling clouds, which make patterns of light and shadow on the land below.[4] These same ships appear in a number of Birch's harbor views, indicating that he used a stock collection of drawings to work up paintings in his studio. A review of *View of the Delaware near Philadelphia* when it was exhibited at the annual exhibition of the Pennsylvania Academy of the Fine Arts indicates Birch's reputation as a painter of ships: "The water is very transparent and aerial perspective excellent. The figures in the foreground attract the eye from the most pleasing part of it, the vessel in the distance."[5] The ships in this painting include a topsail schooner on the left and a merchantman at the far right. The Birch scholar Richard Anthony Lewis has suggested that the artist's precise, idealized delineation of the sails and masts celebrates commerce while sanitizing the growing encroachment of urban industry as well as the sometimes harsh conditions of labor tied to the shipping industry.[6]

In the same way that he separates industrial labor from the commercial ships he depicts, in this picturesque painting Birch downplays problems of urbanization. By the 1830s travel along the eastern seaboard had become a popular pastime. Thanks to improvements in transportation, artists and laymen alike could visit the rugged landscapes of New York and New Hampshire. Although the scenic charms of the Delaware River were not widely known during this period, the spot was a popular destination among Philadelphians.[7] This interest in visiting the countryside coincided with a period of unprecedented commercial and industrial growth in the region. Although it trailed New York, Baltimore, and Boston in commercial activity, by 1825 Philadelphia was beginning to suffer from urban blight because of its thriving coal and steel industries.[8] By 1831, the same year Birch painted this picture, civic groups were advocating for Philadelphia's Delaware riverfront to be restored to its former bucolic beauty by tearing down structures along its shore and creating a tree-lined avenue.[9]

View of the Delaware near Philadelphia is an innovative painting that incorporates elements of the genre, landscape, and marine traditions. Birch's earlier scenic views focus on specific locales in and around Philadelphia, usually featuring well-known landmarks and monuments.[10] In the Corcoran's picture, however, we are provided with a more generic view of the Delaware River and only a hint of the Philadelphia skyline, barely visible in the middle of the horizon in the form of several small towers of varying height. Additionally, most of Birch's paintings that include people are essentially pictures of a harbor or landscape with an added incidental narrative, but here that emphasis is reversed. The figural grouping in the foreground draws the viewer's attention, thereby reducing the city and boats to secondary consideration. While this painting marks a high point in the artist's career, by the end of the decade, Birch's picturesque views of the American countryside and harbors would be eclipsed by the growing popularity of the Hudson River School's grandiose vistas.

JC

Thomas Cole (Bolton-le-Moor, Lancashire, Eng., 1801–Catskill, N.Y., 1848)

The Departure, 1837

Oil on canvas, 39½ × 63⅝ in. (100.5 × 161.6 cm)
Signed and dated lower center right: TC / 1[8]37
Gift of William Wilson Corcoran, 69.2

The Return, 1837

Oil on canvas, 39½ × 63⁹⁄₁₆ in. (100.3 × 161.4 cm)
Signed and dated twice, middle left and lower center right: T Cole / 1837; T Cole. 1837
Gift of William Wilson Corcoran, 69.3

In December 1836 William Paterson Van Rensselaer wrote to Thomas Cole to commission two landscapes.[1] Earlier in the year the artist had enjoyed critical and popular success for his epic five-canvas series, *The Course of Empire* (1836, The New-York Historical Society), and in his letter, Van Rensselaer expressed his "great admiration of the high genius exemplified" in that work. Other than specifying that the pictures represent morning and evening, he left the details entirely to the artist, which, Cole replied, "is gratifying to me, and is a surety for my working con amore."[2] The resulting paintings, *The Departure* and *The Return*, were completed in early December 1837 and delivered to Van Rensselaer in New York; Cole received two thousand dollars for his work. They are among the most beautiful and moving paintings of his entire career.

Born in England in 1801, Cole immigrated with his family to America when he was in his teens. In the early 1820s he began working as a landscape painter and soon rose to prominence in the field. His early reputation was based on dramatic views of wild American scenery such as *Sunrise in the Catskills* (1826, National Gallery of Art, Washington, D.C.), but Cole was aware that purely topographical

landscape traditionally ranked low among the various types of painting. By contrast, history paintings—works that depicted human figures and took their themes from history, mythology, literature, religion, or other sources—ranked at the top as the greatest artistic challenge. Cole determined to create what he called "a higher style of landscape," which would integrate narrative elements into landscape.[3] Figures would play a role in these narratives, but so, too, would elements from nature—trees, rocks, streams, mountains, clouds, light, time of day, and the seasons. Cole realized that making paired paintings would allow him to extend the narratives even further, encompassing changes in time and/or physical space; in 1828 he made his first attempt at pendant historical landscapes, *The Garden of Eden* (Amon Carter Museum, Fort Worth) and *The Expulsion from the Garden of Eden* (Museum of Fine Arts, Boston). Van Rensselaer may have known those pairs, but he unquestionably would have been familiar with the two companion landscapes his father, Stephen Van Rensselaer III, had commissioned from Cole early in the artist's career, *Lake Winnepesaukee* (1827 or 1828, Albany Institute of History and Art) and *View near Catskill* (1828, private collection).[4]

With other commissions ahead of Van Rensselaer's, Cole was not able to start work on the pictures until the summer of 1837. In July he wrote to his patron, explaining that he wanted to produce something worthy of the generous commission:

Sunrise & Sunset will be the Seasons of the pictures: but I shall endeavor to link them in one subject by means of Story, Sentiment & Location. It will perhaps be as well not to mention more explicitly the subject, until the work is about completed. The size of the pictures you left in a measure to me & I hope the canvasses I have chosen will not be found too large, as I think the subject requires the size, which is about 5 ft long. I shall now proceed with the pictures, I hope, without interruption. But I must ask your indulgence in time. I am afraid the pictures cannot be finished before the Autumn.[5]

Cole wrote again to Van Rensselaer in October, apologized that the pictures were still not completed, and offered a detailed description of them:

Having advanced so far, I thought it might be agreeable to you to learn something of the work which I am about to offer you. I have therefore taken the liberty to give you a hasty sketch of what I am doing; at the same time, let me say, that a written sketch can give but an inadequate notion of my labors.

The story, if I may so call it, which will give title, and, I hope, life and interest to the landscapes, is taken neither from history nor poetry; it is a fiction of my own, if incidents which must have occurred very frequently can be called fiction. It is supposed to have [a] date in the 13th or 14th century.

In the first picture, Morning, which I call The Departure, a dark and lofty castle stands on an eminence, embosomed in the woods. The distance beyond is composed of cloud-capt mountains and cultivated lands, sloping down to the sea. In the foreground is a sculptured Madonna, by which passes a road, winding beneath ancient trees, and, crossing a stream by a Gothic bridge, conducting to the gate of the castle. From this gate has issued a troop of knights and soldiers in glittering armour; they are dashing down across the bridge and beneath the lofty trees, in the foreground; and the principal figure, who may be considered the Lord of the Castle, reins in his charger, and turns a look of pride and exultation at the castle of his fathers and his gallant retinue. He waves his sword, as though saluting some fair lady, who from battlement or window watches her lord's departure to the wars. The time is supposed to be early summer.

The second picture—The Return—is in early autumn. The spectator has his back to the castle. The sun is low; its yellow beams gild the pinnacles of an abbey, standing in a shadowy wood. The Madonna stands a short distance from the foreground, and identifies the scene. Near it, moving towards the castle, is a mournful procession; the lord is borne on a litter, dead or dying—his charger led behind—a single knight, and one or two attendants—all that war has spared of that once goodly company.

You will be inclined to think, perhaps, that this is a melancholy subject; but I hope it will not, in consequence of that, be incapable of affording pleasure. I will not trouble you with more than this hasty sketch of my labors. I have endeavored to tell the story in the richest and most picturesque manner that I could. And should there be no story

understood, I trust that there will be sufficient truth and beauty in the pictures to interest and please.[6]

Cole's choice of a medieval theme for these pendants was consonant with the growing fascination with the Middle Ages during the 1830s in England and America. Buildings and furniture in the Gothic Revival style began to appear, and the literary works of such writers as Sir Walter Scott and Thomas Gray were increasingly popular. Van Rensselaer's initial reaction was not, however, entirely positive. He replied to Cole on 19 October:

> As I said nothing on the subject matter of the paintings before you commenced but left it entirely to your discretion, it does not become me to say anything about it now, but my first impression on reading your letter was that I did not like the 13th century & the knights; upon reflection I am much pleased with the general idea of the piece and I know I shall not be disappointed. The agreeable impression made by a picture depends upon the artist entirely: I remember an old painting very much admired & praised representing a man at work on a corn on another's toe and so I have read a fine poem abounding in beautiful passages on a buck-wheat cake. I intended to make you a visit at Catskill but I am prevented by my father's illness, and I wish to know whether you could order the frames in New York, you know what would be most suitable, & if it is convenient to you I should be pleased to have the pictures delivered also in New York.[7]

Cole must have been concerned by this somewhat less than enthusiastic reception and apparently wrote (the letter is missing) that he was worried Van Rensselaer would be disappointed by the pictures. The patron replied with reassuring words:

> Had my unfavorable impression been left upon my mind from your description I would have said nothing about it but would have waited until my opinion would have been made up by actual study & inspection of the subject. You need entertain no fears that I shall be disappointed with your creations for I have such confidence in your taste & judgment that I am determined to be pleased with what [I] have ordered.[8]

Cole was still struggling to finish the pictures when he wrote to Asher B. Durand on 2 November: "I am still at *the* pictures—when will they be done?" He also asked Durand to order two frames "to be massy, covered with small ornament, no curves or scallops, resembling the frames in [*sic*] the Course of Empire, though not necessarily the same pattern—the best gold, not the pale."[9] Cole finished the pictures by the end of the month and arranged to deliver them to Van Rensselaer in New York, who hung them in his parlor and invited friends and members of the press to see them.[10]

The Departure and *The Return* were Cole's first major paintings to follow *The Course of Empire*. As such, they were subjected to particular scrutiny to see if they measured up to his previous achievement. The reviewer for the *New-York Mirror* was duly impressed by Cole's skills both in depicting the natural world and in telling a story, writing:

> If, after expressing our opinion, as we did some months past, of Mr. Cole's five pictures on "The Progress of Empire," we were now only to say that he has *equalled himself*, we should, to those who have seen that series of paintings, appear to bestow great praise. But we can do more: we can say that, in our opinion, he has, as far as the subjects would admit, *outdone himself*, and produced two more perfect works of art. These pictures represent Morning and Evening, or Sunrise and Sunset; and are, merely from that point of view, invaluable. They contrast the glowing warmth of one,

with the cool tints and broad shadows of the other; and to do this is the work of a master, who has studied nature and loves her. But the painter has added the charm of poetick fancy and the Gothick structures of the middle ages to that profusion of beauties, which nature presents at all times. Not only this is done, but a story is told by the poet-painter, elucidating at once, the times of chivalry and feudal barbarism, and the feelings with which man rushes forth in the morning of day and of life, and the slow and funereal movements which attend the setting of *his sun*.[11]

Cole drew from a variety of literary and visual sources in realizing *The Departure* and *The Return*, but, in the end, what he achieved was very much his own creation.[12] In particular, his depictions of the castle in the former and the chapel in the latter, although not based on any actual structures, are meticulously rendered. Infrared reflectography reveals underdrawing that indicates Cole (who had aspirations as an architect) carefully planned them using ruled lines on the ground layer before painting them.[13] Yet what most distinguishes *The Departure* and *The Return* in conception from *The Course of Empire* is the focus on a single story—with the protagonist the lord of the castle—over a far shorter span of time. Whereas in *The Course of Empire,* Cole imagines the rise and fall of a civilization over the centuries, the drama in the 1837 paintings occurs between early summer and autumn of one year (the shepherd and young girl who appear in both paintings seem little changed). The writer for the *New-York Mirror* understood perfectly well that this is an allegory of a different, more personal nature, with life and death pertaining to an individual, not to an entire civilization. The grandeur and historic sweep that form the basis of *The Course of Empire* are succeeded in *The Departure* and *The Return* by an elegiac sense of human loss and futility.

William Paterson Van Rensselaer clearly appreciated the meaning and sentiments of Cole's painting. In July 1839, following the death of his father, he wrote to Cole with a second commission for a pair of pictures:

> If it is in your power just now and will not interfere with other engagements, I should be pleased to give some employment to your pencil. My mother and sister intended in the autumn giving up the manor house as their residence and they naturally would like to take with them some representation of the home scenes with which they have become so familiar and which are endeared to them. I know of no one who can do justice to nature like yourself and if you can soon visit Albany, that is before the season changes, and take some . . . sketches you will convey a favor.[14]

Cole immediately replied: "It will give me great pleasure to make the sketches of which you speak. . . . I feel gratified that you should wish to employ me, for it seems a proof that what I formerly did for you has not ceased to give pleasure."[15] The paintings that resulted (both now in the Albany Institute of History and Art), *Gardens of the Van Rensselaer Manor House* (1840) and *The Van Rensselaer Manor House* (1841), are topographically accurate representations of the house and grounds, but they also manage to evoke a palpable mood of loneliness and nostalgia. The former is set in summer and the latter in autumn, a seasonal contrast that Cole had employed to such effect in *The Departure* and *The Return*. The death of Stephen Van Rensselaer III, the departure of his widow and daughter from the estate that had been in his family for generations, and the division of that property between his sons marked the end of an era for the Van Rensselaers, the setting of the sun on what had once been a virtual New World empire. William Paterson Van Rensselaer would surely have seen the parallels between what Cole had expressed allegorically in *The Departure* and *The Return* and what had now taken effect in his own life and that of his family.

F K

William Sidney Mount (Setauket, N.Y., 1807–Setauket, N.Y., 1868)

The Tough Story—Scene in a Country Tavern, 1837

Oil on panel, 16¾ × 22 in. (42.6 × 55.9 cm)
Signed and dated lower left: Wᵐ S. Mount– / 1837
Museum Purchase, Gallery Fund, 74.69

In the decades before the Civil War, William Sidney Mount was America's most celebrated painter of genre, or scenes of everyday life. His paintings delighted audiences with their humor, complex verbal puns, and stereotypical American characters. Mount was usually reluctant to explain the narratives of his paintings.[1] Many of his works from the 1830s and 1840s in particular were veiled political and social allegories as well as comic images, and their power to entertain and surprise resulted in part from the knowledge-able viewer's ability to discern Mount's jokes for themselves. In the case of *The Tough Story*, however, Mount wrote a letter to his patron, the prominent Baltimore collector Robert Gilmor, Jr., providing a detailed explanation of the painting's subject. He identified the scene as a Long Island tavern and the man puffing on a pipe as "a regular built Long Island tavern and store keeper." The artist, who was born on Long Island and trained in New York, had settled in Stony Brook in 1827 and thereafter made middle-class Long Islanders his subject. According to Mount, the standing figure behind "is a traveler . . . , and is in no way connected with the rest, only waiting the arrival of the Stage—he appears to be listening to what the old man is saying."[2] Mount continues with a fuller explanation of the central figure, "the old invalid," who sits on a broken chair, his head and knee wrapped in bandages. He is

> A kind of Barroom Oracle, chief umpire during all seasons of warm debate, whether religious, moral or political, and first taster of every new barrel of cider rolled in the cellar; a glass of which he now holds in his hand while he is enter-taining his young landlord with the longest story he is ever supposed to tell, having fairly tired out every other frequenter of the establishment.[3]

Mount invites his audience to laugh along with the eavesdropping traveler at the captive tavern keeper's plight. Insofar as his painting is the story of a loquacious storyteller, Mount's declaration in his letter to Gilmor that the painting is a "conversation piece," a scene portraying people in conversation, may have been tongue in cheek.[4] But we should also take the artist at his word when he wrote that his painting is fundamentally about conversation, albeit one-sided. Indeed, Mount does not just show a conversation; in the composi-tion, coloring, and other formal properties of *The Tough Story*, he seeks to capture the total effect of the conversation.[5]

Mount was obsessed with painting technique. He kept exten-sive diaries documenting his experiments and observations about such topics as the layering of glazes and recipes for varnishes, copy-ing into his diaries entire texts of art instruction manuals.[6] He even describes the particular means of lighting he used when painting another tavern scene, *Barroom Scene* (Fig. 1): "two windows (in winter) a curtain to divide the two lights. The artist by one window & the model by the other."[7] Such attention to details was not an empty exercise for Mount. Sound technique could maximize the narrative impact of a painting. "The story must be well told," he instructed himself in his journal, with "[c]oncentration of idea and effect."[8] This was to be achieved not just through outward manifestations

of inward thoughts, as expressed by the poses and gestures of the figures, but throughout the painting, in such aspects as the coloring, lighting, and compositional arrangement.[9]

In *The Tough Story*, Mount provides us with the outlines of the narrative, but it is the rendering of the tavern itself that offers the most compelling gloss on the scene. Mount presents the conversa-tion unfolding against the empty space of the room. Antebellum American taverns were characteristically sparsely furnished, usually containing a bench, some chairs, a stove, and perhaps a carriage schedule, like the Long Island Railroad notice pinned to the back wall here.[10] Such is the case in *Barroom Scene*, but the empty room also characterizes the "long" or "tough story," presumably the invalid storyteller's account of his injuries and misfortunes.[11] Com-pared with *Barroom Scene, The Tough Story* is rendered in a narrower range of tones. Dull in its buff and beige color, monotonous in its row of broad plank floorboards (broader than the planks in *Barroom Scene*), and boring in its expanse of bare walls, it mimics the long and tedious story that is the subject of the painting. Indeed, Edgar Allan Poe complained of *The Tough Story*, "What can be more displeasing . . . than the unrelieved nakedness of the wall in the background . . . ?" He accused Mount of sacrificing aesthetics to story line.[12] Critics also faulted the painter's use of the stovepipe that divides the space from the top down.[13] The stovepipe, however, separates the down-and-out barfly's side with its signs of damage and decay—the broken chair, the cards falling from a worn hat, and the bandaged storyteller himself—from the more comfortable side with the traveler and tavern keeper, the stove, and the stocked tavern shelves. The wood chips scattered on the floor before the barfly may also allude to

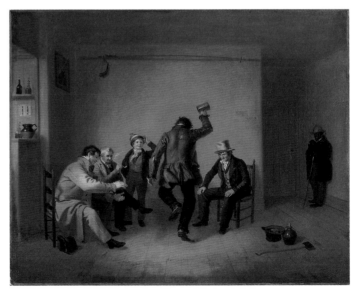

Fig. 1. William Sidney Mount, *Barroom Scene*, 1835. Oil on canvas, 22⅝ × 27⁷⁄₁₆ in. (57.4 × 69.7 cm). The Art Institute of Chicago, The William Owen and Erna Sawyer Goodman Collection, 1939.392

woodcutting as the punishment for public drunkenness.[14] The men might be engaged in conversation, but it is a conversation born of circumstance and compromised by the one-sided joke enjoyed by the tavern keeper, traveler, and viewer at the expense of the barfly. Just as humor relies on the wry distance between audience and comic spectacle, so the painting's humor—and legibility—rests with the emphatic distinction between those laughing and the person at whom they laugh.

If Mount attempted to tell his story as effectively as possible, he appears to have succeeded. Gilmor, who provided his own interpretation of the painting in an earlier, now lost, letter to Mount, accurately determined "with but a slight difference," the painting's story just by looking at it.[15] The painting was also the inspiration for a story by the humorist Seba Smith, which was illustrated by a line engraving after Mount's painting in the 1842 edition of *The Gift: A Christmas and New Year's Present for 1842*.[16] Smith's narrative was almost identical to Mount's, although Smith, of course, could not have known of the painter's letter. That Mount achieved this success by marrying form and content is attested to by critics. "His great skill," wrote one in response to *The Tough Story*, "is to tell history in

the most forcible and familiar manner. To this end, color, light, and shade, and composition are all made to bend."[17] Another praised Mount for producing "by far the most finished composition of its kind, of any American artist. . . . It is a difficult thing to draw or color well, and with truth; and still more difficult to paint a complex scene of various attitudes and expressions, each personage preserving his own character and costume and each contributing to the formation of the collective thought which the subject presents."[18] This effective marriage of form and content is likely what Mount referred to when he closed his letter to Gilmor by saying, "I agree with you that it is my most finished painting yet."[19]

LS

John Neagle (Boston, 1796–Philadelphia, 1865)

Richard Mentor Johnson, 1843

Oil on canvas, 29⅞ × 24¹³⁄₁₆ in. (76 × 63.3 cm)
Gift of Mrs. Benjamin Ogle Tayloe, 02.4

John Neagle, the son-in-law of Thomas Sully (see *Andrew Jackson*), was already a very successful Philadelphia portrait painter when he was commissioned in 1842 by a group of Whig Party members to paint a full-length life-size portrait of Henry Clay (The Union League of Philadelphia) to serve as the political icon of the Germantown (Pennsylvania) Clay Club during the Kentuckian's bid for the presidency. According to Robert Torchia, Neagle's recent biographer, "The full-length of Clay was an immense success among the hospitable Southerners, who provided their visitor with a host of commissions. He stayed in Kentucky much longer than expected, and did not return to Philadelphia until early April 1843."[1] While in Kentucky, Neagle painted this smaller portrait of Richard Mentor Johnson in Frankfort on 9 March 1843, a date recorded in an inscription on the back of the canvas that is no longer visible.[2] Neagle's preparatory drawing of Johnson (Fig. 1)—inscribed "Saturday Feby–11th–1843 Col. R.M.J."—helps to date the first sitting.[3]

Neagle's image of Colonel Johnson is lively and romantic. Johnson looks off to the viewer's right, into the near distance. He wears a dark blue jacket over a bright red vest, colors that are echoed by his bright blue eyes and ruddy cheeks. The soft curls of his wispy gray hair seem softly blown by a breeze. Behind Johnson is a tree with reddish leaves, and a distant landscape on the left appears to depict a setting sun and possibly a body of water. A few days before Neagle left Kentucky at the end of his long visit, his portrait of Johnson was praised in an article in a Frankfort paper: "friends of the old soldier . . . will never see another picture of him with which they will be so well pleased. The singular taste of the Col. in a scarlet vest, was adroitly met by the artist. He compelled a harmony of coloring by throwing in the background, against the blazing scarlet, a scene of green woods, the best color in contrast with red."[4]

In 1843 Johnson (1780–1850) was nearing the end of a long, distinguished political career. Born in Beargrass, Kentucky, now part of Louisville, he studied law and was admitted to the bar in 1802. He was elected to the United States House of Representatives in 1806, in part for his support of Kentucky farmers' title to their lands. During the War of 1812, he organized a Kentucky regiment of mounted riflemen and as colonel served in the Canadian campaign. When the American forces attacked the British and their Indian allies at the battle of the Thames River on 5 October 1813, the Indian leader Tecumseh was killed in close fighting. Johnson, wounded badly, was later credited with killing the Shawnee leader. He returned to Congress and served in both the House and the Senate until 1836, becoming a major supporter of Andrew Jackson before and during Jackson's eight years as president. For that support, Johnson was selected as vice presidential candidate in 1836. After he and Martin Van Buren served for one term, they lost the 1840 election to William Henry Harrison. Johnson was a member of the Kentucky State Legislature again in 1850, the year he died.

Neagle's visual references are to Johnson's fabled wartime feat, credited to him throughout his years. His red waistcoat was a trademark piece of apparel that was seen by contemporaries as a reference to the death of Tecumseh. A clue to its meaning was published years later, in 1878, when Corcoran curator William MacLeod wrote

Fig. 1. John B. Neagle, *Henry Clay and Richard Mentor Johnson*, 1842–43. Graphite on cream, textured, wove paper, 12¾ × 9⅛ in. (32.4 × 23.2 cm). National Portrait Gallery, Smithsonian Institution; acquired through the generosity of the Director's Circle, NPG.2003.33.b

about a life-size marble sculpture, *The Dying Tecumseh* by Ferdinand Pettrich (modeled c. 1837–46, carved 1856, Smithsonian American Art Museum), then on view at the Corcoran. Describing what he thought was proof that Johnson had killed Tecumseh, MacLeod wrote: "It would not be a bad idea for the Corcoran Gallery to secure, and hang above this statue a capital portrait of Colonel Johnson, painted by Neagle, showing his rugged, plain features, and the familiar red vest alluded to in an old political song—'He always wore his waistcoat red / Because he killed Tecumseh.'"[5] The setting, with the tree and the distant river, may also be references to the battle, since Pettrich's sculpture depicts Tecumseh lying wounded at the base of a tree. MacLeod was, at this time, assertively promoting his wish to acquire Neagle's portrait of Johnson for the gallery along with the rest of the extensive, very important collection of paintings, sculpture, and historical items belonging to Washington resident Phebe Warren Tayloe, the widow of Benjamin Ogle Tayloe.[6]

In 1851, soon after Johnson's death, Neagle had tried to sell the portrait to the state of Kentucky for the state capitol. On 19 November he wrote to George Robertson, the speaker of the Kentucky House of Representatives, offering to sell portraits that he had painted of Clay and Johnson. "As I prefer that the two paintings

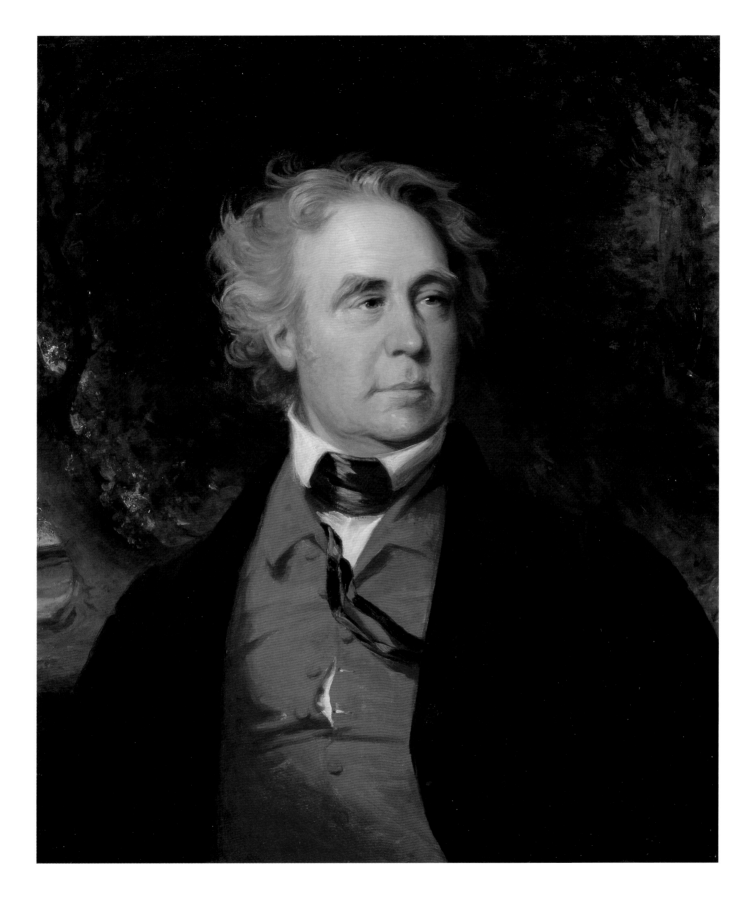

offered should be preserved to posterity in the Legislative Hall of Kentucky, and as the amount of a return in a pecuniary light is not so much an object with me as the honor of such a destination for my pictures, I have concluded first to offer them to your State."[7] Neagle wrote Robertson again on 21 December to ask if the government had decided to acquire the portraits.[8] The portraits were not, in the end, sold to the state of Kentucky.

The paintings of Clay and Johnson that Neagle offered to the state of Kentucky could have been replicas painted by the artist especially for the legislature. There is a second life-size full-length

portrait of Clay (United States Capitol, Washington, D.C.) as well as a second portrait of Johnson that is virtually identical to this one.[9] The Corcoran's painting, which had remained in the artist's collection and was in his estate before being acquired by Tayloe, later served as the source for a marble bust of Johnson that was carved by James Paxton Voorhees on commission from the United States Senate in 1895. The artist was the son of Senator Daniel W. Voorhees of Indiana, a member of the Joint Committee on the Library, which had authorized the purchase of a bust of Johnson.[10]

EGM

Robert Salmon's *Boston Harbor* opens a window onto a scene of Boston Harbor in about 1840 as merchant, fishing, and tourist vessels sail past Fort Independence on Castle Island. This painting offers more than a pleasant view of a busy day in Boston long ago; it also reflects on the history of England and the United States in addition to the life of the artist who painted it. At the time he completed this painting, the British-born Salmon had recently returned to England from a fourteen-year sojourn in Boston.[1] *Boston Harbor* later found its own place in American history.

By about 1800 the young Salmon was becoming an accomplished ship painter.[2] He left his native port town of Whitehaven about 1806 to travel to Liverpool and London, as well as Greenock, Scotland, where he painted harbor scenes, ship portraits, panoramas, and sets for plays until he left for America more than two decades later.[3] Salmon's carefully delineated style demonstrates the influence of maritime masters from the previous century such as the Englishman Samuel Scott, the Italian Giovanni Antonio Canal (Canaletto), and their seventeenth-century Dutch precursors Willem van de Velde the Elder and the Younger, whose works he could have seen in London and Liverpool.[4] Indeed, Salmon represented sails and rigging so exactly that some speculate he had been a sailor or shipbuilder.[5]

Salmon sailed from Liverpool to New York in June 1828.[6] By the middle of August of that year he had settled in Boston, where he would remain for most of his time in America.[7] Salmon became the leading maritime painter in that city and one of the top-ranking ship painters in the United States. His most notable follower, Fitz Henry Lane (see *The United States Frigate President Engaging the British Squadron, 1815*), seems to have been particularly influenced by Salmon's more serene harbor scenes.[8]

While in America, Salmon painted many scenes of Boston Harbor from different viewpoints, concentrating variously on towering frigates or the details of the city's wharves, warehouses, and prominent structures. Salmon's friend Henry Hitchings recalled decades later that the artist's studio "was at the lower end of the Marine Railway wharf, and directly over a boat builder's shop. . . . He had a bay window built from his studio, and overhanging the wharf, which was so arranged that it gave him not only a direct view across the harbor, but also an opportunity to see both up and down stream."[9] Not only did his studio give Salmon excellent views of his nautical subject matter, but he was also able to obtain views from the water after trading paintings for a boat and sails.[10]

The Corcoran's painting takes virtually the same viewpoint as one of Salmon's most spectacular paintings, *Boston Harbor from Castle Island (Ship Charlotte)* (Fig. 1), although the latter is much larger and places more emphasis on ships sailing in the harbor.[11] In both paintings, Fort Independence on Castle Island, which stands at the southwestern edge of Boston's outer harbor, appears at the left edge, while the dome of the Massachusetts State House can be discerned in the distance. The Corcoran's panel brings the viewer closer to a smaller group of vessels nearer shore and thus focuses more attention on the stone walls of the fort. At the center are a schooner sporting an American flag as it heads toward the harbor and a three-masted ship sailing out of the harbor toward the viewer. The latter ship's flag is mostly hidden by its sails, but enough of the red ground appears to suggest that it may be British, and the row of gun ports and the figures in the blue coats and black hats of naval officers hint that it may be a military frigate. For the British-born artist newly returned

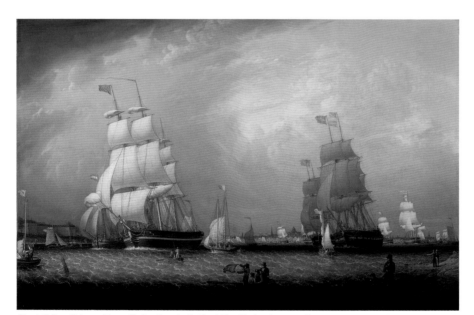

Fig. 1. Robert Salmon, *Boston Harbor from Castle Island (Ship Charlotte),* 1839. Oil on canvas, 40 × 60 in. (101.6 × 152.4 cm). Virginia Museum of Fine Arts, Williams Fund, 1973, 73-14

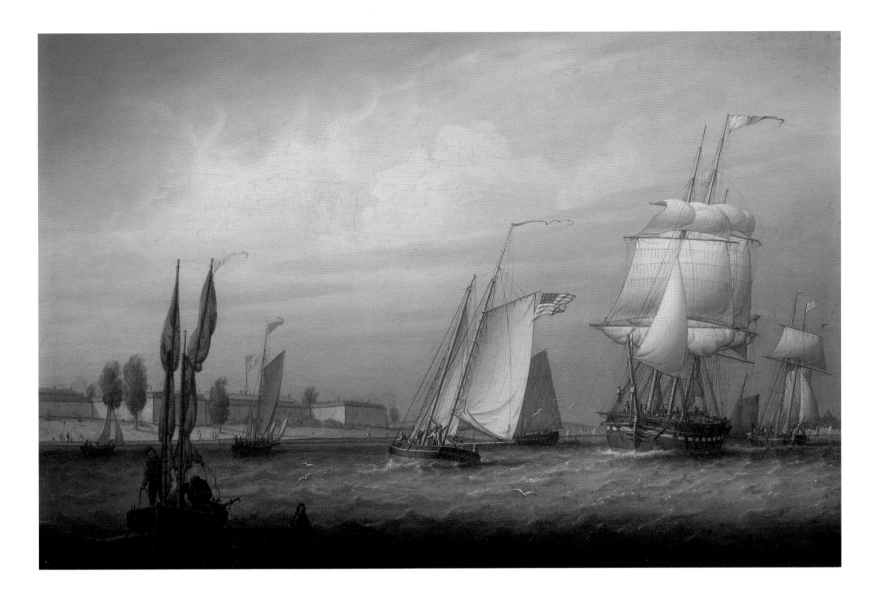

from America, American and British ships, one arriving and the other departing, would have formed a parallel to his own life.

The Corcoran's painting, in which an armed foreign ship sails peacefully through an American harbor, may have reminded viewers that twenty-seven years before this, the United States and Great Britain had been enemies. During the War of 1812, American trade embargoes and the powerful British fleet trapped hundreds of American ships in Boston Harbor, where they rotted at anchor. Only slowly did the ill feeling between the two countries fade after the war.[12] Fort Independence had played a modest role in the Revolutionary War and never fired its guns during the War of 1812, but its mighty presence prevented the British from attacking Boston by sea.[13] After 1815 Boston entered a period of thriving prosperity.[14] Emphasizing the lack of military threats, Salmon shows boats bringing tourists to walk and fish on the shores of Castle Island in the shadow of Fort Independence. Beginning in 1836, the fort underwent renovations, which continued, with some interruptions, until 1851. Since no evidence of construction appears in the painting, Salmon's picture apparently shows the massive fort during one of the hiatuses in building.[15]

Salmon's sunny view of Boston Harbor enjoyed a moment on the national stage 120 years after it was painted, when the Corcoran Gallery of Art lent it to the White House.[16] President John F. Kennedy displayed the panel in his office among a profusion of nautical paintings and ship models.[17] The Corcoran's painting was ideally suited for this new role, for it reminded visitors of President Kennedy's World War II naval service and glowingly depicted the Kennedy family's hometown. Salmon's harbor scene appeared over President Kennedy's left shoulder in well-known photographs, including ones showing presidential announcements to the press about civil rights and the Cuban missile crisis, as well as charming images of young Caroline and John romping in their father's office.[18]

APW

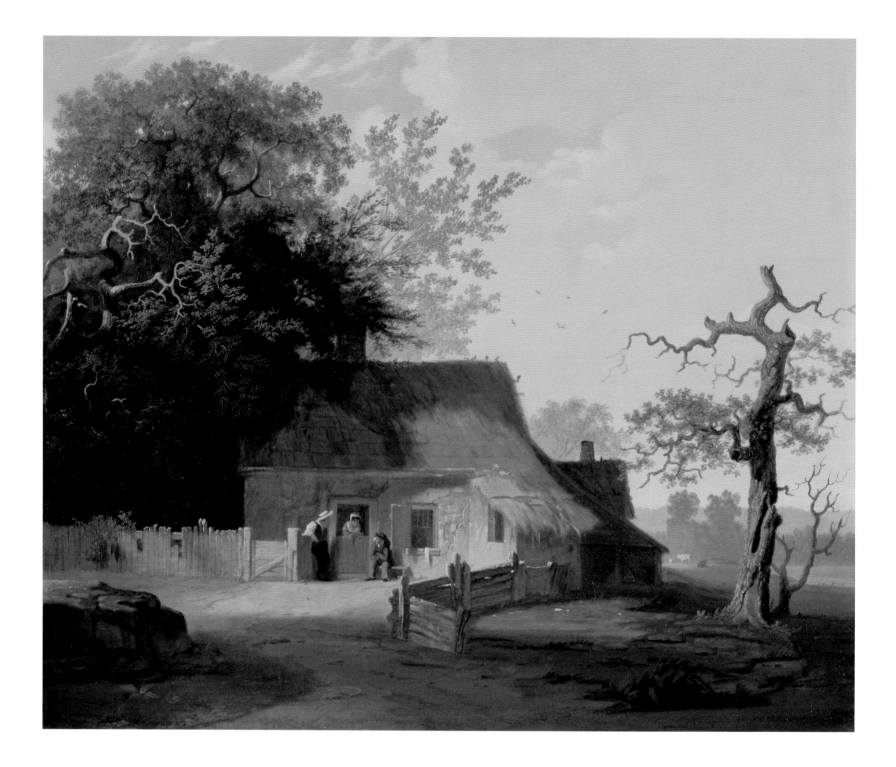

George Caleb Bingham (Augusta County, Va., 1811–Kansas City, Mo., 1879)

Cottage Scenery, 1845

Oil on canvas, 25½ × 30 in. (65 × 76 cm)
Signed lower left: G. C. Bingham.
Museum Purchase, Gallery Fund and gifts of Charles C. Glover, Jr., The Honorable
Orme Wilson and Mr. and Mrs. Landsell K. Christie, 61.36

The year 1845 was an auspicious one for the rural Missouri-born painter George Caleb Bingham. That December, the American Art-Union—an important early force in the promotion and distribution of contemporary American art, based in New York City—accepted four of his paintings for display in its annual exhibition. The Art-Union's purchase of this group of works, which included *Cottage Scenery, Landscape: Rural Scenery* (Godel & Co. Fine Art, New York), *The Concealed Enemy* (Stark Museum of Art, Orange, Tex.), and the now iconic *Fur Traders Descending the Missouri* (The Metropolitan Museum of Art, New York), marked the beginning of a long and fertile relationship between Bingham and the pioneering arts organization.[1]

The largely self-taught Bingham began his career as a portrait painter. With limited early exposure to the arts as a child living on the frontier, Bingham was inspired by the itinerant American portraitist Chester Harding, who took up temporary residence at Bingham's father's Franklin, Missouri, inn in 1820 while painting portraits of an aging Daniel Boone, who lived sixty miles south.[2] In the early 1840s, encouraged by the popular success of genre paintings by such artists as William Sidney Mount (see *The Tough Story*) and fellow Missourian Charles Deas, Bingham expanded his repertoire to include subjects from everyday life.[3] Bingham's contributions to the American Art-Union in 1845 are among the earliest examples of his investigation of western themes, a subject he treated for more than a decade.

Bingham's choice of subject for *Cottage Scenery* may have been specifically intended to appeal to the interests of the American Art-Union and its largely urban membership. The Art-Union's 1844 annual report encouraged American artists to create native landscape pictures: "To the inhabitants of cities . . . a painted landscape is almost essential to preserve a healthy tone to the spirits. . . . Those who cannot afford a seat in the country . . . may at least have a country seat in their parlors; a bit of landscape with a green tree, a distant hill, or low-roofed cottage."[4] Eighteenth-century English rustic cottage views, numerous examples of which would have been readily available to the artist through drawing books and imported landscape prints, are a possible compositional and thematic source for Bingham's canvas. Another likely influence is the work of the British-born, Philadelphia-based painter Joshua Shaw, whose popular picturesque landscapes Bingham likely encountered on one of his numerous trips to the eastern seaboard, beginning in 1838.

Bingham's unique perspective as a frontier-born artist with political aspirations—a background that would increasingly shape his subject matter in the later 1840s and 1850s—also informs *Cottage Scenery*.[5] The scholar Nancy Rash has argued that Bingham's vision of the West "grew quite decidedly out of the artist's Whig ideas about the importance of promoting development, economic growth, and civilization." Domesticated landscapes such as *Cottage Scenery*, with its winding dirt road leading to an inhabited cottage, "represented the kind of settlement that Bingham had known in his early days in Missouri and that he felt was essential for the establishment

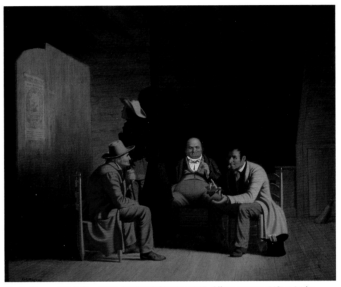

Fig. 1. George Caleb Bingham, *Country Politician*, 1849. Oil on canvas, 20⅜ × 24 in. (51.8 × 61 cm). Fine Arts Museums of San Francisco, Gift of Mr. and Mrs. John D. Rockefeller 3rd, 1979.7.16

of civilization."[6] The art historian Christine Klee posits that the cows lolling in the pasture in the right background of *Cottage Scenery* can also be tied to western settlement, as "signs of husbandry and the productive labor of the white man."[7]

Even if the intriguing connection of Bingham's landscapes to the Whig party and its nationalist advocacy of westward expansion cannot be confirmed, the compositional structure and narrative component of this early work clearly formed the basis of Bingham's later, more explicitly political paintings. The pose and costume of the three triangulated figures in the middle ground of *Cottage Scenery* mimic those of the protagonists in canvases such as *Country Politician* of 1849 (Fig. 1). Here, as in many of Bingham's mature works, the artist adapted the more generic device of the informal conversation to a scene in which public discourse and political engagement are the explicit subjects.[8]

It is only fitting that Bingham's politically engaged images of the American populace often reached that audience through the quasi-populist forum of the Art-Union, which guaranteed its members one engraving a year as well as the chance to win one of the original paintings featured in the annual exhibition, a prize that was awarded by lottery. James D. Carhart of Macon, Georgia, was the recipient of this canvas, which descended in the Carhart family until 1960, a provenance that accounts for its scant history of exhibition and publication.[9] When the Corcoran Gallery of Art purchased Bingham's *Cottage Scenery*, it became the first painting by the artist to enter the collection of a Washington, D.C., museum.[10]

EDS

Thomas Sully (Horncastle, Eng., 1783–Philadelphia, 1872)

Andrew Jackson, 1845

Oil on canvas, 98¹⁄₁₆ × 61⁵⁄₁₆ in. (246.6 × 155.7 cm)
Signed and dated lower left: TS 1845.
Gift of William Wilson Corcoran, 69.49

The Philadelphia artist Thomas Sully painted Andrew Jackson from life on two occasions, in 1819 and 1824. From these, he made at least eleven paintings as well as three related drawings and watercolors.[1] The Corcoran's triumphant image is the largest and most heroic and one of the artist's last works. The dramatic full-length, which is signed and dated in the lower left "TS 1845.," exhibits the lifelong talents that made Sully the leading portraitist of the Jacksonian era. Painting confidently and with little reworking, using dry brushes as well as brushes heavily loaded with medium-rich paint, Sully depicted General Jackson as the artist imagined Jackson would have appeared after the battle of New Orleans on 8 January 1815, at the end of the War of 1812. Jackson's historic defeat of the British army prevented the capture of New Orleans by the enemy. His leadership at the battle made him a military hero and led ultimately to his presidency (1829–37). In Sully's depiction, Jackson, in uniform with a military cape, stands near a cannon and a tent as the nearby battle rages and smoke swirls around him. He pauses while writing on a large piece of paper and looks off to the viewer's right. He wears one riding glove; the other has fallen to the ground.[2] Soldiers marching to battle can be seen in the lower left.

The portrait, painted thirty years after the battle and a month after Jackson's death on 8 June 1845, is based on a life study that Sully had painted in December 1824. That, however, was not Sully's first encounter with Jacksonian imagery. In 1817 he had designed the allegorical image of Victory and Peace for the reverse of the Congressional medal awarded to Jackson after the battle.[3] Two years later Sully had his first opportunity to paint Jackson from life, on the invitation of the Association of American Artists, a Philadelphia group. The portrait (Fig. 1), painted when Jackson visited Philadelphia in February 1819, differs in pose and imagery from the later full-length. It shows the general in three-quarter length, in uniform, facing the viewer and looking off to the left. Jackson rests his right hand on his sword hilt and his left arm on the saddle of a white horse that stands behind him.[4] Five years later Sully had a second opportunity to paint Jackson from life, in December 1824, in Washington, D.C.[5] Sully had gone to the national capital to paint a likeness of the marquis de Lafayette and while there seized the chance to paint Jackson (private collection) and John Quincy Adams (National Gallery of Art, Washington, D.C.). The two men had been candidates in the November presidential election, and the outcome was not yet decided.

Sully returned to the 1824 painting for the image of Jackson's face when he painted the Corcoran's posthumous full-length portrait more than twenty years later. He also returned to the concept of the victorious general. Although we do not know why Sully painted the full-length portrait, the occasion was closely tied to a commission from Francis Preston Blair, editor of the pro-Jackson newspaper in Washington, D.C., the *Globe,* for a copy of the 1824 life portrait of Jackson, which he owned by this time.[6] Blair, who had commissioned Sully to paint portraits of his wife and daughter in 1840 and 1843, also commissioned a portrait of himself, two of his son Montgomery Blair, and one of his son-in-law Samuel Phillips Lee.[7] After Jackson's death, Sully painted a second replica of the 1824 portrait for his

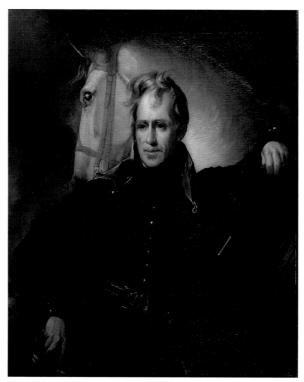

Fig. 1. Thomas Sully, *Andrew Jackson*, 1819. Oil on canvas, 46½ × 37 in. (118.1 × 94 cm). Clermont State Historic Site, New York State Office of Parks, Recreation and Historic Preservation, CL.1974.1.a.b

friend Francis Fisher Kane of Philadelphia (R. W. Norton Art Gallery, Shreveport, La.).[8] He began work on the full-length on 8 July 1845, finishing it three weeks later, on 31 July. He listed the price in his Register of Paintings as eight hundred dollars. On 2 August he "sent whole length of Jackson to Gallery,"[9] referring to the commercial gallery that he co-owned with the carver and gilder James S. Earle, who may have made the frame, as he had for many of Sully's portraits.[10] The portrait was on view at the Artists' Fund Society Hall in the Tenth Annual Exhibition of the Artists' Fund Society and the Pennsylvania Academy of the Fine Arts, both in Philadelphia, for a week that fall, from 27 October through 1 November 1845.[11]

In 1857 the portrait, still owned by the artist, was sent to Washington, D.C., for the first annual exhibition of the Washington Art Association, from 10 March to 19 May.[12] William Wilson Corcoran was a member of the association's board and a lender to the exhibition.[13] After the exhibition closed, the portrait was placed on loan at the National Institute Museum, in the Patent Office Building.[14] Before Corcoran acquired it, however, the portrait was purchased by Jacob Thompson, secretary of the interior in the administration of James Buchanan.[15] Later, perhaps during the Civil War, it became the property of John F. Coyle, a Washington collector and patron of the American artist Eastman Johnson.[16] By 1867 Coyle

had sold the portrait to William Wilson Corcoran, who by this time could have been planning a national portrait gallery, a goal made public a decade later.[17] Corcoran later rejected Thompson's claim to the portrait, as he reported to William MacLeod, the curator at the gallery in 1876:

> Mr. Corcoran gave some interesting information about the Jackson portrait by Sully, which I never had before. He bought it from John F. Coyle for $350, paying further sums for its repair. Jacob Thompson, Ex. Secy of the Interior under Mr. Buchanan, . . . claims again—as he has before— this Jackson portrait from Mr. C. on the plea that it belonged to him, & was only deposited with Coyle. Mr. C. says his reply was as before that if he (Thompson) would repay the price of it & its repairs, he might take it. Which Thompson won't or can't do. . . . It seems Coyle declared Thompson's wife gave him the picture. Mr. Corcoran also adds that Thompson thinks he ought to get thousands for it, whereas he offered it once in Paris to C. for $500.[18]

After the portrait was placed on view at the newly opened Corcoran Gallery of Art in 1874, it became a favorite of many visitors.[19]

EGM

Severin Roesen (Germany, 1815/16–United States, after 1872)

Still Life, Flowers and Fruit, 1848

Oil on canvas, 36 × 26 in. (91.4 × 66 cm)
Signed and dated lower right: S. Roesen/1848.
Museum Purchase through the gift of Orme Wilson, 61.20

Still Life, Flowers and Fruit is the earliest work signed and dated by Severin Roesen after the artist arrived in New York in 1848. Little is known about his life before he immigrated, but art historians have posited that he was born near Cologne and began his career as a painter of fruit and flower designs on porcelain.[1] Roesen quickly established himself in New York, submitting two paintings (one of which was possibly the Corcoran's still life) to the 1848 American Art-Union exhibition. He would exhibit and sell at least nine more fruit and flower pieces in New York before moving to Pennsylvania in 1857.

Still Life, Flowers and Fruit shows an opulent assortment of irises, tulips, cabbage roses, bluebells, and dahlias alongside an apple, orange, half a lemon, grapes, pear, peach, Italian plums, and a delicately painted stem of red currants, each at their peak of bloom or ripeness. The art historian William H. Gerdts has noted that these fruits and flowers are never at their best in the same season. Moreover, the sheer abundance of produce would have had Roesen painting long after his models began to decay. Because of this, Gerdts postulates that Roesen used some form of template, possibly intricate stencils or patterns of fruits and flowers, in composing his paintings.[2] Bolstering this claim is the fact that several motifs repeat throughout Roesen's oeuvre. The downward-facing peony with a smaller peony to the left and the rose in profile above, which appear at the lower left in the Corcoran's painting, also can be seen in *Still Life—Flowers in a Basket* (Fig. 1), *Still Life of Flowers and Fruit with River Landscape in the Distance* (1867, Amon Carter Museum, Fort Worth), *Still Life with Fruit and Flowers* (c. 1855, National Gallery of Canada, Ottawa), and *Victorian Bouquet* (1850–55, The Museum of Fine Arts, Houston). The composition of one painting, *Still Life* (1848, Worcester Art Museum, Mass.), exists in twelve different iterations.[3] The gray marble slab with a rounded projection in the Corcoran's canvas likewise is an element in many of Roesen's early paintings.[4]

Roesen was the first American painter to draw in earnest on the tradition of seventeenth-century Dutch still-life paintings, which offered profuse arrays of fruits and flowers crisply rendered in richly saturated, vibrant colors. As with his Dutch models, Roesen's painting includes such ephemeral items as waterdrops, on the petal of the pink rose at center left, a ladybug on a leaf at center right, and two butterflies poised before flight: a brown-and-blue brushwing variety on the edge of the marble slab and a small white butterfly clinging to a flower stem above the grapes.[5] Such elements suggest the transience of life by representing a single, passing moment. The small nest of eggs at the lower left, which appears in many of Roesen's paintings, was an emblem of fertility and abundance in Dutch still-life paintings, and the fly perched on the perfectly ripe peach was a common emblem of decay.[6]

Until Roesen's arrival, American art boasted only the austere assemblages of fruit, vegetables, crackers, or meat painted by members of the Peale family. Roesen's lush compositions appeared at an auspicious time, as historians have noted, since the rich abundance portrayed in these works appealed to midcentury American taste for elaborate decoration.[7] Although the artist was relatively unknown during his lifetime and may have left New York City in 1857 for want

Fig. 1. Severin Roesen, *Still Life—Flowers in a Basket*, 1850s. Oil on canvas, 30 × 40¼ in. (76.2 × 102.2 cm). Museum of Fine Arts, Boston, M. and M. Karolik Fund, 69.1228

of commissions, Roesen indirectly but profoundly influenced the history of American still-life painting. In the years following Roesen's career in New York, there was a slow but marked increase in the number of fruit and flower still lifes exhibited there, particularly larger-scaled works.[8] Examples of the genre produced by the next generation of American artists, including Fannie Palmer, F. E. D. Smith, and John Adams, include features that seem to have been modeled on those in Roesen's painting, and the slightly older still-life painter John Francis changed his style later in life to Dutch-influenced tableaux of abundant fruit and flowers, possibly inspired by Roesen.[9]

Roesen enjoyed more financial success after moving to Pennsylvania and settling in prosperous Williamsport. There he became a fixture of the arts community, taking on students and painting many still lifes as well as portraits and landscapes.[10] His last signed painting was executed in 1872. After that date, he disappeared from the Williamsport directory, and art historians have been unable to locate any further documentation of his whereabouts. Some have speculated that he may have set out for New York to attend his daughter's wedding in 1872 but died en route.

LS

Thomas Doughty (Philadelphia, 1793–New York City, 1856)

View on the Hudson in Autumn, 1850

Oil on canvas, 34⅛ × 48¼ in. (86.5 × 122.5 cm)
Gift of William Wilson Corcoran, 69.70

Thomas Doughty, a pioneer of American landscape painting, was born in Philadelphia in 1793 and lived there until 1828.[1] Little is known about his formal education, but he apparently displayed a strong talent for drawing at an early age. When he was fifteen or sixteen, Doughty was apprenticed to a leatherworker, and by 1814 the city directory listed him as a "currier." Two years later, he was described as a "painter" when he exhibited a landscape at the Pennsylvania Academy of the Fine Arts. Doughty's early career as an artist seems to have met with little success, and in 1818 to 1819 he returned to making his living as a leather currier. It was not until 1820 that he made landscape painting his full-time career.

Doughty formed his style by studying and copying European landscapes that he saw in the Pennsylvania Academy and in collections such as that of his early patron, Robert Gilmor, Jr., of Baltimore. From such paintings and prints, Doughty mastered the main conventions of the European landscape tradition and gained a working knowledge of the styles of such old masters as the Frenchmen Claude Lorrain and Nicolas Poussin as well as the Italian Salvator Rosa. He also made regular sketching trips in the eastern United States, especially during the early years of his career, to gather material for his paintings. Indeed, as one observer noted: "From his earliest boyhood he loved the woods, the streams, the hills, and the valleys. He dwelt with them—he felt their power—he made them his study and delight."[2] Many of his works of the 1820s were topographical, such as *View of Baltimore from Beech Hill* (Fig. 1). Gilmor, for one, found Doughty's works in this manner particularly pleasing, for, as he wrote to Thomas Cole: "As long as Doughty *studied* and *painted* from nature (who is always pleasing however slightly rendered in drawings or paintings made on the spot) his pictures were pleasing, because the scene was real, the foliage varied and *unmannered*, and the broken ground & rocks & moss had the very impress of being after *originals*, not *ideals*."[3] However, by the mid-to-late 1820s Doughty had begun to move beyond the purely topographic in favor of grander, more ambitious landscapes. His travels took him farther afield now, with trips to more rugged, mountainous areas in Pennsylvania, Massachusetts, and upstate New York.

In 1828 Doughty moved to Boston, but he had resumed residence in Philadelphia by 1830. There, for the next two years, he and his brother John edited a monthly magazine called *The Cabinet of Natural History and American Rural Sports*, which also published Doughty's hand-colored lithographs of animals. The magazine ceased publication in 1832, and Doughty returned to Boston, where he enjoyed considerable success exhibiting and selling his works and teaching drawing and painting. He made his first trip abroad in 1838, visiting England, and between 1845 and 1847 he returned to England and also visited Ireland and France. The last years of his life were spent in New York.

Doughty classified his works in three distinct types: "from nature," "from recollection," and "composition."[4] Painted late in Doughty's career, *View on the Hudson in Autumn* may have had its origins in an actual place he once visited. However, it was more likely based on his memories of many experiences of the river's scenery over the years. Nothing suggests the specific; the house is a generic country cottage, and the contours of the river's banks and the distant mountains do not evoke any particular topography of the Hudson River valley. The mood is idyllic, even nostalgic. This is a pastoral panorama of American scenery at its most beautiful and benign, in which American citizens are comfortably integrated into the natural world.

View on the Hudson in Autumn is among the most accomplished of Doughty's late works. Its composition is balanced and orderly, and its effects of light and atmosphere convincing and effective. Doughty's palette throughout his career was generally subdued, and he tended to favor a restrained tonal approach.[5] Here, however, his use of bright colors to capture autumn's hues is particularly notable. William Wilson Corcoran acquired *View on the Hudson in Autumn* in 1852, relatively early in his collecting of American works of art.[6]

F K

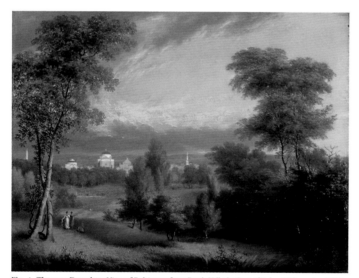

Fig. 1. Thomas Doughty, *View of Baltimore from Beech Hill, the Seat of Robert Gilmor, Jr.*, 1822. Oil on wood panel, 12⅞ × 16⅝ in. (32.7 × 42.3 cm). The Baltimore Museum of Art, Gift of Dr. and Mrs. Michael A. Abrams, BMA 1955.183

Daniel Huntington (New York City, 1816–New York City, 1906)

Mercy's Dream, 1850

Oil on canvas, 89⅝ × 66 in. (227.6 × 167.6 cm)
Signed, inscribed, and dated lower left: D Huntington /
This 2nd picture of Mercy's Dream / painted 1850.
Gift of William Wilson Corcoran, 69.67

The source for Daniel Huntington's *Mercy's Dream* is *The Pilgrim's Progress* by the seventeenth-century English writer and Protestant theologian John Bunyan. Among antebellum American audiences, few books surpassed the popularity of this allegorical tale of Christian struggle and salvation, and its fame in turn made Huntington's painting one of the most acclaimed and widely circulated of its day. Though also renowned for his landscapes and society portraits, the artist aspired to be remembered for his works in the tradition of the old masters, particularly history paintings and large-scale, multifigure religious subjects like this seven-by-five-foot canvas. At the time, Huntington's ambitions confronted widespread ambivalence toward religious art, but he shrewdly appealed to Victorian taste for sentimental subjects in order to neutralize potential misgivings among his patrons and expand the American market for works like *Mercy's Dream*, which harmonize beauty, learning, and belief.

Over the course of two volumes (published in 1678 and 1684), *The Pilgrim's Progress from This World to That Which Is to Come* narrates the journeys of an Everyman hero and his family along an obstacle-ridden earthly road to spiritual redemption. Their party includes a young neighbor woman named Mercy, who experiences a vision in which an angel comforts her with a glimpse of heaven and its splendors. She tells her friends:

> I was a-dreamed that I sat all alone in a solitary place, and was bemoaning of the hardness of my Heart. . . . I looked up, and saw one coming with Wings towards me. So he came directly to me, and said, Mercy, what aileth thee? Now when he had heard me make my complaint, he said, Peace be to thee. He also wiped mine eyes with his Handkerchief, and clad me in Silver and Gold: he put a Chain about my Neck, and Ear-rings in mine Ears, and a beautiful Crown upon my Head.[1]

Huntington paints the moment of Mercy's coronation, when the angel descends into the dark landscape under a beam of celestial light toward the young woman who reclines on the ground with eyes closed in a rapturous trance. "It is truly a *blissful reverie*," wrote one early reviewer. "The figure and face of Mercy are transcendentally beautiful, and fully convey the fine classic taste of the artist."[2]

This "classic" appreciation for beauty and refinement was a product of Huntington's thorough liberal arts education at Hamilton College in Clinton, New York, and his artistic training at New York University with Samuel F. B. Morse and Henry Inman. After finishing his studies with a tour of Italy in 1839–40, he debuted the first version of *Mercy's Dream* (Pennsylvania Academy of the Fine Arts, Philadelphia) at the American Art-Union's 1841 annual exhibition in New York. This early *Mercy's Dream* was bought by the Philadelphia publisher and collector Edward L. Carey, and prints and copies emerged throughout the ensuing decade. Concerned about weaknesses and inaccuracies in these reprisals of his work, Huntington arranged for the production of a high-quality mezzotint by the engraver Alexander Hay Ritchie, executing a second version of the painting to be used for this project. When Ritchie's prints were finished, the Philadelphia Art-Union distributed them as a

Fig. 1. Gian Lorenzo Bernini, *The Ecstasy of Saint Teresa*, 1647–52. Cornaro Chapel, Sta. Maria della Vittoria, Rome, Italy. Scala/Art Resource, NY

subscription gift for all members, and Huntington sent the painted 1850 version of *Mercy's Dream* to the Broadway art dealers Williams, Stevens & Williams, from whom William Wilson Corcoran purchased it soon thereafter.[3]

Learning of Corcoran's interest in *Mercy's Dream*, Huntington urged him to buy *Christiana, Her Children, and Mercy* (John and Mable Ringling Museum of Art, Sarasota, Fla.), its pendant scene from *The Pilgrim's Progress*. He wrote: "I am very desirous the two pictures, which are perhaps the best and certainly the most pleasing I ever painted, should have a place in that collection which you are forming."[4] Corcoran nonetheless bought only *Mercy's Dream*, perhaps preferring it, as did many critics, for the freedom of imagination that dream imagery afforded the artist and encouraged in viewers. The painters Thomas Cole and Emanuel Leutze, both also represented in Corcoran's collection, had recently experimented with dream subjects, and William H. Gerdts suggests that this trend determined Huntington's selection of this scene, despite its being a minor episode within Bunyan's lengthy book.[5]

Perhaps more important, *Mercy's Dream* displays Huntington's skill as a figure painter and his admiration for Italian Renaissance and Baroque art, particularly the biblical scenes and depictions of saints he had studied in Rome. In 1851 he delivered a public lecture entitled "Christian Art" at the National Academy of Design, praising this "highest class of art" as practiced by both the old masters and European contemporaries like Johann Friedrich Overbeck, a German who lived in Rome and painted Christian subjects mimicking the style of Raphael.[6] His lecture responded to widespread distaste among Americans for Roman Catholic subject matter, which many regarded as overly sensual and corrupt.[7] Furthermore, as Sally Promey has elaborated, there existed in the 1840s a complicated

"pictorial ambivalence" among American Protestants, the result of xenophobic anti–Roman Catholic campaigns, lingering Puritan traditions of shunning material excess, and other conditions.[8]

Huntington therefore sought ways to present religious imagery in terms that would appeal to Protestants, guided, as Wendy Greenhouse has argued, by his own moderate convictions as an Episcopalian.[9] *Mercy's Dream* was the most successful of these feats, displaying in the soft features of the girl and angel the stylistic influences of Raphael and Guido Reni. More provocatively, its composition echoes another famous work of art in Rome, *The Ecstasy of Saint Teresa* by Gian Lorenzo Bernini, which depicts a sixteenth-century nun's mystical experience of an angel piercing her with a fiery arrow (Fig. 1). Although Bernini's sculpture notoriously disgusted most American viewers, Huntington evidently recognized its merits as an evocative representation of contact between a human and an angel, made more powerful by the theatrically visible shafts of light. His painting therefore reworks Bernini's figural grouping and astutely negates its potentially offensive erotic tension by presenting no physical contact between Mercy and her handsome celestial visitor. The maiden's unconscious gesture of modesty, clutching her blouse tightly to her chest, further bespeaks her purity and that of the picture. Through these references, Huntington affirms that the combined influences of Protestant piety and Italian artistic training could ennoble paintings that also celebrated the sensual beauty of the human body. The success of *Mercy's Dream* thus results not only from the popularity of Bunyan's *Pilgrim's Progress* but also from the painting's ability both to please the eye and to nourish the soul.

CAM

Fitz Henry Lane (Gloucester, Mass., 1804–Gloucester, Mass., 1865)

The United States Frigate "President" Engaging the British Squadron, 1815, 1850

Oil on canvas, 28 × 42 in. (71 × 107 cm)
Signed and dated lower right: F. H. Lane 1850.
Gift of Mr. and Mrs. Lansdell K. Christie, 61.7

This rendition of a fierce naval battle is profoundly at odds with what one expects from Fitz Henry Lane. The artist is best known for his placid views of harbors with towering ships floating silently on glassy waters, such as *Boston Harbor* (Fig. 1). His painting *The United States Frigate "President" Engaging the British Squadron, 1815* demonstrates that the artist could take a very different approach to a subject that demanded it.[1]

Through the influence of the British-born maritime painter Robert Salmon, whom he encountered in Boston, Lane became part of the long tradition of British and American nautical painters.[2] The War of 1812 began appearing in naval art during the war itself and continued for decades thereafter.[3] While Lane was training in the Pendleton lithography firm in Boston in the 1830s, he presumably was exposed to popular prints of the war. In this painting, Lane perhaps drew on those memories when he made the unusual choice to look back thirty-five years to the War of 1812, a conflict he is known to have depicted in only one other painting.[4] Lane may have been working for a now-unknown patron, but the artist also had his own memories of the conflict, which had raged while he was growing up in Gloucester, Massachusetts, devastating the local economy. A Stephen Lane, who may have been Lane's older brother, died serving in the local militia.[5]

Although he could have portrayed one of many American naval victories, Lane instead painted the devastating loss to the British of the *President*, one of six frigates constructed about 1800 as the foundation of the American navy.[6] The painting focuses on the *President* as the ship fights alone against a squadron of British vessels. Lane placed the American ship in the foreground riding a rough sea and firing its cannons at the British (a ship to the *President*'s right appears in the middle ground, while smoke from the *President*'s cannons indicates another ship outside the canvas to the American vessel's left). A dismasted hulk almost lost in the smoke

of battle is all that remains of a vessel the Americans have already defeated, while a fresh British ship emerges from the distance to join the group confronting the beleaguered *President*. American sailors swarm through the rigging of their ship to replace torn-away sails, heedless of the missiles that splash into the waves just short of the *President*'s hull. Although the distant British ships are sketchily painted and shrouded in smoke, Lane's crisp brushwork and clear lighting accentuate the heroic Americans in the foreground.

Lane's vision of the *President*'s final battle seems inspired by American accounts. The Boston Athenæum, where Lane exhibited paintings and whose library he probably used to do research, owned contemporary books that included the incident.[7] Lane probably knew Abel Bowen's popular book *The Naval Monument*, which had been in the Athenæum's collection since 1816.[8] Bowen related the tale of the battle through letters from Commodore Stephen Decatur, captain of the *President*, to the secretary of the navy. Lane was accustomed to making painstakingly precise renderings of ships at peace; here he applied this exactitude to narrating the particulars of the battle.

In early 1815 the British maintained a naval blockade of New York Harbor, trapping the USS *President*. As a strong west wind diverted the British squadron from the coast, Decatur attempted to run the blockade, precipitating the events shown in Lane's painting.[9] Decatur wrote that on the morning of 14 January 1815, "the ship in going out [of the harbor] grounded on the bar." The ship was badly damaged, but high winds prevented its return to port. The *President*, once off the bar, was chased by four ships that fired on her. The American attempted to retreat from her pursuers, increasing her speed by jettisoning water, anchors, and other heavy objects. Lane therefore depicts the American vessel riding high in the water but with an anchor still at her bow. The British ship *Endymion* (the dismasted vessel in the background) caught up to the *President*, and the

Fig. 1. Fitz Henry Lane, *Boston Harbor*, c. 1850–55. Oil on canvas 26 × 42 in. (66 × 106.7 cm). Museum of Fine Arts, Boston, M. and M. Karolik Collection of American Paintings, 1815–1865, by exchange, 66.339

two ships exchanged fire. The American vessel, too crippled by its grounding to maneuver well, was unable to board the *Endymion* with its marine force. The fight continued until many of the *President*'s crew were injured or killed and her rigging badly damaged, as shown in detail by Lane. In the painting, the *Endymion* fires what must be some of her last shots before Decatur's ship "disabled and silenced" the British vessel. The British ships *Pomone* and *Tenedos* approached and fired on the Americans, as seen in Lane's painting. In the face of this new force, Decatur stated, "We were of course compelled to abandon her [the *President*]."

Decatur wrote to the secretary of the navy, "It is with emotions of pride I bear testimony to the gallantry and steadiness of every officer and man I had the honor to command on this occasion . . . almost under the guns of so vastly a superior force, when . . . it was . . . self-evident, that whatever their exertions might be, they must ultimately be captured."[10] Lane, in showing the *President* engaging two British ships and having already defeated a third, chose the most heroic moment from the battle, when the Americans fought on in the face of inevitable defeat.

Lane's image accords with the words of the court of inquiry that investigated the loss of the *President*. The president of the court wrote to the secretary of the navy, "[The crew of the *President*] fought with a spirit, which no prospect of success could have heightened. . . . In this unequal conflict the enemy gained a ship, but the victory was ours."[11] Lane celebrated, not an American triumph, but a more complex and tragic event. The praise of bravery even in defeat accords well with the romantic aura of his more contemplative paintings.

APW

William Tylee Ranney (Middletown, Conn., 1813–West Hoboken, N.J., 1857)

The Retrieve, 1850

Oil on canvas, 30⅛ × 40⅜ in. (76.4 × 102.4 cm)
Signed and dated lower center: W Ranney / 1850
Gift of William Wilson Corcoran, 69.62

The Retrieve was the third of at least eight paintings of duck hunting William Ranney made over an eight-year period.[1] The artist was an enthusiastic hunter whose scenes were likely inspired by his experiences on the salt marshes near his home and studio in West Hoboken, New Jersey.[2] In an interview, the artist's grandson Claude J. Ranney identified the location of *The Retrieve* as the Hackensack Meadows, which Ranney could see from his studio. The model for the kneeling figure was Ranney's younger brother Richard, and that for the standing figure may have been a neighbor's groomsman who often sat for Ranney.[3]

The artist's first foray into the subject, *Duck Shooters* (Fig. 1) was an instant success when it was exhibited at the American Art-Union in 1849, the year it was painted. The Art-Union purchased it and offered it in the institution's raffle.[4] Ranney recognized the popularity of duck hunting as a subject and followed *Duck Shooters* with what became his most successful composition, *On the Wing* (1850, private collection). This dramatic scene shows hunters stalking ducks that fly unseen beyond the canvas's edge. The painting was widely praised by critics when it was exhibited at the National Academy of Design, and the Art-Union subsequently purchased it for engraving and distribution to members. Ranney may have painted as many as four more versions of the scene about 1850.[5]

In 1850 Ranney also executed *The Retrieve*. Here the artist shifts the focus from the human hunters to the hunting dog, which is seated in the foreground with a canvasback duck in its mouth. The art historian Linda Bantel has noted the artist's paintings often model proper hunting practices. In *The Retrieve*, the dog delivers the bird directly to his master, as a well-trained hunting dog should do.[6] Indeed, the title under which the painting was first exhibited in 1851 specifies that Ranney's subject is the dog's act of retrieval rather than duck hunting more generally.[7] Likewise, Ranney's *On the Wing* shows hunters stalking birds in flight. Shooting a bird in the air, or on the wing, was considered both the most challenging and the fairest means of bringing down a bird.[8]

Ranney's sport paintings likely owed their popularity to the artist's observance of such codes. Sport hunting had grown in favor among the American middle class by midcentury, and Ranney's audience undoubtedly knew such prescriptions. Bantel has described how even art critics commented on Ranney's observance of the duck hunters' code of conduct. For example, critics pointed to a particular, if small, anomaly in both *Duck Shooters* and *Duck Shooter's Pony* (1853, private collection): a pink-toned sky that seems to indicate warm weather, whereas the ideal weather for hunting ducks is the cool of late fall or early winter.[9] Ranney apparently sought to correct this mistake by setting *The Retrieve* in the fall. He rendered the landscape in shades of ocher and brown and clothed the hunters in thick coats. Indeed, one writer noted that "[t]he sky wears the autumnal dark, the gray and purple shades."[10]

Ranney's attention to details of the marsh grasses, the glassy water, and the carefully observed, dark gray stratus clouds recalls the work of such Hudson River School artists as Asher B. Durand

Fig. 1. William Tylee Ranney, *Duck Shooters*, 1849. Oil on canvas, 26 × 40⅛ in. (66 × 101.9 cm). Museum of Fine Arts, Boston, Gift of Maxim Karolik for the M. and M. Karolik Collection of American Paintings, 1815–1865, 1948, 48.470

and John F. Kensett, who were at the peak of their powers in the 1850s. Ranney's venture into landscape suggests his range of subject matter. In his brief career, Ranney, who appears to have been almost entirely self-taught, tackled portraiture, genre painting, religious scenes, history paintings, and western scenes. Although western subjects made up only a fifth of his oeuvre, over time their notoriety eclipsed that of his other subjects, and he became known as a western painter.

William Wilson Corcoran purchased *The Retrieve* sometime before the annual exhibition in 1851 of the National Academy of Design, whose catalogue lists him as the lender.[11] He may have purchased the painting through Williams, Stevens & Williams, a New York dealer that sold him other paintings and that also sold works for Ranney, although there is no documentation of this particular sale.[12] Corcoran was likely familiar with Ranney's work through one of the New York art institutions that promoted it, such as the National Academy of Design and the American Art-Union. Over the seven years it was in operation (1844–51), the Art-Union purchased more than one-third of Ranney's paintings, three of which it selected for engraving and distribution to its members.[13] Ranney also enjoyed steady sales to middle-class buyers as well as to major collectors. The artist was so well regarded within the art community that when he died of tuberculosis at forty-four, the artists George Caleb Bingham and A. F. Tait completed two of his unfinished canvases. These, along with more than one hundred other works from Ranney's studio and about one hundred painted and donated by fellow artists, were auctioned for the benefit of his widow and two young sons.[14]

LS

Jasper Francis Cropsey (Rossville, Staten Island, N.Y., 1823–Hastings-on-Hudson, N.Y., 1900)

Tourn Mountain, Head Quarters of Washington, Rockland Co., New York, 1851

Oil on canvas, 22¹³/₁₆ × 27¾ in. (58 × 70.5 cm)
Signed and dated bottom center: 1851 / J. F. Cropsey
Gift of William Wilson Corcoran, 69.17

Jasper Francis Cropsey's 1851 painting *Tourn Mountain, Head Quarters of Washington, Rockland Co., New York* celebrates both the landscape and the history of his home state, New York. Cropsey was born on Staten Island in 1823. He studied art and painted in England, France, and Italy from 1847 to 1849. In July 1849 he returned to the United States, where he devoted himself to painting scenery in and near his native state, as he would for most of the rest of his career.[1]

Kenneth W. Maddox has identified four paintings that Cropsey made during the 1850s depicting Torne Mountain along the Ramapo River valley in the far southeastern corner of New York State: *Torn Mountain, Rockland County, N.Y.* (1850, The Saint Louis Art Museum),[2] *Winter Scene, Ramapo Valley* (1853, Wadsworth Atheneum Museum of Art, Hartford, Conn.),[3] *American Harvesting* (1851, Indiana University Art Museum, Bloomington), and the Corcoran's view of the mountain.[4] This suite of works depicts an impressive mountain with a rocky crest, shown dramatically framed by foreground trees and background clouds in a manner distinctly reminiscent of paintings by Cropsey's idol, the leading Hudson River painter Thomas Cole.

Cropsey's *Tourn Mountain, Head Quarters of Washington* is full of life, with every form implying motion, from the spreading trees to the mist and the flight of birds rising off the hills at the right. The choppy surface of the stream is evocative of a brisk breeze that tosses the tree branches leaning over the water. A little house appears in a pool of sunlight in the middle ground of Cropsey's painting, serving by its modesty and stillness to heighten the grandiosity and vitality of the mountain behind it. Torne Mountain catches the eye with its bold shape and the jagged forest that covers it, with occasional particularly tall trees standing up against the sky and bleached dead trunks catching the sun among their darker brethren.

Cropsey's *Tourn Mountain, Head Quarters of Washington* is based on a pair of drawings Cropsey made, dated "September 16, 1846," which Maddox notes are two halves of a single scene (Figs. 1a, 1b).[5] It was not unusual for Cropsey to base his paintings on drawings he had made some years earlier. Among many other instances, drawings made in 1853 were sources for his 1865 painting of Starrucca Viaduct, near Lanesboro, Pennsylvania.[6] For his 1851 painting, Cropsey made a number of changes from his drawings of Torne Mountain; for example, the single house as depicted in the painting is smaller than either of the two houses in the two drawings.[7] The painting's simpler composition thus leads the eye more directly to the mountain than is the case in the two drawings. The outline of the mountain in the painting remains very close to that seen in the drawings, while Cropsey's other paintings of Torne Mountain exaggerate its profile.

The rickety fence and untended yard around the small white house on the riverbank, which appear more dilapidated in the painting than in the drawing in the collection of the Newington-Cropsey Foundation, draw attention to the damage wrought by the passage

Fig. 1a. Jasper F. Cropsey, Study for *Tourn Mountain, Head Quarters of Washington, Rockland Co., New York* (left side), 16 September 1846. Pencil and whiting on blue-tinted paper, 10¾ × 8 in. (27.3 × 20.3 cm). The Newington-Cropsey Foundation

Fig. 1b. Jasper F. Cropsey, Study for *Tourn Mountain, Head Quarters of Washington, Rockland Co., New York* (right side), 16 September 1846. Pencil and whiting on blue-tinted paper, 10¾ × 8 in. (27.3 × 20.3 cm). Private collection

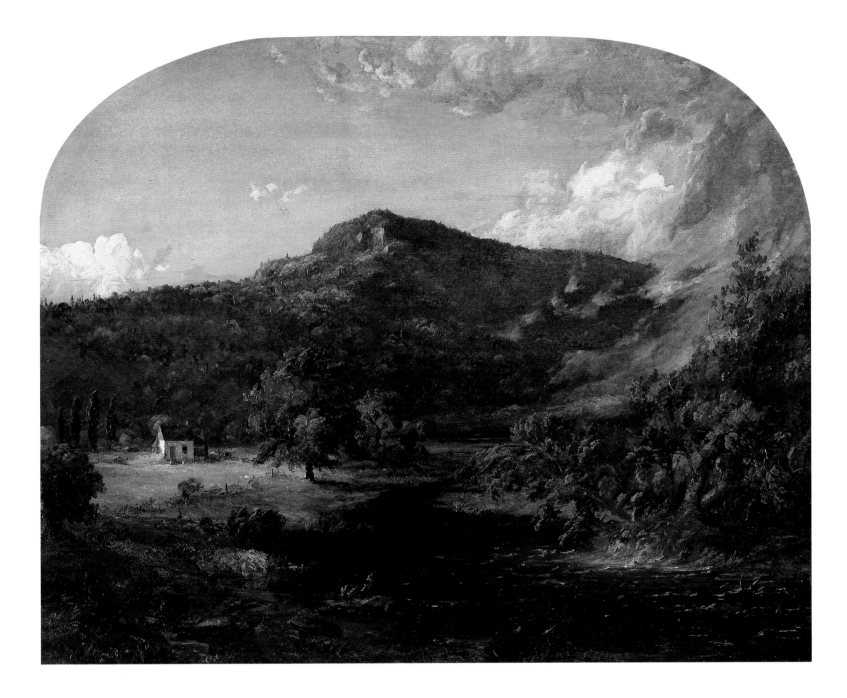

of many years. Certainly Cropsey was thinking of this location's past when he visited Torne Mountain in 1846. The artist noted in his journal that he went on "an excursion to the peak of the Torne Mountain. . . . The view from the mountain is very extensive. It is said that from here Gen. Washington watched the motions of the armies during some of those Revolutionary strugles [sic] that passed off in contention for the Hudson River."[8] The American Revolution had figured in Cropsey's art before; in 1845 the artist had made a sketching excursion to Fort Ticonderoga.[9]

The importance of these historical connections is confirmed by the exhibition of Cropsey's Corcoran painting under the lengthy title *Tourn Mountain, Head Quarters of Washington, Rockland Co., N.Y.* in the 1853 *First Semi-Annual Exhibition of Paintings in the Gallery of the Massachusetts Academy of Fine Arts.*[10] In the only known critical response to Cropsey's painting, an unidentified reviewer in *Dwight's Journal of Music* made the request that "Cropsey of New York must send us a better specimen of the landscape talent, for which he is justly distinguished."[11] Cropsey apparently responded to this slighting reference, for the following month the same publication included a statement from an unknown writer, "C," that "J. F. Cropsey . . . has sent us

(since your notice of the opening) a large canvas, with 'Recollections of Italy,' as its title."[12]

The more intimate American view appealed to William Wilson Corcoran, who had acquired *Tourn Mountain, Head Quarters of Washington, Rockland Co., New York* by 1857, when it appeared in a catalogue of his gallery. By this time confusion had already accumulated around the locale shown in the painting, for it was listed as *Washington's Headquarters on the Hudson River.*[13] This title wrongly identified the house in the painting as one of those used by the general during the Revolutionary War. Washington used several headquarters in New York State during the Revolution, but the house in the Corcoran's painting is not known to have been one of them. Cropsey never identified the house in this way on his sketches or in his journals.[14] Simple confusion transferred the identification with Washington from the mountain to the small structure. With this correction in place, viewers can now appreciate Cropsey's painting, not as the portrait of a little historical house, but correctly as a tribute to picturesque and historic Torne Mountain.

APW

Ball Playing among the Sioux Indians, 1851

Oil on canvas, 28⅛ × 40⅝ in. (71.5 × 103.3 cm)
Signed and dated lower right: S. Eastman / 1851
Gift of William Wilson Corcoran, 69.63

Ball Playing among the Sioux Indians shows a group of Santee in a vigorous game that was a precursor to lacrosse. The men, wielding long sticks with a small mesh hoop at one end, pursue a small clay ball, which the artist highlights against a patch of dirt in the center foreground. The dramatic landscape is loosely based on the area near Fort Snelling, a military post near the confluence of the Minnesota and Mississippi Rivers, where Captain Seth Eastman, a career army officer and topographic artist, was stationed from 1841 to 1848. An important outpost, Fort Snelling represented the military's northernmost peacekeeping presence among the Santee (or Eastern Dakota) and Ojibwa. While serving as post commander, Eastman became fluent in Santee and over the course of seven years sketched more than four hundred scenes of life in the seven neighboring villages of the Mdewekanton, a subgroup of the Santee.[1] He also made early use of daguerreotypes to document and compose his subjects.[2] In 1849 his active duty was temporarily suspended, and he returned to Washington, D.C., where he devoted himself to painting scenes based on his time at Fort Snelling, among them *Ball Playing among the Sioux Indians*.

In the mid-nineteenth century American viewers appreciated scenes of Native American sport because they offered points of imagined comparison between Native and non-native Americans. Eastman had already painted two such scenes. *Indian Women Playing Ball on the Prairie* (Stark Museum of Art, Orange, Tex.) was exhibited at the American Art-Union, New York, in 1849, and *Ballplay of the Dakota on the St. Peters River in Winter* (1848, Amon Carter Museum, Fort Worth) was shown at the same venue in 1850 and engraved for distribution in 1852.[3] Eastman was surely familiar with Dakota ball-playing from his time at Fort Snelling, but the art historian Sarah Boehme has pointed out that he likely relied on his rival George Catlin's portrayals of ball-play, particularly *Ball Playing of the Women* (Fig. 1) from Catlin's influential *Letters and Notes on the Manners, Customs, and Conditions of the North American Indians* (1841), for his friezelike arrangement as well as for some of the poses.[4]

Native American peoples across the Northeast, Southeast, and Midwest had engaged in ball-play for centuries, but relatively little historic documentation of the games' rules of play or larger meaning exists.[5] Written and visual descriptions provided by observers such as Eastman and Catlin offer some of the few accounts that historians have. Ball-play probably had spiritual or ceremonial significance. Sacred substances were worked into the ball and sticks, miniature sticks were at times used for divination, and heroic players were interred with their equipment. Moreover, games between rival tribes or nations served as surrogates for warfare, hence the nickname "little brother of war."[6] Indeed, the Ojibwa, longtime enemies of the Santee, occasionally met the Santee in battle near Fort Snelling.[7]

Eastman's painting shows the players dressed in traditional buckskin hunting shirts and fringed leggings worn by the Santee but also includes a figure in a striped calico shirt and a plumed red turban, who may represent an Ojibwa man.[8] Other ballplayers wear a mixture of clothing traditional among different Native American peoples. The figure in the center with the yellow-belted shirt also has a sash decorated with silver conchas from the Southwest. Such silver

items, obtained through circuits of Native American trade that predated white contact, were fashionable among the peoples living in the Upper Missouri region in the mid-nineteenth century.[9] Eastman carefully rendered the details of their shirts, jewelry, and hair ornaments in relatively thick impasto but painted their lower limbs very thinly, apparently by design.[10]

Eastman portrays the ball game as a violent and dangerous activity. Several figures purposefully shove one another in an attempt to gain advantage, while others wave their sticks overhead despite being far from the ball. The early anthropologist Henry Rowe Schoolcraft, in his multivolume history of the North American Indians (1851–57), described how "[t]heir ball-plays are manly, and require astonishing exertion," and noted, "[l]egs and arms have often been broken in their ball-plays, but no resentments follow an accident of this kind."[11] Eastman's wife, Mary Henderson Eastman, wrote several books about the Dakota based on her experiences at Fort Snelling. She reported that the games could last several days. The matches were fiercely contested because the winners received food and prizes, like the striped and patterned calico cloths some of the ballplayers are shown wearing.[12] Summer games, such as the one pictured in *Ball Playing among the Sioux Indians*, were consequently less serious because the need for food was not as great. Describing the engraving *Ball Play on the Prairie*, a variation on *Ball Playing among the Sioux Indians* that illustrated one of her books, she wrote, "the Indian cannot enter into the spirit of the game, in summer, on the plain, with the same delight he feels when he performs it in midwinter, when he performs it on the ice; he needs the music of the north wind to animate him, and his limbs are not so active as when

Fig. 1. George Catlin, *Ball Playing of the Women*, engraving, from *Letters and Notes on the Manners, Customs, and Conditions of the North American Indians* (New York: Wiley and Putnam, 1841), 2: facing 146

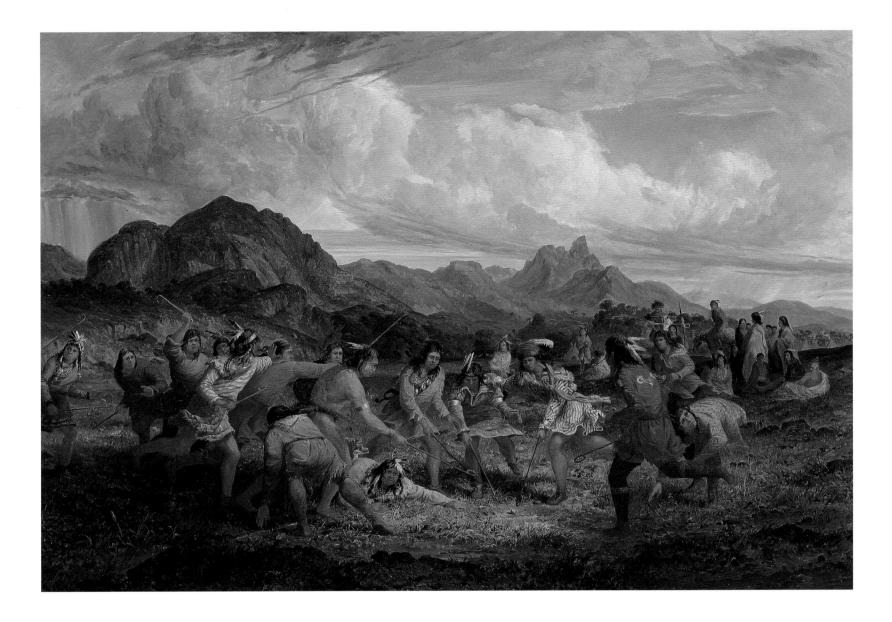

his system is invigorated by cold. While the grass is green and the warm sun shines above him, he cares little for the offered stakes—the food and the clothing."[13]

William Wilson Corcoran purchased this work for his collection by 1857, perhaps after seeing it in Eastman's studio, at 333 G Street, or possibly in conjunction with Eastman's work as a director for the Washington Art Association, of which Corcoran was a patron and honorary member.[14] Corcoran's purchase of this and other western subjects, including John Mix Stanley's *The Trappers*, acquired by 1859, and Albert Bierstadt's *Mount Corcoran*, acquired in 1877 (see essays in this catalogue), helped reinforce the idea that his collection was a national one by broadening its geographic scope and expanding its range of subjects to include a people who, in spite of racial prejudice, were long regarded by Europeans and Americans alike as a unique and defining part of the nation.[15]

LS

Richard Caton Woodville (Baltimore, 1825–London, 1855)

Waiting for the Stage, 1851

Oil on canvas, 15 × 18⅛ in. (37.6 × 46 cm)
Signed, dated, and inscribed lower right: R. C. W. 1851. / PARIS
Museum Purchase, Gallery Fund, William A. Clark Fund, and through
the gifts of Mr. and Mrs. Lansdell K. Christie and Orme Wilson, 60.33

In his brief life, Richard Caton Woodville painted fewer than fifteen oil paintings and left no diaries or account books and little correspondence to document his career.[1] Born in Baltimore to one of its most prominent families, he was educated at St. Mary's College, where he may have received early art instruction.[2] He also likely studied with Alfred Jacob Miller (see *Election Scene, Catonsville, Baltimore County*).[3] He later enrolled in medical school but abandoned his studies after an early work, *Two Figures at a Stove* (1845, private collection), was included in the prestigious National Academy of Design annual exhibition and purchased by the prominent New York collector Abraham M. Cozzens.[4] Following this triumph, Woodville moved to Düsseldorf, Germany, where he studied at the academy and honed his skills in genre painting. He spent the next four years painting in Paris and London; he died in London from an overdose of medicinal morphine in 1855.[5]

Although he spent the decade of his mature career abroad (he painted *Waiting for the Stage* in Paris), his most famous paintings depict life in his hometown of Baltimore.[6] *Waiting for the Stage* shows people in a tavern, a site that often served as a waiting room for stagecoaches, playing cards to pass the time.[7] The man seated with his back to the viewer, a carpetbag at his side, is clearly a traveler and likely a conman who conspires with the figure standing behind the table. The standing figure wears the glasses of a blind man, but his newspaper, cheekily titled *The Spy*, betrays his condition. From his vantage point, he can see both men's cards and could easily telegraph the competitor's hand to his accomplice.[8]

Like his contemporary William Sidney Mount, whose work Woodville was familiar with from Baltimore collections (such as that of Robert Gilmor, Jr., who owned *The Tough Story*, also in the Corcoran's collections), Woodville liked to paint colorful characters in narratives of humor and deception.[9] An earlier work, *The Card Players* (1846, The Detroit Institute of Arts), similarly shows three men attempting to cheat one another at cards, while his *Politics in an Oyster House* (1848, The Walters Art Museum, Baltimore) more subtly implies the persuasive powers of a young conman over his older companion.[10] Woodville's paintings, however, are darker in tone than Mount's sunny stories of talkative barflies or dancing drunks. As one art historian has noted, "no one ever really gets hurt in Mount's paintings."[11] In Woodville's, however, trusting and naïve figures such as the bearded cardplayer run the risk of real financial loss. The ring prominently displayed on his hand implies the existence of family members whose well-being is imperiled by their patriarch's poor judgment.

Woodville's darker narratives are echoed in his compositions. Whereas Mount used a broad, expansive space to characterize his protagonist in *The Tough Story*, Woodville's spaces are typically small and cramped, with a wealth of apparently reportorial but actually superfluous objects rendered in minute detail: the sooty cigar lying on the floor in the foreground, the ashes scattered across the stove's bib, the caricature doodled on the chalkboard hanging to the right, and the red spittoon, an object that appears in at least three other

Fig. 1. Richard Caton Woodville, *Self-Portrait from a Carte de Visite,* c. 1853. Oil on panel, 12 × 9¼ in. (30.5 × 23.5 cm) (framed). The Walters Art Museum, Baltimore, 37.2644

of his Baltimore genre scenes.[12] Moreover, the spaces themselves are difficult to read. Woodville often adopts a raking angle that imaginatively traps the viewer in the corner of the room, offering only tantalizing peeks at spaces opening up through doors or cupboards. Indeed, an 1851 print after *Waiting for the Stage* captures this effect in its title, *Cornered!*[13]

The art historian Justin Wolff has taken particular note of the doodle on the chalkboard, noting that its pointy beard and ears make the face resemble Woodville's own, as portrayed in *Self-Portrait from a Carte de Visite* (Fig. 1).[14] According to Woodville family lore, the artist frequently inserted himself or family members in his paintings.[15] By including a caricatural self-portrait, Woodville instigated a private joke that resonates on several levels. As Wolff notes, the chalked face looks devilish, as if to suggest the artist himself created a waiting room that, if not quite hell "with its fiery-hot woodstove and corrupt gamblers, is certainly the devil's workshop."[16] But the rough caricature on a slate is an artistic creation twice over, both a crude representation and a very sophisticated, trompe l'oeil one. The chalkboard, particularly if we understand the face to be Woodville's, reminds us that the work as a whole is a painted construction. In that sense, Woodville's self-portrait could also serve ultimately as a warning to his viewers: Don't mistake this painting for a mirror of reality, or you risk being conned yourself.[17]

LS

Frederic Edwin Church (Hartford, Conn., 1826–New York City, 1900)

Tamaca Palms, 1854

Oil on canvas, 26¾ × 35¹⁵⁄₁₆ in. (68 × 91.4 cm)
Signed and dated lower left: CHURCH 1854
Gift of William Wilson Corcoran, 69.16

Born in Hartford, Connecticut, in 1826, Frederic Edwin Church initially studied with two local artists. In 1844 his father arranged an apprenticeship for him with Thomas Cole, America's leading landscape painter. From the first, Church showed a remarkable talent for drawing and an inclination to paint in a crisp, tightly focused style. In 1845 he made his debut at the National Academy of Design in New York, where he showed throughout his career. In 1849, at twenty-three, he was elected to full membership in the National Academy, the youngest person ever so honored.

In the early 1850s Church received critical and popular success with a series of North American landscapes that included such works as *West Rock, New Haven* (1849, New Britain Museum of American Art, Conn.) and *New England Scenery* (1851, George Walter Vincent Smith Art Museum, Springfield, Mass.). Although he could have easily, and profitably, continued to produce similar works, in 1853 he decided to go to South America in search of new subject matter; it was a bold move. Few Americans were familiar with the tropics, and there was no certainty that paintings of such scenery would appeal. He was, however, powerfully inspired to undertake the project by the eloquent writings of the German naturalist Alexander von Humboldt. Of particular influence was the summary work of Humboldt's career, *Cosmos: Sketch of a Physical Description of the Universe*, in which Humboldt attempted to synthesize existing scientific knowledge about the world into a grand theoretical system. While formulating the ideas expressed in *Cosmos*, Humboldt had made extensive tours in South America, studying the region's extraordinary diversity of landscape environments. Humboldt felt that an understanding of the full range of nature could be achieved only by seeing such scenes. He called on painters to visit South America and create detailed depictions that could convey these wonders to a wide audience.[1] Church took up this challenge with such determination that, in a few years, he became known as "the very painter Humboldt so longs for in his writings."[2]

Church left New York for South America on 28 April 1853, traveling with his friend Cyrus W. Field. Church made numerous sketches in oil and in pencil, recording the landscapes they traversed before returning to New York, on 29 October.[3] Once back in his studio, Church used his studies to create four tropical paintings that were displayed at the National Academy of Design's annual exhibition in the spring of 1855; one of them was *Tamaca Palms*.[4]

Tamaca is a now obscure, but once common, name for *Acrocomia aculeata*, a species of palm native to tropical regions of the Americas, found from southern Mexico and the Caribbean south to Paraguay and northern Argentina. Church made a drawing of the tallest tree at the left in *Tamaca Palms* while traveling on the Magdalena River in Colombia, carefully recording its features (Fig. 1). He likely used the same sketch for the shorter palms, varying the arrangement of the fronds for each. He also sketched the distinctive boat in the foreground, a type of watercraft known as a *champan* or *bongo*. In the drawing (Cooper-Hewitt, National Design Museum), the figure at the front and the one on the roof are shown in the same positions as in the painting; Church also added an inscription describing the "fireplace in the bow."

Fig. 1. Frederic Edwin Church, *Botanical Sketch Showing Two Views of the Tamaca Palms*, probably May 1853. Graphite on gray paper, 11⅛ × 8⁷⁄₁₆ in. (28.2 × 21.5 cm). Cooper-Hewitt, National Design Museum, New York, NY, Gift of Louis P. Church, 1917-4-107

In *Tamaca Palms*, as in his other early South American works, Church depicted the rich diversity of the tropical world Humboldt had described in *Cosmos*. William Wilson Corcoran surely appreciated this, having formed a close friendship with Humboldt during his 1855 trip to Europe. In 1876, when Church's masterpiece, *The Heart of the Andes* (1859, The Metropolitan Museum of Art, New York), a much larger but essentially similar view of South American scenery, was sold at auction, Corcoran lobbied the museum's Committee on Works of Art to purchase it (to his disappointment, the bid authorized was not sufficient to secure it). *Tamaca Palms* also held another personal significance for Corcoran, having been first owned by the New York art collector Abraham M. Cozzens, who had helped him greatly during his early years of collecting.

Late in 1876 the Corcoran's curator William MacLeod observed that the sky in *Tamaca Palms* was becoming disfigured by "dingy" lines, and he wrote to Church seeking a remedy. Church replied that the painting was "suffering from the improper use of sugar of lead in the preparation of the canvas" and noted that it "only affects thinly painted parts of a picture."[5] Such vertical streaking is seen in many American paintings of the mid-nineteenth century, including works by Fitz Henry Lane and Martin Johnson Heade. In February 1877 the painting was sent to Church's studio in New York; it was returned to the Corcoran in early March. According to the dealer Samuel P. Avery, Church, "Besides going over the streaks

in the sky . . . [also] scumbled the mountains giving more atmosphere and altogether improving the picture."[6] MacLeod noted that the painting "was found in fine order, the sky repaired by being repainted & the mountains and middle-ground scumbled so as to show a charming hazy effect. It is like a new picture."[7]

The retouchings Church made to *Tamaca Palms* are no longer visible, nor is there any obvious streaking in the sky (there is some darkening in the valleys of the canvas threads, but it is not especially noticeable).[8] There is no earlier paint layer under the present sky, which indicates that it is the original Church painted in 1854; likewise, although mists are depicted in the lower slopes of the mountain, the "charming, hazy effect" described by MacLeod is not evident. When Church repainted the sky of *Niagara* (see entry) in 1886, he admitted that he would have allowed himself "more freedom" if the picture were not so well known through reproductive prints. That was not the case with *Tamaca Palms*, and Church may have felt free to change it. His painting style in the 1870s was quite different from what it had been in the 1850s, and in works such as

El Rio del Luz (1877, National Gallery of Art, Washington, D.C.), he created vaporous, diffuse atmospheres that suggest the "hazy effect" noted by MacLeod. Church must have done the repainting of *Tamaca Palms* on top of an existing varnish that was later removed (possibly in 1890, when Corcoran records note the painting was treated). The painting in its present state is perfectly consonant in style and handling with Church's other works of 1854.

F K

Emanuel Gottlieb Leutze (Schwäbisch-Gmünd, Baden-Württemberg, Germany, 1816–Washington, D.C., 1868)

Evening Party at Milton's, Consisting of Oliver Cromwell and Family, Algernon Sydney, Thurlow, Ireton, &c., 1854

Oil on canvas, 60¼ × 84 in. (153 × 213.5 cm)
Signed, inscribed, and dated lower right: E. Leutze. Dsdf. 1854.
Gift of William Wilson Corcoran, 69.32

The success of *Washington Crossing the Delaware* (1851, one version at The Metropolitan Museum of Art, New York) secured the reputation of Emanuel Leutze as America's premier history painter, generating dozens of commissions throughout the 1850s and 1860s. These include *Evening Party at Milton's*, one of several works in which Leutze addresses the English Civil War and the complicated, often violent, interplay of politics and religion in mid-seventeenth-century Britain.[1] Despite its impressive scale, on a five-by-seven-foot canvas, this is no grand scene of military triumph, belonging instead to a subcategory of history painting that illustrates minor anecdotes from the domestic lives of famous individuals.[2] By narrating history primarily through psychology and interpersonal drama, *Evening Party at Milton's* encourages viewers to associate these past events with contemporary political concerns.

Many Americans of Leutze's generation regarded the Puritan Revolution as an important prefatory chapter in the history of the United States, making it a popular subject among artists.[3] In the 1640s Oliver Cromwell and fellow supporters of a Parliamentary government (nicknamed the Roundheads) gradually wrestled military and political control of England away from King Charles I and his royalist allies (the Cavaliers). They publicly executed Charles for treason and created the short-lived Commonwealth of England (1649–60), governed first by Parliament, then principally by Cromwell as a military dictator with the title Lord Protector.

Widely read histories of England and biographies of Cromwell prepared Leutze's audiences to understand the context and cast of *Evening Party at Milton's*. Its specific inspiration may be the evocative concluding passage in Thomas Babington Macaulay's oft-reprinted "Milton" (1825), a reverential fantasy of encountering the great poet, best known as author of *Paradise Lost* (1667), in precisely this setting: "We can almost fancy that we are visiting him in his small lodging; that we see him sitting at the old organ . . . that we can catch the quick twinkle of his eyes, rolling in vain to find the day; that we are reading in the lines of his noble countenance the proud and mournful history of his glory and his affliction."[4] As Macaulay suggests, Milton's "affliction" is blindness, here figured by the deep shadow across the center of the painting that obscures all but his gracefully curving silhouette at the right.[5] Joining viewers in admiration and sympathy is Cromwell, seated in a high-backed chair and flanked by his family and his chief military and political assistants.[6] Milton, his Latin secretary, allegedly performed private organ recitals during which the Puritan leader, a vociferous opponent of all High Church pomp and liturgy, briefly set aside his legendary asceticism and took pleasure in the inspired music making.

This moment of Cromwell's indulgence is the fulcrum of *Evening Party at Milton's*, which transforms it from a simple anecdote of power paying homage to art into a sermon on tolerance and freedom of expression. The bodily comportment of the two protagonists visually registers this drama. Cromwell's stiff posture suggests the notorious inflexibility of his religious views, while his forceful, double-handed grasp on his sword mimics his iron grip on England as Lord Protector. With this authority, he enforced Puritan codes of morality and stripped churches of their art and ornamentation

(including organs). Milton is the foil for Cromwell's misdirected zeal, and his dynamic organ playing enacts his rejection of doctrinal rigidity in favor of creativity, liberty, and imagination. Similarly, Macaulay describes the poet as reconciling Puritan self-discipline with a pious appreciation for beauty: "In his character the noblest qualities of every party were combined in harmonious union."[7] Leutze invites viewers to compare the two figures, study Cromwell's face, and ponder whether the heart of "Old Ironsides" has truly softened under the influence of Milton's melodies.

Early commentators understood this theme: "It represents the Power of Music," wrote the reviewer for the *Crayon*, America's leading art magazine.[8] The following year, an essay entitled "The Mystery of Music" proclaimed, "In all time and to every heart [music] speaks one and the same language." Its author then lists ten remarkably disparate famous individuals from history, including Milton, Cromwell, and King Charles II, asserting that "all, while agreeing in no other point of belief, united to pay true, hearty homage to the science of music."[9]

In this way, Leutze's domestic anecdote resonates beyond Milton's parlor, proposing music and the arts as peacemakers for contemporary conflicts. Viewers might reimagine the lessons of the Puritans and Roundheads in terms of the growing animosity between North and South in the United States, then on the eve of its own civil war. Leutze lived in Düsseldorf, Germany, while creating this picture, and it may also concern strife in that region between the predominantly Catholic local population and the Protestant monarchy in Berlin.[10] The German-born painter identified closely with both countries, having immigrated to America as a young boy and later returning to study at the prestigious Düsseldorf Art Academy. He remained there through the failed 1848 movement for unification and reform, subsequently leading his German colleagues in founding an artists' club that deliberately mingled their professional and political goals. Named the Malkasten (Paintbox), this club strove to create a diverse but harmonious brotherhood of artists of all creeds and from all corners of the German states. It organized both exhibitions and social events, including sports, festivals, and concerts, thereby fostering an ideal community around the values expressed in *Evening Party at Milton's*.

William Wilson Corcoran evidently recognized the serious motives within this painting, despite its quiet, familial setting. He purchased it from the artist shortly after its completion, and within a year, *Evening Party at Milton's* had been exhibited in New York and Baltimore and praised on both sides of the Atlantic.[11] Like Milton's music, this painting has a higher motive than sheer aesthetic pleasure. It is a masterful conjunction of two themes prominent throughout Leutze's work: the relevance of the past to current events, and the potential of artists to be agents of positive social change.

CAM

Fredreric Edwin Church (Hartford, Conn., 1826–New York City, 1900)

Niagara, 1857

Oil on canvas, 40 × 90½ in. (106.5 × 229.9 cm)
Signed and dated lower right: F.E. Church. / 1857.
Museum Purchase, Gallery Fund, 76.15

Among all the scenic wonders of the New World, Niagara Falls was foremost in the minds of mid-nineteenth-century Americans. First visited by European explorers in the late seventeenth century, the cataracts had come to symbolize for many the power and vitality of their new nation. Citizens of the New World were eager to prove their equality to the Old World in all things, and Niagara was judged as good as or even better than anything Europe could offer in the way of spectacular scenery.

After Frederic Edwin Church successfully exhibited four tropical paintings at the National Academy of Design in 1854, he turned his attention to painting a large picture of South American scenery in which he broke new stylistic and compositional ground. *The Andes of Ecuador* (Fig. 1) was, by considerable measure, the largest work he had yet executed. Viewers were amazed at the vast panorama it presented; as one wrote, "Grandeur, isolation, serenity! Here there is room to breathe."[1] Church had once again managed to dazzle his audience, and in doing so, he had entered a new phase in his art. *The Andes of Ecuador* was his first full-scale masterpiece and the first to express what Alexander von Humboldt called "the feeling of unity and harmony of the Cosmos" (see *Tamaca Palms*).[2] Church's contemporaries recognized that the painting was indeed a dramatic breakthrough for the young painter, for he had "caught and conveyed a new feeling to mind. . . . His pictures speak their meaning, have an influence, excite feelings."[3] From this point on, his audience expected him to paint major pictures for public display at regular intervals, and for the next decade or so he would comply, producing an extraordinary sequence of masterful landscapes.

The first of that sequence was *Niagara*, the picture that made Church the most famous and admired painter in America. Unlike his earlier works, *Niagara* was exhibited neither at the National Academy nor at other venues. Instead, it was shown as a one-picture special exhibition at the commercial gallery Williams, Stevens & Williams in New York. The gallery purchased the painting and copyright from Church for $4,500, and visitors were charged twenty-five cents admission to see it. Church had realized, no doubt in part because of the success of *The Andes of Ecuador*, that he was capable of creating major works that could stand on their own and be best and most fully appreciated outside the crowded conditions of normal art exhibitions. He clearly knew, as well, that he stood to gain financially in the bargain, both from the outright sale of *Niagara* to the dealer and from the publicity that would accrue to him from the exhibition and from chromolithographs and engravings after the painting the dealer would arrange to issue. *Niagara* was thus Church's first attempt in the genre known as the "Great Picture," individual works (or multipart series) that were conceived for independent exhibition, usually with carefully managed publicity.[4]

Many other artists before Church had, of course, depicted the famous falls.[5] None, however, had ever been judged fully successful in capturing on canvas their true majesty, and many of Church's contemporaries thought it was impossible to do so. Church rose to the task. Just two years earlier, a critic viewing his *Tequendama Falls, near Bogotá, New Granada* (1855, Cincinnati Art Museum) had admonished, "He should not paint falling water—for he cannot," and

Church must have taken the challenge to heart.[6] His *Niagara* was greeted with rave reviews from press and public alike. As one "cultivated and charming" observer stated: "If the object of painting be to render faithfully, and yet poetically, what an artist's eye discerns, this is Niagara, *with the roar left out.*"[7]

Church, following his now well-rehearsed procedure, made numerous pencil sketches and oil studies when visiting the falls. His first trip was in March 1856, when there was still snow on the ground and ice in the river; although that encounter resulted in some of his most striking oil sketches of the falls (such as *Niagara from Goat Island, Winter*, Cooper-Hewitt, National Design Museum, New York), he never made a finished oil showing the scene in such conditions. He was back in July and then in September and October, when he was able to secure the studies he needed to begin planning the final composition, which depicts a view across Horseshoe Falls from the Canadian side. As David Huntington pointed out, no one drawing or oil sketch provides the precise view seen in the finished painting, which is a composite of details taken from various vantage points.[8] Two pencil and white gouache drawings now at the Cooper-Hewitt contain much of the visual information Church needed; one is a panoramic view from a point very similar to that of the completed painting, while the other is a more closely focused study of the falls, with particular attention paid to the white, foaming appearance of the water as it makes its descent.

Once back in his New York studio, Church began working out his ideas through more finished, detailed oil sketches. One sketch, presently in the Heinz collection, shows that at some point he considered an even more panoramic view, with the American falls also included (Fig. 2). A second, *Horseshoe Falls* (Fig. 3), eliminates the left half of the composition seen in the former and comes very close to the final arrangement of the 1857 painting. Notices in journals and newspapers in New York and Boston from December 1856 and January and February 1857 make it clear that Church allowed

Fig. 1. Frederic Edwin Church, *The Andes of Ecuador*, 1855. Oil on canvas, 48 × 75 in. (121.9 × 190.5 cm). Reynolda House Museum of American Art, Winston-Salem, North Carolina, Original purchase fund from the Mary Reynolds Babcock Foundation, Z. Smith Reynolds Foundation, ARCA Foundation, and Anne Cannon Forsyth, 1966.2.9

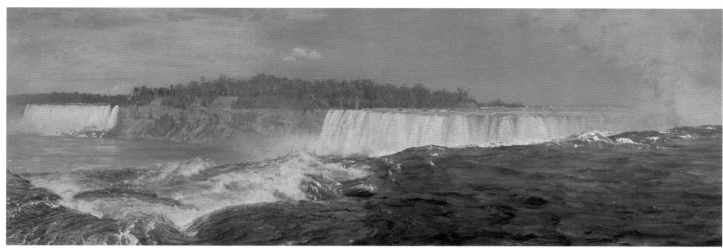

Fig. 2. Frederic Edwin Church, *Sketch of Niagara*, c. 1856. Oil on canvas, 12¾ × 35¼ in. (32.4 × 89.5 cm). Collection of Teresa Heinz

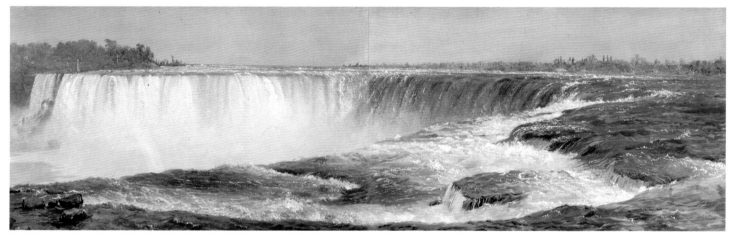

Fig. 3. Frederic Edwin Church, *Horseshoe Falls*, December 1856–January 1857. Oil on two pieces of paper, joined together, mounted on canvas, 11½ × 35⅝ in. (29.2 × 90.5 cm). Olana State Historic Site, New York State Office of Parks, Recreation and Historic Preservation, OL.1981.15

writers into his studio to see how he was progressing.[9] These reports served as excellent advance publicity for the future showing of the large canvas. A discussion of *Horseshoe Falls* (Fig. 3) appeared in the *Crayon* in February:

> Mr. CHURCH, as one of the results of his summer studies, exhibits a sketch of Niagara Falls, which more fully renders the "might and majesty" of this difficult subject than we ever remember to have seen these characteristics of it on canvas. The point of view is happily chosen, and its impressiveness seems to be produced by admirable drawing aided by a skillful subordination of accessories; the eye is not diverted, led away, as it were, from the soul of the scene by diffuse representation of surrounding features.[10]

In working out the ultimate composition, Church met several significant challenges. So great was his concern that he capture the exact color and appearance of the water, he reportedly worked on the large canvas only when "the sky was clear and the sun shining bright."[11] Remarkably, he was said to have completed it in less than two months.[12] Church knew that he could not take many liberties with the general look of Niagara, which was already well known to the public through printed and photographic illustrations. Yet, while he gave a view of the falls that was immediately recognizable, he enhanced the illusionism through certain pictorial devices. The painting shows a view that, in fact, could not be taken in by the human eye all at once: Church expanded the field of vision and adjusted the perspective so that both near and far sides of the falls come into sight. Rather than using a canvas with a traditional ratio of height to width such as two to three, he selected a format of one to two as better suited to evoke the great lateral expanse of the scene.[13] He also pushed the plane of the falls nearest the viewer downward (comparison with a photograph of the falls, Fig. 4, makes

Fig. 4. Niagara Falls, 1984. Photograph. Franklin Kelly

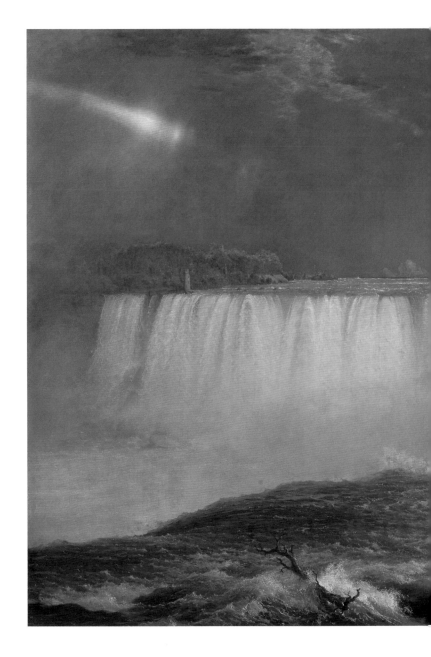

it clear how much he distorted actual reality), so that more of the far side could be brought into view to present a fuller image of the water's rush from top to bottom. Yet, in addition to its great compositional breadth and sweep, *Niagara* also contains remarkable detail. The water coursing over the rocks in the foreground—which serves as a kind of microcosm of the larger falls beyond—is meticulously delineated: Terrapin Tower, with a tiny figure on its balcony, is clearly visible in the distance at the far left, and farmhouses can be made out on the far shore.[14] And then there is the remarkable prismatic display of the rainbow arcing through the mist from the upper left corner to the bottom center. When he saw the painting in London in the summer of 1857, the famous English critic John Ruskin found this so convincing he believed it must be refraction of light from the gallery windows.[15]

Church's most radical innovation in depicting Niagara was to dispense with a foreground of any kind, as was noticed by viewers from the start. The result was a dramatic, even somewhat disorienting experience:

> The spectator stands looking directly upon the troubled waters, flowing at the very base line of the canvas; . . . the eye naturally travels with the current until it reaches the brink of the invisible abyss into which the water tumbles; the running along the edge of the great horse-shoe curve, towards the extreme right of the picture, the eye follows round the receding bend to Goat Island, at which point the sheet of water appears in full height.[16]

As this description suggests, the painting so immediately engages the viewer's attention and so skillfully leads the eye through the canvas that it breaks down the seemingly indestructible barrier between the work of art and the scene itself. Spectators could imagine they were actually present at the falls; all that was missing was indeed the roar.

Following its successful debut in New York, *Niagara* was shown in London during the summer of 1857; a second exhibition was

held in London in May 1858, and that was followed by stops in Glasgow, Manchester, and Liverpool. By the fall of 1858, *Niagara* was back in New York, where it appeared for a second time at Williams, Stevens & Williams before going on an extensive tour that included showings in Baltimore, Washington, D.C., Richmond, New Orleans, Boston, and Philadelphia. By 1861 Williams, Stevens & Williams had forfeited possession of the painting to Brown Brothers Bankers of New York; it was subsequently sold to John Taylor Johnston, who amassed one of the most important collections of American and European art in America during the 1860s and 1870s.[17] In 1867 Johnston lent it to the selection of American pictures displayed at the Exposition Universelle in Paris, where it was awarded a medal. Reportedly, when the French painter Jean-Léon Gérôme saw it, he pronounced it the beginning of a distinctly American school of painting.[18]

Given that William Wilson Corcoran actively (and unsuccessfully; see *Tamaca Palms*) lobbied the museum's Committee on Works of Art to acquire Church's *The Heart of the Andes* when it came up for public sale in 1876, it would be natural to assume he was instrumental in the institution's purchase, for $12,500, of *Niagara* from the sale of the Johnston collection later that same year. However, no correspondence survives suggesting this was the case, and there is no written record that he ever even offered his opinion on the painting.[19] Thus, it is ironic that the single American painting most closely identified with the Corcoran Gallery of Art's public identity

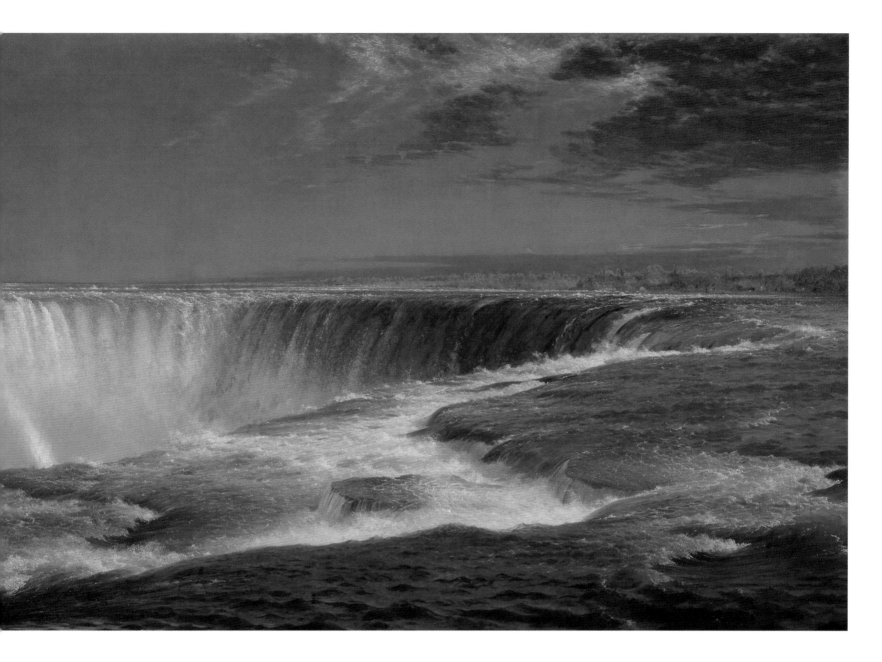

Fig. 5. Chromolithograph published by Charles Day and Son, London, 1862–63. Oil over chromolithograph, 17⅛ × 30⅜ in. (43.6 × 77.3 cm). Charles Risdon, after Frederic Edwin Church, *Under Niagara*, 1862. Olana State Historic Site, New York State Office of Parks, Recreation and Historic Preservation, OL.1980.1257

should be one with seemingly little direct connection with the founder himself.

Church created two other major canvases of the falls following the success of *Niagara*. The first was *Under Niagara Falls*, from late 1862, which is now unlocated but is known through a contemporary chromolithograph (Fig. 5). This four-by-six-foot picture was based on studies Church made in 1858 from the tourist boat *Maid of the Mist* and was reportedly painted in a single day.[20] Also in 1858 Church apparently thought about painting another view of the falls, this time from the American side.[21] It would not, however, be until 1867 that he undertook that work, *Niagara Falls, from the American Side* (National Gallery of Scotland, Edinburgh), the largest canvas he ever painted. Although both of these later paintings were generally well received, neither attained the fame of his earlier version. The 1857 *Niagara* and the 1859 *Heart of the Andes* remained unrivaled as Church's most famous paintings, both nationally and internationally.[22]

F K

John Frederick Kensett (Cheshire, Conn., 1816–New York City, 1872)

View on the Genesee near Mount Morris, 1857

Oil on canvas, 30 × 48¾ in. (76.2 × 123.7 cm)
Signed and dated lower left: JF. K. 57 (*J* and *F* in monogram)
Museum Purchase, Gallery Fund, 77.15

John F. Kensett painted *View on the Genesee near Mount Morris* in August 1857 while visiting the Genesee River valley in New York State with his friend and patron Robert Morrison Olyphant.[1] The painting shows a popular tourist's view from the Mount Morris Highbanks, also known as Squawkie Hill, near the town of Mount Morris (Fig. 1).[2] Below, the Genesee winds north toward its terminus in Lake Ontario, near Rochester; a number of landmarks pepper the surrounding valley. To the left, barely visible in the far distance, rise the spires of the village of Geneseo; on a hillside on the right bank is a square, white mansion, the Murray Estate, which was owned by Olyphant's sister Anna and which Kensett and Olyphant visited that summer.[3] The road at left appears on an 1858 wall map of Livingston County but is unnamed.[4]

Like many other Hudson River School artists, such as Thomas Cole, Kensett painted very specific views whose locales were often indicated in his titles.[5] The locations he selected, like the Genesee River valley, were almost always popular tourist sites.[6] Oliver Bell Bunce, the author of the 1874 illustrated travelogue *Picturesque America*, noted that the Genesee River was "not marked by any exceptional beauty or peculiar charm" in its lower course. But beginning with the falls at the town of Portage, twelve miles south of Mount Morris, the river carved out a chasm that made it "one of the most beautiful and picturesque of all our Eastern streams." He wrote,

> Beginning abruptly at a point not far above the Upper Fall, it increases in depth and wildness until the village of Mount Morris is reached, at which point the stream makes its exit from the rocky confines as abruptly as it entered them, and, as though to atone for the wildness of its early course, settles at once into a gentle and life-giving current, gliding through rich meadows and fertile lowlands, its way marked by a luxuriant growth of grass and woodland.[7]

Here, as he typically did, Kensett turns from the "depth and wildness" of the chasm to the south to face the peaceful, fertile valley that lies to the north. Kensett generally eschewed wild scenery in favor of quiet, pastoral views.[8] He famously painted the rocky pools below Niagara Falls rather than the falls themselves. He also avoided scenes of labor, populating his landscapes with tourists or people at rest.[9] On the river below, we see a packet boat taking passengers on a scenic voyage and a small party upstream near the shores bathing or sailing. Indeed, the artist himself preferred "soft beds and fine cigars" to the labors of hiking and frequently painted views close to his hotels rather than trekking great distances to sketch.[10]

Kensett's peaceful scenery is reflected in his painting style. The glowing sky takes up half of the canvas. It is articulated in deceptively thick, impasted strokes, which blend to create a glowing, crystalline effect when viewed from a distance of a few feet. The cliffs and banks of the far shore are less fully realized in thinner strokes and reveal sketchy underpainting, which may be the result of overcleaning in the past. The trees, shrubs, and rocks in the foreground are rendered in abundant detail. Known by contemporary critics as the master of rock painting, Kensett made works that appealed in particular to those nineteenth-century tourists interested in the fashionable study of geologic formations.[11] The artist articulates a wealth of information but retains the effect of large, simplified compositional masses of sky, riverbanks, and water by using a tight tonal range of brown, buff, and green.

View on the Genesee near Mount Morris is an example of Kensett's mature style. The artist began his career as an engraver and then studied painting for seven years in France, England, and Italy. His works bear the influence of the particularized landscapes of the English artist John Constable and of the smoothly modeled, glowing landscapes in works by the Venetian Renaissance masters and the eighteenth-century Italian artist Antonio Canaletto.[12] Kensett's

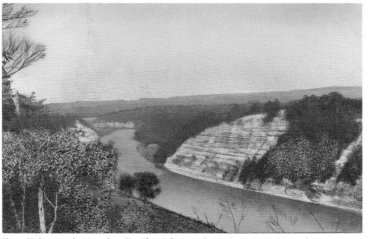

Fig. 1. Unknown photographer, *River from Whitmore, Crow's Nest*, c. 1910. Postcard. Collection of Thomas A. Breslin, Courtesy of Exploring Letchworth Park History, www.letchworthparkhistory.com

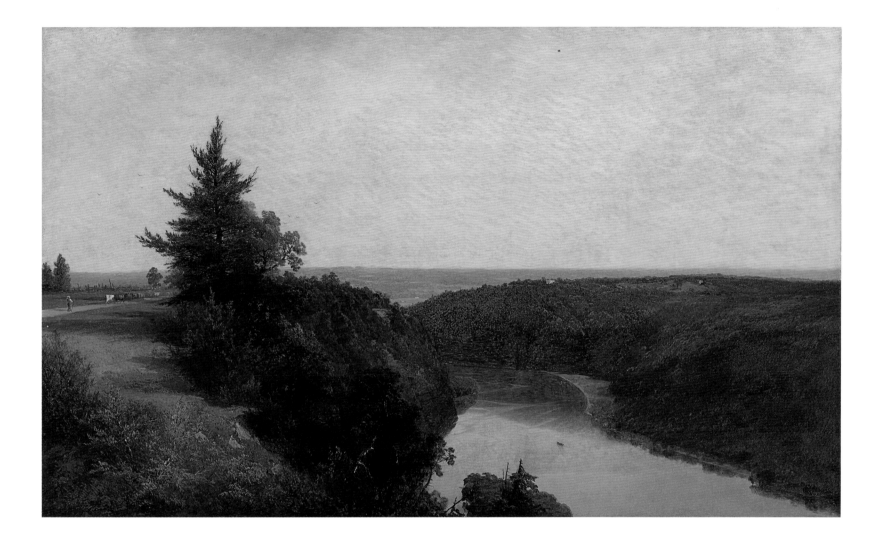

early landscapes were panoramic in scope, with clearly defined foreground, middle-ground, and background spaces and careful rendering of rocks and vegetation. By the mid-1850s he began painting scenes like *View on the Genesee near Mount Morris* and *Beacon Rock, Newport Harbor* (1857, National Gallery of Art, Washington, D.C.), in which incidental details are subdued and few in number and the composition is dominated by broad masses of sky, water, and rock.[13]

The painting's peaceful scenery and relatively small scale stand in sharp contrast to the large, dramatic works of Kensett's contemporaries, such as Albert Bierstadt's *Mount Corcoran* or Frederic Edwin Church's *Niagara* (see essays in this catalogue). The art historian Alan Wallach has argued that in this period, Kensett was developing an austere aesthetic that appealed to a class of monied elite collectors who wished to display superior taste through their embrace of the subtle over the bombastic.[14] Robert Morrison Olyphant was just such a person. A successful merchant from an old family, he was a confident collector who purchased at least sixteen of Kensett's works, including this painting, bought the year it was painted.[15] Rebecca Bedell also notes that Olyphant, the director of railroad and steamboat companies, had a vested interest in the tourism Kensett's paintings promoted. Moreover, his correspondence indicates that at the

time he purchased Kensett's painting, he was looking for a tract of land in the valley near his sister's estate on which to build his own country home.[16] Although Kensett's aesthetic and subject matter clearly appealed to him, Olyphant frames his preference for *View on the Genesee near Mount Morris* in terms at once practical and somewhat wistful. After their return from the Genesee River valley, Olyphant wrote that he had visited the Highbanks again and that Kensett's picture was "the spot itself viewed with inverted telescope." He continued: "I do sometimes envy your power of carrying away in your trunk such veritable resemblances of nature,—only imagine yourself having to trust, like me, to memory only."[17]

LS

Frank Blackwell Mayer (Baltimore, 1827–Annapolis, Md., 1899)

Leisure and Labor, 1858

Oil on canvas, 15⁹⁄₁₆ × 22¹³⁄₁₆ in. (39.6 × 58 cm)
Signed and dated lower right: F. B. Mayer / 1858.
Gift of William Wilson Corcoran, 69.65

Over his lengthy career, the Maryland artist Frank Blackwell Mayer established a local and regional reputation as a highly skilled painter of historical subjects and genre scenes.[1] Mayer also actively supported the arts in his home state, becoming a founding member of numerous professional organizations including the Maryland Art Association, the first recorded arts group in Baltimore.[2] The painter credited Alfred Jacob Miller (see *Election Scene at Catonsville, Baltimore County*), a family friend with whom he may have studied in the late 1840s, with inspiring his interest in the arts.[3] Mayer not only emulated two of Miller's preferred choices of subject (local genre and images of Indian life on the frontier) but also adopted the elder artist's practice of basing his paintings on sketches often made years earlier. In addition, *Leisure and Labor* contains scored guidelines (see the sign to the right of the standing figure), a technique Mayer may have learned from Miller (see the bricks in the house in *Election Scene*).[4]

Leisure and Labor is the culmination of Mayer's exploration of the blacksmith theme, which lasted more than a decade. A sketchbook dated 1845–50 (Maryland State Law Library, Annapolis) includes a number of detailed pen-and-ink drawings of the interior and exterior of a smithy. In addition, a collection of sketches dating from 1854 to 1857 (Baltimore Museum of Art) features studies for the painting's two central figures and the horse being shod as well as for humbler compositional details such as the open window at the back of the blacksmith's shop, the wooden toolbox on the ground in front of the smith, and the horsetail hanging from a nail at the far right.[5] Mayer also painted a watercolor version of *Leisure and Labor* (Fig. 1). This highly finished study was most likely made to show to potential purchasers. Subtle compositional changes in the finished oil strengthen the image's moral content. Mayer replaced the spotted dog crouching at the far right of the watercolor with a lithe greyhound standing erect at his master's side, enhancing the contrast between the laboring smith and his gentlemanly client. He also eliminated the sign on the roof of the blacksmith shop that identified its owner, rendering the scene more universal in resonance.

Some scholars have interpreted Mayer's painting—which was completed just three years before the Civil War began—as an expression of Northern antipathy toward the landed gentry of the South. The graceful hound evokes one of the idle pursuits of the Southern aristocracy during this period: the breeding of animals for sport and show.[6] During the war, the greyhound was used as one of the symbols of the Confederacy in anti-Southern political satires.[7] For the historians William Rasmussen and Robert S. Tilton, the canvas poses the question, "Should the nation be led by members of an aristocratic fellowship, modeled on the gentility of the South . . . or should the work-a-day lifestyle of the merchants and industrialists of the north become the norm?"[8] Yet both the prominent Baltimore merchant and art collector William T. Walters, who commissioned *Leisure and Labor* from Mayer in 1857, and William Wilson Corcoran, who purchased the work in 1859, were Southern sympathizers who had defended the right of states to secede from the Union.[9] During the Civil War, Walters, Corcoran, and Mayer—the last of whom was equivocal regarding the nation's sectional differences—all went to Paris.[10] The Mayer scholar Jean Jepson Page speculates that Mayer "resisted going to New York because his work had—with the beginning of the Civil War—been more or less 'blackballed,' due to his known ambivalence regarding North/South tensions."[11]

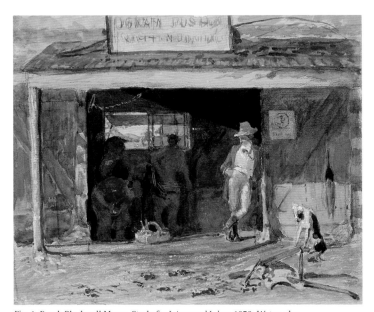

Fig. 1. Frank Blackwell Mayer, Study for *Leisure and Labor*, 1858. Watercolor and pencil on cream paper, 7½ × 9¹¹⁄₁₆ in. (19.1 × 24.4 cm). Corcoran Gallery of Art, Museum Purchase, 66.24

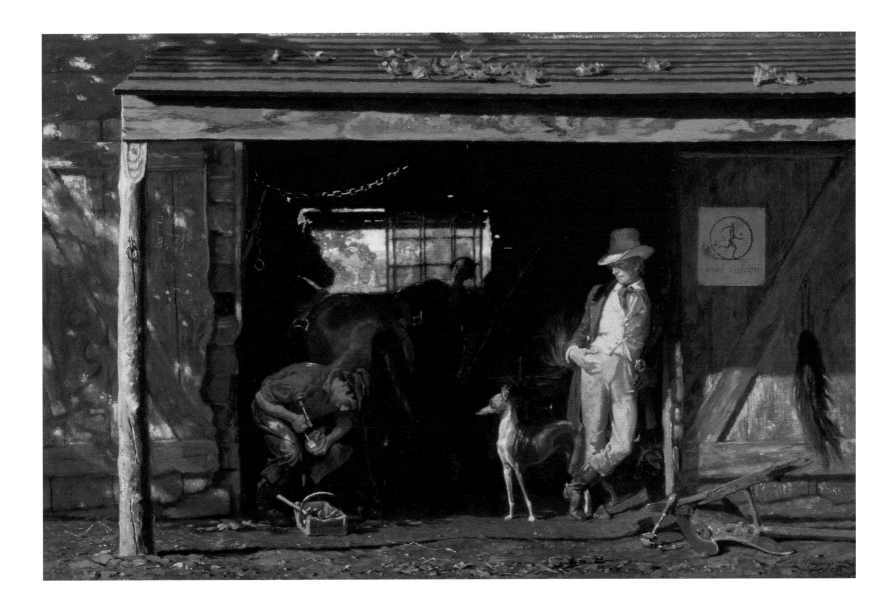

To be sure, the iconography and compositional structure of Mayer's bifurcated canvas—not to mention its title—strongly suggest that he intended the painting to serve as more than a simple record of a blacksmith in his shop. Mayer contrasts the rugged, industrious smith stooped over his work with the elegantly attired standing squire who leans against the open shop door, his hands in his pockets and one leg crossed casually in front of the other. The broken plow at his feet further implies a lack of productivity.[12] The poster to his right—which depicts a man running with scythe in hand who resembles the Grim Reaper above the misspelled text "Stop Theif!!"—counsels that time is precious and not to be wasted.

Mayer's discussion of the significance of his canvas *Burritt's Study* (location unknown), another painting of a blacksmith in his shop, painted in 1859, confirms that his interest in the theme included—but extended beyond—a desire to transcribe scenes from everyday life. Writing of this portrait of Elihu Burritt, who was known widely in mid-nineteenth-century America as "the learned blacksmith," Mayer explained: "The shop is as near like

his as memory could draw it . . . the bayonet he uses as a rake, the sword beaten into a grasshook, and the ploughshare in the fire, illustrate his fearce character, as the water-pitcher refers to his temperate principles. . . . He is chosen as the type of intellectual labor."[13] As James Boyles has documented, mid-nineteenth-century American artists regularly employed the figure of the blacksmith to represent self-sufficiency and productivity. The smithy had become, as Boyles explains, "the symbol for an entire array of mechanical trades, a synecdoche for the practical arts."[14]

Mayer is known to have been familiar with William Hogarth's famous 1747 moral series *Industry and Idleness*, which no doubt influenced the painter's thinking in composing *Leisure and Labor*.[15] As a kind of manual laborer himself, as well as a devoted chronicler of preindustrial American culture, Mayer made his masterfully executed painting as a thematic and stylistic assertion of the artist's skilled handicraft in an increasingly mechanized age.

EDS

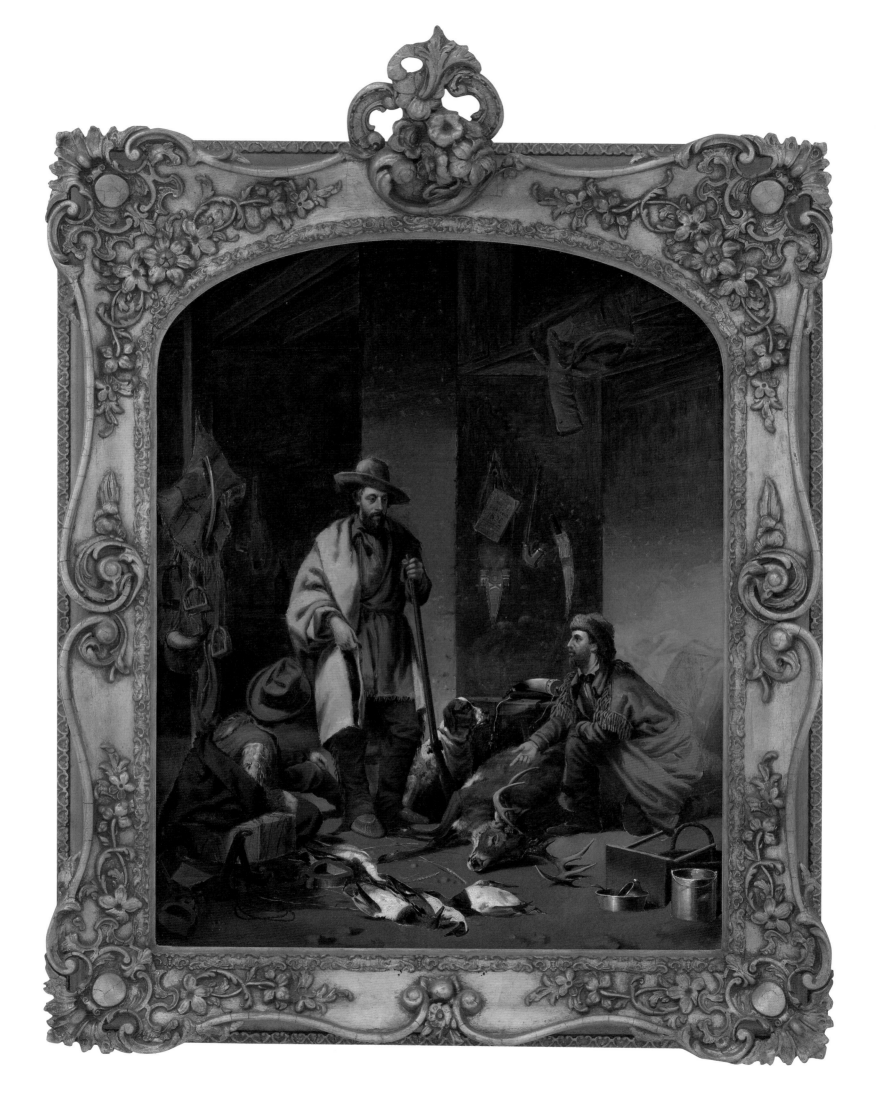

John Mix Stanley (Canandaigua, N.Y., 1814–Detroit, Mich., 1872)

The Trappers, 1858

Oil on canvas, 36 × 28¹⁵⁄₁₆ in. (91.5 × 73.5 cm)
Signed and dated lower left: J. M. Stanley. / 1858
Gift of William Wilson Corcoran, 69.5

Fig. 1. Charles Deas, *Long Jakes*, 1844. Oil on canvas, 30 × 25 in. (76.2 × 63.5 cm). Jointly owned by the Denver Art Museum and The Anschutz Collection. Purchased in memory of Bob Magness with funds from 1999 Collectors' Choice, Sharon Magness, Mr. & Mrs. William D. Hewit, Carl & Lisa Williams, Estelle Rae Wolf-Flowe Foundation and the T. Edward and Tullah Hanley Collection by exchange, 1998.241

Few artists of his generation traveled as widely or spent as much time in the West as did John Mix Stanley. He made his first visit in 1839, to Fort Snelling in Minnesota, and spent the next fifteen years crisscrossing the region from Texas to the Pacific Northwest, sketching its scenery and inhabitants. In 1854 he stopped traveling and devoted himself to painting and exhibiting his work and lobbying Congress to buy his collection of Indian portraits and genre scenes as part of a national gallery. Many of Stanley's works were destroyed by fire, first in 1865 at the Smithsonian Institution, and then in two studio fires. *The Trappers*, one of Stanley's few non-Indian genre scenes, is one of three hundred surviving works.[1]

Stanley painted *The Trappers* in his Washington, D.C., studio on Pennsylvania Avenue.[2] Although there is no way to ascertain this, the dirt floors, high ceiling, and loft storage of the building in which the men are shown may be based on the stables at Fort Snelling. The pintail and scaup ducks at their feet are native to the Great Lakes Region, and the otter skin tobacco pouch hanging on the wall behind the standing figure is also characteristic of bags made by the Dakota who lived near the fort. The painting depicts the men dressed in their characteristic mix of Native American buckskin hunting shirts, leggings, and moccasins and Anglo-American cloth shirts and trade blankets, gathered around a large white-tailed deer. In addition to artifacts he amassed during his travels, Stanley presumably used daguerreotypes as models for the clothing and accoutrements pictured, since he is known to have made plates during his trips.[3]

Stanley's convincing depiction of the objects in the painting might suggest that the work is both transcriptively and narratively accurate, but several inconsistencies point to an alternative, allegorical reading. First, if the men are trappers, it is strange that they are dividing a haul of game animals, rather than the beaver they customarily trapped. Second, the interior setting is unusual in Stanley's art and uncommon in scenes of trappers generally.[4] Trappers in the American fur trade roamed widely throughout the Rocky Mountain region and worked and lived outdoors or in small encampments for most of the year.

The interior setting and the game animals imply that the men are meant to be understood as hunters, not trappers. Fur trade companies strictly separated duties at their forts, according each class of employee different wages and privileges. Hunters did not trap but provided meat for the fort, and their status and pay were below those of trappers and traders.[5] In fact, although the painting was exhibited (most likely for the first time) in 1859 under the title *The Trappers*, it entered the gallery's collection in 1869 with the title *The Disputed Shot*.[6] According to an early account, the painting depicted "Three hunters having returned to their cabin from the chase, have just assorted their game . . . ; and while two of them are apparently disputing as to whose shot brought down the deer, they are watched with grave dignity by a noble settler in the background."[7] Visible beneath a thin layer of brown paint are an incompletely realized beaver trap (on the wall behind the standing figure) and an Indian trade blanket (to the right of the seated figure); these changes are evidence of Stanley's efforts to transform his painting from a scene of trappers to a narrative of a disputed shot.

Another idiosyncratic detail suggests the painting may allude to a more serious dispute: the sectional conflict gripping the country at the time. Pinned to a beam over the otter skin bag in the background is a pamphlet prominently bearing the date 1820, the year in which Congress passed the Missouri Compromise. The Missouri Compromise was an attempt to balance power in the United States between slave and free states by allowing Missouri to enter the union as a slave state and Maine as a free state. The bill also prohibited slavery above the thirty-sixth parallel. In 1854 it was repealed by the Kansas-Nebraska Act, and in 1857, one year before this work was completed, the Supreme Court declared the Missouri Compromise unconstitutional in the Dred Scott decision.[8] William Wilson Corcoran purchased *The Trappers* soon after its completion, perhaps because of its allusions to sectional conflict.[9] Although Corcoran's exact views on slavery are not known, his letters in the 1850s express his dismay over the divisiveness of the issue.[10] *The Trappers'* narrative of a disputed shot being peacefully resolved in a western setting may thus have appealed to Corcoran because it offered a hope-filled metaphor of the West as a place for compromise between contending regional factions.[11]

If the painting offered optimism, however, it was tinged with nostalgia. The fur trade had seen its heyday in 1837, and the way of life of the freewheeling trapper had largely disappeared in the years since, a fact much lamented in the art and literature of the period. More than one hundred books on the fur trade were published between 1840 and 1860, and Charles Deas's *Long Jakes* began a vogue for nostalgic paintings of rugged trappers dressed in buckskin and red hunting shirts (Fig. 1); the appearance and dress of Stanley's standing figure owes a debt to *Long Jakes*.[12] Indeed, *The Trappers* was housed in an arched frame, a display format associated elsewhere in the Corcoran's collection with retrospective and sentimental subjects (see Durand, *The Edge of the Forest* and Cropsey, *Tourn Mountain, Head Quarters of Washington*). In this context, *The Trappers* functioned less as a documentary work than as a depiction of a West whose promise of freedom—both as a way of life and as a legal condition—was passing away.

LS

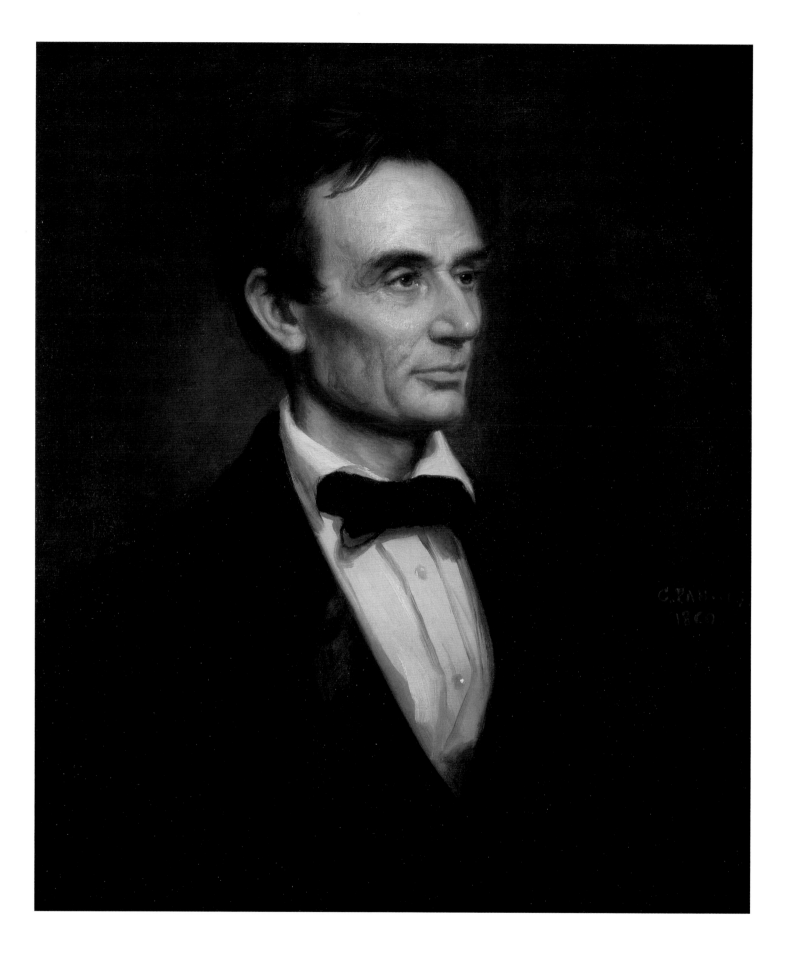

George Peter Alexander Healy (Boston, 1813–Chicago, 1894)

Abraham Lincoln, 1860

Oil on canvas, 30 × 25 in. (76 × 63.4 cm)
Signed and dated center right: G. P. A Healy. / 1860.
Museum Purchase, Gallery Fund, 79.19

Nearly thirty-five years after he painted his 1860 portrait of then president-elect Abraham Lincoln, George Peter Alexander Healy recalled a conversation he had with his sitter. Going through his correspondence as Healy worked, Lincoln burst into laughter over a letter, exclaiming:

> As a painter, Mr. Healy, you shall be a judge between this unknown correspondent and me. She complains of my ugliness. It is allowed to be ugly in this world, but not as ugly as I am. She wishes me to put on false whiskers to hide my horrible lantern jaws. Will you paint me with false whiskers? No? I thought not. I tell you what I shall do: give permission to this lover of the beautiful to set up a barber's shop at the White House![1]

The letter was undoubtedly the famous one from the schoolgirl Grace Bedell, who wrote Lincoln the month before he was elected and asked him to grow a beard, because "All the ladies like whiskers and they would tease their husbands to vote for you and then you would be president."[2] Healy's recollection thus highlights an important feature of the 1860 portrait. It is the last portrait painted of Lincoln without a beard. Lincoln began growing a beard sometime after he first sat for Healy, about 10 November, and must have had enough of a growth that the portrait by Jesse Atwood, completed later in the month, showed him with a beard (The Lilly Library, Indiana University, Bloomington).[3] By the time of Lincoln's inauguration in March 1861, he sported a full beard.[4]

Although beards were fashionable in antebellum America, and his party had long urged him to grow one to hide his angular features, Lincoln had resisted. In his reply to Bedell, he protested: "As to the whiskers, having never worn any, do you not think people would call it a piece of silly affectation if I were to begin it now?"[5] Indeed, Lincoln was accused by the press of just such an affectation after he grew the beard, and his choice became a source of partisan controversy.[6]

Healy's likeness of Lincoln lacks the iconic features that characterize the sitter's later identity—full beard, gaunt face, and pensive solemnity—but it is nevertheless a remarkably sensitive and recognizable likeness of the sixteenth president of the United States. The art collector and museum founder Duncan Phillips noted of the painting:

> There is hardly a hint of the craggy skull, the rugged features, the sunken line, the infinite sadness of the more familiar likenesses. . . . This is a happy Lincoln with a glint of the famous humor which was to mitigate his sorrows and his cares. . . . It is a disarmingly personal impression of the eyes of true greatness at a moment when they were lighted with the surprise, the honor and the vision of supreme opportunity.[7]

Although he is little known today, Healy was one of the nineteenth century's most successful portrait painters and one of the first American portraitists to achieve an international reputation. Born in Boston in 1813, he was entirely self-trained, and at the age of seventeen, he opened a portrait studio. After experiencing moderate success in Boston, Healy traveled to Europe to study and seek commissions. The portrait style he developed, evident in the Corcoran's painting of Lincoln, combines an emphasis on fine draftsmanship, naturalistic coloring, and a smoothly finished surface.[8] The young artist settled in London and then Paris, where his congenial personality and ability to produce recognizable yet "artistic" likenesses in a timely manner facilitated his assimilation into the sophisticated milieus of Europe.

As testament to Healy's European success, the artist received a commission from the French king Louis-Philippe to return to the United States and produce a series of portraits of distinguished American statesmen. For this commission, Healy painted several posthumous presidential portraits from originals by Gilbert Stuart, Jean Jacques Amans, and John Vanderlyn as well as portraits from life, such as those of John Quincy Adams, Andrew Jackson, John Tyler, and James K. Polk. The Revolution of 1848 and the subsequent abdication of the French king scuttled the completion of the series and directed Healy's attentions to more prosaic commissions.[9]

In 1860 the Chicago businessman and philanthropist Thomas B. Bryan purchased the original series of portraits from Healy for his gallery—Bryan Music Hall[10]—and commissioned additional portraits to update this collection, including one of the newly elected president. Four days after Lincoln's election, Healy was dispatched to Springfield, Illinois, with a letter of introduction. "I have commissioned him [Healy]," Bryan wrote to Lincoln, "to stop at Springfield and solicit of you the kindness to give him two or three sittings that he may add to my National Gallery the portrait of the President-elect."[11] The completed portrait was taken to Chicago, where a notice in the *Tribune* indicated that it was available for viewing at Healy's studio on Lake Avenue.[12]

William Wilson Corcoran purchased the Healy series of presidential portraits from Bryan in 1879 for the Corcoran Gallery of Art. "This interesting and valuable series of portraits of our Presidents," wrote the curator William MacLeod, "shows the determination of Mr. Corcoran and the trustees to make national portraiture a strong point in the gallery."[13] Changes in public taste during the first decades of the twentieth century, however, precipitated the removal of the Healy presidential portraits from the gallery. In 1926 the Lincoln portrait was deemed a copy and lent to the Abraham Lincoln School for African American children in southeast Washington, D.C. In 1943 the portrait was extensively researched and cleaned. The cleaning revealed an inscription with the artist's name and date of execution. The painting subsequently served as the model for a postage stamp commemorating the sesquicentennial of the president's birth.[14] Later it hung at the White House with a second, more famous, portrait of the president by Healy painted just before Lincoln's assassination in 1864, showing him with the iconic beard.[15]

RM

Alfred Jacob Miller (Baltimore, 1810–Baltimore, 1874)

Election Scene, Catonsville, Baltimore County, c. 1860

Oil on academy board, 11⁵⁄₁₆ × 15½ in. (28.7 × 39.4 cm)
Signed lower right: AJM (in monogram)
Gift of Mr. and Mrs. Lansdell K. Christie, 60.3

Alfred Jacob Miller is known for his images of the American West, specifically of the Rocky Mountain fur trade and its participants. Yet the artist spent most of his lengthy career in his native Baltimore, where, in addition to western scenes, he painted portraits, landscapes, and religious pictures. He also painted a small number of local genre scenes, of which *Election Scene, Catonsville, Baltimore County* is one of the rare surviving examples.[1]

Miller was the son of a successful grocer and tavern keeper. His early training included instruction from the Philadelphia portraitist Thomas Sully in 1831–32 as well as a study tour of France and Italy in 1833–34. In 1837 Miller met Captain William Drummond Stewart, a Scottish adventurer who invited the artist to accompany him to the Rocky Mountains and paint scenes of his adventures. Stewart and Miller's party traveled as far as the Green River in present-day Wyoming with a caravan of Saint Louis fur traders and then made a hunting and fishing expedition into the Wind River Mountains before returning east that fall. Miller exhibited some of his western paintings at New York's Apollo Gallery in 1839 before joining his patron in Scotland in 1840.

Once back in the Baltimore area in 1842, Miller purchased a farm north of Catonsville, about five miles west of the city. His sketchbooks include many drawings made in the area, including Catonsville.[2] At the time, Catonsville consisted of a small strip of shops and taverns along Frederick Turnpike, the main toll road into Baltimore.[3] It was the location of the polling place for Maryland's first election district during most of the mid-nineteenth century and would have been the place where Miller himself voted.[4] As indicated by its title, *Election Scene, Catonsville, Baltimore County* represents voting on election day.[5] The two men in the foreground are engrossed in conversation, and the man on horseback to the left

reads the newspaper aloud, activities that suggest study and debate in preparation for voting. The lively hand gestures of the two men who beckon toward the building in the distance and a third at the left who points his riding crop all direct attention toward the polling station, the site of the painting's narrative culmination.

The building pictured in the background is probably one of two locations in Catonsville. It could be Feelemeyers post office and grocery on Frederick Turnpike, which was advertised in the late nineteenth century as Catonsville's polling place.[6] It could also be Castle Thunder (Fig. 1), a two-story, brick-and-stucco structure with stone quoining and a porch, which early descriptions say was either painted yellow or made of yellow-colored bricks. The building in Miller's painting resembles this description and even includes thin, ruled lines for bricks that a technical examination indicates were inscribed over the paint composing the house.[7] Castle Thunder, which stood at the intersection of the Frederick Turnpike and Beaumont Avenue until it was demolished in 1907, was likely operated as an inn or tavern in the early nineteenth century, making it a good candidate for a polling station.[8] This would explain what appears to be a large sign erected in front of the porch in Miller's painting.

Miller's work is not dated, but scholars have assumed it is the *Election Scene* Miller exhibited in May 1861 at the Pennsylvania Academy of the Fine Arts.[9] Historians have therefore supposed that *Election Scene, Catonsville, Baltimore County* depicts the 1860 contest in which Abraham Lincoln was elected.[10] However, Miller first conceived the scene in a pencil-and-wash drawing inscribed "Election Scene at Catonsville 1845" (Fig. 2). Despite its inscribed date, Miller probably made the drawing sometime in the 1850s.[11] This discrepancy can be explained by the fact that the date Miller wrote on his sketches did not always refer to the year in which he painted the

Fig. 1. Unknown photographer, Castle Thunder, c. 1907. Archival photograph. Public Library, Catonsville, Maryland

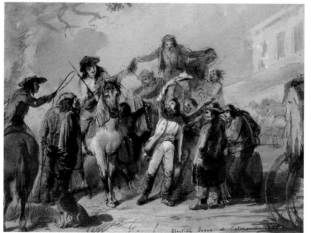

Fig. 2. Alfred Jacob Miller, *Election Scene at Catonsville, Maryland*, 1845. Graphite, brush, and wash on brown paper, heightened with white, 8³⁄₁₆ × 10¹³⁄₁₆ in. (20.8 × 27.5 cm). Museum of Fine Arts, Boston, Gift of Maxim Karolik for the M. and M. Karolik Collection of American Watercolors and Drawings, 1800–1875, 51.2537

scene but instead to the year in which the depicted scene took place. Miller frequently sketched nostalgic scenes, such as *Recollections—Milk Man 1825* (L. Vernon Miller Collection, Baltimore), a mature sketch that, if done in 1825, would have been executed by a fifteen-year-old. Miller's attention to details of costume in the watercolor *Election Scene at Catonsville, Maryland* and his loose handling of ink line and wash are consistent with his works from the late 1850s.[12] His choice to depict an earlier election may have been prompted by one of two events: the creation in January 1845 of the United States' first uniform election day or by a pivotal Maryland state election that year. In that contest, John Pendleton Kennedy, a prominent and well-connected Baltimorean who was known by many in Miller's social circle if not by the artist himself, was elected to the State House of Delegates.[13]

Miller's decision to return to the election subject in an oil and, more important, to exhibit the painting in Philadelphia in 1861 is significant. Although Maryland joined the Union (Miller himself supported the Union and was very likely a Whig), many in Baltimore privately sided with the Confederacy. In April 1861 a mob of Southern sympathizers attacked a regiment of Union soldiers moving through Baltimore, prompting President Lincoln to deploy Union troops to the city for the duration of the war. More crucially, sectional strife compromised fair elections from 1860 onward. Historians have

supposed that the presence of Union troops at polling places meant that "[i]n no election throughout the [Civil War] did all the people in Maryland voice their true sentiments."[14] In light of Baltimore's history of civil unrest and compromised elections, it is significant that Miller's painting shows an election scene devoid of a military presence or apparent strife or corruption. One figure leans on a barrel (which could contain liquor), but there is otherwise no overt evidence, as there is in the works of George Caleb Bingham, of drinking, coercion, or ballot stuffing. In fact, Miller's portrayal of discussion and debate in the foreground undertaken by a cross section of class and ethnic types emphasizes the free decision making of election day. His inclusion in the oil version of a small group of African American spectators standing apart from the group gathering outside the polling place provides a subtle allusion to the issues at stake. His painting presents a rosy or, perhaps in the context of the sketch, nostalgic view of politics in Maryland. Miller may have intended the painting to counter Baltimore's growing national reputation as a mob town and to hark back to a more peaceful time in Maryland history, when elections were less fraught.

LS

John La Farge (New York City, 1835–Newport, R.I., 1910)

Flowers on a Window Ledge, c. 1861

Oil on canvas, 24 × 20 in. (61 × 50.8 cm)
Signed lower center: La Farge
Museum Purchase, Anna E. Clark Fund, 49.1

Flowers on a Window Ledge is one of the floral still lifes that John La Farge began in the late spring or early summer of 1861, just two years after he took up painting.[1] The young artist had begun his training in Newport, Rhode Island, under the tutelage of William Morris Hunt, but he quickly mastered all that Hunt offered him, and their interests diverged enough that La Farge decided to design his own course of study.[2] To learn how to paint objects in varying lights and at different angles, he set himself the task of painting scenes of happenstance—flowers, bowls, curtains, and the like as positioned by the domestic workers in his household.[3] Although he was influenced by the writings of the influential British art critic John Ruskin, his careful nature studies did not aim, strictly speaking, at mimesis.[4] It is often impossible, for instance, to identify with exactitude the genus or species of flower he paints. Instead, La Farge was interested in capturing the ephemeral qualities of a flower's color at its peak of bloom or the minute differences in effect between indoor and outdoor light as it hits a white curtain.[5] La Farge recalled that Hunt told him, "it was useless to carry the refinement of tone and color to the extent which I aimed at in my studies . . . there would be not one in a hundred or five hundred artists capable of appreciating such differences of accuracy—their eyes and their training would not be sufficient."[6]

The subtlety Hunt noted in La Farge's early still-life compositions obscures their originality. *Flowers on a Window Ledge* was painted just four years after Severin Roesen's *Still Life, Flowers and Fruit*, also in the Corcoran's collections, yet La Farge's spare, loosely brushed, casually arranged canvas seems to hail from a different era than Roesen's arrangement, which was steeped in the Dutch Baroque still-life tradition of opulent, staged arrangements, smooth surfaces, and crisply realized contours.[7] La Farge, a modern Victorian, was very interested in the science of optics and color theory as outlined in the work of the nineteenth-century French chemist Michel Eugène Chevreul.[8] He recognized that conventional methods for rendering shadows or contours in dark to light tones did not necessarily replicate the way objects looked in nature, nor did they allow for the realization of different qualities of light produced by season, weather, time of day, and location. La Farge endeavored to show the effects of sunlight reflecting off the curtain in *Flowers on a Window Ledge* by blending peach, creamy white, and a light, green-tinged gray. A spot of bright light hitting the ledge just under the bowl takes on the petal pink hue of the rose above. The fabric of the curtain is distinguished from the window ledge and the background sky not by outline or color—all three are the same shade of grayish white—but by the direction or texture of brushwork or the thickness of paint application. This near-monochromatic coloring varied by brushwork boldly anticipated modernist art styles such as Post-Impressionism but looked quite odd to the Victorian eye. One critic, otherwise sympathetic to La Farge's aims, complained that "the window curtains . . . are too heavy an accompaniment, and degenerate into a disproportionate mass of whiteness."[9]

La Farge's experimentations with light and color suggest a preoccupation with formal concerns, but *Flowers on a Window Ledge* may also express his personal, romantic sentiments. Critics at the time

perceived a "tender delicacy" in La Farge's early flower paintings, which were said to be "touched with . . . exquisite feeling" and painted "with an indescribable tenderness."[10] James Jackson Jarves wrote that a La Farge flower "has no botanic talk or display of dry learning, but is burning with love, beauty, and sympathy." "Their language is of the heart," Jarves continued, "and they talk to us of human love."[11] This perceptible sense of romance in *Flowers on a Window Ledge* may have been an expression of La Farge's feelings for his new bride, Margaret Mason Perry, whom he married in October 1860, less than a year before embarking on his floral still lifes.[12] Some scholars have similarly suggested the artist's painting of a floral wreath, *Agathon to Erosanthe*, painted in 1861 (private collection), represents a Greek marriage offering and may have been inspired by the artist's own nuptials.[13] *Flowers on a Window Ledge* was painted from the window of Hessian House, in Middletown, Rhode Island, an inn where he and Margaret stayed in the early years of their marriage.[14] La Farge himself suggestively linked flowers and his desire for Margaret in a letter written during a separation during their courtship: "It seems to me often at night as I sink to sleep that I wander about with you in a country all green & soft & full of flowers."[15]

La Farge's simple, earnestly painted subject evokes love and marriage in several ways. The preponderance of white, particularly the thick folds of white curtain fabric, suggests a bridal gown; the pale pink roses and cherry blossoms and the ruby red poppies, a bouquet; and the domestic interior, the domesticity of marriage. Finally, La Farge's close attention to the flower results in an intimacy with his subject that was noted by the artist and fellow flower painter Maria Oakey Dewing: "One feels that all flowers yielded their most intimate beauty and expression, told a secret to this wizard hidden from every other painter."[16]

The new and original vision La Farge captured in *Flowers on a Window Ledge* ultimately proved fleeting. The artist cut short his still-life experiments in 1866 after a bout of serious illness (lead poisoning brought on by handling artist's materials) and financial stress. When he resumed work, his art making took a more conservative turn as he took up mural painting and decorative stained glass.[17] His radical vision seems to have vanished hand in hand with his youthful, romantic attachment to Margaret. His wife later recalled a day in 1863 when she first realized La Farge's passion for art had eclipsed his passion for her. He had just left her and their new baby on Long Island for his studio in New York: "I knew then that [he] no longer had the same complete affection for me. I knew there was no more sense in weeping. He was going to lead his own life, and I said to myself, this will be my life from henceforth; I must face it and do the best that I can."[18]

LS

James McNeill Whistler (Lowell, Mass., 1834–London, 1903)

Battersea Reach, c. 1863

Oil on canvas, 20 × 30 1/16 in. (50.8 × 76.3 cm)
Bequest of James Parmelee, 41.30

Writing in 1867, James McNeill Whistler characterized his early years in London as a time "when I threw everything down pell-mell on the canvas—knowing that instinct and fine color would always bring me through in the end." He complained especially of the "damned Realism" he had earlier learned in Paris and its notion that "all [a painter] had to do was to open his eyes and paint what was there in front of him!" He characterized his early paintings, including "the Thames pictures," as "canvases produced by a nobody puffed up with pride at showing off his splendid gifts."[1] The Corcoran's *Battersea Reach*, which indeed represents what Whistler would have seen from the window of his London home near Battersea Bridge were he to paint what appeared "in front of him," must number prominently among these pell-mell works.[2]

Everything about *Battersea Reach* conveys quotidian modernity, quickly observed and rapidly conveyed to canvas: moored barges (part of the Greaves boat business) are, barring their particolored sterns, little more than parallel brown strokes; pedestrians and loiterers become vivid with the merest caricature-accurate touch.[3] Many of the pedestrians and the brown and red sails of the freight-carrying barges are so thinly laid in that the architectural forms beneath them remain readily visible. Battersea Reach, across the Thames from Whistler's comfortable Chelsea home, flaunts its industrial architecture (turpentine factories, lumberyards, and sawmills)[4] and links to modern transportation (one of two steamers in the picture docks at a newly developed steamboat pier).[5] Whistler's viewpoint and cropping, with parallels in photography as well as in Japanese and advanced French art, convey a sensation of casual speed. His accentuation of the painting process

itself—all those bold, obvious brushstrokes—prompted the owner of the picture in 1892 to write of it, mistakenly, as "unfinished."[6]

Whistler balanced his modern iconography and technique by setting the whole scene aglow in early evening light. This effulgence belies those commentaries of the 1860s that emphasized the Thames's "sad banks" and "sombre and funereal appearance."[7] Instead, the distant cityscape, for all its speed of execution, resolves—especially when seen from a distance—into an atmospheric space, while the seemingly random brushstrokes in the foreground transmute themselves into a river's surface reflecting the sky while revealing hidden currents. As the catalogue of its earliest recorded exhibition noted, the scene has "subtle arrangements and introductions of color, which may not attract attention at once. . . . [T]here is far more to be seen here than can be seen immediately."[8]

This early published response to the picture postdates its creation by almost fifty years. Whistler made the painting not for public view but, apparently, as an airy complement to *The Last of Old Westminster* (Fig. 1), shown earlier in both Paris and London. The first owner of both pictures was George John Cavafy (1805–1891), a Turkish Greek merchant and Whistler's banker, who bought them in the summer of 1863.[9] Once the two Thames pictures entered the Cavafy collection, they stayed out of public view for the next three decades.[10] This changed only in 1892, after Cavafy's son and heir decided to sell them.

Whistler, working with Cavafy fils by letter and telegram from Paris, soon had two American patrons interested in the paintings: the collector John Chandler Bancroft and the dealer Edward Guthrie Kennedy.[11] Whistler's self-interest settled the deal, amid a flurry of correspondence, in favor of Kennedy.[12] In preparation for the

Fig. 1. James McNeill Whistler, *The Last of Old Westminster*, 1862. Oil on canvas, 24 × 30¾ in. (60.96 × 78.1 cm). Museum of Fine Arts, Boston, A. Shuman Collection, 39.44

paintings' travel to America, Whistler arranged for them to be cleaned, varnished, and reframed, prompting him to write that *Battersea Reach* was "painted as well as I remember, in one go."[13] He elaborated to the restorer:

> The Battersea was very simply painted—long ago—one evening from my window—I dare say the paint itself is far from thick in its rapid laying on—and perhaps the canvas is in places but slightly covered. Also doubtless thin places may by this time have become filled with London filth brown and not unlike what you might have supposed was a *ground prepared*—Clean the picture *very* tenderly because of these very places—and when varnished it will be all that I wish.[14]

Apparently it was so, for in August he wrote from Paris to his sister-in-law of "the little evening on the Battersea Reach—a most gorgeous bit of colour—greatly admired here."[15]

In February 1893 Kennedy wrote to Whistler: "I think I can sell the 'Thames at Chelsea' if I can get a line from you as to when it was painted &c. You are aware that it is not signed, so if you will write a few lines to the effect that you painted it in 1860 or whatever the year may be, no doubt I can dispose of it. . . . Will you kindly send me the required line as to the picture by return mail?"[16] Six months later Whistler responded:

> The picture called "Battersea Reach" was painted by me, I cannot remember exactly in what year, but when I was living in Lindsey Row, Chelsea. It was a view of the opposite bank of the river, from out of my window, on a brilliant autumn evening—and the painting is a favorite of mine.[17]

In the twentieth century, although the painting has appeared in important Whistler exhibitions, it remains underrepresented in the Whistler literature.[18] This is in part because of its transitional nature: within a year of finishing it Whistler began painting the Thames as a misty, foggy wonderland—a theme that evolved into the Nocturnes of the 1870s. The bright colors, urban subject, and overt paint handling of *Battersea Reach* mark it, in spite of its London subject, as among the last and most vivid of Whistler's "damned" French Realist canvases.

MS

View of Marshfield, c. 1866–76

Oil on canvas, 15¼ × 30¼ in. (38.4 × 76.8 cm)
Signed lower right: M J. Heade
Museum Purchase, 1981.61

While many of his Hudson River School colleagues were painting grand, well-known American vistas such as Lake George, Niagara Falls, and the Hudson River valley, Martin Johnson Heade turned to the subdued, anonymous marshlands of the eastern seaboard. Beginning about 1859 and continuing through much of the rest of his life, he studied these flat, seemingly undistinguished terrains, painting more than one hundred views of them in all, first in Massachusetts, Rhode Island, and Connecticut, and then in New Jersey and Florida.[1] If some of his contemporaries depicted marshes as a backdrop for hunting, sporting, or haying scenes, Heade was the first to render them for their own sake.[2] The subject, which he painted more than any other, was popular with his patrons and may be considered uniquely his own.

Heade was largely self-taught; he received minimal training in the mid-1830s, when he studied with the naïve painter Edward Hicks and possibly with that artist's cousin Thomas Hicks, near Heade's native Lumberville, Pennsylvania. Heade produced conventional portraits before taking up landscapes in the mid-1850s, traveling extensively in search of subjects throughout New England and to Europe (1840–41, 1848, and 1865) and South America (1863, 1866, and 1870). Once in his studio—the location of which changed frequently between New York, Boston, and Providence—he painted landscapes, seascapes, and views of salt marshes as well as hummingbirds and orchids in their native South American settings. His mature career is characterized by the recurrent and prolific treatment of these themes, along with a group of chilling thunderstorm views and cut-flower still lifes.[3]

Heade painted salt marshes, including the Corcoran's undated view, during his years of greatest creativity, the late 1860s and early 1870s.[4] The marsh-filled Massachusetts coastline was one of the artist's favorite destinations during this time. Although it is difficult to identify the locales of these scenes, he made several oils of Marshfield, a town about twenty-nine miles southeast of Boston, near the confluence of Cape Cod Bay and Massachusetts Bay.[5] Home to three rivers—the North, the South, and the Green Harbor—the town is named for its many salt marshes. The Corcoran's canvas most likely depicts the Green Harbor section, in eastern Marshfield. The rocky point on which a house sits, at the left of the composition, appears to be Blue Fish Rock, located across the mouth of the Green Harbor River.[6] This detail, along with the painting's composition and emphatic horizontality—it is more than twice as wide as it is high—derives from the artist's double-sheet preparatory sketch inscribed "E. Marshfield" in the collection of the Museum of Fine Arts, Boston (Fig. 1).[7] However, in the finished painting, Heade added the haystacks and eliminated the craggy tree in the right middle ground.

Like most of Heade's wetlands scenes, the Corcoran's picture is characterized by meticulous, nearly invisible brushwork and a composition organized in rhythmic planes. From left to right, the viewer's eye passes over rocks, scrub, and grass to the flat, lush expanse, on which shadows from passing clouds contrast with glowing areas of bright green, illuminated by the brilliant if unseen sun. Cut by a narrow, winding river, the marsh opens to a sliver of shore that meets the rolling tide of Green Harbor. The foremost haystack and its six successors lead the eye out to the horizon, where sailboats are suggested by slight dashes of paint that vary from bright to pale, the color dependent on the cloud-dotted sky above. The gundalow (flat-bottomed boat) and the small pile of hay to its right indicate the recent activity of a farmer, who would have rowed to his marshland at high tide to build, inspect, or repair his haystacks. These activities usually occurred in late August or early September, when bundles of harvested hay were stacked to dry on platforms, or

Fig. 1. Martin Johnson Heade, *East Marshfield, Massachusetts*, c. 1858–76. Graphite on paper, 3⁷⁄₁₆ × 11⁵⁄₁₆ in. (8.7 × 28.8 cm) (sheet). Museum of Fine Arts, Boston, Gift of Maxim Karolik for the M. and M. Karolik Collection of American Watercolors and Drawings, 1800–1875, 60.1015

staddles—composed of large, raised, stabilizing stakes—like the one visible at the bottom left of the central haystack.[8] In late winter, farmers hauled the carefully packed hay away by boat or over ice to use as fodder or straw.

Although Heade depicted a salt marsh, the true subject of *View of Marshfield* is the passage of time. This can be seen in two distinct but related ways: by the vignettes of seasonal human activity—haystacks and grazing cows, working boats and sailing vessels—and by the artist's capture of the ever-shifting effects of light and shadow through the humid atmosphere over the watery, fertile grasses, rendered in saturated greens of bright and dark tones. Heade's inscription on the verso of his preparatory sketch evidences his interest in how the changing times of day affect the scene's hues: "At early twilight there is very little difference between sky and water—water grass darkens gradually . . . Twilight—moon / waves very light near shore and very dark outside. Water darker than sky. Dark gray sand from sea weed."[9]

Taken as a group, this painting and Heade's other tranquil, almost mesmerizing marsh vistas may be seen as vehicles for his study of the effects of variable light and weather conditions that characterize East Coast wetlands, where a few minutes' wait could produce an entirely new scene for the artist to study.[10] The resulting evocation of an intense connection between viewer and nature and the strong horizontal format of paintings like *View of Marshfield* characterize a significant strain of American landscape painting in the third quarter of the nineteenth century that has been called "luminism."[11] However, the paintings may also be seen, more generally, as visual representations of the idea of an immanent spirituality within nature that had been written about throughout the century, both in this country and abroad, and found its most heightened expression in the Transcendentalists of New England. Heade's marsh scenes such as the Corcoran's seem to embody Ralph Waldo Emerson's poetic words: "Nature is a mutable cloud, which is always and never the same."[12]

SC

The Edge of the Forest, 1868–71

Oil on canvas, 78¹⁄₁₆ × 63 in. (198.3 × 160 cm)
Signed and dated lower right: A B Durand / 1871
Museum Purchase, Gallery Fund, 74.7

In 1894 John Durand wrote that his father's painting *The Edge of the Forest* was one that "sum[med] up the labor of his life."[1] Rendered in Asher B. Durand's signature vertical format, the painting depicts a peaceful, wooded landscape with a stream in the foreground.[2] From the stream's bank, the space recedes quickly through the edge of a carefully realized forest in the middle ground to a distant lake bordered by mountains shrouded in delicate, pink-tinted clouds. The brilliant green foliage and pastel sky prompted the Corcoran's first curator, William MacLeod, to observe that the painting's "coloring is the verdure of early summer."[3] In its marvelously detailed foreground, soft light, and meditative mood, the painting can be said to represent the culmination of Durand's career. Durand started the painting at the age of seventy-two, when he began to close his Manhattan studio of twenty-five years and move back to his boyhood home in New Jersey; he put the finishing touches on it three years later in his Maplewood studio.[4]

His son, John, recounted how Durand used "his most important studies from nature" as the models for the picture.[5] Durand's nature studies formed a fundamental aspect of his working process. In the woods, Durand sketched such individual elements as rock outcroppings and tree branches, attempting to imitate the objects' color, texture, and contour in various lights. Through these exercises, Durand claimed to realize not just the proper means of capturing the outward appearance of an object but certain truths about that object's essence. In his "Letters on Landscape Painting," a set of instructive texts published in 1855, Durand enjoined: "It should be your endeavor to attain as minute portraiture as possible of these objects, for although it may be impossible to produce an absolute imitation of them, the determined effort to do so will lead you to a knowledge of their subtlest truths and characteristics."[6] In the process of painting such studies, Durand advised, "you will have learned to represent shape with solidity, . . . the coöperation of color with form, . . . above all, you will have developed and strengthened your perception of the natural causes of all these results."[7] Not only did Durand's nature studies provide the visual components of his landscape paintings, but they also recorded the hard-won lessons of his art.

According to Durand's theory of landscape painting, the foreground was the place to insert the rocks and plants verbatim from the nature studies.[8] He then made the foreground, middle-ground, and background elements cohere spatially through skillful use of atmospheric perspective (the gradual diminishment of color and contour as forms recede within the painting's space). The softening effect of atmosphere in *The Edge of the Forest* gives a melting quality to the light, which seems to be coming, not through a break in the trees, but from the trees themselves.[9] This softness, which is characteristic of Durand's late work, is enhanced by the rounded contour of the frame liner.[10] The arched frame evokes the housing of early medieval altarpieces, suggesting that the painting offers a scene for spiritual meditation.[11] The arched opening, however, also makes the painting resemble a vignette, an image bounded by shaped contours, for insertion into printed documents. Durand began his career as an engraver and was frequently called on to render vignettes.[12] His use of a shaped picture surface may thus hark back to his early career as an engraver. The break from the established convention of the square-edged frame as a window also calls attention to the constructed nature of the view and cues the viewer to see the image within as both imagined and, given other contextual clues in *The Edge of the Forest*, retrospective.

Unlike the forests in such iconic paintings as *Early Morning at Cold Spring* (1850, Montclair Art Museum, N.J.), which include buildings and figures in contemporary dress, there are no indications of present-day life in *The Edge of the Forest*. At first glance, there is no sign of human habitation either. Yet a close inspection of the near bank of the lake reveals three very tiny, cursorily described structures with thatched roofs (Fig. 1). Both John Durand and his father's contemporary Daniel Huntington referred to the subject of the painting as a primeval forest.[13] *The Edge of the Forest* thus suggests a time when the land itself was new. Insofar as it was composed from some of Durand's "most important studies from nature," presumably done

Fig. 1. Asher Brown Durand, *The Edge of the Forest*, detail

over the course of his career, the painting includes relics of a time when Durand's own perceptions of the landscape were new as well.

The retrospective and restful quality of the painting is an essential component of what Durand thought a landscape painting should be.[14] In "Letters on Landscape Painting," Durand imagines a merchant-capitalist patron arriving home after a long day's work and resting in an armchair before a landscape painting: "many a fair vision of forgotten days will animate the canvas, and lead him through the scene: pleasant reminiscences and grateful emotions will spring up at every step, and care and anxiety will retire far behind him."[15] *The Edge of the Forest* had just such an effect on its viewers. One visitor to the Corcoran described how, after an afternoon in the galleries, the ladies in his party liked to "make a farewell visit [to the painting] and

drink in its tender, quiet beauty, until they are thoroughly rested in body and mind."[16]

By the time Durand died, he had outlived his contemporaries among American landscape painters and some of the younger generation as well. His paintings were viewed as old-fashioned, and many believed he would be remembered as an engraver, not as a painter. Only at the turn of the century did major institutions begin actively collecting and exhibiting Durand's work.[17] The Corcoran was thus prescient when, in 1874, it purchased the painting directly from the artist for exhibition that year in its newly opened galleries.[18] One of Durand's finest canvases, *The Edge of the Forest* offered the capstone to the collection of Hudson River landscape paintings that William Wilson Corcoran had begun acquiring a quarter century earlier.

LS

Edward Lamson Henry (Charleston, S.C., 1841–Ellenville, N.Y., 1919)

The Old Westover House, 1869

Oil on paperboard, 11⁵⁄₁₆ × 14³⁄₈ in. (28.9 × 36.5 cm)
Signed and dated lower right: E L Henry, 69
Gift of the American Art Association, 00.11

In 1864, the Southern-born New York–bred artist Edward Lamson Henry joined the Union Army so that, in his words, he could "see the pictorial side of the Civil War."[1] The twenty-three-year-old worked as a commissary clerk aboard a transport ship on the James River in the tidewater region of Virginia, spending his off hours sketching what he observed from the deck of the vessel.[2] In the decade that followed, Henry completed a series of paintings based on these wartime drawings, including two small oils depicting Westover House, a stately eighteenth-century Georgian mansion on the north shore of the James. In 1869 he finished the Corcoran's painting for the Philadelphia industrialist and art collector George Whitney.[3]

The Old Westover House depicts the Union Army's occupation of a structure that had long been a symbol of the dignity and grandeur of Southern plantation life. Built in the 1730s by the successful planter and politician William Byrd II, the spacious two-and-a-half-story red-brick mansion was an early example of English manorial architecture in the rough-and-tumble American colonies. In the antebellum period, the property represented the endurance of genteel plantation society as the region's traditional agrarian economy was increasingly called into question. The facade of the high-style Georgian structure conveyed what the historian Alexander O. Boulton has described as "a seemingly frozen expression of [i]mperturbable calm, an apparent serenity often in striking contrast with the confusion and turmoil of the surrounding society."[4]

Based on sketches made during the siege of Petersburg, a series of battles that greatly weakened the Confederate Army and precipitated General Robert E. Lee's surrender, Henry's painting of Westover depicts broken windowpanes and missing shutters. Fire has destroyed one of the mansion's two brick dependencies. The wooden fence that once served as a grand riverside entrance has been dismantled for use as firewood, the job of demarcating the borders of the estate taken over by a bayonet-bearing Union sentinel. A unit of federal troops enters the grounds on horseback and in horse-drawn wagons, and the muddy lawn is littered with pitched tents. Northerners infiltrate the house itself, peering from open windows and lounging with proprietary ease in the elaborate front entranceway, above which hangs a Union flag. Two signalmen stand on a makeshift wooden platform erected on the steep shingled roof, one of the two men proudly raising his flag as if in triumph.

Henry surely would have recognized the symbolic potency of an image depicting the physical destruction and political usurpation of the Byrd family seat. Contemporary accounts of Westover's wartime occupation highlight the emblematic role that this house had played in asserting the cultural and political sovereignty of the American South. An article entitled "The Old Estates of Virginia," published in August 1862, lamented that the historic property would likely be "more or less destroyed" by the Union Army.[5] Westover was so ravaged during the war that when its owner returned after the withdrawal of Union forces, he "leaned his head against one of the battle-scarred poplars and wept, and that very day sold the place."[6]

About 1865, when Henry completed his first painting of Westover, it likely resonated with a Northern audience fresh from a military and political victory (the owner of this scene—the Century

Association—was an active supporter of the Union cause). By the time Henry completed the Corcoran's version, however, four years had elapsed, and images of the conflict had entered the realm of history painting. Although the wounds of war were far from healed, the passage of time had altered the cultural resonances of Henry's subject in the eyes of the American public and brought into higher relief his motivations for choosing to paint this theme.

An 1870 letter from Henry to the Richmond sculptor Edward Valentine suggests that the painter's interest in Westover was far from political. Explaining that he had "illustrated nearly all the old Houses and Churches in Phila, New York, Newport & other places where there is anything worth looking at," Henry wrote of Westover: "[M]y trip was very profitable though I had to be so 'loyal' so I could see all these things . . . fortunately that work is 'all played out' now in New York, the loyal won't go down any more now some new political word will come up just as absurd."[7] Henry's disavowal of partisanship may have been informed by a desire to gain the trust of a respected Southern colleague. Yet Henry, who asked Valentine to take him to "all the old places worth seeing in the antique line" the next time he visited, possessed a keen interest in the artifacts of American history that transcended politics. One of Henry's primary passions was the nation's architectural heritage. Paintings such as his 1865 *John Hancock House* (Fig. 1) demonstrate the artist's efforts to document historic structures before they were, in his words, "taken down for common modern houses."[8] Henry's images of Westover might thus be understood as part of his more general desire to preserve the artifacts of America's past.

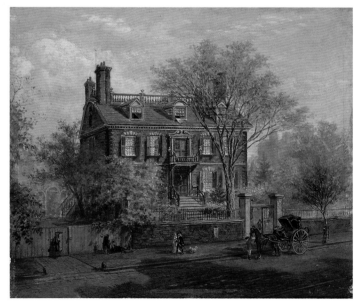

Fig. 1. Edward Lamson Henry, *The John Hancock House*, 1865. Oil on wood, 7 × 8¼ in. (17.8 × 21 cm). Yale University Art Gallery, Mabel Brady Garvan Collection 1948.99

Perhaps the politics of Henry's 1869 rendering of Westover House occupied by Union troops lay in the painting's respectful approach to both Northern and Southern audiences. As Amy Kurtz Lansing suggests, during Reconstruction Henry's images often "served a public and private need to establish a unifying identity . . . through the medium of history."[9] Indeed, shortly after the artist completed *The Old Westover House*, *Harper's New Monthly* published a feature-length essay about the house, which had recently returned to Southern hands: "the origin of the Westover estate, together with the interesting incidents which have occurred within its precincts, and its connection with names of historic renown, have rendered it memorable in the annals of the State as well as of the nation."[10] Henry's Reconstruction-era rendering of Westover occupied by Northern troops portrayed the American South as a dignified and worthy foe and posited national reconciliation and reinvention through the evocation of historical patrimony.[11]

EDS

Eastman Johnson (Lovell, Maine, 1824–New York City, 1906)

The Toilet, 1873

Oil on paper board, 26⅛ × 22⅛ in. (66.4 × 56.2 cm)
Signed and dated lower right: E. Johnson / 1873
Gift of Captain A. S. Hickey, USN (Ret.), in Memory of his wife,
Caryl Crawford Hickey, 57.21

Fig. 1. Eastman Johnson, *A Glass with the Squire*, 1880. Oil on canvas, 30½ × 23½ in. (77.5 × 59.7 cm). Brown University Library, Providence, Annmary Brown Memorial Collection

Eastman Johnson showed *The Toilet* with three other works at the National Academy of Design's annual exhibition in 1875. Although reviewers paid greater notice to his more elaborate history painting, *Milton Dictating to His Daughters* (location unknown), a few chose to comment at length on *The Toilet*. The novelist Henry James singled out the "desirable mahogany buffet" for admiration.[1] The critic Susan Noble Carter noted, "the conceit of its composition is a graceful one. . . . A handsome woman in a black velvet wrapper stands before a looking glass, with her back to the spectator. The view of her form and of the back of her head is very graceful, and in the mirror one sees her fair blonde face and delicate hands as she adjusts an ear-ring in her ear."[2] These reviews, which mention the prominence of the sideboard and the pose of the graceful woman as seen from behind, point to the work's two primary themes, nostalgia and intimacy.

After concentrating on depictions of Native Americans, blacks, and rural subjects in the late 1850s and 1860s, Johnson turned to a series of interiors featuring lone women and girls. The subject of the solitary female was fashionable in Europe at midcentury, when Johnson was studying in Düsseldorf, The Hague, and Paris, and was taken up by American artists in the years after the Civil War. The popularity of the theme likely stemmed from exposure to European trends, in themselves the results of renewed interest in the quiet interiors of the seventeenth-century Dutch painter Johannes Vermeer and awareness of Japanese prints. Arguably, the subject matter reflected not only a Reconstruction-era domestic ideology that confined women to the sphere of the home but also a desire for introspection in what was perceived as a hostile, industrial culture.[3]

The Toilet, while containing each of these artistic and social references, also alludes to a familiar topic in Johnson's oeuvre: nostalgia. The interior in which the woman concludes her morning toilet is actually a downstairs room (evidenced by the reflection of the staircase in the looking glass)—most likely a dining room, given the presence of the sideboard. It is fashionably decorated with the tripartite wall treatment of lower wainscoting, middle field, and upper frieze advocated by the British designer Charles Eastlake, and a portiere, or doorway curtain, which gained wide favor during the last quarter of the century.[4] The most prominent features of the room, however, are the massive sideboard on which the woman leans and the framed looking glass into which she gazes while donning her earrings. These pieces of furniture date from the Federal and colonial periods, respectively, lending the composition a notably antiquated air. The Federal sideboard appears in at least two other paintings by Johnson: *After the Feast* (1872, location unknown) and *A Glass with the Squire* (Fig. 1).[5] The scholar Elisabeth Garrett, identifying the furniture form as an emblem of hospitality, has interpreted its presence in these two works specifically as denoting "a nostalgic yearning for the tranquil hospitality of an irretrievable earlier time" in an increasingly alienating urban society.[6] In *The Toilet*, hospitality, as embodied in the substantial sideboard with its open bottle case, is certainly recalled but ultimately conceived as a vestige of history. The sideboard is now used to complete dressing and as a place to keep handiwork. The woman wears a loose-fitting morning dress one would wear strictly in the presence of kin.[7] This and the covered basket of material set atop the sideboard to her left suggest that she prepares herself only to sew in a familial atmosphere, not to promote social ties by hosting a meal for outsiders.

At the same time that *The Toilet* recognizes the loss of a past hospitality in the present industrial, urban society, it extols the intimate home life that this very environment began to produce. A year before Johnson painted *The Toilet*, he purchased a town house in New York for his new family, Elizabeth Buckley, whom he married in 1869, and their daughter, Ethel, born in 1870. In an unusual act for an artist at the time, Johnson elected to move his studio to the top floor of the house.[8] His pictures soon reflected his domestic surroundings as well as its private activities. *The Toilet* portrays the intimacy of family life in a variety of ways. Its title and subject matter both allude to the toilet of Venus, a traditional representation of the goddess of love looking in a mirror.[9] Thus, the image can be interpreted as capturing a private moment of sensual admiration of a wife or mistress by her lover. A sense of inwardness is also suggested by the closed-off space of the dining room. Rather than depicting the more public parlor, Johnson chose a downstairs room used less often for entertaining guests. He painted the portiere as drawn across the doorway rather than open and included on the window Venetian blinds, which were used to limit outside distractions during mealtimes.[10] The idea that this is familial space is further underscored by the presence of a child's sketch tacked on the wall to the right of the mirror.[11] Finally, the free manner in which Johnson applied paint to certain areas of the composition, especially in his portrayal of the sideboard, woodwork, and woman's morning dress, emphasizes the informality and immediacy of the scene. His loose brushwork technique adds to the feeling of intimacy that the subject matter acclaims.

LGN

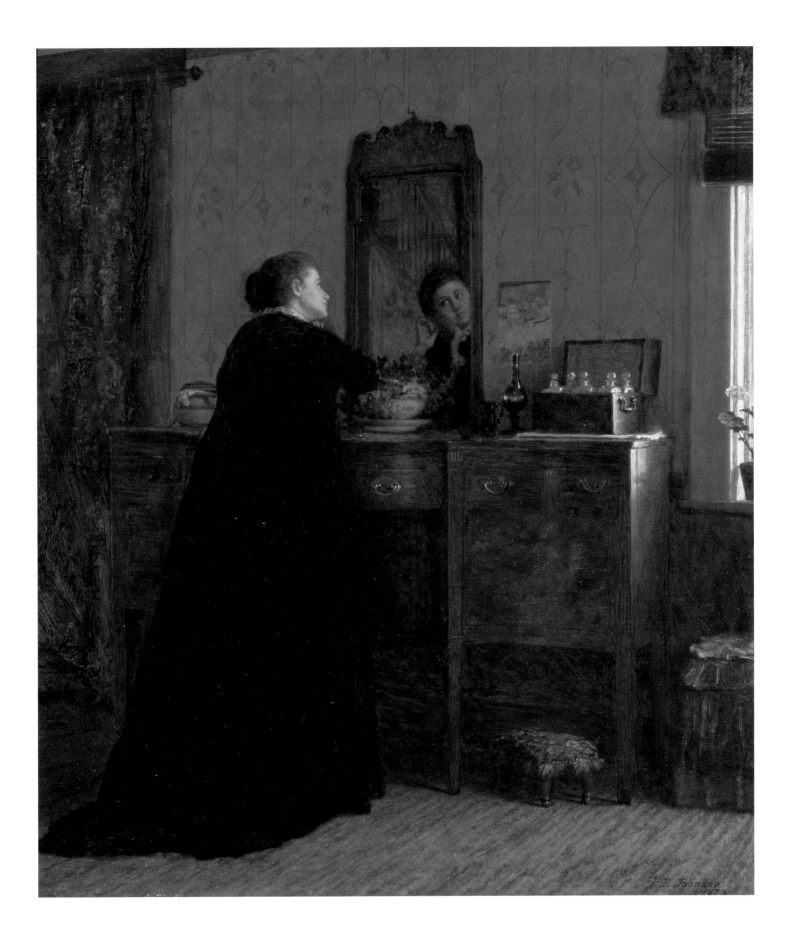

Worthington Whittredge (Springfield, Ohio, 1820–Summit, N.J., 1910)

Trout Brook in the Catskills, 1875

Oil on canvas, 35⁵⁄₁₆ × 48³⁄₁₆ in. (89.5 × 122 cm)
Signed lower left: W. Whittredge
Museum Purchase, Gallery Fund, 75.5

In 1875 Worthington Whittredge was at the height of his career. The mid-1870s were, as he recalled later in his autobiography, "the most crucial period of my life."[1] His paintings were praised by critics and purchased by collectors. Between 1874 and 1877 he served as president of the prestigious National Academy of Design. Just one year after opening its doors to the public in 1874, the Corcoran Gallery of Art purchased *Trout Brook in the Catskills* from the academy's annual exhibition, adding this image of a fisherman in a sun-dappled woodland stream to a collection already strong in American landscape painting. But Whittredge's picture marks a departure from an earlier mode of representing the landscape, epitomized by the grand, boisterous canvases of second-generation Hudson River School artists like Frederic Edwin Church and Albert Bierstadt, who rose to popularity in the 1850s and 1860s. Unlike Church's *Niagara*, also in the Corcoran's collection, Whittredge's painting does not represent a famed national landmark. Instead of expansive vistas, vertiginous mountains, or powerful waterfalls—the vocabulary of the sublime— Whittredge depicts a calm forest scene. His painting evokes a sense of interiority, with impressionistic brushwork creating the pictorial equivalent of a whisper, intimate and tentative rather than sweeping and declarative.

Whittredge grew up fishing and trapping on the Little Miami River in Springfield, Ohio. He tried his hand at sign painting, daguerreotypes, and portraits before settling on the landscape genre. Committed to his discipline, Whittredge traveled to Europe, where he spent five years studying in Düsseldorf and living in Rome.[2] He returned to New York a better artist, but he also discovered that the American landscape now looked strangely unfamiliar. "I was in despair," Whittredge wrote in his autobiography. Instead of "well-ordered forests," the American wilderness offered "primitive woods with their solemn silence." The painter immersed himself in this silence, spending months sketching "in the recesses of the Catskills," in the woods that had captivated the first generation of Hudson River School artists, including Thomas Cole and Asher B. Durand.[3] He found material there that he would return to for the rest of his career.

Trout Brook in the Catskills is a painting of luminous browns and greens. The trees lining the banks of the brook form a canopy that invites the viewer's eye to follow the water into the depths of the forest, but this arboreal arc ultimately obscures a clear view of the distance. Only a few daubs of blue are offered to indicate the sky beyond. At the point where the forest closes in and the stream disappears from view, several fallen trees lie across the water, a more literal indication of our blocked access to the background. A narrow band of sunlight cuts across the canvas in the middle ground, creating a striking swath of illumination without highlighting any particular object or element. Whittredge's light instead calls attention to itself and to the paint that creates this effect. Using techniques associated with the French Barbizon School, Whittredge first applied a reddish brown imprimatura to the canvas—an initial stain of color that he allowed to show through in some areas.[4] He then added thin, transparent layers of neutral tones, followed by more opaque colors, and, finally, highlights achieved through a thick, pastelike

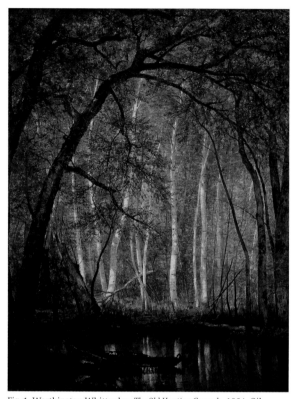

Fig. 1. Worthington Whittredge, *The Old Hunting Grounds*, 1864. Oil on canvas, 36 × 27 in. (91.4 × 68.6 cm). Reynolda House Museum of American Art, Winston-Salem, North Carolina, Gift of Barbara B. Millhouse, 1976.210

application of white pigment.[5] The sunlight therefore takes on a physical quality—as if Whittredge were attempting to express its warmth—while the entire painting, with its transparent layers, retains a sense of intangibility. The painterly gestures of the artist— both visible and transparent—are echoed by the figure of the fisherman, who is camouflaged by the foliage around him. He casts his line into the trout brook, creating a graceful gesture that is duplicated by the curve of the tree limbs overhead and that furthers his disappearance into the landscape. Through these subtle details, Whittredge creates a connection between paint, painter, nature, and man—the fisherman's flick of the arm, the artist's sweep of the hand.

Like Whittredge's first major landscape, *The Old Hunting Grounds* (Fig. 1), *Trout Brook in the Catskills* presents a vaulted interior space, a natural architecture composed of trees "like the Gothic columns of a cathedral," as one reviewer described it. Yet the painting is marked most definitively, as the same writer suggests, by its strong sense of "repose." The artist achieves both grandeur and repose through "a subtle sympathy" with the "evanescent" details of the landscape.[6] Unlike the most popular landscape painters of the midcentury, Whittredge is not interested in representing great distances

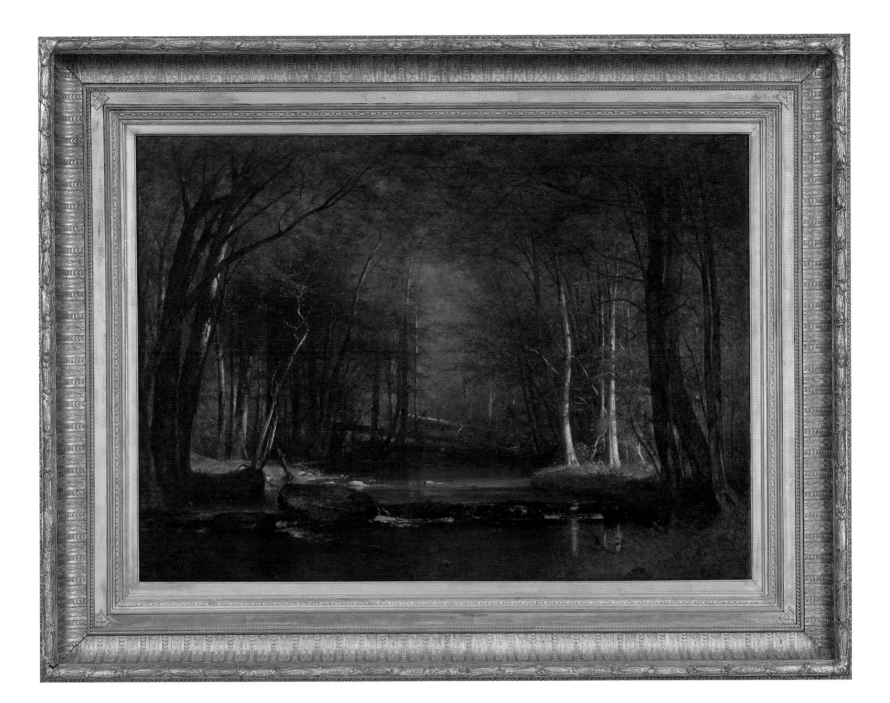

or soaring heights. He presents nature as a place of retreat and contemplation—the interior of a church—rather than as a vast territory ready for man to explore and conquer. Looking back at landscape painting of the nineteenth century, one critic asserted in 1904 that Whittredge had distinguished himself by becoming "free from that fallacy of bigness" and bravado, which had led "his more famous contemporaries . . . far astray." Paintings like *Trout Brook in the Catskills* eschew an "imperious point of view" that elides nature with the self. They embrace a vision of the natural world marked by "reverent questioning."[7]

Critics claimed a social function for Whittredge's painting, as if its "reverent questioning" could be a balm for the nation in the midst of Reconstruction. *Appletons' Journal of Literature, Science and Art* lauded the picture for "conceal[ing] no breath of poison" in its painted woods.[8] What was the "poison" that *Trout Brook in the Catskills* was free from? Perhaps the reviewer was relieved to

see no reminders of a deadly war, no references to urban industry, no signs of the contentious debates involving race and immigration. It is this lack—this striking quietude—that makes the painting such a compelling product of its historical moment. Painted in the aftermath of the Civil War, *Trout Brook in the Catskills* suggests the impossibility of discerning what is too far in the distance. Like the fisherman, the viewer must concentrate on—even take solace in—the simple act of casting a line, of seeing what is there.

JR

Albert Bierstadt (Solingen, Germany, 1830–New York City, 1902)

Mount Corcoran, c. 1876–77

Oil on canvas, 60¹¹⁄₁₆ × 95⁷⁄₈ in. (154.2 × 243.4 cm)
Signed lower right: ABierstadt. (*A* and *B* in monogram)
Museum Purchase, Gallery Fund, 78.1

Albert Bierstadt first submitted *Mount Corcoran* to the 1877 annual exhibition of the National Academy of Design with the generic title *Mountain Lake*.[1] There the painting met with a hostile reception. Critics saw the canvas as empty, meaningless, and "a mistake" and complained that it was hung in one of the best locations at the expense of better works.[2] The near-unanimous negative verdict was something new for Bierstadt. Early in his career, his dramatic subject matter and careful attention to detail and textures, evident in *Mount Corcoran*'s simultaneously transparent and reflective water, were objects of praise. His style showed the effects of early training in Düsseldorf, Germany. Although he did not attend the Düsseldorf Academy, Bierstadt quickly mastered the school's trademark detailed naturalism and smooth surfaces by studying the work of his fellow students Worthington Whittredge and Emanuel Leutze.[3] After returning to the United States, the ambitious Bierstadt tried to find a niche that would distinguish his work from that of other American landscapists. He found it on a trip to the Rocky Mountains in 1859 with the survey team of Colonel Frederick West Lander. Bierstadt established himself as the premier painter of the American West and the first artist to devote large-scale oils exclusively to western landscape. Showpiece canvases such as *The Rocky Mountains, Lander's Peak* (1863, The Metropolitan Museum of Art, New York), which he sold for the sensational amount of twenty-five thousand dollars, and *Storm in the Rocky Mountains, Mount Rosalie* (1866, Brooklyn Museum) were so popular that visitors were willing to wait on line or pay admission to see them.[4] But by the time he began work on *Mount Corcoran*, public taste had shifted to smaller, more intimate works, and Bierstadt's notorious self-promotion had begun to alienate the art establishment.[5]

Stung by the critics' disapproval of *Mountain Lake* but undaunted in his pursuit of recognition, Bierstadt determined to have his work acquired by a major American museum and set his sights on the Corcoran Gallery of Art. Bierstadt's biographers have illuminated how the artist succeeded in placing his painting at the Corcoran, but recent research has added new details to the story.[6] After the academy exhibition closed, Bierstadt rechristened the painting *Mount Corcoran*, took it to Washington, D.C., and asked William T. Walters, who sat on the Corcoran's board of trustees, to look at it. When Walters refused, Bierstadt sent the painting to Samuel Ward, a prominent Washington lobbyist and Corcoran's longtime friend, who had it installed in Corcoran's home while the banker was away.[7] Corcoran had the painting sent to the gallery, where it hung for six months while he mulled over its purchase. In January 1878, after twice threatening to remove the painting and exhibit and sell it elsewhere, Bierstadt visited Corcoran and convinced him to purchase the work for seven thousand dollars.[8]

From that point, documents offer conflicting accounts of how the sale proceeded. Gallery curator William MacLeod recorded in his journal:

> Letter from Mr. Bierstadt, intimating that the Mt. Corcoran was bought by Mr. Corcoran & expressing his delight that it was to remain here. Showed it to Mr. Corcoran, with a

copy of my last letter to Mr B. and Mr. C. then stated that he *had* bought the picture for $7,000 for *his own house*, but as Bierstadt wrote as if he expected it to be placed in the Gallery, he would let it remain there.[9]

Rather than purchasing the painting himself and giving it to the gallery, it appears that Corcoran arranged for the gallery to pay at least half the purchase price.[10] Revealing his own confusion, MacLeod wrote that the board had allocated seven thousand dollars "to pay Mr. Bierstadt for his landscape bought ~~for~~ by William Wilson Corcoran."[11] In later reminiscences, MacLeod noted that the painting's name and purchase invited "much spiteful comment."[12] Either to deflect criticism of Corcoran for overriding the board, which did not support its purchase (a New York newspaper claimed Walters resigned from the board of trustees over the matter), or to place blame for the painting's acquisition where it most rightly fell, MacLeod continued to assert that the painting had been purchased by Corcoran himself.[13]

MacLeod's reservations about *Mount Corcoran* were not confined to the circumstances of the purchase. Although Linda Ferber has pointed out that no one seems to have noticed that *Mount Corcoran* and *Mountain Lake* are one and the same painting (the National Academy of Design's catalogue includes an illustration of *Mountain Lake*),[14] questions were immediately raised about whether Mount Corcoran was a real mountain or Bierstadt's invention. MacLeod expressed relief when Bierstadt brought him a map from the War Department that indicated the location of Mount Corcoran, but the next day he wrote in exasperation, "It seems after all that Mt. Corcoran was not engraved on the War Dept. map, but written there by one of the officials *at Mr. Bierstadt's request*! That seems a *sharp* practice by the artist."[15] MacLeod also took issue with the quality of Bierstadt's rendering, asking the artist to rework an area of the clouds after the painting first arrived at the Corcoran and again a year later.[16]

The suspicion aroused by Bierstadt's choice of title for *Mount Corcoran* has obscured the fact that the artist did, in fact, name a specific peak he had visited in the Sierra Nevada in 1872 after Corcoran, albeit after he had worked up *Mountain Lake* and decided to pursue the banker as a patron.[17] The peak he designated Mount Corcoran came to be known locally as Mount Langley and was officially named such in 1943.[18] Bierstadt's efforts to establish a real Mount Corcoran in the Sierra Nevada and MacLeod's efforts to confirm the fact, however, appear to have been of little importance to the collector, who later referred to the painting as a "Rocky Mountain scene."[19]

LS

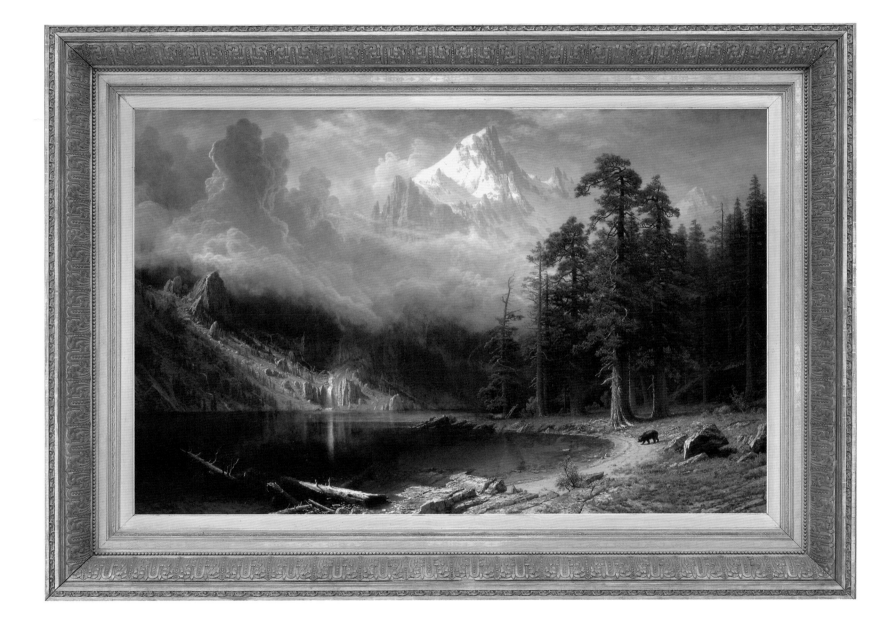

En route pour la pêche (Setting Out to Fish), 1878

Oil on canvas, 31 × 48⅜ in. (78.8 × 122.8 cm)
Signed, inscribed, and dated lower right: JOHN S. SARGENT. / PARIS 1878
Museum Purchase, Gallery Fund, 17.2

John Singer Sargent, descended from a New England family active in trade and shipping, was born in Florence to American parents who traveled with their children to European seaside locales according to the seasons. Consequently, Sargent displayed an early fondness for marine subjects, and his passion for the sea is evident in the body of work that includes *En route pour la pêche*.[1] In the 1870s, while his family was living in Paris, Sargent trained at the prestigious École des Beaux-Arts and with the fashionable French portrait painter Carolus-Duran.

The exhibition of *En route pour la pêche* at the Paris Salon in the spring of 1878 concluded a fertile year for the young Sargent, during which he created his first genre paintings and his first large body of work devoted to one locale.[2] He painted the canvas in his Paris studio over the winter of 1877–78 while completing a closely related work, *Fishing for Oysters at Cancale* (1877–78, Museum of Fine Arts, Boston).[3] *En route pour la pêche* presents a picturesque view of women and children setting out to gather fruits of the sea in the small Breton fishing port of Cancale, 250 miles west of Paris. Against a backdrop of glistening sand and cloud-filled blue skies, a woman and boy lead two other pairs of figures across a beach at low tide; the group is followed by several more figures descending the slipway. Behind them is a granite lighthouse from which a quay and short jetty, known as La Fenêtre, extend; these separate the broad beach from the town beyond. In the distance can be seen numerous masts and sailboats; in the left middle ground, more figures as well as oyster beds are suggested by slight brushstrokes of dark paint.

The canvas signaled an important step toward the independence of professional life for Sargent. He arrived in Cancale for a two-month stay in mid-June 1877, accompanied by fellow art student Eugène Lachaise, but—significantly, for the first time—without his family. Although the working village of Cancale was not a major destination for artists of the era, Sargent may have chosen it as a painting venue for one of several reasons. He may have visited or passed the township on a trip with his family in the summer of 1875 and surely was aware of its reputation, since ancient times, as "the famous oyster garden of France," as his father called it.[4] Occupying a liminal space between land and sea, Cancale was the perfect spot for Sargent—the memories of his recent seaside and transatlantic journeys still fresh—to prepare intensively for the first subject pictures of his career. He may have seen paintings depicting Cancale's fishing and oystering activity at the Salon exhibitions, such as those by the Feyen brothers;[5] during this period, canvases depicting peasants engaged in agricultural and market activities held great nostalgic appeal for an increasingly urban French public.

Sargent soon discovered the bivalves were not harvested in the summer (spawning) months.[6] Turning his attention to other shoreline activities, he encountered the scene ultimately recorded in *En route pour la pêche* and sketched it in a small oil (Fig. 1). This canvas also shows women, children, and a few older men who were not away on summer fishing expeditions foraging for the makings of their dinner when low tide exposed vast public tidelands.[7] They would have found shrimp, clams, mussels, crabs, sea snails, scallops,

Fig. 1. John Singer Sargent, Sketch for *En route pour la pêche* and *Fishing for Oysters at Cancale*, 1877.
Oil on canvas, 8¾ × 11½ in. (22.2 × 29.2 cm). Private collection

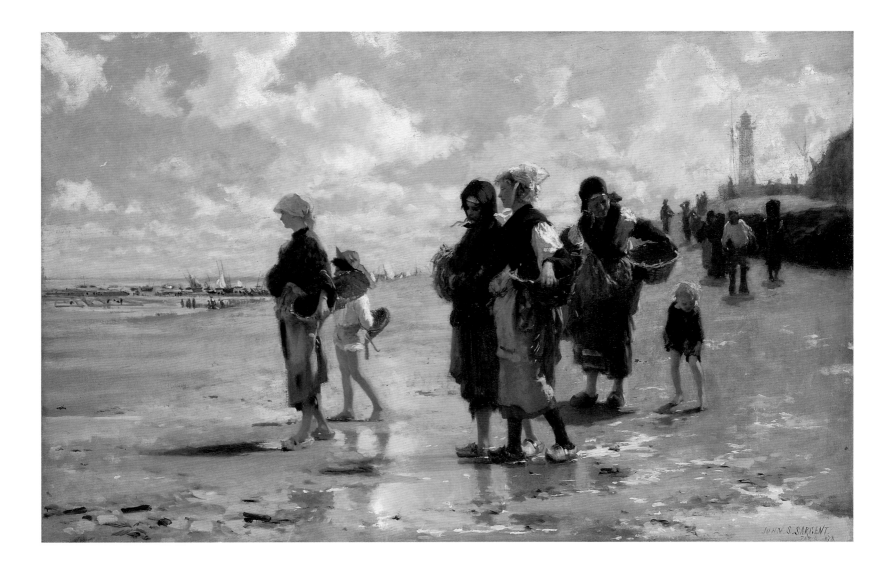

small fish, seaweed, and possibly the odd oyster, either washed up on shore or trapped in pools left by the receding tide. It is this subject that Sargent described in his title for the Salon painting. *En route pour la pêche* (*Setting Out to Fish*) emphasizes the path or procession toward fishing, in this case on foot.[8]

While the impression conveyed by the Corcoran canvas is one of freshness and facile execution, Sargent devoted an extraordinary amount of effort to it. After brushing the compositional sketch, he created ten freshly handled and closely interrelated plein air figure sketches in both oil and pencil. The five studies in oil appear to derive from the five pencil drawings.[9] After transporting the entire group of studies back to his Paris studio in late August, Sargent populated the Boston and Washington canvases with selected large and small elements from each preparatory work. Such an orchestration of on-site studies into one or more studio compositions was consistent not only with Sargent's training under Carolus-Duran but also with his working methods at this time in his career.[10] Indeed, if he were to have a painting accepted—and noticed—at the highly regulated annual Salon exhibition, the artist knew that he would have to execute it as formally and as tightly brushed as his training had prepared him to do.

While at the Salon, *En route pour la pêche* garnered only one critical mention, albeit a lengthy and positive one.[11] Roger Ballu, writing for the prestigious *Gazette des Beaux-Arts*, praised Sargent's free, broad brushwork as well as the effects of sunlight on the wet sand relieved by the reflections of the blue sky in the tide pools. He paid the artist a further compliment, commissioning from him a drawing after the painting to be reproduced in the article.[12] Even before the Salon closed, the painting had found a patron, marking the second sale of the young artist's career.[13] This was the Sargent family friend Rear Admiral Augustus Ludlow Case, who had retired to Newport, Rhode Island, just three years before, after a long and distinguished naval service.[14] While we know only that he "liked the picture," his devotion to a life on the sea cannot be discounted as a motive for the purchase, thereby suggesting a parallel with the artist's own maritime heritage and its influence on his artistic pursuits of the 1870s.[15] Case's son (and the painter's friend) Daniel Rogers Case, who inherited the painting at his father's death, sold the painting to the Corcoran in 1917, making it the first of the museum's many Sargent acquisitions.

sc

Horace Bonham (West Manchester, Pa., 1835–York, Pa., 1892)

Nearing the Issue at the Cockpit, 1879

Oil on canvas, 20⅛ × 27 in. (51.3 × 68.6 cm)
Signed and dated upper right: <u>Horace</u> <u>Bonham</u> / 79–
Museum Purchase, Gallery Fund, 99.6

Nearing the Issue at the Cockpit depicts a group of men watching the culmination (the issue) of a cockfight. Although we do not see the fight itself, the framed RULES affixed to the cracked plaster wall and the plank railing of the ring provides the meager furnishings of the temporary arena. The thirteen men who lean forward in suspense, hands on one another's backs and shoulders, represent the diverse citizenry of the artist's lifelong home, York, Pennsylvania. Although cockfighting was illegal in Pennsylvania, fights were said to have been held each Saturday night during the late nineteenth century in York's Violet Hill neighborhood. The roosters, outfitted with sharp steel spurs, fought to the death, and spectators wagered on the outcome.[1] According to town lore, each man in the painting sat for

Bonham and was identifiable, although only three can be named today. The man who appears to be just passing through, with his coat, top hat, leather gloves, monocle, and cane, is Horace Bonham himself.[2] The African American man with the white mustache at the center of the painting was a coachman for a prominent judge, and the African American man at the far right was Washington Dorsey, who appears in another of Bonham's paintings.[3]

Scholars frequently note Bonham's depiction of a range of ethnicities in *Nearing the Issue at the Cockpit.*[4] In fact, half of Bonham's documented works include African American figures.[5] As a strong supporter of the Union and a onetime political appointee of the Lincoln administration, the artist may have had an interest in

depicting York's free black community in positive terms.[6] His sketches, prints, and paintings of Billy Bullfrog, a scissors grinder, for instance, show a neatly dressed man absorbed in his work (Fig. 1). More generally, Bonham dedicated his career to recording aspects of York's public life, particularly scenes observed in the Centre Square Market: an old man named Dixie Pluffer drinking the day away in an empty market booth (n.d., private collection), two Amish women smoking pipes and gossiping while shopping (*The Gossips*, 1885, location unknown), or young boys playing cards, secreted among the boxes, baskets, and barrels of the market (*Little Scamps*, 1880, Historical Society of York, Pa.).[7]

On the face of it, *Nearing the Issue at the Cockpit* is about the unifying role of sports in a community. Sports was one of the few activities in the nineteenth century in which men of various ethnicities and classes could socialize freely (see, for instance, the Asian American man wearing an eye patch to the right of Bonham).[8] In Bonham's painting, citizens from all walks of life are brought together and entertained by a contest on which they wager. Any one of them, rich, poor, black, Asian American, or white, could emerge the victor if his judgment and luck proved right.[9] But, as one art historian has noted, it is unlikely Bonham would have chosen such a brutal competition simply to showcase community spirit. Rather, aspects of Bonham's painting suggest that it offers a comment on the state of politics in America at the time.[10]

Bonham had followed political events for most of his life. Born and raised in York, he began his career as a lawyer, then owned and

Fig. 1. Horace Bonham, *The Scissors Grinder*, 1880. Graphite on paper, 19 × 17½ in. (48.3 × 44.5 cm). From the Collection of the York County Heritage Trust, York, Pennsylvania, 1991.1688

edited the *York Republican* and started the *York Daily Recorder*, for which he wrote political, particularly pro-Union, editorials. He was appointed York Internal Revenue Commissioner during the Lincoln and Johnson administrations and served until he lost his appointment under Ulysses S. Grant. It was only then that he decided to pursue a lifelong interest in art. He studied in Munich for about a year and then returned to York, where he married and spent the remainder of his life painting and exhibiting.[11]

Given Bonham's political experience, the range of people in his painting may represent the male voting public, which included African Americans, who were enfranchised in 1870 by the Fifteenth Amendment.[12] Newspapers frequently referred to elections as "cockfights," and political cartoons often depicted candidates as roosters in the ring.[13] Other aspects of the painting may also refer to the voting process. The loosely painted tickets tucked under the brim of the conductor's hat, at the far right, could suggest ballots, and the RULES on the wall could also refer to election regulations.[14]

Bonham's painting may also point specifically to one of the most contentious presidential elections in history, the Tilden versus Hayes campaign of 1876. Samuel Tilden led Rutherford B. Hayes in the popular and electoral vote, but the deciding twenty electoral votes were contested in three states. The twenty votes were eventually given to Hayes in a compromise in which Democrats forfeited the presidency in exchange for an end to Reconstruction and, in effect, the disenfranchisement of Southern African Americans. The controversy had particular relevance in York, which had voted heavily for Tilden. Judge Jeremiah Black, a politician and native of York, actively protested the election results and testified before a congressional commission on Tilden's behalf in a well-publicized show of support. Although Black does not appear in the painting, his coachman, at center, may have been included as his surrogate.[15] Bonham's ambiguous title also suggests a double meaning. Rather than using the word *cockfight*, Bonham chose *cockpit*, a more general word meaning battleground. Bonham's phrase "nearing the issue" is also provocative. An editorial that ran in the *York Gazette* in December 1876 was entitled "The Issue" and argued that the issue was not the outcome of the contest itself but, rather, voters' rights.[16]

Although Bonham exhibited *Nearing the Issue at the Cockpit* at the National Academy of Design in 1879 to positive reviews (none of which, unfortunately, commented on its content), the painting did not sell until after the artist's death. The prominent collector Thomas B. Clarke purchased the work sometime after 1896 and exhibited it at the Union League Club and the Heights Club in New York before selling it at auction the following year. When the Corcoran Gallery of Art purchased it from Clarke's auction, it had the distinction of being the only painting by Bonham to enter a public collection. The remainder of his works, many of which Bonham exhibited at important venues such as the annual exhibitions of the Pennsylvania Academy of the Fine Arts and the Museum of Fine Arts, Boston, were sold locally or remained in family hands following his death and have yet to receive their due.[17]

LS

John George Brown (Durham, Eng., 1831–New York City, 1913)

The Longshoremen's Noon, 1879

Oil on canvas, 33⅟₁₆ × 50⅛ in. (84 × 127.3 cm)
Signed, inscribed, and dated lower left: J. G. Brown. N. A. / N.Y. 1879
Museum Purchase, Gallery Fund, 00.4

One of the most popular American painters of the late nineteenth century—an artist whose "characterful and well studied" genre images were proclaimed by a contemporary critic "as sure of conversion into gold and silver as any legal tender"—John George Brown emerged from humble beginnings.[1] Born to working-class parents in England, as a teen Brown apprenticed with a glass cutter. In his early adulthood, he labored as a craftsman by day and art student by night, first in England and Scotland and later in the United States at the Brooklyn Flint Glass Company. When he married his Brooklyn employer's daughter in 1855, Brown was able to pursue the study of fine art full-time.[2]

In his early years as a professional artist, Brown specialized in sun-dappled scenes of rural children, lighthearted images inspired by sentimental English genre paintings that appealed to a harried urban clientele.[3] By the early 1860s he had established himself in the New York art world, working in the prestigious Tenth Street Studio Building and being named full academician of the National Academy of Design. Perhaps inspired by English social realist art, in the mid-1870s Brown turned his attention to the urban experience, taking as his primary subject newsboys, bootblacks, and other working-class male youths (see the Corcoran's *Allegro* and *Penseroso*). During this period, he began participating regularly in New York's major exhibitions, including those held by the Century Club, the Brooklyn Art Association (of which he was a founding member), and the National Academy.[4] Many of Brown's images also circulated as wood engravings in popular illustrated newspapers or as chromolithographs.

The Longshoremen's Noon, a seemingly casual grouping of men on a bustling Hudson River wharf, is one of Brown's most celebrated paintings of the urban milieu.[5] Poised before a backdrop of plump bales of cotton, these figures are depicted on their noontime break in various states of repose. Behind them, a dense harborscape filled with commercial watercraft obscures the horizon line. In the foreground, tufts of cotton, seashells, bits of straw, and other detritus litter the dock. Three still-life elements—an upturned hat, a crumpled newspaper, and a battered canteen—frame the central figure, whose spoken words are made emphatic by his expressive hand gestures. Three boys at the far right pay tribute to the images of street urchins for which Brown was most famous.[6]

The friezelike configuration of *The Longshoremen's Noon* simultaneously calls attention to the social relationships between the figures and creates a dynamic formal arrangement. Flashes of vibrant red pigment—in such details as a kerchief, a shirt, the horse's collar, and a ladder on the barge at right—enhance the painting's pictorial coherence. Brown claimed that he "always composed his pictures, and often made as many as eight or ten sketches . . . before fixing on the shape that he would give it."[7] The figure study *A Longshoreman* (Fig. 1), a portrait likely painted in preparation for the larger exhibition picture, attests to the artist's laborious image-making process.[8]

The structure and iconography of Brown's 1879 canvas reflect long-standing traditions and conventions of genre painting (see William Sidney Mount's *The Tough Story*). Like Mount—and many of his seventeenth-century Dutch predecessors—Brown took as his primary subject a group of men engaged in conversation and further populated the image with carefully rendered and strategically placed props that provide the viewer with additional information about the narrative. Brown's canvas also evokes the conventional rural genre theme of the nooning picture, an iconography typified by Mount's 1836 painting *Farmers Nooning* (Fig. 2). Brown similarly portrays his

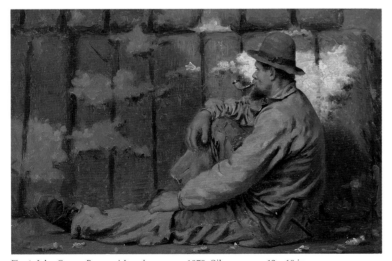

Fig. 1. John George Brown, *A Longshoreman*, c. 1879. Oil on canvas, 12 × 18 in. (30.5 × 45.7 cm). Corcoran Gallery of Art, Museum purchase by exchange: Mr. and Mrs. Ignatius Sargent, 2009.002

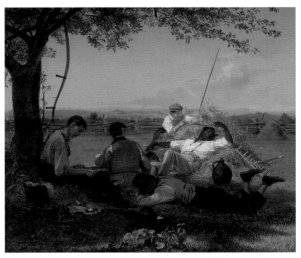

Fig. 2. William Sidney Mount, *Farmers Nooning*, 1836. Oil on canvas, 20¼ × 24½ in. (51.4 × 62.2 cm). The Long Island Museum of American Art, History & Carriages. Gift of Frederick Sturges, Jr., 1954

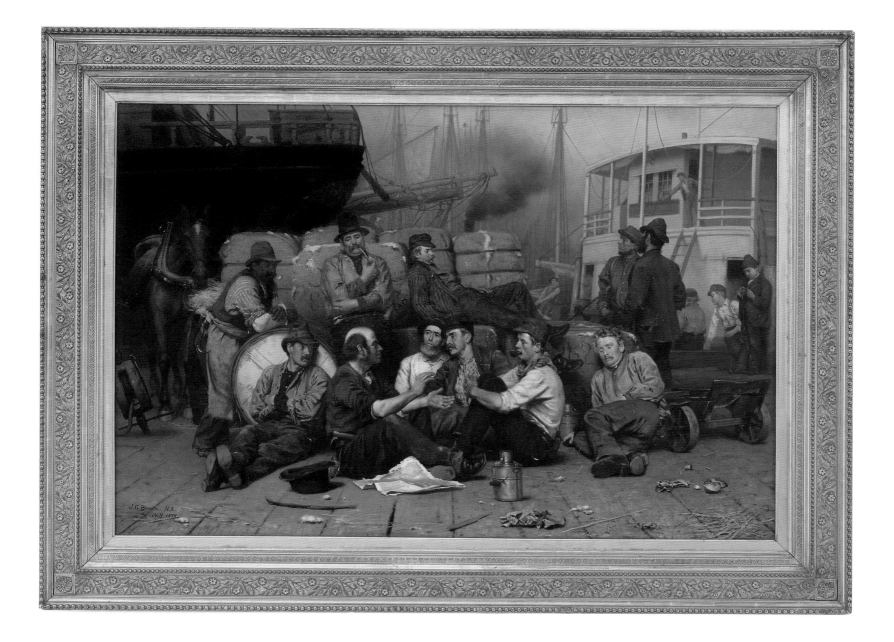

subjects in an unguarded moment of relaxation and social interaction that both disassociates his picture from the day-to-day drudgery of working life and instills it with a sense of humanity.[9]

Brown's depiction of the longshoremen during a moment of rest was particularly fitting, because waiting was an integral part of work on the docks. Most wharves attracted twice as many men as were needed each day, and, as outlined in an 1879 *Scribner's Monthly* article, those who were not initially selected for employment often waited on the pier for hours in the hope that "a stevedore [labor contractor] seeking a few more hands to help unload one of the steamers" would appear.[10] Moreover, as the labor historian Bruce Nelson explains, even those laborers "lucky enough to be chosen to work the ship's cargo" were at the mercy of "ships sailing from distant ports and facing the vagaries of weather along the way."[11]

Indeed, the Gilded Age stereotype of the dockworker as a figure characterized by "habitual stolidity and inertia" stemmed largely from the conditions of the occupation rather than from any inherent slothfulness.[12] Longshoremen were a well-organized and active labor group in the late nineteenth century. In 1877 and 1878 the New York press included nearly daily reports of strikes organized

by local dockworker unions. The prominent position of the *Sun* newspaper in the center foreground of Brown's painting suggests that the longshoremen's conversation likely concerned current events, perhaps even the workers' own plight. One critic characterized the informal gathering of laborers as a "poor man's parliament"; another described the central figure as "telling a story or giving his ideas about some grievance."[13]

In a period of significant labor unrest, an image of dockworkers assembling to discuss the pressing issues of the day might have intimidated American art audiences. Yet Brown's aestheticized treatment of the subject diffused any such threat. One critic called the men in *The Longshoremen's Noon* "preternaturally and decorously fresh," while another stated that dockworkers "never looked so washed, even on a Sunday."[14] Ultimately, Brown's painting is more a study of character and community than it is an exploration of the harsh realities of life on the docks. A successful artist and businessman with working-class roots, Brown succeeded in creating a multivalent image that was sympathetic toward labor without alienating his largely upper-middle-class clientele.[15]

EDS

John Singer Sargent (Florence, Italy, 1856–London, 1925)

Marie Buloz Pailleron (Madame Édouard Pailleron), 1879

Oil on canvas, 83⅛ × 41⅛ in. (211.2 × 104.4 cm)
Signed, inscribed, and dated lower right: John S Sargent / Ronjoux 1879
Museum Purchase and gifts of Katharine McCook Knox, John A. Nevius
and Mr. and Mrs. Lansdell K. Christie, 64.2

John Singer Sargent's portrait of Marie Buloz Pailleron (1840–1913) was calculated to make an impression, even amid the almost four thousand paintings in the Paris Salon of 1880, where it made its debut. It succeeded thanks to at least three factors. First, its sitter: she was the daughter of François Buloz (1804–1877), who for more than four decades ran the prestigious French literary review *Revue des Deux Mondes*, in the process making an immense fortune.[1] Her husband, Édouard Pailleron (1834–1899), was nearing the pinnacle of fame as a writer and playwright.[2] Further, in spite of her status, she rarely went into society but instead entertained a small circle of writers and artists in her Paris apartment in the Hôtel de Chimay, "one of the most celebrated residences in Paris." Because of her wealth, her family, and her reclusive habits, she possessed the allure of mystery.[3] Second, the painter's efforts for this Salon necessarily drew attention, since in 1879 Sargent had won an honorable mention for the portrait of his teacher, *Portrait of Carolus-Duran* (Fig. 1), prompting critics and patrons alike to want to see what the young American would do next.[4]

The painting itself, however, was the signal means of drawing attention. In it, painter and sitter both pushed at conventional notions of portraiture by showing Pailleron outdoors, in motion, at an informal moment.[5] The gesture of lifting her skirt—as if to dislodge a leaf from her petticoat—and her expression (wholly without pretense of affability) lend the work an unsettling spontaneity. The generally downward viewpoint raises the picture's horizon line, emphasizing an expansive lawn dotted with fallen leaves and autumn crocuses; large, schematic leaves at the top right signal a nearby tree just beyond the field of vision.[6] The viewer's attention cannot settle anywhere on the canvas, a restlessness underscored by the point of view that simultaneously looks down onto Pailleron's figure yet directly into her face.[7]

The Pailleron family was among Sargent's earliest French patrons, their enthusiasm prompted by the *Portrait of Carolus-Duran*.[8] Sargent's father bragged of the painting:

> There was always a little crowd around it. . . . But as the proof of the pudding is in the eating, so the best, or one of the best evidences of a portrait's success is the receiving by the artist of commissions to execute others. And John received six such evidences from French people. He was very busy during the two months we were in Paris, in executing these commissions, and [referring to the Paillerons] he is now about going to the vicinity of Chambéry to paint the portrait of the wife of a gentleman whose portrait he was finishing when we left him.[9]

Sargent's mother and elder sister visited Ronjoux, the Buloz country estate in Savoy for a day; his sister reported having "a charming breakfast with the people he is staying with. They are very clever, & have lots of literary & artistic friends, besides a delightful country place, John's time passes very agreeably & he works at the lady's portrait every propitious afternoon."[10]

Marie Buloz Pailleron was Sargent's first full-length portrait at life scale. Coupling that challenge with setting the scene outdoors reveals the extent of his ambition. His decision to show it at the Salon of

Fig. 1. John Singer Sargent, *Portrait of Carolus-Duran*, 1879. Oil on canvas, 46 × 37¾ in. (116.8 × 96 cm). Sterling and Francine Clark Art Institute, Williamstown, Massachusetts, 1955.14

1880 and its success there, at least among French writers, proclaim his achievement. One critic wrote that he was "infinitely charmed" by it.[11] Another, that it showed "great progress" over the very fine *Carolus-Duran* of the year before, and that it demonstrated Sargent to be "more modern than the impressionists."[12] American writers tended to be less positive. One "regretted" that Sargent showed "a work so unworthy," "a red-haired, red-faced damsel in black, standing in the midst of a field that shows like a Brobdingnagian dish of green peas."[13] Another declared it "of the French, Frenchy."[14]

To those who knew her, the image of Marie Pailleron presented a true likeness:

> The oldest image that I maintain of my mother conforms exactly to her portrait painted by J. S. Sargent in 1879. She is tall (1.73 meters), thin and delicate, of clear color, her eyes the color of pure hazelnuts rising a little towards the temples, Chinese-like, which gave to her smile something enigmatic. Her head, small, which she held strictly upright, was topped by thick copperish curls. Her manner was reserved, she smiled little. Her hands are ravishing.
>
> When she is alone or with intimates, her face often becomes melancholy and seems to reflect some deep passing memory; I know then that she dreams of the little child she has lost [a young son, Henri, had died of diphtheria early in the 1870s].
>
> In my childhood she was very retiring and fled visits and the worldly life. . . . [S]he fled more and more from strangers.[15]

That Pailleron was willing not only to welcome Sargent into her country retreat but submit herself to the portraitist's scrutiny was an act of courage. The energy of the finished work, which so helps draw attention, perhaps reflects the tensions within the sitter about this display of self as well as Sargent's sensitivity to them.

MS

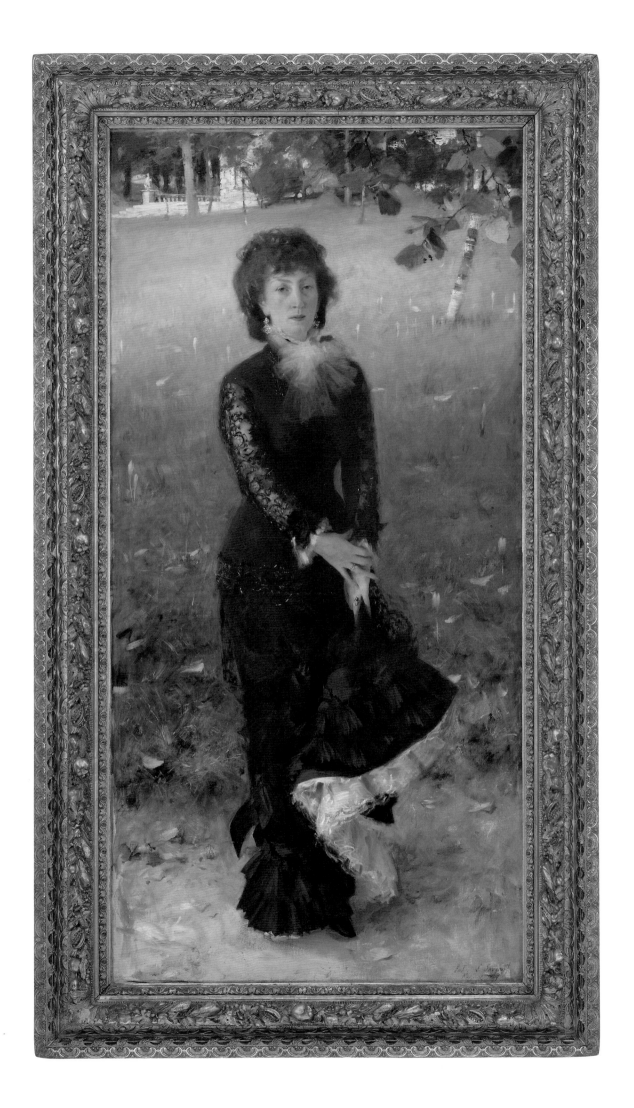

Sanford Robinson Gifford (Greenfield, N.Y., 1823–New York City, 1880)

Ruins of the Parthenon, 1880

Oil on canvas, 27⅜ × 52¼ in. (69.4 × 132.5 cm)
Signed and dated lower left: S. R. Gifford 1880
Museum Purchase, Gallery Fund, 81.7

Ruins of the Parthenon is Sanford Robinson Gifford's last important painting, and he considered it the crowning achievement of his career. Based on sketches he made on a visit to the Acropolis in Athens in May 1869, the painting, according to the artist, was "not a picture of a building, but a picture of a day."[1] Much the same might be said of the majority of his works, for he was unsurpassed in his ability to capture the subtleties and nuances of an astounding variety of light and atmospheric effects. Ultimately, Gifford's mature works—and this is a prime example—are less about the specific physical facts of the scenes they portray (although those are not unimportant) and more about the very act of perception and vision. As one of his close friends observed: "Gifford's art was poetic and reminiscent. . . . It was nature passed through an alembic [a device that refines or transmutes through distillation] of a finely-organized sensibility."[2]

Raised in the town of Hudson, on the east bank of the river of the same name, Gifford knew the Catskill Mountains and their environs perhaps more intimately than any other member of the Hudson River School of landscape painters.[3] But he also traveled extensively over the course of his career, visiting Europe, the Near East, and the American West. His visit to the Parthenon in 1869 came at the end of an excursion that had taken him to Egypt, Jerusalem, Lebanon, Syria, and Turkey.[4] When he returned to his New York studio, paintings based on the sites he had seen gradually began to appear, although only a few were large and important works, and none approached the significance of *Ruins of the Parthenon*.

The immediate source for the painting was a detailed, two-page sketchbook drawing Gifford made on the Acropolis (private collection).[5] In painting the finished work, Gifford adhered generally to the scheme of this drawing, with the east facade of the Parthenon at the left, a field of scattered architectural fragments across the center, and a brick tower of medieval origin at the right. Two figures are near a large block at the lower center; the one who kneels to sketch or take notes is possibly the artist, the other his Greek guide. At the far right, Gifford added the western end of the Erectheum and its distinctive Porch of the Maidens, where the columns take the form of graceful female figures. Other than the distant water and mountains, the rest of the painting is given over to an expanse of sky, which undergoes the most exquisitely delicate transitions from pale pinks to deep blues. Gifford labored long and hard to get that sky precisely right, even to the extent of repainting it at least once after having publicly exhibited it and against the advice of his friend Frederic Edwin Church.

Church's own painting of the Parthenon (Fig. 1) may be constructively compared with Gifford's version. For Church, the building —which he showed in its entirety—was the subject of the painting; one can sense its primary role in the way it is set high in the picture's space so that it looms powerfully over its surroundings. The landscape is divided diagonally into light and dark halves. The foreground, with its scattered architectural fragments and single figure leaning casually against a block of stone, is a world of disorder and dissolution, one that contrasts starkly with the calm quiet of the sunlit building, the achievement of the mind and hand of man.

Fig. 1. Frederic Edwin Church, *The Parthenon*, 1871. Oil on canvas, 44½ × 72⅝ in. (113 × 184.5 cm). The Metropolitan Museum of Art, Bequest of Maria DeWitt Jesup, from the collection of her husband, Morris K. Jesup, 1914, 15.30.67

Church's vision of history remained in the mold of that of his mentor, Thomas Cole, for whom man was always the central agent in the rise and fall of civilizations. Lessons about the past could be learned from gazing on a building like the Parthenon, or a painting of it. Gifford's "picture of a day" offers no such invitation to ponder the cycles of time in historical depth. Instead, it presents the beauty of an immediate moment, one of specific conditions of light and atmosphere, and one that will, like all such moments, prove fleeting.

Gifford hoped that *Ruins of the Parthenon* would be acquired by an American public museum, and he made some efforts to that end while he was alive. According to his brother James, the artist "frequently said that no picture of his had cost him so much painstaking labor as this one, being very anxious it should be accurate as well as artistic." He went on to recount Gifford's "remark when at the Corcoran Gallery about a year ago. Reaching the space near Church's 'Niagara,' he said, 'there would be a good place for my 'Parthenon.'"[6] Although the painting remained unsold at the time of Gifford's death, his wish was realized when the Corcoran purchased it at the estate sale in 1881 for $5,100, at the time, the highest price ever paid for one of his paintings.

F K

Richard Norris Brooke (Warrenton, Va., 1847–Warrenton, Va., 1920)

A Pastoral Visit, 1881

Oil on canvas, 47 × 65¹³⁄₁₆ in. (119.5 × 167.1 cm)
Signed, dated, and inscribed lower right: Richd. N. Brooke. 1881. / (ELÈVE DE BONNAT—PARIS)
Museum Purchase, Gallery Fund, 81.8

In the spring of 1881, Richard Norris Brooke wrote to the director of the Corcoran Gallery of Art offering his painting *A Pastoral Visit,* then on view at the gallery, for purchase, stating, "it has been my aim, while recognizing in proper measure the humorous feature of my subject, to elevate it to that plane of sober and truthful treatment which, in French Art, has dignified the Peasant subjects of Jules Breton, and should characterize every work of art." Furthermore, African American domestic life, he marveled, afforded a "fine range of subject" and "has been strangely abandoned to works of flimsy treatment and vulgar exaggeration."[1]

Having just returned to Virginia after a year studying in Paris with Léon Bonnat, Brooke claimed to look on the subject with a "Continental eye," supposedly free from the biases of white Americans.[2] Seated around the table, the family receives a visit from the local pastor. Rural congregations were seldom able to offer a minister a parsonage, so it was the custom for members of the congregation to invite their pastor for Sunday dinner. In keeping with tradition, the pastor is served first. The host props his arm on a cigar box holding the weekly contribution from the congregation. The family will present this to the minister, together with the fruit tied in a cloth on the bench at the right, following the meal. Their home is rustic, but comfortable, furnished with a large brick hearth and a sturdy cabinet, lined with pottery and china. A circus poster and a string of drying chilies enliven the back wall, and the mantel is laden with a coffee grinder, a tea jar, and an apple. Although the host wears the heavy boots and thick, dusty coat of an artisan or farmer, his daughters bear the mark of their parents' modest aspirations. The youngest has a bright white petticoat peeping below the hem of her dress, and the eldest sits politely erect in her lace-trimmed calico dress, a bow in her hair. Many art historians have pointed to Brooke's stereotypical depictions of the nurturing African American mother and the earnest black preacher as well as the presence of the banjo, a sign of African American musicality.[3] But several have also noted that the particularity of the individual models' features (identified by Brooke as his Warrenton neighbors George Washington, Georgianna Weeks, and Daniel Brown) and Brooke's rigorous academicism, evident in his well-balanced composition, bravura brushwork, and monumental forms, help him avoid caricature.[4]

Just as Breton's Brittany peasants lived an antiquated life, following centuries-old religious and agricultural traditions, the family in Brooke's painting represented a Southern way of life that Brooke believed was fast disappearing.[5] The setting, which Brooke claimed was his own invention, was already antiquated before the Civil War.[6] By 1880 the single-room cabin with its large, sooty hearth had been replaced by separate dining and cooking rooms and efficient iron stoves, like the one Brooke had in his studio on Vernon Row.[7] Even the pastoral visit was a relic of an earlier time.[8] Critics recognized this feature, commenting that Brooke's painting was set in an "old-fashioned negro's cabin" that was "in every way a typical picture of the home life of the negro a quarter of a century ago—a life simple, natural, and contented and a people genuine, guileless and affectionate."[9] Brooke himself commented, "My painting was a

Fig. 1. William Ludwell Sheppard, "A Spring Scene near Richmond, Virginia," *Harper's Weekly* 18, no. 699 (21 May 1870), Courtesy of The Virginia Historical Society

true picture, a sincere reproduction of a phase of pastoral life familiar to every American. But the war changed everything. The romance, the essential pastoral qualities of negro life were undermined. I had caught the last flashes of a fast changing social order."[10]

Brooke cited French Realism as his source, but there were closer precedents for his depiction of African American life in the art of Winslow Homer, Eastman Johnson, Thomas Hovenden, Thomas Anshutz, and Horace Bonham (see *Nearing the Issue at the Cockpit*) as well as in popular illustrations. The Reconstruction era brought African Americans citizenship and protection under the Constitution as well as voting rights. In some Southern states, African Americans controlled state legislatures, and in 1870 Hiram Rhodes Revels became the first African American elected to the United States Senate. In the wake of such social changes, Southern African American life became a subject of interest, and in the 1870s and 1880s white artists produced a spate of images that purported to address the subject.[11] The illustrator and Confederate veteran William Ludwell Sheppard, for instance, made a career of depicting scenes of rural African American life in the South during Reconstruction. His drawing of an elderly couple tending their chickens outside their one-room cottage shows the same careful attention to the setting and accoutrements of folklife that Brooke's painting does (Fig. 1).

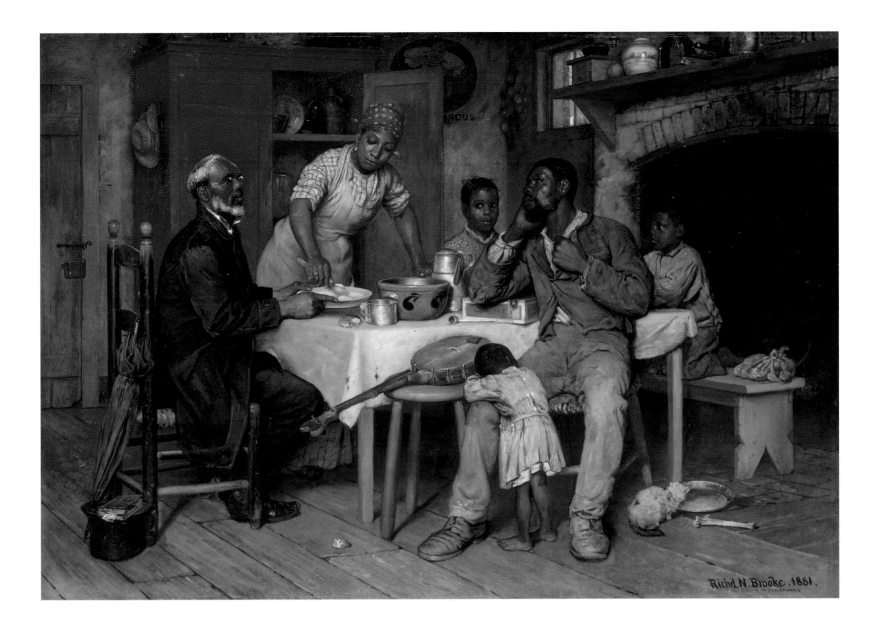

Fig. 2. Richard Norris Brooke, *Dog Swap*, 1881. Oil on canvas, 47⅛ × 65⅞ in. (119.6 × 167.2 cm). Smithsonian American Art Museum, Gift of Colonel Thomas G. Young, Jr., 1956.11.2

A Pastoral Visit was popular from its first exhibition at the Corcoran.[12] Nevertheless, one critic wrote that Brooke's African American subject matter threatened to become a "life-long handicap" for the artist.[13] Brooke seems to have started out with ambitious plans for his subject matter and even painted a companion piece for *The Pastoral Visit* using some of the same models: the monumental genre scene *Dog Swap* (Fig. 2). Later, however, the artist echoed the writer's prejudice, noting that *The Pastoral Visit* "was my first decided success, and unfortunately fixed my reputation as a painter of negro subjects."[14] At the end of his life, his account books listed only eleven paintings of African Americans among more than 750 works. Brooke focused on landscape and portraiture and served the Washington, D.C., art community for more than twenty-five years as a vice principal and art instructor at the Corcoran School of Art, as an officer of the Washington Art Association, and as a founder of the Washington Art Students League. Nevertheless, not one obituary omitted a mention of *The Pastoral Visit*, and it remains today his best-known work.[15]

LS

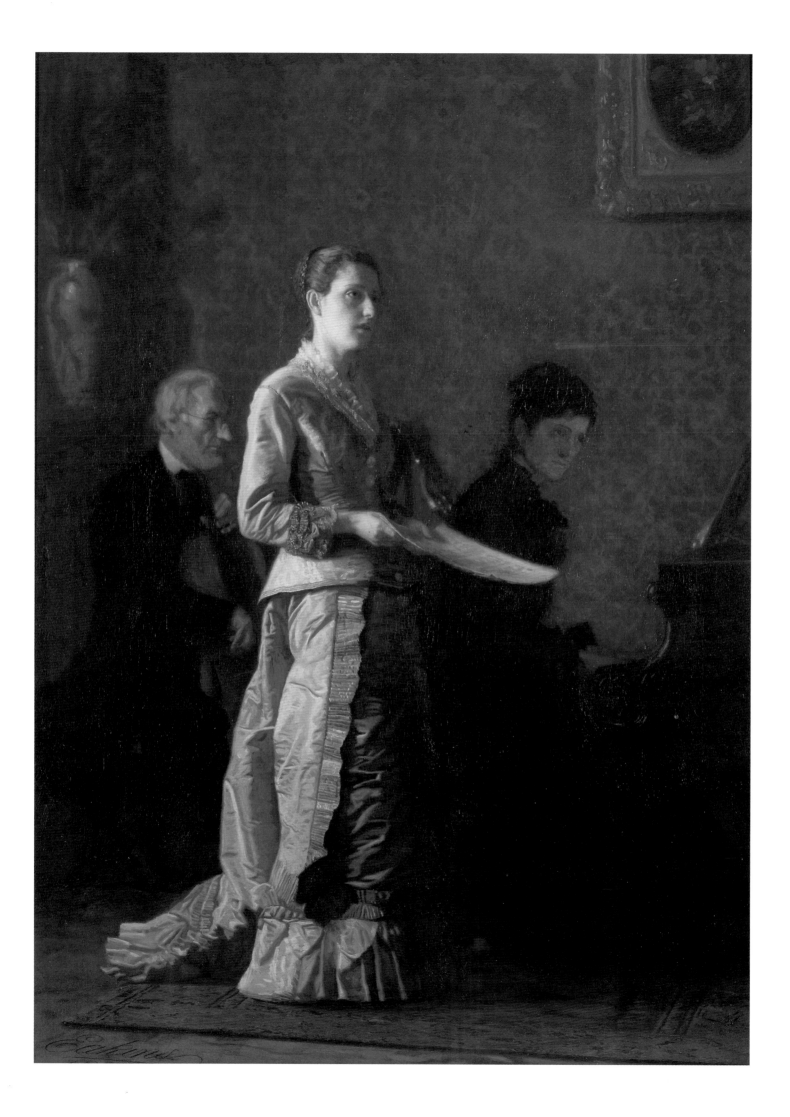

Thomas Eakins (Philadelphia, 1844–Philadelphia, 1916)

Singing a Pathetic Song, 1881

Oil on canvas, 45 × 32³/₁₆ in. (114.3 × 81.7 cm)
Signed and dated lower left: Eakins / 1881
Museum Purchase, Gallery Fund, 19.26

The Philadelphian Thomas Eakins portrayed his friends, family members, and modern professionals in the fields of the arts, sciences, and religion with an unflinching eye, recording every facial feature and bodily characteristic with an honesty that sometimes alienated his viewers and even his sitters. Moreover, he often conflated portraiture with genre painting (scenes of everyday life), tipping the balance toward one or the other depending on his goals. He pictured his subjects engaged in their chosen profession or avocation, whether at the city's rivers and parks, in its surgical amphitheaters, or in its public and private performance venues, as in *Singing a Pathetic Song*.

The artist's emphasis on active figures allowed him to study the subject that most inspired him, the human body in motion. This practice reflected his unusual training: he studied not only art, at the Pennsylvania Academy of the Fine Arts and in France under the realists Jean-Léon Gérome and Léon Bonnat, but also anatomy, at the Pennsylvania Academy and Philadelphia's Jefferson Medical College. Eakins promoted his dual artistic philosophies as a teacher at the academy, where his insistence that students work from nude models, combined with behavioral scandals, ultimately led to his dismissal.

A passionate devotee of music, Eakins hosted and attended many musical gatherings, particularly those involving the voice, like the one depicted in *Singing a Pathetic Song*. This evocative rendering of the home musicale so popular in Victorian America features an earnest young singer, accompanied by a cellist and pianist in a richly decorated interior, concentrating on holding a note of her tune. The pathetic song, the most popular type of melody in 1860s and 1870s America, told tales of tragedy and grief. Recited in the first person, such ballads commonly moved audiences to tears, not only because

of their sad themes but because, as the scholar Elizabeth Johns notes, they provided "a release from the tensions of striving, of rationality, and of control that marked the era."[1]

Eakins's portrayal of his commanding protagonist absorbs our attention. We almost strain to hear the sound escaping from her mouth, to see the notes on the graceful curve of her sheet music. The artist meticulously recorded her opened lips, the taut diagonals of her throat and neck, and the veins of her delicate, freckled hands, stressing the singer's physical effort. He also characterized her as formidable and deflective, her fashionable dress, with its stiff pleats, bows, and folds of white lace and violet-gray satin, echoing her rigid posture.[2] Bathed in light coming from the left, she embodies the isolation of the soloist. Reinforcing this separation, the tight brushstrokes that describe her dissipate into the more painterly treatment of her companions, who are rendered in the somber tones of the shadowy room they occupy.

This carefully planned composition was not realized without effort. Eakins made eleven photographic studies, a perspective drawing, and an oil sketch of the model for the singer, thirty-year-old Margaret Alexina Harrison, one of his students at the academy.[3] The photographs reveal Eakins's close study of his model, dressed and posed precisely as in the painting, in his studio, documenting details of head, face, and shoulders as well as bodice, hand, and sheet music. Some show Margaret full-scale against a piece of fabric with a mottled pattern that appears as wallpaper in the finished canvas.

Of these photographs, by far the most revealing are three that show Margaret in a noticeably uncluttered studio with a stool, a piano, and, most important, a partial view of the unfinished painting itself (Fig. 1). Recent scholarship has shown Eakins took pains

Fig. 1. Thomas Eakins, *Margaret Harrison posing for the painting "Singing a Pathetic Song,"* 1881. Dry-plate collodion negative, 4 × 5 in. (10.1 × 12.7 cm). Courtesy of the Pennsylvania Academy of the Fine Arts, Philadelphia. Charles Bregler's Thomas Eakins Collection. Purchased with the partial support of the Pew Memorial Trust, 1985.68.2.867

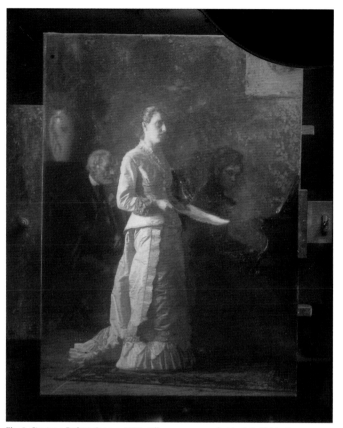

Fig. 2. *Singing a Pathetic Song*, c. 1881. Oil on canvas, unfinished, in Eakins's studio. Modern print from 4 × 5 dry-plate negative, Courtesy of the Pennsylvania Academy of Fine Arts, Philadelphia, inventory no. 87.26.52

to conceal his use of photographic studies.[4] As the conservator Mark Tucker has observed, "the apparent purpose of these self-conscious 'artist-before-the-motif' photographs seems to have been . . . to suggest that increasingly photographic-looking paintings were not photograph-dependent."[5]

A comparison of the photographed canvas with the completed painting reveals yet another aspect of Eakins's working methods: after filling out the composition with the remaining figures and details, he cut the painting to its present size. The left half of the canvas visible in Figure 1, showing the left side of Margaret's figure blocked in against a blank background, is 3½ inches wider at left and 1⅞ inches taller than the present painting.[6] As Kathleen Foster writes, Eakins marked "borders . . . after the figure was painted, demonstrating [his] tendency to generate the edges of his canvas from the inside out, in response to the forms depicted."[7] She further notes that his method prioritized the figures and space over the composition's two-dimensional design.[8]

Even after he cropped and restretched the canvas, however, Eakins continued to refine details of the picture frame and wallpaper, reworked the head of the pianist, and added his signature, as is evident in two undated archival photographs (Fig. 2).[9] The original pianist strongly resembles the artist's sister Margaret, who died in December 1882. Probably soon thereafter, Eakins reworked the figure to depict Susan Macdowell, to whom he became engaged in September of that year and married in 1884.[10] There are no known studies for the pianist or the cellist, C. F. Stolte, a well-established Philadelphia musician and cello instructor.[11]

Singing a Pathetic Song marked not only Eakins's last and most ambitious genre scene but also the culmination of his domestic views of women musicians.[12] When he exhibited it soon after its completion, nearly every critic praised its verisimilitude (though some agreed with one writer that the artist made no "concessions to the more superficial aspect of beauty").[13] Mariana Griswold Van Rensselaer called it "admirably painted, and . . . absolutely true to nature,—a perfect record of the life amid which the artist lives."[14] A single detractor, Edward Strahan (the pseudonym used by the painter Earl Shinn), criticized the singer's commonplace and rigid appearance.[15]

The painting remained in Eakins's collection until December 1885. At that time Edward Hornor Coates, a trustee of the Pennsylvania Academy and the chairman of its Committee on Instruction, paid the artist eight hundred dollars and returned to him his more controversial *Swimming* (1885, Amon Carter Museum, Fort Worth) in exchange for *Singing a Pathetic Song*.[16] The Corcoran purchased the latter painting from Coates's son-in-law John E. D. Trask two years before Coates's death in 1921.[17]

SC

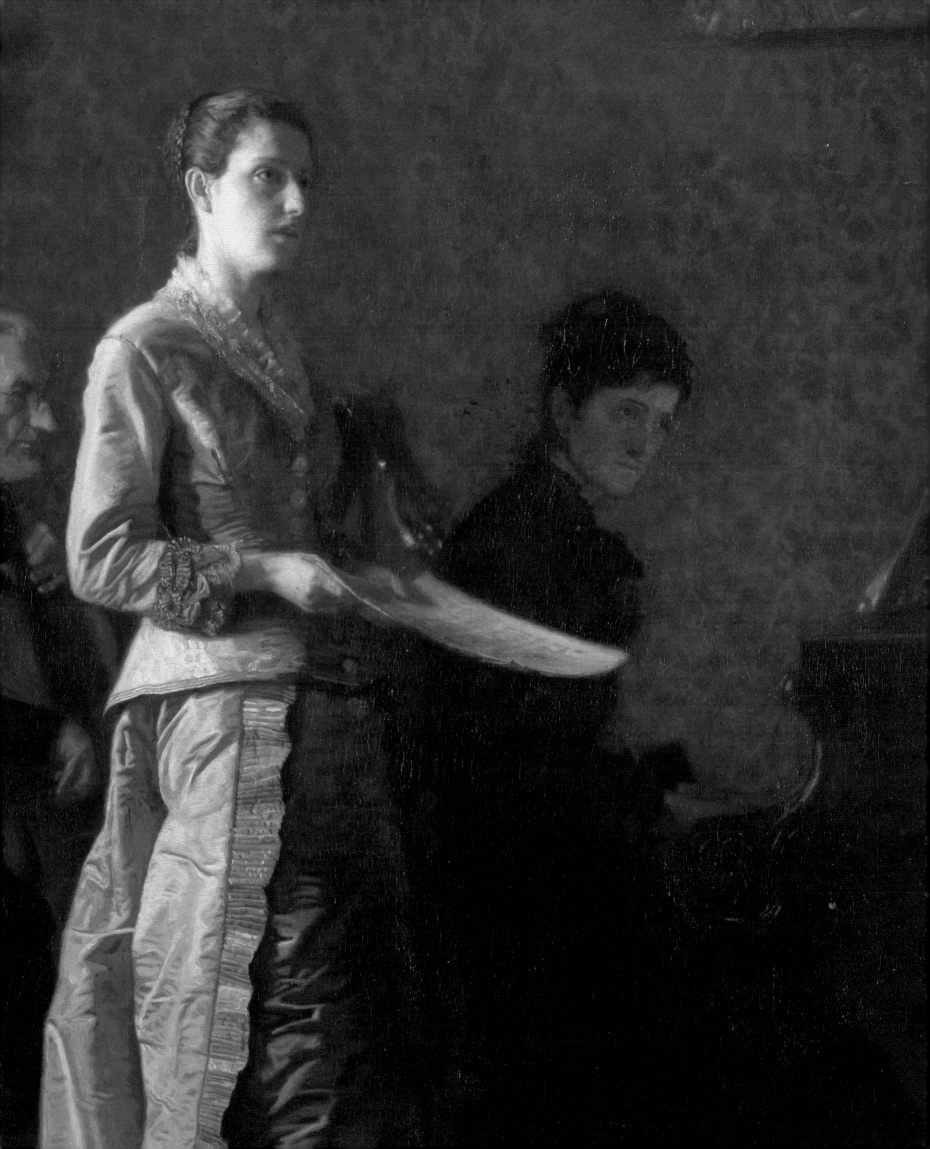

William Michael Harnett (Clonakilty, Ireland, 1848–New York City, 1892)

Plucked Clean, 1882

Oil on canvas, 34³⁄₁₆ × 20³⁄₈ in. (86.8 × 51.7 cm)
Signed and dated lower left: ᵂₘ͏HARNETT. / 1882.
Museum Purchase, William A. Clark Fund, 1977.38

William Michael Harnett painted *Plucked Clean* while he was living in Munich, in the middle of a six-year study trip during which he completed some of his best trompe l'oeil pictures, including the four versions of *After the Hunt*.[1] It was there that he developed and perfected his vertical format, in which arrays of objects, ranging from dead game to musical instruments, are seen attached to a plank wall.

Harnett's choice of dead animals as subjects was clearly influenced by the artists in the circle of Wilhelm Leibl, a German painter who advocated country subjects, rendered objectively. But Harnett's pictures also connected to dead game traditions that extended in a number of other directions: to the work of such northern European artists as Jean-Baptiste Oudry and Jan Baptist Weenix; to the Renaissance painter Jacopo de' Barbari, whose *Still Life with Partridges and Iron Glove* Harnett could have seen in the Alte Pinakothek in Munich; and to contemporary photographs by the Alsatian designer Adolphe Braun.[2] All of the vertical-format game pictures by these artists adhere to the same compositional and narrative formulas as Harnett's: one or more dead animals, sometimes accompanied by the instruments of the hunt, hang centered on a simple backdrop that closes off the distance. They have all been recently caught or killed by some anonymous person who has temporarily, sometimes casually, fastened them to a wall. Unlike taxidermied animals that are permanently installed on walls, these are fresh kills, the violence done to them only a few hours old.

Harnett's picture, however, is a wry twist on that tradition. Historically, game pictures feature a wild bird—a partridge, sheldrake, or pheasant, for example—that had to be stalked with the aid of hunting dogs, outwitted by a guileful hunter, and shot with acumen. The dead bird was a prize of the hunt as well as an emblem of the male prowess that led to its death. But Harnett's poor bird is a mere barnyard rooster that required no special cleverness to capture and kill. Instead of being elegantly arranged and hauntingly alive in death, as the traditional pictures make their birds out to be, this rooster is ignominiously plucked clean and ready to be cooked. Its raw skin is not attractive, and the few remaining feathers on the tail only underscore the recent denuding. Harnett actually magnified the inelegance in a variant picture from 1888, *For Sunday's Dinner* (Fig. 1). That bird's neck has clearly been slit, its tail feathers stripped, and its skin turned morbidly pallid. "Ironic" hunting pictures must have had some appeal in Munich, since *Plucked Clean* is extremely similar to *Plucked Hen* by Nikolaus Gysis, a Greek expatriate working in Munich (Fig. 2).[3]

Like most of Harnett's paintings, *Plucked Clean* is highly illusionistic. The bird, its feathers, and the plank backing are so meticulously painted with regard to detailing and shading that any one part of the picture has the capacity to trick viewers into believing that what they are seeing—perhaps a fluff of down or the boards themselves—is real. Technical reports on the canvas tellingly indicate that Harnett went to extreme measures to make the illusion convincing. He started by applying whitish ground that was so thick that it disguised the telltale weave of the canvas underneath. He then scored the ground vertically to physically mimic the vertical

Fig. 1. William Michael Harnett, *For Sunday's Dinner*, 1888. Oil on canvas, 37⅛ × 21¹⁄₁₆ in. (94.3 × 53.6 cm). The Art Institute of Chicago, Wilson L. Mead Fund, 1958.296

Fig. 2. Nikolaus Gysis, *Plucked Hen*, 1881. Oil on canvas, 24½ × 15½ in. (62.2 × 39.4 cm). Bayerisches Staatsgemäldesammlungen, Munich, 8084

splints in the planks. To simulate the direction of the wood grain, Harnett vertically stroked a thin glaze of pinkish brown color. Finally, dark brown and black details were painted in, wet paint on wet paint, and further details were added in opaque pigments.

Plucked Clean was found by Alfred Frankenstein, the art and music critic for the *San Francisco Examiner*, in an antique store on Sutter Street in San Francisco in 1942. Frankenstein devoted himself to the American trompe l'oeil painters of the nineteenth century, and his insistent research has produced much of what we know about Harnett.

PS

Kenyon Cox (Warren, Ohio, 1856–New York City, 1919)

Flying Shadows, 1883

Oil on canvas, 30 × 36¼ in. (76.2 × 92.1 cm)
Signed and dated lower left: KENYON COX – 1883 –
Museum Purchase, Gallery Fund, 22.2

Kenyon Cox is best known today for his conservative art criticism and his classically inspired work as a figure painter and muralist. Trained at Cincinnati's McMicken School of Art and at the Pennsylvania Academy of the Fine Arts in Philadelphia, as well as with Carolus-Duran, Alexandre Cabanel, and Jean-Léon Gérôme in Paris, Cox underwent rigorous academic studies that focused on drawing and painting the human form. While the Corcoran's *Flying Shadows*— an expansive and dynamic view of the rolling hills of the upper Ohio River valley—was a somewhat unusual subject for the artist, the visually striking canvas nevertheless offers insight into Cox's aesthetic philosophy and goals.[1]

For Cox, an academician par excellence, the figure was the basis of all art. In an 1885 letter responding to his father's urging that he focus on landscape painting as the most commercially viable of the genres, Cox explained: "I find that my figure pictures, if they are not liked, at least command attention, while my landscapes are scarcely looked at," continuing, "I prefer to struggle for what seems to me the best, rather than an easy attainment of something lower."[2] Yet *Flying Shadows*, painted in the artist's native Ohio, held a special place in his oeuvre. Cox exhibited the canvas in numerous prestigious national and international venues, including the Exposition Universelle in Paris (1889) and the Pennsylvania Academy's Sixtieth Annual Exhibition (1890), where the painting was described by one critic as "the strongest landscape we have seen from the artist's hands."[3] Cox must have felt similarly about the painting, because it was the sole landscape he submitted to these exhibitions.[4]

The critical response to *Flying Shadows* in the decade following its completion was largely positive and emphasized Cox's significant skill as a draftsman and colorist. As one reviewer wrote of the painting at its 1884 public debut, *Flying Shadows* was "broadly and magnificently painted; the effects of cloud shadows poetically caught; the whole delightfully composed."[5] *Flying Shadows* is an early example of the artist's exploration of form, color, and composition as means of conveying, as the *New York Evening Post* succinctly put it, "the large and prominent truths of the scene."[6] Indeed, the origins of Cox's better-known figural works can be found in *Flying Shadows*. As John Davis has noted, contemporary critics often described the painting in corporeal terms.[7] One writer focused on "the well modeled contours of the ground," another spoke of the "soft-bosomed Ohio hills," and yet a third described a "wild green landscape of a violently undulatory country," all phrases that evoke the human figure.[8] The soft curves and swells in Cox's landscape anticipated more characteristic works such as the 1892 canvas *Echo* (Fig. 1). The gently sloping diagonals of the seated figure's legs resemble those of the hills in *Flying Shadows*, and the tight, regular curl of the lock of hair hanging over Echo's right breast recalls the crisscross of the rail fence bisecting Cox's earlier composition.[9]

A vocal critic of modern art movements, Cox's attitude toward Impressionism sheds light on his understanding of the goals of landscape painting. "In the treatment of landscape, impressionism may still be tolerable, because light naturally plays a great role," he wrote in 1911, "but no painter who cares for the anatomy of earth or the growth and life of trees will ever be quite satisfied with it."[10] Cox eschewed those artists' interest in the visual effects of light when he thought it came at the expense of form and composition. Writing to his father from Grez, France, some decades earlier, he explained: "I do not like the effect of sunlight much anyhow preferring much [more] gray days when there is full color and everything is not eaten up with light."[11] In *Flying Shadows*, the hills form an alternating pattern of light and dark registers that articulate the "anatomy of [the] earth." In this 1883 canvas, made just months after returning from his academic studies in Paris, Cox worked through the visual possibilities of natural light while preserving the primacy of the forms it illuminates. Notably, the painter published an essay in the *Studio* later that year entitled "The Philosophy of the High Sky-Line," in which he recommended that artists utilize a "a narrow strip of sky near the horizon" (such as that in the Corcoran's canvas) as a "very serviceable" means of accurately conveying height and depth as well as ensuring "truth of tone."[12]

By the early twentieth century Cox had firmly established his reputation as a painter of classically inflected, idealized figural works, garnering important mural commissions for the World's Columbian Exposition, the Library of Congress, and several state capitols. Yet a 1901 letter from Cox to his wife, Louise, documents that the artist maintained an enduring interest in the aesthetic possibilities of landscape painting: "Oh, if only one had a little money!" he wrote. "I should so like to rest from potboiling and wait until I wanted to paint something, and do even a little landscape work again."[13]

Cox's *Flying Shadows* enjoys a distinguished provenance. In 1892 or 1893 the struggling painter sold the canvas to the prominent New York architect and designer Stanford White. In a letter dated 3 April 1892, the artist told his mother: "I met Stanford White yesterday and he said, 'I suppose, now you are going to be married, you would like business?' He has always meant to buy the *Flying Shadows* someday, and long ago gave me $100 on account. Now the other $400 will come in very handily."[14] The architect Charles Adams Platt, Cox's summer neighbor in Cornish, New Hampshire, purchased the painting from White's estate sale in 1907.[15] Finally, at the suggestion of the artist Willard Metcalf (see *May Night*), Platt approached the Corcoran about purchasing *Flying Shadows* in 1922.[16] The following year, the *New York Times* reported on the Corcoran's new acquisition, acknowledging the relative rarity of the subject in Cox's body of work and lauding the museum for its daring: "It was in line, apparently, with the present policy of the Corcoran Gallery to acquire something by a well-known painter at once characteristic of his quality and refreshing in its unfamiliarity."[17]

EDS

Fig. 1. Kenyon Cox, *Echo*, 1892. Oil on canvas, 35¾ × 29¾ in. (90.8 × 75.7 cm). Smithsonian American Art Museum, Gift of Mrs. Ambrose Lansing, 1983.114.1

John Singer Sargent (Florence, Italy, 1856–London, 1925)

Margaret Stuyvesant Rutherfurd White (Mrs. Henry White), 1883

Oil on canvas, 88⅝ × 56⅝ in. (225.1 × 143.8 cm)
Signed and dated lower right: John S. Sargent 1883
Gift of John Campbell White, 49.4

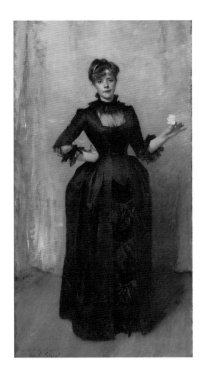

Fig. 1. John Singer Sargent, *Lady with the Rose (Charlotte Louise Burckhardt),* 1882. Oil on canvas, 84 × 44¾ in. (213.4 × 113.7 cm). The Metropolitan Museum of Art, Bequest of Valerie B. Hadden, 1932, 32.154

Henry James wrote from London in 1888: "*The* happy American here, beyond all others, is Mrs. Henry White, the wife of the First Secretary of the American legation—who is very handsome, young, rich, splendid, admired and successful, to a degree which leaves all competitors behind."[1] Born Margaret Stuyvesant Rutherfurd (1854–1916), Daisy White was from a prominent academic and social New York family.[2] Educated at home and Ashcliffe on the Isle of Wight, she was a strikingly beautiful young woman. Edith Wharton, reminiscing, wrote of seeing her at Edgerston, the Rutherfurd estate at Newport, Rhode Island: "It is hard to picture nowadays the shell-like transparence, the luminous red-and-white, of those young cheeks untouched by paint or powder, in which the blood came and went like the lights of an aurora."[3] Even in a society given over to "an almost pagan worship of physical beauty," Rutherfurd stood out, prompting in strangers "a gasp of delight at her loveliness."[4] In 1876 a photograph of her prompted Henry White, of a distinguished Maryland family, to pursue an introduction; they married in 1879.[5] The "tall bride," who possessed a "commanding voice," was "placid" and "rather eagle-eyed; family laces, French dressmakers, pearls from the bridegroom, did not lessen that detachment which seemed to express her favorite hymn . . . 'Let all your converse be sincere, / Your conscience as the noonday clear.'"[6]

Before his marriage, Henry White was devoted to sport, society, and charity. "But shortly after my marriage," he wrote, "my wife, who had an exceptionally interesting mind and a strong sense of public duty, began to talk to me of doing something useful in the world, . . . Eventually we came to the conclusion that diplomacy would be on the whole the best way in which I could serve my country, especially as she would be of great assistance to me in the pursuit of that profession."[7] Before White's inaugural diplomatic posting to Vienna in 1883, the couple lived mostly in Paris.[8]

Sargent's *Lady with the Rose* (Fig. 1) in the Salon of 1882 prompted White to choose Sargent to do her portrait.[9] There are similarities between the canvases. Both show their young subjects wearing fashionable gowns with historical overtones—that in *Lady with a Rose* echoing seventeenth-century Spanish costume, while White's white dress (in reality a mélange of grays, tans, lilacs, and blues) alludes to the eighteenth century—standing before luxuriant, warm-toned hangings.[10] The distinctions, however, are significant. White's fan and opera glasses provide the skeleton of a narrative, and her attenuated chaise longue suggests a usable interior space. More important, Sargent has made White's portrait atypically wide. As a result, she shines forth from the space around her.

Sargent began working on the painting in late 1882, intending it for the Salon of 1883 (along with the portrait of another Paris-residing American, Virginie Amélie Gautreau [*Madame X*, 1884, The Metropolitan Museum of Art, New York]). Difficulties with both, however, arose.[11] For White, family and social obligations caused her to leave for the south of France after only a few sittings.[12] Sargent pressed on when in Nice over the holidays: "I have been here over two weeks, paying my people the usual winter visit and going on with my Salon portrait for the original who was obliged to leave Paris before the portrait was half done fortunately went to Cannes."[13]

White's correspondence in early February records some of their activity, noting long sittings and the conflicting opinions of her parents and others about the picture (though all admitted "it is a most marvelous likeness").[14] After her final sitting she wrote: "Sargent came to dinner. . . . The picture is to go to Paris tomorrow as also my dress. . . . In a certain way I am sorry my sittings are over. . . . I like Sargent immensely, he is so refined, such a gentleman (somehow one does not expect to find artists exactly gentlemen!) & so clever. We are really, I hope, good friends."[15] Back in Paris, however, Sargent could not complete the portrait in time for the Salon. He wrote to White on 15 March 1883:

> This is the evening of the fatal sending in day & I have sent nothing in. Neither you nor Mme Gautreau were finished. I have been brushing away at both of you for the last three weeks in horrid state of anxiety. Your background has undergone several changes & is not good yet.
> Well the question is settled and I am broken.[16]

Sargent did indeed brush away on the canvas; obvious brushwork, apparently random when seen up close but resolving into forms with distance, fills the canvas. The picture also shows extensive reworking; Sargent modified the types and dimensions of the furniture, the position of White's arm and fan, the fall of her gown's train, and the incline of her head.[17] When he finally finished the picture, however, Sargent must have been pleased with it, for he showed it at key exhibitions in London and Paris in the later 1880s.[18]

Initial responses to the picture were mixed, some finding "all the *élan* and freshness of youth," others, that "the painting is almost metallic."[19] Many writers were struck by the size of "the very large picture," especially its width.[20] When it was on view in Paris in 1885, one critic thought the whole "un peu vide, sans doute."[21] Henry James, writing privately to an artist friend that the painting was "splendid and delightful" and "a masterpiece (*selon moi*) of style and tone," nonetheless found it "a very big canvas."[22]

White suffered from polyneuritis from 1884, although she maintained her grace and poise.[23] In March 1899, however, a particularly severe attack initiated her gradual withdrawal from social duties. She died in 1916, prompting her husband to write of her "rare nature, great and without any pettiness, wholly without feelings of jealousy, and of great heart."[24]

MS

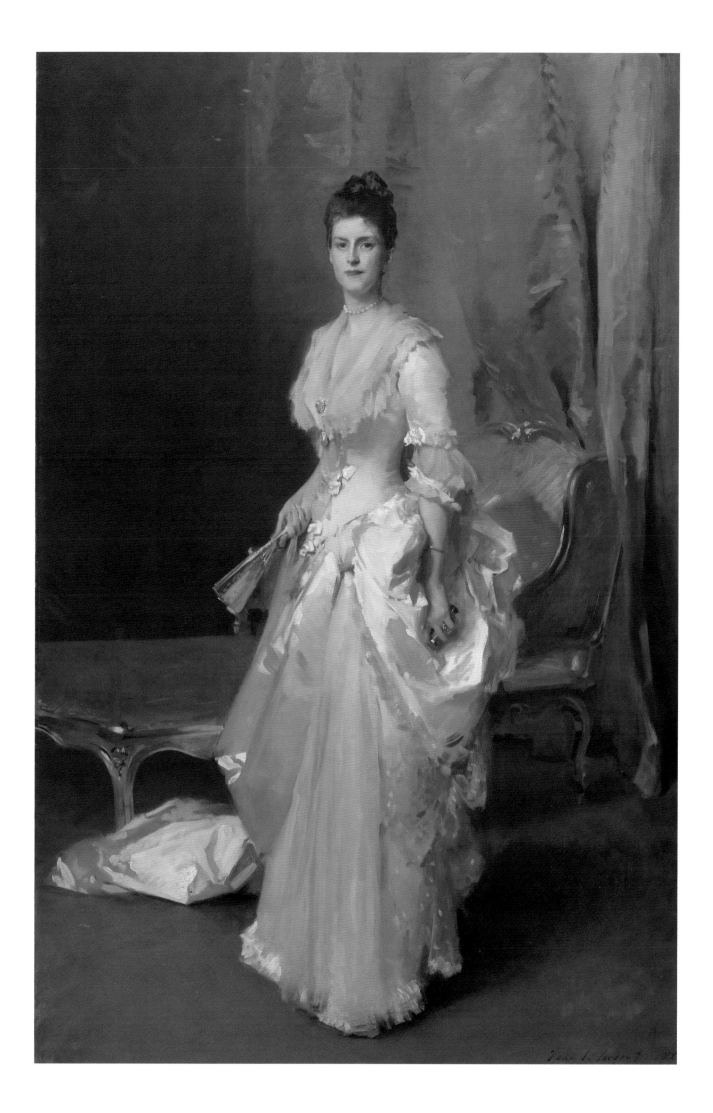

Mary Cassatt (Pittsburgh, 1844–Mesnil-Théribus, Oise, France, 1926)

Young Girl at a Window, c. 1883–84

Oil on canvas, 39⁹⁄₁₆ × 25½ in. (100.5 × 64.8 cm)
Signed lower right: Mary Cassatt
Museum Purchase, Gallery Fund, 09.8

Remembered today primarily as a painter of women and children, Cassatt made that her dominant theme only after about 1890. Before then, she explored a range of subjects drawn from her life as an upper-class American expatriate in Europe. A native of Pittsburgh, Cassatt grew up in Philadelphia and in France and Germany, where her wealthy family lived between 1851 and 1855. She began her artistic training at the Pennsylvania Academy of the Fine Arts and pursued further study in Paris under Charles Chaplin and Jean-Léon Gérôme. Edgar Degas sought her out after admiring her entry in the Salon of 1874. When, three years later, he invited her to exhibit with the Impressionists, she "agreed gladly," she recalled. "I had already acknowledged who my true masters were. I admired Manet, Courbet, and Degas."[1] The only American formally associated with the Impressionists, Cassatt participated in four of their eight exhibitions.

Cassatt was distinguished from her contemporaries by her commitment to exploring all the stages of a woman's life. Whereas other painters, especially men, tended to depict only beautiful young women, Cassatt portrayed women of all ages and of varied appearances. The fresh-faced model in this painting, identifiable by her full lips, prominent teeth, and (in other works) auburn hair, posed for at least nine pictures by Cassatt between about 1882 and 1885.[2] She is thought to have been Susan, the cousin of Mathilde Valet, an Alsatian housekeeper who worked for Cassatt beginning in 1882.[3] Here, she holds Cassatt's pet Belgian griffon, which Degas obtained for her from his friend the painter and dog breeder Ludovic Lepic.[4]

The details of the railing and the cityscape behind the model suggest that the work was painted on the uppermost floor of 2, rue Duperré, where Cassatt had a studio in the 1880s.[5] The building's main facade opens onto the place Pigalle on the edge of Montmartre. Artists including Degas and Pierre-Auguste Renoir had studios in the neighborhood and congregated at the Café de la Nouvelle Athènes on the square. The young woman's garments are in the height of fashion. Although her hat and gown are essentially white, Cassatt explores the range of hues produced by sunlight playing over the fabric. Touches of blue describe the shadows on the dress, while the hat shimmers in luscious tones of violet and pink. Cassatt's varied brushwork distinguishes between the smooth, blended paint on the model's face and the broadly worked, more heavily textured costume and background.

The Corcoran's painting is most likely the one shown in the last Impressionist exhibition, held in Paris in 1886, as *Jeune Fille à la Fenêtre* (*Young Girl at a Window*). It was lent to that exhibition by a Monsieur Berend.[6] One review of the exhibition raises questions, however. "The *Jeune fille à la fenêtre* [is] graceful and flourishing like a young plant in full bloom," Gustave Geffroy wrote. "[She] stands wearing a white straw hat enveloped in gauze."[7] The model is seated and her hat does not appear to be straw, but those could have been natural mistakes by a critic relying on memory and scribbled notes to review an exhibition of 246 works. Another contemporary's comments link the Corcoran's painting more securely to the Impressionist exhibition. Using a title that better describes the work, George Auriol wrote, "Mary Cassatt is showing a very pretty *Femme au chien* [*Woman with a dog*]. This woman is at her window, lit by full sunlight.

Indifferent to the people swarming below, she is lost in distant reverie."[8] A third critic raved, "Look at the young girl at the window: her lips breathe, her eyes have the moist and mobile flash of life, her hat adorned with white gauze and pink silk has the delicacy of a flower in bloom."[9]

After 1886 the painting did not surface again until 17 January 1900, when its owner, Dr. George Viau, sold it to the influential Paris dealer Paul Durand-Ruel.[10] The gallery sent the canvas to the United States, where it was shown at the Pennsylvania Academy of the Fine Arts' annual exhibition in early 1903 as *La Femme au Chien*. One Philadelphia reviewer called it "brilliantly well painted . . . , while at the same time preserving what seems to be an excellent likeness of an interesting personality."[11] The *Public Ledger* described the painting as "one of those problems in light of which Miss Cassatt is so fond and which she manages so well."[12] The *Studio* declared it "faultless in drawing and original in color scheme."[13]

Durand-Ruel included the canvas in its *Exhibition of Paintings and Pastels by Mary Cassatt* at its New York galleries in 1903. "[T]he beautiful picture called 'La Femme au Chien'. . . seems almost an echo of Degas," the *Daily Tribune* critic wrote, adding that it was "undoubtedly [Cassatt's] best production."[14] Durand-Ruel again presented the painting in Cassatt's solo exhibition in 1906; a reviewer commented, "A woman in a white dress, 'Femme au Chien,' discloses a delicate scheme of values well maintained."[15]

Durand-Ruel had lent Cassatt's *Woman and Child* (now *Reine Lefebvre Holding a Nude Baby*, 1902, Worcester Art Museum, Mass.) to the Corcoran's first biennial, held in 1907; after the exhibition closed, the Corcoran purchased it for the permanent collection.[16] Durand-Ruel sent *La Femme au Chien* to the second biennial, which opened in December 1908. In January 1909 the Corcoran arranged to acquire *La Femme au Chien* in partial exchange for *Woman and Child*. Replying to an inquiry from Corcoran director F. B. McGuire, a Durand-Ruel representative wrote, "In spite of the greater importance of . . . 'La femme au chien,' and the very low price that was quoted specially to your museum, I am willing to make an exchange between the two [paintings] upon payment of the difference of $250. in their prices."[17] With that transaction, the Corcoran replaced a painting on what had become Cassatt's signature theme with a masterly example of her earlier work.

SGL

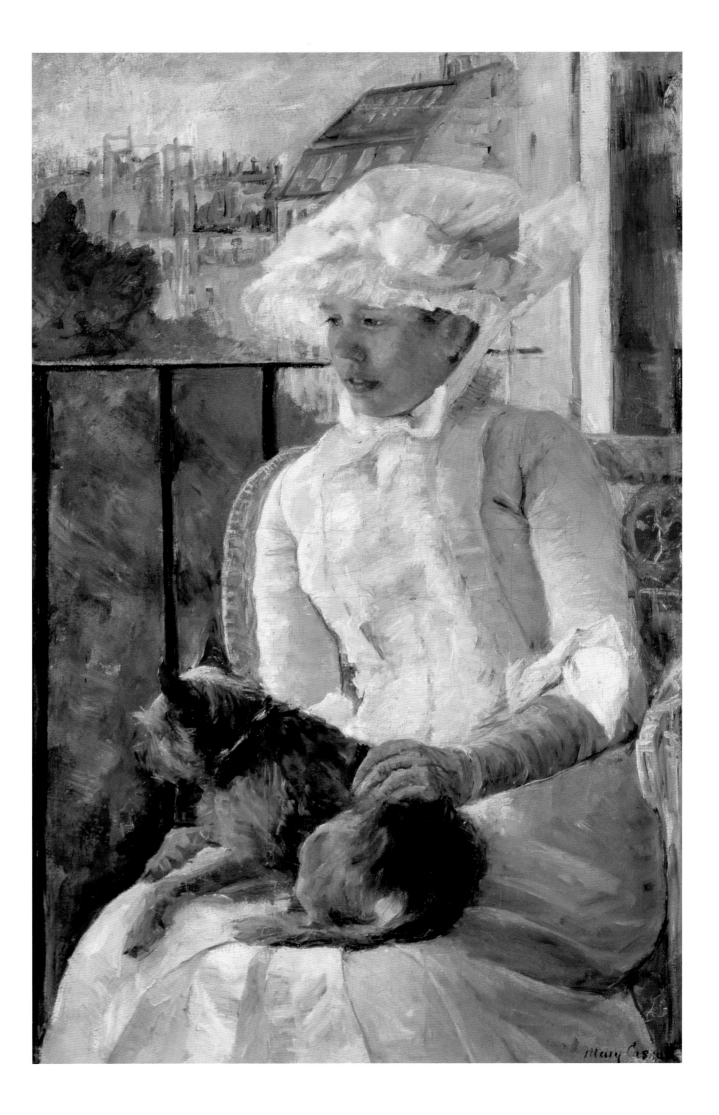

In the Land of Promise, Castle Garden, 1884

Oil on wood panel, 28⅜ × 36 in. (72 × 91.4 cm)
Signed and dated lower left: Copyright by Charles F. Ulrich. ANA / .1884.
Museum Purchase, Gallery Fund, 00.2

Charles Ulrich established his reputation as one of New York's leading artists in the early 1880s with a series of carefully observed images of working-class life. *In the Land of Promise, Castle Garden* is Ulrich's most complex and ambitious composition from this period and the artist's most celebrated painting. Described by one critic as "the strongest, heartiest art product of the year,"[1] *In the Land of Promise* was awarded the first Thomas B. Clarke Prize for figure painting from the National Academy of Design in 1884, an honorable mention at the 1889 Paris Exposition Universelle, and a medal at the World's Columbian Exposition in Chicago in 1893. Moreover, Ulrich's picture reached countless American households when it was reproduced as a wood engraving in the 2 February 1889 issue of the popular illustrated periodical *Harper's Weekly*.[2] A rare nineteenth-century painted depiction of the experience of émigrés arriving in the United States, *In the Land of Promise* offers a sympathetic view of the immigrant plight in an era in which the "promise" of the New World was called into question by nativists and newcomers alike.

Born in 1858 in New York City, Ulrich was the only son of Germans who had fled their native land in the revolutionary year of 1848. Perhaps with the encouragement of his father, a professional photographer, Ulrich enrolled in the National Academy's School of Fine Arts in 1873. Around the age of fifteen, the precocious painter left the United States to continue his schooling at the Munich Academy, where he joined other American artists-in-training such as William Merritt Chase and Frank Duveneck. Ulrich studied at the academy for several years, becoming a master of the precisely delineated realism that dominated contemporary German art.[3]

The Munich School's stylistic and thematic attention to the humble details of everyday life had a profound influence on Ulrich, as did the legacy of seventeenth-century Dutch art. When he returned to the United States sometime between 1879 and 1882, the artist began a series of highly finished genre pictures executed on wood panels. Ulrich often sought subjects that showed a side of life

ignored by his artistic contemporaries, whose images typically consisted of more lighthearted scenes of upper-class leisure.[4]

Castle Garden, the locale depicted in the Corcoran's painting, had been a center of political, social, and cultural activity throughout the nineteenth century. Located on the southernmost tip of Manhattan, the circular stone structure was originally built by the federal government in 1808 to defend New York Harbor against attack. In the early 1820s Castle Garden was turned into a leisure park and concert hall, serving as the setting for such popular entertainments as the American debut of the world-famous Swedish soprano Jenny Lind. In 1855 the Board of Commissioners of Emigration transformed Castle Garden into an official landing depot, where the city's rapidly growing foreign population could "depart for their future homes without having their means impaired, their morals corrupted, and probably their persons diseased."[5]

Ulrich's multifigural composition depicts a sample of the millions of ethnically diverse immigrants who passed through Castle Garden's gates between 1855 and 1890. The landing station's waiting area is filled with these pilgrims, who converse in small groups or rest on benches and trunks, whiling away the hours until local officials inspect and register them. The pictorial drama focuses on four figures in the foreground: a young Swedish mother nursing her infant,[6] an old soldier pulling at his pipe to her left, and a slight girl on a trunk behind mother and baby seated in a position that suggests both inquisitiveness and unease. The weary and anxious expressions on the older figures' faces imply that their futures and fortunes in America are still uncertain. Indeed, as one critic wrote of Ulrich's painting, "He calls it 'The Land of Promise,' but there is no suggestion in the work itself of any milk-and-honey prospect for the uncouth, awkward immigrants, whose condition is more to be commiserated than envied."[7]

Just two years before Ulrich completed *In the Land of Promise*, the federal government had passed the first national immigration

Fig. 1. William St. John Harper, *Castle Garden—Their First Thanksgiving Dinner*, *Harper's Weekly* 28, no. 1458 (29 November 1884): 783. Provided courtesy HarpWeek

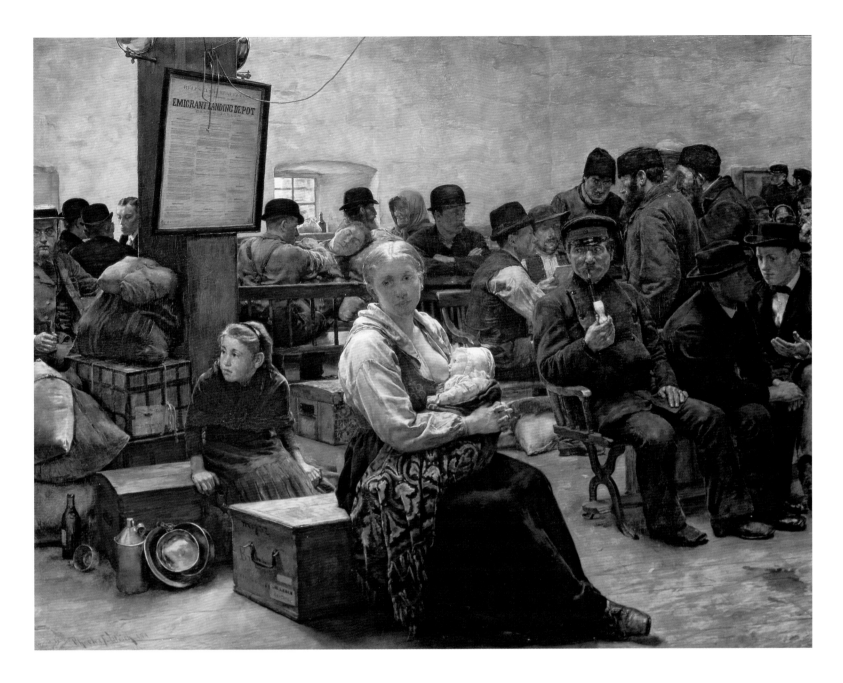

law imposing restrictions on the number and nationality of people allowed into the country. Fueled by a strong lobby concerned that the nation's population was growing faster than its economy, restrictionist sentiment played an increasingly powerful role in turn-of-the-century immigration policy. The plight of foreigners was likely of particular concern to Ulrich, the son of German émigrés,[8] and to his patron, William T. Evans, a leading collector of contemporary American art and a naturalized American citizen born and raised in Ireland.[9]

Ulrich portrays the figures in his painting with a dignity that defies their humble origins and trying circumstances. In particular, the young Swede nursing her baby recalls her famous compatriot Jenny Lind;[10] with the sunlight streaming in from above and surrounding her head like a halo, she also suggests a secular Madonna. By choosing a nursing mother as his protagonist, rather than one of the many men coming to America in search of work, the painter put a sympathetic face on the immigrant plight.[11] William St. John Harper's wood engraving *Castle Garden — Their First Thanksgiving Dinner*

(Fig. 1), published in *Harper's Weekly* just months after the completion of *In the Land of Promise* and undoubtedly inspired by the central figures in Ulrich's widely known composition, reiterates the painter's strategy of calling forth the traditional ideal of family to gain the compassion of his audience.[12]

Despite critical and financial successes like *In the Land of Promise*, in 1885 Ulrich left America "with proclaimed disgust at the sordidness of an unappreciative public" who lamented that the artist had "descended to subjects that, however well they are executed, are devoid of all charm, either as suggestive of agreeable ideas, as objects of beauty, or as pleasing realism."[13] The artist remained in Europe for the rest of his life, rejecting the socially engaged themes that were his trademark in favor of picturesque genre scenes painted in a looser, more romantic style. As Edward J. Nygren and Andrea C. Wei have noted, "it is ironic that [Ulrich], like many of his artistic contemporaries, sought his artistic land of promise abroad."[14]

EDS

Ralph Albert Blakelock (New York City, 1847–Elizabethtown, N.Y., 1919)

Moonlight, 1886/1895

Oil on canvas, 27¹⁄₁₆ × 37¹⁄₁₆ in. (68.5 × 94 cm)
William A. Clark Collection, 26.8

Moonlight is widely acknowledged to be among the finest of Ralph Albert Blakelock's many renderings of this romantic theme. The exceptional nature of the painting was first noted in Blakelock's lifetime; his friend the painter Elliott Daingerfield noted that "In the profession it has been called a perfect moonlight. . . . Its beauty depends quite entirely on the sky,—there is little else."[1] Blakelock also favored sunset and twilight scenes; his paintings in these three genres—all undated, but probably painted between the mid-1880s and 1899—make up nearly two-thirds of his output of pure landscapes.[2] Despite his modest output and his nominal success, which grew slightly in his later years, as well as his posthumous inclusion in the canon of American painting, on the whole Blakelock endured a tragic life and career.

The son of a homeopathic physician, the New York City native studied medicine at the Free Academy of the City of New York (now the City University of New York) for a short time before turning to painting. With the exception of some instruction from the self-taught landscapist James A. Johnson, Blakelock was untrained. However, he achieved a level of proficiency that allowed him, at age twenty, to have a painting accepted for exhibition at the National Academy of Design, New York's premiere art venue, where he would exhibit throughout his life. Although he garnered some early success painting landscapes in the style of the Hudson River School, his often melancholy canvases became increasingly unconventional in subject and technique as well as variable in quality. Over time, their meager popularity in the art market diminished, and emotional problems began to plague the father of nine. In 1891 the artist suffered his first mental breakdown, and from 1899 throughout most of the rest of his life, he was institutionalized for schizophrenia. Ironically, during his illness Blakelock's work achieved greater critical and commercial success than it had earlier (a situation that led to numerous forgeries).

The Corcoran's painting boasts all of the hallmarks of Blakelock's most successful moonlight compositions. A dark, thin strip of shore in the foreground curves around a glistening body of water in the middle ground. At left, three delicate, silhouetted trees break the low horizon and introduce a sweep of movement into the right distance under the expansive sky, which occupies more than four-fifths of the picture plane. The ethereal glow of a full moon, seen through a thick, nearly palpable, cloudy haze, is mirrored in the lake or river and suffuses the entire scene, effectively becoming its subject. The strong contrast of bright moonlight with the foreground's deep, murkily rendered shadows creates an aura that is by turns romantic and ethereal, stark and desolate. The almost lacelike and (for Blakelock) rather short and sparsely foliated trees, whose careful delineation manifests the artist's characteristic attention to their growth patterns, contribute to the sense of an uninhabited and even uninviting stretch of land.[3]

The painting's strongly mystical, even primeval, mood is heightened by Blakelock's style and his experimental technique of accretion. His freely handled brushwork and nondescriptive application of paint mitigates the viewer's ability to see detail and form. In the sky, water, and land, the work's surface is very active, with layers of richly textured and toned areas of thick, opaque paint applied with a brush and palette knife; in contrast, the sun is rendered as a smooth, round disk of paint. In some passages, the artist scored the paint with a sharp tool, perhaps the end of a brush, and in other areas, he rubbed and abraded the surface, allowing the ground and texture of his canvas to show through.[4] He created tonal atmospheric effects by covering the underlayers with multiple glazes of dark, resinous paint. Typical of his working method, the artist did not wait for the paint to dry before applying additional layers. Indeed, as Mark Mitchell has noted, although Blakelock was appreciated as a colorist in his day, his nocturnes are now better known for their dark, nearly monochromatic appearances due to the ephemeral effects he achieved by experimenting with such unstable materials as transparent bitumen. These darkened appearances, in fact, amplified the artist's reputation for the melancholy.[5]

Much has been written about how Blakelock and his paintings such as *Moonlight* are to be understood within the history of American art. Grouped by some modern scholars with American Barbizon and Tonalist painting, the art of his mature period has most often been compared with that of the French Barbizon School, which he may have known through visiting exhibitions or collections of their work or through prints.[6] Blakelock shared with these artists a fascination with evoking the poetry of mood, often in crepuscular or nocturnal scenes. Also like them, he favored painting imaginary, generalized, or remembered views, including his moonlights. His daughter Marian described one of them as manifesting his "artistic imagination," which she characterized as "so unusual . . . that . . . he conceived the idea of painting [the moonlight] from a bathtub. . . . He saw this picture in black and white, and getting his paints out laid the foundation for this Moon-Light picture."[7] The artist's wife, Cora, supported her daughter's statement and allowed that her husband "saw pictures everywhere, in an old board, a piece of rusty tin, a stone, in everything he could see a picture."[8]

The importance of *Moonlight* in Blakelock's career, signified by its notable early exhibition history and critical mentions, is matched by its role in the exploding secondary market for his work following his institutionalization in 1899.[9] Desperate for income when his eighth child was born about 1895, the artist sold the painting to his devoted friend and patron Harry Watrous. Watrous, in turn, sold it to the prominent American art collector William T. Evans in 1896 for $600; Evans sold the painting to the Corcoran benefactor William A. Clark in 1913 at the American Art Galleries for $13,900, the highest auction price paid to date for the work of a living American artist.[10]

SC

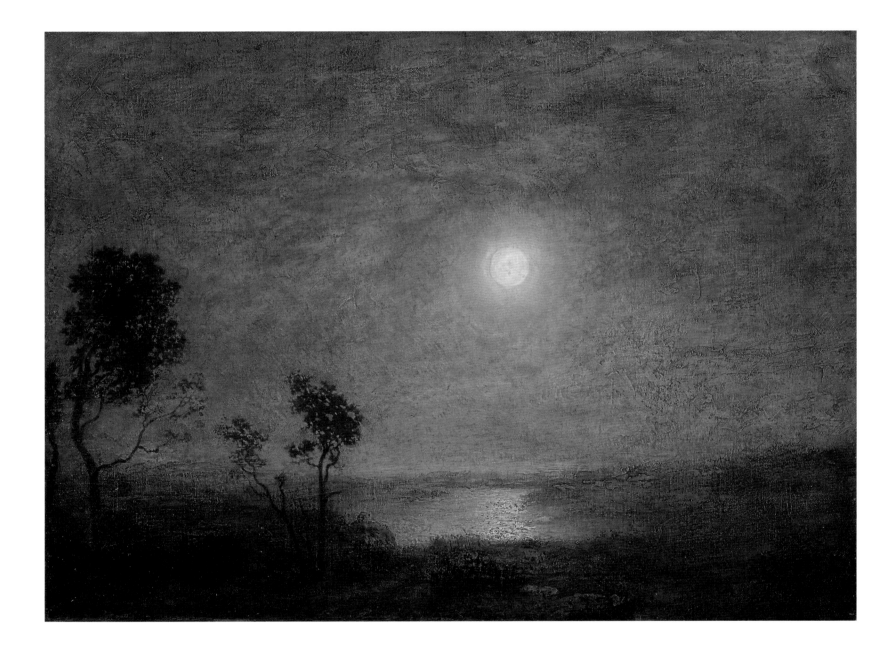

Albert Bierstadt (Solingen, Germany, 1830–New York City, 1902)

The Last of the Buffalo, 1888

Oil on canvas, 71 × 118¾ in. (180.3 × 301 cm)
Signed lower right: Albert Bierstadt
Gift of Mary Stewart Bierstadt (Mrs. Albert Bierstadt), 09.12

The Last of the Buffalo is one of Albert Bierstadt's final western showpieces and a work he described as one of "my best efforts."[1] He unveiled it at the Union League Club in New York in 1889 and then submitted it to the Art Committee for inclusion in the American section of the Exposition Universelle in Paris that spring.[2] The committee's rejection of the painting on the grounds that it was too large and did not "represent him as he should be in a national exhibition like this one" created a firestorm in the press, which accused the committee of professional jealousy and artistic snobbery.[3] The painting's hyperrealism, large scale, and dramatic subject matter ran directly counter to the new, French Barbizon–influenced style of the younger generation of painters on the Art Committee, who favored small-scale, painterly, suggestive works. Bierstadt claimed indifference to the verdict and offered his canvas to the Paris Salon, where, because he was a member of the Legion of Honor, his submissions were automatically accepted.[4] Most likely in response to the controversy, Bierstadt let it be known that the painting was sold that fall for fifty thousand dollars to John Thomas North, a British mine speculator.[5] The artist then took the painting on tour to Washington, D.C. (where it was shown at the Corcoran Gallery of Art), and Minneapolis, where it was received more favorably.[6]

The painting's whereabouts for the next two decades are unknown. Although Bierstadt made a point of justifying the painting's value in spite of the Art Committee's rejection by saying, "there is only one *Last of the Buffalo*," there are, in fact, two: the Corcoran's and the slightly smaller version at the Buffalo Bill Historical Center in Cody, Wyoming (Fig. 1).[7] The relation between the canvases is not entirely clear. In 1889, during a studio interview, Bierstadt identified the Wyoming version by saying, "That is the study . . . for the picture now in the Salon."[8] Technical examinations, however, reveal that the artist worked on both paintings at the same time. For instance, infrared reflectography shows that Bierstadt added antelope to each

painting and then removed them. Pentimenti on both canvases show that Bierstadt struggled to realize the depth of the pictorial space.[9] The conservators Dare Hartwell and Helen Mar Parkin suggested that he began the canvas now in Wyoming and, unsatisfied with its rendering of space, copied it onto a slightly larger canvas, then brought the two to completion simultaneously.[10] The similarity of the two compositions and the slight, but proportional, difference in size— the lone bison standing at left in the Cody version, for instance, is 10 percent smaller than the same animal in the Corcoran version— suggest that Bierstadt may have used mechanical means to assist in his project. Indeed, the Corcoran curator William MacLeod recorded a conversation with the artist in which Bierstadt recommended to him the use of lantern slides to project an image for reproduction in oil on canvas.[11]

Scholars had long assumed that the Corcoran's painting was the work purchased by North and hung at Avery Hill, his home in Kent. However, a recently discovered illustrated catalogue from the sale of North's estate in 1898 confirms that North actually owned the painting now in Wyoming.[12] North likely took possession of his painting following its exhibition at the Hanover Gallery in London in 1891, when the painting's sale, particularly the steep price the patron was said to have paid, was widely reported in papers from London to Chicago.[13] The first notice of North's purchase had come earlier, in September 1889, following the exhibition of the Corcoran's painting at the Paris Salon. This raises the possibility that North intended to purchase the Corcoran's painting but received delivery of what Bierstadt termed the "sketch" instead. In 1908 the Corcoran's version of the painting was offered in New York at the estate sale of Edward Bierstadt, the artist's brother, and purchased by D.G. Reid (probably Daniel Gray Reid, the "Tin Plate King");[14] the following year, Bierstadt's widow, Mary, gave it to the Corcoran.[15]

Fig. 1. Albert Bierstadt, *The Last of the Buffalo*, c. 1888. Oil on canvas, 60¼ × 96½ in. (153 × 245.1 cm). Buffalo Bill Historical Center, Cody, Wyoming, Gertrude Vanderbilt Whitney Trust Fund Purchase, 2.60

Fig. 2. John Mix Stanley, *Buffalo Hunt on the Southwestern Prairies*, 1845. Oil on canvas, 40½ × 60¾ in. (102.8 × 154.3 cm). Smithsonian American Art Museum, Gift of the Misses Henry, 1985.66.248,932

Mary Bierstadt's efforts to have *The Last of the Buffalo*, rather than another of her late husband's works, placed at the Corcoran suggest its significance in Bierstadt's oeuvre. Aspects of the painting itself also signal its importance. The canvas is particularly large, even for Bierstadt, and contains an ambitious landscape that inventories nearly every salient feature of the Great Plains, from the dry, rocky meadow in the foreground to the verdant banks of the river in the middle ground to the far foothills, plateaus, and snowcapped peaks. Likewise, the fertile landscape is home to a profusion of wildlife, including elk, antelope, fox, rabbits, and even a prairie dog (one contemporary critic pronounced it a painting "whose interest is ethnological and zoological rather than artistic"[16]). In addition to presenting an encyclopedic account of the flora and fauna of the plains, Bierstadt's painting also pays homage to earlier works of western American art, with which he was almost certainly familiar from a variety of illustrated publications as well as from the wealth of western-themed artworks and artifact collections on view in Washington, D.C., museums and New York galleries. The compositional format of bison and mounted hunter moving in unison across the canvas from right to left, parallel to the picture plane, was frequently repeated by western American artists from the early illustrations of Titian Ramsey Peale through George Catlin, Alfred Jacob Miller, and Seth Eastman. John Mix Stanley's *Buffalo Hunt on the Southwestern Prairies* (Fig. 2), which similarly poses the hunter on a white horse with raised lance, was on view in Washington, D.C., in the 1860s and likely for years thereafter and may have provided an inspiration for Bierstadt's composition.[17] Bierstadt's studies show that he experimented with the exact pose of the hunter, at first positioning him slightly more upright (Fig. 3). He also gave his hunter heavier musculature and experimented with a more classical nude or buckskin-clad leg. In the end, Bierstadt altered his composition in ways that magnified the sense of tragedy and mutual destruction. He reversed the direction of the bison, depicting the moment at which the hunter's lance and the bison's horn each plunge into their targets. The hunter's arched back and outstretched arm echo the line of his lance and create a diagonal that extends through the horse's torso and forelegs to the bison's hind leg, which, ironically, bolsters the sense of the animal's forward momentum as it gores the rider's horse and, at the same time, amplifies the force of the lance impaling him. Stanley's composition similarly uses a line running from the lance through the horse's head to the bison's foreleg, uniting the figures of hunter and prey. By reversing the direction of the bison and bending his hunter backward and inward, Bierstadt creates a longer, more elegant line that helps emphasize the presence of his central figural group.

Native American subjects, presented as genre or quasi ethnography, were the stock-in-trade of the first generation of artists painting the American West, but Bierstadt only occasionally included suggestions of Indian life in his early works, as in the tepees in the foreground of his first western showpiece, *Rocky Mountain, Lander's Peak* (1859, The Metropolitan Museum of Art, New York). His decision to focus on Indians in this painting recalls the work of his predecessors and, more generally, the history of western American art.

Fig. 3. Albert Bierstadt, Figure Study for *The Last of the Buffalo*, 1888. Oil on paper, 13¼ × 19³⁄₁₆ in. (33.7 × 48.7 cm). Corcoran Gallery of Art, Museum Purchase, by exchange: Mrs. J. Laurence Laughlin, and Mr. Louis E. Shecter, 1994.16.2

Others have also noted his composition's similarity to a classical frieze in its relatively flat space, profile figures, and classical physiques.[18] Bierstadt's allusion to the history of western American art and western art as a whole helps gives the painting an added sense of gravitas beyond that granted by its environmental scope and monumental scale.

The art historian Linda Ferber has observed that Bierstadt's painting succeeds because it is "a masterfully conceived fiction that addressed contemporary issues."[19] When Bierstadt painted *The Last of the Buffalo*, the number of bison on the plains had been reduced to only a thousand from sixty million at the beginning of the century. In 1886 the Smithsonian Institution biologist William Hornaday spearheaded a call for bison conservation after he traveled to the plains in search of specimens for taxidermy and returned almost empty-handed. Hornaday published his influential tract *The Extermination of the American Bison* the following year and mounted an exhibition on the subject for the Cincinnati Exposition in 1888. He even attempted to establish the animals on the grounds of the Smithsonian Castle as a means of preserving the species.[20] Bierstadt, who was familiar with Hornaday's efforts, shrewdly capitalized on interest in bison preservation by voicing his own conservationist clarion call in the form of *The Last of the Buffalo*. His title is not intended as a paradox; if efforts to preserve the species were unsuccessful, the painting would itself be the last of the buffalo.[21]

In this sense, as Ferber notes, Bierstadt's painting does not imagine bison of the past so much as it attempts to conjure them into the present.[22] Indeed, the sheer force of will Bierstadt evinces by creating so many animals on his canvas and the detail with which he renders their textures, colors, and forms suggest not a nostalgia for what is past so much as a desire to restore what has

been lost to the present. The essayist Henry Guy Carleton, whose article in the *New York World* Bierstadt had reprinted as a brochure for distribution at his exhibitions, exulted in the scale of Bierstadt's act of creative restoration by composing his own sublimely palpable text: "Hear that muffled thunder from the vast slope of the plain above?" he asked,

> it is the voice of those billowing, dun-colored clouds which you know are dust arising from the trample and rush of ten thousand hoofs—a living cataract pouring down from the table-land to the valley, eager for the grateful coolness of the stream, never ceasing its movement and roar—all buffalo. The very hills are crawling, the pools are seething masses of brown, the broad meadows a swirl and sweep of currents and eddies of life, whose tide sets ever onward and onward—yes, count them if you can—all buffalo.[23]

The intensity of the artist's efforts to resuscitate the bison intimates that a more personal metaphor may be operating beneath the surface of the painting. The bison were a dying breed, but so, too, was Bierstadt. As early as 1880 critics characterized Bierstadt as out of fashion, grouping him with an older generation who were being rapidly eclipsed by younger painters. Commenting on the Union League's annual exhibition for 1888, one reviewer quipped that Bierstadt's submission was an interesting example of "the dreadful things which were considered good art less than a generation ago."[24] More fashionable works, such as John Singer Sargent's *Margaret Stuyvesant Rutherfurd White (Mrs. Henry White)* and Kenyon Cox's *Flying Shadows* (see essays for both in this catalogue), which were selected for inclusion in the American section of the Exposition Universelle, were more contemporary in subject matter or smaller in scale and, in the case of the paintings by Sargent and Cox, softer in focus. In the context of such works, Bierstadt's landscape subject and panoramic scale do more than adhere to an older style; they flaunt it. As such, *The Last of the Buffalo* is not simply a poignant evocation of a lost West, nor is it merely a stubborn, misguided attempt to continue working in an outmoded style. Rather, it can be understood as a stylistic last stand, akin to the genre of vernacular imagery depicting George Armstrong Custer's futile resistance to the Lakota and Northern Cheyenne in the 1876 Battle of the Little Bighorn, and also as a complement to the last-stand images of Frederic Remington, which originated with his *Last Lull in the Fight* (1888, location unknown), a silver medalist at the Exposition Universelle.[25]

Whether coincidence or perhaps just a fable, it seems significant that the Corcoran's painting was said to have found an admirer in Rocky Bear, a Lakota participant in Buffalo Bill's Wild West Show—which also included Sitting Bull and Red Cloud, veterans of the Battle of the Little Bighorn—while it toured Europe in 1889. Rocky Bear saw the painting at the gallery Boussod, Valadon et Cie in Paris (which prepared a plate of the painting for reproduction as a photogravure, copyrighted 1891) following the close of the Salon.[26] According to the *New York Times*, Rocky Bear and his companions went to the gallery each day to visit the painting. Rocky Bear was said to have praised Bierstadt for "giving breath and life to the

glorious past of the redskin and to the buffalo, when the Indian was master to all he could survey."

The article continues:

> Our artist is undoubtedly accustomed to success, and the poor Indian's tribute to admiration is a modest one; yet it is pleasant to learn that these men of the plains leave their tents in the Cody camp each morning to come and breathe the air—as they put it—of their native soil; and their . . . satisfaction after a silent half hour of contemplation should be a joy to the painter's soul, for it is a recognition of the truth of the scene and is eloquent to its sentiment and poetry.[27]

LS

George Inness (Newburgh, N.Y., 1825–Bridge of Allan, Scotland, 1894)

Sunset in the Woods, 1891

Oil on canvas, 48⅛ × 72⅛ in. (122.2 × 183.2 cm)
Signed and dated lower left: G. Inness 1891
Museum Purchase, Gallery Fund, 91.10

This picture, like many others by George Inness, made its way into the American consciousness through the agency of the New York collector, patron, and dealer Thomas B. Clarke. Inness, who began his career studying with the Hudson River School landscapist Régis François Gignoux and then at the National Academy of Design, traveled extensively in France and Italy in the 1850s, becoming one of the leading American exponents of the French Barbizon style. In an era in which European art was in vogue, Clarke assiduously promoted "the Younger Men," American painters such as Winslow Homer, A. H. Wyant, and, most enthusiastically, Inness.[1] Letters between Clarke and the Corcoran tell the intriguing backstory of the museum's acquisition of *Sunset in the Woods*. In March 1891 Clarke approached the officers of the museum with an offer of "the great forest picture," an extraordinarily large work by the artist.[2] At the time, Inness was away on a trip to California, and Clarke, acting as his agent, assured the Corcoran that the painting would "reach a triumphal finish" when the artist returned to his studio in Montclair, New Jersey. In early June, Clarke notified the museum that the picture, then titled *Sunlit Forest*, was now complete, that Inness thought it his "masterpiece," and that "the frame is being overhauled."[3] In July Frederick B. McGuire, a trustee on the acquisitions committee, looked at the picture.[4] From a letter to Samuel Hay Kauffmann, the Corcoran's president, it seems that the museum suggested— or requested—that the title be changed to the present one before paying Clarke the purchase price of five thousand dollars.[5]

During the acquisition process, Inness explained, via Clarke, the genesis of the picture. Perhaps the letter was part of the sales pitch; certainly it was an unprecedented occasion to hear Inness speak in detail about one of his pictures. "The motive for the picture was taken from a sketch made near Hastings Westchester Co. over twenty years ago. I commenced this picture several years since, but until last winter I had not obtained any idea commensurate with the impression received on the spot. . . . The idea is to represent an effect of light in the wood towards sundown but to allow the imagination to predominate."[6] As was his way, Inness allowed memory to inflect his landscape compositions. The twenty-year-old sketch (location unknown) was likely useful to Inness as a means of documenting emotional "impressions" that day in Hastings. To paint the great canvas, however, he had to wait for an imaginative "idea" to emerge, what the art historian Nicolai Cikovsky has described as "the fusion of subjectivity and objectivity, feeling and fact, suggestion and precision."[7] Unlike Hudson River School landscapists of the previous generation, Inness fully embraced imagination and thought it superior to description. "A work of art," Inness stated in 1878, "does not appeal to the intellect. It does not appeal to the moral sense. Its aim is not to instruct, not to edify, but to awaken an emotion."[8] As a devotee of the teachings of the eighteenth-century Swedish mystic Emmanuel Swedenborg, Inness came to think of painting as the instrument of metaphysics, the method for penetrating into a spiritual world, ordinarily unseen, that lies within the "outer facts" of the material world, but that can be unlocked by the spiritually receptive.[9]

Fig. 1. Unidentified artist, drawing after George Inness, *In the Woods*, in *National Academy Notes and Complete Catalogue*, 5 April – 15 May 1886, 82. National Gallery of Art Library, Washington, D.C.

To radiate the "inner life" of *Sunset in the Woods*, Inness evolved a unique painting technique, which a contemporary described as "that rapid brushwork—that scrubbing, rubbing, spreading of the paint across the canvas without seeming to lift the brush from its surface which I have never seen anyone else do in anything like the same way."[10] Uncontained by tradition, Inness's instinctual brushwork bypassed superficial description and endowed his pictures with mystery: the pulsing caress of light on old tree trunks, the mulched blur of a grassy field in autumn, and the ominous slumber of a colossal boulder.

Complicating the history of the 1891 painting's genesis is the likelihood that *Sunset in the Woods* was begun and brought to an initial state of completion five years earlier, when Inness exhibited a nearly identical canvas at the National Academy of Design with the title *In the Woods* (Fig. 1).[11] Critics described it as "large and powerful" and noted that "Mr. Inness certainly did retouch this picture very considerably after it was hung."[12] We can thus surmise that after the show at the academy in 1886, Inness put the picture aside in his studio and returned to it in 1891 with the Corcoran beckoning. At that point, Inness made changes to the picture. As Clarke explained to the Corcoran, "you will remember the beautiful tree trunks—these are grander than before, and after removing the figure of a man as was suggested, he opened up a passage to what seems to be brilliantly lighted clearing beyond the huge rock."[13] Inness retitled *In the Woods* as *Sunlit Forest* and retitled it again for the Corcoran.

PS

Theodore Robinson (Irasburg, Vt., 1852–New York City, 1896)

The Valley of the Seine, from the Hills of Giverny, 1892

Oil on canvas, 25¹⁵⁄₁₆ × 32⅛ in. (65.9 × 81.6 cm)
Museum Purchase, Gallery Fund, 00.5

Theodore Robinson spent about half of every year between 1887 and 1892 in Giverny, a Norman village forty-five miles northwest of Paris, where Claude Monet had settled in 1883. In 1885 the French landscapist Ferdinand Deconchy introduced Robinson to Monet, and two years later Robinson returned with the Canadian painter William Blair Bunce and the Americans Willard Metcalf, Henry Fitch Taylor, and Theodore Wendel. The five were the first in what became a large art colony.[1]

Monet held himself aloof from the group, befriending only Robinson, Lilla Cabot Perry, and Theodore Butler. In his diary, Robinson recorded meals at Monet's home and visits by the older artist, whom he sometimes referred to as "the Master."[2] Under Monet's influence, Robinson lightened his palette and modified the academic techniques he had studied at the National Academy of Design in New York and the École des Beaux-Arts in Paris. In emulation of Monet's series, Robinson began to produce multiple paintings depicting the same subject under different light effects.[3] He had completed several pairs of related canvases and one sequence of three when he began a new series devoted to the valley of the Seine.

On 4 June 1893 Robinson set his easel high on a hillside on the outskirts of Giverny. Below, meadows swept along the river to a bridge leading to Vernon, the market town on the opposite bank. The Gothic church of Notre Dame gleamed in the sunlight, its arched windows and pale stone an ancient counterpoint to the modern bridge, then just thirty-one years old. Later that day, Robinson made the first diary notation about his new project: "Commenced a *Vue de Vernon* most charming in the morning sunlight. I will try two canvases, one, the later, will try by cloud shadows, to have the river light against its banks—foreground and parts of meadow beyond in shadow. Cathedral and parts of bridge, etc., in bright sunlight—like the old landscapes in the battle pictures at Versailles!"[4]

Over the next two mornings, Robinson alternated work on two canvases, capturing the play of sunlight and clouds on the meadows. One of these is the Corcoran's *Valley of the Seine, from the Hills of Giverny*; the other, *Valley of the Seine*, is in the Addison Gallery of American Art (Andover, Mass.). On 9 June, a "grey day, beautiful and still," he began a third version, also titled *Valley of the Seine*, now in the Maier Museum of Art (Lynchburg, Va.).[5] He explained his method on 12 June: "I had two canvases—worked on the first—grey for an hour, then the sun began to come thro giving me a chance on the other."

It was not the first time Robinson found inspiration in the topography of Giverny. For some canvases, like *Valley of the Seine, Giverny* (1887, Los Angeles County Museum of Art), he positioned himself in the village, looking up at the fields; for others, including *A Bird's Eye View* (1889, The Metropolitan Museum of Art, New York), he chose a vantage point on the hillside, gazing down on the rooftops.[6] But none of Robinson's previous canvases had commanded such a wide panorama as this new series. On the first day, he acknowledged the influence of "the battle pictures at Versailles," undoubtedly a reference to the Galerie des Batailles in the Palace of Versailles, where thirty-three panoramic views of French military victories are displayed. Those by Horace Vernet are especially notable for expansive vistas seen from a high vantage point.[7]

Robinson had devoted more than a month to his panoramic paintings when, on 12 July he wrote, "Am afraid I am losing time on my vues—they are perhaps too large for me—or I get tired carrying my stuff so far." His fatigue was understandable. He lugged two or three canvases, each about twenty-six by thirty-two inches, along with an easel, paints, brushes, and other supplies, from the village to his vantage point a half hour's walk away.[8] The trek was challenging for one who suffered from debilitating asthma, rarely slept through the night, and was so small that he bought shoes in boys' sizes.[9] Bad weather deepened Robinson's gloom. "Caught in the rain again this a.m. on the côte—will stop working there soon," he wrote on 17 July. By 23 July, however, the weather and his spirits had lifted: "Lovely morning on the hill—sunlight after bad weather for several days. Distance most delightful. Worked on the two sunlight ones."[10]

The three large panoramas were completed by early August. Robinson wrote to J. Alden Weir on 14 August 1892, "For six weeks, I worked mornings on two landscapes—sort of panoramic affairs. . . . They are not great successes, I fear."[11] Robinson was cheered a month later when Monet complimented his work: "A call from the Master who saw my things—he liked best the 'Vue de Vernon'—the one I tho't nearest my ideal—he said it was the best landscape he had seen of mine—he liked the grey—the other sunlight one less."[12] Monet repeated his approval later that year when he called to say good-bye before Robinson left for New York. "He did not care for many," Robinson noted, but "said I ought to have success with the 'Vue de Vernon.'"[13]

Buoyed by Monet's praise, Robinson sent the canvas now in the Addison Gallery to the Society of American Artists exhibition in the spring of 1893. There, it was acquired by the collector George A. Hearn. The artist did not exhibit any of the others before his untimely death on 2 April 1896, but as he painted in Connecticut, New Jersey, New York, and Vermont, he recalled the series as a touchstone of artistic achievement.

The Valley of the Seine, from the Hills of Giverny was first publicly exhibited in the artist's estate sale in March 1898, where it was purchased by William T. Evans. Two years later, Evans sold it along with about 270 other paintings. At that auction, the Corcoran acquired Robinson's sunniest view of the valley of the Seine.

SGL

"Who Is Sylvia? What Is She, That All the Swains Commend Her?" 1896–99; reworked 1900

Oil on canvas, 48 × 48 in. (122 × 122 cm)
Signed and dated lower right: E. A. Abbey 1899 / 1900
William A. Clark Collection, 26.1

"Who is Sylvia? What is she, that all the swains commend her?" Thus Shakespeare opens the song that callow Proteus (one of the so-called heroes of *Two Gentlemen of Verona*) composes in hopes of winning Silvia's affection.[1] With it, Proteus acts against his friend Valentine, who loves Silvia; plays false to the older Thurio, whose futile suit for Silvia he pretends to support; and betrays his own vows to Julia. Just as the song misleads, the Corcoran's painting, too, is not what it seems. Although Edwin Austin Abbey was one of the era's foremost illustrators, *"Who Is Sylvia?"* shows no moment from the play.[2] By removing the song from the drama's action, Abbey focuses attention on the maiden rather than the machinations of the song's writer. He achieves something comparable formally through his overall arrangement of dark and light, his placement of the brightest reds and lights, Sylvia's unbroken contour, and the cue that everyone in the square composition looks at her.[3] Viewers of the picture, too, must turn to Sylvia.

Abbey began the painting in 1896. He had had a notable success at the Royal Academy summer exhibition earlier that year with his first Shakespearean painting, *Richard, Duke of Gloucester, and the Lady Anne* (Yale University Art Gallery, New Haven), earning associate academician status.[4] His wife, writing after months away from home, reported:

> The great surprise in the studio was a picture for next year's Academy, at least half finished. . . . "Who is Silvia, what is She?" There are six or seven figures in it coming down a staircase, Silvia in front, in the white silk dress[5] with shot flame and gold Venetian sleeves.[6]

Progress on the canvas, however, was sporadic, even though Abbey had, as he wrote earlier, a "rattling good model, who knows her business and sits well. . . . Has been sitting for a long time to Holman Hunt for a 'Lady of Shalott.'"[7] Other projects drew his attention, and family problems prompted a long trip to New York at the end of the year.[8] After his return to England in March 1897, his father died unexpectedly, and that, too, kept him from the picture: "Ned has not begun to work yet . . . cannot seem to settle down."[9] Trips to Paris and the United States further interrupted work. In August, home again, his wife reported: "He has had a bad day—wiped all he had done on Silvia." Even so, she was able to write that several days later Lawrence Alma-Tadema "got rather excited over 'Silvia,' which he thought very beautiful—better painted than anything Ned had done."[10]

Still Abbey did not push at the painting.[11] Only in early 1899, amid the flurry of establishing a London residence, did he finish *Sylvia*. He showed both it and *O Mistress Mine, Where Are You Roaming?* (Walker Art Center, Liverpool)—inspired by a song set in *Twelfth Night*—at that summer's Royal Academy exhibition.

Both paintings had prominent positions, *Sylvia* hanging in the largest of the paintings galleries. The critical response to them was tepid. For one writer, *Sylvia* may have breathed "the spirit of Shakespeare's song,"[12] but for others it was "little more than a study of figures in Renaissance costume."[13] After condemning Abbey's general manner of painting, perspective, massing of figures, and foreshortening, one went on to say that none of these mattered compared to the "commonness of the principal figure," concluding: "Mr. Abbey repainted the head of the principal figure *in* the exhibition surrounded by his brother Academicians. It looks as though some of them had done it for him."[14] Whether or not Abbey actually repainted the head while the painting was at the Royal Academy, his biographer noted that after the exhibition, Abbey scraped the head down "altogether, repainting this from another model," which perhaps accounts for the "1900" in the inscription.[15]

Abbey sold this new state of the painting to Senator William A. Clark, who circulated it to a series of important venues from 1902 to 1911; it generally garnered mixed reviews.[16] Thereafter the painting was not seen outside Clark's home or, after his bequest in 1926, the walls of the Corcoran until late in the century, with the reemergence of scholarly and commercial interest in Abbey and the second-generation Pre-Raphaelite Brotherhood whom he emulated.[17]

The ties between the Pre-Raphaelites and *Sylvia* extend beyond comparable themes and treatments. In August 1896, just as Abbey began the picture, Sir John Everett Millais, one of the original Pre-Raphaelite Brothers and a friendly mentor to the American, died. Abbey wrote of the full pomp of the funeral service at St. Paul's Cathedral:

> We joined the procession. . . . [I]t was a curious sensation having all those eyes curiously looking at you, every eye all along the route staring right at you. . . .
>
> It was not until I looked up and saw the old palette and bunch of brushes and mahlstick tied with crape that I couldn't seem to stand it any more. . . . But for the very first time since you went away, dear, I felt that I wanted to paint. . . .
>
> We came down the nave again and stood upon the steps . . . and the crowd was still there, all eyes—like things one sees in a dream.[18]

Sylvia—making direct reference to the Pre-Raphaelite Brotherhood, having at its core the idea of being looked at, and using a Pre-Raphaelite's model—exemplifies Abbey's gift of infusing the literary past with both emotional resonance and a stylistic bravura all his own.

MS

Winslow Homer (Boston, 1836–Prout's Neck, Maine, 1910)

A Light on the Sea, 1897

Oil on canvas, 28³/₁₆ × 48⅛ in. (71.5 × 122.2 cm)
Signed and dated lower right: HOMER 1897
Museum Purchase, Gallery Fund, 07.3

Throughout his long career, Winslow Homer made pictures that featured women, curious light effects, or, most famously, especially as he grew older, the Atlantic Ocean. On occasion he combined these interests. In the last of his works to show all three motifs, *A Light on the Sea*, Homer created one of his most enigmatic paintings.[1]

Homer presents an apparently simple scene. A woman walks along a rocky shoreline, a fishing net with buoys slung over her shoulder. Light gleams on the water behind her while a gull glides in the air above to the right. Details can be identified. The site is demonstrably Prout's Neck, Maine, where Homer had made his home since 1884, looking southward across Saco Bay; the rocks are ones he often fished from.[2] The model was a local woman named Ida Meserve Harding, who had earlier posed for him.[3] Yet such factual details do little to elucidate the picture.

Homer shows the woman walking to the left, hands at waist and arms akimbo (her feet, which Homer emphasized after the painting's debut by repainting the area surrounding them, show her to be in movement).[4] There is, however, a mystery. Something has caught her attention, causing her to stop midstride and look back over her shoulder—perhaps a sound raised by whatever has caused the gull to rise from its roost and soar away.[5] Suggesting that the viewer, too, follow her glance, Homer makes the picture's narrative focus on a point just beyond the right edge of the scene, the land- and cloudscape subtly rhyming with the arrowhead shape of the woman's elbow, pointing there.

Yet when Homer arranged for the painting's exhibition in New York, he wrote: "It is a large landscape figure—with the title, & subject, 'A Light on the Sea.'"[6] "Landscape figure" combines two generally separate categories of painting and is not a term that he (or anyone else) commonly used. Omitting any relational preposition, it identifies the figure with the landscape, the one as the embodiment of the other.[7] Further, by declaring that both title and subject were "a light on the sea" (a phrase open equally to literal, poetic, and nautical interpretation), Homer, through words, directed attention to the light. His facture emphasizes the point. He portrayed its reflected brightness stretching to the horizon with thick, pasty white paint, scored with myriad long, parallel ridges. Nearer to shore, his aqua, blue, and olive swoops suggest it catching the crests of incoming waves. Closer in, shoreward of the rocks, his more varied brushwork portrays light on roiling water. *A Light on the Sea* establishes that light—dominant through brightness and brushwork—is the principal element of pictorial interest, even as human sympathy with its figure evokes curiosity about its story.[8] The resulting tension energizes the picture.

There is another source of disquiet in the work. What is the weather? What is the time of day? Some early writers thought the picture showed a "cold but keen white wintery sunlight."[9] For others, it was "a beautiful picture of the sea at night."[10] Viewers today are no less divided.[11] Homer often declared that he was true to his observations: "When I have selected the thing carefully, I paint it exactly as it appears."[12] Yet diametrically opposed readings of his paintings over the years reveal the elusiveness of his truths, a seemingly intended ambiguity that has kept them vital and brings to the fore the viewer's share of a painting's meaning.

If we opt to see the scene as a calm summer's evening, then it is moonlight that casts the woman's garb into such mysterious colors, the presumably pink skirt turned iridescent with gray-green reflections, and her dark shirt—with whimsical sailor collar—neither blue nor gray. The flight of the lone gull, generally a night-roosting bird, lends an unsettling alarm. Keeping faith with his title, Homer blocked any hint of the moon with the woman, casting her figure into shadow (barring the inexplicable glint of her ring) and heightening, by contrast, the moon's bright reflections on the water. This darkening of the woman, and the rough, patchy painting of her face, encourages the viewer to step back from the picture, strengthening its suggestions of atmosphere and depth.[13] Some critics understood this strategy. One, complaining of its "lack of refinement in the treatment of the details," carried on: "But at a distance from which these things are not noticeable the picture masses with unaffected and powerful simplicity. The figure and the shore, dark against the moonlit sea, merge into a single confirmation that is singularly impressive."[14]

Homer finished *A Light on the Sea* in 1897 and sent it in November to the Carnegie Institute's Second Annual Exhibition. In January 1898 it was hung in the place of honor at the Union League Club in New York.[15] Beginning in April, the New York dealer Knoedler's represented the painting, which it showed in its gallery as well as at important public venues until the Corcoran purchased it in 1907. Wherever it was seen, *A Light on the Sea* attracted critical attention, much of it unenthusiastic: "not as repellent in color as usual," wrote one; "impressive without being very successful," another.[16] It was, opined a third, "spoilt by the badly drawn figure of the fisherwoman that prevents our enjoyment of the sea and cliffs."[17] Even negatively inclined writers, however, generally found something good to say about Homer's works. While *A Light on the Sea* was, for one writer in 1906, "much less interesting" than others of the artist's works, it nonetheless had "bigness and directness. A large breath of the ocean blows from his marines."[18]

MS

Childe Hassam (Dorchester, Mass., 1859–East Hampton, N.Y., 1935)

A North East Headland, 1901

Oil on canvas, 25⅛ × 30¹/₁₆ in. (63.7 × 76.4 cm)
Signed and dated lower right: Childe Hassam 1901
Museum Purchase, Gallery Fund, 07.8

The Isles of Shoals, a cluster of islands nine miles off the coast of New Hampshire and Maine, attracted Childe Hassam for frequent summer stays from about 1886 until about 1916.[1] On Appledore, the largest of the islands, a hotel owned by the Laighton family accommodated four hundred guests. The poet Celia Laighton Thaxter, who helped her brothers manage Appledore House, hosted a lively salon of writers, artists, and musicians in her cottage adjacent to the hotel. Guests gathered for music, readings, and conversation in her parlor, which was fragrant with arrangements gathered from her cutting garden, a luxuriant oasis of color on the windswept, nearly treeless island.[2]

Hassam became close friends with the poet, twenty-four years his senior. She advised him to drop his first name, Frederick, in favor of his unusual middle name; marketed his paintings to other guests; and had him produce the illustrations for her most famous book, *An Island Garden*, which was published in 1894, the year of her death.[3] Hassam celebrated the parlor, the garden, and its creator in a splendid group of oils and watercolors that remain among his finest works. But without Thaxter's skilled nurturing, the garden undoubtedly declined. Beginning in 1899, Hassam turned from the tender beauties of poppies, hollyhocks, nasturtiums, and larkspur to the austere grandeur of the islands' rocks. Thaxter may also have awakened him to the possibilities of that subject. She was knowledgeable about geology, writing of the isles that "no two are alike, though all are of the same coarse granite, mixed with masses and seams of quartz and feldspar and gneiss and mica-slate. . . ."[4] She savored the aura of timelessness that the glacier-sculpted crags conveyed, the

way the "incessant influences of wind and sun, rain, snow, frost, and spray, have so bleached the tops of the rocks, that they look hoary as if with age."[5] Thaxter's writing helped make tourist attractions of Appledore's rocks—remnants of the ice age in a place where evidence of human history was limited.

Hassam painted *A North East Headland* during a stay on Appledore in August 1901. He turned his back on the bustling resort hotel and the tennis courts, swimming area, and pier on its western, mainland-facing side. Strolling past the cottages and outbuildings behind the hotel, he set his easel in Broad Cove, visible from the hotel windows. The islands in the distance are probably Eastern and Mingo, the easternmost of the Isles of Shoals.[6] From his vantage point, Hassam could have heard the chatter of hotel guests, but he included no sign of human presence in the scene he captured on canvas. Applying the thick, stiff paint in decisive strokes, he left the light-colored ground layer exposed in many areas to suggest the sun-struck rocks. Daubs of red, brown, and purple describe the seaweed and mosses exposed by low tide. The blue sea, lapping gently at the headland, complements the rocks' golden tones. In contrast to the loose, free brushwork in the rocks and sea, the sky is more tightly painted. A conservator's examination reveals that it was originally a brighter, clearer blue. After the paint had dried, Hassam repainted it in a greener, duller shade.[7]

Broad Cove appears in another painting of about the same size also dated 1901, *Coast Scene, Isles of Shoals* (The Metropolitan Museum of Art, New York). Hassam may have created that work in his studio, however, juxtaposing the northeast headlands with another rock

Fig. 1. Childe Hassam, *Isles of Shoals, Broad Cove*, 1911. Oil on canvas, 33½ × 35⅜ in. (85.1 × 89.9 cm). Honolulu Academy of Arts Purchase, Academy funds and gifts of Mrs. Robert P. Griffing, Jr., and Renee Halbedl, 1964, 3194.1

formation about a quarter mile away.[8] Ten years later, the artist reprised the Corcoran's composition in *Isles of Shoals, Broad Cove* (Fig. 1). The vantage point is more elevated and the tide higher than in the Corcoran's painting. The canvas is nearly square, with the horizon line, accentuated by the distant islands, pushed nearly to the upper edge.

A North East Headland was first exhibited at the Lewis and Clark Centennial Exposition in Portland, Oregon, in 1905. Two years later, Hassam sent it to the First Annual Exhibition of Oil Paintings by Contemporary American Artists at the Corcoran Gallery. It was one of thirteen paintings the museum acquired from that exhibition for the permanent collection. In reviewing the exhibition and reporting the purchases, the critic for the *New-York Daily Tribune* wrote approvingly that "Childe Hassam's 'Northeast Headlands, Coast of Maine,' No. 240, is a fine example of the work of this brilliant and accomplished leader in America of sound and sane Impressionism. . . .

The white rocks and blue water are so convincing even to the layman (who happens not to be prejudiced against it by looking at the canvas first at close range). At the proper distance, it is delightfully real, and like looking upon the scene through an open window."[9] The *Washington Herald* called Hassam's painting "a powerful landscape, rugged and strong, on which it seems as if the color had been laid on with a palette knife."[10]

Five years later, Helen W. Henderson devoted two paragraphs to the painting in *The Art Treasures of Washington*, paying special attention to its colors. "Taking blue as the note, Hassam has played the harmonies by contrast of a true impressionist; placing one colour against another . . . to make each count its utmost value in the vibrating whole. His headlands run to gorgeous *aubergines*, founded upon yellows, and through the beach the colour is of a most amusing variety."[11]

SGL

Alfred Henry Maurer (New York City, 1868–New York City, 1932)

Young Woman in Kimono, c. 1901

Oil on canvas, 30 × 28¹³⁄₁₆ in. (76.2 × 73.2 cm)
Signed lower right: Alfred H. Maurer
Gift of Edith Newlands Johnston and Janet Newlands Johnston, 50.11

Young Woman in Kimono marks a significant moment in the evolution of Alfred Maurer's bold, modern style. Settling in Paris after briefly studying at the Académie Julian in 1897, Maurer quickly shed his renditions of breezy women in the manner of fellow American illustrator Charles Dana Gibson and began to explore the subjects that had gained currency in the French capital—refined interiors of women amid decorative objects and genre scenes of cafés, dance halls, and other urban venues. Bolstered by this initial period of experimentation with vastly different pictorial languages, for the rest of his career Maurer created a diverse body of work, all inflected with a decidedly European quality, ranging from the colorful, thrashing landscapes made after seeing the Fauves in the 1905 Salon d'Automne to the expressionist portraits of the mid-1920s and Synthetic Cubist still lifes in the later part of his oeuvre (Fig. 1). *Young Woman in Kimono,* along with the other paintings made around the turn of the century, reveals an increasingly confident Maurer, an American artist who was beginning to embrace European modernism.[1]

Here, Maurer features an elegant woman shown in profile and swathed in a sumptuous kimono, one hand resting on the back of a wooden chair, the other holding a partially opened fan, the folds of which visually echo and thereby link her long red neckband and the textile draped on the table next to her.[2] One of the most striking aspects of the painting is Maurer's use of bright red—in the trim of the gown and the tablecloth's border—for the pigment glows against the dark palette used throughout the rest of the canvas. The vivid color also unifies the disparate elements of the painting both visually and thematically. The same red used to lead our eye around the figure and tablecloth is carried into the Japanese print above the table with the dab of crimson by the wrestler's leg. With this move, Maurer announces that Japanese prints provided the visual precedent and inspiration for his painting.

Indeed, with its shallow space, decorative patterning, and display of Japanese objects, *Young Woman in Kimono* evinces Maurer's fascination with *japonisme,* the interest in all things Japanese.[3] *Japonisme* became the fashion in Europe following the 1867 Exposition Universelle in Paris and peaked in the United States in the 1880s and 1890s in such venues as the 1893 World's Columbian Exposition in Chicago. During this period, American collectors, spurred by connoisseurs such as Ernest Fenollosa, were eagerly amassing their own holdings of Japanese decorative objects and art. At the same time, Japanese prints were being widely circulated in European and American markets, and their availability allowed many artists to emulate the compositional techniques of Japanese printmakers. Maurer, too, was inspired and painted several other works imbued with Japanese influences in addition to the Corcoran painting: his breakthrough picture, *An Arrangement* (1901, Whitney Museum of American Art), which won the coveted first prize in the Sixth Annual Carnegie International competition, and *The Peacock: Portrait of a Woman* (c. 1903, Philadelphia Museum of Art), which shows a woman in a kimono seated on the floor next to pieces of pottery.

Throughout his career, Maurer was more interested in exploring formal problems of color and composition than in creating

Fig. 1. Alfred Maurer, *Abstract Heads,* 1930–31. Oil on gesso panel, 26 × 18 in. (66 × 45.7 cm). Corcoran Gallery of Art, Museum purchase through the William A. Clark Fund, 1979.76

compelling narratives, and this is readily seen in *Young Woman in Kimono.* Instead of adding anecdotal details and creating a persona for the model, Maurer emphasizes the purely visual, aesthetic aspects of the painting—the use of diagonals, asymmetry, and contrasting colors. This emphasis on beauty and decoration over subject matter suggests Maurer's interest in Aestheticism, an artistic movement encapsulated by the mantra "art for art's sake" and most famously advocated by the American expatriate artist James McNeill Whistler. Most notably in the full-length pose and pensive mood of the model, *Young Woman in Kimono* owes much to Whistler and Aestheticism.

Before his career as a painter, Maurer trained as a lithographer in New Jersey and took a few classes at the National Academy of Design. Maurer's father, Louis Maurer (a pupil of William Merritt Chase), was a well-known printmaker for Currier and Ives. Yet after a few years working as a commercial artist, Maurer left New York for Paris to learn the academic method.[4] Often seen walking the streets with paintbrush and palette in hand, Maurer quickly became enmeshed in the artistic community in Paris, becoming friends with Leo and Gertrude Stein and participating in their salon of artists, writers, and other intellectuals.[5] With the exception of a few visits

to New York, he lived there for the next seventeen years. The political turmoil leading up to World War I caused Maurer to return to the United States in 1914. Thus, for a significant portion of his artistic career, Maurer was an expatriate.

Despite later successes including exhibiting at such landmark venues of modernism as Alfred Stieglitz's 291 Gallery and the 1913 Armory Show in New York, Maurer's life ended tragically; he committed suicide in New York in 1932, just two weeks after his father's death. Over a decade later, in 1949, the Whitney Museum of American Art honored the late artist with a retrospective exhibition.

AN

George de Forest Brush (Shelbyville, Tenn., 1855–Hanover, N.H., 1941)

Mother and Child, 1902

Oil on canvas, 37¹⁵⁄₁₆ × 28½ in. (96.3 × 72.3 cm)
Signed and dated lower right: Geo de Forest Brush / 1902
Museum Purchase, Gallery Fund, 02.1

Fig. 1. George de Forest Brush, *Mother Reading*, 1905. Oil on canvas, 41⅛ × 32 in. (104.5 × 81.3 cm). Corcoran Gallery of Art, Gift of Mabel Stevens Smithers, 1949, The Francis Sydney Smithers Memorial, 49.52

Although George de Forest Brush is better known today for the paintings he made of Native Americans early in his career, he was more esteemed during his lifetime for his large body of work featuring mothers and children (often titled simply *Mother and Child*). These works began in 1891 with a family portrait and continued into the late 1920s. Brush always used his own family—his wife, Mittie, and various of their numerous children and grandchildren—as models. The Corcoran's *Mother and Child* features Mittie and most likely their fifth daughter, Jane, born 2 September 1900.[1]

Brush was among the most celebrated in a group of turn-of-the-century American painters that also included Abbott Handerson Thayer, Gari Melchers, and Elizabeth Nourse who created images of secular mothers and children containing references to the Christian subject of the Virgin and Child. These artists took up the theme partly in response to their exposure to Italian Renaissance art and to contemporary French Salon paintings with religious undertones, such as those by William-Adolphe Bouguereau and Jules Breton, during their European training.[2] Returning to the United States, they practiced art in what is now known as the American Renaissance style, a mode that drew inspiration from existing art (particularly that of the Italian Renaissance) rather than from the observation of nature and favored depictions of the human figure. Brush, like many of his colleagues, revered the work of Raphael, especially the *Madonna of the Chair* (1514, Palazzo Pitti, Florence). The compositions of several of his paintings titled *Mother and Child*, including the Corcoran's, relate to Raphael's then famous and beloved oil.[3]

American Renaissance artists' adaptation of the theme of the Virgin and Child reflected not only historical and contemporary European influences but also the cultural beliefs of a certain segment of the United States populace at the time. After the mid-nineteenth century, American upper- and middle-class white women were idealized in the belief that they were inherently aesthetic, moral, and pious. In their role as mothers, they were thought to be a civilizing force, perfectly suited to socializing children to carry on Anglo-American values. Mary, mother of Christ, who had been increasingly admired and humanized by Protestants in literature and art during the second half of the nineteenth century, became the embodiment of ideal motherhood. By association, images of mothers in the late nineteenth century exuded a sacred quality.[4]

Art historians of the period often noted a certain mood in Brush's mother and child paintings that differentiated them from those of his colleagues. Samuel Isham remarked in 1905:

> He does not paint the mother radiant, strong, and incredibly young, seated among a group of rollicking chubby cherubs; she is, on the contrary, if not sad, at least grave, and holds tenderly the very human child in her arms. Youthful freshness and something of health and strength have been paid as the price of maternity, but there is no sign that the price is regretted or even considered.[5]

Later, Royal Cortissoz characterized Brush's maternal figures as "warmly sympathetic human creatures, pensive and serene."[6] Brush's modern Madonnas thus hint at the weight of sacrifice and

Fig. 2. George de Forest Brush, *Mother and Child*, c. 1897. Oil on canvas, 39¼ × 39¼ in. (99.7 × 99.7 cm), tondo. Courtesy of the Pennsylvania Academy of the Fine Arts, Philadelphia. Joseph E. Temple Fund, 1898.2

responsibility that actual mothers must have felt trying to live up to the idealized version of their societal role.

Following its completion and for decades afterward, *Mother and Child* was regarded as Brush's most successful painting of maternity. The Corcoran quickly acquired it through the artist's dealer in February 1902, and it was the only oil the museum purchased that year.[7] Touring the gallery in 1903, the artist William Merritt Chase "declared [*Mother and Child*] the finest" of Brush's pictures of the theme.[8] Another critic, reviewing the National Academy of Design's

winter exhibition of 1906–7, where *Mother and Child* was on view, stated it was "the best of this class of the famous artist's work," while the poet and future collector Walter C. Arensberg thought it "an excellent example of the emaciated, almost ascetic, type of motherhood which the artist repeats so often."[9] In 1936 Leila Mechlin of the *Washington Evening Star* pronounced it Brush's masterpiece and "one of the finest paintings produced in America."[10]

What sets the painting apart from others of Brush's images of mothers and children, such as *Mother Reading* (Fig. 1) and even those very close in composition like *Mother and Child* (Fig. 2) and *Mother and Child* (c. 1897–1900, The Detroit Institute of Arts)? Perhaps its appeal centers on the intensity of the pensive mood so admired in Brush's modern Madonnas. Several writers singled out the 1902 version for the "wistfulness of expression in the face of the mother," the "brooding look of maternity in the eyes," the "pang of the pain of motherhood seen in the face maternal."[11] The apple in the child's hand, exclusive to this painting, contributes to the somber tone of the work. The fruit was a common attribute of the baby Jesus in Renaissance depictions, where it symbolizes the fall of man, which

the grown Christ redeemed through his Crucifixion.[12] The presence of the apple here, then, could signal the mother's mournful anticipation of the eventual loss of her child to adulthood.

The tension Brush creates between the real and the ideal, as identified by the Brush scholar Mary Lublin, also may have impressed his contemporaries.[13] The group is nearly life-size, and the faces and the hands of the figures are rendered in such glowing, three-dimensional detail as to seem alive. Yet the pair appears without context; there are no other figures or any indication of location, as there are in the Philadelphia, Detroit, and 1905 Corcoran works. In addition, the monochromatic, abstract background, the frontal poses of the figures, and the linear depiction of portions of the clothing give the painting a two-dimensional, iconic quality reminiscent of early Renaissance paintings of the Virgin and Child. Appearing simultaneously living and emblematic, the figures in *Mother and Child* exhibit both the secular and sacred nature of motherhood at the turn of the century.

LGN

An English Cod, 1904

Oil on canvas, 36⅜ × 40⅛ in. (91.8 × 102.3 cm)
Signed lower left: WM M. CHASE.
Museum Purchase, Gallery Fund, 05.5

"It may be that I will be remembered as a painter of fish," William Merritt Chase remarked near the end of his life.[1] That comment will astonish those who associate Chase with impressionistic renderings of New York's parks, Long Island's beaches, and his wife and children at home. But from about 1900 to 1916 and for two decades after his death, his dark-toned paintings of dead fish were the works most praised by critics and pursued by collectors.

Chase produced still lifes throughout his career. During his early years in the Midwest and New York, paintings of fruit earned him a modest income. The first time he exhibited at the National Academy of Design, in 1871, he was represented by a portrait and two still lifes of fruit. He shifted his focus to figurative work during his student years in Munich and to landscape about 1885, but from about 1900 until his death, fish still lifes dominated his oeuvre.[2] He was so identified with the genre that a contemporaneous caricature depicts a dandified Chase standing in front of a painting of a lunging fish, with a card marked SOLD tucked into the corner of the ornate frame (Fig. 1).

The specialty was a reliable source of income for an artist known for his expensive tastes, but the paintings were not merely potboilers. Instead, they enabled Chase to position himself in the grand tradition of European art. Adopting a darker palette than he employed for his Impressionist landscapes, he evoked the mellow tones of Dutch, Spanish, and Italian old master paintings. The eighteenth-century French painter Jean-Siméon Chardin produced numerous still lifes of fish and shellfish. Chardin's nineteenth-century disciple Antoine Vollon brought his influence literally into Chase's home; the American artist owned eight still lifes by Vollon.[3] The fish still life also provided Chase an opportunity to demonstrate his bravura technique. He reverted to the dashing brushwork he had developed as a student in Munich, rendering his subject in quick, bold strokes with little or no reworking.

"I enjoy painting fishes," Chase explained, "in the infinite variety of these creatures, the subtle and exquisitely colored tones of the flesh fresh from the water, the way their surfaces reflect the light, I take the greatest pleasure."[4] *An English Cod* exemplifies the challenge in which he took such delight. He contrasted the soft, supple flesh of the gutted cod with the stiffer forms of the sardines in the foreground and distinguished among the reflective surfaces, setting the moist gleam of the fish against the harder sheen of the Canton plate, the battered brass vessel, and the polished tabletop. Draped across a platter, the cod is as voluptuous as an odalisque reclining on a sofa.

Chase chose *An English Cod* to represent him in the prestigious Comparative Exhibition of Native and Foreign Art held in New York in late 1904. The eagerly anticipated exhibition of some two hundred paintings provided the opportunity to measure American artists against Europeans including Jean-Baptiste Camille Corot, Eugène Delacroix, Théodore Géricault, Claude Monet, Jean-François Millet, and Théodore Rousseau.[5] The *Washington Post* called it "the greatest show of paintings in oil, foreign and American, ever gathered under one roof in America" and predicted that "a hundred years from now" Chase's painting "may be one of the world's most

Fig. 1. "Good-Natured Caricatures of Well-Known People," *Scrap Book* 7 (February 1909): 24.

coveted masterpieces."[6] A few months later, *An English Cod* was shown at the One Hundredth Anniversary Exhibition at the Pennsylvania Academy of the Fine Arts. Helen W. Henderson, writing in *Brush and Pencil*, declared that the canvas "can stand with anything that Chase has done, and distances contemporary work in this line."[7] The Corcoran Gallery purchased the still life from that exhibition.

The Corcoran lent *An English Cod* to the Third Annual Exhibition of Selected Paintings by American Artists at the Albright (now the Albright-Knox) Art Gallery in Buffalo in 1908, where it continued to garner praise. "Mr. Chase's picture is one of the strongest pieces of still life ever painted in any country," one reviewer gushed. "It is finer in quality, color, and texture than the famous fish picture by Vollon, which hangs in the Gallery of the Luxembourg, in Paris."[8]

It was not the rave reviews that ensured the fame of the Corcoran's still life but an article by Chase himself that appeared in the women's magazine the *Delineator*. "How I Painted My Greatest Picture" was the second in a series by artists, actors, and others on the creation of their finest work.[9] Chase had a great story to tell about *An English Cod*. He related that during a stay in London several years earlier, he had noticed "a magnificent cod" in a market stall. "Whatever my mood for color was that morning, that fish completely fitted and filled it," he wrote. He struck a deal with the proprietor to rent the fish for two hours. If he had not finished painting it by then, he

would buy it. At the appointed time, the fishmonger tiptoed into the studio and peered over Chase's shoulder. "In a few minutes," Chase reassured him, but the Cockney told him not to hurry, remarking, "She's gettin' on! Hi'll take my chances, sir!" On his next trip to London, Chase visited the fishmonger to tell him that the Corcoran had purchased the painting. The fishmonger expressed no surprise at the painting's fame. "Ah! but it was a fine cod, sir," he said, "*now wasn't it?*"

Chase relished that anecdote, which none too subtly reminded listeners of his virtuoso technique. However, his pride in the painting was genuine. Harrison Morris, the influential director of the Pennsylvania Academy of the Fine Arts, recalled visiting the Corcoran with Chase. When they arrived at *An English Cod*, Morris recounted, Chase admired it in silence, then exclaimed, "'Say, Morris, now isn't it beautiful! It ought to be in a foreign gallery.' He took his hat off to it."[10]

SGL

William James Glackens (Philadelphia, 1870–Westport, Conn., 1938)

Luxembourg Gardens, 1906

Oil on canvas, 23⅞ × 32⅛ in. (60.7 × 81.6 cm)
Signed lower left: W[m?] Glackens
Museum Purchase, William A. Clark Fund, 37.1

William Glackens's *Luxembourg Gardens* revels in the casual moment in its celebration of an everyday, lazy afternoon in a Parisian park. The canvas pays homage to Édouard Manet while at the same moment evidencing a vitality and verve that are unique to Glackens. The canvas was painted in 1906, when Glackens and his wife, the artist Edith Dimock, took a postponed honeymoon to Europe. After a sojourn in Madrid, the couple spent three productive weeks in Paris, where Glackens worked on a series of canvases that took the Luxembourg Gardens as their subject.[1]

Though painted more than thirty years earlier, the work did not enter the Corcoran's collection until 1937, following its appearance there at the Fifteenth Biennial Exhibition of Contemporary

American Paintings. Glackens was chairman of the jury of admissions and awards for the biennial that year, and *Luxembourg Gardens* was one of three works representing him in the exhibition. Although the biennials were celebrations of contemporary art, the jury was permitted to select earlier paintings for inclusion, though such older works were not eligible for awards. Reviewers acknowledged the painting's age; a critic for the *New York Times* went so far as to declare it "ancient" but nevertheless referred to it as "one of the most emphatic high spots" of the exhibition.[2] Glackens died a year later, and *Luxembourg Gardens* was among the works in the memorial exhibition, which traveled to the Corcoran in 1940.[3]

Born in Philadelphia in 1870, Glackens entered the Pennsylvania Academy of the Fine Arts in 1892. Like many of his classmates, Glackens worked as a newspaper illustrator, initially for the *Philadelphia Record* and *Philadelphia Press* and later at the *New York Herald* and *McClure's Magazine*. Among his earliest acquaintances was John Sloan, who in turn introduced him to Robert Henri. Henri's studio became a site for social and artistic exchange, and the artist exerted considerable influence on Glackens throughout his career. Later, after the group of artists relocated to New York, Glackens participated in the legendary 1908 exhibition of the Eight that Henri organized at the Macbeth Gallery.

Luxembourg Gardens is a deftly observed leisure scene in which women and children predominate. Nursemaids attend to needlework or socialize with one another while children play. A smartly dressed boy sporting a dark hat and knee breeches stands in the center of the canvas, anchoring the scene. His hands are in his pockets and his legs are planted firmly on the ground as he oversees the two girls who play an early form of badminton called battledore. On the left, a couple engaged in intimate conversation bend their heads toward each other. An iron fence and the windows of Luxembourg Palace loom just beyond the trees and shrubs in the background.

Blackish green tree trunks divide the social activity of the gardens while unifying the space through their repetition. Above, branches and background foliage merge into one another in a rapid blur of yellow and green brushwork. The spontaneous application of paint and evidence of wet-into-wet blending suggest the painting was produced in only two or three sessions.[4] The ground is predominantly brown and tan, with patches of highlighting giving the appearance of sunlight filtered through the trees. The subdued palette is brightened by occasional pops of color, noticeable in the red trousers and hat of the standing soldier, the royal blue skirt of the woman seated at left, and the pink frock of the young girl at center. The empty central foreground contributes to the painting's immediacy by creating a space for the viewer to enter the scene.

The painting owes a considerable debt to Manet's *Music in the Tuileries Gardens* (Fig. 1) in subject and handling. William Gerdts notes that Glackens could have seen the Frenchman's painting in the spring of 1895, when a Manet exhibition was held at the Durand-Ruel Gallery in New York.[5] Both works feature a multifigure composition rendered in a shallow space and depict a leisurely afternoon in a Parisian public garden. There are tonal similarities as well; in each, one finds a dark, understated palette enlivened by spots of red. The points of divergence, however, are telling. Glackens's figures are more animated and less polished than the still, dignified figures in Manet's tableau. Glackens's background in newspaper illustration and his interest in caricature contributed to the lively, sketchy quality of the painting.

Glackens was an admirer of the English illustrators Charles Keene and Harry Furniss, whose caricatures were distinguished by their use of clear, vivid line and emphasis on gesture. From them, the artist learned the importance of rendering a scene with economy and energy. In *Luxembourg Gardens*, his figures are not individualized. As Rebecca Zurier notes, "Glackens rarely indicated faces of passersby, instead conveying personality through gesture, pose, or the tilt of a hat."[6] In the Corcoran's canvas, personality is insinuated through the cocked bowler hat of the young boy presiding authoritatively over the children's game and the casual body language of the woman at left, who tilts her head toward her companion with her arm resting on the back of the wire garden chair. Her body is oriented toward the man at her side with whom she is talking, yet her gaze is directed outward at the viewer. Here, we see Glackens the artist as reporter, capturing the essence of a scene without dwelling on unnecessary particulars. This eye for the telling detail lends the composition a realism and vitality that distinguishes it from the lighter and more genteel style of American Impressionism favored by earlier artists such as Childe Hassam and J. Alden Weir.

KR

Fig. 1. Édouard Manet, *Music in the Tuileries Gardens*, 1862. Oil on canvas, 30 × 46½ in. (76.2 × 118.1 cm). The National Gallery, London, Bequest of Sir Hugh Lane, NG 3260

Willard LeRoy Metcalf (Lowell, Mass., 1858–New York City, 1925)

May Night, 1906

Oil on canvas, 39³⁄₁₆ × 36¹⁄₈ in. (99.5 × 91.8 cm)
Signed and dated lower left: W. L. METCALF '06
Museum Purchase, Gallery Fund, 07.7

Completed during his second of three summers at the burgeoning artists' colony in picturesque Old Lyme, Connecticut, *May Night* is Willard Metcalf's homage to the creative ferment he experienced there and to its chatelaine, Florence Griswold. The focus of the moonlit nocturne is the late-Georgian-style home of Miss Florence, as she was known, the last surviving member of a prominent local shipbuilding family. Forced to take in boarders to survive financially, Miss Florence welcomed landscape painters, including Childe Hassam, who arrived in 1903.[1] Crossing the shadow-strewn lawn toward a seated companion is an ethereally dressed figure that surely represents Miss Florence, for whom Metcalf painted the canvas.[2] Set beneath a canopy of stars, lush trees frame the scene; the triangular shapes of the dogwood tree and the white horse-chestnut blossoms echo those of the women's pale gowns.

Born to mill workers in Lowell, Massachusetts, Metcalf apprenticed to a wood engraver and to the painter George Loring Brown before studying at the School of the Museum of Fine Arts, Boston. In 1883 he departed for study in Paris at the Académie Julian and soon frequented French artists' colonies, including Giverny, where he was among the first American painters to visit Claude Monet. There, Metcalf's exposure to French Impressionism and the development of his interests in botany and ornithology predisposed him to accept invitations from Miss Florence and his old friend Hassam to visit Old Lyme. Further impetus was provided by Metcalf's declaration of a "renaissance" in 1904, when he began to paint the New England landscape while living with his parents in Maine; this followed dire financial and health problems in New York after his 1888 return to the United States.[3]

Apparently thrilled with the natural beauty, artistic camaraderie, and opportunities to paint *en plein air*, Metcalf enjoyed a productive first summer in Old Lyme in 1905. He likely conceived *May Night* before returning the following May, and the ambitious canvas apparently occupied him through the following autumn.[4] His work was aided by inclement weather early that summer; as Hassam wrote to J. Alden Weir, "Metty [Metcalf] is working hard at a moonlight. We are all doing moonlights. The weather has been so bad that we have been forced to it."[5]

The artist enhanced his painted tribute in several ways. He improved on the somewhat dilapidated appearance of the mansion and grounds; even income from boarders could not cover the upkeep. He also rendered the house as otherworldly and nearly templelike, perhaps in reference to its nickname, Holy House;[6] the analogy was not lost on contemporary critics.[7] The oblique perspective and obscured bays on either side of the portico, combined with the exaggerated height of the Ionic columns and distance between the first- and second-story windows, emphasize the portico, the most classical feature of the house (Fig. 1).[8] Moreover, the pale color and unstructured appearance of the women's gowns suggest the togalike garments in which his friend Thomas Wilmer Dewing dressed his models in Cornish, New Hampshire. The only reminder of modernity is the glowing yellow light seen in the doorway and the windows on the left, suggesting lamplight.[9] The nearly square format lends a

Fig. 1. Historic photograph of the Florence Griswold House, Florence Griswold Museum, Lyme Historical Society, Archives, 109.23

final note of calm and classicism to the view.[10] Completing the carefully planned scene is the frame, whose corner ornament features anthemion (honeysuckle). Perhaps recalling the sweetly scented plant at Old Lyme, Metcalf must have been pleased to secure the frame from a Philadelphia artisan in 1908, one year after selling the painting to the Corcoran.[11]

Metcalf unveiled *May Night* in his studio in September 1906, first to his fellow artist in Old Lyme Arthur Heming and then to Miss Florence herself.[12] As Heming later recalled, Miss Florence was thrilled with the painting, saying it "was the best thing he had ever done." When Metcalf offered her the painting in exchange for room and board, however, she refused it, instead encouraging him to exhibit it in New York. She remarked, "they'll snap it up . . . for thousands," displaying her characteristic desire to promote "her" artists.[13]

May Night was first shown publicly two months later in Boston and in early 1907 was featured in the Corcoran's First Annual Exhibition of Contemporary Art. Miss Florence correctly predicted the painting's reception: it received the Corcoran's prestigious First William A. Clark Prize and the Corcoran's Gold Medal and was immediately purchased for the remarkable sum of three thousand dollars, marking the artist's first national award and museum sale.[14] Shown at four more venues over the next two years, the painting inspired at least sixty notices in the national press by the end of 1908, most of them focusing on the romantic, poetic nature of the canvas and on the transformations in Metcalf's painting career. The words of the *New York Daily Tribune* critic Royal Cortissoz were typical, stating that Metcalf "adds poetic beauty to realism, and leaves the picture not only a work of skill but a work of imagination" and continuing, "[i]t is a distinguished painting—one of the finest things American art has produced in recent years."[15] Many writers also commended Metcalf's ability to capture successfully "just the

elusiveness that real moonlight has," as the artist-critic Philip Leslie Hale wrote."[16] The eloquent words of another New York writer matched the elegance of Metcalf's scene, calling it a "nocturnal hymn . . . imparting to the beholder the poetry and personal charm of a place."[17]

The success of *May Night* led to a spate of purchases by prominent collectors, such as William T. Evans and Charles Lang Freer, and museums, including the Museum of Fine Arts, Boston, and the Pennsylvania Academy of the Fine Arts. It also inspired other American artists to paint moonlight views, which became something of a

trademark in Old Lyme.[18] Having finally achieved professional triumph, critical recognition, and financial security, Metcalf continued a productive career until his death of a heart attack shortly after the opening of a large exhibition of his paintings at the Corcoran in January 1925.

SC

George Wesley Bellows (Columbus, Ohio, 1882–New York City, 1925)

Forty-two Kids, 1907

Oil on canvas, 42 × 60¼ in. (106.7 × 153 cm)
Signed lower left: Geo Bellows.
Museum Purchase, William A. Clark Fund, 31.12

Forty-two Kids was painted in August 1907, less than three years after George Wesley Bellows had left his home state of Ohio at the age of twenty-two to study art in New York City.[1] He enrolled at the New York School of Art under Robert Henri, the artist and influential teacher around whom congregated the so-called Ashcan School of urban realists. Bellows fully subscribed to his mentor's credo, creating work "full of vitality and the actual life of the time."[2] *Forty-two Kids* is exemplary of Bellows's early work, much of which depicts metropolitan anecdotes, including the illegal boxing matches for which he would become best known.

In *Forty-two Kids*, nude and semiclad boys engage in a variety of antics—swimming, diving, sunbathing, smoking, and possibly urinating—on and near a dilapidated wharf jutting over New York City's East River.[3] The wharf is painted with broad, fluid strokes from a heavily laden paintbrush, and the "little scrawny-legged kids in their naively indecent movements" are sketched with Bellows's characteristic vigor and economy of means.[4] The vague grid formed by the wharf's rough-hewn planks provides a stable compositional platform for the jumble of "spindle-shanked little waifs" distributed seemingly at random across the foreground and middle ground of the canvas.[5]

Forty-two Kids elicited significant attention when it was first exhibited. It was recognized as "one of the most original and vivacious canvases" at the National Academy of Design's 1908 exhibition,[6] where Bellows won the second-place Julius Hallgarten Prize for another painting, *North River* (1908, Pennsylvania Academy of the Fine Arts, Philadelphia).[7] This was only the second year Bellows had submitted to the academy. It was an auspicious sign; in April 1909 the organization inducted Bellows as one of the youngest academicians in its history.

Although it was viewed with "a pleasurable sensation" and relished for its "humor" and "humanity,"[8] *Forty-two Kids* did not receive universally positive reviews. One critic condemned it for "the most inexcusable errors in drawing and general proportions,"[9] while another denounced it as "a tour de force in absurdity."[10] It had been controversially denied the prestigious Lippincott Prize at the Pennsylvania Academy's 1908 annual exhibition owing to the jury's fear that the donor might be offended by the title and subject of the painting.[11]

Bellows was aware of this incident. He wanted Robert C. Hall, who purchased *Forty-two Kids* from the Thirteenth Annual Exhibition of the Carnegie Institute in 1909, to know that "the management, feeling that Mr. Lippincott would not like the decision, would not allow the award."[12] When asked if he thought the jury feared Lippincott would object to the naked children, Bellows deflected attention by quipping: "No, it was the naked painting that they feared."[13] He did not elaborate, leaving unclear whether he meant the painting's sketchy appearance or its lowly subject.

Although Bellows's painting appears innocent enough to viewers today, the mixed reception likely stemmed from the connotations of what one critic called the "curiously freakish subject."[14] Even as Bellows's scene recalls Thomas Eakins's 1885 painting *Swimming* (Fig. 1), it also echoes the lowbrow style and content of comic strips

like *Hogan's Alley*, which chronicled the capers of its slum-dwelling protagonist, the Yellow Kid.[15] Where Eakins evokes a tradition of Arcadian naturalism, aligning his nude, sun-dappled students with classical antiquity, Bellows's undeniably modern kids are accorded nothing of the sort. Around 1900, the slang term *kid* connoted young hooligans with predilections for mischief and petty crime; its lower-class associations would have been clear to Bellows's audience.[16]

Bellows had used colloquial titles before, in his 1906 paintings *Kids* (Collection of James W. and Frances G. McGlothlin) and *River Rats* (private collection, Washington, D.C.). The latter employs an epithet

Fig. 1. Thomas Eakins, *Swimming*, 1885. Oil on canvas, 27⅜ × 38⅜ in. (69.9 × 97.8 cm). Amon Carter Museum of American Art, Fort Worth, Texas, Purchased by the Friends of Art, Fort Worth Art Association, 1925; acquired by the Amon Carter Museum, 1990, from the Modern Art Museum of Fort Worth through grants and donations from the Amon G. Carter Foundation, the Sid W. Richardson Foundation, the Anne Burnett and Charles Tandy Foundation, Capital Cities/ABC Foundation, Fort Worth Star-Telegram, The R.D. and Joan Dale Hubbard Foundation, and the people of Fort Worth, 1990.19.1

for juvenile delinquents that draws on an established rhetorical link between immigrants and animals. This association was also applied to the kids in the Corcoran's picture, who were described as "simian."[17] This was likely a reference to the prevalent caricature of Irish Americans as apelike,[18] although the varied skin tones of Bellows's kids appear to reflect the range of ethnicities—Italian, Russian, German, Polish, and Irish—represented in the poor neighborhoods of Manhattan's East Side.

The "simian" slur was surpassed by a critic who declared: "most of the boys look more like maggots than like humans."[19] Another simultaneously likened Bellows's kids to insects and germs when he suggested that "the tangle of bodies and spidery limbs" was akin to "the antics of magnified animalculae."[20] Even Bellows's widow, Emma, used entomological vocabulary when she recalled the "old dock" north of the Fifty-ninth Street Bridge from which her

husband might have made preparatory sketches for *Forty-two Kids*, describing the area as a "dead end neighborhood—swarming with growing boys."[21]

Contemporaneous literary descriptions of New York City's tenements relied on metaphors that linked recently arrived immigrant slum-dwellers and their dirty environments with all manner of unhygienic animals. The colorful similes applied to *Forty-two Kids* can be understood in this context.[22] Between 1890 and the mid-1920s, some twenty-five million immigrants entered the United States. With the Immigration Act of 1891, the federal government established rigorous medical screening that, among other things, barred persons suffering from contagious diseases. Foreigners, in general, came to be judged as diseased and contagious.[23] Bathing, in municipal swimming pools and open-water floating baths, was endorsed as a healthy and hygienic form of exercise, a way of cleaning,

quite literally, recently arrived immigrants. Bellows's swimming hole, however, is far from salubrious. As one critic noted, the painting has "a bituminous look ill assorted with the idea of bathing."[24]

Although Bellows reportedly said, "One can only paint what one sees,"[25] *Forty-two Kids* elicited responses that went beyond the painting's superficial and purely visible subject and drew on the distasteful metaphors with which the city's immigrant populations were associated. Described as bacteria, maggots, and insects, Bellows's kids were characterized as vectors of contagion, an affiliation quite in keeping with the widely held belief at the beginning of the twentieth century that unrestricted immigration posed a very real threat to individual Americans' well-being and the nation's social health.

AG

Edmund Charles Tarbell (West Groton, Mass., 1862–New Castle, N.H., 1938)

Josephine and Mercie, 1908

Oil on canvas, 28⅛ × 32¹⁄₁₆ in. (71.5 × 81.4 cm)
Signed lower right: Tarbell
Museum Purchase, Gallery Fund, 09.2

Edmund Tarbell, acclaimed in the early years of the twentieth century as "the poet of domesticity,"[1] established his reputation as a painter of well-bred young women in sunlit gardens and tastefully appointed interiors. Along with Frank Benson, Joseph DeCamp, William Paxton, and other painters of the Boston School, Tarbell synthesized a wide range of cosmopolitan stylistic influences in representing the contemporary world of the elite New England culture he knew best. *Josephine and Mercie,* which depicts two of the artist's daughters in a sitting room of the family's summer home in New Castle, New Hampshire, was immediately praised for its "perfect rendering of values" and for "discover[ing] in familiar surroundings elements of genuine beauty."[2] Declared "the best picture of the year" by a Boston critic in 1908,[3] *Josephine and Mercie* entered the Corcoran's permanent collection the following winter, and it continued to be regularly exhibited for the next ten years, both at large loan shows and smaller private galleries. Although he was occasionally criticized for superficiality, Tarbell fared well with the exhibition-going public and was regarded as a sort of living old master. His friend the painter-critic Philip Leslie Hale noted in 1908, "It is almost a commonplace nowadays to say: 'Have you heard such and such a museum has bought a Tarbell picture—or given him a prize.'"[4]

In the years after the Civil War, New England in general and Massachusetts in particular experienced especially rapid social, economic, and political change that destabilized traditional hierarchies of class, gender, and ethnicity. Brahmin elites became, in the words of the art historian Theodore E. Stebbins, Jr., "a society on the defensive" that nevertheless continued to exert considerable influence in the cultural arena.[5] The critical reception and pictorial content of *Josephine and Mercie* speak simultaneously to the tenuous persistence of that society's traditional values and, perhaps, to a nostalgic recognition of their imminent passing. As the *New York Times* would explain in 1917, "Interiors by Mr. Tarbell should be prized by Americans for their truthful interpretation of a singularly distinct phase of American life that can hardly survive the influences of the present century."[6]

Tarbell was deeply rooted in the New England culture represented in his art. His ancestors had lived in Massachusetts since 1638, and he grew up and received his early artistic training in Boston. After two years of study at the Académie Julian in Paris, the young painter returned home, where he adapted his cosmopolitan training to a recognizably Yankee subject matter.[7] Stylistically, Tarbell combined an interest in realistic representation with an aestheticist approach that favors decorative arrangement over narrative content. He counted Edgar Degas and James McNeill Whistler among his favorite artists and, like them, took pictorial cues from Japanese prints.[8] After the turn of the century, Tarbell was increasingly influenced by seventeenth-century Dutch art as well. In the Corcoran's painting, the rhythmic alternation of light and dark and the strong horizontal and vertical elements supplied by the lines of the furniture, the window frames, and other architectural elements were likely derived from the art of Johannes Vermeer. This structural grid gives the seemingly casual scene an aura of permanence. Tarbell purchased his house at New Castle, a coastal village

Fig. 1. Edmund Tarbell, *Josephine Knitting,* 1916. Oil on canvas, 26¼ × 20¼ in. (66.7 × 51.4 cm). Corcoran Gallery of Art, Bequest of George M. Oyster, Jr., 24.2

that had once been the colonial governmental seat, in 1905, and he immediately set about making it into "the ideal home."[9] The house consisted of a central Greek Revival structure, flanked by Federal style and "Cape Cod" additions; the interior was furnished with period pieces, Colonial Revival reproductions, and Asian imports that evoked New England's early involvement in the trans-Pacific trade. In *Josephine and Mercie,* the mahogany secretary and the gateleg table beneath the window, the wicker chair and Japanese prints on the wall, all hark back to a preindustrial past; they were "impressed," as Susan Strickler has observed, with "the stamp of old New England."[10]

Enlisting his wife and children as models, as he also did for the Corcoran's *Josphine Knitting* (Fig. 1), Tarbell deployed the interior spaces of the house as a surrogate studio in which his family members are as artfully arranged as the furniture. *Josephine and Mercie* shows the girls seated in a small sitting room in the original part of the house. Absorbed in reading and writing and both dressed in white, Tarbell's daughters are perfect embodiments of the American Girl—wholesome, healthy, and literate. Their dresses, which visually rhyme with the ruffled curtains, establish a close relation between the interior setting and the figures: the Colonial Revival interior and the girls both suggest innocence and continuity with an idealized New England past.[11]

Contemporary critics rarely discussed the content of Tarbell's painting in any detail, preferring to focus on the artist's technical ability and the verisimilitude of his subject matter. More recently, scholars have noted that Boston School painting in general tended to reflect and reinforce "the conservative social values of both the painters and the Boston Brahmin patrons."[12] The two perspectives are not, however, mutually exclusive: "In substituting expression for representation and affecting us by abstract suggestions rather than by concrete facts," observed the critic Charles Caffin in 1908, "Tarbell proves himself responsive to the mental needs and conditions of his time."[13]

LG

William McGregor Paxton (Baltimore, 1869–Newton, Mass., 1941)

The House Maid, 1910

Oil on canvas, 30⅛ × 25³⁄₁₆ in. (76.5 × 63.9 cm)
Signed and dated upper left: PAXTON / 1910
Museum Purchase, Gallery Fund, 16.9

William McGregor Paxton, along with his Boston School colleagues Edmund Tarbell, Frank Benson, and Joseph DeCamp, achieved institutional recognition and popular acclaim for paintings based on a single theme: a refined interior inhabited by a young woman as decorative as the still-life objects that surround her. "What one might call the well-to-do interior is becoming something like a staple," observed a critic on seeing *The House Maid* at its public debut at the Pennsylvania Academy of the Fine Arts in 1911. "Tarbell and Paxton," he concluded, "are, perhaps, the leaders of this kind."[1] *The House Maid*, which depicts a uniformed servant engrossed in a book and standing behind a table on which a group of still-life objects is displayed, reached audiences across the country before it was purchased from the artist by the Corcoran Gallery of Art after it was shown at the museum's biennial exhibition of 1916.[2] *The House Maid* was painted at a time when industrialization, immigration, and the emergence of consumer culture were effecting dramatic change in American society. Women's activity and authority were expanding beyond the home, challenging traditional ideas about domesticity and feminine identity. Yet Paxton's painting, with its meticulous surfaces and austere composition, suggests that in art, at least, women remained icons of timeless values, beautiful, but inanimate.[3]

Born in Baltimore, Paxton spent his childhood in Newton, Massachusetts, a suburb of Boston, and received his first artistic training at that city's Cowles Art School, under Dennis Miller Bunker. He continued his studies in Paris, where he spent several years at the École des Beaux-Arts with Jean-Léon Gérôme, whose highly finished style had an enduring influence on him. *The House Maid* was painted with layer after layer of thin pigment, wet into wet, resulting in a smooth, luminous surface that is analogous to the surfaces of the still-life objects and the translucent skin of the housemaid.

Along with other members of the Boston School, Paxton was known, according to fellow artist and friend Philip Leslie Hale, to be "awfully keen on [Johannes] Vermeer."[4] Though he probably first encountered the Dutch artist during his student days in Paris, Vermeer's influence became obvious in Paxton's art only after the turn of the century. Hale had published an illustrated book on Vermeer in 1904, which Paxton received as a birthday present from his father the following year, and it was around this time that Paxton began to paint a series of interiors in which light is used, as it is in the Corcoran's picture, to define form and to render the optical clarity that Hale describes in a 1909 essay on Paxton as "uncompromising verity."[5] In *The House Maid*, the stable triangular composition, muted palette, precisely rendered textures, meticulous arrangement, and sense of quiet absorption all have parallels in Vermeer's work. Moreover, Paxton shared Vermeer's interest in depicting the trappings of the bourgeois interior, "their fine houses . . . and their Chinese vases," which were chosen in part, as Hale noted of seventeenth-century Dutch artists, to appeal to patrons who appreciated seeing their own fine possessions represented in works of art.[6]

With the exception of the open stationery box on the far left, most of the objects represented in *The House Maid* are East Asian: a white Chinese lidded jar, a bronze, and a porcelain figurine, both from nineteenth-century Japan, and a Qing dynasty blue-and-white porcelain pot. Reminders of New England's long history of trade with Asia, this bric-a-brac, as it was called at the time, had become a standard part of the typical prosperous Bostonian interior, where the objects were valued both for their decorative qualities and for their suggestive association with an imaginary vision of the East. As many scholars have noted, the Asian aesthetic, and especially that of Japan, was often identified with the private interior and construed as exotic, passive, and feminine, a distinct contrast to the public realm, which was characterized as worldly, vigorous, and masculine.[7] Here, Paxton establishes a close compositional and chromatic connection between the still-life elements and his eponymous housemaid, offering them up as nearly equivalent objects of visual pleasure. The luminous curve of the white jar is repeated in the figure's curved neck, bust, and apron; even her hairstyle, gathered into a soft topknot, is related to the shape of the two lidded pots.

The juxtaposition of Asian objects and a lovely woman was a typical motif in American turn-of-the-century painting. Reading was likewise a familiar and oft-repeated device: Paxton was unusual, however, in representing a servant rather than the usual lady of leisure. The objets d'art on the table are the housemaid's responsibility but are most decidedly not her property. One contemporary observer noted that "her dust brush, and the china vases, show how busy she must have been before she became interested in the book."[8] Reading had a variety of connotations in the late nineteenth and early twentieth centuries. It could be viewed positively, as a form of personal edification and uplift; conversely, it could be seen as a transgressive activity that diverted the reader's attention from more practical tasks.

In *The House Maid*, the act of reading forecloses narrative and represses questions about social context and class identity suggested by the black-and-white uniform and the feather duster. The brightly illuminated blank pages of the book form a visual parallel with the open box on the table, and the volume is a critical element in the triangular structure of the picture that links the figure to the still-life arrangement. Thus, in the context of this painting, reading isolates the young woman from the outside world and relieves her from physical labor, placing her figuratively, as well as literally, close to the ideal world of art and beauty. She has, as Jessica Todd Smith suggests, "transcended the limits of her position" and become a work of art.[9] A writer for the *Washington Sunday Star* summed it up when, in 1916, she described Paxton's picture as "a straightforward piece of still life . . . in which a figure takes its place as a fine bit of color and form."[10]

LG

John Sloan (Lock Haven, Pa., 1871–Hanover, N.H., 1951)

Yeats at Petitpas', 1910–c. 1914

Oil on canvas, 26¹/₁₆ × 32 in. (66.2 × 81.3 cm)
Signed lower right: John Sloan
Museum Purchase, Gallery Fund, 32.9

In August 1910 the realist painter John Sloan began his group portrait of frequenters of Petitpas', a French restaurant and boardinghouse in the Chelsea district of New York City. The work joined other Ashcan School artists' depictions of casual dining experiences in urban eateries that focused on portraiture and narrative, such as *At Mouquin's* by William Glackens (1905, The Art Institute of Chicago).[1] The Ashcan School, informally led by Robert Henri, generally focused on the everyday life of the working classes rather than idealized views of the city. George Luks and George Bellows completed a watercolor and a print, respectively, featuring Petitpas' as well (Fig. 1), but Sloan's image is the most ambitious of the three in its larger format and use of the more venerable medium of oil paint.[2]

The scene takes place in the enclosed backyard of the restaurant, where the dining room was located in the hot summer months. The party gathers around a table placed under an awning decorated with a French flag.[3] At the head sits John Butler Yeats, smoking and sketching. Yeats, the Irish portrait painter and father of the poet William Butler Yeats, lived at Petitpas' from 1909 until his death in 1922. While in residence, he attracted artists and literary figures to his table with his reputation as an excellent conversationalist. Those who dine with Yeats in Sloan's depiction include (around the table from left to right) Van Wyck Brooks, the future literary critic, to the left of Yeats; Yeats; Alan Seeger, a poet; Dolly Sloan, wife of the artist; Robert Sneddon, a Scottish writer of popular fiction; Eulabee Dix, a miniature painter; Sloan; Frederick King, the editor of *Literary Digest*; and Vera Jelihovsky Johnston, the wife of the Irish scholar Charles Johnston.[4] Celestine Petitpas, the youngest of the three sisters who ran the establishment, stands behind Sneddon and offers him a piece of fruit.

While many twentieth-century writers and critics characterized the painting as an illustration of the conversationalist Yeats's nightly salons or as a representation of early New York bohemianism, recent scholars have interpreted the group portrait set at Petitpas' as a tribute to the artist John Butler Yeats, who was a significant mentor to Sloan.[5] Sloan's first influential adviser, Henri, had advocated depicting urban subjects quickly and succinctly in order to capture their vitality. According to Van Wyck Brooks, Sloan's biographer, although Henri's methods initially appealed to Sloan, later in his career he believed Henri's teaching had not adequately emphasized detailed study.[6] This bothered Sloan the most when attempting portraits, with which he struggled his entire career. Unlike Henri, Yeats encouraged the younger man to "finish his work to the last degree . . . to give it importance and force."[7] Yeats strongly believed that taking likenesses was a vital learning tool for all artists, and that the practice of self-portraiture tested an artist's skills most heavily, since it was especially hard to render one's own likeness to one's satisfaction.[8] Yeats himself constantly made self-portraits, including them in his letters to family and friends. In addition to his advice, Yeats's regular practice of drawing his companions influenced Sloan and his work. Sloan owned several of Yeats's sketches, including portraits of Dix, Celestine Petitpas, and Sneddon (Fig. 2). Sloan probably referred to these drawings when painting *Yeats at Petitpas'*, as his renderings of these individuals appear very similar to Yeats's sketches.[9]

Sloan's admiration of, and even deference to, Yeats as a portraitist reveals itself in *Yeats at Petitpas'*. Most New Yorkers, even his intimates, saw the older man's contribution as that of a superb conversationalist and a direct link to the Irish literary revival, led in part by Yeats's famous son.[10] Bellows's lithograph of Petitpas' features Yeats standing in discussion with Henri and Bellows while

Fig. 1. George Bellows, *Artist's Evening*, 1916. Lithograph, 8⅞ × 12¼ in. (22.5 × 31.3 cm) (image). Fine Arts Museums of San Francisco, Museum Purchase, Achenbach Foundation for Graphic Arts Endowment Fund, 1967.22.11

Fig. 2. John Butler Yeats, *Robert W. Sneddon*, c. 1909–10. Pencil on heavy paper, 5 × 7 in. (12.7 × 17.8 cm). Delaware Art Museum, Gift of Helen Farr Sloan, 1978

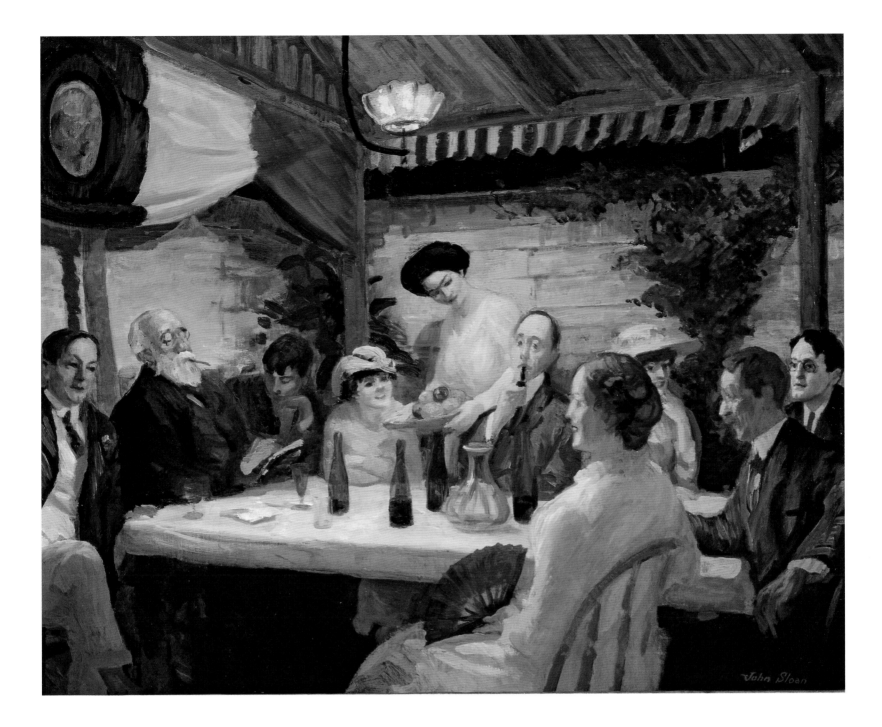

Henri's wife draws at a table in the background. But in Sloan's painting, Yeats appears silent, cigar in mouth, and the red-haired Frederick King holds forth. Importantly, Sloan shows Yeats making a portrait, likely of Mrs. Johnston, who poses opposite him on the near side of the table, while he, Sloan, sits quietly at the far corner of the table, nearly removed from the scene altogether. By picturing Yeats sketching one of the group, Sloan refers to the fact that Yeats helped supply the likenesses of these people. Sloan's careful rendering of himself also functions as a tribute to Yeats, the perpetual self-portraitist. Sloan's head is the most finished of the group. His bust-length pose and detached gaze, which make him seem distanced from the interactions of the table, are more in line with formal portraits than with the quickly sketched, animated likenesses of his friends. Sloan has taken the advice of his mentor and worked hard on his own visage, an exercise he must have hoped would aid him in the future.

The painting's title reflects its tribute to one man, but *Yeats at Petitpas'* can also be interpreted as a commemoration by Sloan of an important period in his own life. Sloan's diaries reveal that as his friendship with Yeats gathered momentum during late 1909 and 1910, Yeats introduced the Sloans to his coterie of friends who frequented Petitpas', including many of those featured in this painting. Soon the couple were regular, welcomed members of an exclusive circle. In addition to warm social connections, Sloan must have associated Petitpas' with several professional accomplishments of that year. In April a party was held there after a viewing of the exhibition of Independent Artists, a project Sloan had worked ceaselessly to realize and which enjoyed great popular success.[11] Then on 10 June at Petitpas', Yeats paid Sloan an important compliment, which the artist eagerly recorded in his diary: "of all the contemporary painting and etching in America mine was most likely to last!"[12] That Sloan decided to begin *Yeats at Petitpas'* on his birthday, 2 August, attests to the painting's function as a commemoration of a year of new friends and artistic self-confidence.[13]

LGN

Thomas Wilmer Dewing (Boston, 1851–New York City, 1938)

Lady with a Mask, 1911

Oil on canvas, 22⅛ × 24⅛ in. (56.2 × 61.3 cm)
Signed lower left: T. W. Dewing
Museum Purchase, 11.18

There is no better description of *Lady with a Mask* than the anonymous notice that appeared in the *Washington Evening Star* in 1911, on the occasion of the Corcoran's acquisition of the painting:

> its chief charm lies in its exquisitely artistic manner of rendering. The predominating color of the general scheme is gray; the wall, the floor, the lady's gown are all gentle variations of this tint. It is, indeed, as though a lovely twilight had enveloped and veiled the whole composition. To see distinctly the feature of the lady's face one must use scrutiny. And yet the picture is not cold nor somber, and is neither vague nor indefinite. The soft, clinging fabric of the gown shows in its weave touches of pink and other colors—the blank wall which serves as a background is by no means bald or dreary. The picture is atmospheric, and the sense of pigment is entirely lost.[1]

The reviewer accurately described the dreamy effect of the picture and the sophisticated painting technique, in which the colors are desaturated, the contrasts between lights and darks are minimized, and the stippling actions of the brush are intricate and subtle. Technical studies of the picture help to explain Dewing's method and the resulting effects so praised by the *Star* critic: "The artist built up his design with many thin applications of paint that often only partially cover the layers below. In many places the paint appears to have been wiped or rubbed while still wet, partially removing it from the high points and leaving it in the hollows of the fabric texture. The face and many other parts of the design were executed with innumerable small strokes of variously-colored paint, applied with a tiny brush."[2]

Ultimately, Dewing's mesmerizing technique and the aesthetic sensibility behind it derived from the groundbreaking work of James McNeill Whistler (see *Battersea Reach*), who cast a long shadow across American art in the late nineteenth and early twentieth centuries. Also like Whistler, Dewing developed a composition that shows the influence of Japanese ukiyo-e prints: the intriguing off-center placement of the figure that weights the picture to the left and leaves the right side empty; the shallow, planar space; and the slight yet deliberate misalignment where the wall and floor meet. The motifs, too, are Japanese: the chair, the hanging scroll, and the mask that suggests the wooden masks of Noh theater. Dewing had become familiar with Japanese art through his patron, the Detroit industrialist Charles Lang Freer, and purchased Japanese art for Freer in New York City. In turn, Freer exhibited Dewing's pictures in his house alongside Japanese works because he saw them united as "members of the same spiritual family."[3]

The model for the picture is Gertrude McNeill, who had just begun working for Dewing in 1911.[4] Perhaps because of the newness of the artist-model relationship (which lasted until 1917), Dewing painted the head in *Lady with a Mask* with light-and-dark shading that is deeper than the modeling in the rest of the figure, as if he were striving to get to know his model and her facial architecture. Even the area surrounding her head has a smudged aura that calls special attention to her as an individual. As a result, the figure is

Fig. 1. John Sloan, *Sunday, Women Drying Their Hair*, 1912. Oil on canvas, 26⅛ × 32⅛ in. (66.4 × 81.6 cm). Addison Gallery of American Art, Phillips Academy, Andover, Massachusetts, 1938.67

personalized as if it were a portrait, whereas most of Dewing's other women are vaporous and nearly generic.

In other ways, though, *Lady with a Mask* reverts to type. She, like so many of Dewing's women, is elegant, poetic, and listless. Though situated in an interior space, she is not engaged in domestic activity nor is she seen as a professional. A work of art like the hanging scroll to her right, she is an idealized vision of woman at the highest echelon of civilization, refined in body and mind, proof positive of the evolutionary ascent of humanity, "quite different," in the words of Dewing's critic Sadakichi Hartmann, "to what we generally understand by modern women."[5] The delicate way she holds the mask between her third finger and thumb with pinkie and index fingers raised, the drop of her endlessly long arm that terminates in an extended finger that brushes the edge of the frame, and her attenuated figure that stretches out impossibly on the vertical, all point to some wondrous future species of woman. Painted in his New York studio in 1911, Dewing's image of feminine perfection clashed, however, with emerging trends in American art, especially the Ashcan painters and the avant-garde in the circle of Alfred Stieglitz. The three sturdy women in John Sloan's proletarian *Sunday, Women Drying Their Hair* of 1912 (Fig. 1) speak to the Progressive era, while Dewing's *Lady with a Mask* epitomizes Aestheticism, which aimed to disengage from the vicissitudes of a complex modern world. As Hartmann perfectly phrased it, the artist's "instinct of beauty, poetic expression and mystic grace satisfy my desire to forget every-day life completely."[6]

PS

John Singer Sargent (Florence, Italy, 1856–London, 1925)

Simplon Pass, 1911

Oil on canvas, 28¼ × 36⁷⁄₁₆ in. (71.8 × 92.6 cm)
Signed lower right: John S Sargent
Bequest of James Parmelee, 41.22

In the years around 1900, John Singer Sargent was both the pre-eminent portraitist of Anglo-American elites and in the midst of the first of several significant mural projects.[1] Although he painted murals literally to the end of his days, in 1907–8 he tried to stop making portraits, declaring to one friend: "I now only paint landscapes and religious decorations. . . . I really am shutting up shop in the portrait line."[2] These landscapes largely record the sites of his vacation travels.[3]

A popular destination for the painter and his coterie was the Simplon Pass, on the border between Switzerland and Italy.[4] He probably visited in 1904; he certainly spent extended time there in the summers of 1909, 1910, and 1911.[5] One of the glories of these later sojourns is the Corcoran's *Simplon Pass.* In it Sargent looks southeast from near the Hotel Bellevue Simplon-Kulm, where he and his party stayed.[6] The distinctive outline of the Hübschhorn lies in the distance.[7] The canvas conveys not only place but the scene's light and air, testifying to what a writer in 1914 called Sargent's "dazzling capacity to realize unfalteringly as much as the artist sees."[8]

In *Simplon Pass,* Sargent establishes a formal grammar of paint by differentiating four distinct registers of color and touch. In the lowest of these, a hodgepodge of many-colored strokes depicts a cascade of frothing water, sunlight on tumbled boulders, and brilliantly colored vegetation sprouting in the rock-strewn field. In the topmost register, thick swirls of white paint and smooth patches of blue denote sky. In between Sargent suggests two divisions of land. In the distance, a mute, thinly washed purple-gray provides the form of the Hübschhorn, with calligraphic swirls of lilac showing sunlight striking bare stone. Beneath this he creates the middle ground with parallel strokes sketched drily in green, yellow, and brown, their sloping horizontality interrupted only by strategic vertical strokes. The diverse brushwork and color in these four registers suggest a rhyming of hue and stroke with a particular division of space.

The affect of *Simplon Pass*—ranging from decorative flatness to deep illusionistic space—depends on the viewer. The decorative is most obvious when someone stands close enough so that individual brush marks and separate colors (particularly the many departures from local color effects) are readily overt. Greater distance allows these individual touches of paint to merge into recognizable forms. Viewers often move back and forth between these ranges, allowing first the perception of the painted surface and then the illusion it creates to dominate. One critic in 1914, writing of *Simplon Pass,* noted this effect when claiming that Sargent had "outdone himself in juggling with perspective" and yet saved himself "by giving the result a look of spontaneous unconcern."[9] It is crucial, however, to stand yet farther back from the canvas, for greater distance prompts another equally dramatic transformation. From twenty feet away, the foreground cascade and rock pile gain solidity; the middle ground smooths into an expansive upward-rolling plain; and the Hübschhorn, wrapped in the haze of atmospheric perspective, separates itself from the middle ground. The scene gains an almost mind-numbing immensity—what might be called the horizontal sublime.[10] Sargent's manner allows the canvas to be different, yet effective, from each stance and renewed with each viewing.

Adrian Stokes, who was with Sargent in the Simplon, makes it clear that the painter's aim was for effective picture making rather than snapshot veracity:

> I saw him once begin a four foot canvas. The larger part of the subject was composed of vigorous mountain forms . . . : brilliant, clear-cut white clouds . . . boiled up amongst them, while patches of blue sky showed through above. . . . When, in two or three hours, it was time to go, the whole of the upper half of the picture was magnificently complete. Afterwards, on a similar day, he painted the lower part but, being dissatisfied with it, scraped it out.
>
> At that time, in the same neighbourhood, I was engaged on a careful study of rocks. . . . Sargent thought they would form a better foreground than those actually in the place where he had begun his picture. . . . He came to work beside me, and that was the first occasion when, for any length of time, I saw him paint.
>
> [W]hat was really marvelous was the rightness of every touch. . . . [E]very touch was individual and conveyed a quick unerring message from the brain. It was—if you will—a kind of shorthand, but it was magical![11]

Sargent sold *Simplon Pass* to M. Knoedler & Co., the London dealers, in March 1912. James Parmelee bought it that fall; he and his wife were the only owners before the picture entered the Corcoran in 1941.[12] The picture's relative seclusion kept contemporary critical response to a minimum. The Parmelees lent it to one Corcoran show, however, in late 1914, when newspaper reviewers found it to be "brilliant and self-assured," "done with all the ease and skill of a past master technician," and possessing "immense cleverness." They tempered their praise, however, by claiming that the picture "leaves one indifferent" and prompted thoughts of the "fatal facility" that prevented Sargent from "delving deeper into the meaning of art."[13]

Simplon Pass (and Sargent's landscape paintings in general) challenge viewers to hold simultaneously an awareness of their distinct and contradictory achievements: wizardly paint application, decorative composition, apparent topographic accuracy, evocation of the horizontal sublime. Since each of these qualities waxes or wanes depending on the physical and doctrinal position of the individual, the picture can always be seen as falling short of expectations. The converse, of course, is that it possesses always a variety of riches awaiting the receptive viewer.

MS

Abbott Handerson Thayer (Boston, 1849–Dublin, N.H., 1921)

Mount Monadnock, probably 1911/1914

Oil on canvas, 22³/₁₆ × 24³/₁₆ in. (56.3 × 61.4 cm)
Signed lower right: Abbott H. Thayer; inscribed on back: To Franklin MacVeagh,
from Abbott H. Thayer / In Memory of the former's great kindness / in the
summer of 1911. Dublin, N.H.
Museum Purchase, Anna E. Clark Fund, 34.6

Abbott Thayer, who was a naturalist as well as an artist, spent much of his life in the shadow of New Hampshire's Mount Monadnock, hiking its trails, studying its flora and fauna, and protecting its pristine beauty. "This dear mountain," as Thayer described it, was also an abiding source of artistic inspiration and personal solace: he would feed his soul, he said, by "gazing at Monadnock from afar."[1] He painted its snowcapped peak many times, occasionally waking his entire family before dawn to watch the first rays of sunlight strike the summit.[2]

The Corcoran's *Mount Monadnock* depicts just such a view of the mountain that had been a totem for an earlier generation of Transcendentalist poets and philosophers. Ralph Waldo Emerson, who had dedicated a long poem to "Monadnoc" in 1846, called it "the new Olympus." Henry David Thoreau climbed its summit four times between 1844 and 1860, making detailed botanical and geological notes; ascending the mountain, he said, was like climbing the steps of a temple.[3] A great admirer of both men, Thayer kept a portrait bust of Emerson by his front door, and he shared Emerson and Thoreau's pantheistic reverence toward nature, particularly their belief that the natural world was a concrete manifestation of invisible spiritual facts.[4]

Born in Boston and raised in the rural environment of Keene, New Hampshire, Thayer was deeply rooted in the New England culture that produced Transcendentalism. As a boy, he spent much of his time outdoors, collecting animal specimens to draw and paint; as an adult, he resumed his study of animals and their habitats, developing an elaborate theory of animal camouflage and producing a corpus of detailed illustrations drawn from nature.[5] As a young man, however, Thayer sought a more cosmopolitan artistic education. From 1875 until 1879, he lived in Paris and studied at the École des Beaux-Arts with Henri Lehmann and Jean-Léon Gérôme. On returning to New York, Thayer became a successful portrait painter and a leading member of the newly formed Society of American Artists, whose goal was to challenge the conservative styles and exhibition policies of the National Academy of Design.

Despite his full participation in the culture industry of New York, however, Thayer retained his love of the countryside, and in 1888 he acquired a property in Dublin, New Hampshire, which had been recently developed as a summer colony for artists, writers, and intellectuals. There, on the south side of Dublin Pond, he built a rustic cottage with spectacular views of Mount Monadnock and resumed the naturalist pursuits of his boyhood.[6] Throughout the 1890s Thayer grew increasingly intolerant of the "squalor" of urban life, and by 1901 he was living in Dublin year-round.[7] High-strung and, by present-day diagnostic standards, probably bipolar, Thayer seems to have taken particular comfort from the mountain, with its timeless, monumental presence and its rich literary associations. His life in Dublin generally, and his encounters with the mountain more particularly, became a form of self-therapy, imbuing images like the Corcoran's *Mount Monadnock* with a specifically biographical significance.[8]

The painting was probably completed between 1911, the date mentioned in the artist's inscription as a time of "great kindness"

Fig. 1. Abbott Handerson Thayer, *Monadnock in Winter*, 1904. Oil on canvas, 35⅝ × 35⅝ in. (90.5 × 90.5 cm). Freer Gallery of Art, Smithsonian Institution, Washington, D.C.: Gift of Charles Lang Freer, F1904.359a

from his friend and former Dublin resident Franklin MacVeagh, and 1914, when the magnificent frame was designed by Hermann Dudley Murphy at the Boston shop of Carrig-Rohane.[9] However, the canvas is remarkably similar to an earlier version of 1904, now in the Freer Gallery of Art (Fig. 1), hinting that the later picture may have been started much earlier and subsequently altered. The art historian Susan Hobbs has proposed that the Corcoran's painting may have been based on a sketch for the 1904 work, since Thayer continued to work on paintings for many years. This idea is supported by examination of the 1911 painting by Corcoran conservators, which revealed strokes of more heavily textured paint in the underlayers of the foreground, suggesting that Thayer may have begun with a more tactile surface, which he then painted over, creating the enamel-like finish of the final work.[10]

The surface differences notwithstanding, the Corcoran's version follows the earlier example in depicting the snowy peak rising in the background against a chilly dawn sky, protected by an expanse of snow and a stand of dark spruce trees in the foreground. Much of the scene is in shadow, so that the stark white of the mountaintop becomes the focal point of the composition. In many of Thayer's Monadnock pictures, calligraphic brushstrokes are an important structural element; here, however, the pigment is smoothly applied, creating a uniform surface broken only by the thick impasto of the snowy peak and floating strokes of magenta around the trees. These areas of more visible facture rupture the naturalism of the scene and

introduce a level of aesthetic subjectivity and expressiveness belied by the smooth surface of the foreground.

Thayer regarded his landscapes as a type of portraiture and therefore true to nature.[11] Indeed, his work as a naturalist was bound up with his interest in landscape painting. In 1911, the very year mentioned in the painting's inscription, he learned that a group of private developers wanted to buy an expanse of the mountain. Fulminating against their plans, Thayer declared that, if he owned the mountain, "I should feel that my only rights were to see that no deterioration of its virginity occurred."[12] He was ultimately successful in organizing the Dublin community around the conservation of Monadnock, thus ensuring his images of the mountain would endure as faithful portraits, timeless rather than nostalgic. Along with fidelity to nature, Thayer also strove to communicate what he called "an exalted atmosphere" in his art.[13] This idea was literalized in the winged figures for which he is best known today.[14] But the Corcoran's *Mount Monadnock* and its many iterations were also an expression of that aspiration, invested, as the mountain was for Thayer, with cultural, spiritual, and personal significance. When

he died, Thayer's ashes were scattered, according to his wishes, on the summit of his favorite mountain, and his son Gerald instructed the mourners, "Regard Monadnock, the mountain, as in a very real sense his monument."[15]

LG

Childe Hassam (Dorchester, Mass., 1859–East Hampton, N.Y., 1935)

The New York Window, 1912

Oil on canvas, 45⅞ × 35⅟₁₆ in. (116.5 × 89.1 cm)
Signed and dated lower left: Childe Hassam / 1912
Museum Purchase, Gallery Fund, 12.10

The New York Window is one of a thematically linked group of paintings depicting women in quiet interiors that Hassam began in 1907 and continued through the 1910s. Two of his earlier oils anticipate the so-called Window series. *Summer Evening* (1886, Florence Griswold Museum, Old Lyme, Conn.), painted on Appledore Island, portrays the artist's wife tending a pot of geraniums on a windowsill overlooking meadows stretching to the sea. *Improvisation* (1899, Smithsonian American Art Museum, Washington, D.C.) depicts a young woman playing the piano in front of an open window.[1] But it was only beginning with *Bowl of Nasturtiums* (location unknown) in 1907 that Hassam made a specialty of the theme of a well-dressed woman framed in a window and balanced by a still-life element.[2]

Other painters also depicted women in tastefully furnished interiors. Images of demure women plying their needles, trying on hats, toying with jewelry, or doing nothing at all had been staples in the exhibitions of the Ten American Painters since their first in 1898. The Boston artists Frank Benson, Joseph DeCamp, and Edmund Tarbell met success with variations on the theme. Hassam's interpretations differed from theirs by offering a glimpse of the outside world. The seventeenth-century Dutch master Johannes Vermeer is usually cited as the inspiration for such works, but the Spaniard Bartolomé Esteban Murillo and the German Caspar David Friedrich are among other European precedents.

Hassam's Windows won immediate critical acclaim. Three of the earliest examples—*Spring Morning* (1909, Carnegie Museum of Art, Pittsburgh), *Against the Light* (1910, The Art Institute of Chicago), and *The Breakfast Room* (1911, Worcester Art Museum, Mass.)—were acquired by museums the year they were painted. Hassam found an inspiring setting for his series in the duplex apartment at 130 West Fifty-seventh Street into which he and his wife moved in January 1909.[3] The two-story, skylit studio faced north, the orientation long favored by artists, offering an enviable view of Central Park. But Hassam painted many examples of this genre, including *The New York Window*, not in the studio but in the dining or breakfast room, which faced south into the densely built commercial heart of the city.[4] Beyond the closed, veiled windows, tall buildings crowd shoulder to shoulder, forming a dynamic abstract pattern on the sheer

Fig. 1. Childe Hassam, *Bowl of Goldfish*, 1912. Oil on canvas, 25¼ × 30⅝ in. (64 × 77 cm). Ball State University Museum of Art, Frank C. Ball Collection, Gift of the Ball Brothers Foundation, 1995.035.073

curtains. The woman, whose loose, flowing gown and languid posture contrast with the vigorous verticals of the skyscrapers, turns inward. Beside her, the rounded forms of a bowl of fruit—traditional symbol of female fecundity—reinforce the contrast between the feminine home and the masculine city.

In the spring of 1912 Hassam sent *The New York Window* to the annual exhibition of the National Academy of Design, where it was acclaimed the star of the show. The *New York Evening Post* critic called it "the most interesting painting on these walls" and one that "tempts one to return from time to time" for repeated enjoyment.[5] The artist-critic Guy Pène du Bois wrote that "the masterpiece of the collection . . . is without doubt Childe Hassam's 'The New York Window,' wherein is shown a woman whose beauty is doubled by a glorifying screen of atmosphere. Behind her through faintly indicated curtains may be seen houses of the city that have become similar to the castles of the romanticist's fairyland without the bane of his mysticism and untruth."[6] Later that year, Hassam sent *The New York Window* to the Fourth Exhibition of Oil Paintings by Contemporary American Artists at the Corcoran, where it won the First William A. Clark Prize and the Corcoran Gold Medal and was purchased for the permanent collection.

One reviewer of the Washington exhibition captured the painting's meditative mood: "Twilight has fallen, or it is afternoon of a gray day; through the window shadowy forms of great buildings loom as ghosts against the sky. It is the hour of rest, of meditation, and every line of the figure seated by the window conveys this suggestion."[7] As that writer implied, the woman's posture and downcast eyes convey an aura of melancholy that sets this painting apart from others in the Window series, especially those executed in rural Connecticut. Hassam sent one of the country Windows—*Bowl of Goldfish* (Fig. 1), painted in Cos Cob, Connecticut—to the exhibition at the Corcoran together with *The New York Window*. Although the city and country paintings did not hang side by side, two writers mentioned both of them. After reporting Hassam's prize for *The New York Window*, a Buffalo reviewer continued, "Mr. Hassam was also represented in the exhibition by 'A Bowl of Gold Fish,' which, beautiful in color and drawing, is thought by many critics to be, if not his best work, certainly in the forefront of all his canvases which continually sing their inspiring song of vibration, light, and solar radiance."[8] The *New York Evening Post* critic wrote, "Childe Hassam won the first prize and the Corcoran gold medal with his *New York Window*. In addition to this beautiful canvas the same artist has here *The Bowl of Goldfish*, in which color is unusually fresh and luminous. It is a fine specimen of his most felicitous work."[9] Whereas the model in *The New York Window*, sequestered behind closed, curtained windows, turns away from the city outside, her Cos Cob counterpart looks out at the sunlit landscape beyond the flung-open windows. A bowl of swirling goldfish, an unstill life, integrates interior and exterior, home and nature, in contrast to the pyramid of fruit in *The New York Window*, which underscores the division between the feminine (domestic) and masculine (urban) realms.[10]

Hassam presented *The New York Window* in a handsome, hand-carved frame he ordered from the prestigious Boston frame makers Carrig-Rohane in October 1910. A variant of the style Carrig-Rohane designated "Hassam pattern," it is an elegant cassetta form with a reeded sight edge, wide flat cove, and basketwork corners. Hassam commissioned the frame for an unidentified horizontal canvas and used it on several others before selecting it for *The New York Window*.[11] It provides a spacious, harmonious setting for the painting.

SGL

209

Marsden Hartley (Lewiston, Maine, 1877–Ellsworth, Maine, 1943)

Berlin Abstraction, 1914/15

Oil on canvas, 31¹³⁄₁₆ × 25½ in. (80.8 × 64.8 cm)
Museum Purchase, Gallery Fund, 67.3

Berlin Abstraction numbers among the most innovative works in Marsden Hartley's career, and indeed in that of any artist in the first wave of the American avant-garde. The canvas is one of a dozen deeply symbolic and personal paintings Hartley produced between November 1914 and the fall of 1915, during his second stay in the German city. The name by which the group is best known today, the German Officer portraits, derives from the most oft-discussed aspect of its content: the World War I soldiers to whom the paintings pay tribute, especially the artist's cherished friend Lieutenant Karl von Freyburg. Although their primary significance is elegiac, the War Motifs, as Hartley called them, are as rich with layers of meaning as they are vibrant and complex in appearance.[1]

Born in Lewiston, Maine, to working-class English immigrant parents, Hartley received some artistic training in Cleveland in the 1890s after his family relocated there. When he moved to New York in 1899, he studied at William Merritt Chase's School of Art and the National Academy of Design. This restlessness was to characterize Hartley's later life as well as his art: he traveled frequently in Europe, North America, and Mexico, painting landscapes, still lifes, and abstractions in many different styles. The location closest to his heart, however, was Berlin—he called it "without question the finest modern city in Europe."[2] His first two excursions there were financed by the photographer and art dealer Alfred Stieglitz, who promoted Hartley's work in a one-man exhibition at his gallery 291 in 1909 and in a pioneering group show there the following year, *Younger American Painters.*[3]

In April 1914, reunited in Berlin with von Freyburg and his cousin the sculptor Arnold Rönnebeck, both of whom he had met during his first European trip in 1912–13, Hartley resumed his enthusiastic embrace of the "movement and energy" of the fast-growing modern metropolis[4]—the brilliantly colored military uniforms, lively parades, and other pageantry of the imperial capital—and the city's gay subculture, which was closely intertwined with the German military at that time.[5] Simultaneously, his friendship with von Freyburg intensified, and the two likely became lovers.[6] In the fall of 1914, however, Hartley's exuberance was dashed by a series of tragedies: he learned that his father had died in August, the month that saw the outbreak of World War I; on 7 October von Freyburg was killed in battle on the western front; and soon thereafter Rönnebeck was seriously wounded and hospitalized. These events, and above all von Freyburg's death, led to Hartley's creation of the War Motifs. After a month of intense grieving, Hartley began the series to memorialize his friend and the many other war dead and to express his abhorrence of the war in general.[7]

As one Hartley scholar has written, despite this primary meaning, the artist's War Motifs are multivalent and represent a major synthesis of modernism's pictorial vocabulary. They contain heavily coded expressions of Hartley's life in Berlin's vibrant homosexual culture and the role of the German military in that culture, and an outpouring of the artist's thoughts about war.[8] Like the brightly colored, effusive Berlin canvases that predated Hartley's emotional downturn, the Corcoran's and other War Motif paintings were strongly influenced by the modernism to which he had been exposed

Fig. 1. Marsden Hartley, *Portrait of a German Officer*, 1914. Oil on canvas, 68¼ × 41⅜ in. (173.4 × 105.1 cm). The Metropolitan Museum of Art, Alfred Stieglitz Collection, 1949, 49.70.42

on his first European trip. The juxtaposition of flat, geometric, black-outlined shapes continues the artist's espousal of Synthetic Cubism—he was the first American artist to fully adopt the style—which he saw when he met Pablo Picasso at Gertrude and Leo Stein's famous salon in Paris in 1912. His loosely brushed, bright palette recalls the bold German Expressionist work by Blaue Reiter members Vasily Kandinsky and Franz Marc, with whom he became friendly in Berlin the following year; the two not only strongly influenced his style but led him to embrace the spiritual aspects of art.

Berlin Abstraction incorporates general allusions to German military pageantry found in the other War Motif paintings: the sleeve cuffs and epaulets of uniforms; a helmet cockade denoted by two concentric circles; and the blue-and-white diamond-patterned Bavarian flag. Other symbols refer specifically to von Freyburg: the red 4 signifies the Fourth Regiment of the Kaiser's guards, in which he fought, and the red-and-white checkerboard pattern recalls his love of chess. The central black cross on a white background circumscribed by a red and a white circle is likely an abstraction of the Iron Cross medal for bravery bestowed posthumously on von Freyburg. The calligraphic red *E* refers to Elisabeth, queen of Greece, the patroness of Rönnebeck's regiment.

The content and style of the War Motifs evolved from symbol-laden and hieratically, even anthropomorphically, composed paintings that refer specifically to von Freyburg early in the series to increasingly patterned canvases that more generally evoke the vivid designs of German military uniforms.[9] *Portrait of a German Officer* (Fig. 1), acknowledged to be the first painting in the sequence, incorporates explicit references to von Freyburg—his initials (K.v.F.), his age when he died (24), and his regiment number (4)—into a composition of interlocking elements evocative of a human torso against a black background. In contrast, *Berlin Abstraction* is one of the three latest, most abstract paintings in the series. Along with *Painting No. 5* (1914–15, Whitney Museum of American Art, New York) and *Military* (1915, The Cleveland Museum of Art), it achieves a total absence of illusionistic space and a near erasure of recognizable subject matter, its more loosely arranged pictorial elements extending to the edge

of the canvas and incorporating fewer symbols referring specifically to von Freyburg.[10]

In the spring of 1916, forty of the Berlin paintings, including the War Motif series, were exhibited at 291. *Berlin Abstraction*, owned by Stieglitz's great friend and champion, the cultural critic and author Paul Rosenfeld, was likely included.[11] Although some critics wrote favorably about the Berlin paintings' formal qualities, others criticized them for their perceived pro-German messages. In 1916 Hartley issued a statement claiming that the group had no hidden meaning. He described their forms as "those which I have observed casually from day to day" and having "no symbolism whatsoever."[12] It was only after his death that the more private nature of these paintings was revealed.

SC

Joseph Rodefer DeCamp (Cincinnati, 1858–Boca Grande, Fla., 1923)

The Seamstress, 1916

Oil on canvas, 36⁵/₁₆ × 28³/₁₆ in. (92.1 × 71.6 cm)
Signed and dated upper left: JOSEPH–DE–CAMP–1916
Museum Purchase, Gallery Fund, 16.4

A founding member of the group of artists known as the Ten American Painters, Joseph DeCamp was one of the leading figures in American Impressionism and the Boston art scene in the early decades of the twentieth century. *The Seamstress*, an example of DeCamp's mature style, masterfully balances description and mood, solid modeling and ethereal effect, immediacy and extended looking. DeCamp completed the painting only when specific weather and light conditions prevailed, explaining that he needed a "couple of grey days [to] turn the trick."[1] The result is a painting that flickers with differing textures—thick impasto next to fine brushstrokes—and luminous shades of white and gray, from the ruffled curtains and the glimmer of the outside seen through the window to the simple blouse of the seamstress and mottled reflections on the table.

Born in Cincinnati, Ohio, Decamp studied at the Cincinnati School of Design with one of the leading realist painters of the time, Frank Duveneck. DeCamp spent a considerable amount of time with Duveneck, following him to the Munich Royal Academy in Germany and then to Florence and Venice for several years, meeting the renowned expatriate artists James McNeill Whistler and John Singer Sargent along the way.[2] When he returned to the United States in the 1880s, DeCamp settled in Boston and decided to work as a portrait painter, which, along with teaching, provided a steady source of income after he married and had children. At the urging of his close friend and colleague Edmund Tarbell, DeCamp abandoned the dark tones associated with Duveneck and the Munich School and began to pursue the effects of sunlight and a brighter palette. Tarbell's style, a distinctly American kind of Impressionism, was commanding to say the least: those artists within Tarbell's circle in Boston, such as Frank Benson, William McGregor Paxton, and DeCamp, were dubbed "Tarbellites" by the critic Sadakichi Hartmann.[3] Indeed, DeCamp's *The Seamstress* portrays a subject well known to the Boston School: sun-dappled interiors with women by windows offered the artists a way to experiment with light and color, most notably seen in Tarbell's *Josephine and Mercie* and the series of window paintings by Childe Hassam from the 1910s, such as *The New York Window* (for both, see the essays in this catalogue).[4]

These domestic vignettes of women engaged in the quotidian—performing household chores, reading, or absorbed in other forms of leisure—not only recall the quiet, still interiors of the seventeenth-century Dutch painter Johannes Vermeer but also suggest a nostalgic set of attitudes and beliefs toward women that was losing its foothold in the twentieth century as more and more women entered the workforce. Not surprisingly, critics of the time praised works like DeCamp's for their escape from the "frippery and vulgarity" of modern-day living.[5] In contrast to Elizabeth Paxton's *The Open Window* (Fig. 1), for example, which shows a woman using a sewing machine (a device that had been popular since the 1860s) and dress patterns pinned on the wall nearby, *The Seamstress* depicts its subject sewing without the convenience of technological advances, set in a scene that is arranged purely for visual effect. Like the porcelain cup on the table, the model is presented to us for decorative purposes. In conjunction with this formal quality, the woman in DeCamp's picture appears as an icon of domestic virtue, as suggested by the window mullions

Fig. 1. Elizabeth Vaughan Okie Paxton, *The Open Window*, 1922. Oil on canvas, 24¼ × 18¼ in. (61.6 × 46.4 cm). Museum of Fine Arts, Boston, Bequest of Gertrude H. Donald, 1997.173

forming a cross behind her.[6] Further testament to DeCamp's emphasis on symbolic over literal meaning in *The Seamstress* is the fact that neither needle nor thread can be seen in the woman's hands.

Even though DeCamp avoids realistic detail, the Corcoran's painting emphasizes extended observation and precise draftsmanship, central tenets of the artist's pedagogical beliefs. Known for his gifts as an academic technician, DeCamp was a highly esteemed and beloved instructor at the School of the Museum of Fine Arts, Boston, and, later, the Massachusetts Normal Art School and Pennsylvania Academy of the Fine Arts. In a 1909 interview, the artist discussed a telling aspect of his methodology: "Put your canvas up near your sitter . . . and sit for ten solid minutes just looking and deciding things. Then get on your feet and go to work. Deliberately paint some one fact you have seen. You'll be astonished to see how fast you'll get ahead."[7]

DeCamp received many awards and honors around this time, including the Second William A. Clark Prize and Silver Medal in the Corcoran's Second Exhibition of Oil Paintings by Contemporary American Artists in 1908–9, and his artistic talents and renown earned him a commission to paint a full-length portrait of President Theodore Roosevelt at the White House in 1908 for the Harvard University Union. Made during the height of his career, the presidential portrait is, like *The Seamstress*, a tour de force of indoor light.

While still a popular style, Impressionism was losing its allure in domestic and international markets, primarily because of the insurgence of modernism. With the influx of the gritty realism of the Ashcan School in 1908 and the 1913 New York Armory Show introducing American viewers to the likes of Marcel Duchamp's splintered, Cubist *Nude Descending a Staircase, No. 2* (1912, Philadelphia Museum of Art), Impressionism was no longer the epicenter of the avant-garde. As one critic put it, "[Impressionism] was a cause. It is,

alas, ancient history. . . . Impressionism is a fixed, settled, accepted quantity, . . . A new 'cause' occupies the thinkers. . . ."[8] From our vantage point, however, the critic was shortsighted in his assessment, for Impressionism and such fine contributions as DeCamp's *The Seamstress* paved the way for artists to pictorialize the immediate and the fleeting in new and daring ways.

AN

Ernest Lawson (Halifax, Nova Scotia, 1873–Miami, Fla., 1939)

Boathouse, Winter, Harlem River, c. 1916

Oil on canvas, 40⅜ × 50 in. (102.6 × 127 cm)
Signed lower right: E. Lawson
Museum Purchase, Gallery Fund, 16.3

Ernest Lawson went to New York in 1891 to study at the Art Students League. He followed his teachers John H. Twachtman and J. Alden Weir to Cos Cob, Connecticut, for summer school in 1892. He could more readily absorb their Impressionist idiom painting in the open air than in a crowded city studio. "Ernest Lawson was the leading member of the class," fellow student Allen Tucker recalled later, "for from the first he got hold of things, and painted canvases made of color and filled with light and air."[1] The following year, Lawson went to Paris for further studies at the Académie Julian. An encounter with the French painter Alfred Sisley confirmed his tendency to Impressionism. Lawson later recalled Sisley's criticism: "All he said was, after looking over the canvas and then taking in my appearance, 'Put more paint on your canvas and less on yourself.'"[2]

After a brief visit to the United States in 1894, Lawson returned to France and remained there until 1896. Together with his wife and two daughters, he settled in New York in 1898. For the next two decades, the city's landscapes and people would be his major theme. Urban subject matter was favored by many artists of Lawson's generation. Some of them, later dubbed the Ashcan School, produced gritty views of New York's unglamorous neighborhoods and working-class population at work and play. Lawson exhibited with some of the Ashcan painters in the landmark show of the Eight in 1908, but he navigated a middle course between realism and Impressionism, often using snow, darkness, or fog to veil the landscapes in unexpected beauty.

Lawson stood on the west bank of the Harlem River at about 202nd Street in upper Manhattan to paint *Boathouse, Winter, Harlem River*.[3] The composition is divided into four unequal horizontal bands: the foreground of heavy white snow animated by twiggy shrubbery; the green, ice-flecked river; the opposite bank, crowned by a cluster of buildings; and the pale wintry sky, tinted with pearly hues of the deeper colors in the picture. The boathouse of the title is a wooden shack. By contrast, the buildings on the opposite bank convey the civic ambition of a rising metropolis. They emerge from an atmospheric haze, which further distances them from the workaday world of the foreground. Built in 1900 to the designs of the architectural firm McKim, Mead and White, they were the centerpiece of New York University's uptown campus (now Bronx Community College). The large domed building in the center is Gould Memorial Library, with the arcaded Hall of Fame of Great Americans below it. Flanking the library are the Cornelius Baker Hall of Philosophy and the Hall of Languages. The buildings Lawson chose to depict are still admired by architectural historians. According to one source, "These three buildings . . . together with the Hall of Fame Arcade, are the *pièce de résistance* of this campus, and their design is attributed to architect Stanford White himself. Looked at in terms of their exquisitely detailed stone exteriors, they achieve a grand Classical Revival composition."[4]

Lawson most likely painted this canvas in the first quarter of 1916, when New York endured exceptionally snowy weather, with thirteen inches of snow in February and more than two feet in March.[5] That May or June, he left for Spain. On his return in late November or early December, he sent *Boathouse* to the Corcoran's Sixth Exhibition of Oil Paintings by Contemporary American Artists, where it was awarded the Second William A. Clark Prize of $1,500 and a Silver Medal. Lawson's letter of 10 December to the Corcoran's

Fig. 1. Ernest Lawson, *Boat Club in Winter*, c. 1915. Oil on canvas, 16½ × 20¼ in. (41.9 × 51.4 cm). Milwaukee Art Museum, Samuel O. Buckner Collection, M1928.6

president, Charles C. Glover, conveys his pride at receiving the award and establishes the approximate dates of his stay in Spain, providing rare documentation of the artist's sketchy chronology. "Thanks for your telegram telling me about the prize awarded me," Lawson wrote. "It is the biggest honor I have received and I am very proud of it. . . . I have just come back from a six month stay in Spain where I worked hard at the mixture of sunny and gloomy landscape with good results I think."[6] The Corcoran purchased *Boathouse* through Lawson's dealer, Charles Daniel of New York.

Recognition from the Corcoran came at the peak of Lawson's career. He had exhibited in the landmark Armory Show of 1913 and won a gold medal at the Panama-Pacific International Exposition in San Francisco in 1915. In addition to the Corcoran award, he also received the second Altman Prize at the National Academy of Design in 1916. The following year he won the Inness Gold Medal and was elected to full membership in the National Academy.

The Corcoran's painting is the largest of four related works. *Boat Club in Winter* (Fig. 1) and *Harlem, Winter* (n.d., destroyed) are both less than half the size of the Corcoran's canvas.[7] The latter may have been painted earlier, possibly in late 1915; however, the Milwaukee canvas suggests a spring thaw. Most of the snow that covers the dock

in the Corcoran's painting has melted, and a bare-armed man works in the boatyard. A painting with the same title as the Corcoran's in a private collection is signed and dated 1918. That version, which is twenty-five by thirty inches, is a near replica of the Corcoran's.[8]

The Corcoran's canvas retains what is most likely its original frame, an Arts and Crafts style with crosseted corners and a basket-work frieze, made by Newcomb-Macklin Company. The gilding has been rubbed down to the red bole in some areas, notably the beadlike ornaments near the sight edge. The muted red picks up the red and pink tones in the painting, lending warmth to the snowy landscape.

SGL

Frank Weston Benson (Salem, Mass., 1862–Salem, Mass., 1951)

The Open Window, 1917

Oil on canvas, 52⅛ × 42³⁄₁₆ in. (132.4 × 107.2 cm)
Signed and dated lower left: F. W. Benson / 1917.
Museum Purchase, 19.30

Frank Benson was born in his grandfather's house in Salem, Massachusetts, and grew up surrounded by objects his seafaring forebears had collected during the decades that Salem was a major port in the China Trade.[1] An inherited taste for New England tradition spiced with cosmopolitan overtones pervades his paintings of women in interiors.

Benson began his formal art training at the newly established School of the Museum of Fine Arts, Boston, in 1880. Among his classmates was Edmund Tarbell, who became a lifelong friend. In 1883 Benson traveled to Paris, where he studied at the Académie Julian for two years, refining his skills in draftsmanship and figure painting. Back in the United States, he married, settled in Salem, and in 1889 began commuting into Boston to teach at the Museum School along with Tarbell. Under their leadership, the institution emerged as one of the most influential art academies in America.

Benson maintained a studio in Boston, where his twenty-three-year-old daughter Elisabeth posed for The Open Window.[2] In earlier canvases, Elisabeth and her siblings (two sisters and a brother) appear in brilliant sunlight, often against the shimmering backdrop of the sea. During summers in Newcastle, New Hampshire, and, beginning in 1901, on the island of North Haven, Maine, the children's days of swimming, fishing, and boating were punctuated with quiet hours of posing in the open air.[3] By about 1910, however, Benson moved indoors to portray women in quiet interiors inspired by Johannes Vermeer. Enthusiasm for Vermeer bloomed after the publication in 1904 of the first American monograph on the seventeenth-century painter.[4] That year, Tarbell exhibited his first painting indebted to the Dutch master, Girl Crocheting (The Arkell Museum, Canajoharie, N.Y.),[5] and before long, other artists—especially in Boston—followed suit. A contemporary critic described a typical painting of the Boston School: a "characteristic damsel sits sewing or knitting, writing or drinking tea in a room the charm of which is enhanced by colonial furniture, quaint mirrors, old porcelains, and a highly polished floor."[6]

Benson used his studio in the Riverway Building near the Charles River as a carefully furnished stage set for his paintings of interiors.[7] In The Open Window, the tripod table, two chairs, and footed French porcelain bowl are antiques. The Chinese jacket, embroidered tablecloth, and Japanese chest recall Salem's historic connection to trade with the East, an effect reiterated in the calli-

graphic line on Elisabeth's skirt, culminating in a barely delineated ball of yarn at her feet. The bronze sculpture atop the chest was a gift from Benson's close friend Bela Lyon Pratt, a popular teacher at the Museum School.[8] The sculpture of a reclining nude (Fig. 1), dated 1908, represents Artemis, the Greek goddess of virginity, fertility, and the hunt.[9] In The Open Window, Elisabeth's head and the bronze share the center of the composition. The pairing of Greek goddess and American maiden is emphasized by the similar contours of their heads and shoulders and the dark tonality of the bronze and Elisabeth's hair and jacket. Knitting in a refined New England interior, the artist's daughter embodies ties to classical antiquity and the exotic Orient.

In March 1917, Benson sent The Open Window to the Twentieth Annual Exhibition of Ten American Painters. Writing in the New York Herald, Gustav Kobbe called the canvas the "high water mark in this year's exhibition."[10] Other critics were less impressed. The New York Times declared that the setting was "so discreetly unfurnished as to somewhat flaunt the discrimination of the decorator. . . . The only trouble with this room is that it is not a living room. It has no pulse, the air fails to stir in it, the light that illumines the pinkish drab of the innocent walls has no suggestion of change. It is a room in a trance at best."[11] Some reviewers accused Benson of encroaching on Tarbell's territory. One labeled The Open Window "a Tarbell composition" but admired the "rendition of light and air."[12] The Art World critic remarked that with this painting, Benson "approaches the chosen ground of Edmund C. Tarbell, painting the modern interior adorned with figures as if in memory of the old Hollanders."[13]

Two years later, Benson sent the painting to the Seventh Exhibition of Oil Paintings by Contemporary American Artists at the Corcoran. There, it captured the First William A. Clark Prize of $2,000 and the Corcoran Gold Medal. Again, critics noted Benson's relation to Tarbell and Vermeer, but this time they evaluated his painting on its own merits. The American Art News reviewer judged that the canvas "is reminiscent of Tarbell, as well as Vermeer, but has a certain breadth and facility of handling which distinguish it among American paintings of the kind."[14] Acknowledging the theme as typical of the Boston School, another commented, "Mr. Benson has handled the subject with the utmost skill, enveloping the interior with limpid light from an open window."[15] Benson's interpretation of light—judged "masterly" by one writer—drew the greatest acclaim.[16] "Everything is transfigured by this wonderful, iridescent light," Anna Seaton-Schmidt rhapsodized, "each bit of color against every other color is a joy to the beholder."[17]

Between the Ten's exhibition in 1917 and the Corcoran biennial in 1919, Benson commissioned Walfred Thulin, a Swedish-born wood-carver who had a shop on Boylston Street in Boston, to create a new frame for The Open Window. The back of the frame is incised with the framemaker's insignia, the year 1919, and the number 565. The black polychromed centers, a characteristic of many of Thulin's frames, accentuate the dark tones of the sculpture and the mandarin jacket. The frame's crosseted corners show the influence of earlier Dutch designs—especially appropriate for a painting indebted to Vermeer.

Fig. 1. Bela Lyon Pratt, Artemis, 1908. Bronze, 13⅛ × 9⅜ × 17⅝ in. (33.5 × 23.4 × 43.9 cm). New Britain Museum of American Art, Stephen B. Lawrence Fund, 1996.14

SGL

Frederick Carl Frieseke (Owosso, Mich., 1874–New York City, 1939)

Peace, 1917

Oil on canvas, 40 × 60 in. (101.6 × 152.4 cm)
Signed and dated lower right: F. L. Frieseke / 191[7?]
Museum Purchase, Gallery Fund, 21.8

The American Impressionist and expatriate Frederick Carl Frieseke painted *Peace* near the end of a long period of summer stays in Giverny, France, an artists' colony forty-five miles northwest of Paris. Home to Claude Monet, Giverny attracted artists from the United States and other parts of the world with the beauty of its landscape. During his years there, from 1906 to 1918, Frieseke became the leader of a circle of American artists who favored painting in the walled gardens of the village houses. The Giverny Group, nicknamed by critics after two shows in 1910 at the Madison Art Gallery in New York, practiced a style described by the art historian William Gerdts as "decorative Impressionism."[1] They combined a French Impressionist interest in depicting the varied effects of sunlight with the Nabis' penchant for flat decorative patterns, including those found in flowering gardens and on wallpaper, rugs, and fabrics. Most members of the Giverny Group, including Frieseke, took the female figure as their favored subject, painting her nude and clothed, indoors and in private garden spaces.

Frieseke's Giverny-period style is well represented in *Peace*, an interior featuring a woman sewing or mending near a painted cradle, in which a baby is assumed to be sleeping.[2] The dry, matte surface of the canvas is dominated by pastel blues and whites, characteristic of the lightening of the painter's palette over time.[3] Frieseke covered the picture surface with patterns made of variously sized dots—large cobalt marks on the sheer curtains, tiny indigo specks on the woman's dress, and white and blue flecks on the wallpaper—to flatten the space and produce a rippling effect that is further emphasized by the impressionistic play of light and shadow on the back of the cradle's bonnet. The artist broke up the dichromatic look of the work by carrying through the warm colors on the painted cradle to the item the woman is sewing, the striped rug, and the flower arrangement on the table.

The artist and his family remained in France throughout World War I, during which time he painted *Peace*. He wrote to his dealer, William Macbeth, "I couldn't stand leaving Paris [the Friesekes' winter residence] after the years I've lived here. Seemed like running away."[4] At first he volunteered at the American Ambulance Hospital at Neuilly. Directed by Anne Vanderbilt, it had been founded by American women expatriates eager to help in the war effort. Both trained nurses and socialite volunteers worked there, caring for the wounded, making dressings, and washing soiled linens.[5] After five months they had less for Frieseke to do, and he again took up painting, telling Macbeth that he found it "the only relief from the sadness of it all."[6] He created *Peace* in the summer of 1917 in Giverny, where the Friesekes still summered despite the nearby presence of the German army.[7]

Frieseke likely titled the canvas with the help of his wife, Sadie, not long before sending it to the Macbeth Gallery in late October 1917.[8] The word *peace* reiterates the mood of the work; surrounded by calming blues and whites, the mother enjoys a brief respite from child care, catching up on her handiwork as her infant sleeps. The title, of course, also relates directly to the war. By portraying a tranquil moment in time, the painting palliated the threat of war-related violence under which civilians in France lived throughout

the conflict, made concrete in the victimization of women and children in German-occupied northern France and aerial bombardments throughout the rest of the country.[9] The painting might refer as well to Frieseke's experience of seeing women working outside their traditional roles at the American Ambulance Hospital. It could be read as a statement that peace would return women, who had taken up medical and industrial work during the war, to their "rightful place" in the domestic and maternal sphere.[10] This view echoes the French belief that women's patriotic contribution to the war was the production not of bullets and bandages but of babies. *Peace* thus appears to ally itself with the rhetoric that called for Frenchwomen to replenish the population so that in peacetime the country could move forward.[11] One American reviewer of the painting picked up on this when he or she wrote: "Woman as the hope and consolation of the race is the basic thought. . . . The only high light in the picture is on the woman's fair-brown hair, and seems to symbolize a supernal blessing bestowed upon tender motherhood."[12]

The painter must have felt that *Peace* was an important picture, for in October 1917 he instructed Macbeth not to sell it for less than three thousand dollars.[13] Tellingly, in February 1919 he requested that the gallery send *Peace* to represent him at the *American Paintings and Sculpture* exhibition at the Luxembourg Museum in Paris, an event organized by the French at the end of the conflict in appreciation of American war aid.[14] By 1921, when the Corcoran Gallery of Art bought the painting from its Eighth Biennial Exhibition, *Peace*'s association with the war had waned. Viewing it at various American exhibitions from 1918 onward, critics commented almost exclusively on the work's formal aspects. They saw the painting as "a complete type of his [Frieseke's] peculiar style," in which "the accessories of the mother and of the cradle are viewed quite as important as the human element."[15] Yet its tender narrative still appealed to people. As one reviewer of the 1921 biennial recognized, *Peace* was "by no means a subject picture, the painter's interest undoubtedly lay in composition, color, effect of light and atmosphere, but the public will find in the painting something more, and when the art is fine, subjective appeal distinctly adds to the value of a painting."[16]

LGN

Robert Henri (Cincinnati, Ohio, 1865–New York City, 1929)

Indian Girl in White Blanket, 1917

Oil on canvas, 32 × 26 in. (81.3 × 66 cm)
Signed lower right: ROBERT HENRI
Museum Purchase, Gallery Fund, 23.15

Robert Henri is best known as one of the Eight, a group of progressive urban realist painters, and as one of the most influential teachers of his generation.[1] After studying at the Pennsylvania Academy of the Fine Arts and the Académie Julian in Paris, he established himself in Philadelphia and then New York as a painter of landscapes and urban scenes. In New York he began his career as an instructor, teaching at various schools and organizations including the New York School of Art and the Arts Students League, where from 1915 through 1927 he influenced several generations of students. His lectures on art were published in 1923 in the landmark volume *The Art Spirit*. In 1902 Henri decided to dedicate himself to portraiture; rather than taking commissions, he sought out his own subjects, painting people of diverse ages and nationalities. He traveled widely in search of subjects, making trips abroad as well as to the American West, including three productive visits to Santa Fe, in 1916, 1917, and 1922. There, he produced a sizable body of work depicting Latino and Native American subjects, including the Corcoran's portrait of Julianita, a schoolgirl from the San Ildefonso pueblo.

Henri first painted Julianita on his second trip to Santa Fe. He arrived in July and initially experienced frustration finding compelling subjects and settling down to work. On 19 August he wrote to George Bellows of his continuing struggle: "I'm sorry . . . I haven't done anything exceptional to show you so far. Shall have to work up or try to get one at least before you come."[2] By 17 November, following Bellows's visit, Henri finally expressed satisfaction to his friend: "[I] have been doing *some* since you left—got some good ones. Got a line of very beautiful Indian girls."[3] These included Julianita, a student at an Indian school located near Henri's studio in the Palace of the Governors.[4] Julianita modeled for nine other portraits besides *Indian Girl in White Blanket*, five that season and again for four more canvases when Henri returned to Santa Fe in 1922.[5]

Henri frequently produced a series of compositions based on similar ideas, often using the same model, the same pose, or a similar compositional device.[6] He first experimented with swathing his figure in a stark white wrap in a painting of the previous summer, *Mexican Girl, (Maria)* (1916, private collection, Kansas City, Mo.), which shows the model with a white cloth wrapped around her head. Henri also used the white blanket in two other portraits from 1917, *Maria (Lucinda)* (New Mexico Museum of Art, Santa Fe) and *Gregorita, Indian of Santa Clara* (Fig. 1). In the latter work, the blanket is loosely wrapped around the girl; its folds obscure her body and create an abstract design that nearly overwhelms other elements of the composition. Henri exploits the motif of the blanket to its fullest in *Indian Girl in White Blanket* by enveloping Julianita's head and body more tightly. The thick folds of the fabric around her head and neck fall in concentric ovals that echo the shape of the sitter's face, while the more angular creases across her body repeat the lines of the decorative blanket in the background. Together, the folds of the white blanket strike a balance between articulating Julianita's form and creating visual interest in the composition as a whole.

During his three visits to Santa Fe, Henri increasingly integrated Native American–inspired decorative elements into his compositions. Unlike other artists who painted in the Southwest, he was not interested in documenting Native American ways of life, nor did he want to represent their material culture with an eye toward anthropology. Gregorita later recalled that Henri and his wife often posed the models and supplied the various accessories, including shawls and blankets.[7] In at least fifteen paintings, including *Indian Girl in White Blanket*, he used colorful blankets with geometric designs for formal purposes, to enliven the compositions.[8] As Henri himself noted, "I do not wish to explain these people, I do not wish to preach through them, I only want to find whatever of the *great spirit* there is in the Southwest. If I can hold it on my canvas, I am satisfied."[9]

The fall and winter of 1917 culminated in one of the most creative and productive periods in Henri's career. Despite the slow start, the season resulted in a number of his most important portraits of Native Americans, including *Indian Girl in White Blanket*. As Henri noted, "I didn't really get above average until towards the end—then things began to happen and they happened right along to the end. . . . Had I quit at the end of the usual summer term I should have been nowhere."[10] By the conclusion of the 1917 Santa Fe sojourn, he had completed more than one hundred major works, seventy-six of which were portraits.[11]

Indian Girl in White Blanket was first included in the inaugural exhibition of the New Mexico Museum's new art gallery in 1917.[12] The work then appeared at a number of venues in New York, Baltimore, and Columbus, Ohio, where critics pointed to its bold, vigorous brushwork and its characterization of southwestern life.[13] One critic, in particular, noted that Henri's works were not too literal and praised his ability to express a "vivid appreciation for the spirit of the being he interprets."[14] *Indian Girl in White Blanket* was later featured in the Corcoran's Ninth Exhibition of Contemporary American Oil Paintings in 1923, where it was one of the audience favorites; it was purchased by the gallery that year and was among the early acquisitions by a museum of Henri's southwestern subjects.[15]

VAL

Fig. 1. Robert Henri, *Gregorita, Indian of Santa Clara*, 1917. Oil on canvas, 31⅜ × 25⅝ in. (79.7 × 65.1 cm). Gilcrease Museum, 0137.570

Daniel Garber (North Manchester, Ind., 1880–Lumberville, Pa., 1958)

South Room—Green Street, 1920

Oil on canvas, 50½ × 42¼ in. (128.3 × 107.3 cm)
Signed lower right: Daniel Garber
Museum Purchase, Gallery Fund, 21.6

A prominent Pennsylvania Impressionist, Daniel Garber was best known for his landscapes, but the artist also made a number of figure studies and interiors that brought him considerable recognition. *South Room—Green Street* was one such painting, winning the First William A. Clark Prize at the Corcoran Eighth Biennial Exhibition in 1921 and attracting many admirers.[1] Critics of the day commented on the lush, painterly brushstrokes, saturated hues, and detailed execution, praising the work as "infinitesimally observed and infinitely unified."[2] One of several paintings Garber made that featured his family members in their Philadelphia home, *South Room—Green Street* is the largest and most ambitious of the series.[3]

Revealing an early skill at drawing, Garber studied at the Art Academy of Cincinnati with Vincent Nowottny and later at the Pennsylvania Academy of the Fine Arts with Thomas Anschutz, William Merritt Chase, J. Alden Weir, and Cecilia Beaux. In 1904 Garber started teaching at the Philadelphia School of Design for Women and illustrating for such popular periodicals as *Scribner's*, *McClure's*, the *Century*, and *Harper's Bazaar*. Garber left Philadelphia a year later, with a prestigious award from the Pennsylvania Academy in hand, to travel through Europe for two years. While in England, Italy, and France, he developed his mature style of weaving together different strands of pigment and blending stitchlike brushstrokes. When he

returned to the United States, the artist acquired a second home in Lumberville in Bucks County, Pennsylvania, and began to paint the landscapes that would earn him national acclaim. Garber spent the rest of his career in Pennsylvania, moving between Lumberville in the summers and Philadelphia in the winters, where he painted interiors and taught at the nearby Pennsylvania Academy.

Painted at the apex of Garber's career, *South Room—Green Street* showcases his ability to manipulate light and form to create a cohesive, intricate composition. He utilizes alternating passages of light and shadow, which, along with the overlapping structure of figure and furniture, result in a work that is at once sun-dappled and dim, open and confining. In a 1922 interview, Garber emphasized the central role of the window and light in the work:

> *South Room—Green Street* is about the finest thing I've done so far. It is certainly the most colorful and the best interpretation of light sifting into a room. As the light came through the heavy cretonne curtains it made them seem almost like stained glass, and you felt the wonder and charm of its passage. When you feel those things it seems to me they are really worthwhile recording.[4]

South Room—Green Street, then, is a visual treatise on light, its effects on the objects and experiences of everyday life and, in turn, the perceptual responses these effects initiate. Specifically, Garber manipulates how light confounds substance, turning heavy curtains into stained glass, strands of hair into a golden aura, and the shadow of a wicker chair into a lacy design on the floor. Continuing this exploration of illusory modes of vision is Garber's inclusion of two mirrors in the painting, which not only provide another view of the girl's head but also reflect the light in intriguing ways. Critics of the time remarked on this: "the hair of the little girl standing near the window, with the light falling on it from three directions [is] cleverly managed with the aid of two mirrors, one in front and one at the side."[5] The pleasant nature of Garber's domestic scene thus belies the complex issues of light, reflection, and vision that the artist so deftly manages in the painting.

Also of particular importance is the setting of *South Room—Green Street*. Conjoining art and life, the painting depicts Garber's wife, Mary Franklin Garber, and daughter Tanis in the front parlor of their Philadelphia row house at 1819 Green Street. While Garber was not alone in using his home as studio and family members as models, he and his fellow Impressionists (such as Edmund Tarbell) placed particular emphasis on the rooms themselves, in marked contrast to other artists who made paintings featuring their homes.[6] One prominent example of the latter is Thomas Eakins, who had lived a generation earlier at 1729 Mount Vernon Street, little more than a block away from Garber's home, and painted his wife, sisters, and father in various rooms throughout the 1870s and 1880s.[7] In *The Artist's Wife and His Setter Dog*, Eakins, like Garber, depicts his wife seated in a comfortable room in their home (Fig. 1). But whereas Eakins focuses on portraying his wife as accurately as possible—her facial features, her hands, her dress—with the surroundings rendered in softer focus and with less detail, Garber mostly clouds his

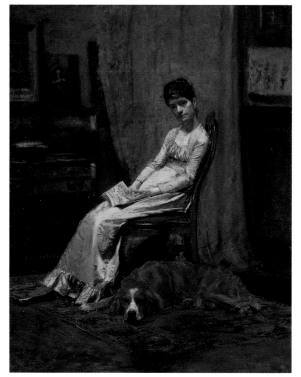

Fig. 1. Thomas Eakins, *The Artist's Wife and His Setter Dog*, c. 1884–89. Oil on canvas, 30 × 23 in. (76.2 × 58.4 cm). The Metropolitan Museum of Art, Fletcher Fund, 1923, 23.139

wife and daughter in shadow, devoting his attention to the material objects in the room and, more important, to the light coming through the front window of their row house.

It is this commitment to Impressionism, its exploration of light and the immediacy of sensations, in both interiors and land-scapes, that so significantly informed Garber's artistic enterprise. With a career that spanned more than four decades and honored with awards from such prestigious institutions as the National Academy of Design and the Art Institute of Chicago, Garber created a body of work that warrants close looking even today.

AN

Emil Carlsen (Copenhagen, Denmark, 1853–New York City, 1932)

The Picture from Thibet, c. 1920

Oil on canvas, 38³/₁₆ × 27⅛ in. (97.1 × 68.9 cm)
Signed lower left: Emil. Carlsen
Bequest of James Parmelee, 41.3

Fig. 1. Emil Carlsen, *Blue and White Jug and Vase*, c. 1910. Oil on canvas, 23⅛ × 23⅛ in. (58.7 × 58.7 cm). Courtesy of the Arkell Museum at Canajoharie, Gift of Bartlett Arkell, 31737

Emil Carlsen's *The Picture from Thibet* displays the artist's technical virtuosity as well as his ability to instill in his arrangements an enigmatic feeling one critic described as "quiet magic."[1] The artist's reputation was based on austere compositions of ordinary household objects that he began to create in the mid-1880s. Consciously emulating the work of the eighteenth-century French painter Jean-Siméon Chardin and drawing on early training in architecture at the Royal Academy in Copenhagen, Carlsen painted carefully constructed arrangements of modest objects—a pottery jar, a copper kettle, a tattered basket, an onion, a game hen—in a tightly restricted palette of earth tones.[2] His airy and uncluttered compositions lent monumentality to commonplace items and established the sense of quietude lauded by critics. One reviewer explained, "These still-life subjects have a marvelous quality of repose. They suggest peace and give the observer that strange quiet joy that comes from an appreciation of all that is fine and subtle."[3]

Carlsen had included Asian objects in his still lifes throughout his career, but sometime between 1910 and 1920, he began painting scenes that focused almost exclusively on such objects, often rendered in a shallow, decorative space. *The Picture from Thibet* is one of the most sophisticated and best known of these. In the right foreground, a small figurine stands in front of a porcelain vase, the curve of the figure echoing the sinuous form of the vessel. To the left, a strand of prayer beads rests near a jade bowl; wisps of incense float upward, mingling with the clouds and deities depicted on the Tibetan *tangka*, or scroll painting executed on cloth, that fills the background.[4] Although *The Picture from Thibet* is more elaborate than the sparse arrangements of Carlsen's earlier work, the picture nonetheless retains the enigmatic quietude that infuses so many of them.

Following the 1893 World's Columbian Exposition, which included a Japanese exhibit in the Palace of Fine Arts, the American public came to accept Chinese and Japanese ceramics, jade, sculptures, and paintings as artworks, rather than anthropological objects.[5] In the late nineteenth century, artists in the West had been chiefly interested in the bright patterning, asymmetry, and two-dimensionality of Japanese prints and blue-and-white export porcelain.[6] But after the exposition, museums began to collect Asian art in greater depth, expanding the scope of collections to include objects from earlier centuries as well as from China and India.[7] Carlsen's choice of objects—Tibetan scroll, plain porcelain vessel, and jade dish—reflects that change in taste.

Moreover, the way *The Picture from Thibet* is painted reveals the influence of literati art (*wenrenhua*) from China, particularly that of the Southern Song (1127–79), Yuan (1279–1368), and Ming (1368–1644) dynasties, a style that was in vogue in the early decades of the twentieth century in both Japan and the United States.[8] Carlsen's work displays the delicate, tonal coloring and simplified forms found in literati painting, just as his brushwork, which echoes literati brushwork, replicates the texture of the objects it represents. Alternating passages of scumbling and impasto suggest the age-worn paint of the *tangka*, the polish of porcelain and ivory, and the smoke of the incense. Emulating aspects of the literati style while describing Chinese objects allowed Carlsen to explore new approaches to color

and composition, artistic concerns that had engaged him throughout his career. In *The Picture from Thibet*, he demonstrates the extent to which modern formal concerns could be explored in the traditional Western genre of still life as well as through the study and depiction of traditional non-Western media such as scroll painting.

If Carlsen's style embraces some aspects of modern painting, the peeling paint of the scroll, its light, seemingly faded colors, and the dusty floor all suggest age and reveal his newfound fascination with antiquarian objects. From the mid-1910s onward, Carlsen was also painting classical artifacts, sometimes juxtaposing ancient Roman objects with Asian ones, such as the Roman glass vase at the left in *Blue and White Jug and Vase* (Fig. 1).[9] Such a juxtaposition suggests the current idea that China represented Asia's classical past, analogous to Greece in the East and Rome in the West.

Carlsen's new stylistic approach in this canvas was noted by critics when it was first exhibited in 1921. Royal Cortissoz, somewhat disapprovingly, described Carlsen's new palette and style: "[H]e was nearer to Chardin, in the old days, when his color schemes were simpler and broader; and we think, too, there was a more authoritative touch in his handling of them."[10] The artist, not surprisingly, disagreed. He assigned a high value, both monetary and artistic, to *The Picture from Thibet*. He was reluctant to part with the canvas, carefully considering the prestige of the individual venues that requested the painting for exhibition, and he repeatedly expressed the desire to sell the painting at a price considerably higher than he asked for his other still lifes.[11] Following the Corcoran's Tenth Exhibition of Contemporary American Oil Paintings, Carlsen sold the painting to James Parmelee, a member of the gallery's board of trustees, with the understanding that the painting would eventually enter the permanent collection of the museum—an institution that the artist considered "the most important art gallery in the country."[12] *The Picture from Thibet* remains the finest example of the complex Asian compositions that Carlsen explored during the last decades of his life. The Corcoran's painting embodies Carlsen's belief that "there is no better road to complete understanding, to acquiring the ability to see and judge . . . than the study of inanimate objects, arranged to a purpose, and studied through to a finish."[13]

RM

Landscape with Figures, 1921

Oil on canvas, 32½ × 42½ in. (82.5 × 108 cm)
Signed and dated on verso: Maurice B. Prendergast / 1921
Museum Purchase, William A. Clark Fund, 23.17

Landscape with Figures dates from the last decade of Maurice Brazil Prendergast's life, when he dedicated himself almost exclusively to creating variations on the theme of group leisure in waterfront park settings. The artist depicted crowds at play throughout his career. Earlier, he had produced dappled watercolors of people gathered at New England coastal resorts, promenading along Venice's canals, and enjoying New York's Central Park. After his 1907 trip to France, where he studied the paintings of Paul Cézanne, both Prendergast's style and his interest in representing specific locales changed.[1] The artist later wrote to the critic Walter Pach that Cézanne's work had "strengthened and fortified me to pursue my own course."[2] Indeed, Prendergast absorbed Cézanne's use of broken brushwork, emphasis on the contour of forms, and layering of color to create his own vision.[3] After 1914 he incorporated into his modernist idiom thematic aspects of the work of Giorgione, Nicolas Poussin, Pierre Puvis de Chavannes, Pierre-Auguste Renoir, and Paul Gauguin, producing scenes of classicized women in generalized landscapes based loosely on the coastal parks surrounding Boston.[4] These last paintings, *Landscape with Figures* among them, have been described by scholars as idylls that refer to an ideal world removed from industrialization, technological advance, materialism, and war.[5]

Formally, *Landscape with Figures* exemplifies Prendergast's large, late oils, which are consistent in composition and paint application. Horizontal banding, in which the frieze of figures in the park, the water zone, and the sky are stacked one on top of the other, contributes significantly to the overall flatness of the picture. The composition, although containing many disparate elements, is unified by several trees, which extend from the lower into the upper registers, and by the decorative patterning of the repeating circles of heads, bodices, hats, parasols, rocks, and sun.[6] The painting is also held together by its lively brushwork. Prendergast daubed, stippled, and dragged the paint, primarily muted reds, yellows, blues, and greens, to create a syncopated effect. Because he often skipped his brush over the heavily textured surface, which he had built up over time, Prendergast never completely obscured the paint layers beneath. Art historians have noted that this technique lends his paintings a sense of mystery and unreality.[7] In *Landscape with Figures* this can be seen most easily in the lower right, where the bottom half of a woman in a red dress appears spectral.

Nancy Mathews has argued persuasively that Prendergast's idylls served as elegies for turn-of-the-century leisure activities, such as group excursions by train and long resort holidays, which were replaced by individualized automobile travel, limited vacation time, and a devastating experience of world war that destroyed belief in the existence of an increasingly civilized society.[8] According to Mathews, Prendergast retreated from reality in his late paintings by monumentalizing and making timeless the group leisure he and his audience no longer experienced.[9] Significantly, *Landscape with Figures* belongs to a subset of Prendergast's idylls that features a low or setting sun.[10] The yellow light of the fading day that so forcefully falls on and between the legs of the women in *Landscape with Figures* suggests the waning of the type of leisure Prendergast valued.

In December 1923 the Corcoran Gallery of Art awarded Prendergast the Third William A. Clark Prize of one thousand dollars and the accompanying Corcoran Bronze Medal for *Landscape with Figures*, which he had sent to the Ninth Biennial Exhibition in a gilded frame probably made by his brother, Charles. The jury that honored Prendergast consisted of the artists Gari Melchers (chairman), Lilian Westcott Hale, Rockwell Kent, Ralph Elmer Clarkson, and Daniel Garber. The award was one of the few official recognitions of this kind that Prendergast received in his lifetime (the other being a bronze medal at the Pan-American Exposition in Buffalo, New York, in 1901). When he received notice of the honor, he supposedly remarked to his brother: "I'm glad they've found out I'm not crazy, anyway."[11] He wrote to the Corcoran's director, "I shall prize it very much."[12]

In truth, Prendergast had been receiving positive recognition for his work from progressive critics and collectors since the 1913 Armory Show had exposed Americans to European modernism, but reviews in the more conservative capital city were mixed.[13] Many admired the Corcoran's canvas as "a pleasing example of futurism," but others agreed with Leila Mechlin of the *Washington Star*, who complained that the painting "brings to mind nothing other than an old-fashioned hooked rug, or a composition in cremel worsteds, it is an uneasy composition at that, and one wonders. But one almost always does wonder at the decision of prize juries."[14] Exhibition-goers voting for the popular prize that year picked Sidney E. Dickinson's *Nude*, a realistic painting of a bare-breasted model, by a wide margin. *Landscape with Figures* received only one vote.[15]

In contrast to the ambivalent reception by the district's art community, the Corcoran sought acquisition of *Landscape with Figures* just two days after the biennial opened. The staff most likely concurred with the jury of Prendergast's artist-peers, who, as director C. Powell Minnigerode explained, valued the painting's "technical quality, originality, and execution."[16] Prendergast agreed to sell *Landscape with Figures* to the gallery at a one-third discount, for, he wrote, "I prefer Washington to have it."[17] The sale made the Corcoran the first public institution to recognize Prendergast's important contribution to American art; before this, individual collectors such as John Quinn, Lillie P. Bliss, Dr. Albert C. Barnes, and Duncan Phillips were his major patrons.[18] Other museums began purchasing Prendergast's work only after the artist's death, which occurred two months following the Corcoran's acquisition of *Landscape with Figures*.

LGN

Edward Willis Redfield (Bridgeville, Del., 1869–Center Bridge, Pa., 1965)

The Mill in Winter, 1921

Oil on canvas, 50 × 56¾ in. (127.6 × 143.5 cm)
Signed lower right: E W REDFIELD.
Museum Purchase, Gallery Fund, 23.11

Edward Redfield painted *The Mill in Winter* in seven hours on a snowy December day in 1921 in Bucks County, Pennsylvania.[1] Early in the morning, he loaded a large fifty-by-fifty-six-inch canvas (he called them 50-56s) into his pickup truck and drove less than a mile from his home to a site near the mill at Centerville. The large canvas was hard to maneuver; Redfield recalled that he attached crossbars to the backs of the stretchers to be able to transport the big pictures more easily. But the canvas's size was not the greatest challenge he faced. He had to dress in several layers of woolen clothing and heavy boots and wore fingerless gloves to keep warm. It was so cold that his paint froze in the tubes. "You have to reduce with a great deal of oil in order to make it soft enough to manipulate," he said. "It's quite a job to cover a canvas that size with small brushes. And mix the many mixes that you make. And you are drawing the same time that you are painting."[2]

Redfield was proud of his ability to complete a 50-56 in one day, but his feat, in five inches of snow, was no mere parlor trick.[3] Rather, it was a central feature of his artistic endeavor. Redfield had trained to become a portraitist at the Pennsylvania Academy of the Fine Arts under Thomas Anshutz and in Paris at the École des Beaux-Arts and the Académie Julian with William-Adolphe Bouguereau, but his love of nature soon prompted him to shift his focus to landscape. Following in the path of the French Impressionists, Redfield sought to unlearn studio conventions in order to paint only what his eye saw. Truthful painting is, of course, a relative concept; Redfield spoke of his willingness to move trees or bridges to realize a composition.[4] His aim, more narrowly, was to make paintings that faithfully recorded the look of particular times of day or weather conditions. Although he painted *The Mill in Winter* in one sitting, he would have spent days visiting the site, choosing his viewpoint, studying its nuances, and carefully planning how to paint it so that he could be ready to capture the light of an exact time of day as it appeared before his eyes.[5]

Like many of his generation, Redfield believed in painting specific locales because they had the potential to present nature in its most characteristic form.[6] Centerville, Pennsylvania, as well as the area in and around the ten acres the artist owned in Center Bridge, offered viewpoints, foliage, and scenery that could be differentiated not only from the Hudson River views of earlier generations but from European scenery as well.[7] Redfield's scenes that included structures like the mill, with its simple, barnlike architecture, were not only uniquely Pennsylvanian but also uniquely American. Critics recognized the seeds of a national art in Redfield's paintings. John E. D. Trask, then the manager of the Pennsylvania Academy of the Fine Arts, wrote: "Among the men whose work may be considered typical of our time no one is more characteristically American than Mr. Redfield. His great successes have been made through the presentation of the aspects of the landscape under climatic and atmospheric conditions peculiarly our own."[8]

Redfield was followed to the area by artists who shared his concerns in painting light and atmosphere, such as Walter Schofield, John Folinsbee, and his neighbor, Daniel Garber; critics christened the group the "Pennsylvania Impressionists." They were known for many of the traits present in Redfield's work: direct observation of nature, bold brushwork, and local scenery. Critics frequently contrasted the Pennsylvania Impressionists with the Boston School of figure painters, which included Edmund Tarbell, Joseph DeCamp, William M. Paxton, and Frank Benson. The Pennsylvania painters were characterized as hardy frontiersmen comfortable in their country surroundings, while the Boston painters were presented as aristocratic, too coddled in their urban setting to understand the rigors of nature. Redfield's *The Mill in Winter* is painted in a style that parallels his rugged persona. The palette is spare: Redfield uses a range of dove grays, green-grays, and blue-grays, pale yellow, and lavender to render both the landscape and the mill. Thick swaths of paint are brusquely applied, coalescing when seen at a distance to create the appearance of a cold, still river, snow-laden trees, and a vast expanse of overcast sky.

Redfield's simple, clear composition, along with his claim to have painted the scene directly from nature, helped to affirm the idea that a unique, rural America both existed and was accessible in his paintings.[9] This likely contributed to the enormous success of *The Mill in Winter* when it was exhibited at the Corcoran's Ninth Exhibition of Contemporary American Oil Paintings in 1923—viewers singled it out as one of Redfield's best, and the gallery elected to buy it before the exhibition opened.[10] The rustic scene offered solace to viewers who had experienced America's transformation from a predominantly rural to an urban society in the 1910s and 1920s with a predicable nostalgia for rituals such as flour milling, sleigh riding, and maple sugaring that appear in Redfield's works in this period.

When snow began falling on 4 December 1921, Redfield painted not just one 50-56 of the snow but a second the next day. His decision was a fortunate one. One of several disappointed patrons, Joseph H. Himes, lamented to the Corcoran's director, C. Powell Minnigerode, that the museum had beat him to the purchase. Minnigerode, a longtime friend of Redfield's who also helped the artist sell his works, lost no time in selling Himes a similar painting, *Reflections* (location unknown), which Redfield claimed to have painted the day after completing *The Mill in Winter*.[11] Years later Redfield would boast, "Each of them done on succeeding days, and netted thirteen thousand dollars. The two of them made the biggest two day sale I had ever done."[12]

LS

Cecilia Beaux (Philadelphia, 1855–Gloucester, Mass., 1942)

Sita and Sarita, c. 1921

Oil on canvas, 44⅝ × 33 in. (113.3 × 83.8 cm)
Signed lower left: Cecilia Beaux
Museum Purchase, William A. Clark Fund, 23.4

The Gilded Age artist Cecilia Beaux established an international reputation in the 1890s for insightful portraits rendered in the gestural style popular with many of her contemporaries on both sides of the Atlantic. Her bold technique invited comparison to that of William Merritt Chase, James McNeill Whistler, and John Singer Sargent, but art historians acknowledge the assertiveness of her female subjects just as readily as the bravado of her brushwork. Beaux is recognized not only as a great woman artist but as a pivotal turn-of-the-century painter who, like Mary Cassatt, helped transform her female sitters from objects of beauty into subjects with presence, intelligence, and wit.[1] *Sita and Sarita*, a portrait of Beaux's cousin Sarah Allibone Leavitt, first painted in 1893 (Musée d'Orsay, Paris) and copied about 1921 (Corcoran Gallery of Art), demonstrates the qualities that earned Beaux such high praise.

Beaux adopted her painterly signature style while studying in Paris in the late 1880s. *Sita and Sarita*'s light-infused palette is indebted to the artist's firsthand exposure to French Impressionism. It also recalls Whistler's exploration of the formal possibilities of the color white. Beaux made a series of well-received white paintings when she returned to the United States. In 1895 she exhibited the first version of *Sita and Sarita* at the Society of American Artists; on seeing it, one reviewer mused, "I don't see how even Mr. Sargent would paint a portrait with more distinction."[2]

The formal similarities between *Sita and Sarita* and Whistler's controversial painting of his mistress, *Symphony in White, No. 1: The White Girl* (1862, National Gallery of Art, Washington, D.C.), also raise the possibility that Beaux intended to draw attention to her subject's sexuality. *Sita and Sarita*, moreover, appears to borrow passages from Édouard Manet's *Olympia* (1865, Musée d'Orsay), notably the black cat and the position of Sarah's right hand, further suggesting that Beaux intended to reveal more with her portrait than her mastery of light and color.[3] Whereas Sarah remains aloof, failing to make eye contact with the viewer, the cat's gaze is direct. Its pose echoes that of the cat at the foot of Olympia's bed, one of several details in Manet's painting that self-consciously reference Titian's *Venus of Urbino*, in which a recumbent Venus is accompanied by a peacefully sleeping dog (1538, Galleria degli Uffizi, Florence). By quoting from *Olympia*, Beaux may have been commenting on nineteenth-century American sexual mores in addition to signaling

her familiarity with progressive French art.[4] Beaux's decision to give *Sita and Sarita* to the Musée de Luxembourg, in Paris, which had also become the owner of *Olympia*, supports its possible function as a tribute to Manet even though contemporary critics largely ignored the painting's provocative undertones.

Before Beaux donated the canvas, she made a copy for herself, which is the version in the Corcoran's collection. In a letter to the museum's director, the artist explained that she made the second painting for her "own satisfaction when the original went to France for good." She expected to keep it, she wrote, "not wanting to lose it forever."[5] After some persuading, the Grand Central Galleries secured her consent to sell *Sita and Sarita* when it was exhibited at the Corcoran in 1923. It was sold "with the understanding that it never be sold to any individual collector."[6] In her review of the Ninth Exhibition of Contemporary Oil Paintings that winter, the critic Leila Mechlin wrote that Beaux's painting demonstrates the artist's "mastery of technique" and ability to render "exquisite gradations of . . . white." "It is a matter of rejoicing," she concluded, "to know that this picture will always remain henceforth in Washington."[7]

JW

Yasuo Kuniyoshi (Okayama, Japan, 1889–Woodstock, N.Y., 1953)

Cows in Pasture, 1923

Oil on canvas, 20⅛ × 30⅛ in. (51.1 × 76.5 cm)
Signed and dated lower right: Y. KUNIYOSHI '23
Gift of George Biddle, 64.23
Art © Estate of Yasuo Kuniyoshi / Licensed by VAGA, New York, NY

Yasuo Kuniyoshi's early paintings, prints, and drawings feature odd, humorous, and even disconcerting subjects: frightened-looking babies with animals and anthropomorphic vegetation, for example. When he tackled more conventional motifs, such as still lifes, landscapes, or nudes, he depicted them in a quasi-surrealistic style, from dizzying perspectives, or in odd arrangements with curious props. *Cows in Pasture*, ostensibly a straightforward view of a coastal New England dairy farm, is a prime example of Kuniyoshi's subtle "strangeness," as a critic characterized the artist's early work.[1]

Kuniyoshi's favorite early subject was the cow; the artist estimated he painted some sixty cow pictures during the mid-1920s.[2] His preoccupation with the animal and the gravity with which he treated it earned him the label of satirist, a charge he would later counter:

> I wasn't trying to be funny but everyone thought I was. I was painting cows and cows at that time because somehow I felt very near to the cow. . . . You see, I was born, judging by the Japanese calendar, in a "cow year." According to

legend I believed my fate to be guided, more or less, by the bovine kingdom.[3]

Kuniyoshi's association with a bovine guardian spirit prompts an autobiographical interpretation of *Cows in Pasture*. The young artist was enjoying a spell of good fortune at this time. He had been given his first solo exhibition in 1922 at the Daniel Gallery in New York, having recently found a patron in the respected painter, critic, and teacher Hamilton Easter Field. In 1919 Field invited Kuniyoshi to attend classes at his art colony in Ogunquit, Maine, a coastal village about seventy miles north of Boston, where Kuniyoshi married Katherine Schmidt, a classmate at the Art Students League.

Kuniyoshi cultivated his infatuation with the cow in Ogunquit. As he wrote to his friend the artist Reginald Marsh in 1922: "Things round here very quiet at present and . . . just [suits] . . . us[.] [W]e started working . . . last week and as usually [here] I begin with a cow[.]"[4] Maine's "severe landscape," which Kuniyoshi later reverently called his "God," provided the setting for *Cows in Pasture*.[5] Maine was also where Kuniyoshi and his Ogunquit compatriots mined American folk art for the stylistic inspiration evident in *Cows in Pasture*. "Most of the summer colony in Maine last year," wrote one observer in 1924, "went mad on the subject of American primitives, and . . . the Kuniyoshis stripped all the cupboards bare of primitives in the Maine antique shops."[6]

The large scale and flat profiles of Kuniyoshi's cattle in *Cows in Pasture* recall the kinds of folk art the Ogunquit artists admired, especially eighteenth- and nineteenth-century livestock portraits commissioned by proud farmers. But the expressive eyes of Kuniyoshi's cows endow these animals with a sentience that is more reminiscent of the benign beasts in Edward Hicks's allegorical *Peaceable Kingdom* pictures. Hicks's canvases depict the fulfillment of Isaiah's Old Testament prophecy in which the calf and the lion live happily together.

Cows in Pasture, though, does not merely mimic a naïve style. Rather, the painting testifies to Kuniyoshi's attempt to reconcile a complex set of artistic traditions, cultural influences, and personal symbols. The disjunctive scale, peculiar geometries, unstable perspective, and oversize animal characters are reminiscent of recent developments in avant-garde European art. Following the 1913 Armory Show, Kuniyoshi admitted that he "tried . . . radical kind[s] of painting without understanding [and] imitated [the] worst side of Van Gogh, Cézanne, Gauguin."[7] Paul Cézanne's influence is apparent in the geometric emphasis in *Cows in Pasture*, particularly in the accordioned cliff faces, boxy farm buildings, and triangular cows.[8] The work of Vincent van Gogh and Paul Gauguin appears to have been even more compelling to Kuniyoshi; both artists borrowed their expressive line, flat areas of intense color, and dramatic asymmetry from the Japanese art that had surrounded Kuniyoshi when he was younger. "My tendency," he said, "was two-dimensional. My inheritance was shape-painting, like *kakemonos* [scroll-painting]."[9]

Kuniyoshi's artistic circle saw evidence of modernism's native roots in the formal similarities between European modernism and American folk art and colonial art.[10] Americana was championed

Fig. 1. Yasuo Kuniyoshi, *Headless Horse Who Wants to Jump*, 1945. Oil on canvas, 57⅛ × 35½ in. (145.1 × 90.2 cm). Ohara Museum of Art, Kurashiki, Japan. Art © Estate of Yasuo Kuniyoshi / Licensed by VAGA, New York, NY

as a valid, indigenous source for modern art. This subtext might have resonated more significantly for the Japanese-born Kuniyoshi. Painting reassuring subjects with precedents in early American art enabled him to express his interest in recent European painterly innovations and traditional Japanese graphic techniques without fear of censure or judgment of foreignness. That Kuniyoshi was not completely successful was hinted at by the critic Henry McBride, who contended: "Those unacquainted with the art of Yasuo Kuniyoshi . . . will probably rub their eyes and wonder whether they are in Japan, Maine or Mars."[11]

Kuniyoshi eventually abandoned the barnyard subjects and what critics saw as the "mischievous humor" of his earlier paintings.[12] By the 1940s his "queer rectangular cows" were replaced by desolate landscapes and still lifes composed of wrecked objects, masks, and semilegible antiwar rhetoric (Fig. 1).[13] It is quite possible that this shift occurred in response to the political and social developments of the intervening decades. As a Japanese immigrant, Kuniyoshi was the subject of intense suspicion following Japan's attack on Pearl Harbor. He was questioned by the FBI and was briefly placed under house arrest, despite being outspokenly prodemocracy, anti-imperialist, and antifascist.[14] He articulated the dire situation in a letter to his friend and the first owner of *Cows in Pasture*, the

artist George Biddle, on 11 December 1941: "A few short days has changed my status in this country, although I have not changed at all."[15] It is not difficult to imagine that Kuniyoshi's "broken, worn, used up . . . rotting" subjects of the 1940s reflect the artist's personal difficulties just as his talismanic cows of the 1920s were products of that earlier, happier time.[16] Kuniyoshi, after all, described his creative process as "feeling, imagination and intuition mingled with reality[, which] creates more than actuality, evokes an inner meaning indicative of one's experience, time, circumstances and environment. This is reality."[17]

AG

Peinture/Nature Morte, c. 1924

Oil on canvas, 28½ × 36 in. (72.4 × 91.4 cm)
Museum Purchase, Gallery Fund, 68.2

Peinture/Nature Morte is one of twenty-five related still-life paintings that Patrick Henry Bruce created in his Paris apartment from 1919 through 1932. In this series, Bruce synthesized geometric forms in a shallow but legible pictorial space. The artist abstracted the horizontal plane in the Corcoran's painting from one of four antique tables he owned, only part of which is shown to suggest that it continues beyond the canvas. Although reduced to a balanced selection of geometric solids, the household objects depicted on the table are still recognizable: drinking glasses, mortars and pestles from the artist's collection of African art, drafting tools, and wooden moldings and magnets used to secure drawings to a table or wall.[1] All of these objects are simplified to produce a composition in which specificity is irrelevant and formal relationships are emphasized. In this regard, Bruce's composition shares traits with the avant-garde movement known as Purism, whose leaders, Charles-Édouard Jeanneret (Le Corbusier) and Amédée Ozenfant, called for an art of synthesis in contrast to what they considered the disjointed, haphazard nature of Analytic Cubism.

A Virginia-born descendant of the Revolutionary War hero Patrick Henry, Bruce trained in New York with William Merritt Chase in 1901 and Robert Henri in 1903. During this formative period, he also spent time with friends Edward Hopper and Guy Pène du Bois. In 1903 he moved to Paris to continue his studies, returning briefly to the United States in 1905 to marry fellow artist and Chase student Helen Kibbey. The couple moved to Paris before the year's end, and Bruce remained there for more than thirty years.

Bruce's initial artistic explorations in Paris led him to the Musée du Louvre to study the old masters. Like his contemporaries who had studied with Chase, he honed his skills by copying portraits in the Louvre's galleries, and his first exhibited works in Paris were full-length portraits inspired by these studies.[2] He grew acquainted with the Paris school of modernists through Gertrude and Leo Stein, who introduced him to Henri Matisse. Bruce partnered with Gertrude and Leo's sister-in-law Sarah Stein to organize the Matisse School, which opened in 1908. His involvement with the school brought him into daily contact with Matisse, who encouraged him to study the work of Paul Cézanne and Pierre-Auguste Renoir, two artists whose work remained extremely important to the American throughout his career. The palette of *Peinture/Nature Morte*—pinks, greens, pale yellow, purple, and blue—is testament to Bruce's exposure to Matisse as well as his reading about the law of simultaneous contrasts, developed by the French chemist Michel Eugène Chevreul, which states that if two colors are juxtaposed, each will be influenced by the complement of the other. After 1912 Bruce's work was exhibited and discussed in conjunction with that of the Orphic Cubists Sonia Delaunay and Robert Delaunay, who promoted the idea that movement and recession in space could be created solely through contrasts of color.

Although Bruce's career began with great promise and focus, the stability he once enjoyed unraveled over time. During the 1920s, when he painted *Peinture/Nature Morte*, he increasingly isolated himself. He wrote, "I am doing all my traveling in the apartment on ten canvases. One visits many unknown countries that way."[3] He did not have a dealer and was famously reticent. Bruce lost confidence in his abilities as he entered middle age and destroyed much of his work. His lack of direction was exacerbated by his struggle with failing health, financial difficulties, and a marriage that ultimately dissolved. His only art world supporter of note was the Frenchman Henri-Pierre Roché, who had supplied photographs of American grain elevators and factories for the Purist design magazine *L'Esprit Nouveau.*[4]

The serial approach that Bruce used when making *Peinture/Nature Morte* was part of a larger trend in modernist painting but likely also reveals a more private process of personal searching. Given the difficulties Bruce faced in his life when he painted *Peinture/Nature Morte,* it may be that painting series over such a long period, 1919 to 1932, not only represents his dialogue with his contemporaries and immediate predecessors, including Cézanne and Claude Monet, who used repetition to create meaning, but also indicates a sustained longing for control. In his still lifes, Bruce progressively removed one or two elements in order to distill and simplify the composition. The middle paintings are the most complex, a result of the artist's experimentation, and the final paintings of the series are characterized by a reduced precision.[5] Bruce never achieved the sense of balance that these paintings worked toward; his life ended tragically in suicide when he was fifty-five.

DM

Arthur Bowen Davies (Utica, N.Y., 1862–Florence, Italy, 1928)

Stars and Dews and Dreams of Night, c. 1927

Oil on canvas, 40⅛ × 26¹⁄₁₆ in. (101.9 × 66.3 cm)
Signed lower left: A B DAVIES–
Museum Purchase, William A. Clark Fund, 28.7

Four days after Arthur B. Davies died while abroad in Italy, the eleventh Corcoran biennial opened to the public. Among the offerings of 1928 were two works by Davies, *Umbrian Mountains* and *Stars and Dews and Dreams of Night*, both of which were purchased by the museum. The artist was no stranger to the Corcoran; no fewer than seventeen of his paintings had appeared in eleven biennials. He was the recipient of the First William A. Clark Prize and the Corcoran Gold Medal in 1916. In 1930 his career would be commemorated by a large memorial exhibition organized by the Metropolitan Museum of Art, which traveled to the Corcoran, home of so many of his earlier successes. Despite such accomplishments, Davies's critical standing diminished dramatically in the decades following his death. In recent years the artist's reputation has been resuscitated, as scholars and critics have begun to recognize the complexity and singularity of his artistic vision as well as his formative role in the introduction of modern art to America.

The painting's title refers to a line from "Atalanta in Calydon," a poem by Algernon Charles Swinburne written in 1865: "O fairfaced sun, killing the stars and dews and dreams and desolation of the night!"[1] The poem concerns a tragic figure in Greek mythology; likewise, the painting exudes an air of melancholy. Like its title, the composition of *Stars and Dews and Dreams of Night* is lyrical and rhythmic. It features a nude woman against a backdrop of dark, dense vegetation. Turning to gaze over her left shoulder, she cranes her neck. This action creates a curving line that is continued by her right arm and leg, culminating in a delicately arched foot. The extension of the head and the toe mirror each other, defining the curve that is in turn bisected by the vertical line of her left arm and standing leg. The artist cropped the top of the figure's head and her standing foot, a decision questioned by at least one critic who noted, "*Stars and Dews and Dreams of Night*, is arbitrarily—rather perversely, one may feel— cut into by the top and bottom of the frame."[2] Yet the cropping introduces an element of tension. This pushing back against the borders complicates the muted reverie of the scene.

The nude's creamy skin tones are subtly and richly modulated, and the pale figure looks luminous against the shadowy background. The subject of the painting does not connect with the audience; her gaze is downward and faraway. Period critics wrestled with Davies's mystifying compositions while lauding his technique: "the strange attenuated nude figure . . . arrests attention and one feels that the 'American poet painter' has visions and dreams that we cannot always follow except to appreciate the delicacy of flesh tints and drawing."[3]

American artists of the late nineteenth century, including Abbott Handerson Thayer and Thomas Wilmer Dewing, favored depictions of woman as ethereal creatures, pure and untouchable. However, Davies's interpretation owes more to Continental sources, including the Frenchman Pierre Puvis de Chavannes, whom Davies admired for his subtle allegories that integrated figure and landscape. The symbolic landscapes and Arcadian pastorals of the Renaissance Italian painter Giorgione also left a strong impression on the artist. Perhaps Davies looked to his own art collection for the inspiration of this painting. Among his two hundred drawings, paintings,

and watercolors was a small painting of Venus then attributed to Giorgione featuring a woman's face in profile, gazing over her shoulder against a backdrop of dark vegetation.[4]

Davies's art collection and his love of antiquities resulted in a collaboration with the archaeologist Gustavus Eisen in the early 1920s. The two men developed a "theory of inhalation," which maintained that ancient art achieved its vitality by depicting the body in the moment of inhalation.[5] Davies attempted to render this moment repeatedly in his own work; *Stars and Dews and Dreams of Night* visualizes inhalation through the uplift of the figure's chest and ribcage as well as her outflung arms.

Davies's romantic leanings were out of step with his contemporaries, though he himself was very supportive of the new directions his fellow artists were taking. He was, for instance, largely responsible for bringing modernism to America through his role as the chairman of the committee that organized the International Exhibition of Modern Art, the infamous Armory Show of 1913. Walter Pach once wrote that "modern art in America owes more to [Davies] than to anyone else."[6] His advocacy of modernism extended to advising major collectors including Lillie Bliss, whose collection was pivotal to the formation of the Museum of Modern Art, New York. His own collecting practices were highly eclectic; he amassed Etruscan vases and Egyptian relics as well as works by Constantin Brancusi and Paul Cézanne. Davies briefly experimented with Cubism immediately after the Armory Show; see, for example, his *Great Mother* of 1914, which also is in the Corcoran's collection. However, for the remainder of his career, he returned to his deeply personal and evocative vision. Davies left a complex legacy; he was both of his time and removed from it, finding equal inspiration in Pompeian murals and Picasso's drawings. With otherworldly works such as *Stars and Dews and Dreams of Night*, Davies makes quiet demands on the viewer, rewarding patience and introspection.

KR

Pierrot Tired, c. 1929

Oil on canvas, 36¼ × 28¾ in. (92 × 73 cm)
Museum Purchase through the gifts of William Wilson Corcoran and Ivan C. Aivasovsky, 1981.116

Conjuring a period and a mood, *Pierrot Tired* underscores Guy Pène du Bois's skills as both a painter and a trenchant social observer. Painted at the end of the 1920s, the canvas demonstrates the artist's talent for transporting solid, majestic Renaissance forms into stylized, urban settings.[1] At a time when abstraction held critical dominance, Pène du Bois's style was characterized by a richly toned, painterly realism as well as a neoclassical devotion to volume and form. Yet the work's emphasis on uneasy social interactions and urban anomie reflects a modern sensibility. The critic Royal Cortissoz was the first to note the artist's "gift for mordant characterization," finding in his work a "cynicism that dispassionately impales a type, and, practicing again the art of omission, leaves it to speak for itself."[2] Despite the simplified figures of the composition, the painting is rich in psychological and sociological detail.

In 1899 Pène du Bois entered the New York School of Art, where he studied under William Merritt Chase. In 1902 he met Robert Henri, whose advocacy of realism and simple forms had a lasting impact on the artist. After studying with Henri for three years, he traveled to Paris, where he immersed himself in French art and made his debut at the Salon.[3] Early collectors of his work included Chester Dale, Albert Barnes, and Gertrude Vanderbilt Whitney.[4] During the 1920s Pène du Bois spent six years living in France, returning to New York in 1930 following the stock market crash. The artist's fascination with the social interactions of the upper crust came from the vantage point of an outsider. He struggled to make ends meet for much of his career, working as a writer to supplement his income. His success as an art critic was not surprising given his literary background: his father, Henri Pène du Bois, was a writer, and the artist was named for Guy du Maupassant, a family friend.[5] Pène du Bois wrote art criticism for the *New York American,* the *New York Evening Post,* and the *New York Tribune,* while also serving as the editor of the magazine *Arts and Decoration* for seven years. The skills of observation and analysis that he honed as a critic inflected his artwork with an incisive understanding of social relations.

In *Pierrot Tired,* two figures are seated in a booth at a Parisian café, sharing a drink. Both are fashionably dressed and decidedly cosmopolitan. The woman sports a sleek helmet of dark hair. A white stole is draped around her neck and over her left shoulder. Her lips are painted red and lined in black. Her companion, by contrast, is more understated. Dressed in a banker's three-piece suit, he sits quietly and studies his drink, a tall glass of amber liquid, a form that is balanced by the stack of coasters on the other side of the table. The mood is quiet and solitary. The figures are physically close yet emotionally distant. Although their bodies brush against each other, their eyes do not meet, each isolated by individual thoughts. Behind the booth is a window onto the street outside, through which a second couple is visible, their heads bent toward each other. The woman wears a hat, and the man, with distinctive cap and epaulet on his shoulder, appears to be in uniform. Though the image seen through the window is murky, the body language of the couple outside is more intimate that that of the couple in the café.

The seated man wears a brown suit that blends almost seamlessly into the colors of the banquette, with the effect that he recedes

Fig. 1. Jean-Antoine Watteau, *Pierrot, Formerly Called Gilles,* c. 1718–19. Oil on canvas, 72⅜ × 58¾ in. (184 × 149 cm). Louvre, Paris, Dr. Louis La Caze bequest, 1869, M.I. 1121

into space. The gentleman is bald with a smattering of white hair at the temples. As evidenced by her youthful hairdo, his companion is a great deal younger than he is. Are they married? Having an affair? Is he an old fool attempting to reclaim his youth through a dalliance with a young woman? Pène du Bois leaves the nature of their relationship an open question. Both faces are expertly modeled yet heavily shadowed; shadows are created through a buildup of rich brown and ocher paint, with lavender contour lines defining the woman's profile. The faces contribute to the ambiguity of the scene, coupling the unreadability of expression with the impossibility of connection.

During Pène du Bois's sojourn in France, the artist found Paris too expensive and lived thirty miles outside the city.[6] He continued his sharp focus on urban scenes from a position of both physical and psychological distance. It is unclear whether the subjects of *Pierrot Tired* are Parisians or Americans. Wealthy Americans were a common sight in Paris at the time, and the artist was fascinated with the expatriate culture. His 1926 painting *Café Madrid* (Museum of Fine Arts, St. Petersburg, Fla.), a portrait of Chester Dale and his wife, attests to his interest in Americans living abroad.

Pierrot, the French variant of the Italian character Pedrolino, was the sad clown of the commedia dell'arte, characterized by his naïveté and his haplessness in matters of love. The best-known depiction of the character is Jean-Antoine Watteau's eighteenth-century painting *Pierrot,* which depicts the clown as a melancholy figure, dressed in an ill-fitting costume, his open face looking toward the viewer with despair (Fig. 1). It has been in the collection of the Musée

du Louvre since 1869, and it is quite possible Pène du Bois encountered it during his six years in France. As in *Pierrot Tired*, the central figure in *Pierrot* is isolated within his social milieu. Watteau's clown is weary; his facial expression and slumped posture suggest that he is exhausted by his designated role. Pène du Bois's Pierrot is similarly moon-faced and dissatisfied. The figure's mannequin-like stiffness and the pervasive air of ennui evoke a man chafing against his designated type, the wealthy fool for love, and tired of fulfilling society's expectations. The title suggests a parallel between the artifice and codified roles that define the commedia dell'arte and the artificial and stultifying world of high society.

The title of the painting was not known when the artist's family found it after his death. The artist's son-in-law, thinking the interior resembled a restaurant that the family frequented in Manhattan, called it *Drink at the "Russian Bear."* The painting was exhibited under this title for the next twenty-five years, until research revealed the artist's original title.[7]

KR

Jerome Myers (Petersburg, Va., 1867–New York City, 1940)

Life on the East Side, 1931

Oil on canvas, 30 × 40 in. (76.2 × 101.6 cm)
Signed, inscribed, and dated lower right: JEROME MYERS N.Y. 1931
Museum Purchase, Gallery Fund, 32.11

Jerome Myers is well known to enthusiasts of early-twentieth-century American painting for his sympathetic depictions of Manhattan's Lower East Side immigrant neighborhoods. During a career that spanned almost fifty years, he recorded the daily activities and special rituals of those who, having recently arrived in the United States, congregated in communities that fostered the culture, religion, and traditions of their homelands. Myers was particularly drawn to the animation, energy, and color of ethnic neighborhoods' kaleidoscopic marketplaces. *Life on the East Side* depicts an open-air market in the Jewish quarter of the Lower East Side. Vendors' mobile carts and freestanding stalls display comestibles to an assembly of predominantly female customers. The impression is of a pleasant scene of neighborhood life captured spontaneously by a serendipitous observer. Myers's brushwork is loose, which gives the feeling of perfunctory or speedy application, and the perspective is slightly off in a casual, unstudied way. He painted similar scenes in Paris but observed that when immigrants "merge here with New York, something happens that gives vibrancy I didn't get in any other place."[1]

Between 1881 and 1910, more than 1.5 million Jews immigrated to the United States, many settling in the Lower East Side. Here, they formed the world's largest Jewish community, which stretched from the Bowery to the East River between Division and Houston Streets.[2] Writing in 1915, Lillian Wald, nurse, social worker, and author, remembered how two decades earlier the East Side aroused a "vague and alarming picture of something strange and alien: a vast crowded area, a foreign city within our own for whose condition we had no concern."[3] Gradually, artists, social workers, and authors explored and publicized the East Side's densely packed foreign communities, and this formerly ignored region of the city became a subject of fascination, debate, and anxiety.

Some argued that it posed a threat to Americans' physical well-being and the nation's social health; the *WPA Guide to New York City*, for instance, characterized the "crowded, noisy, squalid" neighborhood as a "slum" and a "ghetto."[4] Prevalent early-twentieth-century visual and literary descriptions of the Lower East Side reinforced this impression. They tended to focus on overpopulated and ramshackle tenement buildings; crisscrossing laundry lines; narrow streets and alleyways; and dense crowds of the malnourished, dirty, and even criminal. See, for instance, George Bellows's *Forty-two Kids* (in this catalogue) or *Cliff Dwellers* (1913, Los Angeles County Museum of Art). Myers offered a more romantic view. As he noted in his autobiography: "My love was my witness in recording these earnest, simple lives, these visions of the slums clothed in dignity, never to me mere slums but the habitations of a people who were rich in spirit and effort."[5]

Open-air markets such as the one in *Life on the East Side* were regarded as both picturesque and alarming. Myers saw encapsulated in their barter, gossip, and humor the "symphonic freedom" of New York's East Side.[6] *Life on the East Side* reflects his favorable viewpoint. Unlike George Luks's *Street Scene (Hester Street)* (Fig. 1), for example, which also depicts a teeming open-air market in the Jewish quarter, Myers's painting portrays the market in such a way as to offer easy access for its viewers: the urban square is spacious, the pavement

opens invitingly from the center of the canvas's lower edge, and an expanse of pale sky is visible overhead. Luks's congested bottleneck of an avenue, by contrast, is overwhelming, claustrophobic, and virtually impenetrable; it is more a mob scene than a place to go shopping.

Many declared such open-air markets a "menace to sanitation," and they were earmarked for eradication in the 1930s; their relocation to more hygienic indoor venues was part of Mayor Fiorello La Guardia's aggressive campaign to sanitize, revitalize, and modernize the Lower East Side.[7] Myers acknowledged that "daily existence" for East Side immigrants "mingles the old and the new,"[8] but *Life on the East Side*, with its quaint pushcarts, old-fashioned costumes, and idyllic mood, indicates a resistance to, if not an outright rejection of, modernization in favor of the traditional. Indeed, Myers's market reads as a villagelike enclave surrounded on all sides by an ominous and intrusively modern New York City. In the background looms Manhattan's skyline, emblem of Machine-Age technological progress. The year Myers painted *Life on the East Side* witnessed the erection of the Empire State Building, which surpassed the Chrysler Building as the world's tallest skyscraper.[9]

The idea that Myers's market might be read as a besieged refuge or beleaguered sanctuary is underscored by the expression on the face of the old man standing just to the right of center. His bright white hair and beard form an arresting halo against the drab palette of the architectural background and above his stooped, black-clad shoulders. His gaze is direct and hovers somewhere between keen suspicion and outright confrontation. Striking a distinctly disquieting note in the ostensibly harmonious scene, his full-frontal posture acts as a barrier blocking easy passage into the scene; we viewers are apparently not as welcome in the protective confines of the market as we might initially have thought.

Fig. 1. George Luks, *Street Scene (Hester Street)*, 1905. Oil on canvas, 25¹³⁄₁₆ × 35⅞ in. (65.5 × 91.1 cm). Brooklyn Museum, Dick S. Ramsay Fund, 40.339

Life on the East Side subtly testifies to the threat of disruption
to which these tight-knit communities—financially poor, perhaps,
but culturally and spiritually rich, in Myers's assessment—were
subjected during the 1930s. Myers appears to have been conflicted
about the systematic eradication of colorful scenes of urban immi-
grant life like the open-air marketplaces when he wrote in his 1940
autobiography, "it is not for me to say that conditions are not better
in the beautified and sanitary New York of today."[10] His conclusion,
"to me the human drama seems to have been diluted, to have
become thin and respectable," voices a nostalgic lament visualized
in subtly melancholic paintings like *Life on the East Side*.[11]

AG

Oscar Bluemner (Prenzlau, Germany, 1867–South Braintree, Mass., 1938)

Imagination, 1932

Casein with ground watercolors, prepared by the artist, 31¼ × 23³⁄₁₆ in. (79.3 × 58.4 cm)
Signed lower right: BLÜMNER
Museum Purchase through the gift of Mr. and Mrs. Myron L. Cowen and the
William A. Clark Fund, 1979.15

Oscar Bluemner was an innovative modernist painter who, along with Arthur Dove, John Marin, Georgia O'Keeffe, and other artists of the Alfred Stieglitz circle, used a European-inspired vocabulary to infuse the American landscape with feeling, energy, and spirituality. However, Bluemner's paintings fit less neatly into narratives of early modernism than those of his peers. He focused neither on the vitality of the American urban experience nor on the restorative qualities of the rural landscape but on an evocative combination of the two, as in his haunting painting of 1932, *Imagination*. His work's resistance to easy categorization, the artist's eccentric personality, and the copious theoretical and technical notes that he kept in his painting diaries lent an air of mystery to Bluemner's career and legacy that was not dispelled until long after his death.[1]

German thought and art were important sources for Bluemner's expressive use of color in paintings like *Imagination*. Following the lead of Johann Wolfgang von Goethe, in the eighteenth century, and the Expressionist painters Vasily Kandinsky and Franz Marc, in the early twentieth, he endowed color with the ability to express aspects of his inner consciousness and to communicate moods and emotions.[2] When he returned to the United States after a nine-month trip to his native Europe in 1912, five of his works were included in the historic International Exhibition of Modern Art (the Armory Show) in 1913. In 1916 Bluemner was one of seventeen American painters chosen by Willard Huntington Wright, Robert Henri, and Stieglitz to represent the American avant-garde at the Anderson Gallery's Forum Exhibition, also in New York. The organizers of the exhibit wanted to redirect attention to American modernism in the wake of the Armory Show, which had generated commercial interest in primarily European artists.

In the 1920s Bluemner's work continued to garner support and encouragement from the art establishment, but the artist also encountered challenges, including the death of his wife in 1926, which precipitated his move to Braintree, Massachusetts. Roberta Smith Favis has suggested that his early paintings have more political meaning than might be obvious at first sight and that anti-German sentiment in the war and interwar years may have had a negative impact on the reception and sale of his work.[3]

Bluemner's later works, including his series Compositions for Color Themes, of which *Imagination* is one, exhibited at the Marie Harriman Gallery in 1935, increasingly veered toward the mystical and abstract. The artist's continued obsession with red derived less from the color's socialist symbolism, for example, than from a wide range of idiosyncratic associations. Bluemner linked red to masculinity, vitality, life, struggle, imagination, and the self. He considered it the noblest color, identifying it as his alter ego and adopting the pseudonym "the Vermillionaire" in 1929.[4]

In *Imagination*, the red hues of the house and sky stand out so intensely against the green foliage and inky night that they assault the viewer's senses, as if the pigment were burning from within. The artist likened his use of color in this series to music's ability to elicit emotional states. "Look at my work in a way as you listen to music—," Bluemner wrote, "look at the space filled with colors and try to feel; do not insist on understanding what seems strange."[5]

The dreamlike quality of *Imagination* invites the subjective interpretation that the artist advocated. Jeffrey Hayes has noted that Bluemner's late works best embodied the artist's mature theories about art's purpose.[6] The startling juxtaposition of complementary colors and the tension between architectural and natural forms in *Imagination* illustrate ideas Bluemner put forth in a 1929 publication, *What and When Is Painting? Today*:

> Without imagination painting fails of its greatest power and beauty: INTENSITY—the maximum inner tension of divergent experiences, emotions, conflicting moods as expressed by dramatic contrast of color and tone and lines. . . . Without intensity, there is no true painting, because painting does not, as poetry and music do, conduct us slowly towards a climax. It rather is the reality of a single isolated, emotional, ecstatic moment, into which it catapults us with an instantaneous and immediate bounce.[7]

That Bluemner writes about his painting in terms of movement —"catapult" and "bounce"—also speaks to the spatial tensions created by the artist's use of color. The heat of the central red form projects forward, while the cooler green and blue recede. This painting, thanks in part to Bluemner's tireless research into the permanence of different techniques and materials, has the same capacity to jolt viewers toward "a single . . . ecstatic moment" today as when it was first exhibited in 1935.[8]

Bluemner's Harriman Gallery exhibition was an overwhelming critical success. The art critic Emily Genauer wrote that, for Bluemner, "A landscape is . . . only a springboard from which he dives into a sea of color. Nor does he sink there. He emerges a veritable Neptune, king of the brilliant hues into which he has dipped." Despite the positive press, however, and the fact that the critic Henry McBride called the paintings "eminently buyable," the gallery did not sell a single picture, and Bluemner continued to struggle to make ends meet.[9] In 1938, after suffering from two years of increasingly serious illness and deterioration of his eyesight, the artist took his life. It would be nearly half a century before Bluemner's vital role in early American modernism would be recovered and for his passion for color appreciated anew.

JW

Reginald Marsh (Paris, 1898–New York City, 1954)

Smoke Hounds, 1934

Egg tempera on Masonite, 35¾ × 29¹¹⁄₁₆ in. (90.8 × 75.4 cm)
Signed and dated lower right: REGINALD MARSH 1934
Gift of Felicia Meyer Marsh, 58.26

Fig. 1. Berenice Abbott, *"El" Second and Third Avenue Lines; Bowery and Division Street, Manhattan*, from the series *Changing New York*, 1936. Gelatin silver print on paper, 9⅝ × 7⅞ in. (24.4 × 19.9 cm). Smithsonian American Art Museum, Gift of George McNeil, 1983.16.5

Fig. 2. Titian (Tiziano Vecellio), *The Entombment of Christ*, c. 1520. Oil on canvas, 58¼ × 83½ in. (148 × 212 cm). Louvre, Paris, inv. 749

Reginald Marsh was drawn to New York's spectacles: the bawdy titillation of burlesque halls, the sensual exhibitionism of Coney Island's beaches, the gaudy glitz of Manhattan's entertainment districts, and the motley crowds of the subway system. In addition, as the art historian Lloyd Goodrich noted, Marsh "never shrinks from the most miserable and degraded levels of society—drunks, beggars, Bowery bums."[1] Indeed, the artist reckoned, "You can't find anything better to draw."[2] These destitute and downtrodden characters form the subject of *Smoke Hounds*, which highlights both Marsh's dedication to documentary detail and his reverence for the old masters.

In *Smoke Hounds*, two men struggle in the middle of a busy sidewalk to support their fallen companion. The painting's prominent commercial signs place the scene between Pell and Doyers Streets on the Bowery, a major thoroughfare running north–south through the Lower East Side of Manhattan.[3] An inveterate sketcher, Marsh rendered the area's topographic specifics accurately, as related pencil sketches, preparatory ink studies, etchings, and paintings confirm.[4] The painting's title indicates that the central characters are intoxicated; *smoke* was slang for the cheap booze all but guaranteed to "rot your guts" peddled in Bowery saloons (the term derives from the suspicion that so-called smoke hounds would resort, if necessary, to drinking lighter fluid).[5] The association is cemented visually by the men raising a flask—midtoast or midquarrel—beneath the sign for the Lighthouse Bar and Grill at right.

The paint of *Smoke Hounds*—colors of brown, ocher, and aubergine—is applied in multiple thin washes of egg tempera. Marsh was very interested in technical aspects of old master paintings; egg tempera was the primary medium for panel painting before about 1500. He had studied Renaissance and Baroque paintings in the Musée du Louvre, in Paris, and other major European collections and learned the recipe for egg tempera from Thomas Hart Benton and Denys Wortman in 1929.[6] Marsh's emulation of the old master technique imparts to *Smoke Hounds* a muted and mottled appearance convincingly suggestive of a dingy, nocturnal scene lit obliquely by flickering artificial illumination from shop windows and incandescent signage.

A quasi-subterranean impression is created by the Third Avenue Elevated train tracks (the El) that tower overhead. The stout iron I-beam that parallels the left edge of the canvas compresses the painting's already enclosed space; the effect is claustrophobic. From a ground-level perspective comparable to Marsh's, Berenice Abbott similarly conveyed the intimidating menace of the El's hulking structure and the shady inhabitants of its underworld by focusing on the spidery shadow pattern thrown by the looming tracks and girders (Fig. 1).[7]

The Bowery neighborhood, sandwiched between Chinatown to the east and Little Italy to the west, was once a prosperous entertainment district. Following the Civil War, unemployed, injured, and bereft veterans sought cheap accommodations there, and the Bowery experienced a spectacular degeneration. By the 1930s the old theaters had been replaced by stale-beer dives, pawnshops, flophouses, brothels, and tattoo parlors–cum–barber's colleges that catered to the influx of poor transients.[8] In an effort to counteract the influence

of such establishments, rescue missions were established along the street. The All Night Mission, whose sign is visible in *Smoke Hounds*, was begun in 1911 to provide safe overnight haven and spiritual salvation. Dudley T. Upjohn, the mission's founder, believed it was his duty to "bend every energy to win back to God Almighty" the "lost soul belonging to Christ" of each of the "thieves, gamblers, drunkards," and drug addicts wandering the Bowery.[9] He offered a free evening meal, fresh water, and pews in which to sleep (albeit upright) for the chance to save the Bowery's fallen Christian souls. The All Night Mission occupied No. 8 Bowery until it closed in 1948.[10]

Marsh's colloquial title and the centrality of the All Night Mission sign hint that *Smoke Hounds* transcends documentary illustration. The implication is reinforced by marked similarities between the foreground figural group and representations of Christ's Entombment or Deposition, such as Titian's *The Entombment of Christ* (Fig. 2).[11] Located directly below the rescue mission's glowing white cross, Marsh's central figure is a proxy for the crucified Christ, supported by stand-ins for Joseph of Arimathea and Nicodemus. Marsh was explicit about his admiration for the anatomical control of, among

others, Peter Paul Rubens, Michelangelo, and Raphael; his sketch-books are filled with copies of old master paintings, and the draw-ings in his own publication, *Anatomy for Artists* (1945), are based on copies of old master figures.

Marsh's paired admiration for the old masters and dedication to the mundane realities of the modern city were encapsulated in his advice to students: "Stare at Michelangelo [sculpture] casts. Go out into the street, stare at the people. Go into the subway. Stare at the people. Stare, stare, keep on staring."[12] Marsh's exhortation seem-ingly justifies the interchangeability of biblical tropes and Bowery drunkards. This equivalence in *Smoke Hounds* underscores the gravity with which Marsh felt the disenfranchised deserved to be treated. Yet by translating Titian's tragic masterpiece into a grotesque scene of public drunken collapse, Marsh's painting also bristles with satire. Where Titian's dead Christ is lamented by the grief-stricken Virgin Mary and Mary Magdalene, agony etched on their moonlit faces,

Marsh's drama is witnessed by an apathetic spectator, leaning against the El's stanchion at left, whose expression suggests he has seen it all before. Marsh offers a subtle critique of a callous society unmoved by such anonymous nightly dramas.[13]

Smoke Hounds also appears to question whether institutions like the All Night Mission represent an adequate solution for the Bowery's problems. Where, one wonders, will Marsh's latter-day Joseph of Arimathea and Nicodemus lead their fallen companion once they have him upright and figuratively, if not literally, resur-rected? Will they heed the mission's hovering, cruciform invitation, or will they be drawn instead to the nearby Lighthouse Bar and Grill's irradiating beacon? Given the trio's proximity to the latter, one suspects that the bar's illuminated lure may well offer greater temptation than the mission's promised salvation; a lighthouse, after all, is designed to guide vessels to safety.

AG

245

Aaron Douglas (Topeka, Kans., 1899–Nashville, 1979)

Into Bondage, 1936

Oil on canvas, 60⅜ × 60½ in. (153.4 × 153.7 cm)
Signed lower right: AARON DOUGLAS
Museum Purchase and partial gift from Thurlow Evans Tibbs Jr.,
The Evans-Tibbs Collection, 1996.9

The modernist painter and graphic artist Aaron Douglas heeded the call of Harlem Renaissance intellectuals by acknowledging African cultural traditions as a source of pride and inspiration. He embraced a Machine-Age aesthetic but also integrated Egyptian and African motifs into Cubist, Precisionist, and Art Deco designs. Douglas's illustrations for *The New Negro,* the 1925 anthology of Harlem Renaissance writers selected by the philosopher Alain Locke, was his first major commission after moving to New York City from Kansas City in 1924; it established his reputation as a leading artist of the New Negro movement. In 1926 the writer Langston Hughes commended him for inspiring younger African American artists to express their

Fig. 1. Aaron Douglas, *Aspiration,* 1936. Oil on canvas, 60 × 60 in. (152.4 × 152.4 cm). Fine Arts Museums of San Francisco, Museum purchase, the estate of Thurlow E. Tibbs Jr., the Museum Society Auxiliary, American Art Trust Fund, Unrestricted Art Trust Fund, partial gift of Dr. Ernest A. Bates, Sharon Bell, Jo-Ann Beverly, Barbara Carleton, Dr. and Mrs. Arthur H. Coleman, Dr. and Mrs. Coyness Ennix, Jr., Nicole Y. Ennix, Mr. and Mrs. Gary Francois, Dennis L. Franklin, Mr. and Mrs. Maxwell C. Gillette, Mr. and Mrs. Richard Goodyear, Zuretti L. Goosby, Marion E. Greene, Mrs. Vivian S. W. Hambrick, Laurie Gibbs Harris, Arlene Hollis, Louis A. and Letha Jeanpierre, Daniel and Jackie Johnson, Jr., Stephen L. Johnson, Mr. and Mrs. Arthur Lathan, Lewis & Ribbs Mortuary Garden Chapel, Mr. and Mrs. Gary Love, Glenn R. Nance, Mr. and Mrs. Harry S. Parker III, Mr. and Mrs. Carr T. Preston, Fannie Preston, Pamela R. Ransom, Dr. and Mrs. Benjamin F. Reed, San Francisco Black Chamber of Commerce, San Francisco Chapter of Links, Inc., San Francisco Chapter of the N.A.A.C.P., Sigma Pi Phi Fraternity, Dr. Ella Mae Simmons, Mr. Calvin R. Swinson, Joseph B. Williams, Mr. and Mrs. Alfred S. Wilsey, and the people of the Bay Area, 1997.84

"individual dark-skinned selves without fear or shame."[1] A decade later, when the Harmon Foundation selected an artist to paint a series of murals for the Texas Centennial Exposition in Dallas, Douglas was an obvious choice for the commission.

The four large canvases that Douglas made for the lobby of the centennial's Hall of Negro Life welcomed more than four hundred thousand fairgoers who visited the building.[2] Only two of the paintings, however, have been located: *Into Bondage* and *Aspiration* (Fig. 1). Along with *Negro's Gift to America,* a large horizontal work that hung between them in the lobby of the exhibition hall, these canvases depicted the journey of African Americans from their native land to the twentieth-century North American metropolis. *Into Bondage* illustrates the enslavement of Africans bound for the Americas. *Negro's Gift to America* featured an allegory of Labor as the holder of the key to a true understanding of Africans in the New World. *Aspiration* concluded the cycle by calling attention to the liberating promise of African American education and industry. A fourth canvas portrayed Estevanico, a Moroccan slave who accompanied the Spanish explorer Cabeza de Vaca on his expedition through Texas.[3]

Like the works in Douglas's other murals of the same period, such as *Aspects of Negro Life,* created for the Harlem branch of the New York Public Library in 1934 (now the Schomburg Center for Research in Black Culture), the Texas centennial canvases were unified by a subdued palette, silhouetted figures, and repeated motifs that held personal meaning for the artist. In the Corcoran's painting, concentric circles Douglas frequently used to suggest sound—in particular, African and African American songs—radiate from a point on the horizon where slave ships await their human cargo.[4] Warm earth tones accent a palette of cooler blues and greens, just as the composition's undeniable rhythm competes with an overall timelessness. Silhouetted figures move in a steady line to the distant boats, their rust-colored shackles creating a staccato rhythm echoed by the framing foliage. Patchy brushstrokes activate the surface, imbuing the painting with a texture and liveliness that belie the static precision of crisply delineated forms.

For the pose of the central male figure, whose head is turned in profile but whose square shoulders and torso face forward, Douglas looked to Egyptian art as a source of pan-African nationalism. Similarly, the slit-eye masks made by the Dan peoples of Liberia inspired the man's narrow slash of an eye.[5] Standing on a pedestal intended to foreshadow the auction block from which he will be sold, he is the only figure in the composition whose shoulders rise above the horizon. The man's elevated form and uplifted head, cut across by a ray of starlight, signal eventual freedom for his race. A woman who raises her face and shackled hands to the same star, her fingers grazing the horizon, also foretells a distant future without slavery. According to Douglas, the star and ray of light, which appear in a number of his paintings, represent the North Star and the divine light of inspiration.[6] Douglas, a member of the Communist Party U.S.A., may also have included this motif as a political symbol and to advocate socialism as a means of achieving equality for African Americans.[7]

Regardless of its specific meaning, the star's message of hope is clear. Renée Ater has shown how the Texas centennial's Hall of Negro Life offered African Americans the opportunity to "re-articulate their racial and national identities" and "reshape historical memory." Similarly, Douglas's murals, she writes, "set out to rethink and to develop alternative narratives of black history and contemporary life that were embedded in visual references to slavery."[8] Douglas's forward-looking modernist aesthetic that paid tribute to an African past was thus a fitting visual complement to the fair building's empowering themes.

On another level, the mere existence of the murals was indebted to ongoing African American struggle. When the Texas legislature originally neglected to allocate funds to allow African Americans to be included in the centennial, African American community leaders in Dallas took it upon themselves to apply for federal money to participate. Most Dallas press coverage was enthusiastic when the Hall of Negro Life opened in 1936 on 19 June, or Juneteenth, an African American holiday commemorating the end

of slavery. Consistently high attendance figures at the exhibition hall, however, did not succeed in dispelling deep-seated prejudices.[9] Douglas's paintings so impressed white fairgoers that they refused to believe that an African American artist had made them. To help persuade incredulous visitors, administrators posted a sign reading, "These murals were painted by Aaron Douglas, a Negro artist of New York City."[10]

For Douglas, the commemoration of slavery was critical to the rewriting of the history of Texas and to the acknowledgment of African American contributions to the progress of both state and nation. By doing so in a public mural, Douglas was able to reach hundreds of thousands of viewers and, at the same time, proclaim the centrality of African Americans within modern American visual traditions.

JW

Edward Hopper (Nyack, N.Y., 1882–New York City, 1967)

Ground Swell, 1939

Oil on canvas, 36³/₁₆ × 50¹/₁₆ in. (91.9 × 127.2 cm)
Signed lower right: EDWARD HOPPER
Museum Purchase, William A. Clark Fund, 1943, 43.6

In a vast expanse of open sea, a catboat heels gently to starboard as it navigates a course that has brought it close to a bell buoy. Under feathery cirrus clouds and a brilliant blue sky, the boat's three passengers and pilot gaze at, and presumably listen to, the buoy's bell, which tilts toward them as it crests a sequence of rolling waves. Although Edward Hopper is renowned for lonely urban scenes that have led his work to be understood as emblematic of the mood of the modern city and the isolation of its inhabitants, he was a dedicated painter of nautical subjects.

Born in Nyack, New York, Hopper spent his formative years sketching the maritime industry of this bustling shipbuilding port on the Hudson River.[1] From 1930 Hopper and his wife, Josephine "Jo" Nivison, whom he had met in art school, spent summers painting in Truro, Massachusetts, on Cape Cod. In 1934 they built a cottage in South Truro; *Ground Swell* was painted in the adjacent studio. Jo conveyed the anticipation surrounding Hopper's completion of *Ground Swell* in a letter to his sister:

> Ed. is doing a fine large canvas in studio—sail boat, boys nude to the waist, bodies all tanned, lots of sea and sky. It ought to be a beauty. Frank Rehn [Hopper's dealer] will be delighted. Everyone has wanted Ed to do sail boats. He has only 2 or 3 weeks to finish it—and it will need some fine weather with rolling seas to go look at. Dense fog today but scarcely any rain here either.[2]

Ground Swell numbers among a group of similar seafaring subjects Hopper executed during the late 1930s and early 1940s. Along with paintings such as *The Long Leg* (1935, The Huntington Library, Art Collections, and Botanical Gardens, San Marino, Calif.) and *The "Martha McKeen" of Wellfleet* (1944, Thyssen-Bornemisza Museum,

Madrid), *Ground Swell* has come to be seen as exemplary of the artist's recurring theme of escape.[3] It is a motif familiar from better-known paintings like *New York Movie* (1939, The Museum of Modern Art, New York) and *Eleven A.M.* (1926, Hirshhorn Museum and Sculpture Garden, Washington, D.C.) that take as their focus liminal spaces: thresholds, windows, railroads, and so forth.[4] If Hopper's iconic *Nighthawks* (1944, The Art Institute of Chicago) conveys the anxiety of the urban experience through the acidic hue and high contrast of its artificial illumination, *Ground Swell*'s cool palette and balanced, rhythmic composition would seem to illustrate the peaceful solace the artist, a notorious recluse, sought in his idyllic coastal retreat.[5]

Ground Swell's subject is not uncommon in American art. It recalls, for example, Thomas Eakins's *Starting Out after Rail* (1874, Museum of Fine Arts, Boston) and Winslow Homer's *Breezing Up (A Fair Wind)* (Fig. 1), the sparkling vibrancy of which has been interpreted as corresponding to the nation's incipient optimism a decade after the Civil War.[6] Whereas Homer's sailors gaze intently at a clear horizon connoting future promise, Hopper's are transfixed by the bell buoy, which strikes a dark note, literally and figuratively, in the otherwise sunny scene.

The function of a bell buoy is to issue auditory warning of submerged dangers or channel boundaries. Hopper's bell clangs in response to the painting's titular ground swell, a heavy rolling of the sea caused by a distant storm or seismic disturbance. Unseen trouble may lurk beneath the surface or beyond the horizon of Hopper's otherwise serene painting. The visual rhyming of the ocean swells and the cirrus clouds in the upper register might reinforce such a portentous interpretation. Cirrus clouds are often harbingers of approaching storms and also often form at the outer edges of hurricanes and thunderstorms.[7] Indeed, a hurricane had devastated

Fig. 1. Winslow Homer, *Breezing Up (A Fair Wind)*, 1873–76. Oil on canvas, 24³/₁₆ × 38³/₁₆ in. (61.5 × 97 cm). Courtesy of the Board of Trustees, National Gallery of Art, Washington, Gift of the W. L. and May T. Mellon Foundation, 1943.13.1

much of the northeast coast in late August 1938, one year before Hopper completed *Ground Swell*.[8] The accuracy and specificity of Hopper's sky indicate, if nothing else, that it is one the artist had seen, rather than one born of imagination or synthesis.[9]

Alexander Nemerov has noted that while Hopper worked on *Ground Swell*, from August to 15 September 1939, news of the eruption of World War II was broadcast on American radios. As radio waves brought news of distant conflict to U.S. shores, the bell buoy in *Ground Swell* sonically registers the reverberations of some unspecified distant turmoil.[10] Hopper was famously resistant to explaining the meaning of his paintings, but he broached, obliquely, the relation between the war and his work in a 1940 letter to his friend the artist Guy Pène du Bois. Explaining that Jo had wept in a grocery store when she learned of the fall of Paris, Hopper resignedly concluded: "Painting seems to be a good enough refuge from all this, if one can get one's dispersed mind together long enough to concentrate upon it."[11] The artist's canvas, like the catboat's white canvas sail, seemingly offered a means of escape.

That the ramifications of the war were felt in the North American art world is certain. The minutes of an April 1943 meeting of the Corcoran's board of trustees, for instance, testify to a debate regarding the suitability of holding the Eighteenth Biennial Exhibition of Contemporary American Oil Paintings "in view of the existing war situation."[12] The exhibition was mounted and later deemed "unusually successful."[13] Hopper was a juror, and *Ground Swell* was included in the biennial, from which it was acquired by the Corcoran.[14]

AG

Raphael Soyer (Borisoglebsk, Russia, 1899–New York City, 1987)

A Railroad Station Waiting Room, c. 1940

Oil on canvas, 34¼ × 45¼ in. (87 × 114.9 cm)
Signed lower left: RAPHAEL / SOYER
Museum Purchase, William A. Clark Fund, 43.4

Raphael Soyer's *A Railroad Station Waiting Room* treats a common theme in the artist's work: people waiting.[1] He depicted the subject in different contexts throughout his career, from the benign ennui of *Bus Passengers* (1938, location unknown) to the nervous anticipation of *Waiting for the Audition* (Fig. 1). *A Railroad Station Waiting Room* indexes the moods of a diverse group of travelers in the Harlem– 125th Street Station as they wait for trains to take them to the Bronx, New Haven, or New York's northern suburbs.[2] A man in a brown suit staves off boredom by engrossing himself in his newspaper, while a woman seated in the foreground in a brilliant red crocheted hat leans on a paper that has been unfolded and refolded several times over, as if she has exhausted her reading material and now resigns herself to an unrelieved wait. Between these poles of resistance and resignation, other travelers smoke, yawn, or lose themselves in thought. Soyer also conveys the monotony of the wait through various formal means. He repeats the alternation of mint green, brown, and white that makes up the station windows with marked uniformity. The smaller facets of paneling and the lines of the planks composing the walls similarly repeat, echoing the four figures on the bench, whose backs slump one after the next in a series of parallel curving lines.

A Railroad Station Waiting Room was exhibited in the Corcoran's Eighteenth Biennial Exhibition, where it won the Third William A. Clark Prize and a Bronze Medal. Soyer received his awards in person from then first lady Eleanor Roosevelt, who praised his work, saying, "I felt as though I were passing through that waiting room, which I have done so many times, and looking at the people myself."[3] Such comments must have pleased Soyer, not only because Roosevelt complimented his skills as a representational painter, but because his work prompted her empathetic response. The artist is typically classified as a social realist, a painter who was urban and socially aware and who painted figures in a representational style. Indeed, Soyer was the very definition of urban, spending most of his life in New York City after immigrating there from Russia at the age of twelve. He was also socially aware, advocating for the rights of oppressed groups throughout his life.[4] Unlike many of his peers, however, Soyer professed a determination not to allow specific political views to enter into his art.[5] Rather, he sought to present a more universal, humanist view of city life, one with which people from all walks of life, privileged or poor, homeless man or first lady, could relate.[6] Eleanor Roosevelt's ability, then, to empathize with the boredom of the people in the very waiting room she herself had visited proved the success of Soyer's painting.

Because Soyer sought a universal perspective in his art, he downplayed other, more personal influences, particularly his own observant Judaism. The Soyer scholar Samantha Baskind has argued, however, that contrary to his claims, his art expressed a Jewish worldview that was shaped by the concept of social justice known as *tikkun olam*, or "repair the world." "Tikkun olam," Baskind writes, "means in the most universal sense, that Jews are not only responsible for the ethical and material welfare of other Jews but also for the ethical and material welfare of society as a whole."[7] Thus, Soyer did not see his duty, as he said, to "paint so-called class-conscious

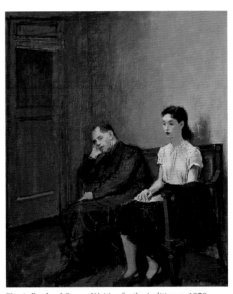

Fig. 1. Raphael Soyer, *Waiting for the Audition*, c. 1950. Oil on canvas, 30 × 24¼ in. (76.2 × 61.6 cm). Corcoran Gallery of Art, Museum Purchase, William A. Clark Fund, 51.16

pictures" that could prompt specific political action[8] but to paint works that were inspired by and that in turn inspired a sense of shared humanity and social consciousness.[9]

In *A Railroad Waiting Room*, boredom is the great leveler. It inspires a sense of alienation that, ironically, unites all of us. But Baskind also understands this sense of alienation, particularly as Soyer expresses it in the context of transience, to be another biographical aspect of his art. A sense of transience indeed pervades the Corcoran's canvas. Soyer portrays not only people in transit; the very instant he captures is by its nature fleeting: a woman yawns, a baby looks curiously over her mother's shoulder, a man holds a cigarette in his mouth.

Soyer and his twin brother, Moses, who was also an artist, were born in Russia, where their father worked as a Hebrew teacher. Their home became a meeting place for students and other Jewish intellectuals, and, as a consequence, their residence permit was revoked in 1912. In a matter of months, the family moved to Philadelphia, where the intellectually precocious teenagers were placed in a kindergarten class because they could not yet speak English.[10] This personal experience of being uprooted, as well as the more general experience of being an immigrant and a part of the larger Jewish diaspora, led Soyer to focus on painting themes of alienation, homelessness, and travel.[11] He regarded these experiences as part of the human condition and thus central to artistic enterprise: "In my opinion if the art of painting is to survive, it must describe and express people, their lives and times. It must communicate. . . . I consider myself a modern artist, or rather an artist of today . . . because I am influenced by the thoughts, the life and the aesthetics of our time."[12]

LS

251

Space Divided by Line Motive, 1943

Oil on canvas, 24 × 32 in. (60.9 × 81.2 cm)
Museum Purchase, William A. Clark Fund, 1968

Arthur Dove belonged to a pioneering group of artists whose increasingly abstract style radically changed the course of American art. The son of a brick manufacturer, he received his first art instruction from an amateur painter near his family's home in Geneva, New York, before graduating from Cornell University, where he studied law and took an occasional art class. After working for four years in New York City as an illustrator for such popular periodicals as *Harper's* and *Scribner's,* Dove traveled to Europe, where his works were included in the progressive 1908 and 1909 Salon d'Automne exhibitions in Paris and where he studied the work of the Impressionists and the Fauves, notably Henri Matisse. When he returned to the United States, Dove often supplemented his income through farming and fishing, and often tied his images to the land and the sea, calling them "extractions."[1] He became a protégé of the influential promoter of modern art Alfred Stieglitz, who included Dove's work in a group show at his 291 gallery (named for its Fifth Avenue address) in 1910–11 and gave the artist his first solo show in 1912.

Space Divided by Line Motive is one of a group of paintings from the early 1940s that marked a transformation in Dove's work toward greater abstraction, a trend that continued until his death in 1946.[2] The shift followed major changes in the artist's life: his move in early 1938 with his wife, Reds (the artist Helen Torr), to a home on Long Island Sound, after which he suffered debilitating health problems. At the same time, he continued to paint and embraced the broad move, by European and American artists alike, toward a universal language of abstraction that occurred in the late 1930s and early 1940s.[3] In fact, Dove was a pioneer of abstraction and has often been cited as the first artist of any nationality to make a nonrepresentational painting. As Debra Bricker Balken notes, "Dove's abstract paintings of 1910/11 and 1912 . . . seem to parallel if not predate by maybe a year the production of Kandinsky's Improvisations, generally touted as the first European paintings to dispense totally with figuration."[4]

In late 1942 Dove's work became consistently nonrepresentational, as the artist noted in a December diary entry: "Made abstract painting."[5] Created just ten months later, *Space Divided by Line Motive* is characteristic of the artist's output between 1942 and 1944, when his lifelong experimentation with line, color, composition, and medium culminated in paintings devoid of representational subject matter and focused almost exclusively on formal concerns. Thirteen large, interlocking planes of opaque, saturated color—bright red and blue contrast with harsher tones of olive green, ocher, and brownish plum—animate and unite the composition. While most of the shapes are unmodulated, four are flecked with small dots of contrasting hues. The active design flows, in three triangular sections, from the lower left to the upper right; these sections, in turn, are cut by three shapes reaching from upper left to lower center. As Dove describes in his title—an unromantic, nonreferential moniker typical of this period—space is divided by lines that are by turns straight, slightly undulating, curvy, and jagged.[6] He references the painting's design in his diary entries, too, which evolve from "Division of Space . . . with motif lines" (10 October) to "space division" (12 and 13 October) to his proclamation that he had "Finished Space divided with line motif" (16 October).[7] The resulting image manifests Dove's increasing interest not only in abstraction but in the specific idea of spatial planes and their interaction. The overall positive-negative effect of the design conveys a strong sense of movement across the canvas's surface, as if to suggest a seismic shifting of plates of land.[8] Other diary entries of this period cite this interest: on 12 August 1939 he wrote about painting "not static planes in space not form but formation. To set planes in motion."[9]

The high-keyed palette Dove employed in *Space Divided by Line Motive* is also evidence of the change in his art during this pivotal period. It diverges from the more naturalistic and subtly modeled hues he had used earlier in his career and shows him to be a master colorist, a characterization also noted by contemporary critics such as the *New York Sun*'s Henry McBride, who remarked that the artist was "the best colorist among American abstractionists."[10] Moreover, the artist's application of broad, clear planes of flat, opaque color in the Corcoran's painting demonstrates his interest in the precise placement of specific colors at this time. In December 1942 Dove recorded his aim of "getting down one shape and one color at a time, as directly and clearly as possible," and wrote of being "[f]ree from all motifs etc just put down one color after another."[11] The uniform intensity of the colors also has the effect of asserting the two-dimensionality of the picture plane; none appears to advance or recede. As the artist stated, "Pure painting has the tendency to make one feel the two-dimensionality of the canvas, a certain flatness which is so important in the balance of things and often so difficult to attain."[12]

When *Space Divided by Line Motive* was first exhibited, in the artist's 1944 one-man show at Stieglitz's American Place gallery, it was not singled out for mention, although critics responded quite positively to the display and took note of the changes that it signaled in Dove's art. A writer for *Art News* identified "a new strength," while a *New York Times* reviewer observed that the works in the exhibition, "[b]orrowing a phrase from the field of color, might [be called] primaries in thought," and asserted that the paintings, in which Dove "has carried simplification of forms and arrangements about as far as possible," are "big-boned compositions [with] impact."[13]

Despite the support he received from Stieglitz and important collectors such as Paul Rosenfeld and Duncan Phillips, and his success in showing his work—he held one-man exhibitions annually and participated in a number of the major exhibitions of the period—Dove struggled for acceptance of his art; even Stieglitz noted that some of his paintings were "above the heads of the people."[14] Nevertheless, Dove vigorously and steadfastly pursued his art, producing some of the most avant-garde paintings of the period. *Space Divided by Line Motive* remained unsold at his death and was purchased by the Corcoran in 1968 from the estate of his widow.

SC

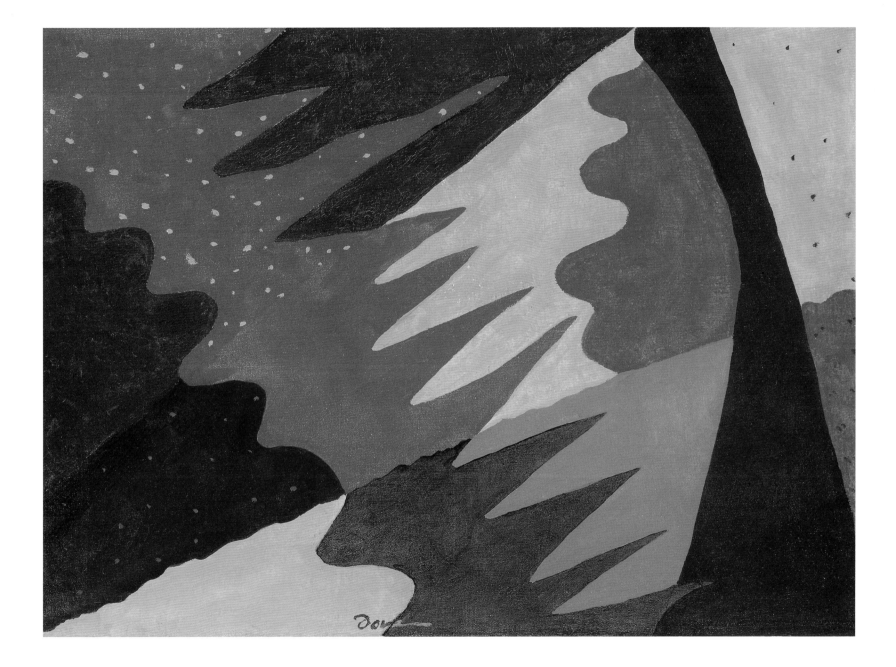

Blackburn, *Portrait of a Gentleman*

1. Richard H. Saunders estimated Blackburn's birth date as c. 1730 and his death date as after 1778, dating his last known work to 1778; see Saunders, "Joseph Blackburn," in *Encyclopedia of American Art before 1914*, ed. Jane Turner (New York: Grove's Dictionaries, 1999), 44–45; and Saunders, *American National Biography Online*, at http://www.anb.org/articles (accessed 16 July 2007). Ellen G. Miles, in *Oxford Dictionary of National Biography* (New York: Oxford University Press, 2004), 5:930, gives the artist's active dates as 1752–77, his last portrait dating 1777. All three sources offer full bibliographies.
2. The two checklists of Blackburn's work appeared more than seventy years ago and are poorly illustrated. Lawrence Park, *Joseph Blackburn: A Colonial Portrait Painter with a Descriptive List of His Works* (Worcester, Mass.: American Antiquarian Society, 1923), 3–62; and John Hill Morgan and Henry Wilder Foote, *An Extension of Lawrence Park's Descriptive List of the Work of Joseph Blackburn* (Worcester, Mass.: American Antiquarian Society, 1937), 3–69. The most recent studies focus on groups of portraits made in a particular location. These include William B. Stevens, Jr., in "Joseph Blackburn and His Newport Sitters, 1754–1756," *Newport History* 40, part 3 (Summer 1967): 95–107; and Elizabeth Adams Rhoades Aykroyd, "Joseph Blackburn, Limner, in Portsmouth," *Historical New Hampshire* 30, no. 4 (Winter 1975): 231–43. His English work is discussed in Louisa Dresser, "The Background of American Colonial Portraiture: Some Pages from a European Notebook," *Proceedings of the American Antiquarian Society* 76 (1966): 41–53.
3. Mary Cary Russell to Chambers Russell, her brother-in-law, Boston, probably dated 1757, not located, quoted in Park, *Blackburn*, 6, with some spellings modernized. The letter without spelling changes is quoted in Morgan and Foote, *An Extension of Park's List*, 69.
4. On Blackburn's influence on the young Copley, see the discussion of Copley's portraits of Ann Tyng (1756, Museum of Fine Arts, Boston), Theodore Atkinson, Jr. (c. 1757–58, Museum of Art, Rhode Island School of Design, Providence), and Mrs. George Watson (Elizabeth Oliver) (1765, Smithsonian American Art Museum), in Carrie Rebora, Paul Staiti, Erica E. Hirshler, Theodore E. Stebbins, Jr., and Carol Troyen, *John Singleton Copley in America* (New York: Metropolitan Museum of Art, 1995), cat. nos. 7–8, 176–81, and cat. no. 20, 206–8.
5. This receipt is in the collection of Historic New England, Boston, and is reproduced in Frank W. Bayley, *Five Colonial Artists of New England* (Boston: privately printed, 1929), 69.

6. John P. Nicholson, John P. Nicholson Gallery, New York, to Horace L. Hotchkiss, Jr., CGA, 20 February 1956, CGA Curatorial Files.
7. These can be seen in Aykroyd, "Joseph Blackburn, Limner," which includes a list of Blackburn's Portsmouth portraits.
8. Linda Baumgarten to Ellen Miles, email dated 27 August 2008, discussing the clothing in this portrait.
9. Baumgarten, ibid., cited Aileen Ribeiro, *A Visual History of Costume: The Eighteenth Century* (London: B. T. Batsford, 1983), 51 and 76 for this style.
10. On Hudson, see Ellen G. Miles, "Thomas Hudson (1701–1779): Portraitist to the British Establishment," 2 vols. (Ph.D. diss., Yale University, 1976); for the portrait and its engraving, see 2:204, cat. no. 195, pl. 154.

Copley, *Thomas Amory II*

1. The standard source on Copley remains Jules David Prown's monograph and catalogue raisonné, *John Singleton Copley*, 2 vols. (Cambridge, Mass.: Harvard University Press, 1966).
2. See the entry by Carrie Rebora, in Rebora, Paul Staiti, Erica E. Hirshler, Theodore E. Stebbins, Jr., and Carol Troyen, *John Singleton Copley in America* (New York: Metropolitan Museum of Art, 1995), 278–79.
3. Clifford K. Shipton, *Biographical Sketches of Those Who Attended Harvard College in the Classes, 1741–1745* (Boston: Massachusetts Historical Society, 1960), 11:4; and Gertrude Euphemia Meredith, *The Descendents of Hugh Amory, 1605–1805* (London, 1901), 109, cited in Rebora, in Rebora, Staiti, Hirshler, Stebbins, and Troyen, *Copley in America*, 279.
4. Rebora, in Rebora, Staiti, Hirshler, Stebbins, and Troyen, *Copley in America*, 279; and Prown, *Copley*, 1: fig. 305.
5. Rebora, ibid., attempts to explain this anomaly.
6. Ibid.

West, *Cupid, Stung by a Bee, Is Cherished by His Mother*

1. For comprehensive studies on West's life and art, see Robert C. Alberts, *Benjamin West: A Biography* (Boston: Houghton Mifflin Company, 1978); and Helmut von Erffa and Allen Staley, *The Paintings of Benjamin West* (New Haven: Yale University Press, 1986).
2. Francis Fawkes, *The Works of Anacreon, Translated from the Greek*, in *Select British Poets, and Translations*, ed. Robert Anderson (London: W. Griffin, c. 1810), 5:182; and Fawkes, *The Idylliums of Theocritus* (London: D. Leach, 1767), 97–99.
3. "Cupid Wounded," in Fawkes, *The Works of Anacreon*, 99.
4. For example, *Mrs. West with Raphael West* (Utah Museum of Fine Arts, Salt

Lake City, and Yale Center for British Art, New Haven, Paul Mellon Collection). He also produced a tondo self-portrait with their son Raphael about 1773 (Yale Center for British Art). See von Erffa and Staley, *The Paintings of West*, 456–60; and Alan Staley, *Benjamin West: American Painter at the English Court* (Baltimore: Baltimore Museum of Art, 1989), 21–23.
5. Von Erffa and Staley, *The Paintings of West*, 233. See Fawkes, *The Idylliums of Theocritus*, 182.
6. Von Erffa and Staley, *The Paintings of West*, 232.
7. Desmond Guinness, *Lucan House* (Bruges, Belgium: Die Keure, 2005).
8. Von Erffa and Staley, *The Paintings of West*, 181.
9. For a 1925 photograph of the Lucan House dining room, see Guinness, *Lucan House*, 12.

Wright, *Elizabeth Stevens Carle*

1. A label on the reverse gives her dates as 13 August 1761–12 November 1790; a stone marker at the First Presbyterian Church, Trenton, New Jersey, gives her death date as 12 March 1790, age twenty-nine, and her name as Eliza; see Eli Field Cooley, *Genealogy of the Early Settlers in Trenton and Ewing, "old Hunterdon County," New Jersey* (Trenton, N.J., 1883), 313n; and John Hall, *History of the Presbyterian Church in Trenton, N.J., from the First Settlement of the Town*, 2nd ed. (Trenton, N.J., 1912), 141. Much of the research for this portrait, notably for the biographies and provenance as well as comparative portraits, was done in 2008 by National Portrait Gallery intern Ashlee Whitaker.
2. *A Catalogue of the Collection of American Paintings in The Corcoran Gallery of Art*, vol. 1, *Painters Born before 1850* (Washington, D.C.: Corcoran Gallery of Art, 1966), 21.
3. Carle died on 7 July 1822, age sixty-five. On Carle, see Hall, *History of the Presbyterian Church*, 141; Cooley, *Genealogy*, 313n; and Francis B. Heitman, *Historical Register of Officers of the Continental Army during the War of the Revolution* (1914; Baltimore: Genealogical Publishing Company, 1973), 144. Carle was described in tax records for the township of Trenton in 1779 as a single man; by 1786 he was no longer listed as single. See Francis Bazley Lee, *Genealogical and Personal Memorial of Mercer County New Jersey* (New York, 1907), 1:29, 32. Genealogical information was also supplied by Helen Kull of the First Presbyterian Church of Ewing, New Jersey, to Ashlee Whitaker; emails dated 13 and 14 March 2008. A letter in the CGA Curatorial Files from Israel Carle's great-great-great-granddaughter Elizabeth D. Keyes of Philadelphia, dated 2 January 1976, questioned the identification of Carle as a Hessian and provided a short biography that confirmed this

research; she owned a Carle family Bible that gave his dates as 1756–1822.
4. Marchal E. Landgren, "American Paintings at the Corcoran Gallery of Art, Washington, D.C.," *Antiques* 108 (November 1975): 943.
5. Linda Baumgarten to Ellen Miles, email, 10 November 2008.
6. The hairstyle is described by Aileen Ribeiro in Elizabeth Mankin Kornhauser, *Ralph Earl: The Face of the Young Republic* (New Haven: Yale University Press, 1991), 135–26, 140–41, in the entries for the portraits of Martha Spear Johnston, 1785, and Elizabeth Schuyler Hamilton, 1787.
7. Robin Jaffee Frank, *Love and Loss: American Portrait and Mourning Miniatures* (New Haven: Yale University Press, 2000), 31, 309. These and other portraits by Peale showing this fashion are illustrated and discussed in Charles Coleman Sellers, *Portraits and Miniatures by Charles Willson Peale* (Philadelphia: American Philosophical Society, 1952); and in Lillian B. Miller, ed., *The Selected Papers of Charles Willson Peale and His Family* (New Haven: Yale University Press, 1983), vol. 1. Numerous other portraits by Peale depict women wearing miniatures that are visible, worn on cords around their necks.
8. The portrait is neither illustrated nor discussed in William Sawitsky, *Matthew Pratt, 1734–1805* (New York: New-York Historical Society, 1942), the only book-length study of his work and career. Similar portraits of women dating after the Revolution are attributed to Pratt in this source and could also instead be the work of Joseph Wright.
9. On Wright, see Monroe Fabian, *Joseph Wright, American Artist, 1756–1793* (Washington, D.C.: National Portrait Gallery, 1985).
10. On these portraits and for illustrations, see ibid., 92–106 (Washington), and 116–18 (Hannah Bloomfield Giles and James Giles).
11. A note in the CGA Curatorial Files reads: "Values from H. W. Williams February 21, 1963 Pratt—like ours $15,000. Knoedler now owns Mrs. Smith Stevens by Pratt—Mother of our subject."
12. For these portraits, see the Inventory of American Painting, Smithsonian American Art Museum, at http://siris.artinventories.si.edu. The portrait of the younger Eliza Ann Carle was exhibited in 1975 at the Historical Society of Princeton, New Jersey; see *American Paintings: A Gathering from Three Centuries* (Princeton: Historical Society of Princeton, 1975), 9 and pl. 10.

Stuart, *Edward Shippen and Sarah Shippen Lea*

1. On Shippen and his family, see Charles P. Keith, *The Provincial Councillors of Pennsylvania Who Held Office between*

1733 and 1776, and Those Earlier Councillors Who Were Some Time Chief Magistrates of the Province, and Their Descendants (Philadelphia, 1883), 54–71; "Shippen, Edward," Dictionary of American Biography, ed. Dumas Malone (New York: Charles Scribner's Sons, 1964), 9:117; and Randolph Shipley Klein, Portrait of An Early American Family: The Shippens of Pennsylvania across Five Generations (Philadelphia: University of Pennsylvania Press, 1975).
2. On the history of Stuart's portraits of Washington, see the summary and references in Carrie Rebora Barratt and Ellen G. Miles, Gilbert Stuart (New York: Metropolitan Museum of Art, 2004), 133–90; Stuart painted his better-known Athenæum and Lansdowne portraits of Washington in 1796.
3. The letter is quoted in Lewis Burd Walker, "Life of Margaret Shippen, Wife of Benedict Arnold," Pennsylvania Magazine of History and Biography 26, no. 1 (January 1902): 225. Because of the letter, Shippen's portrait has been redated to 1796, much earlier than the date of 1803 that was provided by Lawrence Park, Gilbert Stuart: An Illustrated Descriptive List of His Works, with an Account of His Life by John Hill Morgan and an Appreciation by Royal Cortissoz (New York: William Edwin Rudge, 1926), 686–87; see Adam Greenhalgh, memo to CGA Registrar, 21 June 2003, Curatorial Files.
4. On the miniature, see Theodore Bolton, "Benjamin Trott, an Account of His Life and Work," Art Quarterly 7, no. 4 (Autumn 1944): 261; and Theodore Bolton and Ruel Pardee Tolman, "A Catalogue of Miniatures by or Attributed to Benjamin Trott," ibid., 282, no. 30.
5. Edwin later recounted Stuart's reaction to the engraving: "'When I carried him the proof of Judge Shippen's portrait, he had a sitter & it was sent in, he came out. You may consider it the greatest compliment ever paid you when I leave my sitter to tell you how much I am pleased with your engraving of this head." William Dunlap heard the anecdote from Edwin when he visited the engraver on 19 June 1833 and noted it in his diary; see Dorothy C. Barck, ed., Diary of William Dunlap (1766–1839), 3 vols. (New York: New-York Historical Society, 1931), 3:690. The anecdote was repeated by Dunlap in his History of the Rise and Progress of the Arts of Design in the United States (1834; New York: Dover Publications, 1969), 1:206, where the wording is slightly different. Dunlap dated the episode to 1798, but Harold E. Dickson has argued instead for a date of 1802, which agrees with Shippen's age on the engraving. See Dickson, "A Misdated Episode in Dunlap," Art Quarterly 9, no. 1 (Winter 1946): 33–36.
6. George C. Mason, The Life and Works of Gilbert Stuart (New York: Charles Scribner's Sons, 1879), 255–56. On the

portrait, see also Park, Stuart, 467–68; and Dorinda Evans, "Mrs. Thomas Lea by Gilbert Stuart," in Philadelphia: Three Centuries of American Art (Philadelphia: Philadelphia Museum of Art, 1976), cat. no. 147, 177–78.
7. Keith, The Provincial Councillors, 59; and Klein, The Shippens, 330.
8. The traditional date of c. 1798 is first found in Park, Stuart, 467–68.
9. On the portrait, see Dorinda Evans, "Robert Lea by Adolph-Ulrich Wertmüller," in Philadelphia: Three Centuries, cat. no. 136, 165–66 (illus.). For the documentation in Wertmüller's "Notte des tous mes ouvrages," see Michel Benisovich, "Wertmüller et son Livre de Raison intitulé la 'Notte,'" Gazette des Beaux-Arts, 6th ser., 48 (July–August 1956): 59 (71–72 in the original MS). Wertmüller noted that he had finished the portrait of Robert Lea on 1 August 1795. He was paid on 5 August 1795 for the portrait as well as for one of "Mme Lea" (now unlocated), which he finished on 25 July.
10. Edward Shippen to Peggy Arnold, 23 May 1801; and Walker, "Life of Margaret Shippen," 238, quoted in Evans, Philadelphia: Three Centuries, 166.
11. Margaretta M. Lovell, Art in a Season of Revolution: Painters, Artisans, and Patrons in Early America (Philadelphia: University of Pennsylvania Press, 2005), 35.
12. Jane Pringle to William Wilson Corcoran, 16 November [probably 1873], CGA Archives.
13. William MacLeod to George C. Mason, 3 September 1878, Director's Correspondence, CGA Archives.

Stuart, *George Washington*, Clark and Tayloe

1. Lawrence Park, Gilbert Stuart: An Illustrated Descriptive List of His Works, with an Account of His Life by John Hill Morgan and an Appreciation by Royal Cortissoz, 4 vols. (New York: William Edwin Rudge, 1926), 2:871, 889; John Hill Morgan and Mantle Fielding, The Life Portraits of Washington and Their Replicas (Philadelphia: printed for the subscribers, 1931), 246, 247, cat. no. 46, 280–81, 308; Gustavus A. Eisen, Portraits of Washington, vol. 1, Portraits in Oil Painted by Gilbert Stuart (New York: R. Hamilton and Associates, 1932), 143, 145, 168, 174–77, 273.
2. For a full discussion of Stuart's three life portraits of Washington, Stuart's difficulties in painting Washington, and the many replicas of the originals, see Dorinda Evans, The Genius of Stuart (Princeton: Princeton University Press, 1999), 60–73; and Carrie Rebora Barratt and Ellen G. Miles, Gilbert Stuart (New York: Metropolitan Museum of Art, 2004), 129–90. Both sources fully cite earlier references on these portraits.

3. This story from Horace Binney, a friend of the artist's, is recounted in George C. Mason, The Life and Works of Gilbert Stuart (New York: Charles Scribner's Sons, 1879), 141.
4. John Dowling Herbert, Irish Varieties, for the Last Fifty Years: Written from Recollections (London: William Joy, 1836), 248.
5. William Dunlap, History of the Rise and Progress of the Arts of Design in the United States (New York: George P. Scott and Co., 1834), 1:197–98.
6. On Stuart's Athenæum portrait of Washington and its replicas, see Evans, The Genius of Stuart, 63–67; and Barratt and Miles, Stuart, 147–66. On his copying technique, see also Evans, 84–85.
7. For a discussion of the 1803 date of the Clark portrait in relation to similar portraits of Washington by Stuart, see the email exchange between Diana Kaw and Ellen Miles, 6–13 May 2008, CGA Curatorial Files.
8. This and similar portraits are discussed in Barratt and Miles, Stuart, 157–59. Eisen also associated the Clark portrait with other portraits that have Philadelphia provenances; see Eisen, Portraits of Washington by Stuart, 167–69.
9. In this detail, the painting is similar to the portrait first owned by John Richards, the British agent for the Baring banking family (Everson Museum of Art, Syracuse, N.Y.). This comparison and other similar portraits are discussed and illustrated in Barratt and Miles, Stuart, 157–61. Eisen, Portraits of Washington by Stuart, 176–83, associated the portrait with other portraits owned by Washington's admirers in Philadelphia, Baltimore, and Washington, D.C.
10. One small piece of evidence unfortunately does not help. On the reverse of the canvas of the Clark picture is a partially visible British tax stamp. These stamps are evidence of the payment of taxes on British commercially prepared fabric and have been found on many late-eighteenth- and early-nineteenth-century British and American paintings. Unfortunately, to date, the information in the numbering system has not been decoded to reveal details about the place and date of the payment of the tax. The technical report by Gay Myers, 22 November 2005, notes that "remains of a British tax stamp are slightly visible through the lining fabric. The only part of the excise stamp that is legible is '623' and possibly a '1 [?]'; the section with a possible date is not visible." For a discussion of the tax stamps found on another of Stuart's portraits of George Washington as well as the portrait of British ambassador Robert Liston, both owned by the National Gallery of Art, see Ellen G. Miles et al., American Paintings of the Eighteenth Century, The Collections of the National Gallery of Art, Systematic

Catalogue (Washington, D.C.: National Gallery of Art, 1995), 222–24, 208.
11. Jane Stuart, "The Stuart Portraits of Washington," Scribner's Monthly 12 (July 1876): 373; and Mason, The Life and Works of Stuart, 107.
12. The Tayloe portraits, in a private collection, are mentioned in Barratt and Miles, Stuart, 239, 258–59.

Polk, *Thomas Corcoran* and *Hannah Lemmon Corcoran (Mrs. Thomas Corcoran)*

1. On the Corcorans, see William Wilson Corcoran, A Grandfather's Legacy: Containing a Sketch of His Life and Obituary Notices of Some Members of His Family Together with Letters from His Friends (Washington, D.C.: Henry Polkinhorn, 1879), 3–6; and Linda Crocker Simmons, Charles Peale Polk, 1776–1822 (Washington, D.C.: Corcoran Gallery of Art, 1981), 12, 15, 70.
2. Corcoran, Grandfather's Legacy, 6, gives her death date as 2 June 1828, age fifty-eight.
3. On Polk's career, see Simmons, Polk, 1–19.
4. Charles Peale Polk to James Madison, 2 April 1801, James Madison Papers, Library of Congress, quoted in Simmons, Polk, 13.
5. According to Corcoran, Grandfather's Legacy, 4, which gives the names and birth dates of the surviving children, the Corcorans had "six boys and six girls, of whom three boys and three girls lived to maturity."
6. Simmons, Polk, 70.
7. This observation was made by William Davis of the National Archives Center for Legislative Archives, National Archives and Record Administration, Washington, D.C., to Ellen Miles; see Miles's memo to Sarah Cash, 20 April 2009, CGA Curatorial Files, regarding attempts to identify the document that Thomas Corcoran holds. Earlier attempts to read the inscription are recorded on an old accession record card in the CGA Curatorial Files on this portrait, which suggests that the center section may have read: "Actus In the United States . . . House of Representatives . . . Monday April 24th / Debate / On the bill . . . the Senate." Davis doubts that the word "Actus" is a correct reading, as it is not typical of early legislative documents.
8. For this legislation, see Journal of the House of Representatives of the United States (Washington, D.C.: Gales and Seaton, 1826), 4:221–26; and Journal of the Senate of the United States of America (Washington, D.C.: Gales and Seaton, 1821), 3:226–33. These journals are available online at the Library of Congress, American Memory project, at www.loc.gov.

Johnson, *Grace Allison McCurdy . . . and Her Daughters*

1. Dr. J. Hall Pleasants rediscovered the artist and first published his findings in "Joshua Johnston, the First American Negro Portrait Painter," *Maryland Historical Magazine* 37, no. 2 (June 1942): 121–49, reprinted as Pleasants, *Joshua Johnston, the First American Negro Portrait Painter* (Baltimore: Maryland Historical Society, 1970), and later in *Catalogue: An Exhibition of Portraits by Joshua Johnston* (Baltimore: Municipal Museum of the City of Baltimore, 1948). In Baltimore directories and records (for the latter, see n2 below), the artist's name is spelled both with and without a *t* (Johnston and Johnson), but more often without, and most scholars since Pleasants have accepted the latter spelling. Pleasants's research was significantly updated and expanded in Carolyn J. Weekley and Stiles Tuttle Colwill with Leroy Graham and Mary Ellen Hayward, *Joshua Johnson: Freeman and Early American Portrait Painter* (Williamsburg, Va.: Abby Aldrich Rockefeller Folk Art Center; Baltimore: Maryland Historical Society, 1987).
2. In the mid-1990s Johnson's bill of sale from 1764 and his manumission record were discovered, laying to rest over half a century of speculation about the artist's parentage and race; see Jennifer Bryan and Robert Torchia, "The Mysterious Portraitist Joshua Johnson," *Archives of American Art Journal* 36, no. 2 (1996): 3–7. McCurdy family descendants believed Johnson was from the West Indies; see Pleasants, *Johnston*, 8; and Weekley and Colwill, *Johnson: Freeman and Portrait Painter*, 48. The 1764 bill of sale documents the sale of Joshua Johnson to his father, George Johnson or Johnston, from a William Wheeler, Sr., the owner of Joshua's slave mother. A second document, from 1782, confirms Joshua's age as between nineteen and twenty-one and records his father's plan to release his son from bondage when the latter completed his apprenticeship to a Baltimore blacksmith named William Forepaugh or when he turned twenty-one, whichever came first.
3. Carolyn J. Weekley, "Who Was Joshua Johnson?" in Weekley and Colwill, *Johnson: Freeman and Portrait Painter*, 55, notes that Johnson probably married a woman named Sarah and had several children in the 1790s; see 55, 58, for his addresses during this period, and 55, 59, for the two known advertisements for his portrait painting business.
4. Grace was born in Philadelphia on 11 January 1775 to Captain William Allison (d. after 1788) and his wife, Grace Chambers Allison (c. 1736–1791), and died in Baltimore on 22 July 1822. Pleasants, *Johnston*, 26, cites Grace's mother's name as Grace (Chambers) Caldwell. Letitia Grace and Mary Jane were the couple's only known children. Letitia, born on 25 September 1797, married the Baltimore merchant Richard Henry Douglass (c. 1781–1829) and died on 25 August 1875; the couple had one child, Grace (b. 1826). Mary Jane died, unmarried, in Baltimore on 8 April 1866. The McCurdy biographical information cited in this essay is taken from Weekley, "Who Was Joshua Johnson?"; "The Catalog," in Weekley and Colwill, *Johnson: Freeman and Portrait Painter*, 107–10, cat. no. 10, 136, cat. no. 41, and 169, cat. no. S7; and Pleasants, *Johnston*, cat. nos. X, XI, 24–29.
5. The painting is dated on the basis of Letitia's apparent age.
6. Hugh was likely a merchant in Baltimore's emergent and lucrative flour-milling and shipping industry. See Mary Ellen Hayward, "Introduction: Baltimore, 1795–1825," in Weekley and Colwill, *Johnson: Freeman Portrait Painter*, 21 and passim. Grace and Hugh married on 17 June 1794 at Fayetteville, the West Baltimore Street home of Hugh McCurdy's brother-in-law (Grace's half sister, Margaret Allison Caldwell, was married to James McHenry, the well-known patriot). Weekley, "The Catalog," cat. no. 41, 136, gives the incorrect marriage date of 22 July 1823. After Hugh's death in 1805, Grace married Edward N. Clopper (b. 1773) on 8 May 1811 and bore several more children.
7. Linda Simmons, in her entry on the Corcoran's painting in *A Capital Collection: Masterworks from the Corcoran Gallery of Art* (Washington, D.C.: Corcoran Gallery of Art, in association with Third Millennium Publishing, London, 2002), 36, surmises that the painting's date, along with its "mood of solemnity" and "somberness of the setting with its truncated black sofa," suggests as much. In an unedited, footnoted draft of this entry, CGA Curatorial Files, Simmons suggests that the Corcoran's portrait "may have also been an attempt to provide a pendant to the image of Hugh McCurdy by Rembrandt Peale."
8. Weekley, "Who Was Johnson?" 61–62. All but one of his ambitious multiple-figure family portraits date from these years. Grace's long neck and ovoid face are characteristic of the artist's portrayal of his adult subjects.
9. Paradoxically, Johnson simultaneously renders his bulky figures weight*less*; save for the top of Mary Jane's brilliant red slipper, the figures' feet are not shown. The girls appear to float in front of the sofa, while their mother's awkwardly posed and extended legs make her seated position unconvincing.
10. Coral necklaces like Mary Jane's were historically thought to provide apotropaic qualities to their wearers. The oval medallion at the center of Letitia's woven gold or hair necklace originally may have borne her initials, but a technical examination in October 2004 by the conservator and Johnson expert Sian Jones did not reveal evidence of this. Jones states that, similarly, it cannot be determined whether other such medallions seen on many of Johnson's young sitters once bore monograms. A medallion very similar to Letitia's, with a monogram, appears in *Adelina Morton*

(c. 1810, National Gallery of Art, Washington, D.C.); see Weekley, "The Catalog," cat. no. 51, 142.
11. Ibid., 136, notes that this encircling gesture appears in several of Johnson's portraits and that he likely borrowed the trope from Charles Peale Polk; her n4 cites specific examples.
12. Picked berries and flowers, both alone and in baskets, are common props in Johnson's work but often appear with other objects such as books, making them less suggestive of a narrative. Moreover, the addition of the parasol here implies an immediate earlier action. Only one other portrait besides the Corcoran work exhibits such a combination of props implying a recent return from alfresco pursuits. This is *The Westwood Children* (c. 1807, National Gallery of Art, Washington, D.C.), in which three boys hold flowers, a flower-filled basket, and cherries, and their dog carries in its mouth a freshly captured bird. This portrait is illustrated in color in ibid., 139.
13. *Baltimore Intelligencer*, 19 December 1798; and Weekley, "Who Was Johnson?" 55. The advertisement continues, stating that Johnson had "experienced many . . . obstacles in pursuit of his studies." For a discussion of the possible meanings of this statement, see Weekley, 50.
14. On the Peale family's potential influence on Johnson, particularly that of Charles Peale Polk, see Weekley, "Who Was Johnson?" 50–54. While some of the stylistic and compositional parallels Weekley draws between Johnson's and Polk's work are acceptable (see n11 above), many of her deductions are by no means conclusive, and some, such as the one suggesting that Johnson was a French-speaking servant owned by Charles Willson Peale (52–53), were disproved by the discovery of Johnson's race and parentage documented in Bryan and Torchia, "The Mysterious Portraitist," 3–7.
15. See Bryan and Torchia, "The Mysterious Portraitist," 6. For example, the authors cite remarkable similarities between a large family portrait by Johnson and one by his Connecticut contemporary Ralph E. W. Earl. Simmons, in *A Capital Collection*, 36, suggests that Johnson may have "learned about fashionable attire and poses from imported French paintings or from the productions of Continent- or French-trained painters visiting Baltimore." She further states that his "training as a blacksmith may also have informed his compositions: the sinuous lines of the furniture suggest the curves and turns of ornamental ironwork, and the rigid columnar quality of the human forms expresses the tautness and rigidity of metal."
16. Johnson thanks his public for encouraging his "first forays" in portrait painting; *Baltimore Intelligencer*, 19 December 1798, reprinted in Weekley, "Who Was Johnson?" 55.
17. Private collection; see Weekley, "The Catalog," cat. no. S7, 169.

18. For the McCurdys' addresses, see ibid., 136n41. For Johnson's addresses during the period in question, see Weekley, "Who Was Johnson?" 55–58.
19. For more on the history of the abolitionist movement in Baltimore and the intersection of abolitionists and Johnson's patrons in the Hanover-German Street area, see Leroy Graham, "Joshua Johnson's Baltimore," in Weekley and Colwill, *Johnson: Freeman and Portrait Painter*, passim and 38, respectively.
20. McCurdy's views on abolitionism have not been confirmed. Graham, "Johnson's Baltimore," 44n29, implies that McCurdy was an abolitionist owing to his proximity to the Hanover-German Street axis and because he was related by marriage to McHenry, an active and published supporter of this cause.
21. The Abolition Society held its meetings directly across the intersection from Johnson's house, but it is not known whether Hugh McCurdy was a member. For more on the society, see ibid., 55 and passim. On Aitken, see ibid., 35; and Weekley, "The Catalog," cat. no. 29, 124.

King, *Poor Artist's Cupboard*

1. Erika Schneider is the first art historian to note the role of the fictional protagonist, C. Palette, and to trace his travails through King's paintings. I am indebted to her careful observations of the paintings' contents. Schneider, "Starving for Recognition: The Representation of Struggling Artists in America, 1810–1865" (Ph.D. diss., Temple University, 2007).
2. Ibid., 32.
3. The titles of King's books are general and most are likely invented to make his point, although the databases WorldCat and Early American Imprints, Series 1, list editions of *Pleasures of Hope*, *Signs of the Times*, and *Miseries of Life* published before 1815. Robert Burton's *The Anatomy of Melancholy* was first published in 1621. In 1724 George Cheyne published *An Essay of Health and Long Life*, which advocates a vegetarian diet. Searches of WorldCat and Early American Imprints, Series I, did not uncover *Choice Criticism on the Exhibitions at Philadelphia*. I thank Andrew D'Ambrosio, CGA summer intern, 2009, for this research.
4. Schneider, "Starving for Recognition," 35.
5. Andrew J. Cosentino, *The Paintings of Charles Bird King (1785–1862)* (Washington, D.C.: Smithsonian Institution Press, for the National Collection of Fine Arts, 1977), 25.
6. Ibid., 27–28; and William H. Gerdts and Russell Burke, *American Still-Life Painting* (New York: Praeger, 1971), 52–53.
7. William Dunlap, *History of the Rise and Progress of the Arts and Design in the United States* (1834; New York: Benjamin Blom, 1965), 2:225, quoted in Cosentino, *The Paintings of King*, 20. King and Sully did, in fact, share a room at Buckingham Place during the eight months Sully was in London, and, according to their landlady, King bragged of subsisting on potatoes. See Cosentino, 20, 23.

8. John Neal, "American Painters Abroad," *Yankee and Boston Literary Gazette*, October 1829, 182, as quoted in Cosentino, *The Paintings of King*, 23.

9. Schneider, "Starving for Recognition," 76.

10. Cosentino, *The Paintings of King*, 28.

11. Wendy Ann Bellion, "Likeness and Deception in Early American Art" (Ph.D. diss., Northwestern University, 2001), 428–29.

12. Schneider, "Starving for Recognition," 72–74, citing transcriptions of inscriptions on the painting made by Professor Daniel Reiff of the Department of Visual Arts at State University of New York, Fredonia, curatorial files, Harvard Art Museum, Fogg Art Museum.

13. On Croesus, see Schneider, "Starving for Recognition," 69; she also discusses the theme of Palette's imprudence and vanity on 72, 76.

14. Theodore E. Stebbins, Jr., "Charles Bird King, *The Vanity of the Artist's Dream (The Anatomy of Art Appreciation, Poor Artist's Study)*," in *A Private Passion: 19th-Century Paintings and Drawings from the Grenville L. Winthrop Collection, Harvard University*, ed. Stephan Wolohojian (New York: Metropolitan Museum of Art, 2003), 456.

15. *Second Exhibition of Paintings*, Athenæum Gallery, Boston, May 1828, cat. no. 127, as *The Poor Artist's Closet*.

16. If so, then Harvard's painting is the one that King is documented as having sold at the Apollo Gallery in 1838 under the title *Still Life, the Property of an Artist*. See *First Fall Exhibition*, Apollo Gallery, New York, October 1838, cat. no. 167. Gaps in the subsequent provenance of the Corcoran's and Harvard's paintings allow for this possibility.

17. Rowena Houghton Dasch, "Unraveling the Deception: *Trompe l'Oeil* as Guide to Charles Bird King's Picture Gallery, 1824–1861," *Athanor* 26 (2008): 45; and Dasch, telephone conversation with author, 11 July 2009. Cosentino, *The Paintings of King*, 115. King is known to have painted a third version of the picture, *Poor Artist's Closet: Property of a Poor Artist*, possibly to replace the one sold to the Apollo Gallery in 1838, which he bequeathed to the Redwood Library, Newport, Rhode Island, in 1861. The work was deaccessioned sometime after 1885 and has not since been located.

Fisher, *Mishap at the Ford*

1. Excerpt from a letter from Fisher to the American artist and writer William Dunlap, reproduced in Dunlap, *History of the Rise and Progress of the Arts of Design in the United States* (New York: George P. Scott and Co., 1834), 2:264. For a thorough discussion of Fisher's art, see Fred B. Adelson, "Alvan Fisher (1792–1863): Pioneer in American Landscape Painting," 2 vols. (Ph.D. diss., Columbia University, 1982); and Robert C. Vose, Jr., "Alvan Fisher, 1792–1863: American Pioneer in Landscape and Genre," *Connecticut Historical Society Bulletin* 27 (October 1962): 97–127.

2. Patricia Hills, *The Painters' America: Rural and Urban Life, 1810–1910* (New York: Praeger Publishers, in association with the Whitney Museum of American Art, 1974), 1.

3. For a discussion of tourism and the search for picturesque scenery in America, see Bruce Robertson, "The Picturesque Traveler in America," in *Views and Visions: Landscape before 1830*, ed. Edward Nygren (Washington, D.C.: Corcoran Gallery of Art, 1986), 189–211; and Beth L. Lueck, *American Writers and the Picturesque Tour: The Search for National Identity, 1790–1860* (New York: Garland Publishing, 1997).

4. Nygren, "*Mishap at the Ford*," in Nygren, *Views and Visions*, 28; and Merri McIntyre Ferrell, "A Harmony of Parts: The Aesthetics of Carriages in Nineteenth-Century America," in *19th Century American Carriages: Their Manufacture, Decoration and Use* (Stony Brook, N.Y.: Museums at Stony Brook, 1987), 34.

5. Donald Blake Webster, *Georgian Canada Conflict and Culture: 1745–1820* (Toronto, Ont.: Royal Ontario Museum, 1984), 186.

6. Nygren, "*Mishap at the Ford*," 28; and Martin Windrow and Gerry Embleton, *Military Dress of North America, 1665–1970* (New York: Scribner, 1973), 54 and fig. 39.

7. Hills, *The Painters' America*, 5.

8. Adelson, "Fisher," 1:154; and Vose, "Fisher," 105. Several drawings relating to this theme in Fisher's sketchbooks dating to 1818 and 1819 are now in the collection of the Museum of Fine Arts, Boston, and a private collection.

9. Vose, "Fisher," 102. The composition of *A Dire Predicament*, signed and dated May 1818, appears to be almost identical to the Corcoran's canvas. See *American Paintings, Drawings & Sculpture*, Sotheby's, New York, 1 March 2006, lot 43.

Allston, *Time after Sunset*

1. Allston speaks of a sunset as the third picture he painted after he returned from England. See Allston to William Collins, 18 May 1821, transcribed in Edgar Preston Richardson, *Washington Allston: A Study of the Romantic Artist in America* (1948; Chicago: University of Chicago Press, 1997), 206; and Nathalia Wright, ed., *The Correspondence of Washington Allston* (Lexington: University of Kentucky Press, 1993), 158–60. The title was changed from *Time, after Sunset* to *A Landscape after Sunset* in accordance with American Paintings Catalogue policy, which restores titles to those under which a painting was first exhibited or published. The first exhibition of the painting was at the Boston Athenæum, 10 May–10 July 1827; see *First Annual Exhibition of Paintings at the Boston Athenæum* (Boston: William W. Clapp, 1827), cat. no. 33; and Lisa Strong, Project Manager, to Registrar, memorandum, 10 March 2010, CGA Curatorial Files.

2. Elizabeth Johns, "Washington Allston's Later Career: Art about the Making of Art," *Arts Magazine* 54, no. 4 (December 1979): 122–29. Hugh R. Crean makes a strong connection to William Wordsworth in "The Influence of William Wordsworth's Concept of Memory on Washington Allston's Later Works," *Arts Magazine* 57, no. 10 (June 1983): 58–63.

3. Johns, "Allston's Later Career," 122.

4. Washington Allston, *Monaldi, a Tale* (Boston: Charles C. Little and James Brown, 1841), 7.

5. Ibid., 23, 24. On Allston and memory, see Brian Wolf, *Romantic Re-Vision: Culture and Consciousness in Nineteenth-Century American Painting and Literature* (Chicago: University of Chicago Press, 1982), 70.

6. Allston, *Monaldi*, 21. See Elizabeth Johns, "Washington Allston: Method, Imagination, and Reality," *Winterthur Portfolio* 12 (1977): 10.

7. Washington Allston, *Lectures on Art and Poems* (New York: Baker and Scribner, 1850), 79.

8. Ibid., 80, 81.

9. Margaret Fuller, "A Record of Impressions Produced by the Exhibition of Mr. Allston's Pictures in the Summer of 1839," quoted in Wright, *The Correspondence of Allston*, 426.

10. Allston relayed his techniques to Henry Greenough, in Jared B. Flagg, *The Life and Letters of Washington Allston* (1892; New York: Benjamin Blom, 1969), 181–203. See David Bjelajac, *Washington Allston, Secret Societies, and the Alchemy of Anglo-American Painting* (Cambridge: Cambridge University Press, 1997), 32–65; and Joyce Hill Stoner, "Washington Allston: Poems, Veils, and 'Titian's Dirt,'" *Journal of the American Institute for Conservation* 29, no. 1 (Spring 1990): 1–12.

11. William Dunlap, *The Rise and Progress of the Arts of Design in the United States*, 2 vols. (New York: George P. Scott and Company, 1834), 2:162.

12. Ibid., 163.

Morse, *The House of Representatives*

1. In an 1823 letter to his wife, Morse reported: "Mr. [Washington] Allston . . . has suggested some small improvements which I can do in 2 days and to-day and tomorrow I shall be busily engaged upon the picture." Morse to Lucretia Pickering Walker Morse, 18 February 1823, Samuel F. B. Morse Papers, Library of Congress. Much of the information in the following essay derives from Paul J. Staiti, *Samuel F. B. Morse* (Cambridge: Cambridge University Press, 1989).

2. William Dunlap, *History of the Rise and Progress of the Arts of Design in the United States*, 2 vols. (New York: George P. Scott, 1834), 2:54.

3. This portrait study and one of William D. Williamson (reproduced in William Kloss, *Samuel F. B. Morse* [New York: Harry N. Abrams, in association with the National Museum of American Art, Smithsonian Institution, 1988], 72) are the two portraits extant of a total of more than eighty likenesses the artist made in preparation for painting *The House of Representatives*. It may have survived because Gales was a longtime friend and supporter of Morse; "By the [illeg.] in Wall Street," *Wall Street Journal*, 19 October 19[?]5, clipping, CGA Curatorial Files.

4. Morse to Lucretia Pickering Walker Morse, undated, Morse Papers, quoted in full in Staiti, *Morse*, 79.

5. In his key to the picture, Morse identifies eighty-six figures; Morse, *Key to Morse's Picture of the House of Representatives* (New Haven: C. Carvill, 1823), n.p.

6. James Sterling Young, *The Washington Community, 1800–1828* (New York: Columbia University Press, 1966), 96.

7. Ibid., 97.

8. Frances Trollope, *Domestic Manners of the Americans* (1832; New York: Dodd, Mead, 1927), 190.

9. Pratt to Morse, 15 March 1823, Morse Papers.

10. Charles Walker to Morse, 15 July 1823, Morse Papers.

11. Leslie to Morse, 13 September 1819, Morse Papers.

12. Jean-Philippe Antoine, in *Center 26: Record of Activities and Research Reports, June 2005–May 2006* (Washington, D.C.: National Gallery of Art, 2006), 64, relates the *House* and Morse's *Gallery of the Louvre* (Terra Foundation for American Art, Chicago) to panorama painting: "disdaining the heroic mode, until then claimed as the proper register of history painting, these pictures depict non-events: contemporary democratic activities of communication in which reproduction plays an important role." Antoine elaborated in the lecture "'The Painting is of a Class Somewhat Novel': Samuel Morse's Panorama Paintings of Republican Democracy" (High Museum of Art, Atlanta, 24 February 2007). See also Kloss, *Morse*, 68.

13. *Key to Morse's Picture*.

Peale, *Washington before Yorktown*

1. Peale began to work on the Corcoran's picture in the summer of 1824 and finished it by December of that year. After its exhibition in the Rotunda of the United States Capitol in the winter of 1825, he reworked it in his New York studio. See memo from Jennifer Carson, Research Fellow, to Registrar's Office, 7 December 2007, CGA Curatorial Files. In 1860 Peale recalled that he "retouched" and "improved" the painting on his return from Italy in 1830. Peale to President James Buchanan, 20 March 1860, Philadelphia Historical Society, in *The Collected Papers of Charles Willson Peale and His Family*, ed. Lillian B. Miller (Millwood, N.Y.: Kraus Microform, 1980), VIA/14A9–11. A second, smaller version (private collection) is a preparatory oil sketch for the final picture; mentioned in Peale to Henry Brevoort, 30 December 1823, in *The Selected Papers of Charles Willson Peale and His Family*, ed. Lillian B. Miller (New Haven: Yale University Press, for the National Portrait Gallery, Smithsonian Institution, 1996), 4:352.

2. Peale had worked on a colossal scale previously. The artist cited his experience with large pictures in a letter to the

Committee on the Portrait of Washington, 16 March 1824, Library Company of Philadelphia, Samuel Breck Papers, in Miller, *Selected Papers*, 4:386–87. He mentions *Napoleon* (location unknown), *The Roman Daughter* (1811, Smithsonian American Art Museum), *The Death of Virginia* (1821, location unknown), *The Ascent of Elijah* (1815, location unknown), and *The Court of Death* (1820, The Detroit Institute of Arts). *The Court of Death* was a sensationalist display of afflictions, from conflagration and pestilence to apoplexy and suicide, all spread across a 300-square-foot canvas. By contrast, *Yorktown*, a 116-square-foot canvas, was dignified and heroic, but it, too, was intended for public display. Peale vigorously campaigned to persuade Congress to buy the picture and hang it in the Rotunda of the United States Capitol, but debates over whether Congress should ever support or commission artists led to its rejection. The picture hung in the Rotunda, unpurchased, until the end of the Civil War. Miller, *Selected Papers*, 4:481; and Lillian B. Miller, *In Pursuit of Fame: Rembrandt Peale, 1778–1860* (Washington, D.C.: National Portrait Gallery, Smithsonian Institution, in association with University of Washington Press, 1992), 144–45.

3. Peale mentions his study of older images of Washington and his effort to create a "Standard likeness" in a letter to Henry Brevoort, 30 December 1823, in Miller, *Selected Papers*, 4:352.

4. Peale could have seen Jacques-Louis David's stirring equestrian portrait *Bonaparte at the Saint Bernard Pass* (1801, Château National de Malmaison) when it hung in Joseph Bonaparte's house in nearby Bordentown, New Jersey, or another version at Les Invalides in Paris, where he had been an art student. Peale himself had painted a *Bonaparte on Horseback* in 1811 (location unknown); Miller, *In Pursuit of Fame*, 106.

5. Peale and Sully, who were friends and, briefly, studio-mates, had competed for the commission to paint Washington for the North Carolina state legislature. Sully was selected, but his *Delaware* was ultimately rejected because of its size. Peale's *Yorktown* may have emerged from his failure to win the competition. See Philipp P. Fehl, "Thomas Sully's *Washington's Passage of the Delaware*: The History of a Commission," *Art Bulletin* 55, no. 4 (December 1973): 584–99.

6. They are identified in Rembrandt Peale to Congressman Elijah Hunt Mills, 13 January 1825, Smithsonian Institution Archives, Washington, D.C., in Miller, *Selected Papers*, 4:478–80.

7. Ibid.

Birch, *View of the Delaware near Philadelphia*

1. William Birch and Son, *The City of Philadelphia in the State of Pennsylvania . . . as It Appeared in the Year 1800* (Philadelphia: William Birch and Son, 1800), partially reprinted in facsimile edition in S. Robert Teitelman, *Birch's Views of Philadelphia: A Reduced Facsimile of The City of Philadelphia. . . .* (Philadelphia: Free Library of Philadelphia, 1982). For biographies of Thomas Birch, see William H. Gerdts, *Thomas Birch, 1779–1851: Paintings and Drawings; with a Selection of Miniatures by His Father, William Russell Birch, 1755–1834, and a Group of Paintings by Other Artists of the Philadelphia Maritime Tradition* (Philadelphia: Philadelphia Maritime Museum, 1966); and Gerdts, "Thomas Birch: America's First Marine Artist," *Antiques* 89 (April 1966): 528–34.

2. For the critical reception of Birch's landscape paintings, see William H. Gerdts, "American Landscape Painting: Critical Judgments, 1730–1845," *American Art Journal* 17 (Winter 1985): 38–39.

3. John Wilmerding, *A History of American Marine Painting* (Salem, Mass.: Peabody Museum of Salem and Little, Brown and Company, 1968), 103–18.

4. Richard Anthony Lewis, "Interesting Particulars and Melancholy Occurrences: Thomas Birch's Representations of the Shipping Trade, 1799–1850" (Ph.D. diss., Northwestern University, 1994), 119.

5. F. G., "Academy of Fine Arts," *Poulson's American Daily Advertiser*, 12 May 1831, 3.

6. Lewis, "Birch's Representations of the Shipping Trade," 233.

7. Matthew Baigell, *19th Century Painters of the Delaware Valley* (Trenton, N.J.: New Jersey State Museum, 1983), 7.

8. Nicholas B. Wainwright, "The Age of Nicholas Biddle, 1825–1841," in Russell Frank Weigly, Wainwright, and Edwin Wolf, *Philadelphia: A 300 Year History* (New York: W. W. Norton & Co., 1982), 281.

9. John Fanning Watson, *Annals of Philadelphia and Pennsylvania* (Philadelphia: Parry and McMillan, 1881), 1:168.

10. Lewis, "Birch's Representations of the Shipping Trade," 481.

Cole, *The Departure* and *The Return*

1. Van Rensselaer to Cole, 10 December 1836, Thomas Cole Papers, New York State Library, Albany, quoted in Ellwood C. Parry III, *The Art of Thomas Cole: Ambition and Imagination* (Newark: University of Delaware Press, 1988), 187.

2. Cole to Van Rensselaer, undated, but c. 15 December 1836; quoted in Barbara Novak, *American Painting of the Nineteenth Century: Realism, Idealism and the American Experience* (New York: Praeger, 1969), 294–95n27.

3. Cole's first use of the term was in a letter to his Baltimore patron, Robert Gilmor, Jr., of 21 May 1828; quoted in *Annual II: Studies on Thomas Cole, an American Romanticist* (Baltimore: Baltimore Museum of Art, 1967), 58.

4. The Van Rensselaers were among the original patroons of the upper Hudson River valley and had been in New York since 1630, when the Dutch West India Company deeded Kiliaen Van Rensselaer a vast tract of land that encompassed present-day Albany and much of several surrounding counties. Stephen Van Rensselaer III was the last of the family to own all of that property; when he died in 1839, the land was divided between his sons, Stephen IV and William, who eventually sold most of it. On the early commission from Cole, see Franklin Kelly, "Lake Winnepesaukee," in Tammis K. Groft and Mary Alice Mackay, *Albany Institute of History and Art: Two Hundred Years of Collecting* (New York: Hudson Hills Press, 1998), 82. For *View near Catskill*, see Michelle A. Erhardt, *The Norma Lee and Morton Funger Art Collection* (Lunenburg, Vt.: Stinehour Press, 1999), 11.

5. Cole to Van Rensselaer, 8 July 1837, Cole Papers, quoted in Parry, *The Art of Cole*, 194.

6. Quoted in Louis Legrand Noble, *The Course of Empire, Voyage of Life, and Other Pictures of Thomas Cole, with Selections from His Letters and Miscellaneous Writings: Illustrative of His Life, Character, and Genius* (New York: Cornish, Lamport and Company, 1853), 244–45.

7. Van Rensselaer to Cole, 19 October 1837, Cole Papers, quoted in Parry, *The Art of Cole*, 197.

8. Van Rensselaer to Cole, 1 November 1837, Cole Papers, quoted in Parry, *The Art of Cole*, 197.

9. Cole to Durand, 2 November 1837, Cole Papers, quoted in Parry, *The Art of Cole*, 198. The frames presently on *The Departure* and *The Return* are likely the originals.

10. Parry, *The Art of Cole*, 198–99.

11. *New-York Mirror*, 23 December 1837, 203, quoted in Parry, *The Art of Cole*, 199.

12. Parry, *The Art of Cole*, 195–97, provides a thorough discussion of the various influences that Cole likely drew on, including American Gothic Revival architecture, Thomas Gray's poems *The Bard* and *Elegy Written in a Country Church-Yard*, and paintings by the Englishman John Martin (whom Cole met on his first European trip in 1829–32). Although Cole told Van Rensselaer that there was no specific source in history or poetry for the paintings, when they were shown in the memorial exhibition of his works in 1848, lines from Sir Walter Scott's long poem about mid-sixteenth-century feudal warfare between the English and the Scots, *The Lay of the Last Minstrel* (1805), were quoted in the catalogue:

> Now over Border, dale and fell,
> Full wide and far was terror
> spread;
> For pathless marsh and mountain cell,
> The peasant left his lowly shed.
> The frightened flocks and herds were
> pent
> Beneath the peel's rude
> battlement;
> And maids and matrons dropped
> the tear,
> While ready warriors seized
> the spear.
> From Branksome's towers, the
> watch-man's eye
> Dun wreaths of distant smoke
> can spy,
> Which, curling in the rising sun,
> Showed southern ravage was
> begun.

Scott's words, although generally evocative of the spirit of Cole's pictures (and he surely knew the poem), are not sufficiently similar to suggest that they were a specific source for them. Jasper Francis Cropsey cited the same lines by Scott in connection with his Cole-inspired *The Spirit of War* (1851, National Gallery of Art, Washington, D.C.) and *The Spirit of Peace* (1851, Woodmere Art Museum, Philadelphia); see Franklin Kelly, *Jasper Francis Cropsey: The Spirit of War and The Spirit of Peace* (Washington, D.C.: National Gallery of Art, 1994).

Cole's success with a medieval subject in *The Departure* and *The Return* may have influenced the New York collector Thomas Hall Faile to commission a painting from him in December 1837; according to the artist, he was given "My own choice of Subject Something of Chivalry Days." Cole was also commissioned to paint a pair of pictures for Peter G. Stuyvesant; although no subject was specified initially, that commission would lead to a second major set of pendants on a medieval theme, *Past* and *Present* (1838, both Mead Art Museum, Amherst College, Mass.). For more on Cole's creative activities following the completion of *The Departure* and *The Return*, see the author's entry on *Italian Coast Scene with Ruined Tower*, in Franklin Kelly et al., *American Paintings of the Nineteenth Century*, part 1, The Collections of the National Gallery of Art, Systematic Catalogue (Washington, D.C.: National Gallery of Art, 1996), 81–87.

13. Infrared examination on both paintings was done by Ingrid Alexander in 1992; summary of findings provided by Dare Hartwell.

14. Van Rensselaer to Cole, 18 July 1839, Cole Papers, quoted in Franklin Kelly, "*Gardens of the Van Rensselaer Manor House* and *The Van Rensselaer Manor House*," in Groft and Mackay, *Albany Institute of History and Art*, 92.

15. Cole to Van Rensselaer, 19 July 1839, Cole Papers, quoted in ibid.

Mount, *The Tough Story*

1. Deborah J. Johnson, "William Sidney Mount: Painter of American Life," in Johnson, *William Sidney Mount: Painter of American Life* (New York: American Federation of Arts, 1998), 45.

2. Mount frequently included such figures in his paintings. These disengaged observers, Alfred Frankenstein argues, stood in for Mount himself. The artist spent much of his life moving back and forth between homes in New York City and the Long Island countryside and consequently saw himself as a traveler and perpetual outsider in both communities; Frankenstein, *William Sidney Mount* (New York: Harry N. Abrams, 1975), 8. See also Elizabeth Johns, "Boys Will Be Boys," in Johnson, *Mount: Painter of American Life*, 10–11.

3. Mount to Gilmor, 5 December 1837, William Sidney Mount Papers, 1830–60, reel N731, Archives of American Art,

Smithsonian Institution, Washington, D.C. (hereafter AAA).

4. The conventional definition of *conversation piece* is a group portrait in a domestic setting, but the term is also loosely applied to genre scenes that portray conversation. See "Conversation Piece," in *Grove Art Online*, www.oxfordartonline.com.

5. John Conron, *American Picturesque* (University Park: Pennsylvania State University Press, 2000), 109–10.

6. Frankenstein, *Mount*, 8.

7. William Sidney Mount, Journal, 1848–57, known as the Whitney Museum Journal, William Sidney Mount and Mount Family Papers, reel SM2, frame 776, AAA.

8. Mount, diaries, 1859, as quoted in Conron, *American Picturesque*, 102; and Frankenstein, *Mount*, 340.

9. Mount's observations echo the instructions Samuel F. B. Morse offered in his lectures on painting that he delivered at the New York Athenaeum in 1826 and other venues until 1830, when Mount was just beginning his studies at the National Academy of Design. Morse argued for the importance of maintaining a thematic consistency, or congruity between style and content. Subtle gradations in coloring, for instance, could signal the subtle evolution of tender feelings in the painting's protagonist; Conron, *American Picturesque*, 92–98, 102.

10. *The Country Traveler: Exploring the Past at America's Outdoor Museums* (Alexandria, Va.: Time-Life Books, 1990), 28–29.

11. The title was changed from *The Long Story* to *The Tough Story—Scene in a Country Tavern* in accordance with American Paintings Catalogue policy, which restores titles to those under which a painting was first exhibited or published. For the first exhibition and publication of the painting, see New York, National Academy of Design, *Catalogue of the Thirteenth Annual Exhibition*, 1838, cat. no. 308. The painting was not known as *The Long Story* until 1879, when it appeared in Edward Strahan [Earl Shinn], ed., *The Art Treasures of America* (Philadelphia: George Barrie Publisher; New York: Garland Publishing, 1977), 1:14. See Emily Shapiro, Curatorial Fellow, to Registrar, memorandum, 28 December 2004, CGA Curatorial Files.

12. Edgar Allan Poe, "Review of New Books: *The Gift: A Christmas and New-Year's Present for 1842*," *Graham's Magazine* 19, no. 5 (November 1841): 250.

13. "The Fine Arts: The Artists' Fund Society," *Saturday Evening Post*, 23 May 1840, 2; Poe, "Review of New Books," 250. The *Post*'s review was otherwise favorable. Poe's review refers to Joseph Ives Pease's engraving after Mount's painting, which is very close to the original, but Poe treats it as Mount's work. For the print, see Joseph Ives Pease, *The Tough Story*, in *The Gift: A Christmas and New Year's Present for 1842* (Philadelphia: Carey and Hart, 1841), facing 99. Mount's younger colleague Richard Caton Woodville knew *The Tough Story*

from Gilmor's collection. In *Waiting for the Stage* in the Corcoran's collection, he bent the stovepipe so as to avoid such an effect. On Woodville and Mount, see Francis S. Grubar, "Richard Caton Woodville: An American Artist, 1825–1855" (Ph.D. diss., Johns Hopkins University, 1966), 31–32; and Justin Wolff, *Richard Caton Woodville: American Painter, Artful Dodger* (Princeton: Princeton University Press, 2002), 21–22.

14. Johnson, "Mount: Painter of American Life," 33, contends this is the reason for the ax on the floor in *Barroom Scene*.

15. Mount to Gilmor, 5 December 1837: "Yours of the 29th I have also recd fulfilling the promise of the preceding as giving your opinion of the picture, and I am happy to find with but a slight difference your impressions of my intentions are what I intended them. The man puffing out his smoke is a regular Long Island tavern and store keeper, . . . and, as you say has quite the air of a Citizen."

16. Seba Smith, "The Tough Yarn," in *The Gift: A Christmas and New Year's Present for 1842* (Philadelphia: Carey and Hart, 1841), 99–114. It was illustrated by Pease's line engraving (see n13 above).

17. "The Fine Arts: National Academy of Design," *New-York Mirror*, 7 July 1838, 5.

18. Clipping, William Sidney Mount Scrapbook, 1855, William Sidney Mount and Mount Family Papers, reel SM1, frame 647, AAA.

19. Mount to Gilmor, 5 December 1837.

Neagle, *Richard Mentor Johnson*

1. On Neagle's career, his trip to Kentucky to paint Clay, and the iconography of the full-length portrait when finished, see Robert Wilson Torchia, *John Neagle, Philadelphia Portrait Painter* (Philadelphia: Historical Society of Pennsylvania, 1989), 70, 93–108. The Johnson portrait sittings are not documented because, according to Torchia, Neagle's record keeping changed character at this time, and he no longer kept entries in his Blotter Book.

2. The artist's inscription on the reverse, "Col. Richard M. Johnson / painted from the life by John Neagle / Frankfort, Kentucky, / March 9th, 1843. / Col. R. M. Johnson, Vice President of The United States, Under the Administration of Martin Van Buren. / Died November 19th, 1850," is no longer visible because the painting has been lined; no photographic record was made. This transcription, published in *A Catalogue of the Collection of American Paintings in The Corcoran Gallery of Art*, vol. 1, *Painters Born before 1850* (Washington, D.C.: Corcoran Gallery of Art, 1966), 57, is the most complete of several known versions. For the history of the gallery's transcriptions of the inscription, see memorandum, Emily Shapiro, Assistant Curator of American Art, 8 April 2008, CGA Curatorial Files. The partially legible typewritten label now on the stretcher, which was probably produced when the painting was lined, records a slightly different version: "Subject: Richard M. Johnson [Paint]ed from life / by JO[HN] [NE]

AGLE, Frankfort, Kentucky, [Ma]rch 9 18[17] [. / Col. R. M. Johns[on] Vice-Preside[nt] U.S. under the / Administrati[o]n of Martin Van Buren. Died November 19, 1850." This most likely occurred before 1958 and thus predates Phillips's publication. The inscription was partially recorded by Charles Henry Hart in 1916 as "Col. Richard M. Johnson, painted from life by John Neagle, Frankfort, Kentucky, March 9, 1843." See Charles Henry Hart, "Portrait of Richard Mentor Johnson Painted by John Neagle," *Art in America* 4, no. 5 (August 1916): 288, 289 (illus.), 291–92.

3. The graphite drawing and a similar drawing of Henry Clay (National Portrait Gallery, Washington, D.C., 2003.33.b) are on the same sheet of paper, on the reverse of a full-length oil study for the portrait of Henry Clay (NPG.2003.33.a).

4. *The Commonwealth*, 6 June 1843, quoted in Edna Talbott Whitley, *Kentucky Ante-Bellum Portraiture* (privately printed for the National Society of the Colonial Dames of America in the Commonwealth of Kentucky, 1956), 728.

5. W[illiam] M[acLeod], "Corcoran Gallery of Art," *Art Journal* 4 (1878): 286–87.

6. Among them were this portrait and a portrait by Gilbert Stuart of George Washington that had belonged to her husband's father, John Tayloe (see in this catalogue Stuart, *George Washington*). "Journal Excerpts Related to Phebe Warren Tayloe (Mrs. Benjamin Ogle Tayloe) Bequest, including Gilbert Stuart's Portrait of Washington," author and date unknown, CGA Curatorial Files.

7. The letter, dated 14 November 1851, was presented to the House by the Speaker on 19 November and was referred to the committee on the library; see *Journal of the House of Representatives of the Commonwealth of Kentucky* (Frankfort, Ky.: A. G. Hodges & Co, 1851), 104–6. The letter was partially quoted in Allan M. Trout, "Art Gets a Brush-Off," *Frankfort (Ky.) Courier-Journal*, 20 December 1953, Magazine sec., 31.

8. For Neagle's second letter, in the Ferdinand J. Dreer Autograph Collection, Historical Society of Pennsylvania, see Torchia, *Neagle*, 106n5.

9. The second portrait of Johnson was owned in 1981 by Norman Flayderman; see Arthur F. Jones and Bruce Weber, *The Kentucky Painter from the Frontier Era to the Great War* (Lexington: University of Kentucky Art Museum, 1981), 60, no. 73, illus. p. 123, lent by Norman E. Flayderman, New Milford, Conn. The portrait first came to the attention of the Corcoran Gallery curators when it was sent to the gallery for examination in 1966 by the Nantucket dealer Frank F. Sylvia. He noted in a letter dated 1 September 1966 that a "label on stretcher bears name of a Philadelphia firm, who sold stretcher and canvas" and, in a second letter dated 21 September, hinted, "I do have vague information that my acquisition has some family area connected with it." It is unlocated today. Another version,

apparently without much background detail, was last recorded in 1975, when owned by the sitter's great-great-great-nephew James V. Johnson, Jr., of Columbia, Ga.; see Marion Converse Bright, ed., *Early Georgia Portraits, 1715–1870* (Athens: University of Georgia Press, 1975), 115, illus. A third, also abbreviated in composition, and framed as an oval, was sold at *18th, 19th and Early 20th Century American Paintings, Watercolors and Sculpture*, Sotheby Parke-Bernet, New York, 13 September 1972, lot 4, from the estate of Letitia Preston Laiser. One of these three may be the version now owned by the Morris Museum of Art, Augusta, Ga.

10. On the provenance of the painting, see Charles Henry Hart, "Portrait of Richard Mentor Johnson Painted by John Neagle," *Art in America* 4, no. 5 (August 1916): 291. For documentation about Voorhees's copy, see William Kloss and Diane K. Skvarla, "Richard Mentor Johnson," in *United States Senate Catalogue of Fine Art*, ed. Jane R. McGoldrick (Washington, D.C.: U.S. Government Printing Office, 2002), 222, 222 (illus.).

Salmon, *Boston Harbor*

1. John Wilmerding, *Robert Salmon: Painter of Ship and Shore* (Salem, Mass.: Peabody Museum of Salem; Boston: Boston Public Library, 1971), 53. Salmon was apparently still in Boston when Howe, Leonard Co. offered one of his paintings for sale on 18 May 1842. On 7 June 1842 Howe, Leonard's advertisement of Salmon's works for sale notes that the artist has returned to Europe. There is a question whether Salmon began making this painting for the American market in 1837 or for the British market in 1843. See Wilmerding, 53–54.

2. For Salmon's paintings of about 1800, see ibid., 13–14.

3. Ibid., xv, 14–34; and James A. Craig, *Fitz H. Lane: An Artist's Voyage through Nineteenth-Century America* (Charleston, S.C.: History Press, 2006), 57.

4. John Wilmerding, *American Marine Painting* (New York: Harry N. Abrams, 1987), 95–96; and Wilmerding, *Salmon*, 16.

5. Craig, *Lane*, 57, citing the National Maritime Museum, Greenwich, Eng.; and Wilmerding, *Salmon*, 25–27.

6. "Left Liverpool 16th June 1828, 32 days pas. to new york, left New York for Boston, 14th of Agust, 1828," in "Catalogue of Robert Salmon's Pictures, 1828 to 1840, From his own notes, now in the possession of Miss Darracott, 1881," MS copied from Salmon's original by an unknown person, Boston Public Library; reproduced as Appendix A in Wilmerding, *Salmon*, 90.

7. See n6 above; also Wilmerding, *American Marine Painting*, 95.

8. Craig, *Lane*, 56–62.

9. Henry Hitchings, report delivered in March 1894 to the Bostonian Society at the Old State House, *Proceedings of the Bostonian Society at the Annual Meeting*,

8 January 1895, 37–38, quoted in Wilmerding, *Salmon*, 10.

10. Wilmerding, *Salmon*, 40–41, 91–92.

11. See John Wilmerding, "Robert Salmon's 'Boston Harbor from Castle Island,'" *Arts in Virginia* 14, no. 2 (Winter 1974): 15–27.

12. Donald R. Hickey, *The War of 1812: A Forgotten Conflict* (Urbana: University of Illinois Press, 1990), 173, 230–31, 305.

13. William J. Reid, *Castle Island and Fort Independence* (Boston: Trustees of the Public Library of the City of Boston, 1995), 81, 85–87.

14. Wilmerding, "Salmon's 'Boston Harbor from Castle Island,'" 19.

15. Nancy S. Seaholes, *Gaining Ground: A History of Landmaking in Boston* (Cambridge, Mass.: MIT Press, 2003), 322–25; and William J. Reid, *Castle Island and Fort Independence* (Boston: Trustees of the Public Library of the City of Boston, 1995), 81, 85–87, 139.

16. Receipt for Loans to Exhibitions, 3 February 1961, CGA Curatorial Files.

17. Yann-Brice Dherbier and Pierre-Henri Verlhac, *John Fitzgerald Kennedy: A Life in Pictures* (London: Phaidon Press, 2003), 138–39, President's Office, 14 August 1961.

18. Charles Kenney, *John F. Kennedy: The Presidential Portfolio: History as Told through the Collection of the John F. Kennedy Library and Museum* (New York: Public Affairs, 2000), 198, 11 June 1963; Geoffrey Perret, *Jack: A Life Like No Other* (New York: Random House, 2001), between 212 and 213, 23 October 1962. For the Kennedy children in their father's office on 10 October 1962, see Dherbier and Verlhac, 218.

Bingham, *Cottage Scenery*

1. *Landscape: Rural Scenery*, which features the same female figure and is set in a related landscape, may have been painted as a pendant to *Cottage Scenery*. Bingham found a ready market for his work in the American Art-Union. At least nineteen of Bingham's paintings were purchased and distributed by the union between 1845 and 1852, and others were purchased and distributed by the union's sister institution, the Western Art Union in Cincinnati. See Michael Edward Shapiro, *George Caleb Bingham* (New York: Harry N. Abrams, in association with the National Museum of American Art, Smithsonian Institution, 1993), 42, 44.

2. David Bjelajac, *American Art: A Cultural History* (Upper Saddle River, N.J.: Prentice-Hall, 2000), 203.

3. Both Mount and Deas participated in the activities of the American Art-Union.

4. Nancy Rash, *The Painting and Politics of George Caleb Bingham* (New Haven: Yale University Press, 1991), 42; and *Transactions of the American Art-Union for the Promotion of the Fine Arts in the United States for the Year 1844* (New York: John Douglas, 1844), 7–8.

5. *Cottage Scenery* is one of the first canvases Bingham completed when he returned to the Midwest following four years painting portraits of politicians in

and around Washington, D.C. (1841–44). Although he had only limited financial success during his stay in the nation's capital, Bingham's time there allowed him to meet influential figures in state and national affairs and bolstered his burgeoning interest in politics. In 1848 Bingham was elected to a seat in the Missouri state legislature; during the Civil War, he was appointed Missouri state treasurer (1862–65); he became president of the Kansas City Board of Police Commissioners in 1874; and in 1875 he was appointed adjutant general of Missouri by the state governor.

6. Rash, *Bingham*, 45. See also *Family Life on the Frontier* (before 1845, private collection), reproduced in Michael Edward Shapiro et al., *George Caleb Bingham* (St. Louis: Saint Louis Art Museum, in association with Harry N. Abrams, 1990), pl. 27.

7. Cristina Klee, "The Happy Family and the Politics of Domesticity, 1840–1870" (Ph.D. diss., University of Delaware, 2003), 81.

8. Shapiro, *Bingham*, 44.

9. *Transactions of the American Art-Union for the Year 1845* (New York: Evening Post, 1845), 28.

10. Jean M. White, "Lost Canvas Is Acquired by Corcoran," *Washington Post*, 25 April 1962, sec. B, 5.

Sully, *Andrew Jackson*

1. On portraits of Jackson by Sully, see Edward Biddle and Mantle Fielding, *The Life and Works of Thomas Sully* (Philadelphia, 1921; New York: Da Capo Press, 1970), 186–87; James Barber, *Old Hickory: A Life Sketch of Andrew Jackson* (Washington, D.C.: National Portrait Gallery; Nashville: Tennessee State Museum, 1990), 42, 50, 82, 116–19; James Barber, *Andrew Jackson: A Portrait Study* (Washington, D.C.: National Portrait Gallery; Nashville: Tennessee State Museum, in association with the University of Washington Press, 1991), 50, 54–57, 207–11; and Robert Wilson Torchia, "Thomas Sully: Andrew Jackson," in Torchia, with Deborah Chotner and Ellen G. Miles, *American Paintings of the Nineteenth Century*, part 2, The Collections of the National Gallery of Art, Systematic Catalogue (Washington, D.C.: National Gallery of Art, 1998), 184–88. Individual portraits and studies are also recorded in the Catalog of American Portraits, National Portrait Gallery, Washington, D.C. The most recent studies of Sully and his portraits include Monroe Fabian, *Mr. Sully, Portrait Painter: The Works of Thomas Sully (1783–1872)* (Washington, D.C.: National Portrait Gallery, 1983); and Carrie Rebora Barratt, *Queen Victoria and Thomas Sully* (Princeton: Princeton University Press, in association with the Metropolitan Museum of Art, 2000).

2. Vincent Price suggested that "the dropped glove is symbolic of the defeat of the hero by death"; see Price, *The Vincent Price Treasury of American Art* (Waukesha, Wisc.: Country Beautiful Corporation, 1972), 56 (illus.).

3. Sully completed two designs, in 1817 and 1822; see Biddle and Fielding, *Life and Works of Sully*, cat. nos. 875, 876, 186. On the medal, completed in 1824, see Barber, *Old Hickory*, 42; and Barber, *Jackson: Portrait Study*, 76–77. The portrait of Jackson on the obverse is by the medalist Moritz Fürst, not Sully.

4. This portrait is discussed in Fabian, *Mr. Sully*, 29–30; and Barber, *Portrait Study*, 54–56, illus.

5. Sully's 1824 portrait of Jackson is not listed in Biddle and Fielding, *Life and Works of Sully*. It is discussed in Barber, *Jackson: Portrait Study*, 208–9; Barber, *Old Hickory*, 50–51, illus.; and Torchia, "Andrew Jackson," 184–88.

6. Now in the National Gallery of Art, Washington, D.C. Although Barber wrote that the version owned by the National Gallery of Art is the 1824 original, Torchia has proven conclusively, by the presence of the canvas stamp of the English firm of Thomas Brown, that the gallery's version is the 1845 replica, while the original is owned by a descendant of Blair's. On these portraits, see Biddle and Fielding, *Life and Works of Sully*, 187, cat. no. 884 (for the 1845 replica); Barber, *Jackson: Portrait Study*, 207–9; and Torchia, "Andrew Jackson," 184–88.

7. These were painted between 1 May and 17 June 1845, in Philadelphia; see Biddle and Fielding, *Life and Works of Sully*, cat. nos. 160–67, 103–4, and cat. no. 1047, 207; and Barber, *Old Hickory*, 82 (of Francis Blair), illus.

8. Biddle and Fielding, *Life and Works of Sully*, cat. no. 881, 187; Barber, *Jackson: Portrait Study*, 208–9, fig. 180.

9. Thomas Sully, Journal, 1792–1793, 1799–1845, typescript, 288 (2 August 1845), Manuscript Division, New York Public Library, reel N18, frame 586, Archives of American Art, Smithsonian Institution, Washington, D.C.

10. On Earle, see Fabian, *Mr. Sully*, 20; they co-owned the gallery from 1819 until at least the end of 1846.

11. The dates of the exhibition are provided in two articles: "The Picture Galleries," *Philadelphia North American*, 27 October 1845, 2, published the day the exhibit opened; and "The Annual Exhibition," *Christian Observer* 24, no. 44 (31 October 1845): 175, which notes that it will close Saturday, which in 1845 was 1 November.

12. *Catalogue of the Works of Art Comprising the First Annual Exhibition of the Washington Art Association, 1857* (Washington, D.C.: Polkinhorn's Steam Job Office, 1856), cat. no. 7; see Josephine Cobb, "The Washington Art Association: An Exhibition Record, 1856–1860," *Records of the Columbia Historical Society of Washington, D.C.*, vol. 63–65 (reprint; Washington, D.C.: Columbia Historical Society, 1966), cat. no. 153, 189. A letter from Sully, written in January 1857, seems to relate to this movement of the portrait. It directs that "the whole length portrait of Jackson" be delivered to Mr. Earle or "the bearer." The letter was owned in 1983 by the Philadelphia

bookseller William H. Allen, who sent a description with partially quoted text to Monroe Fabian, curator, National Portrait Gallery, on 27 June 1983; the dealer's letter and description of the document are in the file on this portrait in the Catalog of American Portraits.

13. For the early history of Corcoran's activities in the arts in Washington, see the introduction to this volume.

14. Institute curator John Varden noted the arrival of the portrait in his diary on 24 June: "General Jackson. A Large full Length Portrait of the Old Hero was deposited in the Hall this evening (Painted by Sully)." John Varden, Diary, 1857–1863, Smithsonian Institution Archives. This information was published by Richard Rathbun, *The National Gallery of Art, Department of Art of the National Museum* (Washington, D.C.: Government Printing Office, 1916), 31, 37. On the early history of the art collections at the Smithsonian, see Lois Marie Fink, *History of the Smithsonian American Art Museum: The Intersection of Art, Science, and Bureaucracy* (Amherst: University of Massachusetts Press, 2007), 7, 176n37.

15. Barber believed that the full-length portrait belonged first to Samuel Phillips Lee, son of "Lighthorse Harry" Lee, who was married to Francis Preston Blair's daughter Elizabeth; see Barber, *Jackson: Portrait Study*, 209–10 and 219n9. However, the portrait that Lee lent to the fourth annual exhibition of the Washington Art Association in 1860 was probably either the 1824 head-and-shoulder portrait or its 1845 replica. The loan is described only as "Title: General Jackson, artist Thos. Sully, possessor Capt. Lee" in *Catalogue of the Fourth Annual Exhibition of the Washington Art Association* (Washington, D.C.: Henry Polkinhorn, 1860); see Cobb, "Washington Art Association," 189, no. 153. Lee did own a portrait of Jackson by Sully by January 1860, when the artist George Caleb Bingham visited him to see the portrait because of a commission he had received to paint a portrait of Jackson for the Missouri State Capitol; it was later destroyed by fire (Barber, *Portrait Study*, 219n7).

16. On Coyle, see Theresa A. Carbone and Patricia Hills, *Eastman Johnson: Painting America* (Brooklyn: Brooklyn Museum of Art, 1999), 33, 59, 245. Coyle lent several works to the exhibitions of the Washington Art Association, including one by Johnson; see *Catalogue of the Third Annual Exhibition of the Washington Art Association* (Washington, D.C.: William H. Moore, Printer, 1859), in Cobb, "Washington Art Association," 170, no. 40, "Pestal."

17. William Wilson Corcoran Papers, Incoming Letters, 17 November 1867, W. W. Corcoran Papers, Manuscript Division, Library of Congress, Washington, D.C.

18. 19 June 1876, in William MacLeod, "Curator's Journal, 1876–1886," Director's Records, CGA Archives (available at the Archives of American Art, Records of the Corcoran Gallery of Art, reel 263); see

also "Some Reminiscences about William Wilson Corcoran," MS 325, William MacLeod Papers, 1839–1890, Historical Society of Washington, D.C. About Jacob Thompson (1810–1885), see the entry in *American National Biography Online*, which describes the "massive embezzlements . . . soon traced back to Secretary of War John B. Floyd," which were exposed in the summer of 1860; at http://www.anb .org/articles/04/04/00986 (accessed 18 February 2009).
19. The painting was noted in several publications that year and the following, including "The Corcoran Gallery: An Hour's Stroll through the Collection," *Washington Evening Star*, 17 January 1874, 1; X. A., "The Art Gallery in Washington," *New York Evangelist*, 19 February 1874, 2; Mary E. Parker Bouligny, *A Tribute to W. W. Corcoran, of Washington City* (Philadelphia: Porter & Coates, 1874), 71–72; and "The Corcoran Gallery of Art, in Washington," *Art Journal* 1 (1875): 144.

Roesen, *Still Life, Flowers and Fruit*
1. He may also have studied for a time in nearby Düsseldorf, home to a leading art academy. His works show the influence in style, subject matter, and composition of the German fruit and flower still-life painter Johann Wilhelm Preyer, who lived and worked in Düsseldorf from 1816 to 1860. William H. Gerdts and Russell Burke, *American Still-Life Painting* (New York: Praeger, 1971), 61.
2. William H. Gerdts, "American Still-Life Painting: Severin Roesen's Fruitful Abundance," *Worcester Art Museum Journal* 5 (1981–82): 13.
3. Judith Hansen O'Toole, *Severin Roesen* (Lewisburg, Pa.: Bucknell University Press, 1992), 33.
4. Gerdts, "Roesen's Fruitful Abundance," 14.
5. Gerdts and Burke, *American Still-Life Painting*, 66.
6. Lois Goldreich Marcus, *Severin Roesen: A Chronology* (Williamsport, Pa.: Lycoming County Historical Society and Museum, 1976), 9.
7. O'Toole, *Roesen*, 27.
8. Gerdts, "Roesen's Fruitful Abundance," 67.
9. O'Toole, *Roesen*, 61–66.
10. Ibid., 52–60, 72–76.

Doughty, *View on the Hudson in Autumn*
1. This essay is based on Franklin Kelly, "*On the Beach*," in Tammis K. Groft and Mary Alice Mackay, *Albany Institute of History and Art: 200 Years of Collecting* (New York: Hudson Hills Press, 1998), 78.
2. Ibid.
3. Gilmor to Cole, 13 December 1826, as quoted in "Correspondence between Thomas Cole and Robert Gilmor, Jr.," in *Annual II: Studies on Thomas Cole, an American Romanticist* (Baltimore: Baltimore Museum of Art, 1967), 45.
4. John Wilmerding, *American Masterpieces from the National Gallery of Art*, rev. ed. (New York: Hudson Hills Press, 1988), 98.
5. Robyn Asleson and Barbara Moore, *Dialogue with Nature: Landscape and*

Literature in Nineteenth-Century America (Washington, D.C.: Corcoran Gallery of Art, 1985), 27.
6. W. W. Corcoran to Messrs Williams, Stevens & Williams, 13 July 1852, Outgoing Letterbook 31, no. 61, W. W. Corcoran Papers, Manuscript Division, Library of Congress, Washington, D.C.; and Thomas Doughty, "My Dear Sir . . . ," *Home Journal* 3, no. 1 (21 June 1851): 3.

Huntington, *Mercy's Dream*
1. John Bunyan, *The Pilgrim's Progress* (New York: Harper & Brothers, 1837), 271.
2. *American Repertory of Artists, Sciences and Manufacturers* 3, no. 5 (June 1841): 356.
3. Huntington to W. W. Corcoran, 28 August 1850, Incoming Letterbook 7, no. 7689, W. W. Corcoran Papers, Manuscript Division, Library of Congress, Washington, D.C.
4. Ibid., as transcribed by Lisa Strong and Kerry Roeder, CGA Curatorial Files.
5. William H. Gerdts, "Daniel Huntington's *Mercy's Dream*: A Pilgrimage through Bunyanesque Imagery," *Winterthur Portfolio* 14, no. 2 (Summer 1979): 176–78.
6. "Fine Arts: Mr. Huntington's 'Christian Art,'" *Literary World* 8, no. 214 (8 March 1851): 196.
7. For a summary of the responses of nineteenth-century American artists and tourists to Italian Baroque painting and sculpture, see William L. Vance, *America's Rome* (New Haven: Yale University Press, 1989), 2:83–88. See also Jenny Franchot, *Roads to Rome: The Antebellum Protestant Encounter with Catholicism* (Berkeley: University of California Press, 1994).
8. Sally M. Promey, "Pictorial Ambivalence and American Protestantism," in *Crossroads: Art and Religion in American Life*, ed. Alberta Arthurs and Glenn Wallach (New York: New Press, 2001), 192–94.
9. Wendy Greenhouse, "Daniel Huntington and the Ideal of Christian Art," *Winterthur Portfolio* 31, nos. 2–3 (Summer–Autumn 1996): 104–21.

Lane, *The United States Frigate "President" Engaging the British Squadron, 1815*
1. Lane did, however, paint several depictions of ships caught in violent storms at sea, such as *Three-Master on a Rough Sea* (1850s, Cape Ann Historical Association, Mass.) and *Merchant Brig under Reefed Topsails* (1863, Collection of Mrs. Charles Shoemaker); see John Wilmerding, *Paintings by Fitz Hugh Lane* (Washington, D.C.: National Gallery of Art, 1988), 86, cat. no. 15, and 87, cat. no. 40.
2. James A. Craig, *Fitz H. Lane: An Artist's Voyage through Nineteenth-Century America* (Charleston, S.C.: History Press, 2006), 55–62.
3. John Wilmerding, *American Marine Painting* (New York: Harry N. Abrams, 1987), 77–80. Robert Gardiner, ed., *The Naval War of 1812* (Annapolis: Naval Institute Press, in association with National Maritime Museum, 1998). The American Antiquarian Society's

(Worcester, Mass.) Catalogue of American Engravings lists 152 subjects from the War of 1812, most of them naval battles in which the American ships were victorious. Most of these date to the years of the war itself or before 1820. There are hundreds of entries for such paintings and prints in the Smithsonian Institution's Inventory of American Paintings and Sculpture.
4. John Wilmerding, *Fitz Hugh Lane: The First Major Exhibition* (Lincoln, Mass.: De Cordova Museum; Waterville, Maine: Colby College Art Museum, 1966), not paginated. On the second painting, see Wildmerding, *Fitz Hugh Lane (1804–1865): American Marine Painter* (Salem, Mass.: Essex Institute, 1964), vii–viii, 64, no. 119.
5. Craig, *Lane*, 30, 42–59.
6. For the complete story of these frigates, see Ian W. Toll, *Six Frigates: The Epic History of the Founding of the U.S. Navy* (New York: W. W. Norton & Company, 2006), 442–45.
7. For Lane's probable use of the Athenæum library, see Craig, *Lane*, 66–69.
8. Abel Bowen, *The Naval Monument: Containing Official and Other Accounts of All the Battles Fought between the Navies of the United States and Great Britain during the Late War . . . with Twenty-five Engravings* (Boston: A. Bowen, 1816). The bookplate on the Athenæum's copy of the book reads, "May 2, 1816 given by Abel Bowen."
9. Robert J. Allison, *Stephen Decatur: American Naval Hero, 1779–1820* (Amherst: University of Massachusetts Press, 2005), 152–53.
10. Commodore Decatur to the Secretary of the Navy, 18 January 1814, in Abel Bowen, *The Naval Monument, Containing Official and Other Accounts of All the Battles Fought between the Navies of the United States and Great Britain during the Late War; and an Account of the War with Algiers, with Twenty-five Engravings* (Boston: published by George Clark, 1830), 160–65.
11. Commander Alexander Murray, president of a court of inquiry, held at New York, to investigate the causes of the capture of the United States frigate *President*, 17 April 1815, printed in Bowen, *The Naval Monument* (1830), 174.

Ranney, *The Retrieve*
1. For the others, see Linda Bantel and Peter H. Hassrick, *Forging an American Identity: The Art of William Ranney* (Cody, Wyo.: Buffalo Bill Historical Center, 2006), *Duck Shooters*, cat. no. 43, *On the Wing*, cat. no. 55, *The Retrieve*, cat. no. 59, *The Retrieve*, cat. no. 78, *Duck Shooter's Pony*, cat. no. 82, *The Fowler's Return*, cat. no. 95, *Retriever with Ducks on Rocks overlooking Water*, cat. no. 124, and *Retrieving*, cat. no. 146.
2. Francis Grubar, *William Ranney, Painter of the Early West* (Washington, D.C.: Corcoran Gallery of Art, 1962), 10; and Linda Bantel, "William Ranney— American Artist," in Bantel and Hassrick, *Ranney*, xviii.

3. Claude J. Ranney, interview, Malvern, Pa., 11 January 1950, on accession record sheet, CGA Curatorial Files.
4. Bantel, "Duck Shooters," in Bantel and Hassrick, *Ranney*, 57, cat. no. 43.
5. Bantel and Hassrick, *Ranney*, cat. nos. 55, 55.2, 56, 57, 58.
6. Bantel, "*The Retrieve*," in Bantel and Hassrick, *Ranney*, 84, cat. no. 59.
7. The painting was first exhibited at the National Academy of Design in 1851 under the title *The Retrieve*. See *Catalogue of the Twenty-sixth Annual Exhibition of the National Academy of Design* (New York: Israel Sackett, 1851), cat. no. 365. It was known by that title until 1857, when Charles Lanman published it as *Duck Shooting* in his *Catalogue of W. W. Corcoran's Gallery* (Washington, D.C., 1857), 9.
8. Bantel, "*On the Wing*," in Bantel and Hassrick, *Ranney*, 79, cat. no. 55.
9. *New York Herald*, 30 September 1849, and *New York Herald*, 8 May 1853, 7, as quoted in Bantel and Hassrick, *Ranney*, 58 and 122, cat. nos. 43 and 82.
10. Mary E. Bouligny, *A Tribute to W. W. Corcoran, of Washington City* (Philadelphia: Porter & Coates, 1874), 77.
11. See n7 above.
12. W. W. Corcoran to Williams, Stevens & Williams, 25 March 1851, Outgoing Letterbook 30, no. 52; 25 February 1852, Outgoing Letterbook 30, no. 805; 13 July 1852, Outgoing Letterbook 31, no. 61; [no date] May 1855, Outgoing Letterbook 36, no. 8; and 27 October 1857, Outgoing Letterbook 40, no. 455; W. W. Corcoran Papers, Manuscript Division, Library of Congress, Washington, D.C.
13. Bantel and Hassrick, *Ranney*, cat. nos. 12, 14, 20, 21–23, 26, 27, 31–33, 35, 37, 38, 40, 42, 43, 47, 52–55, 61, 71, 72, and 80.
14. Bantel, "William Ranney—American Artist," xxii; and "The Ranney Fund Exhibition and Sale," in Grubar, *Ranney, Painter of the Early West*, 57–59, reprinted in Bantel and Hassrick, *Ranney*, 209–14.

Cropsey, *Tourn Mountain, Head Quarters of Washington, Rockland Co., New York*
1. William S. Talbot, *Jasper F. Cropsey, 1823–1900* (Ph.D. diss., New York University, 1972; New York: Garland Publishing, 1977), 272–77.
2. Previously titled *Eagle Cliff, New Hampshire*; Kenneth W. Maddox, "Cropsey's Paintings of Torne: A Legendary Mountain Worthy of the Painter's Pencil," *Orange County Historical Society Journal* 30, no. 1 (2001): 37.
3. Previously titled *Winter Scene on the Hudson River*; ibid.
4. Ibid. The date of 1851, on a foreground rock on the Corcoran's painting, was confirmed in 2001 by Sarah Cash and Dare Hartwell, both of the Corcoran Gallery of Art, by looking at the painting under a microscope. Note from Cash, 12 October 2001, CGA Curatorial Files.
5. Ibid, 4–46.
6. Kenneth W. Maddox, *An Unprejudiced Eye: The Drawings of Jasper F. Cropsey* (Yonkers, N.Y.: Hudson River Museum, 1979), 44, 28, 29, 43.

7. Maddox, "Cropsey's Paintings of Tourne," 40–41, 44–47.
8. Jasper Cropsey, Reinhardt Journals, 14 September 1846, 5, typescript, Newington-Cropsey Foundation, as quoted in Maddox, "Cropsey's Paintings of Tourne," 40–41. Maddox, ibid., 11, also notes that there is no Revolutionary era confirmation of any such story.
9. Maddox, *An Unprejudiced Eye*, 14.
10. *Catalogue of the First Semi-Annual Exhibition of Paintings in the Gallery of the Massachusetts Academy of Fine Arts* (Boston: printed by Dutton and Wentworth, 1854), 5, cat. no. 16.
11. "Massachusetts Academy of Fine Arts," *Dwight's Journal of Music* 2 (29 January 1853): 133. Maddox has noted that the Corcoran's painting, "modest in size and dark in tone, was not intended to be a crowd-pleaser." Maddox to Sarah Cash, 11 February 2002, CGA Curatorial Files.
12. "Massachusetts Academy of Fine Arts, Second Notice," *Dwight's Journal of Music* 2 (26 February 1853): 165.
13. Charles Lanman, *Catalogue of W. W. Corcoran's Gallery* (Washington, D.C.: privately printed, 1857), 14, cat. no. 54, as cited in Maddox, "Cropsey's Paintings of Tourne," 46 and n33. Cropsey's sale of the painting to Corcoran is not recorded in Cropsey's account book, which is unusual; Maddox, "Cropsey's Paintings of Tourne," 46n34.
14. Allan Boudreau and Alexander Bleimann, *George Washington in New York* (New York: American Lodge of New York, 1987), 9–34; and Maddox, "Cropsey's Paintings of Tourne," 45–46.

Eastman, *Ball Playing among the Sioux Indians*
1. Patricia Junker, "*Ballplay of the Dakota on the St. Peters River in Winter*, 1848," in *An American Collection: Works from the Amon Carter Museum*, ed. Will Gillham (New York: Hudson Hills Press, in association with the Amon Carter Museum, 2001), 50, cat. no. 13.
2. Harold McCracken, *Portrait of the Old West* (New York: McGraw Hill, 1952), 67; and Harold Pfister, *Facing the Light: Historic American Portrait Daguerreotypes; An Exhibition at the National Portrait Gallery, September 22, 1978–January 15, 1979* (Washington, D.C.: Smithsonian Institution Press, 1978), 90. I thank William Stapp, Curator Emeritus, National Portrait Gallery, for pointing me to this source.
3. Eastman painted finished canvases at Fort Snelling, some of which he had already sold to the Art-Union before returning to Washington; Junker, "*Ballplay of the Dakota*," 50.
4. Catlin, *Letters and Notes on the Manners, Customs, and Conditions of the North American Indians* (New York: Dover, 1973), 146, as cited in Sarah Elizabeth Boehme, "Seth Eastman: Illustrating the Indian Condition" (Ph.D. diss., Bryn Mawr College, 1994), 121.
5. Thomas Vennum, Jr., *American Indian Lacrosse: Little Brother of War* (Washington, D.C.: Smithsonian Institution Press, 1994), 341–42.

6. Ibid., xv.
7. McCracken, *Portrait of the Old West*, 68. The Chippewa-Ojibwa lived on both the American and Canadian sides of Lake Superior. Today they are the third-largest group of Native Americans in the United States.
8. Thomas L. McKenney and James Hall, *History of the Indian Tribes of North America*, 3 vols. (Philadelphia: E. C. Biddle, 1836–44) contains a hand-colored lithograph depicting Shin-Ga-Ba W'ossin, Image Stone, an Ojibwa man, wearing a red turban with white plume and a western-style shirt and jacket.
9. John C. Ewers, *Indian Life on the Upper Missouri* (Norman: University of Oklahoma Press, 1988), 91–97.
10. Technical examination under ultraviolet light reveals green fluorescence over the lower limbs and landscape background, indicating the presence of an old natural resin varnish. This suggests that those areas have not been cleaned or abraded in the past but remain in close to their original condition.
11. Henry Rowe Schoolcraft, *Historical and Statistical Information Respecting the History, Condition and Prospects of the Indian Tribes of the United States*, 6 vols. (Philadelphia: Lippincott, Grambo, 1851–57), vol. 5 (1855), 277. Schoolcraft commissioned Eastman to produce 275 drawings for his book, among them the Corcoran's *Ball Playing among the Sioux Indians*; ibid., vol. 2 (1852), pl. 20.
12. Mary H. Eastman, *Dahcotah: or Life and Legends of the Sioux Around Fort Snelling* (1849; Minneapolis: Ross and Haines, 1962), 56.
13. Mary H. Eastman, *Chicóra and Other Regions of the Conquerors and the Conquered* (Philadelphia: Lippincott, Grambo, and Co., 1854), 87.
14. Josephine Cobb, "The Washington Art Association: An Exhibition Record, 1856–60," in *Records of the Columbia Historical Society of Washington, D.C., 1963–1965*, ed. Francis Coleman Rosenberger (Washington, D.C.: Columbia Historical Society, 1966), 132; and "Board of Managers, 1857–8," in *Catalogue of the Second Annual Exhibition of the Washington Art Association* (Washington, D.C.: Henry Polkinhorn, 1857), as reproduced in ibid., 153.
15. Philip Deloria, *Playing Indian: Otherness and Authenticity* (New Haven: Yale University Press, 1998).

Woodville, *Waiting for the Stage*
1. Justin Wolff, *Richard Caton Woodville: American Painter, Artful Dodger* (Princeton: Princeton University Press, 2002), 7.
2. His mother, an Ogle, was descended from governors of Maryland, colony and state, and he was related by marriage to Charles Caroll, one of the signers of the Declaration of Independence; "Fine Arts: Richard Caton Woodville," *New York Daily Tribune*, 22 January 1867, 2.
3. Francis S. Grubar, *Richard Caton Woodville: An Early American Genre Painter* (Washington, D.C.: Corcoran Gallery of Art, 1967), n.p., notes the stylistic similar-

ity of Woodville's watercolors to Miller's. Miller had many students in Baltimore, and his account book lists a painting sold to "Woodville" in 1847; Account Book, The Walters Art Museum, Baltimore. Woodville and Miller also had a mutual friend in Miller's student Frank Blackwell Mayer; see essay for *Leisure and Labor*.
4. Henry T. Tuckerman, *Book of the Artists: American Artist Life . . .* (New York: G. P. Putman & Sons, 1867), 410; and Wolff, *Woodville*, 18.
5. For biographical accounts, see Woodville's brother William Woodville to William Pennington, 13 June 1879, Pennington Papers, Maryland Historical Society, Annapolis; and Grubar, *Woodville*, n.p.
6. Other Baltimore scenes include *The Sailor's Wedding* (1853, The Walters Art Museum), which, according to Grubar, *Woodville*, n.p., shows a Baltimore street in the distance, and *The Card Players* (1846, The Detroit Institute of Arts), which, according to Wolff, *Woodville*, 113, shows a Baltimore station.
7. *The Cardplayers* (c. 1846, The Walters Art Museum), a sketch, shows a flyer advertising the Baltimore–Washington stage; Wolff, *Woodville*, 63.
8. Bryan J. Wolf, "History as Ideology: Or, 'What You Don't See Can't Hurt You, Mr. Bingham," in *Redefining American History Painting*, ed. Patricia M. Burnham and Lucretia Hoover Giese (New York: Cambridge University Press, 1995), 259–60; on the standing figure as a blind man, see Wolff, *Woodville*, 138, where the author reproduces a daguerreotype of a blind man wearing such glasses.
9. Tuckerman, *Book of the Artists*, 408; Francis Grubar, "Richard Caton Woodville's *Waiting for the Stage*," *Corcoran Gallery of Art Bulletin* 13, no. 3 (October 1963): 10, 11 (illus.), 13–14.
10. For a discussion of the subject matter in each, see Grubar, *Woodville*, n.p.
11. Wolff, *Woodville*, 114.
12. Grubar, *Woodville*, n.p.; and Wolff, *Woodville*, 113, 137. The other paintings with a red spittoon are *The Card Players*, *Politics in an Oyster House*, and *The Sailor's Wedding* (as in n6 above), all illustrated in Grubar.
13. Francis S. Grubar, "Richard Caton Woodville: An American Artist, 1825 to 1855" (Ph.D. diss., The Johns Hopkins University, 1966), 60, 134, 142, 145–48, 257–61, pl. 80; Christian Schultz made the lithograph *Cornered!* after Woodville's painting. It was printed by Lemercier and published by Goupil and Company, New York, 1851; Wolff, *Woodville*, 141.
14. Wolff, *Woodville*, 153.
15. *Old '76 and Young '48* (1849, The Walters Art Museum), for instance, is said to depict the artist as the old man, his mother and father as the couple behind him, his younger brother William as the soldier, and his sister Dorothea as the young girl; Grubar, *Woodville*, n.p.
16. Wolff, *Woodville*, 153.
17. Ibid., 139, 142.

Church, *Tamaca Palms*
1. Alexander von Humboldt, *Cosmos: Sketch of a Physical Description of the Universe*, trans. Edward Sabine (London: Longman, Brown, Green and Longmans and John Murray, 1849), 2:84.
2. W. P. Bayley, "Mr. Church's Pictures. 'Cotopaxi,' 'Chimborazo,' and 'The Aurora Borealis.' Considered Also with Reference to English Art," *Art-Journal* (London), 4 (1 September 1865): 265.
3. For a detailed account of Church's travels, see Pablo Navas Sanz de Santamaria, *The Journey of Frederic Edwin Church through Colombia and Ecuador, April–October 1853* (Bogotá: Villegas Asociados, S.A., in association with Universidad de Los Andes and Thomas Greg and Sons, 2008).
4. The other three are *The Cordilleras: Sunrise* (private collection), *La Magdalena (Scene on the Magdalena)* (private collection), and *Tequendama Falls, near Bogotá* (Cincinnati Art Museum). See Franklin Kelly, *Frederic Edwin Church* (Washington, D.C.: National Gallery of Art, 1989), 80, 81, 83.
5. Church to MacLeod, 11 January 1877, Director's Records, CGA Archives.
6. Avery to MacLeod, 1 March 1877, Director's Records, CGA Archives.
7. William MacLeod's Curator's Journal, entry for 2 March 1877, Director's Records, CGA Archives.
8. I am grateful to Dare Hartwell for discussing with me the condition of *Tamaca Palms*.

Leutze, *Evening Party at Milton's*
1. The title was changed from *Milton Playing the Organ at Cromwell's House* to *Evening Party at Milton's, Consisting of Oliver Cromwell and Family, Algernon Sydney, Thurlow, Ireton, &c.* in accordance with American Paintings Catalogue policy, which restores titles to those under which a painting was first exhibited or published. Although Leutze referred to the painting in an 1857 letter as "Cromwell's family at Milton's house," his precise title for it is not known, and it was not referred to consistently by this or any other single title during the artist's lifetime. The present title is a corrected form of that under which the work was first exhibited and published in the United States at the Eighth Annual Exhibition of the Maryland Institute for the Promotion of the Mechanic Arts, Baltimore, 1855, 121, no. 80. This roughly approximates the German title, *Die Gesellschaft der Häupter der englischen Revolution bei Milton*, in its first published review in 1854; "Malerei," *Illustrirte Zeitung* 23, no. 585 (16 September 1854): 183. Such a title is consistent with period conventions for titling history paintings with lengthy descriptive phrases identifying the activity, place, time, and protagonists. Similar examples include Leutze's *The Storming of the Teocalli by Cortez and His Troops* (1848, Wadsworth Atheneum Museum of Art, Hartford, Conn.) and Benjamin West's *Agrippina Landing at Brundisium with the Ashes of Germanicus*

(1768, Yale University Art Gallery, New Haven). See Lisa Strong, Project Manager, to Registrar, memorandum, 26 April 2010.
2. On anecdotal history painting and its place in Leutze's work, see Stephen Bann, *Paul Delaroche: History Painted* (Princeton: Princeton University Press, 1997); and Jochen Wierich, "The Domestication of History in American Art: 1848–1876" (Ph.D. diss., College of William and Mary, 1998).
3. Wendy Greenhouse, "The American Portrayal of Tudor and Stuart History" (Ph.D. diss., Yale University, 1989), 23–27.
4. Thomas Babington Macaulay, "Milton," in *Critical and Miscellaneous Essays* (Philadelphia: Carey and Hart, 1843), 66.
5. As noted by Edward Strahan [Earl Shinn], *The Art Treasures of America, Being the Choicest Works of Art in the Public and Private Collections of North America* (Philadelphia: Gebbie & Barrie Publishers, 1878), 1:12.
6. The Corcoran owns a key drawing that identifies these characters, probably created not by Leutze but by his pupil William D. Washington, through whom William Wilson Corcoran arranged the purchase of the painting. The names given in this key match those published in a German review published in 1854, with minor spelling errors. See "Malerei," *Illustrirte Zeitung* 23, no. 585 (16 September 1854): 183.
7. Macaulay, "Milton," 62.
8. *Crayon* 1, no. 10 (7 March 1855): 156.
9. "The Mystery of Music," *United States Democratic Review* 37, no. 2 (February 1856): 150–51.
10. Barbara Groseclose, *Emanuel Leutze, 1816–1868: Freedom Is the Only King* (Washington, D.C.: Smithsonian Institution Press, 1975), 53–57.
11. Thanks to the agency of William D. Washington, Corcoran seems to have purchased *Evening Party at Milton's* without corresponding directly with the busy artist. See W. W. Corcoran to W. D. Washington, Esq., 15 December 1854, Outgoing Letterbook 35, no. 157; and W. W. Corcoran to Messrs Williams, Stevens & Williams, 17 February 1855, Outgoing Letterbook 35, no. 395, W. W. Corcoran Papers, Manuscript Division, Library of Congress, Washington, D.C. The painting was first reviewed by the *Illustrirte Zeitung* while on display in Leutze's studio in 1854, and later, after its purchase, many admired *Evening Party at Milton's* at Williams, Stevens & Williams offices in New York, including the anonymous reviewer for the *Crayon*. It then appeared as entry number 80 in a Baltimore art fair, perhaps before ever physically being in Corcoran's possession. See *The Book of the Exhibition: Eighth Annual Exhibition of the Maryland Institute for the Promotion of the Mechanic Arts* (Baltimore: S. Sands Mills, 1855).

Church, *Niagara*

1. "Pictures Canvassed," *Harper's Weekly*, 30 May 1857, 339. On *Niagara*, see esp. Jeremy Elwell Adamson, *Niagara: Two Centuries of Changing Attitudes, 1697–1901* (Washington, D.C.: Corcoran Gallery

of Art, 1985); and David C. Huntington, "Frederic Church's *Niagara*: Nature and the Nation's Type," *Texas Studies in Language and Literature* 25 (Spring 1983): 100–138.
2. Alexander von Humboldt, *Cosmos: Sketch of a Physical Description of the Universe*, trans. Edward Sabine (London: Longman, Brown, Green and Longmans and John Murray, 1849), 2:91.
3. Adam Badeau, "American Art," in *The Vagabond* (New York: Rudd & Carleton, 1859), 155.
4. For an excellent discussion of the "Great Picture" tradition, its popularity in America and England, and Church's place in it, see Gerald L. Carr, *Frederic Edwin Church: The Icebergs* (Dallas: Dallas Museum of Art, 1980), 21–30.
5. See Adamson, *Niagara*, for a thorough discussion.
6. "Editor's Table," *Knickerbocker* 45 (May 1855): 532.
7. "Our Private Correspondence," *Home Journal*, 9 May 1857, 2.
8. David C. Huntington, *The Landscapes of Frederic Edwin Church: Vision of an American Era* (New York: George Braziller, 1966), 68.
9. See Gerald L. Carr, *Frederic Edwin Church: Catalogue Raisonné of Works of Art at Olana State Historic Site* (Cambridge: Cambridge University Press, 1994), 1:231.
10. Quoted in ibid., 232.
11. "Notes on the West, in Two Letters—Letter One," *Crayon* 6 (July 1859): 221.
12. "Our Private Correspondence."
13. See Adamson, *Niagara*, 62–69.
14. Huntington, *Church*, 70.
15. See ibid., 2–3.
16. "Sketchings," *Crayon* 4 (4 May 1856): 157.
17. At its peak, the Johnston collection included almost three hundred paintings, one-third of which were American. In addition to *Niagara*, Johnston owned the first version of Thomas Cole's *The Voyage of Life* (1840, Munson-Williams-Proctor Institute, Utica, N.Y.), Church's *Twilight in the Wilderness* (1860, The Cleveland Museum of Art), and Winslow Homer's *Prisoners from the Front* (1866, The Metropolitan Museum of Art, New York); see Franklin Kelly, "Nineteenth-Century Collections of American Paintings," in *America: The New World in 19th-Century Painting*, ed. Stephan Koja (Munich: Prestel, 1999), 197–98.
18. See Huntington, *Church*, 3–4, for a discussion of the medal and the French artist's reaction (he was quoted as saying, "Ça commence là bas," in Benjamin Champney, *Sixty Years: Memories of Art and Artists* (Woburn, Mass.: Wallace and Andrews, 1900), 142.
19. See Davira Taragin, "Corcoran" (undated draft of master's thesis, George Washington University), 73–74, CGA Curatorial Files.
20. Carr, *The Icebergs*, 28; and Adamson, *Niagara*, 70.
21. Carr, *Church: Catalogue Raisonné*, 222.
22. On at least two occasions after Church sold his *Niagara*, he repainted the sky because dark streaks began to appear in that area; once when it was in the

collection of John Johnston (1861–76) and once after the Corcoran purchased the picture in the summer of 1876. See correspondence between William MacLeod and Church, culminating in the letter from Church to MacLeod, 28 August 1886, Director's Correspondence, CGA Archives, summarized in 14 June 2007 memorandum by Jennifer Carson, CGA Research Fellow.

Kensett, *View on the Genesee near Mount Morris*

1. The painting was first exhibited at the National Academy of Design in 1858 under the title *View on the Genesee near Mount Moat*, but there is no Mount Moat in the Genesee River valley, and the painting portrays a view of the Genesee River valley about thirty-five miles south of Rochester in the vicinity of the town of Mount Morris, a fact that has been confirmed by several historians of the region. See *National Academy of Design Exhibition Record, 1826–60* (New York: New-York Historical Society, 1943), 276; Kerry Roeder, CGA Research Fellow, to Douglas Morgan, Livingston County Historical Society, emails, 10–11 November 2005, CGA Curatorial Files; Thomas S. Cook to Lisa Strong, emails, 18 May 2009; and Amie Adler, Livingston County Historian, to Lisa Strong, emails, 18 May 2009. I wish to acknowledge the very generous assistance of Thomas S. Cook, Thomas A. Breslin, and Amie Alden, who provided the information about the painting's setting for this essay.
2. Thomas S. Cook to Lisa Strong, emails, 18–19 May 2009; Thomas A. Breslin to Lisa Strong, emails, 18–19 May 2009, CGA Curatorial Files.
3. The mansion was built in 1837 by John Rogers Murray for his bride, Anna Vernon Olyphant. See L. W. Ledyard, "John R. Murray," in the Reverend Levi Parson and Samuel L. Rockfellow, *Centennial Celebration, Mount Morris, 1894* (Mount Morris, N.Y.: Mount Morris Union and Jay Dickey, 1894), 94–100. I thank Amie Alden for the information.
4. *Gillette's Map of Livingston County NY. From Actual Surveys by J. H. French*, Syracuse (Philadelphia: J. E. Gillette, 1858). I thank Thomas Cook for this citation; Cook to Strong, email, 18 May 2009.
5. Rebecca Bedell, *The Anatomy of Nature: Geology and American Landscape Painting, 1825–1875* (Princeton: Princeton University Press, 2001), 94. See, for instance, *Newport, Looking Southwest* (1856) and *The Foot Bridge near Bash Bish* (1857), which Kensett sold to Olyphant; John Frederick Kensett Papers, "Register of Paintings Sold," reel N68-85, frame 477, Archives of American Art, Washington, D.C. (hereafter AAA). Thomas Cole painted *Genesee Scenery* in 1847 (Museum of Art, Rhode Island School of Design) based on sketches of Dehgayasoh Creek made in 1839. Thomas S. Cook, Thomas A. Breslin, Russell A. Judkins, and Thomas C. Richens, *Letchworth State Park* (Mount Pleasant, S.C.: Arcadia Publishing, 2008), 16 (illus.).

6. Bedell, *Anatomy of Nature*, 85–86.
7. Oliver Bell Bunce, "The Valley of the Genesee," in *Picturesque America: or, the Land We Live In; A Delineation by Pen and Pencil of the Mountains, Rivers, Lakes, Water-Falls, Shores, Cañons, Valleys, Cities, and Other Picturesque Features of Our Country*, ed. William Cullen Bryant (1874; New York: D. Appleton, 1894), 2:539.
8. Cook to Strong, email, 18 May 2009. In representing the northernmost Mount Morris Highbanks instead of the more picturesque southern Highbanks and waterfalls near Portage, Kensett also avoided signs of industrialization, such as the railroad bridge that spanned the river as well as the newly constructed Genesee Valley Canal that ran through the area. See, for instance, the illustration of the railroad bridge in *Picturesque America*, 2:538. On the Genesee Valley Canal, which was built 1836–62, see Cook, Breslin, Judkins, and Richens, *Letchworth State Park*, 8, 26–29.
9. Although we see a man at left herding his cattle toward a fenced enclosure, his is leisurely work. John Paul Driscoll, "From Burin to Brush: The Development of a Painter," in *John Frederick Kensett, American Master*, ed. Driscoll and John K. Howat (New York: W. W. Norton and Company, in association with Worcester Art Museum, 1985), 71, 86–90.
10. Bedell, *Anatomy of Nature*, 85. On this trip, Kensett and Olyphant likely stayed at the luxurious Cascade House near Portage, from which Kensett could have chartered a packet boat to carry them north to the Mount Morris Highbanks. That they stayed at the same hotel is indicated by Olyphant's request that Kensett tip the hotel maid, since Olyphant's wife forgot to do so. Cook, Breslin, Judkins, and Richens, *Letchworth State Park*, 39; and Olyphant to Kensett, New York, 22 August 1857, in Edwin D. Morgan Papers, box 32, folder 5, microfilmed in Kensett Papers, reel 1534, AAA.
11. Bedell, *Anatomy of Nature*, 105.
12. For an overview of the artist's biography and early training, see John K. Howat, "Kensett's World," in Driscoll and Howat, *Kensett*, 13–47.
13. Driscoll, "From Burin to Brush," 99.
14. Alan Wallach, "Rethinking Luminism" (lecture, Smithsonian American Art Museum, Washington, D.C., 7 May 2009).
15. Ibid. Henry T. Tuckerman, *Book of the Artists: American Artist Life. . . .* (New York: G. P. Putnam and Son, 1867; New York: James F. Carr, 1966), 625. Bedell, *Anatomy of Nature*, 89. For the sale to Olyphant, see Kensett, "Register of Paintings Sold," reel N68-85, frame 477, AAA. The Corcoran purchased the painting from Olyphant in 1877. See *Mr. Robert M. Olyphant's Collection of Paintings by American Artists. . . .*, Chickering Hall, New York, 18–19 December 1877, lot 65.
16. Bedell, *Anatomy of Nature*, 89; and Mark White Sullivan, "John F. Kensett, American Landscape Painter" (Ph.D. diss., Bryn Mawr College, 1981), 11.
17. Olyphant to Kensett, 22 August 1857.

Mayer, *Leisure and Labor*

1. Although the artist was baptized Francis, he used the name Frank throughout his life. See Jean Jepson Page, "Francis Blackwell Mayer," *Antiques* 109, no. 2 (February 1976): 316.

2. Mayer was also a founding member of the Artists Association of Maryland (1855) and the Allston Association (1860). See Jean Jepson Page, "Notes on the Contributions of Francis Blackwell Mayer and His Family to the Cultural History of Maryland," *Maryland Historical Magazine* 76, no. 3 (Fall 1981): 224–25.

3. Page, "Mayer," 316; and Henry C. Hopkins, "Maryland's Historical Painter: Frank B. Mayer," *Dixie* 2, no. 2 (August 1899): 116.

4. I am grateful to Lisa Strong for bringing this similarity in technique to my attention. Edward J. Nygren and Peter C. Marzio, *Of Time and Place: American Figurative Art from the Corcoran Gallery* (Washington, D.C.: Corcoran Gallery of Art and the Smithsonian Institution Traveling Exhibition Service, 1981), 38. See Page, "Mayer," 316–17.

5. Baltimore Museum of Art, acc. nos. 1936.205, 1936.213, 1936.214.

6. James C. Boyles, "Representations of Blacksmiths in Nineteenth-Century American Art" (master's thesis, University of North Carolina, Chapel Hill, 1989), 60.

7. Bernard F. Reilly, Jr., "The Art of the Anti-slavery Movement," in *Courage and Conscience: Black and White Abolitionists in Boston*, ed. Donald M. Jacobs (Bloomington: Indiana University Press, 1993), 69.

8. William M. S. Rasmussen and Robert S. Tilton, *Old Virginia: The Pursuit of the Pastoral Ideal* (Richmond: Virginia Historical Society; Charlottesville, Va.: Howell Press, 2003), 94–95.

9. In the autumn of 1857 Walters gave Mayer an advance of $100 for an "oil painting called 'Leisure and Labor.'" Walters apparently did not claim the picture, however, because when Mayer exhibited it in 1859 at the Third Annual Exhibition of the Washington Art Association, it was listed as for sale in the catalogue. Corcoran purchased the canvas shortly thereafter for $175. See Frank Blackwell Mayer, Account Book (1842–1862), John Sylvester Jr. Collection, Waynesboro, Ga.

10. Jessie J. Poesch, *The Art of the Old South: Painting, Sculpture, Architecture, and the Products of Craftsmen, 1560–1860* (New York: Alfred A. Knopf, 1983), 300.

11. See Jean Jepson Page to Jack Cowart, 5 August 1993, CGA Curatorial Files.

12. The tool propped against the broken plow at the lower right suggests that even the labor of tilling the gentleman's fields (visible through the open window in the back of the shop) is entirely dependent on the manual skills of the artisan who can keep the farming equipment in working order.

13. Jean Jepson Page, "Frank Blackwell Mayer: Baltimore Artist (1827–1899)," MS, 1973, 88, CGA Curatorial Files.

14. Boyles, "Representations of Blacksmiths," 40–41.

15. Mary Ellen Sigmond, "Frank Blackwell Mayer" (unfinished master's thesis, University of Minnesota, 1945), 4, CGA Curatorial Files.

Stanley, *The Trappers*

1. Julia Ann Schimmel, "John Mix Stanley and Imagery of the West in Nineteenth-Century American Art" (Ph.D. diss., New York University, 1983), iv.

2. He shared this studio with A. H. Clements. Josephine Cobb, "The Washington Art Association: An Exhibition Record, 1856–60," in *Records of the Columbia Historical Society of Washington, D.C., 1963–1965*, ed. Francis Coleman Rosenberger (Washington, D.C.: Columbia Historical Society, 1966), 135; and Mark Herlong, "Vernon Row: An Early Washington Arts Community," MS, 2, CGA Curatorial Files.

3. Robert Taft, *Photography and the American Scene: A Social History, 1839–1889* (1938; New York: Dover Publications, 1964), 261–62. According to Taft, 490n283, the photographer William Henry Jackson, who knew Stanley's son, "made an extensive search for some of these daguerreotypes but was unsuccessful." I thank William Stapp, Curator Emeritus of the National Portrait Gallery, for pointing me to this source.

4. Schimmel, "Stanley," 187.

5. William R. Swagerty, "A View from the Bottom Up: The Work Force of the American Fur Company on the Upper Missouri in the 1830's," *Montana* 43 (1993): 18–33.

6. The title was changed from *The Disputed Shot* to *The Trappers* in accordance with American Paintings Catalogue policy, which restores titles to those under which a painting was first exhibited or published. See Emily D. Shapiro to Registrar, memorandum, 23 October 2003, CGA Curatorial Files; and *Catalogue of the Third Annual Exhibition of the Washington Art Association* (Washington, D.C.: William H. Moore, 1859), cat. no. 1, reprinted in Cobb, "The Washington Art Association."

7. "Our Washington Letter," *Forest and Stream: A Journal of Outdoor Life, Travel, Nature Study, Shooting* 9, no. 15 (15 November 1877): 295. The narrative described echoes the famous conflict over a white-tailed deer in the opening of James Fenimore Cooper's 1823 novel *The Pioneers*. The book, part of Cooper's Leatherstocking Tales, was widely read throughout the nineteenth century and could have inspired Stanley, who, in the late 1850s, was attempting to move away from documentary or scientific paintings of western life toward paintings with more developed narratives. See Schimmel, "Stanley," 187.

8. It is perhaps significant that Dred Scott lived with his owner, army major John Emerson, at Fort Snelling in 1839, when Stanley first visited. Scott's tenure at the fort, then part of the free Wisconsin Territory, was part of the basis of his suit for freedom.

9. It was included in the Third Annual Exhibition of the Washington Art Association in 1859 with Corcoran listed as owner. It was likely purchased through a New York dealer Corcoran frequented, Williams, Stevens & Williams, since the canvas bears the stamp "Wm Stevens Williams—art repository / 353 Broadway." Barbara A. Ramsay, American Paintings Catalogue Technical Examination Report, 20 April 2009, CGA Conservation Files.

10. W. W. Corcoran to James Watson Webb, 9 May 1851, Outgoing Letterbook 30, no. 160, W. W. Corcoran Papers, Manuscript Division, Library of Congress, Washington, D.C. See also Davira Taragin, *Corcoran* (Washington, D.C.: Corcoran Gallery of Art, 1976), 17.

11. The art historian Patricia Hills has argued that the American Art-Union patronized western subject matter because it promoted a vision of America that was neither North nor South, thus appealing broadly to both. Hills, "The American Art-Union as Patron for Expansionist Ideology in the 1840s," in *Art in Bourgeois Society, 1790–1850*, ed. Andrew Hemingway and William Vaughan (Cambridge: Cambridge University Press, 1998), 316.

12. Elizabeth Johns, *American Genre Painting: The Politics of Everyday Life* (New Haven: Yale University Press, 1991), 60–99; and Carol Clark, "Charles Deas," in *American Frontier Life: Early Western Paintings and Prints*, ed. Alan Axelrod (New York: Cross River Press, 1987), 51–78.

Healy, *Abraham Lincoln*

1. George P. A. Healy, *Reminiscences of a Portrait Painter* (Chicago: A. C. McClurg, 1894; New York: Kennedy Graphics and Da Capo Press, 1970), 69–70.

2. Grace Bedell to Abraham Lincoln, 15 October 1860, Detroit Public Library, Burton Historical Collection; copy in CGA Curatorial Files.

3. The commission began after the letter of introduction from Healy's patron, Thomas B. Bryan, to Lincoln, 10 November 1860; see Marie de Mare, *G. P. A. Healy, American Artist* (New York: David McKay, 1954), 190. A letter from Thomas Webster, Jr., to John Sherman, 15 November 1860, describes Webster's visit to Lincoln while Healy was putting the finishing touches on the painting; John Sherman Papers, 1836–1900, Manuscript Division, Library of Congress, Washington, D.C., as cited in Joseph Lyle McCorison, Jr., "Meet Mr. Lincoln," *Christian Science Monitor*, 10 February 1945, Magazine sec., 7. Newspapers record the painting was finished by 15 November 1860: "Interesting from Illinois," *New York Herald*, 17 November 1860, 7; and "The City," *Chicago Tribune*, 17 November 1860, [1]. On Atwood's portrait, see *Illinois State Journal*, 26 October, 1 November, and 14 November 1860, as cited in McCorison, "Meet Mr. Lincoln," 7. The short span of time between Healy's and Atwood's sittings suggests that Atwood may have hurried things along to be the first artist to portray the president-elect wearing a beard.

4. Lincoln is known to have carried Bedell's letter with him long after he received it so he could read it to people for their amusement; this is likely what he did at his sitting with Healy. Historians do not know what prompted Lincoln to grow a beard, but he acknowledged Bedell as his inspiration, picking her out of a crowd at a railroad station en route to Washington for his inauguration and telling her in front of the crowd that he had decided to take her advice. Philip Kunhardt, *Lincoln, an Illustrated Biography* (New York: Gramercy, 1992), 15.

5. Lincoln to Bedell, 19 October 1860, Benjamin Shapell Family Manuscript Foundation, Los Angeles.

6. Kunhardt, *Lincoln*, 13.

7. Duncan Phillips, "Observations on G. P. A. Healy's First Life Portrait of Abraham Lincoln," CGA Curatorial Files.

8. Healy's emphasis on drawing is evinced in his use of a compass to measure and record the features and proportions of his sitters' faces. These measurements were used to facilitate the creation of replicas based on the original; see de Mare, *Healy*, 77, 144–45.

9. In 1857 Congress commissioned Healy to produce a collection of presidential portraits for the White House. They were executed on a grand, life-size scale from Healy's previously painted portraits. Only six were completed: *John Quincy Adams*, *Millard Fillmore*, *Franklin Pierce*, *James K. Polk*, *John Tyler*, and *Martin Van Buren*.

10. "Bryan's New Music Hall—Noble and National Art Decorations," *Chicago Press Tribune*, 20 March 1860, [1].

11. The letter of introduction from Bryan to Lincoln is dated 10 November 1860, quoted in de Mare, *Healy*, 190.

12. A notice in the *New York Herald* ("Interesting from Illinois," 17 November 1860, 7) indicates that Healy left Springfield with the completed portrait on 15 November 1860; see also "The City," *Chicago Tribune*, 17 November 1860, [1].

13. "Corcoran Gallery of Art: Purchase of Fifteen Portraits of Presidents by Healy," *Washington Evening Star*, 3 May 1879, [1]. The Corcoran Gallery of Art's initial purchase included *Martha Washington* (after Stuart) and *George Peabody*.

14. All of Healy's presidential portraits were removed from the gallery between 1916 and 1917. The presidential portraits were lent to public schools in the District of Columbia, where they remained for approximately twenty-five years. The Lincoln School, as it was known, was located at the intersection of Second and C Streets, S.E., and hosted the Lincoln portrait from 1926 to 1943. Katherine McCook Knox, *Healy's Lincoln No. 1* (1956; Washington, D.C.: privately printed, 1959), n.p.

15. Washington, D.C., White House, 19 August–12 September 1974, Temporary Receipt, 19 August 1974, Loans of Works of Art, In and Out, CGA Archives. Although the loan must have been

arranged under the Nixon Administration, the painting arrived ten days after Gerald R. Ford was sworn in as president. On Healy's 1864 portrait, see Marie de Mare, "When Lincoln Posed," *New York Times*, 9 May 1937; and McCorison, "Meet Mr. Lincoln," 6–7.

Miller, *Election Scene, Catonsville, Baltimore County*

1. For a list of the artist's genre scenes, see Ron Tyler, ed., *Alfred Jacob Miller: Artist on the Oregon Trail*, catalogue raisonné by Karen Dewees Reynolds and William R. Johnston (Fort Worth: Amon Carter Museum, 1982), cat. nos. 1–50.
2. Deed from Elizabeth Myers to Alfred Jacob Miller, Estate Papers, MS 1624, Maryland Historical Society, Baltimore.
3. Martha Wight Wise, *Catonsville* (Charleston, S.C.: Arcadia Press, 2005), 13.
4. Email correspondence between the author and Teri L. Rising, Historic Preservation Planner, Baltimore County Office of Planning, 10 February 2009.
5. The title is Miller's as listed in his account book. See Account Book, The Walters Art Museum Library, Baltimore.
6. The core of the building still stands at 825 Frederick Road and is known as the Friendly Farmer. For its status as a polling place, see *Baltimore County Union*, 17 August 1878, as cited in John McGrain, "Castle Thunder: Myth or Fact?" MS, 22 March 2004, Baltimore County Office of Planning, Towson, Md., copy in CGA Curatorial Files. McGrain, 4, also notes that Feelemeyers was advertised in the *Baltimore Republican and Argus*, 3 August 1844, as the site of a pro-Polk rally.
7. Barbara A. Ramsay, American Paintings Catalogue Technical Examination Report, 27 April 2009, CGA Conservation Files.
8. McGrain, "Castle Thunder," 6. McGrain, 3, believes Castle Thunder to have been constructed as an inn sometime after 1832 and before 1845.
9. Tyler, *Miller: Artist on the Oregon Trail*, cat. no. 14A; *Catalogue of the Thirty-eighth Annual Exhibition of the Pennsylvania Academy of the Fine Arts* (Philadelphia: Collins Printers, 1861), cat. no. 537, 32.
10. Edward J. Nygren, "*Election Scene, Catonsville*," in Nygren and Peter C. Marzio, *Of Time and Place: American Figurative Art from the Corcoran Gallery* (Washington, D.C.: Corcoran Gallery of Art and the Smithsonian Institution Traveling Exhibition Service, 1981), 42.
11. Election scenes were commonly depicted in political cartoons, but the date 1845 would be very early for such a portrayal in the American fine arts. George Caleb Bingham, for instance, did not begin exhibiting his election series until the 1850s. Gail E. Husch, "George Caleb Bingham's 'The County Election': Whig Tribute to the Will of the People," *American Art Journal* 19, no. 4 (Autumn 1987): 5. Miller's pyramidal composition, culminating in a figure with outspread arms, recalls the composition of Bingham's *Jolly Flatboatman* (1846, Manoogian Collection), which was distributed as an engraving by the American Art-Union

that same year; Nancy Rash, *The Painting and Politics of George Caleb Bingham* (New Haven: Yale University Press, 1991), 67, 74 (illus.).
12. See, for instance, the collection of two hundred watercolors Miller painted for William T. Walters in 1858–60, illustrated in Marvin Ross, ed., *The West of Alfred Jacob Miller* (Norman: University of Oklahoma Press, 1968).
13. Jean Jepson Page notes that Brantz Mayer, Miller's lifelong friend, was friends with Kennedy; Page, "Notes on the Contributions of Francis Blackwell Mayer and His Family to the Cultural History of Maryland," *Maryland Historical Magazine* 76 (Fall 1981): 217–39. Kennedy was also a member of the Maryland Historical Society, to which at least two of Miller's patrons, Johns Hopkins and Benjamin Coleman Ward, also belonged; Kevin B. Sheets, "Saving History: The Maryland Historical Society and Its Founders," *Maryland Historical Magazine* 89, no. 2 (1994): 133–55.
14. Helen G. Huttenhauer and G. Alfred Helwig, *Baltimore County in the State and Nation* (Towson, Md.: Board of Education of Baltimore County, 1958), 159.

La Farge, *Flowers on a Window Ledge*

1. Date changed to reflect new research by James Yarnall showing that the window ledge in the scene depicts the inn at which La Farge and his wife stayed in the spring of 1861. See Emma Dent and Lisa Strong to Registrar, 1 August 2009, CGA Curatorial Files. Our particular thanks to Professor James Yarnall, Salve Regina University, who generously assisted the Corcoran Gallery of Art in dating this work.
2. James L. Yarnall, *Nature Vivante: The Still Lifes of John La Farge* (New York: Jordan-Volpe Gallery, 1995), 12–14.
3. La Farge, as quoted in Royal Cortissoz, *John La Farge: A Memoir and a Study* (Boston: Houghton Mifflin, 1911; New York: Kennedy Graphics and Da Capo Press, 1971), 114–15.
4. Kathleen A. Foster, "The Still-Life Painting of John La Farge," *American Art Journal* 11, no. 3 (July 1979): 8, 14.
5. La Farge, as quoted in Cortissoz, *La Farge*, 116.
6. La Farge, as quoted in ibid., 114–15.
7. Henry Adams, "William James, Henry James, John La Farge and the Foundations of Radical Empiricism," *American Art Journal* 17, no. 1 (Winter 1985): 60.
8. Foster, "The Still-Life Painting of La Farge," 9.
9. [Henry James], "Art," *Atlantic Monthly* 34, no. 123 (September 1874): 378.
10. "The La Farge Paintings: The Studies and Pictures to Be Sold To-Day and To-Morrow in Boston," *New York World*, 19 November 1878, 5; "The Fine Arts: Mr. La Farge's Exhibition," *Boston Daily Advertiser*, 16 November 1878, 1; and Cortissoz, *La Farge*, 134.
11. James Jackson Jarves, *The Art Idea: Painting, Sculpture, and Architecture in America* (New York: Hurd and Houghton, 1865), 226.

12. Mary A. La Farge and James L. Yarnall, "Nurturing Art and Family: The Newport Life of Margaret Mason Perry La Farge," *Bulletin of the Newport Historical Society* 67, no. 231 (Fall 1995): 66.
13. Scott A. Shields, "Memorable Wreaths: Love, Death, and the Classical Text in La Farge's *Agathon to Erosanthe* and *Wreath of Flowers*," *American Art* 11 (Summer 1997): 87–88, 90.
14. James L. Yarnall, *John La Farge in Paradise: The Painter and His Muse* (Newport, R.I.: William Vareika Fine Arts, 1995), 27.
15. La Farge to Margaret Mason Perry, 1860, private archives, Princeton, as quoted in La Farge and Yarnall, "Nurturing Art and Family," 65.
16. Maria Oakey Dewing, "Flower Painters and What the Flower Offers to Art," *Art and Progress* 6, no. 8 (June 1915): 256, 257–58.
17. Foster, "The Still-Life Painting of La Farge," 5–6, 20–22.
18. Margaret Mason Perry La Farge, as quoted in John La Farge, S.J., *The Manner Is Ordinary* (New York: Harcourt and Brace and Company, 1954), 27.

Whistler, *Battersea Reach*

1. Whistler to Henri Fantin-Latour, c. September 1867; original in French: "ce damné Realisme" and "dans le temps où je jetais tout ca pel mel sur la toile—sachant que l'instinct et le belle couleur me meneraient"; quoted from *The Correspondence of James McNeill Whistler, 1855–1903*, ed. Margaret F. MacDonald, Patricia de Montfort, and Nigel Thorp; including *The Correspondence of Anna McNeill Whistler, 1855–1880*, ed. Georgia Toutziari; online edition, University of Glasgow, http://www.whistler.arts.gla.ac.uk/correspondence. The standard abbreviation for the edition is GUW (i.e., Glasgow University: Whistler). GUW 08045 (30 November 2009); original in Library of Congress, Manuscript Division, Pennell-Whistler Collection, PWC 1/33/25. Among the paintings he mentions specifically are *At the Piano* (1859, Taft Museum, Cincinnati); see Andrew MacLaren Young et al., *The Paintings of James McNeill Whistler* [New Haven: Yale University Press, 1980], cat. no. 24 [hereafter YMSM]); *Symphony in White, No. 1: The White Girl* (1862, National Gallery of Art, Washington, D.C.; YMSM 38); *Wapping* (1861, National Gallery of Art, Washington, D.C.; YMSM 35); and *The Coast of Brittany* (1861, Wadsworth Atheneum, Hartford, Conn.; YMSM 37).
2. Whistler took a three-year lease on 7 Lindsey Row (now 101 Cheyne Walk) from March 1863, although Margaret F. MacDonald writes that he was living there by December 1862, in Susan C. Faxon et al., *Addison Gallery of American Art 65 Years: A Selective Catalogue* (Andover, Mass.: Addison Gallery of American Art, 1996), 490. In February 1867 he moved to 2 Lindsey Row (now 96 Cheyne Walk); see Ronald Anderson and Anne Koval, *James McNeill Whistler: Beyond the Myth* (London: John Murray,

1994), 128; and Richard Dorment and Margaret F. MacDonald, *James McNeill Whistler* (London: Tate Gallery Publications for the National Gallery of Art, 1994), 307–10.
3. A photograph by James Hedderly showing the Greaves boat business in 1872 clarifies the spatial relations among the pedestrians, the stairway to the tidal strand, and the moored boats. The photograph is reproduced in Katharine Lochnan, "Turner, Whistler, Monet: An Artistic Dialogue," in Lochnan et al., *Turner, Whistler, Monet: Impressionist Visions* (Toronto: Art Gallery of Ontario, 2004), 21. Seymour Haden's etching *Battersea Reach* (also 1863) shows a comparable scene, its foreground likewise showing the railing that initially seems so inexplicable at the lower left of Whistler's picture.
4. These would be replaced by the Victoria Steam Boat Yard, Conilys Chemical, and a plumbago works over the next decade. See the Charles Booth Poverty Map (1898–99), at http://booth.lse.ac.uk/cgi-bin/do.pl?sub=view_booth_and_barth&args=531000,180400,6,large,5. The Morgan Crucible Company is farther along the bank to the right, hidden behind the masts and sails.
5. See Stanford's *Map of London* (editions of 1862 and 1867; at http://www.mappalondon.com/) and Whitbread's *Map of London* (1865; http://archivemaps.com/mapco/whit1865/whit.htm) for the identification of the Battersea site. The Charles Booth Poverty Map (1898–99) lists the Lindsey House buildings as "Upper-middle and Upper Classes. Wealthy."
6. John Cavafy to Whistler, 7 June 1892; GUW 00783 (30 November 2009); original in Glasgow University Library, MS Whistler C284.
7. Elisée Reclus, *Guide du voyageur à Londres et aux environs* (1860), quoted in John House, "Visions of the Thames," in Jennifer Hardin et al., *Monet's London: Artists' Reflections on the Thames, 1859–1914* (St. Petersburg, Fla.: Museum of Fine Arts, 2005), 16. Nor is there any allusion to Battersea's reputation as "the sinkhole of Surrey"; Sherwood Ramsey, *Historic Battersea: Topographical Biographical* (1913), quoted in Dorment and MacDonald, *Whistler*, 100.
8. *The Home Exhibition: A Collection of Paintings Owned in Saint Louis and Lent to the Museum* (St. Louis: City Art Museum, 1911), 107.
9. www.whistler.arts.gla.ac.uk/correspondence/people/biog/?bid=Cava_GJ&firstname=&surname=cavafy. See also Whistler to William Hookham Carpenter, 3 August 1863, when he writes (on arranging payment for proofs of his etchings sold to the British Museum): "My bankers address is—Messrs. J. G. Cavafy & Co. 31. Threadneedle St. City"; GUW 11109 (30 November 2009); original in British Museum, Department of Prints and Drawings, Letterbook, 1863.

The Turkish Greek community in London was Whistler's chief support in

the early 1860s. Members of the Ionides, Coronio, Spartali, and Cavafy families played roles as both models and collectors for several of his major works. In July 1862 the artist George du Maurier wrote that Whistler was "painting river pictures for the Greeks"; Daphne du Maurier, ed., *The Young George du Maurier: A Selection of His Letters, 1860–67* (London: Peter Davis, 1951), 160. It seems likely that du Maurier's line refers to an understanding between Whistler and Cavafy, that bore fruit only the next year. Such a delay on Whistler's part would be typical. It is tempting to think that when Whistler, in late May or early June 1863, wrote to decline an invitation, "I must stick to a couple of pictures[,] commissions! For I am just about cleaned out—and tin will be forked over on their completion," he was making reference to these river scenes; Whistler to A. F. Augustus Sandys, 31 May–June 1863; GUL 09455 (30 November 2009); original in Glasgow University Library, MS Whistler LB 16/24. Ionides eventually owned *Brown and Silver: Old Battersea Bridge* (Addison Gallery of American Art, Andover, Mass.; YMSM 33). It, like the Corcoran painting, is undated. Although it has been given a date as early as 1859 on the basis of later reminiscences, to judge by style and subject, it seems likely that it is of a piece with the two paintings owned by Cavafy and that these three—sold to two different members of the Greek community—account for du Maurier's line.

The two Thames views were the first of four paintings by Whistler that Cavafy acquired. The other two were *Variations in Flesh Colour and Green: The Balcony*, purchased c. 1867 (1865–70, Freer Gallery of Art, Washington, D.C.; YMSM 56), and *Harmony in Blue and Silver: Trouville*, which Whistler gave to Cavafy before c. 1878 (1865, Isabella Stewart Gardner Museum, Boston; YMSM 64).

10. Whistler inquired in 1886 about the possibility of borrowing them for exhibitions in both the United States and London; Cavafy's son wrote to decline the former and accept the latter, but neither exhibition took place. Again in early 1892 Whistler hoped to borrow them for the one-person Goupil exhibition, *Nocturnes, Marines and Chevalet Pieces*. Cavafy's son declined: "I beg to say that the few finished pictures by Mr. Whistler in my possession, have all been exhibited—one or two repeatedly—It would be most unpleasant & inconvenient to me to lend any of them again"; John Cavafy to Goupil Gallery, 28 January 1892; GUL 00557 (30 November 2009); original in Glasgow University Library, MS Whistler C58.

11. William B. Sieger, "Whistler and John Chandler Bancroft," *Burlington* 136, no. 1099 (October 1994): 675–82.

12. Kennedy paid £650 for the lot and gave Whistler the *Harmony in Blue and Silver: Trouville* as a finder's fee. He, in turn, sold it several months later to Isabella Stewart Gardner. Kennedy sold the other three works for a significant profit. See Sieger, "Whistler and Bancroft."

13. Whistler to Stephen Richards, 12 June 1892; GUW 08114 (30 November 2009); original in Library of Congress, Manuscript Division, Pennell-Whistler Collection, PWC 2/44/2.

14. The restorer had found the color so warm that he had written to Whistler wondering if the painting had a red ground layer. Whistler retorted: "But what is all this about red ground and the rest of it in my picture Battersea Reach! . . . [N]ever think to discover in my canvases any mysteries of such pretention. There is no red *ground*"; Whistler to Stephen Richards, 29 June 1892; GUW 10716 (30 November 2009); original in Library of Congress, Manuscript Division, Pennell-Whistler Collection, PWC 2/44/4.

15. Whistler to Helen Euphrosyne Whistler, 7 August 1892; GUW 06718 (30 November 2009); original in Glasgow University Library, MS Whistler W712.

16. Edward Guthrie Kennedy to Whistler, 22 February 1893; GUL 07212 (30 November 2009); original in Glasgow University Library, MS Whistler W1200.

17. Whistler to [Isaac Cook, via Edward Guthrie Kennedy], 17 August 1893; original in the CGA Archives.

18. The painting is distinct enough so that Whistler's early biographer Joseph Pennell cast doubt on both the picture's authenticity and its relation to the Whistler letter; Pennell to Madeleine Borggraefe, 27 November 1911; original in Saint Louis Art Museum, Richardson Memorial Files. Subsequent scholars have not shared Pennell's doubts on either the painting's authenticity or the depicted locale.

Heade, *View of Marshfield*

1. I am indebted to the particularly sensitive interpretation of this painting found in Robyn Asleson and Barbara Moore, *Dialogue with Nature: Landscape and Literature in Nineteenth-Century America* (Washington, D.C.: Corcoran Gallery of Art, 1985), 39. *Marsh at Dawn* (1859, Collection of Jerald Dillon Fessenden) is Heade's earliest known (dated) salt-marsh view. See the Heade catalogue raisonné, Theodore E. Stebbins, Jr., with the assistance of Janet L. Comey and Karen E. Quinn, *The Life and Work of Martin Johnson Heade* (New Haven: Yale University Press, 2000), 213, cat. no. 63 (hereafter Stebbins 2000). The Corcoran's canvas is 238, cat. no. 148.

2. Theodore E. Stebbins, Jr., *The Life and Work of Martin Johnson Heade* (New Haven: Yale University Press, 1975), 44 (hereafter Stebbins 1975).

3. In 1883 the artist married and forsook his frequent travels and northeastern roots to settle in St. Augustine, Florida. Like his friend Frederic Edwin Church, he died in relative obscurity and was rediscovered only in the 1940s, when his acknowledged masterpiece, *Thunder Storm on Narragansett Bay* (1868, Amon Carter Museum, Fort Worth), was found in an antique store.

4. The painting's date was changed from 1865–70 to c. 1866–76 in 2007 to reflect the catalogue raisonné's placement of Heade's nearly thirty undated marsh scenes within his classic marsh phase. Karen Quinn, Assistant Curator of Paintings, Art of the Americas, Museum of Fine Arts, Boston, email to Jennifer Wingate, American Paintings Catalogue Research Fellow, 25 June 2007, CGA Curatorial Files.

5. Two of the other such views are *Marshfield Meadows, Massachusetts* (c. 1866–76, Amon Carter Museum; Stebbins 2000, 238, cat. no. 147) and *Marshfield Meadows* (c. 1877–78, The Currier Gallery of Art, Manchester, N.H.; Stebbins 2000, 267, cat. no. 268). Unlike the Corcoran's painting, however, these two scenes include figures. As Stebbins notes (1975, 44), Heade rarely inscribed his works with title or locale. Furthermore, salt marshes, by their very nature, are difficult to locate and identify. The Corcoran's canvas was acquired with the present title, which may derive from the work's compositional similarity to the other two paintings depicting the Marshfield subject; inscribed on the back of the original stretcher of Stebbins 2000, cat. no. 147, is "Marshfield Mead[ows]," and cat. no. 268 has an old label on its reverse that reads "[illegible] field Meadows, no. 70."

6. I am grateful to Dorothy MacMullen, Curator, Marshfield Historical Society, email to Andrew d'Ambrosio, American Paintings Catalogue Intern, 13 July 2009, CGA Curatorial Files, for suggesting the identification of the site and for providing a Google Map Satellite View of Heade's view in the painting.

7. Stebbins 2000, 238, notes that Heade used a second sketch, *East Marshfield, with Small Buildings on Far Shore* (Museum of Fine Arts, Boston, 2007.82), in preparation for the Corcoran's painting. However, its composition, with a rise of land at center and right—rather than at left as in Fig. 1—bears little resemblance to that of the Corcoran's painting.

8. The three diagonally positioned short poles at center and right may be haypoles, used in the lifting and transport of hay to the staddles, or they may be corner stakes used by farmers to mark marsh-lot boundaries. See John D. Fogg, *Recollections of a Salt Marsh Farmer* (Seabrook, N.H.: Seabrook Historical Society, 1983), 21, for useful information about gundalows, haypoles, and the haystack-building process. I am grateful to Betty Moore, Director, Tuck Museum, Hampton, N.H., for this citation and information (email to Andrew d'Ambrosio, 13 July 2009, CGA Curatorial Files).

9. Stebbins 2000, 356, entry for *East Marshfield*, cat. no. 621.3.

10. Stebbins 2000, 124–25, surmises that Heade may have been addressing yet a third subject, disagreements in the 1860s and 1870s (the heyday of saltwater farming) over the future of the Marshfield meadows, which farmers wanted to reclaim to grow valuable crops (a desire opposed by hunters and fishermen). For more on the history of saltwater farming, see John Stilgoe, *Alongshore* (New Haven: Yale University Press, 1994), 108. Although no evidence supports Heade's political motives (he left little in the way of letters or diaries), he maintained an avid interest in hunting, fishing, and nature, as evidenced in his writing for *Forest and Stream*; see Stebbins 2000, 7. His combination in *View of Marshfield* of low marsh, which produces good-quality hay, with high marsh, used as pastureland for cattle, may have constituted comment on the controversy or may be artistic license. I am grateful to James Cunningham, Newbury, Mass., farmer and local historian, for sharing his knowledge of salt marshes with Andrew d'Ambrosio in emails dated 1 and 7 July 2009, CGA Curatorial Files.

11. The term *luminism* was coined by John I. H. Baur in his pioneering essay "American Luminism: A Neglected Aspect of the Realist Movement in Nineteenth-Century American Painting," *Perspectives USA* 9 (Autumn 1954): 90–98. It was explored in depth in John Wilmerding, ed., *American Light: The Luminist Movement, 1850–1875; Paintings, Drawings, Photographs* (Princeton: Princeton University Press, 1989).

12. Ralph Waldo Emerson, "History" (1841), in *Essays: First and Second Series* (New York: Vintage/Library of America, 1990), 12.

Durand, *The Edge of the Forest*

1. John Durand, *The Life and Times of A. B. Durand* (New York: Charles Scribner's Sons, 1894), 198.

2. On Durand's use of the vertical format, see Linda S. Ferber, ed., *Kindred Spirits: Asher B. Durand and the American Landscape* (Brooklyn: Brooklyn Museum, in association with D Giles Limited, London, 2007), 148.

3. "Register of Paintings Belonging to the Corcoran Gallery of Art (1869–1946)," CGA Archives.

4. J. Durand, *The Life and Times*, 178, 198.

5. Ibid., 178. These must have been a selection of nature studies that Durand could not part with in an auction of his studio contents in late 1867. On the auction, see Ferber, *Kindred Spirits*, 200.

6. Asher B. Durand, "Letters on Landscape Painting, Letter V," as reprinted in Ferber, *Kindred Spirits*, 240.

7. A. B. Durand, "Letter III," as reprinted in Ferber, *Kindred Spirits*, 237.

8. A. B. Durand, "Letter V": "Strictly speaking, beyond a few foreground objects, our Art is entirely representation," as reprinted in Ferber, *Kindred Spirits*, 240.

9. On Durand's use of light in his late work, see Lauren Lessing and Margaret Stenz, "Asher B. Durand, *Landscape, Welch Mountain*, 1863," in *The Collections of the Nelson-Atkins Museum of Art: American Paintings to 1945*, ed. Margaret C. Conrads (Kansas City, Mo.: Nelson-Atkins Museum of Art, 2007), 232.

10. The frame on *The Edge of the Forest* was commissioned from the firm of Earles' Galleries in Philadelphia in 1883. However, the arched shape can be seen on the canvas itself, since Durand did not paint in the corners. William McLeod, Curator's Journal, 7 April 1883, CGA Archives; and Dare Hartwell, American Paintings Catalogue Technical Examination Report, 8 December 2005, CGA Conservation Files. Durand, under the tutelage of Cole, had an understanding of the importance of framing and chose his frame purposefully; Annette Blaugrund, "On the Framing of Pictures," in *The Gilded Edge: The Art of the Frame*, ed. Eli Wilner (San Francisco: Chronicle Books, 2000), 17.

11. Durand applied an arched frame to his meditative scene *Early Morning at Cold Spring* (Montclair Art Museum, N.J.).

12. See Durand and Company, *Specimen Sheet*, 1827, line engraving, in Ferber, *Kindred Spirits*, 129, fig. 53.

13. J. Durand, *The Art and Life*, 178, 198; and Daniel Huntington, *Asher B. Durand, a Memorial Address* (New York: Century, 1887), 38.

14. Rebecca Bedell, *The Anatomy of Nature: Geology and American Landscape Painting, 1825–1875* (Princeton: Princeton University Press, 2001), 55, 58.

15. A. B. Durand, "Letters on Landscape Painting, Letter IV," as reprinted in Ferber, *Kindred Spirits*, 239.

16. George Bancroft Griffith, "A Day at the Capital," *Potters American Monthly*, January 1880, 8.

17. Linda S. Ferber, "The History of a Reputation," in Ferber, *Kindred Spirits*, 16, 21.

18. "Register of Paintings Belonging to the Corcoran Gallery of Art."

Henry, *The Old Westover House*

1. Henry to Edward V. Valentine, 21 September 1870, Valentine Richmond History Center, Museum of the Life and History of Richmond, Richmond, Va.

2. The New York State Museum, Albany, houses Henry's collection of Civil War drawings, including *Westover, Charles City County, Virginia, November, 1864*, pencil and pastel on paper, NYSM 40.17.85; and "Westover Details / Cannon / Sailboat, Charles City County, Virginia, November, 1864," pencil on paper, NYSM 40.17.1795.

3. An inscription in the artist's hand on the verso of the Corcoran's painting reads: "'Westover house' James River Va / Painted from a drawing made in Oct– / 1864. During the Campaign of / Gen. Grant, 1864–5. / Painted for Mr. Whitney of Logan Sqr. / Phila–1869–70 / E L Henry."

4. Alexander O. Boulton, "American House Styles: The Best of Georgian," *American Heritage* 40, no. 1 (1989): 111.

5. "The Old Estates of Virginia," *Living Age*, no. 950 (16 August 1862): 332.

6. Mary Ruffin Copeland, ed., *Confederate History of Charles City County* (Richmond, Va.: 1957), 13.

7. Henry to Valentine, 21 September 1870.

8. Elizabeth McCausland, *The Life and Work of Edward Lamson Henry, N.A., 1841–1919* (New York: Kennedy Graphics, 1970), 48.

9. Amy Kurtz Lansing, *Historical Fictions: Edward Lamson Henry's Paintings of Past and Present* (New Haven: Yale University Art Gallery, 2005), 1.

10. "The Westover Estate," *Harper's New Monthly Magazine* 42, no. 252 (May 1871): 801.

11. The turn of the twentieth century marked another step in the physical and psychic "reconstruction" of Westover House. In 1899 a Byrd descendant purchased the property and began an extensive restoration campaign. Henry's painting of the famed Virginia home, which had been languishing in the hands of the gallery and auction house the American Art Association since 1885, entered the Corcoran's collection the following year.

Johnson, *The Toilet*

1. Henry James, "On Some Pictures Lately Exhibited," *Galaxy* 20 (July 1875): 93.

2. S[usan] N[oble] C[arter], "The Academy Exhibition. III. Genre and Fancy Pictures," *New York Evening Post*, 1 May 1875, 1.

3. Edward J. Nygren, "American Genre: Its Changing Form and Content," in Nygren and Peter C. Marzio, *Of Time and Place: American Figurative Art from the Corcoran Gallery* (Washington, D.C.: Corcoran Gallery of Art and Smithsonian Institution Traveling Exhibition Service, 1981), 11; and Isabel Louise Taube, "Rooms of Memory: The Artful Interior in American Painting, 1880–1920" (Ph.D. diss., University of Pennsylvania, 2004), 17–19.

4. Gail Caskey Winkler and Roger W. Moss, *Victorian Interior Decoration: American Interiors, 1830–1890* (New York: Henry Holt, 1986), 116, 170.

5. Patricia Hills, "The Genre Paintings of Eastman Johnson: The Sources and Development of His Style and Themes" (Ph.D. diss., New York University, 1977), 161.

6. Elisabeth Donaghy Garrett, "The American Home, Part IV: The Dining Room," *Antiques* 126, no. 4 (October 1984): 912, 919; and Elisabeth Donaghy Garrett, *At Home: The American Family, 1750–1870* (New York: Harry N. Abrams, 1990), 87.

7. See Ellen M. Plante, *Women at Home in Victorian America* (New York: Facts on File, 1997), 130, for a description of a typical middle-class woman's wardrobe.

8. Teresa A. Carbone, "The Genius of the Hour: Eastman Johnson in New York, 1860–1880," in *Eastman Johnson: Painting America*, ed. Carbone (Brooklyn: Brooklyn Museum of Art, in association with Rizzoli International Publications, 1999), 74.

9. Edward J. Nygren, "The Toilet," in *Of Time and Place*, 55.

10. Garrett, "The American Home," 918.

11. The picture has been identified as a child's sketch by Carbone, "Genius of the Hour," 77.

Whittredge, *Trout Brook in the Catskills*

1. Worthington Whittredge, *The Autobiography of Worthington Whittredge, 1820–1910*, ed. John I. H. Baur (Brooklyn: Brooklyn Museum Press, 1942), 42.

2. For the most detailed survey of Whittredge's life and career, see Anthony F. Janson, *Worthington Whittredge* (Cambridge: Cambridge University Press, 1989).

3. Whittredge, *The Autobiography*, 42.

4. For Whittredge's "conversion to Barbizon," see Janson, *Whittredge*, 158–79.

5. Dare Hartwell, American Paintings Catalogue Technical Examination Report, 12 January 2005, CGA Conservation Files.

6. "Worthington Whittredge," *Aldine, the Art Journal of America* 9 (1 December 1879): 372.

7. Frank Jewett Mather, Jr., "Worthington Whittredge, Landscape Painter," *Outlook* 77 (2 July 1904): 535–36.

8. "The Arts," *Appletons' Journal of Literature, Science and Art* 13 (1 May 1875): 567.

Bierstadt, *Mount Corcoran*

1. *52nd Annual Exhibition of the National Academy of Design*, National Academy of Design, New York, 3 April–2 June 1877, cat. no. 452 (as *Mountain Lake*), illustrated in Nancy K. Anderson and Linda S. Ferber, *Albert Bierstadt: Art and Enterprise* (New York: Hudson Hills Press, in association with the Brooklyn Museum, 1990), 57.

2. "Fine Arts," *New York Evening Mail*, 7 May 1877, 1; *New York Times*, 13 April 1877, 2; *New York Evening Post*, 21 April 1877, 1; and *New York Evening Post*, 10 April 1877, 1.

3. Anderson and Ferber, *Bierstadt*, 112.

4. Ibid., 24–25.

5. Ibid., 30, 58.

6. Ibid., 55–57.

7. Bierstadt to MacLeod, 29 November 1877, CGA Archives; William MacLeod's Curator's Journals, 3 December 1877 and 19 January 1878, Director's Records, CGA Archives; Bierstadt to MacLeod, 28 December 1877, CGA Archives; Bierstadt to Ward, 21 January 1878, Incoming Letterbook 20, no. 11475, W. W. Corcoran Papers, Manuscript Division, Library of Congress, Washington, D.C.; MacLeod to Bierstadt, 19 January 1878, CGA Archives.

9. MacLeod, Curator's Journal, 22 January 1878.

10. Four days after MacLeod's journal entry, cited above, a local paper announced that the gallery, not Corcoran himself, had purchased the painting; "Art Notes," *Washington, D.C., Evening Star*, 26 January 1878, 1. A recently discovered receipt dated 31 May 1878 shows that the gallery paid Bierstadt half the money owed him; "Receipt Book of the Corcoran Gallery of Art, 1874–1890," CGA Archives. A little more than a week later, the board allocated $7,500 for the painting's purchase; "Annual Meeting of the Board of Trustees, 1869–1888, Journal of the Official Proceedings of the Trustees of the Corcoran Gallery of Art," 10 June 1878, 1, 104. In July Corcoran

sent the balance of the payment, drawn on his own bank; Corcoran to Bierstadt, 1 July 1878, Outgoing Letterbook 75, no. 91, W. W. Corcoran Papers.

11. MacLeod, Curator's Journal, 20 June 1878.

12. William MacLeod, "Some Incidents in the Life of the Late Wm. Wilson Corcoran," William MacLeod Papers, 1839–1890, Historical Society of Washington, D.C., 2.

13. MacLeod, Curator's Journal, 18 January 1878: "[Board of Trustees Chairman] Riggs says neither he nor Mr. Walters like Mr. Bierstadt's picture"; William MacLeod, *Catalogue of the Paintings, Statuary, Casts, Bronzes etc. of the Corcoran Gallery of Art* (Washington, D.C.: Gibson Brothers, 1878), 55: "This picture was bought and presented to the Gallery by Mr. Corcoran"; and "Art at the Capital," *New York Sun*, 28 December 1884, 1.

14. Ferber and Anderson, *Bierstadt*, 57, 283, fig. 120.

15. MacLeod, Curator's Journal, 22 and 25 June 1877. In an attempt to verify the location of Mount Corcoran, MacLeod asked the U.S. Geological Survey to provide the location and height of the mountain on three different occasions; Curator's Journal, 5 and 9 July 1877 and 29 January 1878. MacLeod also showed the painting to experts for their opinions on 22 June 1877, 3 November 1877, 11 January 1878, and 29 January 1878.

16. MacLeod, Curator's Journal, 22 June 1877 and 3 and 4 May 1878. Critics singled out the clouds in particular for censure when the painting was first exhibited in New York; *New York Sun*, 15 April 1877, 3, and *New York Evening Post*, 21 April 1877, 1.

17. According to Captain George Montague Wheeler, the peak at 36°31′ N and 118°14′ W "has since been called Mt. Corcoran by the artist, Mr. Albert Bierstadt"; *Report upon United States Geographical Surveys West of the One Hundredth Meridian, in Charge of Capt. Geo. M. Wheeler, Corps of Engineers, U.S. Army* (Washington, D.C.: Government Printing Office, 1889), 1:99. These were the same coordinates provided by the U.S. Engineer's Office to MacLeod, 7 March 1879, CGA Archives. His excursions in 1872 included a brief trip with the geologist Clarence King. Their route took Bierstadt from the Owens Valley west over Kearsarge Pass to Vidette Meadow on the King's River, which would have offered him a good view of the peak Bierstadt would call Mount Corcoran. For information on the route, see *(Independence, Calif.) Inyo Independent*, 5 October 1872; and Samuel Franklin Emmons Diary, 19 October 1872, as quoted in Anderson and Ferber, *Bierstadt*, 226.

18. Francis P. Farquhar, *Place Names of the High Sierra* (San Francisco: Sierra Club, 1926), 56. In 1968 the peak at 36°32′ N and 118°15′ W was designated Mount Corcoran by the Board on Geographic Names. See Charles Duncombe to Sarah Cash, 26 September 2001, regarding

U.S. Board on Geographic Names file on Mount Corcoran, CGA Curatorial Files.

19. Corcoran to Bierstadt, 1 July 1878, Outgoing Letterbook 75, no. 91, W. W. Corcoran Papers.

Sargent, *En route pour la pêche*

1. The title was changed from *The Oyster Gatherers of Cancale* to *En route pour la pêche* (*Setting Out to Fish*) in accordance with American Paintings Catalogue policy, which restores titles to those under which a painting was first exhibited or published. For the first exhibition and publication of the painting, see *Salon de 1878: 95e Exposition Officielle*, Palais des Champs Élysées, Paris, 25 May–19 August 1878, cat. no. 2008. See Sarah Cash, Bechhoefer Curator of American Art, to Registrar, memorandum, 26 April 2010, CGA Curatorial Files.

2. The Salon opened on 25 May and closed on 19 August. For fuller discussions of *En Route pour la pêche* and its preparatory and related works, see Sarah Cash, "Testing the Waters: Sargent and Cancale," in *Sargent and the Sea*, ed. Cash (New Haven: Yale University Press, in association with the Corcoran Gallery of Art, 2009), 89–117; and Richard Ormond and Elaine Kilmurray, *Figures and Landscapes, 1874–1882*, vol. 4 of *John Singer Sargent: Complete Paintings* (New Haven: Yale University Press, published for The Paul Mellon Centre for Studies in British Art, 2006), 83–86 and 108–25.

3. Sargent showed *Fishing for Oysters at Cancale* as his American exhibition debut at the inaugural show of the newly formed Society of American Artists in New York City, 6 March–5 April 1878. For a discussion of Sargent's titling of the Boston painting, see Cash, "Testing the Waters," 95–97.

4. Fitzwilliam Sargent to Anna Maria Sargent, 20 August 1877, Fitzwilliam Sargent Papers, Archives of American Art, Smithsonian Institution, Washington, D.C., quoted in Ormond and Kilmurray, *Figures and Landscapes*, 85.

5. For example, Sargent may have seen Eugène Feyen's scene of oyster gatherers, *Les Glaneuses de la Mer* (1872), in the Salon of that year, or his younger brother's entry into the 1874 Salon, the imposing *Retour de la Pêche aux Huîtres par les Grandes Marées à Cancale*; each was purchased from its respective Salon by the French state for the Musée du Luxembourg.

6. The collection of oysters, whether dredged by boat or harvested from beds, and, by extension, their sale were strictly prohibited in Cancale (and elsewhere in France) by order of the government during the summer months, precisely the time of Sargent's visit. These centuries-old regulations were intended to protect the oyster population, weakened during its egg-laying season and therefore not prime for eating, and were also important in mitigating the effects of long-standing overfishing. See Cash, "Testing the Waters," 93–95.

7. With the greatest tidal mean range in Europe and one of the largest in the world, waters at Cancale can rise fifty feet from their lowest level. See Joseph Pichot-Louvet, *The Oysters of Cancale* (Cancale: Les Éditions du Phare for Musée de l'Huître et du Coquillage/Les Parcs Saint-Kerber, 1994).

8. The title *Oyster Gatherers of Cancale* apparently was assigned to the painting after the artist's death; its first known use was in *Memorial Exhibition of the Works of the Late John Singer Sargent*, Museum of Fine Arts, Boston, 3 November–27 December 1925, cat. no. 14. The painting is so similar to *Fishing for Oysters at Cancale* that both paintings, incorrectly and often confusingly, have been given the same title; see Ormond and Kilmurray, *Figures and Landscapes*, 111.

9. The oil studies are all called Study for *En route pour la pêche* and *Fishing for Oysters at Cancale* and dated 1877. See Cash, "Testing the Waters," 96, fig. 133; 99, fig. 137; 100, fig. 140; 101, fig. 141; and 102, fig. 143. For the drawings, also dated 1877, see 97, figs. 134, 135; 99, fig. 138; 101, fig. 142; and 103, fig. 144.

10. See Monique Nonne's entry on Sargent's portrait of Carolus-Duran in *Carolus-Duran, 1837–1917* (Paris: Réunion des Musées Nationaux, 2003), 196.

11. This, perhaps, was not surprising in an exhibition that featured 2,330 works and for reviewers who were familiar from recent Salons with the subject of fish or oyster gatherers on the seashore.

12. Roger Ballu, "Le Salon de 1878: Deuxième et Dernier Article," *Gazette des Beaux-Arts*, July 1878, 179 (illus.), 185. Sargent's pen-and-ink drawing is in the collection of the Corcoran Gallery of Art (1976.57).

13. It is unknown whether Sargent's 1877 portrait of his friend Fanny Watts (Philadelphia Museum of Art), which is not inscribed to the sitter or her mother, was a commission.

14. Case participated in the Wilkes Expedition of 1837–42 that discovered Antarctica, the Mexican War, and the Civil War and commanded several squadrons.

15. Apparently, at first somewhat nervous that the admiral wanted to purchase the painting as a favor to a family friend, Sargent was reassured by his son Daniel that Case "wanted it for its own sake." See Sargent to Gus Case, 18 July 1878, private collection, quoted in Ormond and Kilmurray, *Figures and Landscapes*, 111.

Bonham, *Nearing the Issue at the Cockpit*

1. Edward J. Nygren and Andrea C. Wei, "*Nearing the Issue at the Cockpit*," in Nygren and Peter C. Marzio, *Of Time and Place: American Figurative Art from the Corcoran Gallery* (Washington, D.C.: Corcoran Gallery of Art and Smithsonian Institution Traveling Exhibition Service, 1981), 61; and Carol Kearney, "Horace Bonham: York's Forgotten Artist" (master's thesis, Penn State University, Capitol Campus, Middletown, 1984), 303. Kearney's information about cockfighting

in York in the late nineteenth century comes from an oral history tape of John Freeland, Tape 11038, York Historical Society, Pa.

2. Bessie Bonham to York Historical Society, 4 December 1940, York Historical Society, Pa., as cited in Kearney, "Bonham," 310.

3. A York paper identified the central figure as the coachman of Judge Jeremiah Black; "A York Picture Sold," *York Gazette*, 16 February 1899; and Kearney, "Bonham," 310.

4. Hugh Honour, *The Image of the Black in Western Art* (Houston: Menil Foundation, 1989), 196; Janet Levine, "Horace Bonham," in Guy C. McElroy, *Facing History: The Black Image in American Art, 1710–1940* (San Francisco: Bedford Arts Publishers, in association with the Corcoran Gallery of Art, 1990), 89; Barbara Groseclose, *Nineteenth-Century American Art* (New York: Oxford University Press, 2000), 86–89; and T. J. Jackson Lears, *Something for Nothing: Luck in America* (New York: Viking, 2003), 149.

5. Carol Kearney, "Horace Bonham," *Susquehanna*, August 1985, 38.

6. George R. Prowell, *History of York County, Pennsylvania* (Chicago: J. H. Beers, 1907; Mt. Vernon, Ind.: Windmill Publications, for Historical Society of York County, 1997), 1:393.

7. For a discussion of these works, see Kearney, "Bonham" (1985), 35, 37, 41.

8. Honour, *The Image of the Black*, 196.

9. Lears, *Something for Nothing*, 149.

10. Nygren and Wei, "*Nearing the Issue at the Cockpit*," 61.

11. Prowell, *History of York County*, 1:458; and Kearney, "Bonham" (1985), 34.

12. Nygren and Wei, "*Nearing the Issue at the Cockpit*," 61.

13. Ibid.

14. Kearney, "Bonham" (1984), 309.

15. Ibid., 310.

16. Ibid., 307–8.

17. *The Gossips* was exhibited at the Pennsylvania Academy of the Fine Arts in 1880; *Little Scamps* was exhibited at the Museum of Fine Arts, Boston, and the Pennsylvania Academy of the Fine Arts also in 1880; and *Opsimathy*, 1885, was exhibited at the National Academy of Design and the Pennsylvania Academy of the Fine Arts in 1885; see Kearney, "Bonham" (1985), 35, 37, 39.

Brown, *The Longshoremen's Noon*

1. "Fine Arts," *New York Herald*, 27 March 1880, 5; and Sylvester Rosa Koehler, *American Art* (New York: Cassell and Company, 1886), 56.

2. Brown became a naturalized U.S. citizen in 1864.

3. In the late 1860s and early 1870s Brown typically spent summers in the countryside of New England gathering material for his rural compositions and painted them in his New York City studio in the fall and winter. See Martha J. Hoppin, *Country Paths and City Sidewalks: The Art of J. G. Brown* (Springfield, Mass.: George Walter Vincent Smith Art Museum, 1989), 13.

4. Beginning in 1858 Brown exhibited in the National Academy of Design annual every year (except 1871) until his death.

5. The unrigged barge *J. R. Baldwin*, depicted at the far right, was registered in Albany, New York, and carried goods up and down the Hudson River. See Edward J. Nygren, "*The Longshoremen's Noon*," in *Of Time and Place: American Figurative Art from the Corcoran Gallery* (Washington, D.C.: Corcoran Gallery of Art and Smithsonian Traveling Exhibition Service, 1981), 64. In Brown's *New York Tribune* obituary ("Newsboys' Artist Dies," 9 February 1913, 6), the painting is described as "one of his best pictures"; the *New York Times* ("J. G. Brown, Painter of Street Boys, Dies," 9 February 1913, 17) called *The Longshoremen's Noon* "Among the best-known of Mr. Brown's pictures."

6. As was typical of nineteenth-century American genre painting, the sole African American laborer in Brown's composition stands on the periphery of the group. Contemporary critics noted that the black figure was "decidedly in the minority here, crowded into the background, as it were, by the Irishmen who have almost a monopoly of work about the malodorous wooden wharfs of the great city of New York"; Koehler, *American Art*, 55–56. The ethnic composition of the laborers in Brown's painting was historically accurate: recent investigation has confirmed that while slaves and free blacks worked as dock laborers during the colonial era and the early years of the republic, by 1880 95 percent of the city's longshoremen were Irish and Irish American; see Bruce Nelson, *Divided We Stand: American Workers and the Struggle for Black Equality* (Princeton: Princeton University Press, 2001), 12–13.

7. Brown, quoted in "The Painter of the Street Arabs," *Art Amateur* 31, no. 6 (November 1894): 125.

8. Elaborating on his working method in the 1894 *Art Amateur* article (ibid.), Brown explained: "In the city it is, for obvious reasons, more difficult to paint out of doors. But I have worked on the docks with a crowd of 'longshoremen about me. The news spread like wildfire that there was a strange stevedore on such a wharf who was paying unprecedented rates [for modeling], and in the twinkling of an eye there were hundreds of men before me."

9. Brown's urban interpretation of the nooning theme likely served as a model for Thomas Anshutz's iconic 1880 labor picture *The Ironworkers' Noontime* (Fine Arts Museums of San Francisco). Anshutz participated in the National Academy's Fifty-fifth Annual Exhibition alongside Brown in the spring of 1880, and the Philadelphia artist surely saw *The Longshoremen's Noon* there.

10. Nelson, *Divided We Stand*, 11; and Charles H. Farnham, "A Day on the Docks," *Scribner's Monthly* 18 (May 1879): 40–41.

11. Nelson, *Divided We Stand*, 4.

12. Farnham, "A Day on the Docks," 41.

13. Greta, "Boston Correspondence," *Art Amateur*, March 1880, 74; and "Fine Arts," *New York Herald*, 3 November 1879, 8.

14. "Academy of Design," *New York Telegram*, 10 April 1880, 2; and "The Fine Arts," *Boston Daily Advertiser*, 9 April 1880, 2.

15. Brown listed among his patrons many of nation's most successful businessmen. The Corcoran purchased *The Longshoremen's Noon* from the dry goods magnate William T. Evans. The New York lace and linen manufacturer Thomas B. Clarke owned *A Longshoreman* (Fig. 1); see *Catalogue of the Private Art Collection of Thomas B. Clarke*, American Art Galleries, New York, 14–17 February 1899, cat. no. 20. The current frame is probably original, but technical examination shows the outer molding has been removed. Barbara A. Ramsay, American Paintings Catalogue Technical Examination Report, 24 June 2009, CGA Curatorial Files.

Sargent, *Marie Buloz Pailleron (Madame Édouard Pailleron)*

1. Charles Baudelaire first published his *Fleurs du mal* there, and other such luminaries as George Sand, Sainte-Beuve, Honoré de Balzac, Victor Hugo, Hippolyte Taine, and Ernest Renan were contributors; "Revue des Deux Mondes," *Encyclopædia Britannica*, 2009, Encyclopædia Britannica Online (accessed 14 May 2009). See also Gabriel de Broglie, *Histoire politique de la "Revue des Deux Mondes" de 1829 à 1979* (Paris: Perrin, 1979); and *Cent ans de vie française à la "Revue des Deux Mondes,"* *Revue des Deux Mondes* centenary issue (1929).

2. He was elected to the Académie Française in 1882. His success as a dramatist was perhaps helped by the fact that, in addition to owning and editing the *Revue des Deux Mondes*, his father-in-law, Buloz, was a director of the Comédie Française.

3. "Fate of the Hotel de Chimay," *New York Times*, 4 July 1884; the article was prompted by the acquisition of the building by the École des Beaux-Arts.

4. Sargent apparently calculated his entries for the 1880 Salon—the portrait of Marie Pailleron and an orientalist fantasy of white-on-white (*Fumée d'ambre gris* [1880, Sterling and Francine Clark Art Institute, Williamstown, Mass.])—to reveal a wide range of progressive (by Salon standards) painting.

5. Writers have noted the disparity between the seemingly formal dress and the setting, although Richard Ormond and Elaine Kilmurray note that the gown is in fact an afternoon dress and appropriate for the time; Ormond and Kilmurray, *The Early Portraits*, vol. 1 of *John Singer Sargent: Complete Paintings* (New Haven: Yale University Press, published for The Paul Mellon Centre for Studies in British Art, 1998), 47. Its relatively somber tone might reflect the fact that Pailleron's father had died within the past two years. Yet something about the costume unsettles many. As late as 1963, the art historian Yvon Bizardel wrote one line

about the work, that it "astonishes, the artist having placed his sitter outdoors without her hat" [étonna, l'artiste ayant placé son personage en plein air et sans chapeau]; Bizardel, introduction to *John S. Sargent: 1856–1925* (Paris: Centre Culturel Américain, 1963), [2].

6. Sargent painted the background with obvious brushwork in cool, pale colors tinged with blue and purple, akin to the fashionable work of such juste-milieu painters as Jules Bastien-Lepage. Paul Mantz made the comparison in 1880: "le paysage du fond abonde en verdures fenders, en clarets à la Bastien-Lepage"; "Le Salon: VII," *Le Temps*, 20 June 1880, 1. The highest points of impasto are at the top edge of the scene, showing the architecture and sky(?) through the leaves; filigrees of paint as well enliven Pailleron's jewelry. Pailleron's hands are prominent; on the back of one, a scribble of liquid blue-gray lines, when seen from a distance, coalesces magically into a web of veins beneath her fine, pale skin.

7. The facture of the background contrasts with the subtle manner in which Sargent painted Pailleron's flesh, where feathering of the brush and gradual tonal transitions convey smooth three-dimensionality to the face. While the paint is thin over much of the painting's surface, revealing the texture of the canvas, it is considerably thicker and more layered, albeit still smooth in application, in her face.

8. Ormond and Kilmurray, *The Early Portraits*: *Édouard Pailleron*, cat. no. 24 (1879, Musée d'Orsay, Paris; their fig. 34 also shows an untraced "drawing" engraved by Charles Baude [1881]). The portrait of his wife followed quickly thereafter. Two years later, in 1881, one of Sargent's two Salon entries was a double portrait of the Pailleron children; ibid., *The Pailleron Children*, cat. no. 37 (1881, Des Moines Art Center). Sargent also made sketches of each of the Paillerons and of Marie's mother, Madame François Buloz, either as part of the portrait process or as presentations to thank them for their hospitality: ibid., *Madame François Buloz*, cat. no. 17 (1879, Los Angeles County Museum of Art); *Marie-Louise Pailleron*, cat. no. 18 (1879, private collection); *Marie-Louise Pailleron*, cat. no. 19 (1879, untraced watercolor); *Édouard Pailleron fils*, cat. no. 614 (1879, private collection); and *Madame Édouard Pailleron*, cat. no. 615 (1879, private collection).

9. Fitzwilliam Sargent to Tom Sargent, 15 August 1879, Archives of American Art, Smithsonian Institution, Washington, D.C. (hereafter AAA). In addition to the portraits of the two Paillerons, the commissions likely included pictures of Robert de Cévrieux (Ormond and Kilmurray, *The Early Portraits*, cat. no. 26, Museum of Fine Arts, Boston), Jeanne and René Kieffer (ibid., cat. nos. 27 and 28, both in private collections), and vicomte de Saint-Périer (ibid., cat. no. 29, Musée d'Orsay). The Pailleron paintings are by far the more ambitious in scale and achievement.

10. Emily Sargent to Violet Paget [Vernon Lee], 3 September 1879, Colby College, Waterville, Maine. Near the end of September, his father again wrote: "John has been spending a few weeks near Aix at the country-seat of a Parisian whose portrait he painted, and who invited him to go to his place and remain while he painted a full length portrait of his wife"; Fitzwilliam Sargent to Tom Sargent, 20 September 1879, AAA.

11. Armand Silvestre, "Le Monde des Arts: Le Salon de 1880," *La Vie Moderne*, 29 May 1880, 340.

12. Paul Mantz, "Le Salon: VII," *Le Temps*, 20 June 1880, 1.

13. Lucy H. Hooper, "The Paris Salon of 1880," *Art Journal* (New York), 6, no. 7 (July 1880): 222.

14. Margaret Bertha Wright, "American Pictures at Paris and London," *Art Amateur* 3, no. 2 (July 1880): 26. Wright continued: "One regrets that so much cleverness could give no lovelier picture to the exhibition than that of a modishly dressed and furiously red-headed woman, who looks as if her hair had not been touched for a week, and whose dim eyes are half closed, either from weakness or drowsiness, it matters not which."

15. Marie-Louise Pailleron, *Le Paradis Perdu: Souvenirs d'Enfance* (Paris: Albin Michel, 1947), 48:

> La plus lointaine image que j'ai gardée de ma mère est exactement conforme à son portrait, peint par J. S. Sargent, en 1879. Elle est grande (1 m. 73), mince et fine, son teint éclatant, ses yeux couleur de noisette claire remontent un peu aux tempes, à la chinoise, ce qui donne à son sourire quelque chose d'énigmatique. Sa tête, petite, qu'elle tient très droite est chargée de lourdes nattes cuivrées. Sa physionomie est réservée, elle rit peu. Ses mains sont ravissantes.
>
> Quand elle est seule ou avec des intimes, son regard devient souvent mélancolique et semble poursuivre quelque souvenir au fond du passé, je sais alors qu'elle songe au petit enfant qu'elle a perdu.
>
> Dans mon enfance elle était très sauvage et fuyait les visites et la vie mondaine [E]t à fuir de plus en plus les étrangers.

Even acquaintances commented on the likeness: "As I was looking for the fiftieth time at Sargent's 'Madame P,' I heard two distinguished French artists criticizing it. They liked everything about it save the face, but commended the artist for faithful adherence to nature even here"; "Notes on the Salon," *American Register*, 8 May 1880, 8.

On the death of Henri, see Pailleron, *Le Paradis Perdu*, 46: "Fièvre typhoïde surtout, diphtérie, etc. . . . Leur plus jeune fils Henri, atteint par cette maladie qui alors pardonnait rarement, succomba dans leurs bras. Ma mère écrasée par la plus terrible des douleurs ne s'en remit que de longues années plus tard. . . ."

Gifford, *Ruins of the Parthenon*

1. "Sanford Gifford," *Art Journal* 6 (1880): 319, quoted in Ila Weiss, "Sanford Robinson Gifford (1823–1880)" (Ph.D. diss. Columbia University, 1968), 325.

2. John F. Weir, "Sanford R. Gifford, His Life and Character as Artist and Man: Address by Prof. John F. Weir, at the Gifford Memorial Meeting of the Century, Friday Evening, November 19th, 1880," in *Catalogue of Valuable Oil Paintings, Works of the Famous Artist, Sanford R. Gifford, N.A., Deceased. . . .* (New York, 11–12 April 1881), 8.

3. Kevin J. Avery and Franklin Kelly, eds., *Hudson River School Visions: The Landscapes of Sanford R. Gifford* (New York: Metropolitan Museum of Art, 2003).

4. Heidi Applegate, "A Traveler by Instinct," in ibid., 69.

5. The drawing is reproduced in Weiss, "Gifford," 323.

6. James Gifford to Jervis McEntee, 21 April 1881, CGA Archives; I am grateful to Sarah Cash and Marisa Bourgoin for bringing this letter to my attention.

Brooke, *A Pastoral Visit*

1. Richard Norris Brooke to Directors of the Corcoran Gallery, 18 April 1881, Office of the Director, MacLeod, Barbarin, and McGuire Correspondence, 1869–1908, CGA Archives.

2. F. E. Y., "Artists at Home: Richard Norris Brooke," *Washington Times*, 9 January 1914, 10.

3. Guy McElroy, "Introduction: Race and Representation," in *Facing History: The Black Image in American Art, 1710–1940* (San Francisco: Bedford Arts Publishers, in association with the Corcoran Gallery of Art, 1990), xviii; Claudia Vess, "*A Pastoral Visit*," in ibid., 93; Lisa E. Farrington, *Creating Their Own Image: The History of African-American Women Artists* (New York: Oxford University Press, 2005), 8–9; and Angela L. Miller, Janet C. Berlo, Bryan J. Wolf, and Jennifer L. Roberts, *American Encounters: Art, History, and Cultural Identity* (Upper Saddle River, N.J.: Pearson/Prentice Hall, 2008), 287.

4. Miller et al., *American Encounters*, 287; and Linda Crocker Simmons, "*A Pastoral Visit*," in Eleanor Heartney et al., *A Capital Collection: Masterworks from the Corcoran Gallery of Art* (London: Third Millennium Publishing, in association with the Corcoran Gallery of Art, 2002), 100.

5. Michael Quick, "Homer in Virginia," *Los Angeles County Museum of Art Bulletin* 24 (1978): 62–66.

6. Richard Norris Brooke, "Record of Work . . . since My Departure for Paris in 1878," c. 1908, National Portrait Gallery/Smithsonian American Art Museum Library, Washington, D.C.

7. Mark Herlong, "Vernon Row: An Early Washington Arts Community," MS, 4, 13, CGA Curatorial Files.

8. Mary Cable, *American Manners and Morals: A Picture History of How We Behaved and Mis-behaved* (New York: American Heritage, 1969), 186–87.

9. Leila Mechlin, "A Gallery of Popular Art: The Corcoran Collection in

Washington," *Booklover's Magazine* 4, no. 1 (July 1904): 28–31. "Notes of Art and Artists," *Washington Star*, 2 May 1920, 26, calls it an antebellum subject.

10. F. E. Y., "Artists at Home."

11. Parke Rouse, Jr., *Virginia: A Pictorial History* (New York: Charles Scribner's Sons, 1975), 218, 218 (illus.); Vess, "A Pastoral Visit," 94; and Andrew J. Cosentino and Henry Glassie, *The Capital Image: Painters in Washington, 1800–1915* (Washington, D.C.: Smithsonian Institution Press, 1983), 155.

12. Richard Norris Brooke to Directors of the Corcoran Gallery, 18 April 1881; "The Round of Society: Ushering in the New Year with a Busy Week," *Washington Post*, 4 January 1885, 5; "In the Studios," *Washington Post*, 25 December 1893, 4; F. E. Y., "Artists at Home"; and "*Pastoral Visit* Charms Many," *Washington Herald*, 23 August 1931, 11. On reproductions of the painting, see William MacLeod's Curator's Journals, 24 February and 8 May 1882, 27 September 1883, and 26 April 1886, Director's Records, CGA Archives. The work was also reproduced in *Harper's Weekly* 10, no. 14 (1882): 648, as *The Pastor's Visit*.

13. James Henry Moser, "The Fad of Old Masters," *Washington Post*, 18 June 1905, sec. C, 11.

14. Brooke, "Record of Work."

15. "Death Claims Noted Artist," *Washington Herald*, 26 April 1920, 8; "Richard N. Brooke Dead; Prominent D.C. Artist," *Washington Evening Star*, 26 April 1920, 7; "R. N. Brooke Dies in Warrenton," *Washington Post*, 26 April 1920, 3; "Notes of Art and Artists," *Washington Star*, 2 May 1920, 26, 26 (illus.); "Messer and Brooke Paintings to be Exhibited at Corcoran," *Washington Star*, 5 November 1920, 24; and "Notes of Art and Artists," *Washington Star*, 14 November 1920, 27.

Eakins, *Singing a Pathetic Song*

1. Elizabeth Johns, *Thomas Eakins: The Heroism of Modern Life* (Princeton: Princeton University Press, 1983), 135. For an in-depth and fascinating discussion of the history of the pathetic song, as well as some examples, see 134–35 and n34.

2. The dress's loose-fitting bodice as well as its lower, natural waistline and deflating bustle were popular right around 1880. I am grateful to Shannon Bell Price, Senior Research Associate, Costume Institute, The Metropolitan Museum of Art, New York, and to her colleague Joyce Fung, for their research on this dress; emails, 29 September 2009, including images of similar dresses, CGA Curatorial Files.

3. Margaret's brothers were the painters Alexander and Birge Harrison. For the photographs, which survive as glass plate negatives, see Susan Danly and Cheryl Leibold, *Eakins and the Photograph* (Washington, D.C.: Smithsonian Institution Press, for the Pennsylvania Academy of the Fine Arts, 1994), 167–68, nos. 183–93. The perspective study, also in the collection of the Pennsylvania Academy,

is reproduced in Kathleen A. Foster, *Thomas Eakins Rediscovered* (Philadelphia: Pennsylvania Academy of the Fine Arts, 1991), 203. The oil-on-panel study is reproduced in Phyllis D. Rosenzweig, *The Thomas Eakins Collection of the Hirshhorn Museum and Sculpture Garden* (Washington, D.C.: Smithsonian Institution Press, 1977), 93–94. Eakins also made a watercolor after the painting, which he presented to Margaret Harrison as a gift for posing; see Donelson F. Hoopes, *Eakins Watercolors* (New York: Watson-Guptill Publications, 1971), 69.

4. See Mark Tucker and Nica Gutman, "Photographs and the Making of Paintings," in *Thomas Eakins*, ed. Darrel Sewell (Philadelphia: Philadelphia Museum of Art, 2001), 225–38.

5. Ibid., 226.

6. I am grateful to Corcoran American Art Department Intern Abby Foster for creating a Photoshop overlay of the photograph and present-day painting; CGA Curatorial Files.

7. Foster, *Eakins Rediscovered*, 75. I am grateful to Kathleen Foster for discussing this issue with me; notes of a telephone conversation, 25 September 2009, CGA Curatorial Files. Indeed, the present painting may be the only documented example of this working method, long recognized by scholars based on the existence of many nonstandard stretcher sizes in Eakins's oeuvre.

8. See Foster, *Eakins Rediscovered*, 67. The painting does not bear its original tacking edges; Lance Mayer, American Paintings Catalogue Technical Examination Report, 15 April 2005, CGA Conservation Files.

9. The second photograph, in the Lloyd Goodrich Papers, Department of American Art, Philadelphia Museum of Art (PMA), marked on its reverse as "#148" (photocopy, CGA Curatorial Files), must be a cropped print from the same negative. The painting's signature and date, cleverly rendered in perspective on the floor at lower left, reveal Eakins's graceful penmanship, learned from his writing-master father.

10. The reworking may have occurred after the painting's inclusion in the academy's Fifty-third Annual Exhibition, 24 October–9 December 1882. I am grateful to Kathleen Foster for suggesting the possibility of Margaret; on a cataloguing sheet filed with the PMA photograph, the Eakins scholar Lloyd Goodrich surmised that the artist may have made the change after his marriage to Susan in January 1884. For a photograph of Margaret from c. 1881, see Foster, *Eakins Rediscovered*, 13; like the painted face visible in the two archival photographs, Margaret's is fleshy with full lips, a broad nose, and rather dark-featured. On the reworking of the face and of other areas in the painting, see Mayer, Technical Examination Report.

11. Johns, *Eakins*, 133n31.

12. This end was also a beginning: the Corcoran canvas represents the artist's first of several portrayals of a woman

demonstrating a professional talent as a composition's central figure. These works may be seen as the female-oriented counterparts to Eakins's more numerous portraits of men engaged in modern pursuits—swimming, rowing, boxing, and demonstrating surgery.

13. "Pennsylvania Academy Exhibition," *Art Amateur* 8 (1882): 8. Another writer noted the painting's "remorseless fidelity"; "Some American Artists: Various Notable Pictures in the Exhibition," *New York Times*, 15 April 1881, 5.

14. The painting was first shown in 1881 at the Fourth Annual Exhibition of the Society of American Artists, in New York; Mariana Van Rensselaer, "The New York Art Season," *Atlantic Monthly* 48, no. 286 (August 1881): 198–99.

15. Edward Strahan [Earl Shinn], "Exhibition of the Society of American Artists," *Art Amateur* 4, no. 6 (May 1881): 117.

16. Coates had received the canvas depicting the artist and his students posed nude in a landscape as a result of commissioning a picture that he "'confidentially' had hoped 'might some day become part of the Academy collection'"; in the same letter, he asked to exchange *Swimming* for another painting "more acceptable for the purpose which I have always had in view"; Edward H. Coates to Thomas Eakins, 27 November 1885, in Charles Bregler's Thomas Eakins Collection at the Pennsylvania Academy of the Fine Arts, quoted in Kathleen A. Foster, "The Making and Meaning of *Swimming*," in *Thomas Eakins and the Swimming Picture*, ed. Doreen Bolger and Sarah Cash (Fort Worth: Amon Carter Museum, 1996), 13n1 and 25n47. See also Bolger, "'Kindly Relations': Edward Hornor Coates and *Swimming*," in ibid., 44n47.

17. Typescripts of letters from J. E. D. Trask to Corcoran director C. Powell Minnegerode, 16 November 1918 and 1 November 1919, CGA Curatorial Files.

Harnett, *Plucked Clean*

1. Versions are at Huntington Library, San Marino, Calif.; Columbus Museum of Art; Butler Institute of Art, Youngstown, Ohio; and the Fine Arts Museums of San Francisco.

2. Barbara Groseclose, "Vanity and the Artist: Some Still-Life Paintings by William Michael Harnett," *American Art Journal* 19, no. 1 (Winter 1987): 59n22; Wendy Bellion, "*Plucked Clean*," in *Deceptions and Illusions: Five Centuries of Trompe l'Oeil Painting*, ed. Sybille Ebert-Schifferer (Washington, D.C.: National Gallery of Art, 2002), 158. On Braun and Harnett, see Douglas R. Nickel, "Harnett and Photography," in *William Michael Harnett*, ed. Doreen Bolger, Marc Simpson, and John Wilmerding (New York: Metropolitan Museum of Art, 1992), 180–82.

3. Roxanna Robinson, "Common Objects of Everyday Life," in Bolger, Simpson, and Wilmerding, *Harnett*, 162–63; and Elizabeth Jane Connell, "After the Hunt," in ibid., 282.

Cox, *Flying Shadows*

1. William A. Coffin identified Cox's landscape as "painted on the banks of the Ohio [River] nearly Bellaire." See "Kenyon Cox," *Century* 41, no. 3 (January 1891): 337.

2. Cox to Jacob Dolson Cox, 3 June 1885, in *An Artist of the American Renaissance: The Letters of Kenyon Cox, 1883–1919*, ed. H. Wayne Morgan (Kent, Ohio: Kent State University Press, 1995), 55.

3. "The Pennsylvania Academy of the Fine Arts—Sixtieth Annual Exhibition," *Studio*, n.s., 5, no. 11 (15 February 1890): 106. The painting also appeared in the Seventh Annual Exhibition of the Society of American Artists in New York (1884); the Inter-State Industrial Exhibition in Chicago (1884); and the Fifth Annual Exhibition of Contemporary American Art in Boston (1885).

4. Cox also selected *Flying Shadows* as one of the works to represent his oeuvre in a 1911 monographic exhibition at the Art Institute of Chicago.

5. "Society of Artists," *New York Times*, 25 May 1884, 9.

6. "The Retrospective Exhibition," *New York Evening Post*, 10 December 1892, sec. 4, 1.

7. John Davis, "Kenyon Cox, between Figure and Landscape" (lecture, in "Between Barbizon and Giverny: Territories of Modern Landscape Painting Conference," 28 April 2007, Musée d'Art Américain Giverny).

8. Coffin, "Kenyon Cox," 337; Minna C. Smith, "The Work of Kenyon Cox," *International Studio* 32, no. 125 (July 1907): viii (engraving after painting), xi; and "The Society of American Artists," *New York Sun*, 1 June 1884, 3.

9. The artist exhibited both canvases at the World's Columbian Exposition in Chicago in 1893.

10. Cox, quoted in H. Wayne Morgan, *Keepers of Culture: The Art-Thought of Kenyon Cox, Royal Cortissoz, and Frank Jewett Mather, Jr.* (Kent, Ohio: Kent State University Press, 1989), 49.

11. Cox to Jacob Dolson Cox, 5 September 1879, in *An American Art Student in Paris: The Letters of Kenyon Cox, 1877–1882*, ed. H. Wayne Morgan (Kent, Ohio: Kent State University Press, 1986), 172.

12. Kenyon Cox, "The Philosophy of the High Sky-Line," *Studio* 2 (27 October 1883): 188–90.

13. Cox, in Morgan, *Letters, 1883–1919*, 138.

14. Ibid., 112–13.

15. "Low Prices Paid for White Pictures," *New York Times*, 12 April 1907, 9.

16. "Register of Paintings Belonging to the Corcoran Gallery of Art, 1869–1946," Curatorial Records, CGA Archives. See C. Powell Minnegerode, Notes on a conversation with James Parmelee and Charles A. Platt, 22 November 1922, CGA Archives.

17. "The World of Art: Some of the Paintings to Be Seen in Washington," *New York Times*, 20 May 1923.

Sargent, *Margaret Stuyvesant Rutherfurd White (Mrs. Henry White)*

1. Henry James to Grace Norton, 5 February 1888, Houghton Library, Harvard University, in *Henry James Letters*, vol. 3, *1883–1895*, ed. Leon Edel (Cambridge, Mass.: Belknap Press of the Harvard University Press, 1980), 215. The letter continues: "She has never read a book in her life, but she is 'high up' all the same." James's claim should not be taken literally. Writing from Elizabeth Sewell's Ashcliffe school in 1873, Margaret "Daisy" expressed regret at the curriculum's focus on poetry to the exclusion of other literature; Julia K. Lehnert, Archivist, Hampton National Historic Site, Towson, Md., to the author, email, 3 September 2009; I am grateful to Lehnert for her generous assistance with White's archival materials in her care. There are also relevant materials in the Stuyvesant-Rutherfurd Papers at the New-York Historical Society. As her husband's biographer later wrote: "she talked well, with animation and distinction, and she had grace and poise. . . . The future Lord Haldane wrote her long letters on literary topics, discussing Zola and Stevenson"; Allan Nevins, *Henry White: Thirty Years of American Diplomacy* (New York: Harper & Brothers, 1930), 76–77.
2. She was the daughter of the astronomer Lewis Morris Rutherfurd and descended, on the part of both father and mother, from notable colonial families; Cuyler Reynolds, *Genealogical and Family History of Southern New York and the Hudson River Valley: A Record of the Achievements of Her People in the Making of a Commonwealth and the Building of a Nation* (New York: Lewis Historical, 1914); and B. A. Gould, *Memoir of Lewis Morris Rutherfurd, 1816–1892* (Washington, D.C.: National Academy of Sciences, 1895). Her social circle included the New York Joneses (Edith Wharton's family) and the Vanderbilts, to whom she was related by marriage. Her widower would, at the age of seventy, marry a Vanderbilt; "Henry White Weds Mrs. Wm. D. Sloane," *New York Times*, 4 November 1920.
3. Edith Wharton, *A Backward Glance* (1934; New York: Library of America, 1990), 818–19. She continued: "[T]he young gods and goddesses I used to watch strolling across the Edgerston lawn were the prototypes of my first novels."
4. Ibid., 818; and Nevins, *White*, 33.
5. Nevins, *White*, 33. Nevins, opp. 36, includes an undated photograph of the youthful White.
6. Mrs. Richard Aldrich, quoted in ibid., 34–35. One gains a complementary sense of White's strong personality from Henry James's note about her from 1899: "I'm so glad you saw & liked Mrs White: she's far & away one of the most charming women I've ever known. Yet I see her rarely—one can't live in her world & do any work or save any money or retain control of 3 minutes of one's time. So a

gulf separates us. I'm too poor to see her! She has extraordinary harmony & grace"; Henry James to Henrietta Reubell, 12 November 1899, in *Henry James: A Life in Letters*, ed. Philip Horne (London: Allen Lane, 1999), 329.
7. Quoted in Nevins, *White*, 36. White was stationed from 1884 to 1905 in London, barring the years 1893 to 1897; from 1897 he was first secretary. He went on to serve as ambassador to Italy (1905–7) and France (1907–9); he was among the American signers of the Treaty of Versailles ending World War I. Theodore Roosevelt wrote, "The most useful man in the entire diplomatic service, during my Presidency and for many years before, was Henry White"; Roosevelt, *Theodore Roosevelt: An Autobiography* (New York: Charles Scribner's Sons, 1920), 356. Various memoirs record Margaret White's success as a diplomatic hostess. See, for example, Frederick Townsend Martin, *Things I Remember* (New York: John Lane, 1913), 100; and Princess Lazarovich-Hrebelianovich [Eleanor Calhoun], *Pleasures and Palaces* (London: Eveleigh Nash, 1916), 342.
8. The Whites had two children: Muriel (1880–1943), who married Count (Ernst Hans Christoph Roger) Hermann Seherr-Thoss, a Prussian aristocrat, in Paris in 1909 and lived in Germany for the rest of her life; and John Campbell White (1884–1967), who served in the U.S. Foreign Service as a diplomat from 1914 to 1945. White did not accompany her husband to the United States in early 1883, where he had to go for family business, nor to Vienna for the last six months of the year when he served as secretary to the American legation. She, instead, stayed with their daughter in London and then Paris.
9. Her husband had earlier chosen the more established Frenchman, and Sargent's occasional teacher, Léon Bonnat for his (1880, Corcoran Gallery of Art). See Nevins, *White*, 40.
10. Costume historians agree to the high quality of White's gown, although there is no consensus as to its maker. Diana De Marly asserts that it is by Charles Frederick Worth; De Marly, *Worth: The Father of Haute Couture* (London: Elm Tree Books, 1980), 114. We know that White later wore Worth—a memorandum from 1897 begins: "I wore my black brocade Worth dress, with tulle sleeves and big yoke on one side, a diamond and pearl chain, and diamond collar with a row of pearls; an aigrette in my hair"; quoted in Nevins, *White*, 89. Aileen Ribeiro, of the Courtauld Institute of Art, however, has pointed out the relative simplicity of the painted ensemble and suggested that Émile Pingat is a likelier designer; note, 10 May 2006, CGA Curatorial Files.
11. For the portrait of Gautreau, see Richard Ormond and Elaine Kilmurray, *The Early Portraits*, vol. 1 of *John Singer Sargent: Complete Paintings* (New Haven: Yale University Press, published for The Paul Mellon Centre for Studies in British

Art, 1998), 112–18. White also wrote of the Gautreau portrait: on 24 February 1883, "Got a line from Sargent saying picture & dress arrived. He has begun painting Mme. Gautreau, the beauty we saw at Mrs. Mortons"; on 6 March 1883, after learning that her portrait would not go to the Salon, "I suppose he has not done a stroke to my portrait since he left but has been working on some other thing which he means to send & which he considers better done perhaps. I know he has been doing a Mme. Gautraud [*sic*] who is very beautiful"; both Margaret White to Henry White, National Park Service/Hampton National Historic Site, MS 1004—Henry White Family Papers, Margaret S. R. White Papers/Personal Correspondence; February–March 1883 (collection not fully processed) (hereafter Hampton National Historic Site, Personal Correspondence).
12. Many writers on the picture have followed the tradition that White's stay in the South was due to her ill health, the lingering effects of typhoid: see, for example, Stanley Olson, *John Singer Sargent: His Portrait* (New York: St. Martin's Press, 1986), 100; Ormond and Kilmurray, *The Early Portraits*, 106. Edith Jones (later Wharton), however, reported in November 1882, on a visit to Paris, that Daisy White "looked wonderful and that the new baby was delightful"; R. W. B. Lewis, *Edith Wharton: A Biography* (New York: Harper & Row, 1975), 46. And White's own diary entries for the period up through mid-November do not mention illness; instead, they are filled with notations of social engagements and shopping, such as hosting a dinner on 4 November that includes among its guests Sargent along with Colonel and Mrs. John Hay and five others. In mid-November the Whites left for the hunting lodge of the vicomte de Mountsaulnin, le Domaine de la Grande-Garenne, in Neuvy-sur-Barangeon; Margaret S. R. White, Diary, 1882, Hampton National Historic Site. Correspondence from White to her husband in February and March 1883 likewise omits any mention of illness.
13. Sargent to Vernon Lee, 10 February 1883, quoted in Richard Ormond, "John Singer Sargent and Vernon Lee," *Colby College Quarterly* 9, no. 3 (September 1970): 173.
14. "Mama has seen the portrait & is of course disappointed. . . . Mama thinks the portrait is too sad looking & and not enough flattered, in spite of which she says it is a most marvelous likeness. It would have amused you to have been present yesterday at the interview between her and Sargent. She tremendously in earnest & bent upon making him see the faults she saw, he not saying much, listening to all she had to say & invariably ending by 'I *am sorry* Mrs. R. I cannot agree with you.' Mama finding that she produced no impression on S. got all the more excited & earnest. Fortunately Sargent's calm determination

prevented any row. . . . You would have enjoyed it *immensely*! Mama did not like the eye brow lifted up, which is S.'s pet hobby about my face. She thought he should have made the mouth smaller than nature. No bumps on the forehead, etc., etc."; Margaret White to Henry White, 7 February 1883, Hampton National Historic Site, Personal Correspondence.
15. Margaret White to Henry White, 13 February 1883, Hampton National Historic Site, Personal Correspondence. Patron and painter did remain in touch. It was at a dinner hosted by the Whites on 26 May 1894 that Evan Charteris, Sargent's future and principal biographer, first met the artist; National Park Service/ Hampton National Historic Site, MS 1004—Henry White Family Papers, Diaries and Scrapbooks: Guest Book, 1894. Other members of the small party included G. W. and Lady Betty Balfour.
16. Sargent to Margaret Rutherfurd White, 15 March 1883, John Singer Sargent Letters, Archives of American Art, Smithsonian Institution, Washington, D.C. The letter continues: "Your frame is charming. One consolation has been that I know you do not care a bit whether your portrait is exhibited or not. Is not that true? May I send it to the academy? P.S. I send the Boit children to the Salon." White's letters to her husband reveal that she initially did care about the Salon exhibition, although Sargent's note defused her pique; Margaret White to Henry White, 6 and 7 March 1883, Hampton National Historic Site, Personal Correspondence. The current frame was put on the painting sometime after 1949.
17. There are no known extant drawings or preparatory studies for the work, as opposed to the bounty of drawings related to the Gautreau campaign. White's was reportedly the first portrait Sargent finished in his new studio on the fashionable boulevard Berthier, to which he had moved in early 1883; Ormond and Kilmurray, *The Early Portraits*, 106.
18. It was also one of six illustrations to the first major monographic article devoted to him in the art press; R. A. M. Stevenson, "J. S. Sargent," *Art Journal* 14 (March 1888): 65–69. The wood engraving (67) shows White's head, right arm, and fan in significantly different positions, prompting some to speculate that Sargent made major changes to the portrait after 1888.
19. "The Exhibition of the Royal Academy," *Art Journal* 10 (1884): 278; and "The Royal Academy (Fifth and Concluding Notice)," *Athenaeum* 83, no. 2956 (21 June 1884): 394.
20. "The Royal Academy: IV," *Graphic* 29, no. 758 (7 June 1884): 562.
21. Alfred de Lostalot, "Exposition Internationale de Peinture (Galerie Georges Petit)," *Gazette des Beaux-Arts* 27, no. 31 (June 1885): 531.
22. Henry James to Elizabeth Boott, 2 June 1884, in Edel, *James Letters*, 42.
23. In 1897, recounting an evening at Balmoral Castle with Queen Victoria,

White reported with pleasure that Victoria "told Lady Lytton she thought I had such a pleasant voice and speech (I suppose this she does not expect from Americans) and that she thinks me very pretty!"; quoted in Nevins, *White*, 91.
24. The original is in French: "Elle avait une rare nature, grande et sans petitesses quelconques, surtout sans sentiments de jalousie, et un très-grande coeur." He continued: "Pendant les trente-six années de notre vie ensemble nous n'avons point eu de querelle—quelque petite que ce fût—ni même de malentendu—jamais rien à expliquer; car nous nous sommes parfaitement entendus depuis le commencement"; White to his half brother, c. 4 September 1916, quoted in ibid., 331.

Cassatt, *Young Girl at a Window*
1. Achille Segard, *Mary Cassatt: Un Peintre des Enfants et des Mères* (Paris: Librairie Paul Ollendorf, 1913), quoted in Nancy Mowll Mathews, *Cassatt: A Retrospective* (Southport, Conn.: Hugh Lauter Levin Associates, 1996), 100.
2. I am indebted to Pamela A. Ivinski, Research Director, Mary Cassatt Catalogue Raisonné Committee, for this and other information about the painting.
3. The model was first identified as "Susan" in Adelyn Dohme Breeskin, *Mary Cassatt: A Catalogue Raisonné of the Oils, Pastels, Watercolors, and Drawings* (Washington, D.C.: Smithsonian Institution Press, 1970), in which the painting is listed as *Susan on a Balcony Holding a Dog*. The painting was first exhibited under that title in *Mary Cassatt, 1844–1926* at the National Gallery of Art, Washington, D.C., in 1970. The catalogue for that exhibition adds (24) that "Susan was a cousin of Mathilde Vallet [*sic*], Cassatt's housekeeper-maid." No additional information on "Susan" has emerged since 1970. I am grateful to Pamela Ivinski for clarifying this issue.
4. Harvey Buchanan, "Edgar Degas and Ludovic Lepic: An Impressionist Friendship," *Cleveland Studies in the History of Art* 2 (1997): 70.
5. The view looks southeast across the square toward a private street, the avenue Frochot, where a building that closely resembles the edifice in the painting, with its distinctive roof shape and studio skylights, still stands. The 2, rue Duperré building is today the Hôtel Villa Royale. It is not known exactly when Cassatt used the Duperré studio. Degas stated in a letter of 26 October 1880, "The Cassatts have returned from [their summer home in] Marly[-le-Roi]. Mlle. Cassatt is settling in a ground floor studio which does not seem too healthy to me"; Marcel Guérin, ed., *Edgar Germain Hilaire Degas: Letters* (Oxford: Bruno Cassirer, 1947), 63. If this letter refers to the Duperré building, Cassatt may have moved to the upper floor or had access to it for the purposes of this painting; she had a studio there until about 1884. I am grateful to Pamela Ivinski for identifying this site and for information about Cassatt's studios.

6. Checklist for the exhibition, in Charles S. Moffett et al., *The New Painting: Impressionism, 1874–1886* (San Francisco: Fine Arts Museums of San Francisco, 1986), 445. M. Berend also lent a painting by Armand Guillaumin.
7. Gustave Geffroy, *La Justice*, 26 May 1886, in Moffett et al., *The New Painting*, 449.
8. George Auriol, *Le Chat Noir*, 22 May 1886, in ibid.
9. Maurice Hermel, *La France Libre*, 27 May 1886, in ibid.
10. That is the first record of the painting in the Durand-Ruel archives; Paul-Louis Durand-Ruel and Flavie Durand-Ruel, email to Susan Larkin, 7 April 2009.
11. "Opening of the Academy's Seventy-second Annual Exhibition of Paintings and Sculpture," *Philadelphia Evening Telegraph*, 17 January 1903.
12. "Annual Exhibition of the Academy of the Fine Arts," *Philadelphia Public Ledger*, 18 January 1903, 5.
13. "Studio Talk—Philadelphia," *Studio* 30 (October 1903): 79–82.
14. "Art Exhibitions: Opening of the Season—Paintings by Mary Cassatt and Louis Loeb," *New York Daily Tribune*, 11 November 1903.
15. "Art and Artists," 10.
16. For an image of the painting, see http://www.worcesterart.org/Collection/American/1909.15.html.
17. Durand-Ruel & Sons to Mr. F.B. MacGuire, 13 January 1909, CGA Curatorial Files. The Worcester Art Museum purchased *Woman and Child* later in 1909.

Ulrich, *In the Land of Promise, Castle Garden*
1. "Art," *Churchman*, 10 May 1884, in Thomas B. Clarke Scrapbooks, reel N598, frame 259, Archives of American Art, Smithsonian Institution, Washington, D.C. (hereafter AAA).
2. See "A Scene in Castle Garden," *Harper's Weekly* 33, no. 1676 (2 February 1889): 86–87, which describes Ulrich's composition as "but a single view of the kaleidoscopic stream which pours from Europe through Castle Garden into the United States." Frederick Juengling made the wood engraving after the painting, which was also reproduced in Sylvester Rosa Koehler, *American Art* (New York: Cassell and Company, 1886). According to "Monthly Record of American Art," *Magazine of Art* 7 (July 1884): xxxiii: "a limited number of signed artist's proofs on Japanese paper" were also produced from Juengling's wood engraving. The Corcoran owns one of this limited edition of signed artist's proofs (acc. no. 1999.8.20). The inscription "Copyright by Charles F. Ulrich" on *In the Land of Promise* suggests that the artist anticipated the translation of his painting into a wood engraving.
3. For a detailed account of Ulrich's early life and career, see Andrea Popowich Meislin, "Charles Frederick Ulrich in New York, 1882–1884" (master's thesis, University of Arizona, 1996).

4. In addition to his working-class themes, Ulrich also painted genteel subjects like the 1883 *Moment Musicale* (Fine Arts Museums of San Francisco).
5. *Annual Reports of the Commissioners of Emigration of the State of New York, from the Organization of the Commission, May 5, 1847 to 1860* (New York, 1861), 187–88. Following the closure of the immigrant landing station at Castle Garden in 1890, the locale served as New York City's Aquarium (1896–1941). In 1946 Congress declared what was left of the historic structure Castle Clinton National Monument. Today the site is the visitor information center for Manhattan's National Parks and Monuments.
6. Contemporary critics consistently identified Ulrich's protagonist as Swedish, likely because a label affixed to the seated woman's trunk reads "Stockholm."
7. "Fifty-ninth Academy, First Notice," *Art Interchange* 7, no. 8 (10 April 1884): 88.
8. Critics noted a kinship between the artist and his largely foreign-born, working-class protagonists. Describing Ulrich's 1883 painting *The Glassblowers* (Museo del Arte de Ponce, Puerto Rico), for example, one writer stated, "Here is a work which displays the sympathetic and interpretive qualities of the profoundest art. The painter has entered into the life of these humble men. They are his brothers; he makes them ours"; "Mr. Ulrich's Glass-Blowers," *Harpers Weekly* 26, no. 1374 (21 April 1883): 251.
9. For documentation of this commission, see Ulrich to Evans, undated, William T. Evans Letters, reel 4055, frames 169–70, AAA. The Corcoran purchased *In the Land of Promise* from Evans in 1900. See *Catalogue of American Paintings Belonging to William T. Evans*, American Art Galleries, New York, 1900, n.p.
10. Late-nineteenth-century viewers of a certain age would have remembered Lind's historic performance at Castle Garden thirty years earlier and made this connection. In the 1889 article in *Harper's Weekly* that accompanied Juengling's engraving after *In the Land of Promise*, the author recalled (86) that Castle Garden was "made sacred by Jenny Lind and the actors and opera singers of long ago."
11. One reviewer described the protagonists in Ulrich's painting as "'real folks,' plain, solid, and well conditioned, lovers of home and family, just the people the waiting West most needs. The young mother, with her sturdy babe at her breast . . . is a brave, enduring, hopeful woman"; "Art," *Churchman*. St. John Harper, "*Castle Garden—Their First Thanksgiving Dinner*," *Harper's Weekly* 28, no. 1458 (29 November 1884): 783.
12. Moreover, by evoking the national holiday of Thanksgiving, Harper's engraving suggests that these newcomers to America are ready and willing to embrace the traditions of their new culture and reminds the viewer that, with the exception of Native Americans, even the earliest citizens came to this nation as immigrants.

13. *Art Age*, August 1885, 11; and "Fifty-ninth Academy, First Notice," *Art Interchange*, 88.
14. Edward J. Nygren and Andrea C. Wei, "*In the Land of Promise—Castle Garden*," in Nygren and Peter C. Marzio, *Of Time and Place: American Figurative Art from the Corcoran Gallery* (Washington, D.C.: Corcoran Gallery of Art and Smithsonian Institution Traveling Exhibition Service, 1981), 70.

Blakelock, *Moonlight*
1. Elliott Daingerfield, *Ralph Albert Blakelock* (New York: privately printed, 1914), 26.
2. Abraham A. Davidson, *Ralph Albert Blakelock* (University Park: Pennsylvania State University Press, 1996), 106–9, states that Blakelock began these undated works, including *Moonlight*, in the mid-1880s and pursued the subject until his confinement in 1899. Davidson bases this dating on four factors: the popularity of the nocturne among artists of this period; the artist's use of nocturnal effects in his Indian Dance pictures, also likely dating to this period; his declining fortunes and health during this period, when "he would have found these off-times of day particularly appropriate"; and the fact that several of these landscapes were acquired in the middle of this period.
3. Davidson, ibid., 109, writes that Blakelock's trees are not "amorphous neutral shapes but . . . living and growing entities, with twigs growing from small branches and those branches growing from larger ones. . . ."
4. These techniques were described by Blakelock's first biographer; see Elliott Daingerfield, *Ralph Albert Blakelock* (New York: Frederic Fairchild Sherman, 1914), 19, quoted in Mark Mitchell, "Radical Color: Blakelock in Context," in Karen O. Janovy, *The Unknown Blakelock* (Lincoln, Nebr.: Sheldon Memorial Art Gallery, 2008), 33.
5. Mitchell, "Radical Color," 29 and passim.
6. The popularity of, and market for, French Barbizon painting expanded rapidly in 1880s America. For example, works by Henri-Joseph Harpignies and Jean-Baptiste Camille Corot were in the collection of the Metropolitan Museum of Art, New York, by 1886 and 1887, respectively.
7. Lloyd Goodrich, *Ralph Albert Blakelock Centenary Exhibition in Celebration of the Centennial of the City College of New York* (New York: Whitney Museum of American Art, 1947), 26, quoted in Davidson, *Blakelock*, 112–14.
8. Cora noted that Blakelock, "seeing a scratch in the surface of the bathtub[,] . . . immediately made a sketch of what he saw." This statement and the one in the text are quoted from Kevin Avery et al., *American Paradise: The World of the Hudson River School* (New York: Harry N. Abrams for the Metropolitan Museum of Art, 1987), 218, quoted in Davidson, *Blakelock*, 114.

9. *Moonlight* was shown, for example, in the Seventy-first Annual Exhibition of the National Academy of Design and at the Saint Louis Exposition and Music Hall, both in 1896, and in 1901 at the Pan-American Exposition in Buffalo.
10. "Trying to Call Blakelock Back to His Art," *New York Times Magazine*, 2 April 1916, 7.

Bierstadt, *The Last of the Buffalo*
1. Quoted in "No Place for Bierstadt," *New York World*, 15 May 1889, 12.
2. The date of the painting was changed from c. 1889 to 1888 based on the painting's exhibition at the Union League Club, New York, in January 1889. See Dorothy Moss, Assistant Curator of American Art, to Registrar, memorandum, 22 March 2000, CGA Curatorial Files.
3. "Bierstadt Excluded from the Paris Exposition," *Springfield (Mass.) Republican*, 21 June 1889, 4; "American Artists in Luck," *New York World*, 17 March 1889, 4; "Real American Art," *New York World*, 31 March 1889, 4; "Art Notes," *Boston Daily Evening Transcript*, 17 April 1889, 10; Montezuma [Montague Marks], "My Note Book," *Art Amateur* 20, no. 5 (April 1889): 98–99; and "Wrangling in the Fine Art Section," *New York World*, 13 May 1889, 1.
4. "No Place for Bierstadt," *New York World*.
5. "Colonel North's New Palace," *British Architect*, 6 September 1889, 173, was the first mention of the sale. The second came the following year in "At the Big Show," *Minneapolis Tribune*, 17 September 1890, 6.
6. Washington, D.C., Corcoran Gallery of Art, 27 May–16 July 1890, no cat.; *Minneapolis Industrial Exposition Fifth Annual Exhibit*, Minneapolis, September 1890, cat. no. 528.
7. "No Place for Bierstadt," *New York World*.
8. Ibid.
9. Dare Myers Hartwell and Helen Mar Parkin, "Corcoran and Cody: The Two Versions of *The Last of the Buffalo*," *Journal of the American Institute for Conservation* 38, no. 1 (1999): 47, 50.
10. Ibid., 50–52.
11. William MacLeod's Curator's Journals, 18 January 1878, Director's Records, CGA Archives; and conversation between Dare Hartwell, Director of Conservation, Corcoran Gallery of Art, and author, 10 August 2009.
12. *Catalogue of the Important and Valuable Collection of Pictures, Water Colour Drawings, 556 Original Sketches by Melton Prior, and Engravings, &c Which Will be Sold by Auction by Messrs. G. A. Wilkinson & Son . . . on Friday, the 18th Day of March 1898: "Avery Hill," Eltham. . . .* (London: G. A. Wilkinson & Son, 1898), in "Art Sales and Exhibition Catalogs, 1810–1898," Special Collections, Getty Research Institute, Los Angeles.
13. London, Hanover Gallery, 26 October–24 December 1891, cat. unlocated. On the sale, see "Artist Albert Bierstadt,"

Bloomington (Ind.) Telephone, 3 February 1891, n.p.; "Cable Brevities," *Chicago Tribune*, 1 November 1891, 9; "People in General," *Washington Post*, 2 November 1891, 4; "American Notes," *Studio* 6, no. 43 (7 November 1891): 399; "Chicago and the West," *Forest and Stream: A Journal of Outdoor Life, Travel, Nature Study, Shooting, etc.* 37, no. 17 (12 November 1891): 331; and "About People," *Christian Union* 44, no. 22 (28 November 1891): 1067.
14. "Daniel G. Reid Dies of Pneumonia at 66," *New York Times*, 18 January 1925, 28.
15. *Catalogue, Art Property Collected by the Late Mrs. A. G. Hunt and Important Works in Oil Belonging to the Estate of the Late Edward Bierstadt*, American Art Association, New York, 22–23 January 1908, lot 75. On the purchaser, see American Art Association Records, 1853–1924, reel 4478, frame 724, Archives of American Art, Smithsonian Institution, Washington, D.C.; and *American Art Annual, 1909–1910* 7 (1910): 18. Mary Bierstadt to Directors of the Corcoran Gallery of Art, 10 February 1909, Office of the Director/Correspondence, Frederick B. McGuire Records, 1908–1915, CGA Archives. Bierstadt may have passed it on to his brother to protect the painting from being seized as an asset when Bierstadt, a notorious spendthrift, faced loan foreclosures in London and New York in 1894; "News of the Art World," *New York Times*, 6 August 1894, 4; and "Judgements against Albert Bierstadt," *New York Times*, 17 January 1895, 13.
16. "Union League Election," *New York Herald*, 11 January 1889, 10.
17. Henry Ives Bushnell, *John Mix Stanley, Artist-Explorer* (Washington, D.C.: Government Printing Office, 1925), 6.
18. Daniell Cornell, *Visual Culture as History: American Accents* (San Francisco: Fine Arts Museums of San Francisco, 2002), 84.
19. Nancy K. Anderson and Linda S. Ferber, *Albert Bierstadt: Art and Enterprise* (New York: Hudson Hills Press, in association with the Brooklyn Museum, 1990), 101.
20. Ibid., 101–2.
21. Ibid., 103.
22. Ibid., 103–4.
23. Henry Guy Carleton, "The Last of the Buffalo: An Entrancing View of Bierstadt's Great Painting," *New York World*, 10 March 1889, 22; and Carleton, *The Last of the Buffalo* (n.p: n.p., 1889). The pamphlet reprints all but the last four paragraphs of Carleton's article. A copy of pamphlet can be found in "Scrapbook," 7 March 1886–19 May 1888, 25, CGA Archives. Bierstadt enclosed this pamphlet in his letter to Francis S. Barbarin, 23 May 1890, Office of the Director, MacLeod, Barbarin, and McGuire Correspondence, 1869–1908, CGA Archives.
24. *Art Amateur*, January 1888, 28, as quoted in Anderson and Ferber, *Bierstadt*, 252.

25. Peter Hassrick, *The American West: Out of Myth, into Reality* (Washington, D.C.: Trust for Museum Exhibitions, 2000), 45.
26. Zaplin-Lambert Correspondence, Bierstadt Photogravure file (2002.9), CGA Curatorial Files.
27. L. K., "French Talk of the Time," *New York Times*, 1 October 1889, 9.

Inness, *Sunset in the Woods*
1. *Catalogue of the Private Art Collection of Thomas B. Clarke* (New York: American Art Galleries, 1899).
2. Clarke to Frederick B. McGuire and S. H. Kauffmann, 17 March 1891, CGA Archives.
3. Clarke to the Trustees of the Corcoran Art Gallery, 9 June 1891, CGA Archives.
4. Clarke to McGuire, 15 July 1891, CGA Archives.
5. Clarke to S. H. Kauffmann, 3 August 1891, CGA Archives. On 2 August Inness acknowledged the receipt of four thousand dollars, suggesting that Clarke took a 20 percent brokerage fee. Clarke to Kauffmann, 3 August 1891; Inness to Clarke, 2 August 1891, Princeton University Library. Two years earlier, Inness said, "I am free to confess that I am greatly indebted to Mr. Thomas B. Clarke for his determined faith in my art, and his persistent efforts to find purchasers for my works; and if art is of use and reputation sound, then is T. B. Clarke deserving of gratitude from the public," reprinted in *George Inness: Writings and Reflections on Art and Philosophy*, ed. Adrienne Baxter Bell (New York: George Braziller, 2006), 135.
6. Inness to Clarke, 22 July 1891, Massachusetts Historical Society. When Clarke relayed Inness's account to the Corcoran, he altered some of the artist's words, most notably changing "several years since" to "seven years ago"; Clarke to the CGA, 27 July 1891, CGA Archives.
7. Nicolai Cikovsky, Jr., *George Inness* (New York: Harry N. Abrams, 1993), 108.
8. George Inness, "A Painter on Painting," in Bell, *Inness*, 60.
9. Bell, *Inness*, 30.
10. Arthur Trumbull Hill, "Early Recollections of George Inness and George Waldo Hill," in Bell, *Inness*, 46. Technical reports on *Sunset in the Woods* note that he painted wet-into-wet and dragged paint over layers that had already dried or into incompletely dried underlayers. Parts of the tree trunks "are painted with thick dabs and convoluted strokes of opaque paint; some of the texture is so pronounced that palette scraping may have been incorporated"; Lance Mayer, American Paintings Catalogue Technical Examination Report, 21 November 2005, CGA Conservation Files.
11. Michael Quick, *George Inness: A Catalogue Raisonné*, 2 vols. (Piscataway, N.J.: Rutgers University Press, 2007), 2:179.
12. Ibid.
13. Clarke to the Trustees of the CGA, New York, 4 June 1891, CGA Archives.

Robinson, *The Valley of the Seine, from the Hills of Giverny*
1. See William H. Gerdts, *Monet's Giverny: An Impressionist Colony* (New York: Abbeville Press, 1993).
2. For Robinson's references to Monet in his diary, see Sona Johnston, *In Monet's Light: Theodore Robinson at Giverny* (Baltimore: Baltimore Museum of Art, 2004), 189–97.
3. See Johnston, *Robinson at Giverny*, 158ff.
4. Theodore Robinson, Diary, 4 June 1892. Robinson's diary from 29 March 1892 to 30 March 1896 can be consulted at the Frick Art Reference Library, New York.
5. The three versions are reproduced in Johnston, *Robinson at Giverny*, 173–75.
6. For color reproductions of the two paintings, see ibid., 83 and 86.
7. Robinson succeeded so literally in selecting a strategic *point de vue* that he was joined on the hillside one morning by a cavalry officer "giving a lesson in topography to a squad of ten or a dozen soldiers—all mounted—pointing to different parts of the valley and asking questions"; Robinson's diary, 25 June 1892.
8. I am grateful to Katherine Bourguignon, Associate Curator, Terra Foundation for American Art Europe, for estimating the distance.
9. The information on Robinson's shoe size is given in his diary notation for 26 December 1893.
10. Robinson did not record that he painted two additional versions of *Valley of the Seine*. One, now in the collection of the Terra Foundation for American Art, was probably a preparatory sketch for the gray-day canvas in the Maier collection. See the catalogue entry for *Étude pour "Vallée de la Seine vue des hauteurs de Giverny"* on the foundation's website: www.terraamericanart.org/collections. The other, now unlocated, may have served a similar function for one of the sunlit versions or may have been produced later in Robinson's New York studio. On 11 May 1895 the New York collector Frank Lusk Babbott called on Robinson "and was enthusiastic over my 'Valley of the Seine' that he saw in Brooklyn—wants something similar but smaller in size." Robinson may have produced a slightly reduced version of the Corcoran's canvas in his studio, intending it for Babbott. The circumstances under which the painting was seen in Brooklyn are unknown. The small version, titled *Valley of the Seine*, is 18⅛ by 21¾ inches. Formerly in the collection of Mr. and Mrs. Raymond Horowitz, it is now unlocated. It is illustrated in Sona Johnston, *Theodore Robinson, 1852–1896* (Baltimore: Baltimore Museum of Art, 1973), 46.
11. Theodore Robinson to J. Alden Weir, 14 August 1892, Weir Family Papers, Department of Archives and Manuscripts, Harold B. Lee Library, Brigham Young University, Provo, Utah, quoted in Johnston, *Robinson*, 172.
12. Robinson's diary, 15 September 1892.
13. Robinson's diary, 30 November 1892.

Abbey, "Who Is Sylvia? What Is She, That All the Swains Commend Her?"

1. William Shakespeare, *Two Gentlemen of Verona*, act 4, scene 2:

Who is Sylvia? What is she?
That all our swains commend her?
Holy, fair, and wise is she;
 The heavens such grace did lend her,
That she might admired be.

Is she kind as she is fair?
 For beauty lives with kindness.
Love doth to her eyes repair,
 To help him with his blindness;
And, being help'd, in habits there.

Then to Silvia let us sing,
 That Silvia is excelling;
She excels each mortal thing
 Upon the dull earth dwelling.
To her let us garlands bring.

2. Shakespeare's stage directions are explicit: minstrels sing the lyric outdoors while Proteus and Thurio look on, themselves observed by the disguised Julia. Only after the musicians and Thurio depart does Silvia appear at her window. This is how Abbey staged his illustration of the scene in a drawing of 1891 that carries the title *The Court of the Palace*. See Lucy Oakley, *Unfaded Pageant: Edwin Austin Abbey's Shakespearean Subjects* (New York: Miriam & Ira D. Wallach Art Gallery, Columbia University, 1994), 32. Abbey's decision to spell the name *Sylvia* rather than *Silvia*—as the character is consistently called elsewhere in the play barring the lyric's opening line—further distances the painting from the drama.
3. The swains behind her, faces shadowed, glance at her shyly. The man to the right of the canvas, the most fully depicted of the painting's male characters, inclines his head in advance of her passing. He is probably not identifiable with one of the play's characters; in his published illustrations for *Two Gentlemen of Verona*, Abbey makes both Proteus and Valentine younger looking, without facial hair, and in more flamboyant garb (Sylvia's dress, by contrast, has many points of similarity between illustrations and painting).
4. He showed his first oil at the Royal Academy only in 1890, *A May Day Morning* (1890, Yale University Art Gallery). The principal study of Abbey and his Shakespearean subjects are Lucy Oakley's dissertation, "Edwin Austin Abbey's Shakespearean Paintings, Illustrations, and Costume Designs, 1888–1909" (Ph.D. diss., Columbia University, 1995) and the exhibition catalogue *Unfaded Pageant*.
5. The white silk dress reappears in other paintings of Italian themes on which Abbey was working: *A Pavane* (1897, Museum of Fine Arts, Boston) and at least two pastels, *Woman in White* and *Desdemona* (both 1895; *American Paintings, Drawings and Sculpture*, Sotheby's, New York, 4 March 2009, lots 25 and 27, respectively).
6. Mary Gertrude Abbey to her mother, October 1896, quoted in E.V.

Lucas, *Edwin Austin Abbey, Royal Academician: The Record of His Life and Work*, 2 vols. (London: Methuen, 1921), 2:305.
7. Abbey to Mary Gertrude Abbey, 2 and 4 September 1896, quoted in ibid., 2:301–2. The model was Rachel Lee; he describes her more fully: "She has been sitting for fifteen years, so she is not young, but very graceful and fine and big and *useful*. . . . She is a splendid model . . . and is remarkably intelligent, knows how to dress herself and how to rest bits without disturbing drapery, and puts things away." Abbey is writing specifically about sessions for *A Pavane*.
8. The most notable projects were the *Play Scene from Hamlet* (1897, Yale University Art Gallery), which he began in October 1896, and *A Pavane*. Foreseeing a long stay in New York, owing to his mother-in-law's health, Abbey had these two and *Sylvia*—and the costumes for each—sent to New York. While there, however, he worked principally on *A Pavane* (finishing it there for the New York collector Whitelaw Reid) and the *Hamlet*, which became his much-praised submission to the Royal Academy for 1897.
9. Mary Gertrude Abbey to her mother, 18 May 1897, quoted in Lucas, *Abbey*, 2:308. On 27 May she added: "Ned cannot seem to settle down," although she noted, "I am in the studio, writing at the desk. Ned is painting Sylvia's dress. . . . I have had a most lovely white cloth bag and girdle trimmed with gold made for Silvia"; ibid., 2:308.
10. Mary Gertrude Abbey to her mother, quoted in ibid., 2:311–12.
11. For the 1898 Royal Academy, he brought to completion yet another Shakespearean work, *Lear and His Daughters* (The Metropolitan Museum of Art, New York). This prompted his election as an academician, an unusually swift progress from associate to full academician status.
12. "The Royal Academy of 1899," *Art Journal* 61 (June 1899): 182. Abbey in both canvases was, for Henri Frantz, "le traducteur émouvant" of Shakespeare's work; "Les Salons Anglais en 1899," *Gazette des Beaux-Arts*, 41 année, 3 périod, vol. 22, 508 livraison (1 October 1899): 347.
13. H. Heathcote Statham, "The Academy, the New Gallery, and the Guildhall," *Fortnightly Review* 66, no. 391 (July 1899): 101.
14. An Exhibitor, "The Royal Academy: The Picture of the Year," *Outlook*, 13 May 1899, 488.
15. Lucas, *Abbey*, 2:345. Sometime, apparently late in the development of the work, Abbey also altered the disposition of the hands and arms. Henry Blackburn described the picture, presumably after its successful submission to the Royal Academy: "Sylvia in rich costume with full crimson and white sleeves, clasping her hands across her breast, descends a stairway. Behind and at her side is a group of gallants. A poet, book in hand, gazes at her forlornly"; Blackburn, *The Academy*

Notes 1899 (London: Chatto and Windus, 1899), 17. The description of her clasped hands invokes two early oil studies for the work (Yale University Art Gallery, 1937.2229 and 1937.2230) that show her in that pose. The painting's long gestation and significant reworking of Sylvia's head are evident in the current state of the canvas.
16. "Academy of Design Exhibit Opened," *World*, 23 December 1906: "The effect is most unhappy. 'Sylvia's' mouth also is a splash of red—converting, by change of expression, an otherwise graceful and attractive woman into a creature of the town. The male figure, lurking to the right and clinging to a marble column is capitally drawn, especially as to the hands, but the effeminacy of the face!"
17. Kathleen A. Foster, "The Paintings of Edwin Austin Abbey," in *Edwin Austin Abbey (1852–1911)* (New Haven: Yale University Art Gallery, 1973), 8.
18. Abbey to Mary Gertrude Abbey, who was in the United States, c. 20 August 1896, quoted in Lucas, *Abbey*, 2:300–301.

Homer, *A Light on the Sea*

1. Lloyd Goodrich noted that this is the last of Homer's paintings to feature a woman; Goodrich, *Winslow Homer* (New York: Whitney Museum of American Art and Macmillan Company, 1944), 146. Although some later commentators have taken issue with this, if we exclude reworked canvases, Goodrich's assertion remains valid.
2. Philip Beam, "1897," in Patricia Junker et al., *Winslow Homer in the 1890s: Prout's Neck Observed* (Rochester, N.Y.: Memorial Art Gallery of the University of Rochester, 1990), 141. Homer and his family were active in the development of Prout's Neck as a summer resort community.
3. Philip Beam, *Winslow Homer at Prout's Neck* (Boston: Little, Brown, and Company, 1966), 153. Harding had earlier served as a model for the etching *Mending the Tears* (1886) and for the painting *The Fisher Girl* (1894, Mead Art Museum, Amherst College, Mass.). She married late in 1894, which might be one point—probably not the most important for the meaning of the painting—that Homer makes through the obvious ring on her hand.
4. Bright red makes her stockings among the most vivid parts of the painting; the details Homer elaborates on the shoes—their heels and their green-blue highlights—indicate his desire to make them a legible element of the work.

In 1902 Homer annotated the illustration of *A Light on the Sea* in a copy of an article by Frederic Morton, writing: "This is the picture only better now as I have put the water a little lower in the left corner & show one foot of the girl—tho this photo looks blacker than the picture—W.H."; Morton, "The Art of Winslow Homer," *Brush and Pencil* 10, no. 1 (April 1902): 42. Examining painting and the photo of its earlier state reveals that Homer lowered the line

between the water and the rock considerably, allowing the bright water to show beneath at least one additional fold of the woman's skirt. The foot was apparently always there, but Homer's amendments made it more obvious.
5. The theme of looking back is one that recurs in Homer's works. Writing about the slightly later landscape *West Point, Prout's Neck* (1900, Sterling and Francine Clark Art Institute, Williamstown, Mass.), Homer jokingly referred to the spume rising at the center of the scene as "the piller [sic] of salt (Formerly Lot's Wife)," the woman in Genesis who, because she looked back, was turned by God into a pillar of salt; Homer to Thomas B. Clarke, 16 January 1901, transcription in the archives of the Lloyd Goodrich and Edith Havens Goodrich/Whitney Museum of American Art Record of Works by Winslow Homer. Recent scholars from at least Carol Troyen onward have in print compared *A Light on the Sea* with *West Point, Prout's Neck*, drawing an analogy between the woman in the earlier work and the spume in the later; see Troyen in Theodore E. Stebbins, Jr., et al., *A New World: Masterpieces of American Painting, 1760–1910* (Boston: Museum of Fine Arts, 1983), 339.
6. Homer to Thomas B. Clarke, 29 September 1897, Winslow Homer Letter Collection, Archives of American Art, Smithsonian Institution, Washington, D.C. (hereafter AAA).
7. Examination reveals that Homer intended the figure from the start of the composition; the author's observation corroborated by conversation with Dare Hartwell and by Gay Myers, American Paintings Catalogue Technical Examination Report, 11 April 2005, CGA Conservation Files.
8. In the earliest book dedicated to Homer's life and work, William Howe Downes rightly describes Homer's typical narrative technique as one of "suggestion and implication," with the catalyst of the tale left to the viewer's imagination; Downes, *The Life and Works of Winslow Homer* (1911; New York: Dover, 1989), 187–88.
9. "The Week in the Art World," *New York Times*, 9 April 1898, Saturday Review of Books and Art, 242.
10. F.M.S., "America's First National Salon," *Brush and Pencil* 19, no. 3 (March 1907): 91.
11. An informal survey taken during the summer of 2009 on the question of time of day among recent writers on Homer—including Margaret C. Conrads, Thomas Andrew Denenberg, Abigail Booth Gerdts, Patricia Junker, and David Tatham—indicates a range of readings or, more commonly, puzzlement as to the time of day.
12. John W. Beatty, "Introductory Note," in Downes, *Homer*, xxvii. To the same interlocutor, he claimed the scientific investigation of color by M.E. Chevreul as "my Bible"; John W. Beatty, "Recollections of an Intimate Friendship," in Goodrich, *Homer*, 223.

13. Homer consistently complained of people looking at his works from too close a distance and wrote to his dealers of various strategies to ensure that people see them from far enough away—"To look at & not smell of," as he wrote to Knoedler on 8 November 1904, Winslow Homer Letter Collection, AAA.
14. *New York Evening Post*, quoted in Downes, *Homer*, 202. "Homer's pictures can hardly have too much light or too much distance," affirmed the painter Kenyon Cox, in "Art Here and Abroad—Cox Talks of Homer's Pictures," *New York Times*, 12 January 1908, sec. X, 10.
15. "The Note-Book," *Art Amateur* 38, no. 3 (February 1898): 56. Homer had made arrangements for the work to go to the Union League Club when he wrote to Thomas B. Clarke on 29 September 1897.
16. "Art at the Union League," *New York Times*, 14 January 1898, 7; and "The Academy's Exhibition," *New York Evening Post*, 22 December 1906, sec. 8, 5.
17. "National Academy of Design. (Third Notice)," *Art Bulletin*, 5 January 1907, 161. Others called the woman "rather clumsy" and felt that she needed "solid feet under so burly a form"; "The Winter Academy: Metropolitan Museum Buys a Brilliant Marine from Winslow Homer," *New York Times*, 22 December 1906, 2.
18. "The Winter Academy: Metropolitan Museum Buys a Brilliant Marine from Winslow Homer," *New York Times*, 22 December 1906, 2.

Hassam, *A North East Headland*

1. The definitive study of Hassam on Appledore is David Park Curry, *Childe Hassam: An Island Garden Revisited* (Denver: Denver Art Museum, in association with W. W. Norton, 1990).
2. The hotel, Celia Thaxter's cottage, and other buildings on Appledore were destroyed in a fire on 13 September 1914; Susan Faxon et al., *A Stern and Lovely Scene: A Visual History of the Isles of Shoals* (Durham: University Art Galleries, University of New Hampshire, 1978), 66.
3. For Thaxter's role in guiding Hassam's career, see Susan G. Larkin, "Hassam in New England, 1889–1918," in H. Barbara Weinberg et al., *Childe Hassam: American Impressionist* (New York: Metropolitan Museum of Art, 2004), 120–37.
4. Celia Thaxter, *Among the Isles of Shoals* (1873; Bowie, Md.: Heritage Books, 1978), 17.
5. Ibid., 13.
6. A map for a proposed subdivision of Appledore in 1908 reveals the location of Broad Cove in relation to the hotel; see http://kittery.org/Pages/KitteryME_WebDocs/Appledore at APPLEDORE %2520ISLAND.pdf. For a map of the entire group of islands, see http://en.wikipedia.org/wiki/Isles_of_Shoals.
7. Gay Myers, American Paintings Catalogue Technical Examination Report, 16 November 2004, CGA Conservation Files.
8. Curry, *Hassam: An Island Garden Revisited*, 180, describes the Metropolitan's oil (his pl. 96) as a "composite studio work."

9. "Pictures from the First Annual Exhibition at the Corcoran Art Gallery, in Washington," *New-York Daily Tribune*, 10 February 1907, clipping, CGA Curatorial Files.
10. "Nation's First Salon," *Washington Herald*, 7 February 1907, 2. The same quotation appears in an expanded version of that review published a month later: F. M. S., "America's First National Salon," *Brush and Pencil* 19 (March 1907): 91–92.
11. Helen W. Henderson, *The Art Treasures of Washington* (Boston: L. C. Page & Company, 1912), 147–48.

Maurer, *Young Woman in Kimono*

1. Though *Young Woman in Kimono* is not dated, scholars consistently have dated the painting to about 1901 owing to its style and subject matter. Similar works, such as *Woman with Pottery* (Curtis Galleries, Minneapolis) and *An Arrangement* (Whitney Museum of American Art, New York), were painted about 1901. See Stacey Beth Epstein, "Alfred H. Maurer: Aestheticism to Modernism, 1897–1916" (Ph.D. diss., City University of New York, 2003), 45–46.
2. The name of the woman posing in *Young Woman in Kimono* is unknown, but she may have lived in Montparnasse, the section of Paris where Maurer was known to search for models; Epstein, "Maurer," 56. Further, Maurer was known to take photographs of his models for use in the studio; Elizabeth McCausland, *A. H. Maurer* (New York: A. A. Wyn, for the Walker Art Center, 1951), 69.
3. The term *japonisme* was first used in 1872 by the French critic Philippe Burty; Phillip Dennis Cate, William R. Johnston, and Gabriel P. Weisberg, *Japonisme: Japanese Influence on French Art* (Cleveland: Cleveland Museum of Art, 1975), xi.
4. For more information on the academic method and American artists in Paris, see H. Barbara Weinberg, *The Lure of Paris: Nineteenth-Century American Painters and Their French Teachers* (New York: Abbeville Press, 1991).
5. Nick Madormo, "The Early Career of Alfred Maurer: Paintings of Popular Entertainments," *American Art Journal* 15, no. 1 (Winter 1983): 21.

Brush, *Mother and Child*

1. "Chronology," in *George de Forest Brush: The Indian Paintings*, ed. Nancy K. Anderson (Washington, D.C.: National Gallery of Art; Burlington, Vt.: Lund Humphries, 2008), 209.
2. Mary Ann Lublin, "The Religion of Maternity: The Mother-and-Child Paintings of George de Forest Brush" (Ph.D. diss., Columbia University, 1989), 118, 136.
3. Ibid., 90.
4. Kristin Schwain, *Signs of Grace: Religion and American Art in the Gilded Age* (Ithaca, N.Y.: Cornell University Press, 2008), 105–7.
5. Samuel Isham, *The History of American Painting* (New York: Macmillan, 1905), 491.

6. Royal Cortissoz, "His Art at Full Length for the First Time," *New York Tribune*, 12 March 1922, sec. 4, 8.
7. *Annual Report of the Director of the Corcoran Gallery of Art* (Washington, D.C.: The Gallery, 1903), 8.
8. James Henry Moser, "Art Topics," *Washington Post*, 19 April 1903, TP2.
9. D. C. P., "The National Academy of Design," *Collector and Art Critic*, January 1907, 100; and Walter C. Arensberg, "The National Academy of Design," *Burlington Magazine for Connoisseurs* 10, no. 47 (February 1907): 336.
10. Leila Mechlin, "Rich Art in Child: George de Forest Brush Won His Place among Successful Painters with Home Beauty and Indian Lore," *Washington Evening Star*, 5 September 1936, sec. B, 3.
11. Naurvik, quoted twice in Lublin, "Religion of Maternity," 264; and Minna C. Smith, "George de Forest Brush," *International Studio* 34, no. 134 (April 1908): 50.
12. Lublin, "Religion of Maternity," 226.
13. Ibid., 129, 209.

Chase, *An English Cod*

1. Quoted in W. H. Fox, "Chase on Still Life," *Brooklyn Museum Quarterly* 1 (January 1915), quoted in Barbara Dayer Gallati, "The Yield of the Waters," in *American Paintings in the Detroit Institute of Arts*, vol. 3, *Forging a Modern Identity: Masters of American Painting Born after 1847*, ed. James W. Tottis (Detroit: Detroit Institute of Arts, in association with D Giles Limited, London, 2005), 32.
2. Ronald G. Pisano, *A Leading Spirit in American Art: William Merritt Chase, 1849–1916* (Seattle: Henry Art Gallery, University of Washington, 1983), 14, 15, 17.
3. William H. Gerdts, *Painters of the Humble Truth: Masterpieces of American Still Life, 1801–1939* (Columbia: University of Missouri Press, 1981), 212.
4. "Good-Natured Caricatures of Well-Known People," *Scrap Book* 7 (February 1909): 241.
5. "The Comparative Exhibition," *New York Times*, 11 November 1904.
6. "Comparative Art Exhibition, *Washington Post*, 18 December 1904, sec. E, 3.
7. Helen W. Henderson, "Centenary Exhibition of the Pennsylvania Academy of the Fine Arts," *Brush and Pencil* 15 (March 1905): 149–50.
8. "Third Annual Exhibition, Selected American Paintings at the Albright Art Gallery," *Academy Notes* (Buffalo Fine Arts Academy), 4, no. 4 (September 1908): 49–50.
9. William M. Chase, "How I Painted My Greatest Picture," *Delineator* 72 (December 1908): 967.
10. Harrison S. Morris, *Confessions in Art* (New York: Sears Publishing Co., 1930), 98.

Glackens, *Luxembourg Gardens*

1. Though the painting is not inscribed with a date, Glackens spent the summer of 1906 in France. This trip marked the artist's first visit since his eighteen-month

stay there in 1895–96. During the 1906 trip, Glackens produced several dated works of the Luxembourg Gardens that bear a compositional relationship to the Corcoran's painting, including *Luxembourg Gardens* (1906, Wichita Art Museum, University of Wichita, Kans.), *Under the Trees, Luxembourg Gardens* (1906, Munson-Williams-Proctor Institute, Museum of Art, Utica, N.Y.), and three prints, either etchings or drypoints, of the Luxembourg Gardens (1906, Museum of Art, Fort Lauderdale, Fla.). Further corroborating the 1906 date for *Luxembourg Gardens* is a black ink stamp on the underside of the frame that reads "MADE IN FRANCE."
2. Edward Alden Jewell, "A Nation-Wide Survey: The Corcoran, for All Its Wealth of Good Painting, Proves an Unexciting Show," *New York Times*, 4 April 1937, Arts sec., 9.
3. Jane Watson, "Work of Glackens on View at Corcoran," *Washington Post*, 28 January 1940, sec. E, 6.
4. Lance Mayer, American Paintings Catalogue Technical Examination Report, 12 April 2005, CGA Conservation Files.
5. William H. Gerdts, *William Glackens* (New York: Abbeville Press, 1996), 21.
6. Rebecca Zurier, *Picturing the City: Urban Vision and the Ashcan School* (Berkeley: University of California Press, 2006), 191.

Metcalf, *May Night*

1. The Griswolds opened the house to boarders because of financial reversals suffered after the Civil War and also owing to the rise of steam travel. The 1817 house and its twelve surrounding acres were purchased in 1841 by Miss Florence's father, Captain Robert Griswold, scion of one of the oldest shipping families in the town. The American Tonalist painter Henry Ward Ranger was the first artist to board with Miss Florence.
2. In his later recollection of the artist's unveiling of *May Night*, Metcalf's fellow Old Lyme student Arthur Heming identified the walking figure as Miss Florence; see Heming, *Miss Florence and the Artists of Old Lyme* (Essex, Conn.: Pequot Press, 1971), 27, quoted in Bruce W. Chambers, *May Night: Willard Metcalf at Old Lyme* (Old Lyme, Conn.: Florence Griswold Museum, 2005), 13. The same identification was made by at least one contemporary reviewer; see F. M. S., "America's First National Salon," *Brush and Pencil* 19, no. 3 (March 1907): 91.
3. On the flyleaf of a scrapbook containing newspaper notices about his art that was likely compiled while he was living with his parents in Maine in 1903–4, Metcalf wrote, "A partial history of the Renaissance"; see William H. Gerdts, *American Impressionism* (New York: Abbeville Press, 1984), 195n15.
4. Chambers, *May Night*, 54, states that the canvas was not completed by the end of the summer of 1906, when Metcalf exhibited two other paintings in the Fifth Annual Exhibition of Recent Pictures Painted in Lyme and the Surrounding

Country at the town library. He states (13) that the unveiling to Heming and Miss Florence (see n2 above) occurred "[s]ometime in September 1906." According to Chambers (52), the canvas was one of about twenty-six Metcalf produced over that summer, a record annual production for him to date.

5. Hassam to Julian Alden Weir, 7 July 1906, Julian Alden Weir Papers, reel 125, Archives of American Art, Smithsonian Institution, Washington, D.C., quoted in Chambers, *May Night*, 46n112 and 116n1. However, given that Metcalf had surely already begun *May Night* by that time, it is more likely that the rain gave Metcalf the welcome opportunity, rather than the immediate impetus, to "work . . . hard" on the canvas.

6. Thomas Andrew Denenberg and Tracie Felker, "The Art Colonies of Old New England," *Antiques* 45, no. 4 (April 1999): 561. Hassam designated the Griswold mansion "Holy House" as a takeoff on the Holley House in Cos Cob, a boarding-house that was home to another Impressionist colony; see Jeffrey W. Anderson, "The Art Colony at Old Lyme," in Anderson, Susan G. Larkin, and Harold Spencer, *Connecticut and American Impressionism* (Storrs: William Benton Museum of Art, University of Connecticut, 1980), 135n36.

7. A *Washington Star* reporter observed: "Looking at [*May Night*], one looks up in to the heavens at the stars and feels the hush and peace, the sensation that here one stands on holy ground—a sense of things sacred—'God's in His heaven, all's well with the world'"; "News and Notes of Art and Artists," *Washington Star*, 13 January 1925, sec. 2, 16.

8. Critics also acknowledged the unusual scale of the house as rendered by Metcalf. Helen W. Henderson, in *The Art Treasures of Washington* (Boston: L. C. Page and Company, 1912), 147, wrote: "If the canvas misses fire at all, it is in the treatment of the house, which is a little out of scale with its environment, in point of size and illumination; while, on the other hand, it is hard to fancy, in the face of a somewhat thin façade, the bulk of the whole substantial structure."

9. Metcalf's reverential tribute to the Griswold house and its role in Miss Florence's distinguished ancestral heritage were part of a larger turn-of-the-century tendency by artists to document and "symbolize the New England past." See William H. Truettner and Thomas Andrew Denenberg, "The Discreet Charm of the Colonial," in *Picturing Old New England: Image and Memory*, ed. Truettner and Roger B. Stein (New Haven: Yale University Press for the National Museum of American Art, Smithsonian Institution, 1999), 95.

10. Metcalf painted more than sixty square canvases.

11. I am grateful to Charles T. Clark for pointing out the anthemion detail. According to Sheila Wertheimer, "The Florence Griswold Museum Documentation of the Historic Landscape," unpublished report from 1996, 20, photos of

the Griswold House from the 1910s show "weedy shrubs growing sparsely, close to the porch . . . [which] may be . . . Ligustrum species (bush Honeysuckle)." I thank Jeffrey W. Anderson, Director, Florence Griswold Museum, for this citation; email, 11 September 2006, CGA Curatorial Files. According to a carved inscription on its back, the current frame was made in 1908 in the Philadelphia shop of E. C. Slater.

12. Heming, *Miss Florence and the Artists of Old Lyme*, 27, quoted in Chambers, *May Night*, 13.

13. Ibid. Miss Florence often helped Metcalf with titles and apparently did so with *May Night*. Elizabeth de Veer and Richard J. Boyle, *Sunlight and Shadow: The Life and Art of Willard L. Metcalf* (New York: Abbeville Press Publishers, for Boston University, 1987), 83, say Miss Florence and the artist probably decided together on *May Night*.

14. The First Annual Exhibition was on view 7 February–9 March 1907. The Clark Gold Medal carried a cash award of one thousand dollars. *May Night* and Homer's *Light on the Sea*, the first contemporary paintings to be acquired from the Corcoran's annual and biennial exhibitions, were both purchased in February 1907.

15. R[oyal] C[ortissoz], "Art in Washington: The First Annual Exhibition of the Corcoran Gallery," *New York Tribune*, 13 February 1907, 7.

16. Philip Leslie Hale, "Show of Metcalf's Pictures at St. Botolph Club Very Attractive," *Boston Herald*, 18 November 1906, Amusements sec., 1.

17. J. N. L., "The Ten American Painters," *New York Evening Post*, 30 March 1907, sec. 3, 5.

18. See Chambers, *May Night*, 59; among the other artists who painted moonlit views were Metcalf's student Robert Nisbet and Will Howe Foote, both of whom painted moonlit scenes of the Griswold House in 1907; Clark Voorhees; and Metcalf's friends Hassam and Weir. Metcalf himself painted more moonlit scenes as well. According to Chambers (46), as early as 1903 Frank DuMond had included the teaching of moonlight effects in his Old Lyme courses, taking his students out at night to look at the sky, stars, and shadows.

Bellows, *Forty-two Kids*

1. The August 1907 date of completion for *Forty-two Kids* is recorded in Bellows's Record Book (Record Book A, p. 39). Thanks to Glenn Peck for providing a copy of the Record Book page.

2. "George Bellows, an Artist with 'Red Blood,'" *Current Literature* 53, no. 3 (September 1912): 342.

3. The setting is established by a letter from Bellows's widow, Emma, to Marian King, 23 January 1959, CGA Curatorial Files.

4. Philip L. Hale, "Boston Art Shown in Philadelphia," *Boston Herald*, 26 January 1908, Special sec., 1.

5. Charles L. Buchanan, "George Bellows: Painter of Democracy," *Arts and Decoration* 4, no. 10 (August 1914): 371.

6. *New York Herald*, quoted in Charles H. Morgan, *George Bellows: Painter of America* (New York: Reynal & Company, 1965), 83.

7. The Julius Hallgarten Prize was bestowed annually from 1884 to three domestically based American artists under the age of thirty-five.

8. John Cournos, "Three Painters of the New York School," *International Studio* 56, no. 224 (October 1915): 244; and James Gibbons Huneker, "The Spring Academy: Second Notice," *New York Sun*, 21 March 1908, 6.

9. Maude I. G. Oliver, "Art News of the Week," *Chicago Record-Herald*, 8 November 1908, sec. 6, 5.

10. Joseph Edgar Chamberlin, "An Excellent Academy Show," *New York Evening Mail*, 14 March 1908, 6.

11. The jury had originally voted 8 to 2 in favor of awarding *Forty-two Kids* the Lippincott Prize. Robert Henri, Diary, 23 January 1908, Robert Henri Papers, reel 886, frame 12, Archives of American Art, Smithsonian Institution, Washington, D.C. (hereafter AAA).

12. Bellows to John W. Beatty, c. 24 May 1909, Papers of the Museum of Art, Carnegie Institute, Pittsburgh, Pa., reel 14, letter group 565, AAA.

13. "Those Who Paint What They See," *New York Herald*, 23 February 1908, Literary and Art sec., 4.

14. C. H. C., "Carnegie Institute Exhibition, the Figure Subjects: First Notice," *New York Evening Post*, 1 May 1909, sec. 1, 5.

15. Rebecca Zurier, *Picturing the City: Urban Vision and the Ashcan School* (Berkeley: University of California Press, 2006), 221.

16. See Marianne Doezema, *George Bellows and Urban America* (New Haven: Yale University Press, 1992), 147.

17. Cournos, "Three Painters of the New York School," 244.

18. L. Perry Curtis, Jr., *Apes and Angels: The Irishman in Victorian Caricature* (Washington, D.C.: Smithsonian Institution Press, 1997).

19. Chamberlin, "An Excellent Academy Show."

20. "Bellows, an Artist with 'Red Blood,'" 345.

21. Emma Bellows to King, 23 January and 6 February 1959.

22. Molly Suzanne Hutton considers connections between Ashcan paintings, animals, and dirt in "The Ashcan City: Representational Strategies at the Turn of the Century" (Ph.D. diss., Stanford University, 2000), chap. 2.

23. Howard Markel and Alexander Minna Stern, "The Foreignness of Germs: The Persistent Association of Immigrants and Disease in American Society," *Milbank Quarterly* 80, no. 4 (2002): 757. See also Ian Kraut, *Silent Travelers: Germs, Genes, and the "Immigrant Menace"* (Baltimore: Johns Hopkins University Press, 1995).

24. Hale, "Boston Art Shown in Philadelphia."

25. "Those Who Paint What They See."

Tarbell, *Josephine and Mercie*

1. Charles DeKay, "Edmund C. Tarbell," *Smith's Magazine* 9 (April 1909): 70.

2. J. Nilsen Laurvik, "The Annual Exhibition of the Pennsylvania Academy of the Fine Arts," *International Studio* 38 (August 1909): xliv; and Leila Mechlin, "The Corcoran Gallery's Second Exhibition of Contemporary American Paintings," *International Studio* 36 (January 1909): xcii.

3. "'Josephine and Mercie': The Best Picture of the Year," *Sunday Boston Herald Magazine*, 27 December 1908, 6.

4. Philip L. Hale, "Corcoran Gallery Secures a Tarbell," *Boston Sunday Herald*, 13 December 1908, Editorial, Society and Financial sec., 1. See also Frederick C. Coburn, "Edmund C. Tarbell," *International Studio* 32 (September 1907): 83, in which he notes that Tarbell has won "a goodly number of the conventional awards."

5. Theodore E. Stebbins, Jr., "The Course of Art in Boston," in Trevor Fairbrother, *The Bostonians: Painters of an Elegant Age, 1870–1930* (Boston: Museum of Fine Arts, Boston, 1986), 6.

6. "Important Painting by E. C. Tarbell Sold," *New York Times Magazine*, 16 September 1917, 12.

7. On Tarbell's early career, see Laurene Buckley, *Edmund C. Tarbell: Poet of Domesticity* (New York: Hudson Hills Press, 2001), 9–42; and Linda J. Docherty, "The Making of an Artist: Edmund C. Tarbell's Early Influences and Career," in Susan Strickler, Docherty, and Erica E. Hirshler, *Impressionism Transformed: The Paintings of Edmund C. Tarbell* (Manchester, N.H.: Currier Gallery of Art, 2001), 29–72.

8. On the relation between Tarbell and Whistler, see Linda Merrill, *After Whistler: The Artist and His Influence on American Painting* (Atlanta: High Museum, 2003), 86, 232, and 254n400. *Josephine and Mercie* bears an obvious debt to Whistler's *Harmony in Green and Rose: The Music Room* (1860, Freer Gallery of Art, Washington, D.C.), which also features a decorative domestic interior inhabited by the artist's female family members. Tarbell would have seen the painting in 1904, at Whistler's memorial retrospective at Copley Hall, and he may also have known it through reproductions, which were widely circulated after its exhibition at London's Goupil Gallery in 1892.

9. Buckley, *Tarbell*, 86.

10. On the interior of Tarbell's house, see Susan Strickler, "A Life That is Art: Edmund C. Tarbell in New Castle," in Strickler, Docherty, and Hirshler, *Impressionism Transformed*, 111–28; for an insightful interpretation of the Colonial Revival generally, see Celia Betsky, "Inside the Past: The Interior and the Colonial Revival in American Art and Literature, 1860–1914," in *The Colonial Revival in America*, ed. Alan Axelrod (New York: W. W. Norton & Co., 1985), 241–67.

11. "Tarbell's Girl Types," *Boston Sunday Herald*, 21 December 1902, 21, identifies "the American Girl" as one of nine personality types illustrated in works by Tarbell. All of the types are from the

leisure class and connected, by costume or setting, to a domestic role. On the turn-of-the-century phenomenon of typing generally and on the American Girl specifically, see Martha Banta, *Imaging American Women: Idea and Ideals in Cultural History* (New York: Columbia University Press, 1987), 1–91, who identifies a specifically "New England" American Girl type, noted for her isolation from the modern city. See also David Park Curry, *James McNeill Whistler: Uneasy Pieces* (Richmond: Virginia Museum of Fine Arts, 2004), 79–84, at 84, who surveys American and European examples of women and girls in white and notes: "Time and time again, paintings of women in white signal fundamental social change."

12. Bernice Leader, "Anti-Feminism in the Paintings of the Boston School," *Arts* 56, no. 5 (January 1982): 113.

13. Charles Caffin, "The Art of Edmund C. Tarbell," *Harper's Monthly Magazine* 117 (June 1908): 73.

Paxton, *The House Maid*

1. "Pennsylvania Academy: Landscapes Strongest Group at the Exhibition," *New York Evening Post*, 8 February 1911, 9.

2. In 1911, following its Philadelphia debut, the painting was shown at the Fine Arts Academy in Buffalo and at the Saint Louis City Art Museum; Paxton lent it to several small gallery installations in New York and Boston between 1912 and 1914, and in 1915 and 1916 it hung in the Fine Arts section at the Panama-Pacific International Exposition in San Francisco.

3. The conservative nature of Boston School painting is thoroughly examined in Bernice Leader, "The Boston Lady as a Work of Art: Painting by the Boston School at the Turn of the Century" (Ph.D. diss., Columbia University, 1980); and Bailey Van Hook, *Angels of Art: Women and Art in American Society, 1876–1914* (University Park: Pennsylvania State University Press, 1996).

4. Philip Leslie Hale to W. P. Valentiner, 1930, quoted in Leader, "The Boston Lady," 315.

5. Philip Hale, "William McGregor Paxton," *International Studio* 39 (December 1909): xli.

6. Philip L. Hale, *Jan Vermeer of Delft* (1904; Boston: Small, Maynard & Co., 1937), 39.

7. See Vivien Greene, "Aestheticism and Japan: The Cult of the Orient," in Alexandra Munroe, *The Third Mind: American Artists Contemplate Asia, 1869–1989* (New York: Guggenheim Museum, 2009), 59; Jessica Todd Smith, "Is Polite Society Polite? The Genteel Tradition in the Figure Paintings of William McGregor Paxton (1869–1941)" (Ph.D. diss., Yale University, 2001), 161–62; and Mari Yoshihara, *Embracing the East: White Women and American Orientalism* (Oxford: Oxford University Press, 2003), 8–10, 47.

8. "The Sixth Annual Exhibition of Selected Paintings by American Artists at the Albright Art Gallery," *Academy Notes* 6, no. 3 (July 1911): 86.

9. Smith, "Is Polite Society Polite?" 26.

10. Leila Mechlin, "Notes of Art and Artists," *Washington Sunday Star*, 24 December 1916, sec. 2, 8.

Sloan, *Yeats at Petitpas'*

1. Valerie Ann Leeds, "Pictorial Pleasures: Leisure Themes and the Henri Circle," in James W. Tottis et al., *Life's Pleasures: The Ashcan Artists' Brush with Leisure, 1895–1925* (New York: Merrell, in association with Detroit Institute of Arts, 2007), 25.

2. Luks's watercolor (location unknown) is entitled *John Butler Yeats at Petitpas'* (n.d.).

3. The backyard of Petitpas' is described in W. Adolph Roberts, "He Started Again after 70," *New York Herald Tribune Magazine*, 19 February 1933, sec. 11, 9.

4. Van Wyck Brooks, *John Sloan: A Painter's Life* (New York: E. P. Dutton, 1955), 102.

5. For older views of the painting, see James C. Young, "Yeats of Petitpas'," *New York Times Book Review and Magazine*, 19 February 1922, 14; Herbert Gorman, "The Bohemian Life in America: Its History from the 1850s down to Greenwich Village Days," *New York Times Book Review*, 5 March 1933, sec. 5, 1; and William M. Murphy, "John Butler Yeats: The Artist and the Man," in Fintan Cullen, *The Drawings of John Butler Yeats* (Albany, N.Y.: Albany Institute of History & Art, 1986), 15. For readings of the picture as honoring and celebrating Yeats, see Laura Groves Napolitano, "*Yeats at Petitpas'*: John Sloan's Tribute to an Artistic Mentor," MS, 2003, CGA Curatorial Files; Leeds, "Pictorial Pleasures," 27; and Katherine E. Manthorne, "John Sloan, Moving Pictures, and Celtic Spirits," in Heather Campbell Coyle and Joyce K. Schiller, *John Sloan's New York* (Wilmington: Delaware Art Museum, 2007), 152.

6. Yeats criticized Sloan's style as having a certain carelessness, which he attributed to Henri's early influence; Brooks, *Sloan*, 118–19.

7. Yeats to Sloan, quoted in ibid., 120.

8. Young, "Yeats of Petitpas'," 14. Yeats wrote to Sloan that "there is nothing so improving as painting portraits, particularly if you meet with terrible difficulties"; quoted in John Loughery, *John Sloan: Painter and Rebel* (New York: Henry Holt, 1995), 166.

9. Rowland Elzea, the author of the Sloan paintings catalogue raisonné, believes Sloan used these portraits as aide-mémoire for the painting; Rowland Elzea to Joan Gaines (daughter of Eulabee Dix), 19 May 1988, CGA Curatorial Files.

10. Van Wyck Brooks, *Scenes and Portraits: Memories of Childhood and Youth* (New York: E. P. Dutton, 1954), 172–73.

11. Sloan, diary entry dated 5 April 1910, in *John Sloan's New York Scene*, ed. Bruce St. John (New York: Harper & Row, 1965), 407.

12. Sloan, diary entry dated 10 June 1910, in ibid., 432–33.

13. Sloan, diary entry dated 2 August 1910, in ibid., 444–45.

Dewing, *Lady with a Mask*

1. *Washington Evening Star*, 11 November 1911, sec. 2, 11. In Dewing's studio daybook, the picture was titled *Woman with Mask*; Studio Daybook, 11 April 1911, private collection, Alexandria, Va., copy in CGA Curatorial Files.

2. Lance Mayer, American Paintings Catalogue Technical Examination Report, 17 November 2004, CGA Conservation Files.

3. Susan A. Hobbs, "Beauty into Art: The Life of Thomas Wilmer Dewing," in Hobbs, *The Art of Thomas Wilmer Dewing: Beauty Reconfigured* (Brooklyn: Brooklyn Museum, 1996), 24.

4. Hobbs, *The Art of Dewing*, 71, 181.

5. On this topic, see Barbara Dayer Gallati, "Beauty Unmasked: Ironic Meaning in Dewing's Art," in ibid., 51–82; Kathleen Pyne, "Evolutionary Typology and the American Woman in the Work of Thomas Dewing," *American Art* 7, no. 4 (Fall 1993): 13–30; Pyne, "On Women and Ambivalence in the Evolutionary Topos," *Nineteenth-Century Art Worldwide* 2, no. 2 (Spring 2003); Sadakichi Hartmann, "Thomas Dewing," *Art Critic* 1, no. 1 (November 1893), reprinted in *S. H. Hartmann, Critical Modernist: Collected Art Writings*, ed. Jane Calhoun Weaver (Berkeley: University of California Press, 1991), 239.

6. Hartmann, *Art Writings*, 237.

Sargent, *Simplon Pass*

1. In 1902 the sculptor Auguste Rodin famously called him "le Van Dyck de l'époque"; "M. Rodin in London," *Daily Chronicle*, 16 May 1902, 6, quoted in Richard Ormond and Elaine Kilmurray, *The Later Portraits*, vol. 3 of *John Singer Sargent: Complete Paintings* (New Haven: Yale University Press, published for The Paul Mellon Centre for Studies in British Art, 2003), xii. Sargent's first and most significant mural project was the *History of Religion*, for the Boston Public Library (installed 1895–1919).

2. Sargent to Ralph Curtis, 27 March [1907], quoted in Charles Merrill Mount, *John Singer Sargent* (London: Cresset Press, 1957), 243. For other of his protestations, see Ormond and Kilmurray, *The Later Portraits*, 213; and Stanley Olson, *John Singer Sargent: His Portrait* (New York: St. Martin's Press, 1986), 227.

3. He was not wholly successful in this. Ormond and Kilmurray (*The Later Portraits*) list just over sixty portraits (roughly 10 percent of his lifetime total)—in both oil and watercolor and of varying degrees of formality. The principal study of Sargent's later travel paintings is Warren Adelson et al., *Sargent Abroad: Figures and Landscapes* (New York: Abbeville Press, 1997).

4. The Simplon Pass extends approximately 28 miles between Brieg (in the Swiss Valais) and Iselle (in Italy). Largely unvisited until the nineteenth century, the place became a tourist site in 1906, when a railway line running 12½ miles through what was then the longest and lowest Alpine tunnel brought streams of visitors to it; *Encyclopedia Britannica*, 11th ed. (New York: Encyclopædia Britannica Company, 1911), s.v. "Simplon Pass." Sargent had been fascinated by Alpine scenery since his youth; see Stephen D. Rubin, *John Singer Sargent's Alpine Sketchbooks: A Young Artist's Perspective* (New York: Metropolitan Museum of Art, 1991); and Stephanie L. Herdrich and H. Barbara Weinberg, *American Drawings and Watercolors in the Metropolitan Museum of Art: John Singer Sargent* (New York: Metropolitan Museum of Art, 2000), 65–104. In 1909, 1910, and 1911 (the summers of his extended, documented stays in the Simplon), Sargent traveled with a shifting contingent that included his unmarried sister; his married sister, her husband, and their six children; his valet; and various male and female friends. Others—British and Italian painters and their families, sitters past and present—joined the party. For a full roster and photographs, see Richard Ormond, "In the Alps," in Adelson et al., *Sargent Abroad*, 68–73.

5. Ormond, "In the Alps," 64, reasonably posits the 1904 stay, in spite of a lack of comparable documentation for the later years, since Sargent showed watercolors of the scene in 1905. When he traveled, Sargent did not alter his daily work habits. According to Adrian Stokes, his "industry was constant"; Stokes, "John Singer Sargent, R.A., R.W.S.," *Old Water-Colour Society's Club* 3 (1926): 53. Martin Birnbaum, recording the reminiscences of the painter Charles Gere, one of Sargent's party in 1911, affirmed: "Despite his air of leisurely culture, he was a tremendous worker. . . . He usually started work after a very early breakfast and never stopped except for lunch, until his evening meal, before which he relaxed only to read omnivorously"; Birnbaum, *John Singer Sargent: A Conversation Piece* (New York: William E. Rudge's Sons, 1941), 11–12.

6. This is the hotel recommended by Baedeker in his *Switzerland and the Adjacent Portions of Italy, Savoy, and Tyrol: Handbook for Travellers*, 24th ed. (Leipzig: Karl Baedeker, 1911), 386 (likewise in the 1901 edition, at 337, as the Hôtel Bellevue).

7. See, for example, the photograph by Richard Ormond, taken in 1995, enclosed in a letter from Ormond to Randall McLean, 16 December 2004, CGA Curatorial Files. Ormond identified the site in print in "In Sargent's Footsteps, 1900–1914," in *Sargent and Italy*, ed. Bruce Robertson (Los Angeles: Los Angeles County Museum of Art, 2003), 123–26.

8. "Painting in Washington: Corcoran Gallery Opens Fifth Biennial Exhibition," *New York Evening Post*, 17 December 1914, 11.

9. Ibid. Sargent's overt interest in maintaining a balance between the fiction of the scene and the flattening, decorative patterns of paint—at least from a certain vantage point—has also prompted recent scholars to speculate on his experiences with photography. Erica E. Hirshler, writing of the later "unusual abstracted

compositions," notes: "He seems to have been inspired by the particular visual vocabulary of the photograph, its characteristic flattening of pictorial space, emphasis on surface pattern, and the manner in which each part of the composition was rendered in equal detail"; Hirshler, "'Big Skies Do Not Tempt Me': John Singer Sargent and Landscape Painting," in Hilliard T. Goldfarb et al., *Sargent: The Late Landscapes* (Boston: Isabella Stewart Gardner Museum, 1999), 65.

10. This parallels what Sargent's colleague Martin Hardie wrote of the watercolors, that Sargent knew "exactly how his free and simple blots and dashes of colour— seemingly indefinite, none of them really irrelevant—would coalesce into form when viewed from further off," marveling at "the almost magical skill by which the swift touches of his brush build up and express the infinite varieties of the surfaces and substances which he was painting"; Hardie, *J. S. Sargent, R.A., R.W.S.* (London: Studio, 1930), 4–5.

11. Stokes, "Sargent," 53–54. Stokes notes further (54): "Alas, that wonderfully painted foreground was not destined to remain. Broad free touches afterward partially effaced it, Sargent having probably found it too much in the nature of a separate study detrimental to the general effect he desired." While Stokes's four-footer is larger than the Corcoran's painting, there are few other extant Simplon paintings that have the blue sky and changing clouds that Stokes describes.

12. Parmelee paid $6,000 for the painting; CGA Curatorial Files.

13. "Corcoran Gallery Exhibit Brilliant," *Philadelphia Inquirer*, 20 December 1914, News sec., 2. "Cleverness" was an accusation that had dogged Sargent's work from the beginning of his career. See Marc Simpson, "Sargent and His Critics," in Simpson et al., *Uncanny Spectacle: The Public Career of the Young John Singer Sargent* (Williamstown, Mass.: Sterling and Francine Clark Art Institute, 1997), 59. "Painting in Washington," *New York Post*. This writer, too, took note of the "healthy change from a blindly idolatrous attitude toward Sargent, clung to by many of his contemporaries and happily shaken off by later men." For an overview of Sargent's reception in the twentieth century, see H. Barbara Weinberg, "John Singer Sargent: Reputation Redivivus," *Arts Magazine* 54 (March 1980): 104–9.

Thayer, *Mount Monadnock*

1. Thayer to Charles Lang Freer, 1 November 1913; and typescript of undated letter from Thayer to Mrs. William Amory and the Reverend George F. Weld, [1911], both in Charles Lang Freer Papers, Freer Gallery of Art and Arthur M. Sackler Archives, Smithsonian Institution, Washington, D.C.

2. See Nelson C. White, *Abbott Thayer: Painter and Naturalist* (Hartford: Connecticut Printers, 1951), 216.

3. Ralph Waldo Emerson, *Emerson in His Journals*, selected and ed. Joel Porte (Cambridge, Mass.: Harvard University Press, 1982), 538; and Henry David Thoreau, *The Journal of Henry David Thoreau in Fourteen Volumes Bound as Two* (New York: Dover, 1962), 10:458. See 453–78 for the description of his hike up the mountain and back.

4. In 1910 Thayer declared, "Emerson's Spiritual Laws . . . is my bible"; Thayer to William James, Jr., 9 September 1910, Nelson White Papers, Archives of American Art, Smithsonian Institution, Washington, D.C. (hereafter AAA).

5. For detailed accounts of Thayer's biography and its relation to his art, see Susan Hobbs, "Nature into Art: The Landscapes of Abbott Handerson Thayer," *American Art Journal* 14, no. 3 (Summer 1982): 4–55; and Ross Anderson, *Abbott Handerson Thayer* (Syracuse, N.Y.: Everson Museum, 1982).

6. The property was a gift from Mary Amory Greene, a wealthy Bostonian whose mother-in-law had purchased the south side of Dublin Lake in 1882 and parceled it out to family members, Boston intellectuals, and artists. See Richard Merryman, "Abbott Thayer in the Spell of Monadnock," in *Where the Mountain Stands Alone: Stories of Place in the Monadnock Region*, ed. Howard Mansfield (Lebanon, N.H.: University Press of New England in Cooperation with the Monadnock Institute of Nature, Place and Culture at Franklin Pierce College, 2006), 196; White, *Thayer*, 53–55; and Raphael Pumpelly, *My Reminiscences*, 2 vols. (New York: Henry Holt, 1918), 2:657–58.

7. While still maintaining a Washington Square studio, Thayer noted that he found it difficult "to work over four hours a day" and that "squalor [was] excessively irritating"; Thayer to Charles Lang Freer, undated letter, postmarked 29 May 1893, Charles Lang Freer Papers.

8. On Thayer's mental condition, see Merryman, "Thayer in the Spell of Monadnock," 197; see also Elizabeth Lee, "Therapeutic Beauty: Abbott Thayer, Antimodernism, and the Fear of Disease," *American Art* 18, no. 3 (Fall 2004): 33–51, who argues that Thayer's interest in ideal subjects, both figural and landscape, was not only biographical but also cultural, reflecting widespread anxiety in response to the heterogeneity of modern life.

9. The "great kindness" refers to the fact that MacVeagh, secretary of the U.S. Treasury during the Taft administration (1909–13), arranged for a case of condensed milk to be sent to Thayer's infant grandchild in the jungles of Brazil in the summer of 1911. See White, *Thayer*, 115–16; and Mary Birch to Abbott Thayer, 12 September 1911, Series 2, Box 1, Folder 20, AAA. The frame, inscribed on its reverse "19 (m) 14 / Carrig-Rohane Shop–Inc / Boston #1184," was ordered in November 1914. It was paid for by Mrs. MacVeagh and delivered (likely on the painting) to the MacVeaghs'

Washington home in January 1915. See Carrig-Rohane 1912–1916 Order Book, 62, reel 4974, frame 1016, AAA.

10. See Hobbs, "Nature into Art," 50; Gay Myers, American Paintings Catalogue Technical Examination Report, 17 November 2004, CGA Conservation Files. The date was changed from n.d. to probably 1911/1914 based on this research. See Lisa Strong, American Paintings Catalogue Project Manager, to Registrar, memorandum, 31 May 2010.

11. See, for instance, Thayer to Emma Beach, 26 June 1891, Nelson White Papers; and Thayer to Charles Lang Freer, 15 August [1901], Charles Lang Freer Papers.

12. Thayer to Mrs. William Amory and the Reverend George F. Weld, [1911], typescript of undated letter, Charles Lang Freer Papers.

13. Thayer to the curator of Smith College Art Gallery, [1912], typescript, Nelson C. White Papers.

14. The relation between Thayer's snowcapped mountains and his winged figures is discussed by Linda Merrill in Thomas Lawton and Merrill, *Freer: A Legacy of Art* (Washington, D.C.: Freer Gallery of Art, 1993), 160; Alexander Nemerov, "Vanishing Americans: Abbott Thayer, Theodore Roosevelt, and the Attraction of Camouflage," *American Art* 11, no. 2 (Summer 1997): 66–69; and Lee, "Therapeutic Beauty," 37–38.

15. Quoted in White, *Thayer*, 174.

Hassam, *The New York Window*

1. *Summer Evening* and *Improvisation* are reproduced in H. Barbara Weinberg et al., *Childe Hassam: American Impressionist* (New York: Metropolitan Museum of Art, 2004), 121 and 307, respectively.

2. Kathleen Burnside, "The Still Lifes of Childe Hassam" (essay for course in American Still Life Painting at the Graduate Center of the City University of New York, 1986, 27 and fig. 53). I am grateful to the author for making this information available to me.

3. Ulrich Heisinger describes the apartment in *Childe Hassam: American Impressionist* (Munich: Prestel, 1994), 141.

4. William H. Gerdts, "Three Themes," in Warren Adelson, Jay E. Cantor, and Gerdts, *Childe Hassam: Impressionist* (New York: Abbeville Press, 1999), 167.

5. "Seen at Spring Academy," *New York Evening Post*, 12 March 1912, quoted in David B. Dearinger, ed., *Rave Reviews: American Art and Its Critics, 1826–1925* (New York: National Academy of Design, 2000), 259.

6. Guy Pène du Bois, "National Academy Exhibit Decorous," *New York American*, 11 March 1912, 6, quoted in Adelson, Cantor, and Gerdts, *Hassam*, 167.

7. "Contemporary Paintings Shown in the Corcoran Gallery of Art at Washington," *Art and Progress* 4, no. 4 (February 1913): 861, quoted in David R. Brigham, *American Impressionism: Paintings of Promise* (Worcester, Mass.: Worcester Art Museum, 1997), 23, 36n30.

8. "The Corcoran Exhibition," *Academy Notes* (Buffalo Fine Arts Academy), January 1913, clipping, Biennial Scrapbook, Fourth Annual Exhibition, CGA Curatorial Files.

9. "Corcoran Exhibit," *New York Evening Post*, 28 December 1912, clipping, ibid.

10. For an extended comparison of *The New York Window* and *Bowl of Goldfish*, see Susan G. Larkin, *The Cos Cob Art Colony: Impressionists on the Connecticut Shore* (New York: National Academy of Design; New Haven: Yale University Press, 2001), 150, 153–54; and Larkin, "'A Regular Rendezvous for Impressionists': The Cos Cob Art Colony, 1882–1920" (Ph.D. diss., City University of New York, 1996), 188–93.

11. The frame on the Corcoran's painting is order no. 800 in the Carrig-Rohane Shop Records, 1903–1962, reel 4974, frame 948, Archives of American Art, Smithsonian Institution, Washington, D.C. An identical frame that Hassam ordered on the same day now surrounds *Golden Afternoon* (1908, The Metropolitan Museum of Art, New York). *Golden Afternoon* is reproduced in its frame in Susan G. Larkin, "How Hassam Framed Hassams," in Weinberg et al., *Hassam*, 331. Carrig-Rohane inscriptions were always on the center back of the lower rail. The position of the inscription and the presence of numerous holes for other attachments indicate that the frame was previously used on other canvases. I am grateful to Corcoran conservator Dare Hartwell for examining the back of the frame and sharing her observations.

Hartley, *Berlin Abstraction*

1. "I am working out some war motifs which people praise highly," Hartley wrote to Alfred Stieglitz, 3 November 1914, Yale Collection of American Literature, Beinecke Rare Book and Manuscript Library, quoted in Patricia McDonnell, "'Portrait of Berlin': Marsden Hartley and Urban Modernism in Expressionist Berlin," in *Marsden Hartley*, ed. Elizabeth Mankin Kornhauser (Hartford, Conn.: Wadsworth Atheneum Museum of Art, in association with Yale University Press, 2002), 53. McDonnell has written extensively on the multivalent meanings and aspects of the War Motifs; in addition to the foregoing essay, see also her "Changes of Heart: Marsden Hartley's Ideas and Art," in *Marsden Hartley: American Modern; Selections from the Ione and Hudson Walker Collection, Frederick R. Weisman Art Museum*, ed. McDonnell (Minneapolis: Frederick R. Weisman Art Museum, 2006). Barbara Haskell's *Marsden Hartley* (New York: Whitney Museum of American Art, in association with New York University Press, 1980) may be considered a pioneering study of these works.

2. Hartley to Alfred Stieglitz, February 1913, Yale Collection of American Literature, quoted in McDonnell, "'Portrait of Berlin,'" 39.

3. Elizabeth Mankin Kornhauser, "Marsden Hartley: 'Gaunt Eagle from the Hills of Maine,'" in Kornhauser, *Hartley*, 16.
4. Hartley to Stieglitz, May 1913, Yale Collection of American Literature, quoted in McDonnell, "Changes of Heart," 14.
5. McDonnell, "'Portrait of Berlin,'" 53.
6. Haskell, *Hartley*, 43, discusses at length (and for the first time) Hartley's homosexuality, his lifelong obsession with masculine beauty, and his love for von Freyburg, which, she notes, may or may not have been consummated. She extensively cites letters and writings by Hartley and von Freyburg and what they reveal of the pair's relationship.
7. McDonnell, "'Portrait of Berlin,'" 43; see also n113, which quotes Hartley's letter to Stieglitz of 23 October 1914, Yale Collection of American Literature, in which Hartley writes of "sit[ting] alone much the spectator of the great tragedy of the heart & soul of mankind—I cannot set up and work."
8. McDonnell, "Changes of Heart," 15.
9. See Gail Levin, "Hidden Symbolism in Marsden Hartley's Military Pictures," *Arts Magazine* 54, no. 2 (October 1979): 158; Haskell, *Hartley*, 45; and McDonnell, "'Portrait of Berlin,'" 54.
10. Two other War Motif paintings in this more abstract vein are *Painting Number 46* (1914–15, Albright-Knox Art Gallery, Buffalo, N.Y.) and *The Iron Cross* (1914–15, Mildred Lane Kemper Art Museum, Washington University, St. Louis), reproduced in Levin, "Hidden Symbolism," 157. Unlike the three mentioned in the text, however, these two retain some of the black background from earlier paintings in the series.
11. Records of this exhibition's content are not extant, but, given Rosenfeld's relationship with Stieglitz, this is a strong possibility. I am grateful to Charles Brock, Associate Curator, American and British Paintings, National Gallery of Art, Washington, D.C., for discussing this with me.
12. Marsden Hartley, "Foreword," *Camera Work*, no. 48 (October 1916): 12, quoted in McDonnell, "Changes of Heart," 15.

DeCamp, *The Seamstress*
1. DeCamp to C. Powell Minnigerode, Director, Corcoran Gallery of Art, November 1916, CGA Curatorial Files.
2. Patricia Jobe Pierce, *The Ten* (Hingham, Mass.: Pierce Galleries, 1976), 65, 72.
3. Sadakichi Hartmann, "The Tarbellites," *Art News* 1 (March 1897): 3–4, cited in William H. Gerdts, *American Impressionism* (New York: Abbeville Press, 1984) 114n41.
4. American Impressionists were loosely divided into the landscape school of the Pennsylvania artists and the figure painters of Boston. DeCamp painted another work similar to *The Seamstress*, titled *The Window* (c. 1910, location unknown); see Ulrich W. Heisinger, *Impressionism in America: The Ten American Painters* (Munich: Prestel-Verlag, 1991), 29. Featuring a woman standing in front of a bright window, the work was praised

as "one of the most exquisitely rendered harmonies of delicate gray tonalities"; J. Nilsen Laurvik, "The Ten American Painters," *Boston Evening Transcript*, 23 March 1911, 16.
5. Charles H. Caffin, "The Art of Frank W. Benson," *Harper's Monthly Magazine* 119 (June 1909): 105.
6. Trevor Fairbrother, "Painting in Boston, 1870–1930," in *The Bostonians: Painters of an Elegant Age, 1870–1930* (Boston: Museum of Fine Arts, Boston, 1986), 69.
7. Quoted by Paul K. M. Thomas, in Donald Moffat Papers, Archives of American Art, Smithsonian Institution, Washington, D.C.
8. *Sun*, 19 March 1916, sec. 5, 8, quoted in Heisinger, *Impressionism in America*, 197.

Lawson, *Boathouse, Winter, Harlem River*
1. Allen Tucker, *John H. Twachtman*, American Artists Series (New York: Whitney Museum of American Art, 1931), 8.
2. Ernest Lawson, "The Credo," c. 1930s, reprinted in Henry Berry-Hill and Sidney Berry-Hill, *Ernest Lawson: American Impressionist* (Leigh-on-Sea, Eng.: F. Lewis, Publishers, 1968), 22.
3. I am grateful to Kathleen A. McAuley, Curator, The Bronx County Historical Society, for identifying the location and the buildings depicted in the painting.
4. Elliot Willensky and Norval White, *AIA Guide to New York City* (New York: Harcourt Brace Jovanovich, 1988), 521. According to the same source, the Hall of Fame is "Not a hall at all but a roughly semicircular Classical arcade between whose columns are arrayed bronze busts of great Americans."
5. The total snowfall for the winter of 1915–16 was 50.7 in., according to "Monthly & Seasonal Snowfall at Central Park," at http://www.erh.noaa.gov/okx/ climate/records/monthseasonsnowfall .html.
6. Ernest Lawson to Charles C. Glover, 10 December 1916, Director's Correspondence, CGA Archives.
7. For *Harlem Winter*, see *Antiques* 135 (July 1989): 22.
8. *Important American Paintings, Drawings and Sculpture*, Christie's, New York, 20 May 2010, lot 56.

Benson, *The Open Window*
1. The basic biographical reference on the artist is Faith Andrews Bedford, *Frank W. Benson: American Impressionist* (New York: Rizzoli, 1994). See also the website Bedford maintains: http:// www.frankwbenson.com. I am grateful to her for answering my questions about the artist.
2. Bedford, *Benson*, 174–75.
3. Benson and Tarbell, who also summered in New Castle, taught a summer class there from 1893 through 1899; Faith Andrews Bedford et al., *The Art of Frank W. Benson, American Impressionist* (Salem, Mass.: Peabody Essex Museum, 2000), 22.
4. The author was probably Philip Leslie Hale, a fellow teacher at the Museum School.

5. The painting is reproduced in Laurene Buckley, *Edmund C. Tarbell: Poet of Domesticity* (New York: Hudson Hills Press, 2001), 79.
6. H. C. N., "Corcoran Biennial a Tribute to American Art," *Globe and Commercial Advertiser*, 24 December 1919, 6.
7. For Benson's use of the decorative arts, see Dean T. Lahikainen, "Redefining Elegance: Benson's Studio Props," in *The Art of Benson*, 75–97.
8. *The Art of Benson*, 31. I am also grateful to Pratt's granddaughter Cynthia Sam for information about the sculpture.
9. Benson had incorporated Pratt's sculpture in an earlier painting, *Figure in a Room* (1912, New Britain Museum of American Art, Conn.).
10. Gustav Kobbe, "Art," *New York Herald*, 11 March 1917, sec. 3, 10.
11. "'Ten American Painters' Hold Exhibition," *New York Times*, 11 March 1917.
12. "Annual Display of 'The Ten,'" *American Art News* 15 (10 March 1917): 2.
13. "The Ten American Painters," *Art World*, June 1917, 239.
14. James B. Townsend, "Seventh Corcoran Exhibit," *American Art News* 18 (27 December 1919): 1.
15. H. C. N., "Corcoran Biennial."
16. "Corcoran Gold Medal Awarded to Salem Painter at Exhibition of American Contemporary Art," *Washington Post*, 21 December 1919, 16.
17. Anna Seaton-Schmidt, "The Corcoran Exhibition," *Boston Evening Transcript*, 24 December 1919, sec. 1, 8.

Frieseke, *Peace*
1. William H. Gerdts, *Monet's Giverny: An Impressionist Colony* (New York: Abbeville Press, 1993), 157, 171.
2. The cradle pictured in *Peace* was made for the artist's only child, Frances, by her uncle Ferdinand Gély. Nicholas and Julia Kilmer gave it to the Corcoran in 2003 in memory of Nicholas's mother, Frances Frieseke Kilmer.
3. Arleen Pancza, "Frederick Carl Frieseke (1874–1939)," in J. Gray Sweeney et al., *Artists of Michigan from the Nineteenth Century* (Muskegon, Mich.: Muskegon Museum of Art, 1987), 173.
4. Frieseke to Macbeth, quoted in Hollis Koons McCullough and Linda McWhorter, "Frederick Carl Frieseke," *American Art Review* 13, no. 2 (March–April 2001): 146.
5. Dorothy Schneider and Carl J. Schneider, *Into the Breach: American Women Overseas during World War I* (New York: Viking, 1991), 9, 35, 87–88.
6. Frieseke to Macbeth, 1 February 1915, quoted in Nicholas Kilmer, "Frederick Carl Frieseke: A Biography," in *Frederick Carl Frieseke: The Evolution of an American Impressionist* (Savannah, Ga.: Telfair Museum of Art, 2001), 36.
7. Gerdts, *Monet's Giverny*, 206.
8. Kilmer, "Frieseke," 35, 37.
9. Susan R. Grayzel, *Women and the First World War*, Seminar Studies in History (New York: Pearson Education Limited, 2002), 52, 57.

10. This reading of *Peace* is reinforced by Frieseke's and his colleagues' frequent portrayal of women in interiors and walled gardens, which reveal their attitudes about the female sex. According to art historians' interpretations, women in Giverny Group paintings are depicted as isolated and therefore protected from the contemporary world; in their "rightful place," they are pictured as symbols of male wealth and position as well as refuges from the harshness of modern life. Gerdts, *Monet's Giverny*, 209; Bailey Van Hook, "Decorative Images of American Women: The Aristocratic Aesthetic of the Late Nineteenth Century," *Smithsonian Studies in American Art* 4, no. 1 (Winter 1990): 53, 59, 62; and Sarah Cash, *The Gilded Cage: Views of American Women, 1873–1921* (Washington, D.C.: Corcoran Gallery of Art, 2002).
11. Margaret H. Darrow, *French Women and the First World War: War Stories of the Home Front* (New York: Berg, 2000), 58–59.
12. "Paintings Contrast Thoughts of Today: Breckinridge's 'The Pestilence' and Frieseke's 'Peace,'" *Philadelphia Evening Telegram*, 1 March 1918.
13. Frieseke to Robert Macbeth, 24 October 1917, Macbeth Gallery Records, reel NMc46, frame 246, Archives of American Art, Smithsonian Institution, Washington, D.C. (hereafter Macbeth Records).
14. Frieseke to Robert Macbeth, 18 February 1919, Macbeth Records, frame 260; and Pancza, "Frieseke," 173.
15. W[illiam] H[owe] D[ownes], "The Fine Arts: The Honorary Members," *Boston Evening Transcript*, 27 December 1920, 11; and Harvey M. Watts, "American Art at the Corcoran Gallery," *Arts and Decoration* 16, no. 4 (February 1922): 322.
16. Leila Mechlin, "Notes of Art and Artists," *Washington Sunday Star*, 25 December 1921, part 2, 8.

Henri, *Indian Girl in White Blanket*
1. The Eight exhibited together only once in a landmark independent exhibition held in 1908 at Macbeth Gallery in New York. Besides Henri, the group included William Glackens, John Sloan, Ernest Lawson, Everett Shinn, George Luks, Maurice Prendergast, and Arthur B. Davies.
2. Henri to Bellows, 19 August 1917, Robert Henri Papers, Yale Collection of American Literature, Beinecke Rare Book and Manuscript Library.
3. Henri to Bellows, 17 November 1917, Henri Papers.
4. Henri's friend Dr. Edgar L. Hewett, an ethnologist and director of the School of American Archeology (now the School of American Research) in Santa Fe, provided the artist with a studio in the Palace of the Governors. For more on Henri and Hewett, see Valerie Ann Leeds, "Robert Henri and the American Southwest: His Work and Influence" (Ph.D. diss., City University of New York, 2000), 123–33.
5. The title was changed from *Indian Girl in White Cermonial Blanket* to *Indian Girl in White Blanket* in accordance with

American Paintings Catalogue policy, which restores the titles to those under which a painting was first exhibited or published or those originally given by the artist. The painting was first exhibited in the *Dedication Exhibit of Southwestern Art*, Museum of New Mexico, Santa Fe, November–December 1917, cat. no. 141, as *Indian Girl in White Blanket* and was recorded under the same title in Henri's ledger; Artist's Record Book, Estate of Robert Henri, LeClair Family Collection, New York City. See Lisa Strong, Project Manager, to Registrar, memorandum, 7 June 2010.

Among the other portraits from 1917 for which Julianita modeled is *Indian Girl of San Ildefonso* (Indianapolis Museum of Art), completed right before the Corcoran painting, which shows the girl wrapped in a brown silk shawl. Other paintings of her are *Julianita Ready for the Dance* and three paintings titled *Julianita*, each in private collections. See Artist's Record Book.

6. Valerie Ann Leeds, *Robert Henri: The Painted Spirit* (Santa Fe: Gerald Peters Gallery, 2005), 14, 26, 30.

7. Gregorita Baca Chavarria, conversation with the author, 9 October 1998. She was another favored model of Henri's that season and also attended the Indian School in Santa Fe.

8. For the history of geometric-patterned blankets produced for the southwestern Indian trade, see Barry Friedman, *Chasing Rainbows: Collecting American Indian Trade and Camp Blankets* (Boston: Bulfinch Press, 2003).

9. Robert Henri, "My People," *Craftsman* 28, no. 5 (February 1915): 467. Henri had not yet visited Santa Fe when he wrote the article, but he had visited Southern California in 1914 and had painted Native American sitters.

10. Henri to Randall Davey, 18 December 1917, Henri Papers. Henri remained in Santa Fe until December 1917 before returning to New York. Henri to his mother, November 1917, Henri Papers. Henri anticipated leaving Santa Fe by 29 November and returning to New York by 3 December.

11. Artist's Record Book.

12. The list of the works with their catalogue numbers is included in "When Dreams Come True," *El Palacio* 4 (November 1917): 95. The work is listed as *Indian Girl in White Blanket*, although the painting is inscribed on the verso in Henri's hand: "Robert Henri / Indian Girl in White Ceremonial Blanket / 21|K [circled]" as well as on the top tacking edge: "JULIANITA WHITE CEREMONIAL BLANKET"; and on the bottom tacking edge: "WHITE CEREMONIAL BLANKET."

13. "Exhibitions at New York Galleries: Tarbell, Henri, Burlin, MacDonald-Wright," *Fine Arts Journal* 36 (March 1918): 62–63; and Charles Henry Dorr, "Brooklyn Artists to the Fore in Corcoran Gallery Show," *Brooklyn Times*, 23 December 1923, 7.

14. Dorothy Grafly, "Charcoal Club's Annual Show of American Art in Balti-

more," *Christian Science Monitor*, 26 February 1923, 10.

15. Viktor Flambeau, "Public Votes This Week on Prize Picture: Corcoran Biennial Exhibition Visitors Will Select Their Favorite," *Washington Herald*, 6 January 1924, March of Events sec., 5.

Garber, *South Room—Green Street*

1. The jury comprised the leading artists of the time, with Frank Benson as the chief, and at least one critic was quick to point out how Garber's work resembled Benson's prize-winning painting, *The Open Window* (see essay), at the Corcoran biennial from two years before. Leila Mechlin, "High Standards Upheld by Corcoran Pictures," *Washington Star*, 18 December 1921, sec. 1, 6.

2. Edith W. Powell, *Philadelphia Public Ledger*, 25 December 1921.

3. Other works featuring the front room of Garber's Philadelphia home include *Fireplace, Green Street* (c. 1923–28, Indiana University Art Museum, Bloomington).

4. Garber, interview by Dorothy Grafly, *Christian Science Monitor*, 2 September 1922, 10.

5. *Laguna Life*, 24 February 1922. Others, however, considered the light effects "baffling," explaining that "the sun should [not] do more than illuminate the outline or edge of the girl's hair. The mirror hanging on the wall perhaps throws a cross light which adds to our confusion"; R. T., "Corcoran Art Display," *Washington Herald*, 4 January 1922. Similarly, some viewers had difficulty reading other passages of the painting: "the pigments have a fractured texture suggestive of light being shattered into prismatic colors as it streams through the glass"; Lance Humphries, *Daniel Garber: Catalogue Raisonné* (New York: Hollis Taggart Galleries, 2006), 1:81.

6. Kathleen A. Foster notes that Edmund Tarbell painted many interiors featuring his family; Foster, *Daniel Garber* (Philadelphia: Pennsylvania Academy of the Fine Arts, 1980), 34. One fine example of Tarbell's is *Mother and Mary* (1922, National Gallery of Art, Washington, D.C.), which shows his wife and daughter at their summer home in New Hampshire.

7. Other examples of Eakins using his home as the background for his paintings include *Home Scene* (c. 1871, Brooklyn Museum), *Elizabeth Crowell with a Dog* (c. 1873–74, San Diego Museum of Art), *Elizabeth at the Piano* (1875, Addison Gallery of American Art, Andover, Mass.), *The Chess Players* (1876, The Metropolitan Museum of Art, New York), and *Singing a Pathetic Song* (1881, Corcoran Gallery of Art; see essay).

Carlsen, *The Picture from Thibet*

1. Edward Alden Jewell, "Still-Life Studies of Carlsen Shown," *New York Times*, 26 April 1935, 17: "Emil Carlsen could produce wonderful results with such reticent, unassertive colors as gray and cool dun silver, with delicately grayed whites and warm though low-keyed earth-browns. The quiet magic thus

wrought is unforgettably exemplified by such still-lifes."

2. Carlsen could have seen the works of Chardin while in Paris in 1875 and later during his extended stay in the city from 1884 to 1886. Furthermore, the Museum of Fine Arts, Boston, acquired and exhibited Chardin's *Kitchen Table* (17[55?]) in 1880, and *Still Life with Teapot, Grapes, Chestnuts, and a Pear* (17[64?]) in 1883, when Carlsen was living in the city, from 1876 to 1884. For a discussion of Carlsen's Boston years, see Ulrich W. Hiesinger, *Quiet Magic: The Still-Life Paintings of Emil Carlsen* (New York: Vance Jordan Fine Art, 1999), 13–17.

3. "Still Life Paintings as Inspiration for Home Decoration: Illustrated by the Work of Emil Carlsen," *Touchstone*, May 1920, 115.

4. Carlsen titled the work *The Picture from Thibet* and referred to the painting in correspondence as his "Tibethean canvas"; Carlsen to William Macbeth, 27 October 1922, Macbeth Gallery Records, reel NMc31, frame 869, Archives of American Art, Smithsonian Institution, Washington, D.C. The figurine and the jade bowl in this arrangement appear in an earlier composition entitled *The Jade Bowl* (c. 1919, location unknown); and the figurine, porcelain vase, and Tibetan *tangka* appear in *The Sung Jar* (1930, Evansville Museum of Arts and Science, Ind.).

5. Steven Conn, "Where Is the East? Asian Objects in American Museums, from Nathan Dunn to Charles Freer," *Winterthur Portfolio* 35, nos. 2–3 (Summer–Autumn 2000): 159, 164, 166–68.

6. Mary Ellen Hayward, "The Influence of the Classical Oriental Tradition on American Painting," *Winterthur Portfolio* 14, no. 2 (Summer 1979): 107.

7. Ibid., 113, 118. Conn, "Where Is the East?" 159, quotes one historian as saying the period 1893–1929 was "the golden age of Asian art collecting." By 1929 the Museum of Fine Arts, Boston, under the guidance of the pioneering curator of Asian art Ernest Fenollosa, boasted a collection of 92,000 pieces. Conn, 157.

8. Hayward, "The Influence of the Classical Oriental Tradition"; Kathleen Pyne, "Portrait of a Collector as an Agnostic: Charles Lang Freer and Connoisseurship," *Art Bulletin* 78, no. 1 (March 1996): 95; and Aida-Yuen Wong, "A New Life for Literati Painting in the Early Twentieth Century: Eastern Art and Modernity, a Transcultural Narrative." *Artibus Asiae* 60, no. 2 (2000): 298.

9. Hiesinger, *Quiet Magic*, 42; see pls. 29 and 30 and figs. 34 and 39.

10. Royal Cortissoz, "Old Works by Jongkind and New Ones by Carlsen," *New York Daily Tribune*, 13 February 1921, sec. 3, 7.

11. The price of *The Picture from Thibet* was noted as $4,500 in *Recent Paintings by Emil Carlsen, N.A.* (New York: Macbeth Gallery, 1921). Similar still lifes in the exhibition, such as *The Moonstone* and *Leeds Jugs*, were listed for $1,500, while *The Valley, Moonlight*, the most expensive

landscape in the show, was offered at $3,000. Later, Carlsen assigned *The Picture from Thibet* the price of $7,000. See Carlsen to C. Powell Minnigerode, 3 April 1925, CGA Archives: "The canvas is my choicest still life, and I have held it at a price of $7,000."

12. Carlsen to William Macbeth, 22 October 1922, Macbeth Gallery Records, reel NMc31, frame 867.

13. Emil Carlsen, "On Still-Life Painting," *Palette and Brush*, October 1908, 8.

Prendergast, *Landscape with Figures*

1. Nancy Mowll Mathews, *The Art of Leisure: Maurice Prendergast in the Williams College Museum of Art* (Williamstown, Mass.: Williams College Museum of Art, 1999), 33.

2. Prendergast to Pach, 2 February 1922, quoted in Richard J. Wattenmaker, *Maurice Prendergast* (New York: Harry N. Abrams, in association with National Museum of American Art, Smithsonian Institution, 1994), 146.

3. Jill Anderson Kyle, "Cézanne and American Painting, 1900 to 1920" (Ph.D. diss., University of Texas, Austin, 1995), 335.

4. Wattenmaker, *Prendergast*, 120; and Mathews, *The Art of Leisure*, 45.

5. Ellen Marie Glavin, "Maurice Prendergast: The Development of an American Post-Impressionist, 1900–1915" (Ph.D. diss., Boston University, 1988), 178, 180, 198; Milton W. Brown, "Maurice B. Prendergast," in Carol Clark, Nancy Mowll Mathews, and Gwendolyn Owens, *Maurice Prendergast, Charles Prendergast: A Catalogue Raisonné* (Williamstown, Mass.: Williams College Museum of Art; Munich: Prestel-Verlag, 1990), 22 (hereafter CR); and Mathews, *The Art of Leisure*, 45.

6. Brown, "Prendergast," 17.

7. Nancy Mowll Mathews, *Maurice Prendergast* (Williamstown, Mass.: Williams College Museum of Art; Munich: Prestel-Verlag, 1990), 38; and Glavin, "Prendergast," 184.

8. Mathews, *The Art of Leisure*, 16.

9. Ibid., 46.

10. Other paintings in this subset include: *Sunset*, c. 1915–18 (CR 434); *Early Evening*, c. 1915–18 (CR 437); *Salem Cove*, c. 1915–18 (CR 439); *Castle Island*, c. 1915–18 (CR 451); *Late Afternoon, New England*, c. 1915–18 (CR 500); *Crepuscule*, c. 1918–23 (CR 504); and *Sunset and Sea Fog*, c. 1918–23 (CR 318).

11. Quoted in William Mathewson Milliken, "Maurice Prendergast, American Artist," *Arts* 9, no. 4 (April 1926): 192.

12. Prendergast to C. Powell Minnigerode, 16 December 1923, Office of the Director Correspondence, C. Powell Minnigerode Records, 1908–1915, CGA Archives (hereafter CPM Records).

13. Gwendolyn Owens, "Maurice Prendergast among His Patrons," in Clark, Mathews, and Owens, *Maurice Prendergast, Charles Prendergast*, 52.

14. Viktor Flambeau, "Public Votes This Week on Prize Picture: Corcoran Biennial Exhibition Visitors Will Select Their

Favorite," *Washington Herald*, 6 January 1924, March of Events sec., 5; and Leila Mechlin, "Notes of Art and Artists," *Washington Star*, 16 December 1923, sec. 2, 13.

15. "Dickinson Picture Wins Public Vote," *Washington Star*, 15 January 1924, 2.

16. Ibid.

17. C. Powell Minnigerode to Prendergast, 17 December 1923; and Prendergast to Minni-gerode, 19 December 1923, CPM Records.

18. The Corcoran was the first museum to *purchase* a painting by Prendergast; in 1918 the Memorial Art Gallery in Rochester, New York, was the first to accept a Prendergast as a gift (*The Ships*, c. 1895–97, monotype on paper [CR 1676]); Owens, "Maurice Prendergast among His Patrons," 48, 56.

Redfield, *The Mill in Winter*

1. The date was determined in consultation with the meteorologist Sam McCown, National Climatic Data Center, Asheville, North Carolina. Snow accumulated in Bucks County in the winter of 1921–22 on two dates, 4 December 1921 (5.0 in.) and 5 February 1922 (3.5 in.). Because there are still leaves on the trees in the painting, the river is not yet frozen, and there is snow clinging to the tree branches, as is typical of the kind of wet snowfall that took place on 4 December, McCown concluded that Redfield's painting must depict the December, rather than the February, snowfall. McCown also determined that Redfield could not have painted snow during the autumn before the painting's first exhibition at the National Academy of Design's 1922 Winter Annual Exhibition because there had been a drought that season. My thanks to Sam McCown for his generosity in conducting this research.

2. "Interview with Edward W. Redfield, Dean of the New Hope Art Colony by Robert H. Lippincott," as transcribed in J. M. W. Fletcher, *Edward Willis Redfield, 1869–1965: An American Impressionist; The Redfield Letters, Seven Decades of Correspondence Plus 426 Photographs of His Paintings in Two Volumes* (Lahaska, Pa.: JMWF Publishing, 2002), 2:471, 473.

3. Ibid., 471. A total of 5–7 inches fell in Bucks County on 4 December 1921; reports from Bucks County Cooperative Observers' Meteorological Records for Neshaminy Falls, George School, Quakertown, and Doylestown, National Climatic Data Center, National Oceanic and Atmospheric Administration.

4. "Interview," 473; and Constance Kimmerle, *Edward W. Redfield: Just Values and Fine Seeing* (New Hope, Pa.: James A. Michener Art Museum, 2004), 38.

5. Kimmerle, *Redfield*, 19–20, 37.

6. Mariana Griswold Van Rensselaer, "Fifty-seventh Annual Exhibition of the National Academy of Design," *American Architect and Building News* 11, no. 329 (15 April 1882): 176, as quoted in Kimmerle, *Redfield*, 14, 15n5.

7. Kimmerle, *Redfield*, 14–15.

8. John E. D. Trask, preface to *Catalogue of the Exhibition of Landscape Paintings by Edward W. Redfield* (Philadelphia: Pennsylvania Academy of the Fine Arts, 1909), n.p., as quoted in Kimmerle, *Redfield*, 14, 15n4.

9. Kimmerle, *Redfield*, 13.

10. Ibid., 14–15, 37–39. W. J. Johnson to Redfield, 25 January 1924; and Edward Duff Balken to Redfield, 23 January 1924, CGA Curatorial Files.

11. Redfield to Minnigerode, 24 January 1924, in Fletcher, *Redfield*, 2:272; Minnigerode to Redfield, 29 January 1924, in ibid., 2:274; and Joseph H. Himes to Redfield, 30 January 1924, in ibid., 2:275.

12. "Interview," 476.

Beaux, *Sita and Sarita*

1. In 1899 the sculptor and art historian Lorado Taft considered Beaux the first "truly great woman painter," cited in Sarah Burns, "The 'Earnest, Untiring Worker' and the Magician of the Brush: Gender Politics in the Criticism of Cecilia Beaux," *Oxford Art Journal* 15, no. 1 (1992): 45. The same year, William Merritt Chase hailed her as "the greatest living woman painter," cited in Burns, *Inventing the Modern Artist: Art and Culture in Gilded Age America* (New Haven: Yale University Press, 1996), 172.

2. Unidentified review from *The Critic*, [1895], Cecilia Beaux Papers, reel 429, frame 1, Archives of American Art, Smithsonian Institution, Washington, D.C., cited in Kevin Sharp, "Cecilia Beaux and the Rise of American Portraiture in the 1890s," in Sylvia Yount, *Cecilia Beaux: American Figure Painter* (Berkeley: University of California Press, 2007), 69.

3. Beaux may have seen Whistler's painting at the Metropolitan Museum of Art, New York, in 1881; Yount, "Family Pictures," in Yount, *Beaux*, 33. She had met Manet and was certainly familiar with *Olympia* and the controversy it caused when it was exhibited at the Paris Salon in 1865. When Beaux was in Paris, a fund was taken up to buy the painting for the French government. Rae Becker, "*Sita and Sarita*," in Ann Sutherland Harris and Linda Nochlin, *Women Artists: 1550–1950* (Los Angeles: Los Angeles County Museum of Art, 1976), 253–54.

4. Frances K. Pohl writes that "Beaux's painting subtly works against the denial of sexual feelings in 'respectable' women that was so much a part of gender discourse at the end of the 19th century and that was undoubtedly drilled into her by her grandmother and aunts, who were of good Puritan New England stock"; Pohl, *Framing America: A Social History of American Art*, 2nd ed. (New York: Thames & Hudson, 2008), 293.

5. Beaux to C. Powell Minnigerode, 28 June 1935, Office of the Director Correspondence, C. Powell Minnegerode Records, CGA Archives.

6. Erwin S. Barrie to C. Powell Minnegerode, 18 December 1923, Office of the Director Correspondence.

7. Leila Mechlin, "Notes of Art and Artists," *Washington Star*, 23 December 1923, sec. 2, 20.

Kuniyoshi, *Cows in Pasture*

1. "Yasuo Kuniyoshi's Development: Interesting Gathering of His Work Shown at the Daniel Gallery," *New York Sun*, February 1928, clipping, Yasuo Kuniyoshi Papers, reel D176, frame 296, Archives of American Art, Smithsonian Institution, Washington, D.C. (hereafter AAA).

2. Lloyd Goodrich, *Yasuo Kuniyoshi Retrospective Exhibition* (New York: Whitney Museum of American Art, 1948), 13. A woodblock print of a kneeling heifer was emblazoned on the cover of Kuniyoshi's first solo exhibition catalogue, *Paintings and Drawings by Yasuo Kuniyoshi* (New York: Daniel Gallery, [1922]).

3. Kuniyoshi, "East to West," *Magazine of Art*, February 1940, 75–77.

4. Kuniyoshi to Marsh, 14 June 1922, Reginald Marsh Papers, reel D308, frame 38, AAA.

5. Kuniyoshi, "Autobiographical Notes," 24 August 1944, typescript, Kuniyoshi Papers, unmicrofilmed, AAA.

6. "Show at Whitney Studio Galleries, 'Early American Art,'" *New York Herald*, 17 February 1924.

7. Kuniyoshi, "Autobiographical Notes." See also Kuniyoshi, "East to West," 74.

8. Although Kuniyoshi claimed he "hadn't been influenced by him at all," his totemic bovines recall Marc Chagall's whimsical folkloric imagery. *Cows in Pasture* also brings to mind the simplified geometric style, intense palette, and zoological subjects of Franz Marc's symbolic paintings; Kuniyoshi admitted he was "greatly influenced by the German Expressionist group," of which Marc would be considered a member. Lloyd Goodrich, "Notes on Conversation with Yasuo Kuniyoshi," Whitney Museum Papers, reel N670, frame 82, AAA.

9. Lloyd Goodrich, "Notes on Conversation with Yasuo Kuniyoshi," Whitney Museum Papers, reel N670, frame 68. On Kuniyoshi's incorporation of his Japanese heritage in his work, see Gail Levin, "Between Two Worlds: Folk Culture, Identity, and the American Art of Yasuo Kuniyoshi," *Archives of American Art Journal* 43, nos. 3–4 (2003): 2–17.

10. Doreen Bolger, "Hamilton Easter Field and His Contribution to American Modernism," *American Art Journal* 20, no. 2 (1988): 94.

12. Henry McBride, "Robust Art of Yasuo Kuniyoshi," *New York Herald*, 3 January [1925], clipping, Kuniyoshi Papers, reel D176, frame 167, AAA.

12. "The World of Art," *New York Times Book Review*, 15 January 1923.

13. "Art in Review: Kuniyoshi, in New One-Man Exhibit at Downtown Gallery, Shows Considerable Progress," *New York Times*, 8 February 1933.

14. Sara Mazo Kuniyoshi, interview, in Wolf, "The War Years," in *Yasuo Kuniyoshi* (New York: Whitney Museum of Ameri-can Art at Philip Morris, 1986), n.p. See also ShiPu Wang, "Japan against Japan: U.S. Propaganda and Yasuo Kuniyoshi's Identity Crisis," *American Art* 22, no. 1 (Spring 2008): 28–51.

15. Kuniyoshi to Biddle, draft, 11 December 1941, Kuniyoshi Papers, unmicrofilmed, AAA.

16. Kuniyoshi, "Autobiographical Notes."

17. Kuniyoshi, "Attitude towards Nature; Statement for Ray Berther's [Bethers's] Book, *How Paintings Happen* [published, New York: Norton, 1951]," Kuniyoshi Papers, unmicrofilmed, AAA.

Bruce, *Peinture/Nature Morte*

1. William C. Agee and Barbara Rose, *Patrick Henry Bruce, American Modernist: A Catalogue Raisonné* (New York: Museum of Modern Art; Houston: Museum of Fine Arts, Houston, 1979), 30.

2. William C. Agee, "Patrick Henry Bruce: A Major American Artist of Early Modernism," *Arts in Virginia* 17, no. 3 (Spring 1977): 14.

3. Bruce to Henri-Pierre Roché, 17 March 1928, quoted in ibid., 26.

4. Kenneth E. Silver, "From Nature Morte to Contemporary Plastic Life: Purism, Lèger, and the Americans," in *A Transatlantic Avant-garde: American Artists in Paris, 1918–1939*, ed. Sophie Lévy (Berkeley: University of California Press; Giverny, France: Musée d'Art Américain Giverny, 2003), 32.

5. Agee and Rose, *Bruce*, 33–34.

Davies, *Stars and Dews and Dreams of Night*

1. Algernon Charles Swinburne, *Atalanta in Calydon and Lyrical Poems*, selected by William Sharp (Leipzig: Bernhard Tauchnitz, 1901), 35.

2. Edward Alden Jewell, "Eleventh Corcoran Exhibit and German Primitives," *New York Times*, 4 November 1928, sec. 10, 12.

3. "Corcoran Show," *Christian Science Monitor*, 19 November 1928, 7.

4. *The Estate of the Late Arthur B. Davies, Sold by Order of Dr. Virginia M. Davies*, American Art Association, New York, 16–17 April 1929, 98.

5. Gustavus A. Eisen, "Davies Recovers the Inhalation of the Greeks," in *Arthur B. Davies: Essays on the Man and His Art* (Cambridge, Mass.: Riverside Press, 1924). For more on this subject, see Robin Veder, "Arthur B. Davies' Inhalation Theory of Art," *American Art* 23, no. 1 (Spring 2009): 56–77.

6. Walter Pach, "A Recollection," in *Arthur B. Davies (1862–1928): A Centennial Exhibition* (Utica, N.Y.: Munson-Williams-Proctor Institute, 1962), 7.

Pène du Bois, *Pierrot Tired*

1. The date of the painting has been changed from c. 1927 to c. 1929 in accordance with American Paintings Catalogue policy, which restores dates to those given when the picture was first exhibited or published; see *Exhibition of Paintings and Water Colors by Guy Pène du Bois*, C. W. Kraushaar Art Galleries,

New York, 26 February–15 March 1920, cat. no. 10; and email correspondence between Emily Shapiro, Assistant Curator of American Art, and Betsy Fahlman, Professor of Art History, Arizona State University, 24 and 25 June 2004, CGA Curatorial Files. See also Shapiro to Registrar, memorandum, 1 July 2004, CGA Curatorial Files.

2. Royal Cortissoz, *Guy Pène du Bois* (New York: Whitney Museum of American Art, 1931), 8–9.

3. John Baker, "Guy Pene du Bois on Realism," *Archives of American Art Journal* 17, no. 2 (1977): 2.

4. Betsy Fahlman, "Guy Pène du Bois, *Jane*," in *Seeing America: Painting and Sculpture from the Collection of the Memorial Art Gallery* (Rochester, N.Y.: University of Rochester Memorial Art Gallery, 2006), 269.

5. Cortissoz, *Pène du Bois*, 7.

6. Betsy Fahlman, "Guy Pène du Bois: The Twenties at Home and Abroad," *American Art Review* 7, no. 5 (October–November 1995): 112–17.

7. See Robyn Asleson, Education Department, CGA, to Becky Tiger, memorandum, 3 August 1984, CGA Curatorial Files.

Myers, *Life on the East Side*

1. Morris Gilbert, "Portrait of an Artist," *New York World Telegram*, 22 February 1940, quoted in Grant Holcomb, "The Forgotten Legacy of Jerome Myers, (1867–1940): Painter of New York's Lower East Side," *American Art Journal* 9, no. 1 (May 1977): 90.

2. *The WPA Guide to New York City: The Federal Writers' Project Guide to 1930s New York* (1939; New York: Pantheon Books, 1982), 109.

3. Lillian Wald, "The House on Henry Street: A Chronicle of Hope," *Atlantic Monthly*, March 1915, 289.

4. *WPA Guide to New York City*, 108.

5. Jerome Myers, *Artist in Manhattan* (New York: American Artists Group, 1940), 48.

6. Ibid., 166.

7. "La Guardia Renews War on Pushcarts," *New York Times*, 22 May 1938, 39. See also "Changes Are Noted in Lower East Side; Indoor Markets Eliminating Pushcarts," *New York Times*, 21 February 1939, 40.

8. Myers, *Artist in Manhattan*, 220.

9. Describing a drawing of mid-town Manhattan, Myers (ibid., 194) notes that "scornfully the skyscraper looks down on" First Avenue.

10. Ibid., 57.

11. Ibid.

Bluemner, *Imagination*

1. See Barbara Haskell, *Oscar Bluemner: A Passion for Color* (New York: Whitney Museum of American Art, 2005); Jeffrey R. Hayes, *Oscar Bluemner* (Cambridge: Cambridge University Press, 1991); and Judith Zilczer, *Oscar Bluemner: The Hirshhorn Museum and Sculpture Garden Collection* (Washington, D.C.: Smithsonian Institution Press, 1979).

2. Haskell, *Bluemner*, 98.

3. Roberta Smith Favis, "Painting 'The Red City': Oscar Bluemner's 'Jersey Silkmills,'" *American Art* 17, no. 1 (Spring 2003): 33–41.

4. Haskell, *Bluemner*, 98.

5. Oscar Bluemner, introduction to *Oscar Florianus Bluemner* (Minneapolis: University Gallery, University of Minnesota, 1939), n.p.

6. Hayes, *Bluemner*, 185.

7. Oscar Bluemner, *What and When Is Painting? Today* (South Braintree, Mass.: privately printed, 1929), reprinted in Haskell, *Bluemner*, 197–98.

8. Guided by a concern for longevity, Bluemner experimented extensively with paints, binders, and supports. He used casein as a binder for his watercolors because he believed it would make them more permanent and lightfast. Ulrich Birkmaier, "In Search of Permanence: Oscar Bluemner's Materials and Techniques," in Haskell, *Bluemner*, 181–91.

9. Excerpts from Emily Genauer's review in the *New York World-Telegram*, 12 January 1935, and Henry McBride's review in the *New York Sun*, 8 January 1935, are reprinted in "What the Critics Say . . . ," in Bluemner, *Bluemner*.

Marsh, *Smoke Hounds*

1. Lloyd Goodrich, "Reginald Marsh," in *American Masters: Art Students League* (New York: Art Students League, 1967), 92.

2. "Manhattan Portrait," *Time*, 7 November 1955, 74.

3. The address No. 8 Bowery, featured prominently in *Smoke Hounds*, is approximately one block north of Chatham Square, which marks the southern terminus of the Bowery.

4. To take just one example, a sketch inscribed "Stood between No. 8 Mission & No. 10—3 feet from wall" (reproduced in Edward Laning, *The Sketchbooks of Reginald Marsh* [Greenwich, Conn.: New York Graphic Society, 1973], 48) records *Smoke Hounds*'s exact location if not its precise perspective.

5. "Talk of the Town: Transients," *New Yorker*, 20 April 1940, 15. Irving L. Allen, *The City in Slang: New York Life and Popular Speech* (New York: Oxford University Press, 1993), 152.

6. See Lance Mayer and Gay Myers, "Old Master Recipes in the 1920's, 1930's, and 1940's: Curry, Marsh, Doerner, and Maroger," *Journal of the American Institute for Conservation* 4, no. 1 (Spring 2002): 21–42.

7. Celebratory and nostalgic views of the El dating from the 1930s were more often taken from perspectives aboard trains or above the tracks. See Sunny Stalter, "Farewell to the El: Nostalgic Urban Visuality on the Third Avenue Elevated Train," *American Quarterly* 58, no. 3 (September 2006): 869–90.

8. *The WPA Guide to New York City: The Federal Writers' Project Guide to 1930s New York* (1939; New York: Pantheon Books, 1982), 119–20.

9. Dudley T. Upjohn, "An Unique But Practical Rescue Mission: New York Churchmen Establish a Mission of Help on the Bowery for the Many Unfortunates in that Great City," *St. Andrew's Cross* 25, no. 11 (August 1911): 18.

10. "Chinatown's Only All-Night Mission Closed; Founder Died Recently after Car Hit Him," *New York Times*, 18 October 1948, 25.

11. Marilyn Ann Cohen, "Reginald Marsh: An Interpretation of His Art" (Ph.D. diss., New York University, 1986), 132.

12. Marsh, "Let's Get Back to Painting," *Magazine of Art* 37 (December 1944): 296.

13. On Marsh as satirist, see Richard N. Masteller, "Caricatures in Crisis: The Satiric Vision of Reginald Marsh and John Dos Passos," *Smithsonian Studies in American Art* 3, no. 2 (Spring 1989): 23–45.

Douglas, *Into Bondage*

1. Langston Hughes, "The Negro and the Racial Mountain," *Nation* 122 (June 1926): 692–94.

2. Jesse O. Thomas, *Negro Participation in the Texas Centennial Exposition* (Boston: Christopher Publishing House, 1938), 25.

3. *Negro's Gift to America* is on the cover of Thomas's *Negro Participation*. Thomas provides a description of all four canvases in the cycle, providing interpretation by the Hall of Negro Life curator, Alonzo J. Aden. For a discussion of *Aspiration*, see Timothy Anglin Burgard, "*Aspiration*," in *Masterworks of American Painting at the De Young*, ed. Burgard (San Francisco: Fine Arts Museums of San Francisco, 2005), 342.

4. Renée Ater, "Creating a 'Usable Past' and a 'Future Perfect Society': Aaron Douglas's Murals for the 1936 Texas Centennial Exposition," in *Aaron Douglas: African American Modernist*, ed. Susan Earle (New Haven: Yale University Press, 2007), 107. According to Earle (ibid., 31), the circles also contribute to a "layered" effect that recalls Surrealist and Art Deco fragmentation of form as well as double-exposure photography from the interwar period; Earle, "Harlem, Modernism and Beyond: Aaron Douglas and His Role in Art/History." The art historian David Driskell has interpreted the circles as the global transmission of black culture by way of radio waves. Driskell, interview by Robert Farris Thompson, in *Black Art: Ancestral Legacy; The African Impulse in African American Art* (Dallas: Dallas Museum of Art, 1989), 136.

5. Ater, "Creating a 'Usable Past,'" 106.

6. Ibid., 106–7.

7. See Amy Helene Kirschke, "The Depression Murals of Aaron Douglas: Radical Politics and African American Art," *International Review of African American Art* 12, no. 4 (1995): 26.

8. Ater, "Creating a 'Usable Past,'" 95, 98.

9. Though much newspaper coverage of the Hall of Negro Life was positive in a general way, both Ater and Burgard cite many examples of headlines that reflect the racial prejudices of the period. Burgard, "*Aspiration*," 535n9, also notes that the Hall of Negro Life was the only building destroyed before the fair reopened the following year as the Greater Texas and Pan American Exposition; and Ater, "Creating a 'Usable Past,'" 104–5, 111.

10. Thomas, *Negro Participation*, 27.

Hopper, *Ground Swell*

1. Hopper's earliest-known oil painting depicts a rowboat in a secluded cove; see Gail Levin, *Edward Hopper: A Catalogue Raisonné* (New York: Whitney Museum of American Art and W. W. Norton & Company, 1995), 3: 1, no. 0-1. His first sale, furthermore, from the Armory Show of 1913, which showcased developments in avant-garde European and American modern art, was a marine subject, *Sailing* (1911). For Hopper's biography, see Gail Levin, *Edward Hopper: An Intimate Biography* (New York: Rizzoli, 2007).

2. Jo Hopper to Marion Hopper, 26 August 1939, quoted in Levin, *Hopper: A Catalogue Raisonné*, 3:266. Hopper's entry in his Record Book (II, p. 33, Whitney Museum of Art) reads: "*Ground Swell*. Finished September 15, 1939. Bright light blue picture. Sail, boat, clouds, boy's slacks white. Mast boom, gaf, edge of hatch 1 & rim of boat yellow, pillar orange. Buoy dark, bluey green with brown seaweed on buoy. Boys very tanned. Red headkerchief & halter on girl & dark slacks. Sky & water blue, water darkest at horizon. Touch of green on water reflected by dark green waterline of boat. Winton canvas, Block x and Winsor & Newton colors, lead white, linseed oil, 1 month painting. Painted in South Truro studio."

3. Levin, *Hopper: A Catalogue Raisonné*, 1:83.

4. Susan Alyson Stein, "Hopper: The Uncrossed Threshold," *Arts Magazine* 54 (March 1980): 156–60.

5. On the connection between Hopper's enthusiasm for nautical subjects and his "love of solitude," see Gail Levin, *Edward Hopper: The Art and the Artist* (New York: Norton, 1980), 42.

6. Nicolai Cikovsky, Jr., "*Breezing Up (A Fair Wind)*," in Franklin Kelly et al., *American Paintings of the Nineteenth Century*, part 1, The Collections of the National Gallery of Art Systematic Catalogue (Washington, D.C.: National Gallery of Art, 1996), 314. On the comparison with Eakins, see John Wilmerding, *A History of American Marine Paintings* (Salem, Mass.: Peabody Museum of Salem; Boston: Little, Brown and Company, 1968), 245.

7. The author thanks Stanley David Gedzelman, professor of earth and atmospheric sciences, City College of New York, for discussing Hopper's cloud formations. See Gedzelman, "Sky Paintings: Mirrors of the American Mind," *Weatherwise* 51 (January–February 1998): 65.

8. Alexander Nemerov, "*Ground Swell*: Edward Hopper in 1939," *American Art* 22, no. 3 (Fall 2008): 57.

9. Fourteen preparatory sketches for *Ground Swell* are extant. Four of these

include roughly delineated cloud patterns; one is a highly detailed cloud study (Whitney Museum of American Art, Josephine N. Hopper Bequest, acc. no. 70.856).

10. Nemerov, "*Ground Swell*," 50–71.

11. Hopper to Pène du Bois, 11 August 1940, Guy Pène du Bois Papers, reel 28, Archives of American Art, Smithsonian Institution, Washington, D.C.

12. Board of Trustees Quarterly Meeting, 16 April 1943, Board of Directors Meeting Reports, 17 April 1942–19 October 1945, CGA Archives.

13. Ibid.

14. Hopper had won the First William A. Clark Prize of $2,000 and a Gold Medal from the Fifteenth Biennial Exhibition of Contemporary American Oil Paintings at the Corcoran Gallery of Art in 1937 for *Cape Cod Afternoon* (1936, Carnegie Museums of Pittsburgh).

Soyer, *A Railroad Station Waiting Room*

1. Lloyd Goodrich, *Raphael Soyer* (New York: Whitney Museum of American Art, 1967), 16.

2. The 1896 building, designed by Morgan O'Brien, the New York Central and Hudson River Railroad architect, still stands.

3. Eleanor Roosevelt, "My Day," *New York World-Telegram*, 22 March 1943, sec. 2, 17; The Poe Sisters, "Corcoran Art Preview Here Draws Crowd," *Washington Times-Herald*, 21 March 1943, sec. B, 1, 2. For a photograph of Soyer telling Roosevelt about his painting, see "Five Thousand Attend Preview of Corcoran's 18th Biennial Exhibition," *Washington Star*, 21 March 1943, sec. A, 3.

4. Milly Heyd, *Mutual Reflections: Jews and Blacks in American Art* (New Brunswick, N.J.: Rutgers University Press, 1999), 73.

5. Raphael Soyer, "An Artist's Experiences in the 1930s," in Patricia Hills, *Social Concern and Urban Realism: American Paintings of the 1930s* (Boston: Boston University Art Gallery, 1983), 27.

6. Soyer, as quoted in Goodrich, *Soyer*, 21.

7. Samantha Baskind, *Raphael Soyer and the Search for Modern Jewish Art* (Chapel Hill: University of North Carolina Press, 2004), 1–16, 92–93.

8. Raphael Soyer, *Self-Revealment: A Memoir* (New York: Random House, 1967), 72.

9. Soyer in Hills, *Social Concern*, 27; and Goodrich, *Soyer*, 12.

10. Goodrich, *Soyer*, 6.

11. Baskind, *Soyer*, 110–79, 181.

12. Soyer, unpublished lecture, Skowhegan School of Painting and Sculpture, Maine, 1960, Raphael Soyer Papers, Series III: Articles, Essays and Lectures, Box 2, Folder 13, p. 20, Archives of American Art, Smithsonian Institution, Washington, D.C.; and Baskind, *Soyer*, 125.

Dove, *Space Divided by Line Motive*

1. "Notes by Arthur G. Dove," in *Dove Exhibition* (New York: Intimate Gallery, 1929), n.p., quoted in William C. Agee, "New Directions: The Late Work, 1938–

1946," in Debra Bricker Balken, in collaboration with Agee and Elizabeth Hutton Turner, *Arthur Dove: A Retrospective* (Andover, Mass.: Addison Gallery of American Art; Cambridge, Mass.: MIT Press, in association with the Phillips Collection, 1997), 134.

2. The title was changed from *U.S.A.* to *Space Divided by Line Motive* in accordance with American Paintings Catalogue policy, which restores titles to those under which a painting was first exhibited or published; see *Arthur G. Dove*, American Place, New York, 1944, cat. no. 6. Sarah Cash, Bechhoefer Curator of American Art, to Registrar, 24 October 2001, memorandum, CGA Curatorial Files.

3. For an excellent discussion of this shift, see Agee, "New Directions," 133–53, esp. 135–39. Agee notes (138) Dove's awareness of abstractionist trends in the work of his contemporaries, for example, his perusal of the fully illustrated catalogue of the Museum of Modern Art's important 1939 exhibition *Art of Our Time* and in his awareness of the recent changes toward more geometric abstraction in the art of Vasily Kandinsky and Paul Klee.

4. See Debra Bricker Balken, "Continuities and Digressions in the Work of Arthur Dove from 1907 to 1933," in Balken, *Dove*, 22.

5. Diary entry for 8 December 1942, Arthur and Helen Torr Dove Papers, 1904–1975, reel 725, Archives of American Art, Smithsonian Institution, Washington, D.C. (hereafter AAA).

6. Titles such as *Space Divided by Line Motive*, like *Structure*, *Parabola* (both 1942), and *Formation I* (1943) signify a departure from Dove's earlier, nature-derived titles. For the last three works, see Ann Lee Morgan, *Arthur Dove: Life and Work, with a Catalogue Raisonné* (Newark: University of Delaware Press; London and Toronto: Associated University Presses, 1984), cat. nos. 42.20, 42.13, and 43.6, respectively. On 17 December 1942 he recorded in his diary "names for pure paintings: Design, arrangement, monochrome—polychrome—unochrome—duochrome trio-quatro-sexo etc. Motif plan—venture adventure Formation"; quoted in Agee, "New Directions," 144–45.

7. Diary entries for 10, 12, 13, 14, and 16 October 1943, Arthur and Helen Torr Dove Papers, reel 725, frames 993–96, AAA.

8. Agee, "New Directions," 146, notes that this "sense of constant, shifting movement is almost cinematic, and raises the possibility that Dove had been touched by the compositions of Léopold Survage," which he may have known through the catalogue *Art of our Time* (see n3 above).

9. Agee, "New Directions," 139. These notations recall Dove's 1913 description of his creative process, when he "remember[ed] certain sensations purely through their form and color . . . by certain shapes, planes, light, or character lines determined by the meeting of such

planes," quoted in Arthur Jerome Eddy, *Cubists and Post-Impressionism* (Chicago: A.C. McClure and Co., 1919), 48.

10. McBride, quoted in *Art News* 42 (1–14 March 1943): 23, in Agee, "New Directions," 140 and 152n28.

11. 5 December 1942, diary entry paraphrased in Agee, "New Directions," 146; and 30 December 1942 diary entry, quoted in ibid., 145.

12. Barbara Haskell, *Arthur Dove* (Boston: New York Graphic Society, 1974), 111.

13. "The Passing Shows," *Art News*, 1–14 May 1944, 19; and Howard Devree, "A Reviewer's Notes: Brief Comment on Some Recently Opened Shows—Dove and Marion Greenwood," *New York Times*, 26 March 1944, Arts sec., 7.

14. "Dove and His Father, 1919," Alfred Stieglitz, as dictated to Dorothy Norman, February 1937, cited in Suzanne M. Mullett, "Arthur G. Dove [1880–], a Study in Contemporary Art" (master's thesis, American University, 1944), 9, cited in Linda Ayres, Jane Myers, Mark Thistlethwaite, and Ron Tyler, *American Paintings: Selections from the Amon Carter Museum* (Fort Worth: Amon Carter Museum, 1986), 84.

Illustrated List of American Paintings to 1945,
Excluding Featured Works

Edwin Austin Abbey (1852–1911)
The Trial of Queen Katharine, 1898–-1900
Oil on canvas, 84¼ × 145¾ in.
(214 × 370.2 cm)
William A. Clark Collection, 26.2

Washington Allston (1779–1843)
Sketch of a Polish Jew, 1817
Oil on canvas, 30¼ × 25¼ in.
(76.8 × 64.1 cm)
Museum Purchase, William A.
Clark Fund, 49.3

Eliphalet Frazer Andrews
(1835–1915)
*Elizabeth Margaret Mossgrove Beard
(Mrs. Oliver Thomas Beard),* 1870
Oil on canvas, 14¼ × 11⅜ in.
(36.2 × 28.9 cm)
Bequest of Olive Elizabeth
Perkins, 67.25

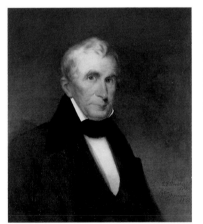

Eliphalet Frazer Andrews
(1835–1915)
William Henry Harrison,
1879
Oil on canvas, 30⅛ × 25¼ in.
(76.5 × 64.1 cm)
Museum Purchase, Gallery Fund,
80.1

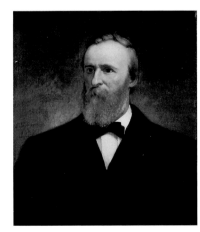

Eliphalet Frazer Andrews
(1835–1915)
Rutherford Birchard Hayes,
1881
Oil on canvas, 30⅛ × 25¼ in.
(76.5 × 64.1 cm)
Museum Purchase, Gallery Fund,
82.2

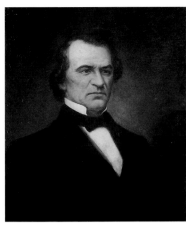

Eliphalet Frazer Andrews
(1835–1915)
Andrew Johnson, 1882
Oil on canvas, 30⅛ × 25¼ in.
(76.5 × 64.1 cm)
Museum Purchase, Gallery Fund,
82.1

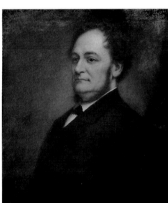

Eliphalet Frazer Andrews
(1835–1915)
James M. Carlisle, 1897
Oil on canvas, 30 × 25 in.
(76.2 × 63.5 cm)
Gift of Eliphalet Frazer Andrews,
97.4

Thomas Pollock Anschutz
(1851–1912)
On the Ohio, c. 1880
Oil on canvas, 9½ × 13⅞ in.
(24.2 × 35.3 cm)
Museum Purchase through
the gift of Joseph Sanders, 63.4

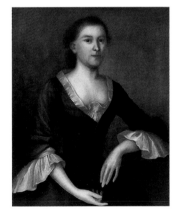

Joseph Badger (1708–1765)
*Grace Spear Foster
(Mrs. William Foster),*
c. 1740/1760
Oil on canvas, 37 × 29 in.
(94 × 73.7 cm)
Gift of Mr. and Mrs. E. D. W.
Spingarn, 1982.42

Samuel Burtis Baker (1882–1967)
Interior with Figure,
c. 1920
Oil on canvas, 50¾ × 40½ in.
(128.9 × 102.9 cm)
Museum Purchase, William A.
Clark Fund, 36.1

Frederic Clay Bartlett (1879–1953)
Canton Street, 1919
Oil on canvas, 36¼ × 40½ in.
(92.1 × 102.9 cm)
Museum Purchase, Gallery Fund,
19.28

Paul Wayland Bartlett (1865–1925)
Figures on the Beach, n.d.
Oil on wood, 5⅜ × 7⅜ in.
(12.7 × 17.8 cm)
Gift of Mrs. Armistead Peter III
(Caroline Ogden-Jones Peter),
64.37.17

Paul Wayland Bartlett (1865–1925)
Building by the Water, n.d.
Oil on canvas, 6⅝ × 8¾ in.
(16.8 × 22.2 cm)
Gift of Mrs. Armistead Peter III
(Caroline Ogden-Jones Peter),
64.37.4

Paul Wayland Bartlett (1865–1925)
Forest, n.d.
Oil on canvas mounted on
cardboard, 8⅛ × 5¾ in.
(20.6 × 14.6 cm)
Gift of Mrs. Armistead Peter III
(Caroline Ogden-Jones Peter),
64.37.13

Paul Wayland Bartlett (1865–1925)
City by the Sea, n.d.
Oil on canvas, 8½ × 10½ in.
(21.6 × 26.7 cm)
Gift of Mrs. Armistead Peter III
(Caroline Ogden-Jones Peter),
64.37.20

Paul Wayland Bartlett (1865–1925)
The Harbor, n.d.
Oil on canvas, 10½ × 8½ in.
(26.7 × 21.6 cm)
Gift of Mrs. Armistead Peter III
(Caroline Ogden-Jones Peter),
64.37.19

Paul Wayland Bartlett (1865–1925)
Cityscape, n.d.
Oil on canvas, 5⁵⁄₁₆ × 7¹⁵⁄₁₆ in.
(13.5 × 20.2 cm)
Gift of Mrs. Armistead Peter III
(Caroline Ogden-Jones Peter),
64.37.11

Paul Wayland Bartlett (1865–1925)
Cliffs, n.d.
Oil on wood, 5¼ × 7 in.
(13.3 × 17.8 cm)
Gift of Mrs. Armistead Peter III
(Caroline Ogden-Jones Peter),
64.37.15

Paul Wayland Bartlett (1865–1925)
Lily Pond, n.d.
Oil on canvas, 8½ × 6½ in.
(21.6 × 16.5 cm)
Gift of Mrs. Armistead Peter III
(Caroline Ogden-Jones Peter),
64.37.6

Paul Wayland Bartlett (1865–1925)
Cottage on the Creek, n.d.
Oil on canvas, 6½ × 8¾ in.
(16.5 × 22.2 cm)
Gift of Mrs. Armistead Peter III
(Caroline Ogden-Jones Peter),
64.37.5

Paul Wayland Bartlett (1865–1925)
On the French Coast, n.d.
Oil on wood, 5¼ × 7 in.
(13.3 × 17.8 cm)
Gift of Mrs. Armistead Peter III
(Caroline Ogden-Jones Peter),
64.37.16

Paul Wayland Bartlett (1865–1925)
Pile Driver and Docks, n.d.
Oil on canvas, 7 × 8¹³⁄₁₆ in.
(17.8 × 22.4 cm)
Gift of Mrs. Armistead Peter III
(Caroline Ogden-Jones Peter),
64.37.3

Paul Wayland Bartlett (1865–1925)
Woods and Pasture, n.d.
Oil on canvas, 11 × 8 in.
(27.9 × 20.3 cm)
Gift of Mrs. Armistead Peter III
(Caroline Ogden-Jones Peter),
64.37.1

Paul Wayland Bartlett (1865–1925)
Sails on the Bay, n.d.
Oil on canvas, 10⅝ × 8½ in.
(27 × 21.6 cm)
Gift of Mrs. Armistead Peter III
(Caroline Ogden-Jones Peter),
64.37.18

Cecilia Beaux (1855–1942)
*Julie Bruhns Kahle
(Mrs. Marcel Kahle),*
1925/1926
Oil on canvas, 48½ × 38 in.
(123.2 × 96.5 cm)
Gift of Lois B. Weigl and Family,
1997.17

Paul Wayland Bartlett (1865–1925)
Seascape, n.d.
Oil on canvas, 7 × 8¾ in.
(17.8 × 22.2 cm)
Gift of Mrs. Armistead Peter III
(Caroline Ogden-Jones Peter),
64.37.48

Frank Weston Benson (1862–1951)
My Daughter, 1912
Oil on canvas, 30¼ × 25¼ in.
(76.8 × 64.1 cm)
Museum Purchase, Gallery Fund,
12.8

Paul Wayland Bartlett (1865–1925)
Summer Sky, n.d.
Oil on canvas, 10½ × 8⅝ in.
(26.7 × 21.9 cm)
Gift of Mrs. Armistead Peter III
(Caroline Ogden-Jones Peter),
64.37.7

Frank Weston Benson (1862–1951)
Still Life, 1925
Oil on canvas, 32 × 40 in.
(81.3 × 101.6 cm)
Museum Purchase, 26.802

Paul Wayland Bartlett (1865–1925)
Trees, n.d.
Oil on canvas, 8½ × 6⅝ in.
(21.6 × 16.8 cm)
Gift of Mrs. Armistead Peter III
(Caroline Ogden-Jones Peter),
64.37.2

Thomas Hart Benton (1889–1975)
Woman, c. 1915/1920
Oil on canvas, 12 × 9 in.
(30.5 × 22.9 cm)
Museum purchase through the
gifts of David Jayne Hill, Dr. and
Mrs. William Chase, and Michael
Straight, 1981.115

Thomas Hart Benton (1889–1975)
Martha's Vineyard, c. 1925
Oil on canvas, 22⅛ × 24³⁄₁₆ in.
(56.2 × 61.1 cm)
Bequest of George Biddle, 1974.2
Art © Benton Testamentary
Trusts/UMB Bank Trustee/
Licensed by VAGA, New York, NY

Oscar Bessau (b. France, active
Washington, D.C., 1855–57)
Little Falls of the Potomac,
1856
Oil on canvas, 16¾ × 24⅛ in.
(41.3 × 61.3 cm)
Gift of William Wilson Corcoran,
69.78

George Biddle (1885–1973)
Terae Hara, 1922
Oil on canvas, 22 × 16 in.
(55.9 × 40.6 cm)
Gift of the Artist, 68.33.1

George Biddle (1885–1973)
*Black Ice on Calabaugh
Pond,* 1929
Oil on canvas, 25¼ × 31¾ in.
(64.1 × 80.6 cm)
Gift of Katherine Garrison Biddle,
58.29

George Biddle (1885–1973)
Helene Sardeau, 1931
Oil on canvas, 25¼ × 35¼ in.
(64.1 × 89.5 cm)
Gift of the Artist, 68.33.5

George Biddle (1885–1973)
Yoke of Oxen, 1932
Oil on canvas, 15⅜ × 19½ in.
(39.1 × 49.5 cm)
Gift of Katherine Garrison Biddle,
63.14

George Biddle (1885–1973)
At Ticino's, 1933
Oil on canvas, 30 × 40 in.
(76.2 × 101.6 cm)
Gift of the Artist, 1969.17

Albert Bierstadt (1830–1902)
*Buffalo Trail: The
Impending Storm,* 1869
Oil on canvas, 29½ × 49½ in.
(74.9 × 125.7 cm)
Museum Purchase, through the
gift of Mr. and Mrs. Lansdell K.
Christie, 60.1

Albert Bierstadt (1830–1902)
Figure Study for *The Last
of the Buffalo,* 1888
Oil on paper, 13¼ × 19⅛ in.
(33.7 × 48.7 cm)
Museum Purchase, by exchange:
Mrs. J. Laurence Laughlin, and
Mr. Louis E. Shecter, 1994.16.1

Albert Bierstadt (1830–1902)
Figure Study for *The Last
of the Buffalo,* c. 1888
Oil on paper, 13¹³⁄₁₆ × 19¼ in.
(35.1 × 48.9 cm)
Museum Purchase, by exchange:
Mrs. J. Laurence Laughlin, and
Mr. Louis E. Shecter, 1994.16.2

Albert Bierstadt (1830–1902)
Horse Study for *The Last
of the Buffalo,* c. 1888
Oil on paper, 13⅞ × 19³⁄₁₆ in.
(35.2 × 48.7 cm)
Museum Purchase, by exchange:
Mrs. J. Laurence Laughlin, and
Mr. Louis E. Shecter, 1994.16.3

Isabel Bishop (1902–1988)
Two Girls Outdoors, 1944
Oil on composition board,
30 × 18 in. (76.2 × 45.7 cm)
Museum Purchase, Anna E. Clark
Fund, 45.6

Attributed to Ralph Albert
Blakelock (1847–1919)
Indian Encampment, n.d.
Oil on canvas, 48⅛ × 67 in.
(122.7 × 170.2 cm)
Gift of Mr. and Mrs. J. C. Stotlar,
1974.62

William Brenton Boggs
(1809–1875)
On Catskill Creek, 1850
Oil on canvas, 26¼ × 36¼ in.
(66.7 × 92.1 cm)
Gift of William Wilson Corcoran,
69.57

Ralph Albert Blakelock
(1847–1919)
A Nook in the Adirondacks,
n.d.
Oil on panel, 10¾ × 9 in.
(27.3 × 22.9 cm)
Bequest of James Parmelee,
41.34

Pietro Bonnani (1789–1821)
Jane Cocking Glover, 1821
Oil on canvas, 29¾ × 24¾ in.
(75.6 × 62.9 cm)
Gift of Mrs. Nancy E. Symington
and Mr. Charles C. Glover III,
1981.71

Ralph Albert Blakelock
(1847–1919)
Colorado Plains, n.d.
Oil on canvas, 16⅜ × 24⅛ in.
(41.9 × 61.3 cm)
Museum Purchase, Gallery
Fund, 05.2

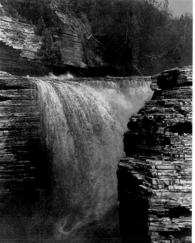

De Witt Clinton Boutelle
(1820–1884)
*Trenton Falls near Utica,
New York,* 1876
Oil on canvas, 50½ × 40 in.
(128.3 × 101.6 cm)
Museum purchase through a gift
of S. H. Kauffmann, F. B. McGuire,
E. F. Andrews, John M. McCartney,
Stilson Hutchins, and V. G. Fischer,
1979.60

Ralph Albert Blakelock
(1847–1919)
Indian Camp at Twilight,
n.d.
Oil on canvas, 7⅛ × 10⅛ in.
(18.1 × 25.7 cm)
Bequest of James Parmelee, 41.33

Ralph Albert Blakelock
(1847–1919)
*Moonlit Landscape,
the Witching Hour,* n.d.
Oil on panel, 16¼ × 22 in.
(41.3 × 55.9 cm)
Bequest of James Parmelee, 41.2

Carl Christian Brenner (1838–1888)
*Afternoon in Early June, a
Kentucky Beech Grove,* 1880
Oil on canvas, 26 × 46 in.
(66 × 116.8 cm)
Museum Purchase, Gallery Fund,
81.3

James Renwick Brevoort
(1832–1918)
Half Moon Cove, Gloucester Bay, Massachusetts, 1871
Oil on board, 8¾ × 14½ in.
(22.2 × 36.8 cm)
Museum purchase with funds from the Ella Poe Burling Bequest to the Women's Committee of the Corcoran Gallery of Art, 2003.27

George Douglas Brewerton
(1820–1901)
Crossing the Rocky Mountains, 1854
Oil on canvas, 30 × 44¾ in.
(76.2 × 112.4 cm)
Gift of William Wilson Corcoran,
69.12

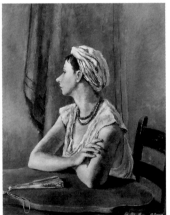

Alfred Thompson Bricher
(1837–1908)
A Headland—Low Tide, 1881
Oil on canvas, 28 × 44 in.
(71.1 × 111.8 cm)
Gift of the Hearst Corporation in tribute to Ambassador Philip Habib, 1983.11

Alexander Brook (1898–1980)
Peggy Bacon, c. 1932
Oil on canvas, 34¼ × 26⅛ in.
(87 × 66.4 cm)
Museum Purchase, Gallery Fund, 32.12

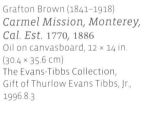

Grafton Brown (1841–1918)
Carmel Mission, Monterey, Cal. Est. 1770, 1886
Oil on canvasboard, 12 × 14 in.
(30.4 × 35.6 cm)
The Evans-Tibbs Collection, Gift of Thurlow Evans Tibbs, Jr., 1996.8.3

John George Brown (1831–1913)
Allegro, 1864
Oil on academy board, 6⅝ × 5¾ in.
(16.8 × 14.6 cm)
Gift of William Wilson Corcoran,
69.72.1

John George Brown (1831–1913)
Penseroso, 1865
Oil on wood panel, 6½ × 5⅝ in.
(16.5 × 14.3 cm)
Gift of William Wilson Corcoran,
69.72.2

John George Brown (1831–1913)
A Longshoreman, c. 1879
Oil on canvas, 12 × 18 in.
(30.5 × 45.7 cm)
Museum purchase by exchange: Mr. and Mrs. Ignatius Sargent, 2009.002

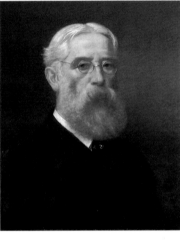

John George Brown (1831–1913)
Self-Portrait, 1901
Oil on canvas, 25 × 20¾ in.
(63.5 × 51.4 cm)
Gift of Virginia Cummings Devine, 2000.19

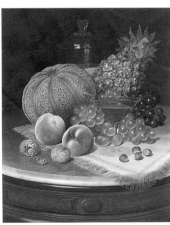

William Mason Brown (1828–1898)
Still Life on a Marble-Topped Table, c. 1860/1895
Oil on canvas, 20 × 16 in.
(50.8 × 40.6 cm)
Museum Purchase through a Gift of Charles and Herbert Dumaresq, 1980.128

Edward Bruce (1879–1943)
St. Père, c. 1932
Oil on canvas, 24⅝ × 34¼ in.
(62.6 × 87 cm)
Gift of His Fellow Artists through Mrs. Edward Bruce, 48.17

Constantino Brumidi (1805–1880)
Benjamin Franklin, c. 1860–75
Oil on canvas, 26¾ × 21¾ in.
(68 × 55.3 cm)
Gift of Mr. and Mrs. Donald F. Bliss
as memorial to Louis D. Bliss, 61.30

Bryson Burroughs (1869–1934)
Demeter and Persephone,
1917
Oil on canvas, 36¼ × 24¼ in.
(92.1 × 61.6 cm)
Museum Purchase, William A.
Clark Fund, 30.7

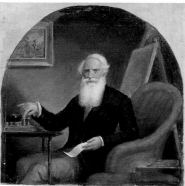

Constantino Brumidi (1805–1880)
Samuel F. B. Morse, c. 1860–75
Oil on canvas, 11 × 10⅞ in.
(27.9 × 27.6 cm)
Gift of Mr. and Mrs. Donald S. Bliss
in memory of Louis D. Bliss, 61.31

Margaret Burroughs (b. 1917)
Still Life, 1943
Oil on compressed particle board,
19⅞ × 15½ in. (50.5 × 39.4 cm)
The Evans-Tibbs Collection, Gift of
Thurlow Evans Tibbs, Jr., 1996.8.4

George de Forest Brush (1855–1941)
Mother Reading, 1905
Oil on canvas, 41⅛ × 32 in.
(104.5 × 81.3 cm)
Gift of Mabel Stevens Smithers,
1949, The Francis Sydney Smithers
Memorial, 49.52

Arthur Beecher Carles (1882–1952)
Untitled, c. 1927
Oil on canvas, 51¾ × 41 in.
(131.5 × 104.1 cm)
Museum Purchase through the
gift of The Honorable Francis
Biddle, 1982.45

Andrew Fisher Bunner (1841–1897)
*Picnic Party at Lake
George,* 1874
Oil on canvas, 29¾ × 23¼ in.
(74.3 × 59.1 cm)
Museum Purchase through a gift
of the Honorable David Jayne Hill,
1981.89

Dines Carlsen (1901–1966)
The Brass Kettle, 1916
Oil on canvas, 20¼ × 24¼ in.
(51.4 × 61.6 cm)
Museum Purchase, Gallery
Fund, 16.6

Emil Carlsen (1853–1932)
Moonlight on a Calm Sea,
1915/1916
Oil on canvas, 58¼ × 47¼ in.
(148 × 120 cm)
Museum Purchase, Gallery
Fund, 16.7

David Burlyuk (1882–1967)
The Dream, n.d.
Oil on canvas, 8½ × 11½ in.
(21.6 × 29.2 cm)
Bequest of George Biddle, 1974.15

Emil Carlsen (1853–1932)
The White Jug, c. 1919
Oil on canvas, 25¾ × 30 in.
(64.1 × 76.2 cm)
Gift of Mrs. Emil Carlsen and
Dines Carlsen, 35.12

John Fabian Carlson (1875–1945)
Woods in Winter, c. 1912
Oil on canvas, 46⅛ × 56⅛ in.
(117.2 × 142.6 cm)
Museum Purchase, Gallery
Fund, 12.5

John William Casilear (1811–1893)
Lake George, 1851
Oil on canvas, 25½ × 45¾ in.
(64.8 × 114.9 cm)
Gift of Josephine E. Harrison, 97.6

Benjamin Champney (1817–1907)
Mount Washington,
after 1850
Oil on panel, 6½ × 12½ in.
(16.5 × 31.8 cm)
Gift of Dr. and Mrs. Albert R. Miller,
Jr., 1982.80

Minerva Josephine Chapman
(1858–1947)
*Still Life with Mirror,
Vase, and Fruit,* c. 1921
Oil on canvas, 24 × 18 in.
(61 × 45.7 cm)
Gift of Mr. and Mrs. Morse G. Dial,
Jr., 1977.48

Henry S. (Harry) Chase (1853–1889)
The Harbor of New York,
1885
Oil on canvas, 40 × 72 in.
(101.6 × 182.9 cm)
Museum Purchase, 89.1

William Merritt Chase (1849–1916)
Still Life with Samovar,
c. 1902
Oil on canvas, 20 × 16 in.
(50.8 × 40.6 cm)
Gift of Mr. and Mrs. David N.
Yerkes, 2000.26

William Merritt Chase (1849–1916)
William Andrews Clark,
c. 1915
Oil on canvas, 50½ × 40¾ in.
(128.3 × 102.2 cm)
Gift of William A. Clark, 17.3

William Merritt Chase (1849–1916)
Self-Portrait, 1915
Oil on canvas, 25 × 20¼ in.
(63.5 × 51.4 cm)
Museum Purchase, Gallery
Fund, 23.3

Thomas Cole (1801–1848)
*Tornado in an American
Forest,* 1831
Oil on canvas, 46⅜ × 64⅝ in.
(117.8 × 164.2 cm)
Museum Purchase, Gallery
Fund, 77.12

George Cooke (1793–1849)
*Mary Anne Foxall
McKenney (Mrs. Samuel
McKenney),* 1837
Oil on canvas, 36 × 28 in.
(91.4 × 71.1 cm)
Gift of Ann MacCarteney
Coulthurst, great-great-
granddaughter of Samuel
McKenney, in memory of
Richard Seton MacCarteney,
1980.99

George Cooke (1793–1849)
Samuel McKenney, 1837
Oil on canvas, 36 × 28 in.
(91.4 × 71.1 cm)
Gift of Ann MacCarteney
Coulthurst, great-great-
granddaughter of Samuel
McKenney, in memory of Richard
Seton MacCarteney, 1980.98

Arthur Bowen Davies (1862–1928)
Frankincense, c. 1912
Oil on canvas, 17⅛ × 22 in.
(43.5 × 55.9 cm)
Bequest of Lizzie P. Bliss, 31.6

Christopher Pearse Cranch
(1813–1892)
*Castle Gondolfo, Lake
Albano, Italy,* 1852
Oil on canvas, 36½ × 54½ in.
(92.7 × 138.4 cm)
Gift of William Wilson Corcoran,
69.23

Arthur Bowen Davies (1862–1928)
The Great Mother, c. 1913
Oil on canvas, 40¼ × 26¼ in.
(102.2 × 66.7 cm)
Bequest of Lizzie P. Bliss, 31.8

Jasper Francis Cropsey (1823–
1900)
View of Mt. Washington,
1881
Oil on canvas, 24 × 44⅛ in.
(61 × 112.1 cm)
Gift of Mr. and Mrs. John C.
Newington, 1977.41

Arthur Bowen Davies (1862–1928)
The Umbrian Mountains,
1925
Oil on canvas, 25⅞ × 39⅞ in.
(65.7 × 101.3 cm)
Museum Purchase, William A.
Clark Fund, 28.8

Randall Davey (1887–1964)
Paddock No. 1, c. 1935
Oil on canvas, 20¼ × 30¼ in.
(51.4 × 76.8 cm)
Museum Purchase, Anna E. Clark
Fund, 35.6

Stuart Davis (1894–1964)
Study for Swing Landscape,
1937–38
Oil on canvas, 22 × 28¾ in.
(55.9 × 73 cm)
Museum Purchase and exchange
through a gift given in memory
of Edith Gregor Halpert by the
Halpert Foundation, 1981.122
Art © Estate of Stuart Davis/
Licensed by VAGA, New York, NY

Arthur Bowen Davies (1862–1928)
Before Sunrise, c. 1905
Oil on canvas, 18¼ × 40¼ in.
(46.4 × 102.2 cm)
Bequest of Lizzie P. Bliss, 31.7

Manierre Dawson (1887–1969)
Player, 1912
Oil on canvas, 36 × 28 in.
(91.4 × 71.1 cm)
Museum Purchase through the
gift of Amelia B. Lazarus, 1981.46

Arthur Bowen Davies (1862–1928)
Hill to Hill, c. 1910–12
Oil on canvas, 17¼ × 22¼ in.
(43.8 × 56.5 cm)
Bequest of Lizzie P. Bliss, 31.5

Sidney Edward Dickinson
(1890–1978)
Portrait of the Artist, 1915
Oil on canvas, 34¼ × 24¼ in.
(87 × 61.6 cm)
Museum Purchase, Gallery Fund,
16.5

William Dunlap (1766–1839)
A Family Group, c. 1794
Oil on canvas, 36 × 42½ in.
(91.4 × 108 cm)
Museum Purchase through a
gift from the Gallery Fund, 66.1

Charles Dunn (1894–1978)
Study of Clouds, 1921
Oil on particle board,
23¹⁵⁄₁₆ × 27¹³⁄₁₆ in. (60.8 × 70.6 cm)
Gift of the Foundation for
Twentieth Century Artists of
Washington, D.C., 1995.56.8

Thomas Doughty (1793–1856)
Tintern Abbey, 1836
Oil on canvas, 29½ × 36⅜ in.
(74.9 × 92.4 cm)
Gift of William Church Osborn,
04.3

Charles Dunn (1894–1978)
Caricature of Edgar Nye,
1929
Oil on canvas, 20 × 16 in.
(50.8 × 40.6 cm)
Gift of the Foundation for
Twentieth Century Artists of
Washington, D.C., 1995.56.3

Thomas Doughty (1793–1856)
Landscape, c. 1849
Oil on academy board,
7¼ × 14¾ in. (18.4 × 37.5 cm)
Gift of William Wilson Corcoran,
69.4

Victor Dubreuil (active 1886–1900)
Safe Money, c. 1898
Oil on canvas, 30¼ × 25 in.
(76.8 × 63.5 cm)
Museum Purchase through a
gift from the heirs of George E.
Lemon, 1980.65

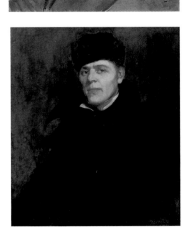

Frank Duveneck (1848–1919)
Dillard H. Clark, 1870
Oil on canvas, 30¼ × 25⅜ in.
(76.8 × 64.5 cm)
Museum Purchase, Gallery
Fund, 21.4

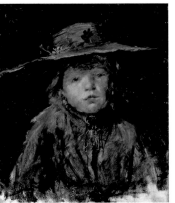

Robert Scott Duncanson
(1821–1872)
Fruit Still Life, c. 1849
Oil on canvas, 13½ × 19 in.
(34.3 × 48.3 cm)
Purchase through a gift from
the Reserve for Purchase of
Works of Art, 68.35

Frank Duveneck (1848–1919)
Head of a Girl, c. 1880
Oil on canvas, 21⅛ × 17½ in.
(53.7 × 44.5 cm)
Museum Purchase, Gallery
Fund, 20.2

Fannie S. Eanes (1885–1974)
Fleta Eanes Stone, c. 1930
Oil on canvas, 24 × 18 in.
(61 × 45.7 cm)
Bequest of Fannie S. Eanes,
1976.17

Louis Michel Eilshemius
(1864–1941)
Meditation, 1889
Oil on canvas, 25⅛ × 19 in.
(63.8 × 48.3 cm)
Gift of Roy R. Neuberger, 61.10.1

Fannie S. Eanes (1885–1974)
*Still Life with Oriental
Objects,* c. 1931
Oil on canvas, 24 × 19 in.
(61 × 48.3 cm)
Bequest of Fannie S. Eanes,
1976.15

Louis Michel Eilshemius
(1864–1941)
New Mexico, c. 1903
Oil on Masonite, 13½ × 19 in.
(34.3 × 48.3 cm)
Gift of The Honorable Francis
Biddle, 60.22

Fannie S. Eanes (1885–1974)
Overlooking Town in Snow,
n.d.
Oil on canvas, 24 × 29⅞ in.
(61 × 75.9 cm)
Bequest of Fannie S. Eanes,
1976.16

Louis Michel Eilshemius
(1864–1941)
Three Nudes in Woods, 1905
Oil on canvas, 20 × 30 in.
(50.8 × 76.2 cm)
Gift of Roy R. Neuberger, 61.10.2

Fannie S. Eanes (1885–1974)
*Still Life with Daffodils
and Hyacinths,* n.d.
Oil on canvas, 24¼ × 19 in.
(61.6 × 48.3 cm)
Bequest of Fannie S. Eanes,
1976.14

Louis Michel Eilshemius
(1864–1941)
Idylls Bathing, 1917
Oil on canvas, 18¾ × 30 in.
(47.6 × 76.2 cm)
Bequest of George Biddle, 1974.4

Louis Michel Eilshemius
(1864–1941)
Two Girls Bathing, n.d.
Oil on composition board,
19¾ × 30 in. (50.2 × 76.2 cm)
Gift of James N. Rosenburg, 59.30

Louis Michel Eilshemius
(1864–1941)
*Dawn over Pacific, Del
Mar, California,* 1889
Oil on canvas, 24⅛ × 37 in.
(61.3 × 94 cm)
Gift of Roy R. Neuberger, 61.10.3

John Adams Elder (1833–1895)
Robert E. Lee, 1876
Oil on canvas, 54½ × 40¾ in.
(138.4 × 103.5 cm)
Gift of William Wilson Corcoran,
84.1

John Adams Elder (1833–1895)
Thomas Jonathan Jackson,
1876
Oil on canvas, 55½ × 40½ in.
(141 × 102.9 cm)
Gift of William Wilson Corcoran,
84.2

Charles Loring Elliott (1812–1868)
William Wilson Corcoran,
1867
Oil on canvas, 97⅛ × 69 in.
(246.7 × 175.3 cm)
Gift of William Wilson Corcoran,
69.1

Charles Loring Elliott (1812–1868)
William Cullen Bryant,
c. 1854
Oil on canvas, 24¾ × 20⅛ in.
(61.6 × 51.1 cm)
Bequest of James C. McGuire, 88.5

Robert Feke (c. 1707–c. 1752)
Simon Pease, c. 1749
Oil on canvas, 50½ × 40⅜ in.
(128.2 × 102.7 cm)
Museum Purchase, Gallery
Fund, William A. Clark Fund
and Anna E. Clark Fund, 65.35

Charles Loring Elliott (1812–1868)
James C. McGuire, 1854
Oil on canvas, 30⅛ × 25 in.
(76.5 × 63.5 cm)
Bequest of James C. McGuire, 88.3

Alvan T. Fisher (1792–1863)
*Autumnal Landscape
with Indians,* 1848
Oil on canvas, 42 × 54 in.
(106.7 × 137.2 cm)
Gift of William Wilson Corcoran,
73.11

John Fulton Folinsbee (1892–1972)
Grey Thaw, 1920
Oil on canvas, 32¼ × 40½ in.
(81.9 × 102.9 cm)
Museum Purchase, Gallery Fund,
21.7

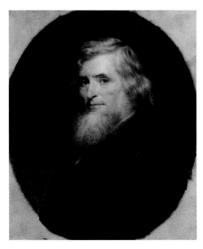

Charles Loring Elliott (1812–1868)
Asher Brown Durand, 1864
Oil on canvas, 27 × 22 in.
(68.6 × 55.9 cm)
Museum Purchase, Gallery Fund,
76.11

Lauren Ford (1891–1981)
Choir Practice, 1934
Oil on panel, 13¾ × 18⅛ in.
(34.9 × 46 cm)
Museum Purchase, Anna E. Clark
Fund, 35.7

Ben Foster (1852–1926)
Sunset in the Litchfield Hills, c. 1910
Oil on canvas, 30 × 36 in.
(76.2 × 91.4 cm)
Museum Purchase, Gallery Fund, 11.4

James Frothingham (1786–1864)
John Pedrick III, c. 1812
Oil on panel, 26⅞ × 22¼ in.
(68.3 × 56.5 cm)
Bequest of Dr. Franklin Burche Pedrick, 51.28

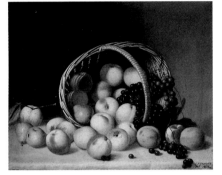

John F. Francis (1808–1886)
Peaches, Pears, and Grapes, 1850
Oil on canvas, 20¼ × 24¼ in.
(51.4 × 61.6 cm)
Museum Purchase through the gift of James Parmelee, 63.5

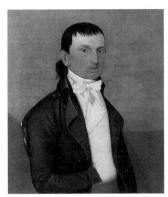

Jacob Frymire (1770–1882)
Gentleman of the Aulick/ Gibbens Family (Probably Charles Christopher Edman Aulick), 1801
Oil on canvas, 29⅛ × 23⅞ in.
(74 × 60.7 cm)
Gift of Mr. and Mrs. Robert Hilton Simmons in memory of Dorothy W. Phillips, 1978.100

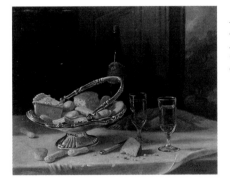

John F. Francis (1808–1886)
Still Life with Silver Cake Basket, 1866
Oil on canvas, 19¼ × 23½ in.
(48.9 × 59.7 cm)
Museum Purchase through the gift of Josephine B. Crane, 57.5

George Fuller (1822–1884)
Evening—Lorette, 1882
Oil on canvas, 49⅞ × 29⅝ in.
(126.7 × 75.3 cm)
Museum Purchase, Gallery Fund, 00.6

Frederick Carl Frieseke (1874–1939)
Dressing Room, 1922
Oil on canvas, 25½ × 31¾ in.
(64.8 × 80.6 cm)
Museum Purchase, Gallery Fund, 23.6

Daniel Garber (1880–1958)
April Landscape, 1910
Oil on canvas, 42¼ × 46 in.
(107.3 × 116.8 cm)
Museum Purchase, Gallery Fund, 11.2

James Frothingham (1786–1864)
Elizabeth Fettyplace (Mrs. John Pedrick III), c. 1812
Oil on panel, 30½ × 24¼ in.
(77.5 × 61.6 cm)
Bequest of Dr. Franklin Burche Pedrick, 51.29

Daniel Garber (1880–1958)
Tanis Garber, 1914
Oil on canvas, 30 × 24 in.
(76.2 × 61 cm)
Bequest of Tanis Garber Page, 2007.011

Daniel Garber (1880–1958)
Ellicott City, Afternoon,
1940
Oil on canvas, 56 × 52 in.
(142.2 × 132.1 cm)
Bequest of Esther G. Garber,
1994.18

William Gilbert Gaul (1855–1919)
Picking Cotton, c. 1890
Oil on academy board,
13¾ × 18¼ in. (33.7 × 46.4 cm)
Museum Purchase through the
gift of Josephine B. Crane, 57.6

Walter Gay (1856–1937)
*Salon in the Musée
Jacquemart-André,*
1912/1913
Oil on canvas, 18½ × 22 in.
(47 × 55.9 cm)
Museum Purchase through
the gift of Orme Wilson, 60.10

Robert Swain Gifford (1840–1905)
*October on the Coast of
Massachusetts,* 1873
Oil on canvas, 11½ × 21¾ in.
(29.2 × 55.2 cm)
Gift of Arthur Jeffrey Parsons,
07.23

Sanford Robinson Gifford
(1823–1880)
Near Ariccia, Italy, 1868
Oil on canvas, 6¾ × 9½ in.
(17.2 × 24.1 cm)
Gift of Anna E. Erickson, 54.1

Régis François Gignoux
(1816–1882)
Landscape, 1849
Oil on canvas, 34½ × 30½ in.
(87.6 × 77.5 cm)
Gift of William Wilson Corcoran,
69.73

Régis François Gignoux
(1816–1882)
Winter Scene, 1850
Oil on canvas, 36 × 50¼ in.
(91.4 × 127.6 cm)
Gift of William Wilson Corcoran,
69.7

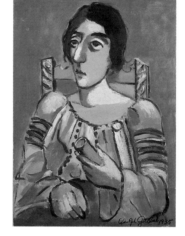

Adolph Gottlieb (1903–1974)
Lucille Corcos, 1934
Oil on canvas panel, 20 × 14⅛ in.
(50.8 × 35.9 cm)
Gift of David C. Levy, 1991.39
Art © The Adolph and Esther
Gottlieb Foundation/Licensed
by VAGA, New York, NY

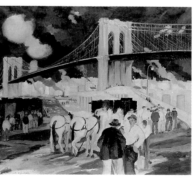

John R. Grabach (1886–1981)
Waterfront—New York,
c. 1923
Oil on canvas, 36 × 42 in.
(91.4 × 106.7 cm)
Museum Purchase, William A.
Clark Fund, 41.88

Henry Peters Gray (1819–1877)
The Judgment of Paris, 1861
Oil on canvas, 50⅞ × 41 in.
(129.2 × 104.1 cm)
Museum Purchase, Gallery
Fund, 77.10

Walter Griffin (1861–1935)
Study of Two Trees, n.d.
Oil on canvas, 23¾ × 29½ in.
(60.3 × 74.9 cm)
Gift of Caroline Ogden-Jones
Peter, 64.38

Philip Leslie Hale (1865–1931)
Portrait—Girl with Muff,
c. 1914
Oil on canvas, 30¼ × 25¼ in.
(76.8 × 64.1 cm)
Purchase, 14.5

Albert Lorey Groll (1866–1952)
No-Man's Land, Arizona,
c. 1906
Oil on canvas, 40½ × 51¼ in.
(102.9 × 130.2 cm)
Museum Purchase, Gallery
Fund, 11.7

George Hawley Hallowell
(1871–1926)
Wissataquoik River Drive,
c. 1920
Oil on canvas, 25¼ × 30¼ in.
(64.1 × 76.8 cm)
Museum Purchase, William A.
Clark Fund, 23.8

Christian Gullager (1759–1826)
A Boston Gentleman, c. 1780
Oil on canvas, 71¼ × 54 in.
(181 × 137.2 cm)
Gift of Eva Markus through the
Friends of the Corcoran, 66.33

William Harper (1873–1910)
Landscape, 1906
Oil on canvas, 20⅛ × 30⅛ in.
(51.1 × 76.4 cm)
The Evans-Tibbs Collection, Gift of
Thurlow Evans Tibbs, Jr., 1996.8.7

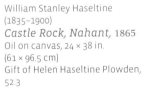

William Stanley Haseltine
(1835–1900)
Castle Rock, Nahant, 1865
Oil on canvas, 24 × 38 in.
(61 × 96.5 cm)
Gift of Helen Haseltine Plowden,
52.3

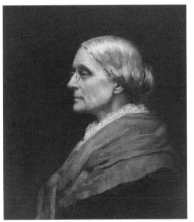

Carl Gutherz (1844–1907)
Susan B. Anthony, 1895
Oil on canvas, 24 × 20 in.
(61 × 50.8 cm)
Gift of Mrs. John B. Henderson,
00.10

Childe Hassam (1859–1935)
Old House at Easthampton,
1916
Oil on canvas, 32¼ × 39½ in.
(81.9 × 100.3 cm)
Bequest of George M. Oyster, Jr.,
24.6

Ellen Day Hale (1855–1940)
The Young Gardener, 1923
Oil on canvas, 29½ × 24⅞ in.
(74.9 × 63.2 cm)
Gift of Col. George R. Ronka,
2002.1

Charles Webster Hawthorne
(1872–1930)
The Fisherman's Daughter,
c. 1912
Oil on wood panel, 60 × 48 in.
(152.4 × 121.9 cm)
Museum Purchase, Gallery
Fund, 23.16

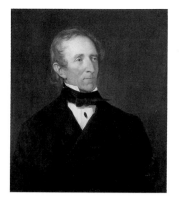

George Peter Alexander Healy
(1813–1894)
John Tyler, 1842
Oil on canvas, 30⅛ × 25⅛ in.
(76.5 × 63.8 cm)
Museum Purchase, Gallery
Fund, 79.13

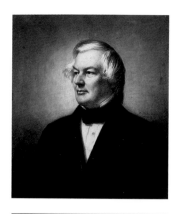

George Peter Alexander Healy
(1813–1894)
Millard Fillmore, 1857
Oil on canvas, 30 × 25 in.
(76.2 × 63.5 cm)
Museum Purchase, Gallery
Fund, 79.16

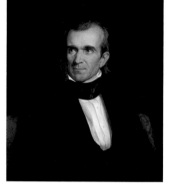

George Peter Alexander Healy
(1813–1894)
James K. Polk, 1846
Oil on canvas, 30½ × 25½ in.
(77.5 × 64.8 cm)
Museum Purchase, Gallery
Fund, 79.14

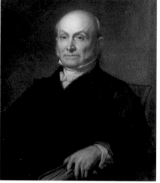

George Peter Alexander Healy
(1813–1894)
John Quincy Adams, 1858
Oil on canvas, 30 × 25 in.
(76.2 × 63.5 cm)
Museum Purchase, Gallery
Fund, 79.10

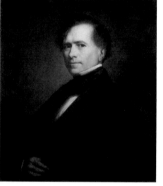

George Peter Alexander Healy
(1813–1894)
Franklin Pierce, 1852
Oil on canvas, 30 × 25 in.
(76.2 × 63.5 cm)
Museum Purchase, Gallery
Fund, 79.17

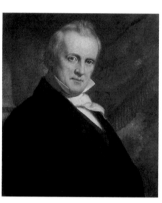

George Peter Alexander Healy
(1813–1894)
James Buchanan, 1859
Oil on canvas, 30 × 25 in.
(76.2 × 63.5 cm)
Museum Purchase, Gallery
Fund, 79.18

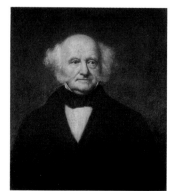

George Peter Alexander Healy
(1813–1894)
George Peabody, 1854
Oil on canvas, 32 × 26 in.
(81.3 × 66 cm)
Museum Purchase, Gallery
Fund, 79.20

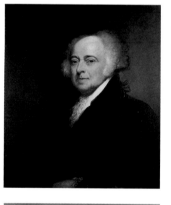

George Peter Alexander Healy
(1813–1894)
John Adams, 1860
Oil on canvas, 30 × 25 in.
(76.2 × 63.5 cm)
Museum Purchase, Gallery
Fund, 79.6

George Peter Alexander Healy
(1813–1894)
Martin Van Buren, 1857
Oil on canvas, 30 × 25 in.
(76.2 × 63.5 cm)
Museum Purchase, Gallery
Fund, 79.12

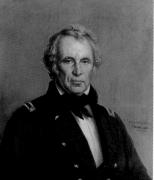

George Peter Alexander Healy
(1813–1894)
Zachary Taylor, 1860
Oil on canvas, 30 × 25 in.
(76.2 × 63.5 cm)
Museum Purchase, Gallery
Fund, 79.15

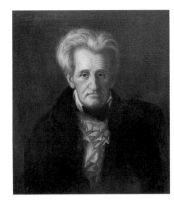

George Peter Alexander Healy
(1813–1894)
Andrew Jackson, 1861
Oil on canvas, 27½ × 23¼ in.
(69.9 × 59.1 cm)
Museum Purchase, Gallery
Fund, 79.11

George Peter Alexander Healy
(1813–1894)
Chester A. Arthur, 1884
Oil on canvas, 30 × 25 in.
(76.2 × 63.5 cm)
Gift of William Wilson Corcoran,
84.3

George Peter Alexander Healy
(1813–1894)
*Mary Martin Anderson
(Mrs. Meriwether Lewis
Clark, Jr.),* 1873
Oil on canvas, 28½ × 23½ in.
(72.4 × 59.7 cm)
Gift of Margaret Clark McIlwaine,
63.23

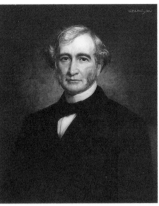

George Peter Alexander Healy
(1813–1894)
*Justin Smith Morrill of
Vermont,* 1884
Oil on canvas, 29¾ × 24⅞ in.
(75.6 × 63.2 cm)
Gift of William Wilson Corcoran,
84.4

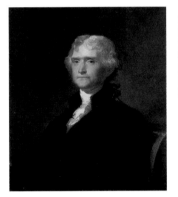

George Peter Alexander Healy
(1813–1894)
Thomas Jefferson, 1848/1879
Oil on canvas, 30 × 25 in.
(76.2 × 63.5 cm)
Museum Purchase, Gallery
Fund, 79.7

Augustus George Heaton
(1844–1931)
William Wilson Corcoran,
1888
Oil on canvas, 37½ × 29¼ in.
(95.3 × 74.3 cm)
Gift of the family of George
Andrew Binney, Jr., 53.31

George Peter Alexander Healy
(1813–1894)
James Madison, 1848/1879
Oil on canvas, 30 × 25 in.
(76.2 × 63.5 cm)
Museum Purchase, Gallery
Fund, 79.8

Howard Helmick (1845–1907)
The Emigrant's Letter, 1868
Oil on paper, 19¾ × 16¼ in.
(50.2 × 41.3 cm)
Gift of William Wilson Corcoran,
69.68

George Peter Alexander Healy
(1813–1894)
James Monroe, 1848/1879
Oil on canvas, 39⅜ × 34¼ in.
(100 × 87 cm)
Museum Purchase, Gallery
Fund, 79.9

Robert Henri (1865–1929)
John Sloan, 1904
Oil on canvas, 56⅝ × 41⅛ in.
(143.8 × 104.5 cm)
Gift of Mr. and Mrs. John Sloan,
39.5

Robert Henri (1865–1929)
Seated Nude, c. 1918
Oil on canvas, 32 × 26¼ in.
(81.3 × 66.7 cm)
Gift of A. M. and Lilian Adler, 67.4

Winslow Homer (1836–1910)
Sketch of a Cottage Yard,
c. 1876
Oil on academy board,
10¾ × 14½ in. (26 × 36.8 cm)
Museum Purchase, William A.
Clark Fund and through the gift
of Orme Wilson, 61.18

James Hope (1818/19–1892)
*Tavern in New Boston,
Vermont,* 1855
Oil on canvas, 25⅞ × 35⅞ in.
(65.7 × 91.1 cm)
Gift of Robert G. McIntyre, 47.10

John William Hill (1812–1879)
View of Cohoes, c. 1820
Oil on panel, 20 × 29½ in.
(50.8 × 74.9 cm)
Gift of the Estate of Harry T.
Peters, 1982.5

William James Hubard (1807–1862)
John C. Calhoun, c. 1832
Oil on panel, 19½ × 14⅝ in.
(49.5 × 37.2 cm)
Museum Purchase, Gallery Fund,
89.4

Thomas Hewes Hinckley
(1813–1896)
Stag in the Adirondacks,
1866
Oil on canvas, 36 × 29 in.
(91.4 × 73.7 cm)
Gift of Captain Robert M.
Hinckley, USN (ret.), 65.10

William Morris Hunt (1824–1879)
The Belated Kid, 1857
Oil on canvas, 54 × 38½ in.
(137.2 × 97.8 cm)
Museum Purchase through the
gifts of William Wilson Corcoran,
1981.22

Stefan Hirsch (1899–1964)
Resting Burros, 1934
Oil on Masonite, 49⅜ × 62³⁄₁₆ in.
(125.4 × 158 cm)
Gift of Andrea Pietro Zerega, 58.33

George Hitchcock (1850–1913)
Dutch Landscape,
c. 1889–92
Oil on canvas, 17¼ × 21½ in.
(43.8 × 54.6 cm)
Edward C. and Mary Walker
Collection, 37.24

William Morris Hunt (1824–1879)
The Essex Woods, c. 1877
Oil on canvas, 22⅛ × 28¼ in.
(56.1 × 71.8 cm)
Gift of Mr. and Mrs. E. D. W.
Spingarn, 1981.101

William Morris Hunt (1824–1879)
Head of a Young Woman,
c. 1877
Oil on canvas, 16 × 12 in.
(40.6 × 30.5 cm)
Museum Purchase, Gallery Fund,
50.8

George Inness (1825–1894)
Hillside at Étretat, 1876
Oil on canvas, 25¾ × 38⅜ in.
(65.4 × 97.5 cm)
Museum Purchase, Gallery Fund
and William A. Clark Fund, 59.6

George Inness (1825–1894)
Harvest Moon, 1891
Oil on canvas, 30 × 44½ in.
(76.2 × 113 cm)
Bequest of Mabel Stevens
Smithers, the Francis Sydney
Smithers Memorial, 52.7

William Morris Hunt (1824–1879)
American Falls, Niagara,
1878
Oil on canvas, 30 × 41¼ in.
(76.2 × 104.8 cm)
Gift of Mr. Cecil D. Kaufmann,
66.34

Lee Jackson (b. 1909)
Fall Practice, 1943
Oil on composition board,
15 × 22 in. (38.1 × 55.9 cm)
Museum Purchase, Anna E. Clark
Fund, 45.7

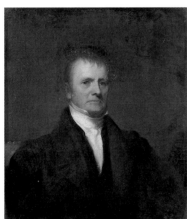

Henry Inman (1801–1846)
John O'Brien, c. 1825
Oil on canvas, 13¾ × 11¼ in.
(34.9 × 28.6 cm)
Gift of Clarice G. Walker, 50.1

Alexander James (1890–1946)
Mrs. Dean Acheson, 1937
Tempera on Weber prepared
panel, 27 × 21 in. (68.6 × 53.3 cm)
Gift of David Acheson, Mary
Acheson Bundy and Jane Acheson
Brown in honor of Alice Acheson,
a longtime member of the
Women's Committee of The
Corcoran Gallery of Art, 1997.16

Henry Inman (1801–1846)
Grace Anne O'Brien, c. 1830
Oil on canvas, 30 × 25 in.
(76.2 × 63.5 cm)
Gift of Clarice G. Walker, 50.2

John Wesley Jarvis (1780–1840)
John Howard Payne, c. 1812
Oil on panel, 33⅞ × 26½ in.
(86 × 67.3 cm)
Gift of William Wilson Corcoran,
83.7

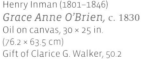

George Inness (1825–1894)
Landscape, c. 1852
Oil on canvas, 18⅛ × 26 in.
(46 × 66 cm)
Gift of William Wilson Corcoran,
69.42

John Wesley Jarvis (1780–1840)
Jacob Jennings Brown, 1815
Oil on canvas, 42½ × 35 in.
(108 × 88.9 cm)
Museum Purchase, Gallery Fund
and gift of Orme Wilson, 58.3

Eastman Johnson (1824–1906)
Girl and Pets, 1856
Oil on academy board,
25 × 28¾ in. (63.5 × 73 cm)
Gift of William Wilson Corcoran,
69.44

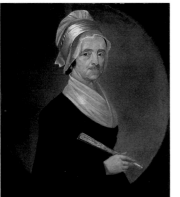

William Jennys (active 1795–1810)
Woman with a Fan, c. 1800
Oil on canvas, 30⅛ × 25 in.
(76.5 × 63.5 cm)
Museum Purchase, Anna E. Clark
Fund, 47.12

Eastman Johnson (1824–1906)
The Truants, c. 1870
Oil on academy board,
23⅜ × 27 in. (59.4 × 68.6 cm)
Museum Purchase, William A.
Clark Fund, Gallery Fund and
through the gift of Louise S.
Thompson, 63.11

John Christen Johansen
(1876–1964)
The Artist and His Family,
1925
Oil on canvas, 30 × 40 in.
(76.2 × 101.6 cm)
Museum Purchase, William A.
Clark Fund, 26.799

Eastman Johnson (1824–1906)
Harriet Hubbard Ayer, 1881
Oil on canvas, 72 × 37½ in.
(182.9 × 95.3 cm)
Gift of Harriet Ayer Seymour
Macy, 63.24

John Christen Johansen
(1876–1964)
*Cuthbert Powell
Minnigerode,* 1942
Oil on canvas, 45⅜ × 31⅛ in.
(114.6 × 79.1 cm)
Museum Purchase, Gallery
Fund, 42.5

Lois Mailou Jones (1905–1998)
*Indian Shops, Gay Head,
Massachusetts,* 1940
Oil on canvas, 21 × 25¾ in.
(53.3 × 65.4 cm)
Gift of the Artist, 1997.2

David Johnson (1827–1908)
*A Study at Tamworth,
New Hampshire,* 1863
Oil on canvas, 13½ × 10¼ in.
(34.3 × 25.4 cm)
Gift of the Women's Committee
of the Corcoran Gallery of Art,
1999.29

Bernard Karfiol (1886–1952)
Summer, 1927
Oil on canvas, 46⅜ × 60⅜ in.
(117.8 × 153.4 cm)
Museum Purchase, William A.
Clark Fund, 28.6

William Keith (1839–1911)
By the Creek, Sonoma, n.d.
Oil on canvas, 40¼ × 50¼ in.
(102.2 × 127.6 cm)
Museum Purchase, Gallery Fund,
11.11

Rockwell Kent (1882–1971)
Adirondacks, 1928/1930
Oil on canvas, 38½ × 54⅞ in.
(97.8 × 139.4 cm)
Museum Purchase, William A.
Clark Fund, 34.4

Attributed to Frederick
Kemmelmeyer (before 1755–1821)
Martin Luther, c. 1800
Oil on canvas, 58½ × 48 in.
(149 × 122 cm)
Museum Purchase, 1981.23

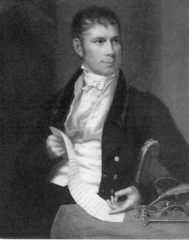

Charles Bird King (1785–1862)
Henry Clay, 1821
Oil on canvas, 36⅛ × 28⅛ in.
(91.8 × 71.4 cm)
Museum Purchase, Gallery Fund,
81.9

Attributed to Frederick
Kemmelmeyer (before 1755–1821)
Charlotte Marstellar, c. 1803
Oil on canvas, 29¾ × 24¼ in.
(75.6 × 61.6 cm)
Museum Purchase, 56.32

A. Kline (active 1880s)
The Target, 1890
Oil on canvas, 24 × 19⅞ in.
(61 × 50.6 cm)
Museum purchase through a gift
from Mrs. Caroline G. Dimmock
in the name of her first husband,
Louis C. Garnier, 1980.64

John Frederick Kensett
(1816–1872)
*Sketch of Mount
Washington,* 1851
Oil on canvas, 11⅜ × 20 in.
(28.9 × 50.8 cm)
Gift of William Wilson Corcoran,
69.74

Leon Kroll (1884–1974)
Girl on Balcony, 1934
Oil on canvas, 17⅞ × 28 in.
(45.4 × 71.1 cm)
Gift of the estate of Mary S.
Higgins, 1971.3.2

John Frederick Kensett
(1816–1872)
*Autumn Afternoon on Lake
George,* 1864
Oil on canvas, 48¾ × 72½ in.
(123.8 × 184.2 cm)
Museum Purchase, Gallery Fund,
77.11

Richard Lahey (1893–1978)
Carlotta, 1943
Oil on canvas, 32⅜ × 32¼ in.
(82.2 × 81.9 cm)
Museum Purchase, Anna E. Clark
Fund, 43.7

Louis Lang (1814–1893)
Norma, 1853
Oil on canvas, 34 × 28 in.
(86.4 × 71.1 cm)
Gift of William Wilson Corcoran,
69.36

Emanuel Gottlieb Leutze
(1816–1868)
*The Amazon and Her
Children,* 1851
Oil on canvas, 40½ × 62¼ in.
(102.9 × 158.1 cm)
Gift of William Wilson Corcoran,
69.20

Jacob Hart Lazarus (1822–1891)
Girl with Flowers, c. 1853
Oil on canvas, 41 × 32 in.
(104.1 × 81.3 cm)
Gift of Virginia Wallach, 07.22

Emanuel Gottlieb Leutze
(1816–1868)
On the Banks of a Stream,
c. 1860
Oil on canvas, 18¼ × 24¼ in.
(46.4 × 61.6 cm)
Museum Purchase, Anna E. Clark
Fund, 63.12

Emanuel Gottlieb Leutze
(1816–1868)
*The Merry Wives of
Windsor,* 1865
Oil on canvas, 30 × 40 in.
(76.2 × 101.6 cm)
Gift of Mr. and Mrs. Lloyd E.
Raport, 1980.97

Thomas Le Clear (1818–1882)
Children in a Storm, c. 1830
Oil on canvas, 25 × 30 in.
(63.5 × 76.2 cm)
Gift of John Cresap Metz and
Virginia Le Clear Metz, 1986.10.9

Hayley Lever (1876–1958)
Dawn, c. 1910
Oil on canvas, 50¼ × 60¼ in.
(127.6 × 153 cm)
Museum Purchase, Gallery Fund,
16.8

Thomas Le Clear (1818–1882)
*Flora Johnson Beard
(Mrs. William Holbrook
Beard),* 1859/1863
Oil on canvas, 24 × 19 in.
(61 × 48.3 cm)
Gift of John Cresap Metz and
Virginia Le Clear Metz, 1986.10.10

Hayley Lever (1876–1958)
Harbor Scene, c. 1920
Oil on canvas board, 13 × 16 in.
(33 × 40.6 cm)
Gift of James N. Rosenburg, 59.35

Thomas Le Clear (1818–1882)
William Page, 1876
Oil on canvas, 24¼ × 20 in.
(61.6 × 50.8 cm)
Museum Purchase, Gallery Fund,
78.5

Abraham Frater Levinson
(1883–1946)
*Woodstock Snow
Landscape,* n.d.
Oil on canvas board, 16 × 20 in.
(40.6 × 50.8 cm)
Museum Purchase, Gallery Fund,
59.9

Jonas Lie (1880–1940)
The Storm, c. 1925
Oil on canvas, 30 × 45 in.
(76.2 × 114.3 cm)
Museum Purchase, William A.
Clark Fund, 26.800

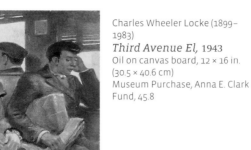

Charles Wheeler Locke (1899–1983)
Third Avenue El, 1943
Oil on canvas board, 12 × 16 in.
(30.5 × 40.6 cm)
Museum Purchase, Anna E. Clark
Fund, 45.8

Morris Louis (1912–1962)
Country House, 1938
Oil on canvas, 29½ × 24½ in.
(74.9 × 62.2 cm)
Gift of Mrs. Martin Codel through
the Friends of the Corcoran,
1976.7

George Benjamin Luks (1867–1933)
Woman with Black Cat,
1932
Oil on canvas, 30⅜ × 25⅜ in.
(77.2 × 64.5 cm)
Museum Purchase, Gallery Fund,
32.13

William Douglas MacLeod
(1811–1892)
Sunrise on the Potomac,
c. 1852
Oil on canvas, 23¹⁵⁄₁₆ × 36½ in.
(60.7 × 92.7 cm)
Museum purchase with funds
from the Ella Poe Burling Bequest
to the Women's Committee of the
Corcoran Gallery of Art, 2003.29

William Douglas MacLeod
(1811–1892)
*Maryland Heights: Siege
of Harpers Ferry,* 1863
Oil on canvas, 30 × 44 in.
(76.2 × 111.8 cm)
Gift of Genevieve Plummer, 54.2

William Douglas MacLeod
(1811–1892)
Great Falls of the Potomac,
1873
Oil on canvas, 34 × 45 in.
(86.4 × 114.3 cm)
Gift of William Wilson Corcoran,
69.47

Edward Greene Malbone
(1777–1907)
Self-Portrait, c. 1798
Oil on canvas, 27¾ × 22½ in.
(70.5 × 57.2 cm)
Museum Purchase, Gallery
Fund, 83.8

Peppino Mangravite (1896–1978)
Family Portrait, 1930
Oil on canvas, 24½ × 30¼ in.
(62.2 × 76.8 cm)
Museum Purchase, Gallery Fund,
32.10

Homer Dodge Martin (1836–1897)
Little Falls, Adirondacks,
n.d.
Oil on canvas, 10 × 8 in.
(25.4 × 20.3 cm)
Gift of Mr. James C. Stotlar, 1972.6

Henry Mattson (1887–1971)
Rocks, 1942
Oil on canvas, 32¼ × 42 in.
(81.9 × 106.7 cm)
Museum Purchase, William A.
Clark Fund, 43.2

Peter McCallion (active 1890–
1900)
*Slate, Pipe, Tobacco, and
Box of Matches,* c. 1890/1900
Oil on canvas, 24¾ × 17¾ in.
(62.9 × 45.1 cm)
Museum Purchase in honor of
Edward J. Nygren, 1989.5

Alfred Maurer (1868–1932)
Abstract Heads, c. 1931
Oil on gesso panel, 26 × 18 in.
(66 × 45.7 cm)
Museum purchase through the
William A. Clark Fund, 1979.76

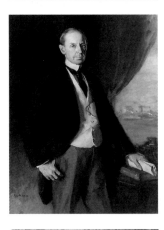

Gari Melchers (1860–1932)
The Letter, 1882
Oil on canvas, 37¼ × 26⅜ in.
(94.6 × 67 cm)
Edward C. and Mary Walker
Collection, 37.35

Alfred Maurer (1868–1932)
Girl with Red Hair, n.d.
Oil on board, 24⅞ × 17½ in.
(63.2 × 44.5 cm)
Gift of The Honorable Francis
Biddle, 60.23

Gari Melchers (1860–1932)
Edward C. Walker, c. 1906
Oil on canvas, 54⅛ × 40⅞ in.
(137.5 × 103.8 cm)
Edward C. and Mary Walker
Collection, 37.34

Louis Maurer (1832–1932)
Still Life, "Trilby," c. 1895
Oil on canvas, 19 × 28 in.
(48.3 × 71.1 cm)
Museum Purchase, Anna E. Clark
Fund, 60.41

Gari Melchers (1860–1932)
Penelope, 1910
Oil on canvas, 53¹¹⁄₁₆ × 49⅝ in.
(136.4 × 126.1 cm)
Museum Purchase, Gallery
Fund, 11.1

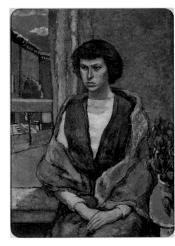

Alfred McAdams (1911–2008)
*By the Window (Portrait
of June),* 1945
Oil on Masonite, 36 × 26 in.
(91.4 × 66 cm)
Gift of the Artist, 1998.22

Gari Melchers (1860–1932)
Maternity, c. 1913
Oil on canvas, 63 × 43 in.
(160 × 109.2 cm)
Museum Purchase, Gallery
Fund, 19.2

Gari Melchers (1860–1932)
James Parmelee, 1927
Oil on canvas, 40 × 29¾ in.
(101.6 × 75.6 cm)
Bequest of James Parmelee, 41.17

Sigmund Menkes (1896–
after 1945)
Pineapple and Peaches,
1943
Oil on canvas, 14 × 22 in.
(35.6 × 55.9 cm)
Gift of Mae and Irving Jurow,
1997.47

Richard Meryman (1882–1963)
Jeremiah O'Connor, c. 1935
Oil on canvas, 20⅞ × 15⅞ in.
(53 × 40.3 cm)
Gift of Jeremiah O'Connor,
68.28.25

Edmund Messer (1842–1919)
Self-Portrait, 1917
Oil on academy board,
20½ × 17⅛ in. (52.1 × 43.5 cm)
Gift of Mary Burt Messer, 58.27

Willard LeRoy Metcalf (1858–1925)
River Landscape, 1874
Oil on canvas, 9¾ × 14⅝ in.
(24.8 × 37.2 cm)
Gift of Estelle Scharfeld
Bechhoefer, 65.29

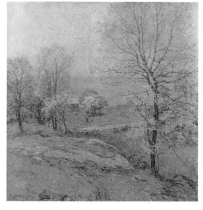

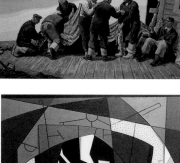

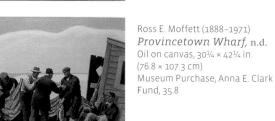

Willard LeRoy Metcalf (1858–1925)
The Budding Oak, 1916
Oil on canvas, 36¼ × 36¼ in.
(92.1 × 92.1 cm)
Bequest of George M. Oyster, Jr.,
24.5

Frances Mary "Jennie" Bellows
Millard (1816–1852)
Mount Vernon, c. 1850
Oil on canvas, 24 × 32⅛ in.
(61 × 81.6 cm)
Gift of Mary Hastings Dickinson,
52.5

Louis Moeller (1855–1930)
The Disagreement, by 1893
Oil on canvas, 24⅜ × 34¼ in.
(61.9 × 87 cm)
Museum Purchase, Gallery Fund,
99.10

Ross E. Moffett (1888–1971)
Provincetown Wharf, n.d.
Oil on canvas, 30¼ × 42¼ in.
(76.8 × 107.3 cm)
Museum Purchase, Anna E. Clark
Fund, 35.8

George Lovett Kingsland Morris
(1905–1975)
Indian Composition,
1942/1945
Oil on canvas, 63¼ × 49¼ in.
(160.7 × 125.1 cm)
Gift of the FRIENDS of the
Corcoran Gallery of Art, 65.21

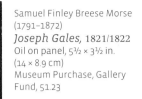

Samuel Finley Breese Morse
(1791–1872)
Joseph Gales, 1821/1822
Oil on panel, 5½ × 3½ in.
(14 × 8.9 cm)
Museum Purchase, Gallery
Fund, 51.23

Robert Loftin Newman
(1827–1912)
Adam and Eve, after 1874
Oil on canvas, 10⅛ × 8⅛ in.
(25.8 × 20.7 cm)
Bequest of Marchal E. Landgren,
1983.18

James Moser (1854–1913)
Umbrella Mender, 1888
Oil on academy board,
12 × 9⅞ in. (30.5 × 25.1 cm)
Museum Purchase, 68.7

Robert Loftin Newman
(1827–1912)
Nude, after 1874
Oil on canvas, 2½ × 4 in.
(6.4 × 10.2 cm)
Bequest of Marchal E. Landgren,
1983.19

Adolfo Felix Müller-Ury
(1862–1947)
General Ulysses S. Grant,
1897
Oil on canvas, 61¼ × 41⅛ in.
(155.6 × 104.5 cm)
Gift of Jefferson Seligman, 00.9

Robert Loftin Newman
(1827–1912)
Girl Blowing Soap Bubbles,
n.d.
Oil on canvas, 20 × 16 in.
(50.8 × 40.6 cm)
Museum Purchase, Gallery Fund,
48.55

John Francis Murphy (1853–1921)
Landscape, 1898
Oil on canvas, 24⅛ × 36⅛ in.
(61.3 × 91.8 cm)
William A. Clark Collection, 26.147

Robert Loftin Newman
(1827–1912)
Landscape, n.d.
Oil on panel, 24¼ × 30⅛ in.
(61.6 × 76.6 cm)
Bequest of Marchal E. Landgren,
1983.17

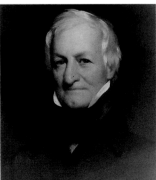

John Neagle (1796–1865)
George Rundle, 1850
Oil on composition board,
20 × 16¾ in. (50.8 × 42.6 cm)
Gift of Joseph E. Coonan in
memory of his wife, 31.3

Robert Loftin Newman
(1827–1912)
The Prodigal Son, n.d.
Oil on canvas, 14⅜ × 16¾ in.
(36.5 × 42.6 cm)
Bequest of Marchal E. Landgren,
1983.16

Hobart Nichols (1869–1962)
Sub-Zero, c. 1935
Oil on canvas, 30 × 35⅞ in.
(76.2 × 91.1 cm)
Gift of Archer M. Huntington, 47.2

Hobart Nichols (1869–1962)
The Creek, n.d.
Oil on canvas board, 14 × 16¾ in.
(35.6 × 42.6 cm)
Gift of Charles C. Glover, Jr., 62.11

John Noble (1874?–1934)
Early Morning, before 1930
Oil on composition board,
16 × 19⅞ in. (40.6 × 50.5 cm)
Museum Purchase, William A.
Clark Fund, 30.8

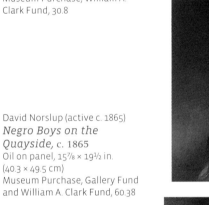

David Norslup (active c. 1865)
*Negro Boys on the
Quayside,* c. 1865
Oil on panel, 15⅞ × 19½ in.
(40.3 × 49.5 cm)
Museum Purchase, Gallery Fund
and William A. Clark Fund, 60.38

Edgar Nye (1879–1943)
Pennsylvania, 1930/1940
Oil on Masonite, 37 × 42 in.
(94 × 106.7 cm)
Gift of John Dunn and Janice
Dunn Rosenberg from the
Charles Dunn Collection, 1979.65

Abigail Tyler Oakes
(1823–after 1886)
Hudson River Landscape,
1852
Oil on canvas, 14⅛ × 20 in.
(35.9 × 45 cm)
Museum purchase through the
Anna E. Clark Fund, 1979.100

Walter Mason Oddie (1808–1865)
*Lake near Lenox,
Massachusetts,* 1850
Oil on canvas, 36 × 49 in.
(91.4 × 124.5 cm)
Gift of William Wilson Corcoran,
69.18

Johannes Adam Simon Oertel
(1823–1909)
The Patriarch's Argument,
n.d.
Oil on canvas, 24 × 20 in.
(61 × 50.8 cm)
Gift of William Wilson Corcoran,
84.6

Charles Willson Peale (1741–1827)
*Rebecca Bryan White
(Mrs. John White),* 1788
Oil on canvas, 22½ × 19¼ in.
(57.2 × 48.9)
Museum purchase through the
Gallery Fund, 66.14

Harriet Cany Peale (1749–1831)
Fruit, c. 1820
Oil on canvas, 17⅛ × 27 in.
(43.5 × 68.6 cm)
Museum Purchase, William A.
Clark Fund, 51.21

James Peale, Sr. (1749–1831)
John White, 1783
Oil on canvas, 23 × 19 in.
(58.4 × 48.3 cm)
Museum purchase through
the Gallery Fund, 66.15

James Peale, Sr. (1749–1831)
Portrait of a Gentleman,
1817
Oil on canvas, 35¾ × 27¾ in.
(90.8 × 70.5 cm)
Museum Purchase, Gallery Fund,
51.24

Harper Pennington (1855–1920)
*Louise Eustis and Mary
Ellen Thom,* c. 1885
Oil on canvas, 30¾ × 24 in.
(76.8 × 61)
Bequest of Ellen Bowers, 2010.006

James Peale, Sr. (1749–1831)
Portrait of a Lady, 1817
Oil on canvas, 35¾ × 28⅛ in.
(90.8 × 71.4 cm)
Museum Purchase, Gallery Fund,
51.25

Ammi Phillips (1787/88–1865)
Portrait of a Gentleman,
1812/1819
Oil on canvas, 30 × 25 in.
(76.2 × 63.5 cm)
Gift of Elizabeth Luessenhop,
1969.33.1

Rembrandt Peale (1778–1860)
*Jacques Henri Bernardin
de Saint-Pierre,* 1808
Oil on canvas, 29 × 23¾ in.
(73.7 × 60.3 cm)
Gift of George W. Riggs, 73.13

Ammi Phillips (1787/88–1865)
Portrait of a Lady, 1812/1819
Oil on canvas, 30 × 25 in.
(76.2 × 63.5 cm)
Gift of Elizabeth Luessenhop,
1969.33.2

Rembrandt Peale (1778–1860)
*Charles-Philibert de
Lasteyrie du Saillant,*
c. 1810
Oil on canvas, 29 × 22⅞ in.
(73.7 × 58.1 cm)
Gift of William Wilson Corcoran,
69.50

George Picken (1898–1971)
Convoy, 1942/1943
Oil on canvas, 15¾ × 40¾ in. (40 × 102.2 cm)
Museum Purchase, William A. Clark Fund, 43.5

Rembrandt Peale (1778–1860)
Joseph Outen Bogart, c. 1822
Oil on canvas, 36 × 28 in.
(91.4 × 71.1 cm)
Museum Purchase, Anna E. Clark
Fund, 57.14

William Picknell (1854–1897)
The Road to Concarneau,
1880
Oil on canvas, 42⅜ × 79¾ in.
(107.6 × 202.6 cm)
Museum Purchase, Gallery Fund,
99.8

Charles Platt (1861–1933)
Cornish Landscape, 1919
Oil on canvas, 26³⁄₈ × 33 in.
(67 × 83.8 cm)
Museum Purchase, Gallery Fund,
19.37

James Amos Porter (1905–1970)
*Ticket-Taker at Griffith
Stadium,* c. 1944
Oil on canvas, 30⁷⁄₁₆ × 41¼ in.
(77.2 × 104.8 cm)
Gift of Constance Porter Uzelac,
Executive Director, Dorothy
Porter Wesley Research Center,
Wesport Foundation and Gallery,
Washington, D.C., 2002.2

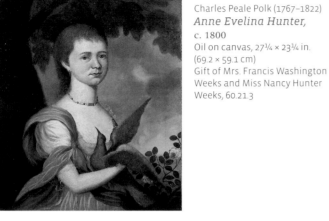

Charles Peale Polk (1767–1822)
Anne Evelina Hunter,
c. 1800
Oil on canvas, 27¼ × 23¾ in.
(69.2 × 59.1 cm)
Gift of Mrs. Francis Washington
Weeks and Miss Nancy Hunter
Weeks, 60.21.3

Maurice Prendergast (1858–1924)
A Dark Day, c. 1902–4
Oil on panel, 10½ × 13¼ in.
(26.8 × 33.7 cm)
Gift of Mrs. Charles Prendergast,
1991.13.1

Maurice Prendergast (1858–1924)
St. Malo, c. 1909–10
Oil on board, 10⁵⁄₈ × 13¾ in.
(27 × 34.9 cm)
Gift of Mrs. Charles Prendergast,
1991.13.3

Charles Peale Polk (1767–1822)
David Hunter, c. 1800
Oil on canvas, 27 × 23 in.
(68.6 × 58.4 cm)
Gift of Mrs. Francis Washington
Weeks and Miss Nancy Hunter
Weeks, 60.21.1

William Matthew Prior
(1806–1873)
Portrait of a Young Girl,
c. 1840/1850
Oil on canvas, 18½ × 13¾ in.
(47 × 34.9 cm)
Gift of Catherine Ridgely Brown,
54.24

Charles Peale Polk (1767–1822)
Moses T. Hunter, c. 1800
Oil on canvas, 27 × 23 in.
(68.6 × 58.4 cm)
Gift of Mrs. Francis Washington
Weeks and Miss Nancy Hunter
Weeks, 60.21.2

Edward Willis Redfield
(1869–1965)
Overlooking the Valley,
c. 1919
Oil on canvas, 38 × 50¼ in.
(96.5 × 127.6 cm)
Bequest of George M. Oyster, Jr.,
24.7

Henry Varnum Poor (1888–1970)
*Still Life with Apples and
Pears,* c. 1935
Oil on canvas, 10¾ × 22 in.
(27.3 × 55.9 cm)
Bequest of George Biddle, 1974.10

Edward Willis Redfield
(1869–1965)
Spring Landscape, 1920/1925
Oil on canvas, 24 × 20 in.
(61 × 50.8 cm)
Edward C. and Mary Walker
Collection, 37.44

Benjamin Franklin Reinhart
(1829–1885)
*An Evening Halt—
Emigrants Moving to
the West in 1840,* 1867
Oil on canvas, 40 × 70 in.
(101.6 × 177.8 cm)
Gift of Mr. and Mrs. Lansdell K.
Christie, 59.21

Edward Willis Redfield
(1869–1965)
The Road to Center Bridge,
c. 1922
Oil on canvas, 38¼ × 50 in.
(97.2 × 127 cm)
Gift of Lady Inchyra, 62.9.3

William Trost Richards
(1833–1905)
On the Coast of New Jersey,
1883
Oil on canvas, 40¾ × 72¼ in.
(102.2 × 183.5 cm)
Museum Purchase, Gallery Fund,
83.6

William Trost Richards
(1833–1905)
Scottish Coast, c. 1892
Oil on wood panel, 8¾ × 16 in.
(22.2 × 40.6 cm)
Bequest of Mrs. William T.
Brewster, through the National
Academy of Design, 53.43

Edward Willis Redfield
(1869–1965)
Road to Lumberville,
1930/1935
Oil on canvas, 21½ × 19½ in.
(54.6 × 49.5 cm)
Bequest of James Parmelee, 41.56

Julian Walbridge Rix (1850–1903)
*Pompton Plains, New
Jersey,* 1898
Oil on canvas, 30¼ × 50⅛ in.
(76.8 × 127.3 cm)
Museum Purchase, 03.2

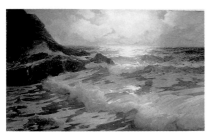

Frank Knox Morton Rehn
(1848–1914)
In the Glittering Moonlight,
n.d.
Oil on canvas, 30½ × 50¼ in.
(77.5 × 127.6 cm)
Gift of Charles E. Foster, 13.2

Theodore Robinson (1852–1896)
Woman with a Veil, 1878
Oil on canvas, 16⅛ × 13¾ in.
(41 × 34.9 cm)
Bequest of the estate of Fanny
Tucker Low, 47.1

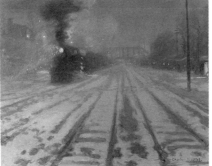

Charles Reiffel (1862–1942)
*Railway Yards—Winter
Evening,* c. 1910
Oil on canvas, 18⅛ × 24³⁄₁₆ in.
(46 × 61.4 cm)
Museum Purchase, Gallery Fund,
11.6

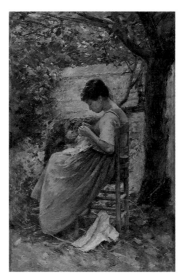

Theodore Robinson (1852–1896)
The Layette, 1892
Oil on canvas, 58⅛ × 36¼ in.
(147.6 × 92.1 cm)
Museum Purchase and Gift of
William A. Clark, 18.4

Thomas Rossiter (1818–1871)
Rebecca at the Well, 1852
Oil on canvas, 39 × 32 in.
(99.1 × 81.3 cm)
Gift of William Wilson Corcoran,
69.30

John Singer Sargent (1856–1925)
Seascape with Rocks,
c. 1875/1877
Oil on canvas, 17 × 14 in.
(43.2 × 35.6 cm)
Joseph F. McCrindle Collection,
2009.004

Albert Pinkham Ryder (1847–1917)
The Stable, c. 1875
Oil on canvas, 7¹⁵⁄₁₆ × 10 in.
(20.2 × 25.4 cm)
Gift of Mabel Stevens Smithers,
the Francis Sydney Smithers
Memorial, 49.51

John Singer Sargent (1856–1925)
Apollo and Daphne,
c. 1916–19
Oil on canvas, 32½ × 28⅞ in.
(82.6 × 73.3 cm)
Gift of Miss Emily Sargent and
Mrs. Francis Ormond, sisters of
the artist, 49.133

Chauncey Foster Ryder
(1868–1949)
Cape Porpoise, c. 1912
Oil on canvas, 32 × 40 in.
(81.3 × 101.6 cm)
Museum Purchase, Gallery Fund,
12.9

William Sartain (1843–1924)
Street in Dinan, Brittany,
1869/1875
Oil on canvas, 19 × 13¼ in.
(48.3 × 33.7 cm)
Gift of John Elderkin, 01.1

Kay Sage (1898–1963)
A Finger on the Drum, 1940
Oil on canvas, 15 × 21½ in.
(38.1 × 54.6 cm)
Gift of the Estate of the Artist,
63.25.1

Edward Savage (1761–1817)
*John Hancock and Dorothy
Quincy Hancock (Mrs. John
Hancock),* 1775/1789
Oil on canvas, 90¾ × 59¼ in.
(230.5 × 180.5 cm)
Bequest of Woodbury Blair, 48.8

Robert Salmon (c. 1775–c. 1851)
Harbor Scene, 1842
Oil on panel, 16¾ × 24¼ in.
(41.3 × 61.6 cm)
Museum Purchase, Gallery Fund,
55.15

Morton Livingston Schamberg
(1881–1918)
*Charles Sheeler and Nina
Allender,* c. 1906
Oil on wood panel, 5 × 3½ in.
(12.7 × 8.9 cm)
Gift of John Detweiler, 62.15.3

Morton Livingston Schamberg
(1881–1918)
Landscape, c. 1912
Oil on composition board,
7½ × 9½ in. (19.1 × 24.1 cm)
Gift of Joan B. Detweiler, 62.15.2

Louis Schanker (1903–1981)
Marchal Landgren,
c. 1935/1939
Oil on canvas, 20¼ × 16⅛ in.
(51.4 × 41 cm)
Bequest of Marchal E. Landgen,
1983.23

Walter Elmer Schofield
(1867–1944)
Cliff Shadows, 1921
Oil on canvas, 50¼ × 60¼ in.
(127.6 × 153 cm)
Museum Purchase, Gallery Fund,
21.9

William Edouard Scott
(1884–1964)
*French Village Scene
around a Crucifix,* n.d.
Oil on canvas, 32 × 26 in.
(81.3 × 66 cm)
The Evans-Tibbs Collection,
Gift of Thurlow Evans Tibbs, Jr.,
1996.8.19

Albert Serwazi (1905–1992)
Model Resting, 1938–39
Oil on canvas, 22¼ × 27¼ in.
(56.5 × 69.2 cm)
Gift of the artist, 1974.79

Leopold Gould Seyffert
(1887–1956)
Myself, 1925
Oil on composition board,
27 × 24 in. (68.6 × 61 cm)
Museum Purchase, William A.
Clark Fund, 26.801

James Jebusa Shannon
(1862–1923)
Girl in Brown, 1907
Oil on canvas, 43¾ × 33¼ in.
(109.9 × 84.5 cm)
Museum Purchase, Gallery Fund,
07.1

Joshua Shaw (1776–1860)
The Truants, 1843
Oil on canvas, 22⅞ × 31⅞ in.
(58.2 × 81 cm)
Museum Purchase through gifts
of Mr. and Mrs. Breckinridge Long,
1981.66

Charles Sheeler (1883–1965)
Dahlias and Asters, 1912
Oil on canvas, 20⅛ × 14⅛ in.
(51.1 × 35.9 cm)
Gift of Joan B. Detweiler, 62.15.1

Walter Shirlaw (1838–1909)
Self-Portrait, c. 1878
Oil on canvas, 22¼ × 13¼ in.
(56.5 × 33.7 cm)
Special Authority of the Director,
68.28.16

George Henry Smillie (1840–1921)
Autumn on the Massachu-setts Coast, 1888
Oil on canvas, 25½ × 50½ in.
(64.8 × 128.3 cm)
Gift of Ralph Cross Johnson, 97.2

George Henry Smillie (1840–1921)
A Long Island Farm, c. 1900
Oil on canvas, 19 × 33 in.
(48.3 × 83.8 cm)
Museum Purchase, Gallery Fund,
00.1

David Smith (1906–1965)
Untitled, 1936
Oil on canvas, 11⅞ × 15¾ in.
(30.2 × 40 cm)
Gift of Dorothy Dehner,
1993.8.1.a–.b
Art © Estate of David Smith/
Licensed by VAGA, New York, NY

Gladys Smith (1890–1980)
*Studio Portrait of Nude
Male in Corcoran Life
Drawing Class,* 1925/1930
Oil on canvas, 49 × 31 in.
(124.5 × 78.7 cm)
Gift of Mr. David Frenzel, 1997.50.7

Gladys Smith (1890–1980)
*Studio Portrait of Seated
Female,* 1925/1930
Oil on canvas, 30 × 27 in.
(76.2 × 68.6 cm)
Gift of Mr. David Frenzel, 1997.50.9

Gladys Smith (1890–1980)
*Studio Portrait of Seated
Male,* 1925/1930
Oil on canvas, 35 × 30¼ in.
(88.9 × 76.8 cm)
Gift of Mr. David Frenzel, 1997.50.8

Gladys Smith (1890–1980)
*Studio Portrait of Standing
Male Nude with Tattoos,*
1925/1930
Oil on canvas, 47½ × 29¾ in.
(120.7 × 75.6 cm)
Gift of Mr. David Frenzel, 1997.50.6

Gladys Smith (1890–1980)
*Studio Portrait of Young
Nude Male,* 1925/1930
Oil on canvas, 47½ × 29 in.
(120.7 × 73.7 cm)
Gift of Mr. David Frenzel,
1997.50.10

Gladys Smith (1890–1980)
Reclining Female Nude,
1929–30
Oil on canvas, 35 × 41¾ in.
(88.9 × 106 cm)
Gift of Mr. David Frenzel, 1997.50.5

William Louis Sonntag (1822–1900)
*Classic Italian Landscape
with Temple of Venus,*
c. 1860
Oil on canvas, 36 × 60 in.
(91.4 × 152.4 cm)
Gift of Charles A. Munn and
Victor G. Fischer in memory of
Orson D. Munn, 12.1

Eugene Speicher (1883–1962)
Sara Rivers, 1924
Oil on canvas, 45¾ × 37 in.
(116.2 × 94 cm)
Museum Purchase, William A.
Clark Fund. 30.9

317

Robert Spencer (1879–1931)
The Red Boat, c. 1918
Oil on canvas, 30³/₁₆ × 36³/₁₆ in.
(76.7 × 91.9 cm)
Museum Purchase, Gallery Fund,
19.29

Maurice Sterne (1878–1957)
After Lunch, 1930
Oil on composition board,
29 × 39 in. (73.7 × 99.1 cm)
Museum Purchase, William A.
Clark Fund, 30.5

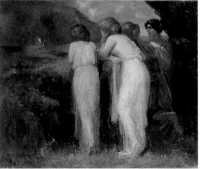

Charles Stetson (1858–1911)
A Galley Is Leaving, 1901
Oil on canvas, 19⁷/₈ × 23⁷/₈ in.
(50.5 × 60.6 cm)
Museum Purchase, Gallery Fund,
13.3

William Stone (1830–1875)
William Wilson Corcoran,
c. 1870
Oil on canvas, 96 × 60 in.
(243.8 × 152.4 cm)
Gift of the United States District
Court for the District of Columbia,
52.29

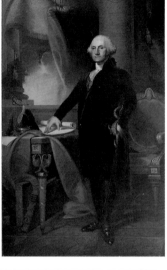

John Storrs (1885–1956)
Holy Spirit, 1945
Oil on panel, 6¼ × 8¹¹/₁₆ in.
(15.9 × 22.1 cm)
Museum purchase through a gift
of the Francis Sydney Smithers
Memorial, 1987.11

Gilbert Stuart (1755–1828)
George Bethune, c. 1819
Oil on panel, 27 × 21⁵/₈ in.
(68.6 × 54.9 cm)
Gift of Mr. and Mrs. Gilbert H.
Kinney, 1975.41

Jane Stuart (1812–1888)
George Washington, c. 1854
Oil on canvas, 106 × 62 in.
(269.2 × 157.5 cm)
Gift of William Wilson Corcoran,
69.55

Thomas Sully (1783–1872)
*William B. Wood as
"Charles de Moor,"* 1811
Oil on canvas, 42¼ × 30⅛ in.
(107.3 × 76.5 cm)
Museum Purchase, Anna E. Clark
Fund, 49.2

Thomas Sully (1783–1872)
Fanny Rundle, 1828
Oil on canvas, 19 × 15 in.
(48.3 × 38.1 cm)
Bequest of Mary Francis Nunns,
59.54

Thomas Sully (1783–1872)
Andrew Jackson, c. 1845
Oil on paperboard, 17⅞ × 12⅛ in.
(45.5 × 30.9 cm)
Gift of Mr. John D. Shapiro, 1986.44

Thomas Sully (1783–1872)
Self-Portrait, 1850
Oil on canvas, 30¼ × 25¼ in.
(76.8 × 64.1 cm)
Gift of William Wilson Corcoran,
69.51

George Symons (1861/65?–1930)
*Where Waters Flow and
Long Shadows Lie,* c. 1919
Oil on canvas, 50¼ × 60¼ in.
(127.6 × 153 cm)
Museum Purchase, Gallery Fund,
19.27

Arthur Fitzwilliam Tait
(1819–1905)
Springtime, 1899
Oil on paper mounted on
composition board, 12⅛ × 18¼ in.
(30.9 × 46.4 cm)
Gift of James Preble, 1981.98

John Robinson Tait (1834–1909)
*A Hazy Day—Upper
Delaware,* c. 1889
Oil on canvas, 18 × 24 in.
(45.7 × 61 cm)
Gift of Mr. and Mrs. Robert Hilton
Simmons, in memory of Charles E.
and Rena Whiting (Carr) Simmons,
by exchange, 2005.019

Henry Ossawa Tanner (1859–1937)
The Good Shepherd, c. 1918
Oil on canvas mounted to particle
board, 23¾ × 19 in. (60.3 × 48.3 cm)
The Evans-Tibbs Collection, Gift of
Thurlow Evans Tibbs, Jr., 1996.8.25

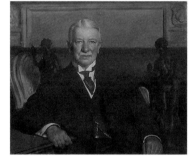

Edmund Tarbell (1862–1938)
Josephine Knitting, 1916
Oil on canvas, 26¼ × 20¼ in.
(66.7 × 51.4 cm)
Bequest of George M. Oyster, Jr.,
24.2

Edmund Tarbell (1862–1938)
Charles C. Glover, 1918
Oil on canvas, 33¼ × 38¼ in.
(84.5 × 97.2 cm)
Museum Purchase, Gallery Fund,
18.6

Abbott Handerson Thayer
(1849–1921)
Self-Portrait, 1919
Oil on wood panel, 22¼ × 24 in.
(56.5 × 61 cm)
Museum Purchase, Gallery Fund,
22.4

Abbott Handerson Thayer
(1849–1921)
Head of a Young Woman,
n.d.
Oil on canvas board,
16¾ × 13⅝ in. (42.6 × 34.6 cm)
Gift of Victor G. Fischer, 11.17

Jeremiah Theüs (1716–1774)
Gentleman of the Jones Family (Probably Samuel Jones, Jr.), before 1755
Oil on canvas, 29⅝ × 24⅝ in.
(75.3 × 62.6 cm)
Museum Purchase, Gallery Fund, 49.62

John Henry Twachtman
(1853–1902)
The Waterfall, 1890/1900
Oil on canvas, 30⅛ × 22¹⁄₁₆ in.
(76.5 × 56.1 cm)
Museum Purchase, Gallery Fund, 18.7

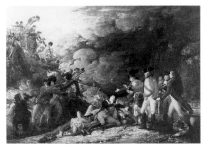

John Trumbull (1756–1843)
The Sortie Made by the Garrison of Gibraltar, 1787
Oil on canvas, 15¹⁄₁₆ × 22¹⁄₁₆ in.
(38.2 × 56.1 cm)
Museum purchase through the Gallery Fund, 66.18

S. Jerome Uhl, Sr. (1842–1916)
Grover Cleveland, 1890
Oil on canvas, 30 × 24⅞ in.
(76.2 × 63.2 cm)
Museum Purchase, Gallery Fund, 91.7

John Trumbull (1756–1843)
Amelia Maria Phelps Wainwright (Mrs. Jonathan Mayhew Wainwright), 1822
Oil on canvas, 30 × 24 in.
(76.2 × 61 cm)
Museum Purchase, Gallery Fund and gift of Ruth Wainwright Wallace, 55.22

Unidentified Artist
The "Belle Creole" at New Orleans, c. 1845/1849
Oil on canvas, 48 × 72 in.
(121.9 × 182.9 cm)
Gift of the Estate of Emily Crane Chadbourne, 65.22

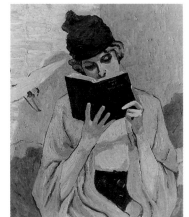

Allen Tucker (1866–1939)
A Book of Verse, 1916
Oil on canvas, 30 × 25 in.
(76.2 × 63.5 cm)
Gift of the Allen Tucker Memorial, 55.2

Unidentified Artist
Eva Cardozo, c. 1845
Oil on board, 19½ × 13½ in.
(49.5 × 34.3 cm)
Gift of the Family of Bernhard and Estelle S. Bechhoefer, 2001.28

Allen Tucker (1866–1939)
November Autumn, n.d.
Oil on canvas, 40 × 50 in.
(101.6 × 127 cm)
Gift of the Allen Tucker Memorial, 55.3

Unidentified Artist (Boston Limner)
Possibly Rebecca Chambers (Mrs. Daniel Russell), c. 1720
Oil on canvas, 30 × 25 in.
(76.2 × 63.5 cm)
Museum Purchase, Gallery Fund, 55.96

Unidentified Artist
Henry Clay, c. 1850
Oil on canvas, 27 × 22 in.
(68.6 × 55.9 cm)
Gift of William Wilson Corcoran,
73.12

Unidentified Artist
John Paul Jones, c. 1770/1780
Oil on canvas, 15⅝ × 12¾ in.
(39.7 × 32.4 cm)
Gift of James Parmelee, 41.27

Unidentified Artist
Portrait of a Gentleman,
c. 1718
Oil on canvas, 30⅛ × 25¾ in.
(76.5 × 65.4 cm)
Museum Purchase, Gallery Fund,
50.21

Unidentified Artist
*An Officer of the United
States Navy,* c. 1830
Oil on canvas, 30 × 25¼ in.
(76.2 × 64.1 cm)
Bequest of Robert Levy, 59.56

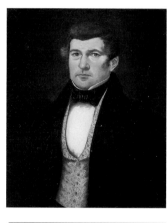

Unidentified Artist
Portrait of a Gentleman,
c. 1840
Oil on canvas, 27 × 22 in.
(68.6 × 55.9 cm)
Museum purchase through a gift
of Mrs. J. L. M. Curry, 1978.124

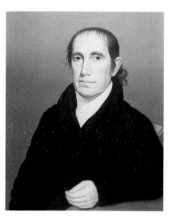

Unidentified Artist
*John Scott of Fredericks-
burg, Virginia,* n.d.
Oil on canvas, 27½ × 22½ in.
(69.9 × 57.2 cm)
Gift of Miss Virginia Jennings
Tolson, 1983.111

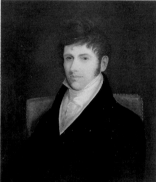

Unidentified Artist
Charles Carroll Glover,
c. 1810
Oil on canvas, 28¼ × 24⅛ in.
(71.8 × 61.3 cm)
Gift of Mrs. Nancy E. Symington
and Mr. Charles C. Glover, III,
1981.72

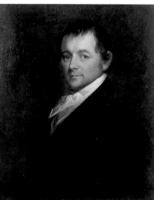

Unidentified Artist
Isaac Thom, before 1827
Oil on canvas, 27 × 21½ in.
(68.6 × 54.6 cm)
Gift of Mrs. Robert Henry Dunlap,
60.2

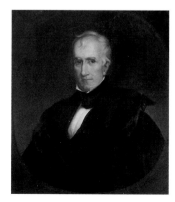

Unidentified Artist
William Henry Harrison,
c. 1850
Oil on canvas, 30 × 24¾ in.
(76.2 × 62.9 cm)
Museum Purchase, Gallery Fund,
79.22

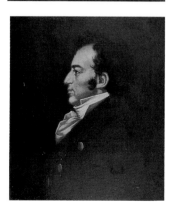

Unidentified Artist
Thomas M. Thompson,
c. 1820
Oil on canvas, 26¾ × 21½ in.
(66.7 × 54.6 cm)
Gift of Paul Magnuson, Jr., 1974.89

Unidentified Artist
The Three Huidekoper Children, c. 1853
Oil on canvas, 35 × 29 in.
(88.9 × 73.7 cm)
Gift of Elizabeth H. Stabler, 53.1

Elihu Vedder (1836–1923)
In Memoriam, 1879
Oil on canvas, 44⅜ × 20 in.
(112.1 × 50.8 cm)
Museum Purchase, Anna E. Clark
Fund, 59.23

Unidentified Artist
John Artis Willson, c. 1810
Oil on canvas, 27⅞ × 22 in.
(70.8 × 55.9 cm)
Gift of Dr. Franklin Burche
Pedrick, 51.30

Robert William Vonnoh (1858–1933)
Notre Dame de Paris, 1890
Oil on canvas, 30 × 36 in.
(76.2 × 91.4 cm)
Bequest of Bessie Potter Vonnoh
Keyes, 55.70

"J.W." Unidentified Artist
Still Life with Bread, c. 1850
Oil on canvas, 17⅞ × 24 in.
(45.4 × 61 cm)
Museum Purchase, William A.
Clark Fund, 51.22

Robert William Vonnoh (1858–1933)
Bessie Potter, 1895
Oil on canvas, 12⅞ × 10 in.
(32.7 × 25.4 cm)
Bequest of Bessie Potter Vonnoh
Keyes, 55.66

Eugene Vail (1857–1934)
Piazza del Campo, Siena,
n.d.
Oil on canvas, 28½ × 31⅛ in.
(72.4 × 79.1 cm)
Mrs. Eugene Vail, 48.45

Robert William Vonnoh (1858–1933)
Picking Poppies, c. 1913
Oil on canvas, 15¾ × 11½ in.
(40 × 29.2 cm)
Bequest of Bessie Potter Vonnoh
Keyes, 55.67

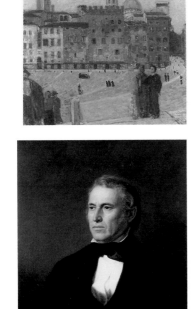

John Vanderlyn (1775–1852)
President Zachary Taylor,
c. 1850
Oil on canvas, 30 × 25¼ in.
(76.2 × 64.1 cm)
Museum Purchase, Gallery Fund,
77.8

Robert William Vonnoh (1858–1933)
Self-Portrait, 1920
Oil on canvas, 22 × 18 in.
(55.9 × 45.7 cm)
Bequest of Bessie Potter Vonnoh
Keyes, 55.69

Samuel Lovett Waldo (1783–1861)
George Washington Parke Custis, c. 1840
Oil on canvas, 36½ × 28¾ in. (92.7 × 73 cm)
Museum Purchase, Gallery Fund, 78.4

Max Weber (1881–1961)
The Visit, 1917
Aqueous media and oil, 36 × 30⅛ in. (91.5 × 76.5 cm)
Museum Purchase through a gift of Mrs. Francis Biddle, 1979.79

James Walker (1819–1889)
Review of Rhode Island and Maine Troops, 1861
Oil on wood panel, 16 × 21 in. (40.6 × 53.3 cm)
Museum Purchase, Gallery Fund, 53.13

Paul Weber (1823–1916)
Scene in the Catskills, 1858
Oil on canvas, 21 × 17¾ in. (53.3 × 43.8 cm)
Gift of William Wilson Corcoran, 69.34

Franklin Chenault Watkins (1894–1972)
Summer Fragrance, 1938
Oil on canvas, 39 × 50¾ in. (99.1 × 128.9 cm)
Museum Purchase, William A. Clark Fund, 39.3

Julian Alden Weir (1852–1919)
Autumn, 1906
Oil on canvas, 36¼ × 29⅛ in. (92.1 × 74 cm)
Museum Purchase, Gallery Fund, 12.4

Nan Watson (1876–1966)
Chrysanthemums II, c. 1930/1940
Oil on canvas, 22⅛ × 18⅛ in. (56.2 × 46 cm)
Gifts of Friends of Forbes and Nan Watson through Olin Dows, 61.3

Julian Alden Weir (1852–1919)
Obweebetuck, c. 1908
Oil on canvas, 24¹⁄₁₆ × 33¾ in. (61.2 × 85.7 cm)
Bequest of George M. Oyster, Jr., 24.3

Frederick Judd Waugh (1861–1940)
Wild Weather, n.d.
Oil on Masonite, 30 × 39⅞ in. (76.2 × 101.3 cm)
Gift of Mr. and Mrs. Ernest E. Quantrell, 44.3

Julian Alden Weir (1852–1919)
The Pet Bird, 1910
Oil on canvas, 30 × 22½ in. (76.2 × 57.2 cm)
Gift of Mabel Stevens Smithers and The Francis Sydney Smithers Memorial, 40.12

Julian Alden Weir (1852–1919)
Portrait of Miss de L., 1914
Oil on canvas, 30³⁄₁₆ × 25 in.
(76.7 × 63.5 cm)
Museum Purchase, Gallery Fund,
14.7

Eugen Weisz (1890–1954)
Portrait of a Woman, n.d.
Oil on paperboard, 21¼ × 15¾ in.
(54 × 38.7 cm)
Bequest of Renee Weisz, widow
of the artist, 1983.124.3

Robert Walter Weir (1803–1889)
*Church of the Holy
Innocents, Highland Falls,
New York,* c. 1850
Oil on canvas, 22 × 29½ in.
(55.9 × 74.9 cm)
Museum Purchase, William A.
Clark Fund, 65.13

Eugen Weisz (1890–1954)
Self-Portrait, n.d.
Oil on canvas, 36 × 24 in.
(91.4 × 61 cm)
Bequest of Renee Weisz, widow
of the artist, 1983.124.2

Eugen Weisz (1890–1954)
Sarah Baker, 1925
Oil on canvas, 78 × 48 in.
(198.1 × 121.9 cm)
Bequest of Renee Weisz, widow
of the artist, 1983.124.1

Benjamin West (1738–1820)
Telemachus and Calypso,
c. 1809
Oil on canvas, 41¼ × 58¾ in.
(104.8 × 149.2 cm)
Gift of Bernice West Beyers,
63.29.2

William Edward West (1788–1857)
*The Muses of Painting,
Poetry, and Music,* 1825
Oil on canvas, 37¾ × 32¾ in.
(95.9 × 83.2 cm)
Gift of Elizabeth H. E. McNabb in
memory of Sarah West Norvell
Leonard, 57.2

Eugen Weisz (1890–1954)
Self-Portrait, 1935
Oil on canvas, 21 × 15 in.
(53.3 × 38.1 cm)
Museum Purchase, Anna E. Clark
Fund, 43.14

Harold Weston (1894–1972)
Fruit Bowl, 1927;
reworked 1931
Oil on canvas, 24 × 18½ in.
(61 × 47 cm)
Gift of Duncan Phillips, 56.31

Eugen Weisz (1890–1954)
*North Penobscot Maine
Houses,* n.d.
Oil on canvas, 20¾ × 26½ in.
(52.7 × 67.3 cm)
Bequest of Renee Weisz, widow
of the artist, 1983.124.4

Irving Ramsay Wiles (1861–1948)
The Artist's Mother and Father, 1889
Oil on canvas, 48 × 36⅛ in.
(121.9 × 91.8 cm)
Museum Purchase, William A.
Clark Fund, 39.1

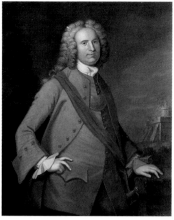

John Wollaston (active 1736–75)
Abraham Barnes, 1753/1754
Oil on canvas, 50¼ × 40¼ in.
(127.6 × 102.2 cm)
Museum Purchase, Gallery Fund
and gift of Orme Wilson, 59.57

Irving Ramsay Wiles (1861–1948)
The Student, 1910
Oil on canvas, 30⅝ × 25¼ in.
(77.8 × 64.1 cm)
Museum Purchase, William A.
Clark Fund, 11.3

Charles Woodbury (1864–1940)
Monadnock, 1912
Oil on canvas, 36½ × 48¼ in.
(92.7 × 122.6 cm)
Museum Purchase, Gallery Fund,
19.36

Hale Woodruff (1900–1980)
Landscape, 1936
Oil on canvas, 30½ × 36 in.
(77.5 × 91.4 cm)
The Evans-Tibbs Collection,
Gift of Thurlow Evans Tibbs, Jr.,
1996.8.30

William Winstanley (active
1793–before 1806)
Timothy Gay, c. 1880
Oil on canvas, 24½ × 19½ in.
(62.2 × 49.5 cm)
Bequest of Mabel Stevens
Smithers, the Frances Sydney
Smithers Memorial, 52.8

Theodore Wores (1859–1939)
White and Pink Blossoms,
1921
Oil on canvas, 16⅛ × 20⅛ in.
(41 × 51.1 cm)
Gift of Dr. A. Jess Shenson
and Dr. Ben Shenson, 1978.20

John Wollaston (active 1736–67)
*Elizabeth Penkethman
Breese (Mrs. Sidney Breese),*
c. 1750
Oil on canvas, 30 × 25⅛ in.
(76.5 × 63.3 cm)
Museum Purchase, William A.
Clark Fund, 47.8

Joseph Wright (1756–1793)
Benjamin Franklin, 1782
Oil on canvas, 31 × 25 in.
(78.7 × 63.5 cm)
Museum Purchase, Gallery Fund,
85.5

Alexander Helwig Wyant
(1836–1892)
*View from Mount
Mansfield, New York,* n.d.
Oil on canvas, 36¾ × 60½ in.
(93.4 × 153.7 cm)
Museum Purchase, Gallery Fund,
01.7

Robert Wylie (1839–1877)
A Fortune Teller of Brittany,
1871–72
Oil on canvas, 33⅞ × 47¾ in.
(86 × 121.3 cm)
Museum Purchase, Gallery Fund,
99.11

Andrea Pietro de Zerega
(1917–1990)
*Life Class, Monday
Morning,* 1936/1937;
inscribed 1939
Oil on canvas, 36¼ × 44⅛ in.
(92.1 × 112.1 cm)
Gift of Andrea Pietro de Zerega,
67.31

Zsissly [Malvin Marr Albright] (1897–1983)
Deer Isle, Maine, c. 1940
Oil on canvas, 28¾ × 62¼ in. (71.8 × 158.1 cm)
Museum Purchase, Anna E. Clark Fund, 45.5

Index

Photographic Credits

© Berenice Abbott/Commerce Graphics, NYC, 244; Michael Agee, © Sterling and Francine Clark Art Institute, Williamstown, Massachusetts, 148; © Dana Appelstein, 223, 297–98; The Art Institute of Chicago, 158; Ken Ashton, 308; Jean-Gilles Berizzi, Réunion des Musées Nationaux/Art Resource, NY, 238; © Estate of George Biddle, 288; © Estate of Isabel Bishop, 289; © Margaret Burroughs, Courtesy of DuSable Museum, 291; Chan Chao, 184; © Cooper-Hewitt, National Design Museum, Smithsonian Institution/Art Resource, NY, 108; Jason Domasky, © Baltimore County Public Library, Catonsville, Maryland, 124; © The Estate of Arthur G. Dove, 253; © Barry Downes, 241; P. Richard Eells, 214; © 2010 John F. Folinsbee Art Trust, 296; © Forum Gallery, New York, 304; © Freylinghuysen Morris Foundation, 309; Ila Furman, 70; Mark Gulezian/QuickSilver Photographers LLC, 49, 55, 57, 69, 87, 111, 120, 114–15, 117, 146, 147, 163, 169, 285, 286–87, 288, 289, 290, 291, 294, 295, 297, 298, 299, 300–301, 305, 306, 307, 309, 311, 313, 317, 318, 319, 320, 321, 324; Mark Gulezian, Collin Sundt, and Jennifer White, QuickSilver Photographers LLC, Frame Photography and Post Production, 75, 78, 79, 95, 111, 120, 139, 147, 149, 151, 175, 179, 187, 189, 193, 195, 197, 203, 207, 208, 213, 215, 217, 223, 227, 229, 231, 249, 250; © Loïs Mailou Jones Trust, 304; Katya Kallsen, © Presidents and Fellows of Harvard College, 64; © Estate of Rockwell Kent, by permission of Plattsburgh State Art Museum, Rockwell Kent Gallery and Collection, Plattsburgh, New York, 305; © Frances Frieseke Kilmer Family Trust, 219, 297; Courtesy of Library of Congress, 104, 188; Robert Lifson, 82; © 2010 Estate of Reginald Marsh/Art Students League, New York/Artists Rights Society (ARS), New York, 245; Joseph McDonald, 142; © Metropolitan Museum of Art/Art Resource, NY, 150, 162, 210, 222; Courtesy of the National Gallery of Art, Washington, D.C., 174; Courtesy of the National Gallery, London, 191; © Family of Hobart Nichols, 311; R. G. Ojeda, Réunion des Musées Nationaux/Art Resource, NY, 244; Courtesy of The Estate of Yvonne Pène du Bois McKenney and James Graham and Sons, New York, 239; © David Picken, 312; Scala/Art Resource, NY, 96; © Estate of Louis Schanker, 316; © Robert Seyffert, 316; © Estate of Raphael Soyer, courtesy of Forum Gallery, New York, NY, 250; © The State Hermitage Museum, 68; © Estate of John Storrs, 318; © Constance Porter Uzelac, 313; © Virginia Museum of Fine Arts, 86; © The Walters Art Museum, Baltimore, 107; © Harold Weston Foundation, 324; Katherine Wetzel, 86; © Nancy Lever Wiegand-Molettiere, 306; © Estate of Hale Woodruff, 325